THE PHOTOGRAPHIC EXPERIENCE 1839–1914

IMAGES AND ATTITUDES

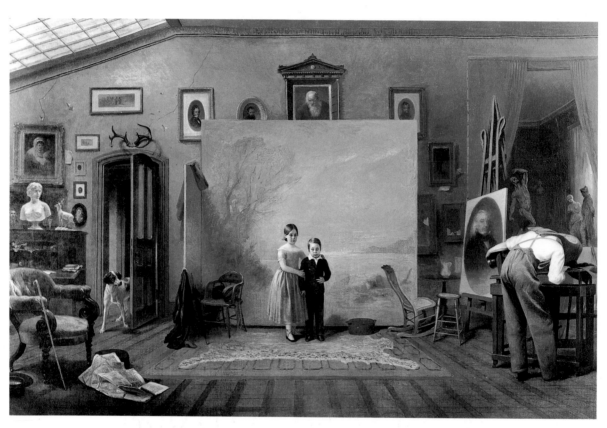

"The Children in the Studio," by Thomas Le Clair. 1865. Oil on canvas, 26¼ × 40½ inches. Reproduced by courtesy of the Hirschl and Adler Galleries, Inc., New York.

HEINZ K. HENISCH AND BRIDGET A. HENISCH

THE PHOTOGRAPHIC EXPERIENCE 1839–1914

IMAGES AND ATTITUDES

THE PENNSYLVANIA STATE UNIVERSITY PRESS
UNIVERSITY PARK, PENNSYLVANIA

Library of Congress Cataloging-in-Publication Data

Henisch, Heinz K.
 The photographic experience, 1839–1914 : images and attitudes /
Heinz K. and Bridget A. Henisch.
 p. cm.
 Includes index.
 ISBN 0-271-00930-6
 1. Photography—History. I. Henisch, Bridget Ann. II. Title.
TR15.H46 1993
770'.9—dc20 92-36781
 CIP

Published by The Pennsylvania State University Press, Suite C, Barbara Building,
University Park, PA 16802-1003
Printed in Singapore

It is the policy of The Pennsylvania State University Press to use acid-free paper for the first printing of all
clothbound books. Publications on uncoated stock satisfy the minimum requirements of American Na-
tional Standard for Information Sciences—Permanence of Paper for Printed Library Materials,
ANSI Z39.48–1984.

To Ann and Benjamin

CONTENTS

PREFACE AND ACKNOWLEDGMENTS

Long ago, while hunting for some choice medieval morsel in a dusty English bookshop, we stumbled across a series of prints of the Crimean War, signed by James Robertson. "Photohistory" was as far from our minds as the Crimean conflict itself, but the find nevertheless marked the beginning of a great adventure. The present book is one of the outcomes, the fruit of much labor, and much love. In the making of it, we have been helped by a host of correspondents, colleagues, and friends, in part by their hints, suggestions, and precious information, in part by their moral support and tolerant understanding of authors in single-minded, and far-too-often self-centered, pursuit of some elusive reference or pictorial prey.

Among those who opened our eyes to the pleasures of the subject was the late Dr. Rudolf Skopec. It is now a quarter of a century since, in the Aladdin's cave of his study in Prague, with a whole-plate daguerreotype by Daguerre propped against the desk, exotic cameras galore stacked from floor to ceiling, shelves of photographically illustrated books, portfolios of original letters signed by prime movers in the field, and drawers filled with delightful ephemera, he introduced us to the endless ramifications and riches of the photographic experience.

For more recent, and very practical help, we are greatly indebted to the following friends, well-wishers, and institutions:

William Allen, N. T. and J. B. Anderson, Felicity Ashbee, Jana Bara, William B. and Frances Becker, Whitney Bolton, J. Buberger, Van Deren Coke, Kathleen Collins, R. J. Craven, Diane Day, Keith DeLellis, K. V. Diage, Frances Dimond, Bonny Farmer, Ron Filippelli, Ken Finkel, Roy Fluckinger, Juliusz Garztecki, Nahum and Pia Gidal, Gillian Greenhill-Hannum, Robin and Diana Gregson, A. K. Grugan, Hellmut and Maria Hager, Michael Hallett, Charles Hamilton, Mark Haworth-Booth, Pauline and Bernard Heathcote, Dyveke Helsted, Alex E. James, Steven Joseph, Estelle Jussim, Karl O. Kemmler, Boris Kossoy, Cliff and Michele Krainik, Rolf H. Krauss, Julie Lawson, E. Leos, R. O. Ley, Elizabeth Lindquist-Cock, Audrey Linkman, Bernd Lohse, Eaton Lothrop, Ellen Maas, Charles W. Mann, Helen Martin, George and Marianne Mauner, Agnes

Mayer, T. McGill, Art Menard, Inge Miller, Susan Munshower, Beaumont Newhall, Colin Osman, B. Öztuncay, Peter E. Palmquist, C. Pieske, Randolph Ploog, Susan Read, Naomi Rosenblum, Jay and Janis Ruby, C. Săvulescu, Larry Schaaf, Uwe Scheid, Pierre E. Schmidt, Ernst Schürer, Lawrence Senelick, Sanford Shaman, Gertrud and Alois Siggemann, A. V. Simcock, Graham Smith, S. Fred Spira, Sandra Stelts, Sara Stevenson, Klaus Storsberg, John Taylor, Peeter Tooming, Bud Wagner, Elizabeth Walters, Stanley Weintraub, Thomas M. Weprich, Peter and Phoebe Wilsher, J. Wilson, Philip Winsor, Erika Wolf, Kristi Wormhoudt, Vicky Ziegler, Jens Zorn.

Amon Carter Museum, Fort Worth, Texas; Belgrade City Museum, Yugoslavia; British Library, London, U.K.; Francis A. Countway Library of Medicine, Boston; Delaware Art Museum, Wilmington, Delaware; Estonian Museum, Tartu, Estonia; Harry Ransom Humanities Research Center, Austin, Texas; Hirschl and Adler Galleries, Inc., New York; Houghton Library, Harvard University, Cambridge, Massachusetts; Lehr- und Versuchsanstalt, Vienna, Austria; Library of Congress, Washington, D.C.; Museum of the History of Science, Oxford, U.K.; National Library, Warsaw, Poland; National Library, Sofia, Bulgaria; National Museum of Photography, Film and Television, Bradford, U.K.; National Portrait Gallery, Smithsonian Institution, Washington, D.C.; National Trust, London, U.K.; New York Public Library; Notman Photographic Archives, McCord Museum of McGill University, Montreal, Canada; Ohio Historical Society; Parker Gallery, London, U.K.; Pattee Library, Special Collections, and the Interlibrary Loan Service, The Pennsylvania State University; Photographic Services, The Pennsylvania State University; Photomuseum Tallinn, Estonia; Royal Archives, Windsor Castle, U.K.; Science Museum, London, U.K.; University Art Museum, University of New Mexico, Albuquerque, New Mexico; The Vatican Museum, Rome, Italy; Vilnius University Library, Lithuania; Worcester Art Museum, Worcester, Massachusetts; Yale University Art Gallery, New Haven, Connecticut.

1

INTRODUCTION

A New Invention

The *annus mirabilis* of photography was 1839, the year in which the two principal inventors of the art, Daguerre in France and Fox Talbot in Great Britain, made their discoveries known to an eager and receptive public. News of the process flashed around the globe, and in no time at all enthusiastic pioneers from Auckland to Zanzibar were following the first instructions and struggling to improve their skills. The invention took root, and flourished in fertile ground. It has since been used by society in a thousand ways, and has changed our modes of perception in many more. "Blessed be the inventor of photography," wrote Jane Carlyle:

I set him above even the inventor of chloroform. . . . I have often gone into my room in the devil's own humour, ready to swear at things in general and some times in particular, and my eyes resting by chance on one of my photographs, a crowd of sad gentle thoughts has rushed into my heart and driven the devil out, as clean as ever so much holy water and priestly exorcism would have done! [T. Carlyle 1883]

Over the years, photography has performed many functions, inside and outside the realm of such informal psychotherapy. As yet, nobody

has called it the "Opium of the People," but even that is only a matter of time; already, Japan, which has more cameras per inhabitant than any other country, has been called a "photocracy" by affectionate admirers of that very feature.

Photography touches our lives, directly and indirectly, in an immense variety of contexts. Almost every form of science, technology, and commerce is in some way dependent on it and, to a much larger extent than is generally appreciated, photography has helped to shape the character of modern art, as well as the teaching of art history. Before the middle of the nineteenth century, artists and laymen grew to maturity having seen mostly paintings, drawings, and engravings as examples of pictorial expression; now their eye is trained mostly by photographs of one kind or another. To these differences of experience correspond differences of outlook and purpose. At its best, photography is itself an artistic pursuit of great sophistication, and its early history is linked with the events, tastes, and aspirations of the nineteenth century. These, in turn, have given more structure and direction to our own world than we normally care to admit.

"Photography" is a very general term; it does not define a precise activity, let alone a single purpose. Accordingly, many statements made about it by critics and defenders alike tend to be true in one sense, and untrue in another. Not surprisingly, then, intense controversies have raged concerning its status and role, but though these have deeply engaged the minds of their respective protagonists, they do not seem to have had a profound effect on photographic activities as such. Once introduced as an image-making technique, photography found its own dynamics of progress and application. Its driving forces were rarely academic; mainly they were aesthetic ("artistic"), technical ("scientific"), commercial, and social. This book is intended to reflect selected facets of this many-sided character.

Photographers themselves, though often scientific pioneers, have always been interested in wearing the artist's mantle. In the earliest years, and well past the turn of the century, they engaged in vigorous debate with skeptics and opponents (real and imagined) as to whether photography should be classified as an "art," their view being emphatically that it should. Modern photographers sometimes engage in the same argument, but tend to have much less patience with it, taking the answer for granted. And yet, this is not a battle that can ever be conclusively won or lost; it must be refought in every generation, not only because photography changes, but because our ideas of art change. Certainly, different generations have placed very different degrees of emphasis on, for instance, the need for art to be creative (imaginative), as distinct from reproductive, selective, interpretive, or linked to manual skill. Yet, photography satisfies all the criteria that we normally apply: it is, at its best, a powerful vehicle for the creative imagination; it has influenced other arts and has, in turn, been influenced by them. It has also given deep aesthetic satisfaction, not only to sophisticated critics, but to wide segments of the artistically sensitive public. It does not follow that all photography is art, let alone "high art," any more than all painting can be classified as art in such a facile way. There is room not only for the sublime, but also for the profane, and for every kind of photographic activity in between. What moves us depends on the mood of the moment; it could be an acknowledged masterpiece, but it could equally well be an impertinent trivium, the photographic equivalent of a pun, an item that appeals to an altogether different part of our mind and heart. The humblest ephemerum, rightly "kitsch" in the eyes of the aesthete, can tell us something about the affection in which photography has been held by large numbers of people. One has to accept that photography is concerned not only with the human condition and the human tragedy, but also,

in ample measure, with the human comedy.

Stenger (1938) has already lamented the fact that photography has few monuments, though the "Goddess of Photography" does appear on medallions and plaques, originally opulent, later slender and athletic, in deference to fashion's decrees (see Fig. 5-33a). There is, however, at least one major tribute paid (albeit with reservations) to photography, by no less an authority on the subject of "worth" than the Vatican. Pope Leo XIII, a daguerreotypist and the author of a Latin ode to photography (see Chapter 15), commissioned a ceiling painting for the Galleria dei Candelabri at the Vatican in 1884. It is ascribed to Domenico Torti. In the upper part of its two-level design (Fig. 1-1) it shows the traditional arts, primarily painting, being blessed by the Church. In the lower part, secondary arts receive the same benediction, photography and carpet-weaving in uneasy partnership. Whether by design or accident, these facts have an echo in that section of modern Madrid in which Calle Fotografia shares the neighborhood with Calle Herreria (blacksmithing) and Calle Carroceria (carriage building) (Anon. 1987).

Even in our own generation, 150 years and more since photography was first announced to the world at large, questions of photographic style and status remain wide open. Thus, for instance, simplicity of line may be regarded as desirable, because it constitutes stylistic purity; it may also be very dull. Conversely, an elaborate setup can give a picture a powerful story-telling mission; it can also make it appear trite and transparently contrived. A photograph can be praised for exploiting "the decisive moment" and, at the same time, accused of ignoring permanent values. In the last analysis, photographs should not be judged by abstract and universal criteria, but by criteria selected to suit the context in which the images were made. All too often, this need is ignored and, as a result, there is today only a tenuous consensus as to what constitutes a "photographic masterpiece." In this

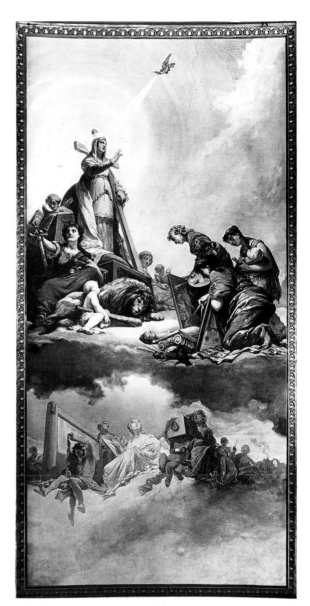

FIG. 1-1. Fresco on a ceiling of the Galleria dei Candelabri, Vatican, c. 1884. Commissioned by Pope Leo XIII and attributed to Domenico Torti. Musei Vaticani Archivio Fotografico (no. II.40.21).

situation, photographers tend to follow personally adopted role-models, drawn from the gallery of illustrious practitioners whose works have acquired the aura of icons. In a sense, artists have always done this, but in photography the diminished role played by sheer manual dex-

terity increases the risk of resting content with reverent imitation.

The same attitude also promotes a widely held view of photography's history as a development promoted almost exclusively by outstanding luminaries here and there, discovered, forgotten, rediscovered, and at last enshrined. This belief has its roots in the historical analysis of paintings, that is to say, of individual creations made for exhibition purposes of one kind or another. After a passage of time, such works call for interpretation and reinterpretation in attempts to find out "what the artist was trying to say" (Keller 1987). This art-historical template may be appropriate for a few selected images taken with a camera, but it does not fit photography as a whole.

The essays here presented are derived from a very different outlook. They invite the reader not only to a celebration of photographic excellence, but also to an informal exercise in social anthropology, an exploration of the varied relationships between photography and painting, book publishing, journalism, war, humor, and the ways without number in which photography has served as a mode of expression for sentiments public and private. To present this variety of elements comprehensively would be an immense task, but a flavor of the enterprise can be conveyed, in a less ambitious way, with a sampler of selected images and photographica in the chapters that follow. No group is exhaustive, but each illustrates one theme or another. The basic facts of photo-history are taken for granted, and technical matters are underplayed, as are most of the Great Names in the photographic pantheon, but text and illustrations are intended to demonstrate by other means "the photographic experience" in its variety, complexity, and richness. Indeed, the very diversity of that experience, and its close relationship to many other aspects of life, defy attempts at classification and linear presentation; a "linear" history of photography would be a misleading abstraction, not a discipline. Instead, the present authors have only an all-pervasive theme, running through the second half of the nineteenth century and into the twentieth, one that can be probed from a variety of angles, and that amply repays each exploration.

The "photographic experience" in its myriad forms belongs to the world at large, but essays on that experience are necessarily personal, informed and honed by close contact with some of its products and by an affectionate appreciation of them. Though it is hoped that readers will find them interesting, no irresistible "ontological" urges (à la Barthes 1981) lead these offerings to search for "metaphysical truths" about the nature of the photographic phenomenon. Hermeneutically reckless as it may be, and in respectful tribute to Malcolm Bradbury (1989), this sentence also contains the book's only reference to Derrida (1972), Foucault (1960), and Saussure (1960). The present essays are concerned more with the living photography of the *agora* than with theoretical models in the groves of *academe*.

In part, this book is also an acknowledgment, long overdue, of the immense debt photography owes to that key practitioner of the art: the illusive peripatetic master, the great "Anon." in person. This tireless worker, more than any named rival, created the pictorial record of the last 150 years, challenging us to distinguish, from the lofty heights of our own experience, the significant from the trivial, the photographic work of art from the family ephemerum. We see all these images now in ways no one intended them to be seen when they were first made. In 1837, just before the formal beginning of photography, Natalie Herzen wrote in this way to her cousin Alexander:

> Looking at your letters, at your portrait, thinking of my letters, of my bracelet, I have wished I could skip a hundred years and see what their fate would be. The things which have been for us holy relics, which have healed us, body and soul, with which

we have talked and which have to some extent deputized for us to each other in absence; all these weapons with which we have defended ourselves from others, from the blows of fate, from ourselves, what will they be when we are gone? Will their virtue, their soul, remain in them? Will they awaken, will they warm some other heart, will they tell the story of us, of our sufferings, of our love, will they win the reward of a single tear? How sad I feel when I imagine that your portrait will one day hang unknown in someone's study, or that a child perhaps will play with it, and break the glass and efface the features. [Herzen 1852]

Natalie could not have foreseen how appropriate her words would be in later times, when the personal memento in the shape of a photograph came to be within everyone's reach. In the nature of things, from 1839 onward, everything under the sun came to be photographed "for the first time," from exotic people to exotic places, the living and the dead, the mighty and the humble, the catacombs, the falling cat, the earth and the moon. Buckland (1980) has compiled an engaging anthology of such "firsts."

The history of photography is a large subject, with wide art-historical, sociological, and technical ramifications, so much so that no single volume can hope to offer a thorough and uniform coverage of it. The authors take comfort in a pronouncement attributed to a distinguished friend and colleague, who on one occasion found himself in the same predicament. "Gentlemen," he is reported to have said in response to suggestions that his exhibition was full of gaps, "gentlemen, it has never been the purpose of islands to cover the sea" (Davezac and Culpa 1985). Likewise, the present book is emphatically about raisins, not about dough. Its aims are not to provide a comprehensive treatise, but to capture the flavor of photography's nineteenth-century beginnings, its images and its attitudes.

A New Word

Photography came into a world already hungry for realism. To depict the appearance of daily life in meticulous, instantly recognizable detail was never officially regarded as the highest form of art, but it was a skill that fascinated society in the eighteenth and early nineteenth centuries.

For a long time, the Dutch or Flemish genre scene remained the yardstick by which efforts to record reality were measured. Boswell at one point spoke of his immense, detailed biography as an attempt to make a "Flemish picture" of its subject, Dr. Johnson. (Brady 1984) The growing popularity of the *camera obscura* as an entertainment, and a universal wonder at its magical ability to catch a likeness of the scene or object before it, led in due course to the use of the instrument as a fresh new synonym for truth in reporting. The readers of Fanny Burney's romance *Cecilia* (1782) were delighted with the realism of her descriptions of London life; a friend, Mrs. Thrale, remarked that the novel was just like "a camera obscura in a window of Piccadilly." (Hemlow 1958)

On December 26, 1812, during the Napoleonic Wars, a Christmas pantomime called *Harlequin and the Red Dwarf* was produced at Covent Garden Theatre in London. One of its characters was The Camera Obscura Man, who came on stage with his equipment, a much enlarged mock-up of a *camera obscura*. With this he presented to the audience two contrasting types: the stay-at-home sailor "who never weathered a gale but in a Thames wherry," and the real heroes, those "jolly tars . . . as pretty a display of British Bull Dogs as ever baited British Foes." He was important enough in the pantomime to appear on a sheet of its main characters, published in February 1813. (Mayer 1969)

One forerunner of the photograph, the silhouette in its simplest form, showed only the outline of a profile, with none of the detail. Even so, skilled hands and sharp scissors could snip

out an arresting likeness, and occasionally the term "silhouette" itself was chosen to characterize a lively, recognizable verbal sketch. An example of this figurative use of the word, a remark made by Lady Morgan in 1819, is recorded in the *Oxford English Dictionary*: "The baron's silhouette of the Lady of Copet was certainly very amusing."

As soon as the daguerreotype arrived on the scene, it eclipsed all rivals. From its first entry it was hailed as the new standard-bearer of truth in observation and accuracy in record, and its name slipped without a ripple straight into the mainstream of fashionable vocabulary. In his June 1840 review for *Fraser's Magazine* of the Royal Academy's summer exhibition, Thackeray singled out the paintings of Daniel Maclise. He marveled at their extraordinary realism ("There is a poached egg which one could swallow") and declared that the artist had a "daguerreotypic eye." Mrs. Gaskell, in her description of Charlotte Brontë's 1849 novel *Shirley*, wrote: "Miss Brontë took extreme pains. . . . She tried to make her novel like a piece of family life" and said of some characters in the story: "The whole family of the Yorkes were, I have been assured, almost daguerreotypes" (Gaskell 1857).

And yet, dissenting views, albeit widely disregarded, began to be heard quite soon. Thus, for instance, in a humorous work of 1847 called *Der Schützling*, Johann Nestroy allows one of his characters to vent misgivings about the attractions of daguerreotype portraiture:

> So ein dicknasets daguerreotypisches
> G'sicht
> Heisst nichts: etwas schmeicheln ist für'n
> Mal'r a Pflicht.
>
> [A big-nosed daguerreian face is (good for)
> nothing; flattery is the painter's
> obligation.]

He goes on to point out that no one can tell from a daguerreotype how the happy bride will look in ten years' time, and remains unmoved by facile notions of "progress":

> Ich schau' mir den Fortschritt ruhig an
> Und Find', 's is nicht gar so viel dran!
>
> [I calmly look at progress, and find that
> there isn't that much to it. See Koppen
> 1987.]

A lonely voice; most authors believed otherwise and exploited the new word shamelessly to tempt the public into purchase. Today's collector of early photographically illustrated books soon learns the hard way to be wary of titles like "Daguerreotype Pictures Taken on New Year's Day" (Osgood 1843) or *Social Life of the Chinese: A Daguerreotype of Daily Life in China* (Doolittle 1868). Such promises of treasure within lead not to sparkling images on silver, but to heartbreak amid impenetrable thickets of Victorian typesetting.

Throughout the world, there was a mushrooming of publications, each with a different aim but all with remarkably similar titles, from the *Daguerreotyp* (1841) of Pozsony, Hungary, to *The Daguerreotype* (1847–49) of Boston (Gernsheim 1984). This journal's preface offers an explanation of the masthead that finds an echo in other editorial offices: "It is intended to supply . . . a series of striking pictures of the constantly varying aspect of public affairs . . . and is, therefore, not inaptly called 'The Daguerreotype.'"

The dominance of the word, in the first, heady years of the new art, is well demonstrated by a tiny, telling change in a caption. In 1844 there was published in Paris *Un Autre Monde*, by J.-J. Grandville. One of the illustrations (Fig. 1-2) shows the moon gazing down at her own reflection in a pool below. The caption reads: "La lune peinte par elle-même." In the 1847 Leipzig edition of the book, the charming fancy has been brought up to date: "Luna sich selbst daguerreotypirend" ("The moon daguerreotyp-

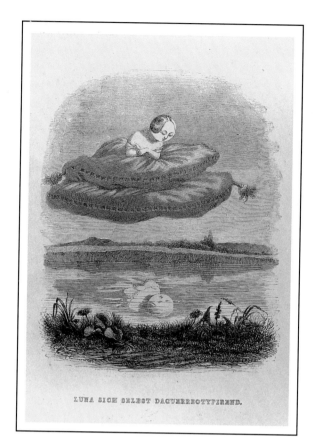

LUNA SICH SELBST DAGUERREOTYPIREND.

FIG. 1-2. Illustration from the 1847 Leipzig edition of *Un Autre Monde*, by J.-J. Grandville (1803–47), first published by Fournier in Paris in 1844. The book gathered together a number of weekly installments that had begun to appear in mid-February 1843. The original (1844) caption reads "La lune peinte par elle-même," but, significantly, for this 1847 German edition the words have been changed to "Luna sich selbst daguerreotypirend" ("the moon daguerreotyping itself"). Grandville, a brilliant artist whose gentle, witty fantasies shimmer with allusions to the topics of the day, had already touched on the new art of photography in his *Scènes de la vie privée et publique des animaux* (1842). T. N. Gidal Collection.

ing itself"); see Gidal and Wilsher 1990.

Just how little the photographic process in general, and the term "daguerreotype" in particular, were understood by the general public can be seen from an article that appeared in the *Pittsburgh Morning Post* of February 23, 1848, having been communicated by Edmund Ruffin of Petersburg, Virginia:

> *A Daguerreotype Image Made by Lightning.* This rain was enlivened with very loud thunder, which was echoed back by the hills in the neighborhood in a frightful manner. There is something in the woods that makes the sound of this meteor more awful and the violence of the lightning more visible. The trees are frequently shivered down to the root, and sometime perfectly twisted. But of all the effects of lightning that I have ever heard of, the most amazing happened in this country in the year 1736. In the summer of that year a surgeon of a ship, whose name was Davis, came on shore at York to visit a patient. He was no sooner got into the house, but it began to rain with many terrible claps of thunder. When it was almost dark, there came a dreadful flash of lightning, which struck the surgeon dead as he was walking about the room, but hurt no other person, though several were near him. At the same time it made a large hole in the trunk of a pine tree, which grew about ten feet from the window. But what was most surprising in this disaster was, that on the breast of the unfortunate man that was killed was the figure of a pine tree, as exactly delineated as any limner in the world could draw it; nay the resemblance went so far as to represent the color of the pine, as well as the figure. The lightning most probably must have passed through the tree first before it struck the man, and by that means have printed the icon of it on his breast. But whatever may have been the cause, the effect was certain, and can be attested by a cloud of witnesses who had the curiosity to go and see this wonderful phenomena [*sic*]. [Weprich 1990]

Even in more sober discourse, the word "daguerreotype" was often used generically, and it

stood for photography as such; the public was not quick to distinguish between different processes. Thus, for instance, the *American Phrenological Journal* of January 1854 carries an article (itself based on one that had appeared in the *Manchester Guardian* of July 1853) entitled "Daguerreotypes on Wood." In this, Robert Langton is credited with producing the first image on silver-halide impregnated wood, for later engraving. It was *reversed*, of course, and "reduced to a miniature, such that no hand of human artist can ever hope to rival in its exquisite delicacy of light and shade, and its elaborate minuteness and detail. . . . Mr. Langton's daguerreotype can now in a few seconds accomplish what it would require hours for the artist to effect." In the article itself, the image is also

called a photograph but, without spending any time on terminological niceties, the *Manchester Guardian* gives the new invention its blessing: "any thing which will cheapen productions calculated to promote the cultivation of popular taste, must be regarded as promoting the education and refinement of society."

"Photography," a less exclusive term, received the same treatment and evoked the same response. When the great chef Alexis Soyer apologized for the difficulty he found in remembering everybody he had encountered during his own quixotic Crimean War campaign, he said: "I met and received attentions and aid from numbers, of whom it is impossible to retain more than a slight photographic sketch of their noble Saxon countenances" (Soyer 1857). Even

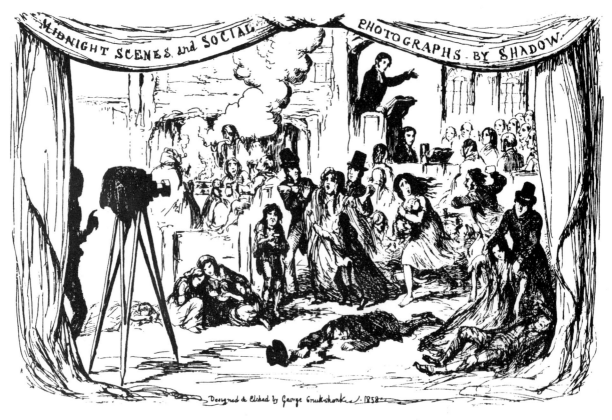

FIG. 1-3. Frontispiece of *Midnight Scenes and Social Photographs, being Sketches of Life in the Streets, Wynds and Dens of the City. By Shadow*, Thos. Murray & Sons, Glasgow, 1858. Designed by George Cruikshank. See also Anon. 1858.

Micah the prophet was once hailed as a photographer with the pen, if not the camera. When the Rev. Andrew Thomson saw the ruins of Samaria in 1869, he found them in exactly the state that had been grimly foretold in the Old Testament: "We confess to our having been startled when we read those ancient prophetic words and saw with what minuteness they had photographed the living picture that lay before us" (Pemble 1988). A bleak report of poverty in Glasgow, published in 1858, took as its title *Midnight Scenes and Social Photographs, being Sketches of Life in the Streets, Wynds and Dens of the City. By Shadow.* Shadow's camera, the only photographic item to be found in the whole book, appears in the frontispiece (Fig. 1-3), designed by George Cruikshank. (Anon. 1858; Stevenson 1990)

Inconsistency is the exasperating, endearing essence of the human mind; truth is praised, but is it wanted? Public and photographer alike soon found that truth unvarnished could be dispiriting, often dull, and even downright disagreeable. Lip service to sober fact put up the smokescreen behind which magic could be demanded, and magic could be made. Clients longed for a heightened, sweetened reality, and operators were happy to oblige. The photographer became a showman in the studio and a conjurer in the darkroom. Fantasy flowered from a heady brew of lenses and chemicals, manipulation and montage. Painted scenery and favorite props set the stage for hopeful dreams and welcomed deceptions. At the still center of the giddy whirl stood the camera, its reputation as an instrument for recording facts secure, busily at work and leaving no pause for anyone to echo Pilate's ever-baffling question: "What is truth?"

Chapter 1 References and Notes

ANON. (1858). *Midnight Scenes and Social Photographs, by Shadow*, 1976 reprint, *Glasgow, 1858*, with an introduction by John F. McCaffrey, University of Glasgow Press, Glasgow.

ANON. (1987). "Detail from a Street Map of Madrid," *History of Photography*, vol. 11, no. 2, p. 122.

BARTHES, R. (1981). *Camera Lucida: Reflections on Photography*, Hill & Wang, New York.

BRADBURY, M. (1989). *Mensonge*, Arena, London.

BRADY, F. (1984). *James Boswell: The Later Years, 1769–1795*, McGraw-Hill, New York, p. 427.

BUCKLAND, G. (1980). *First Photographs: People, Places, and Phenomena, as Captured for the First Time by the Camera*, Macmillan Co., New York.

CARLYLE, T. (1883). *Letters and Memorials of Jane Welsh Carlyle* (ed. J. A. Froude), Longmans, Green & Co., London, vol. 3, p. 15.

DAVEZAC, B., and CULPA, Nostra (1985). We can't for the life of us remember how this piece of information came to hand.

DERRIDA, J. (1984). *Synéponge/Synesponge*, Columbia University Press, New York.

DOOLITTLE, J. (1868). *Social Life of the Chinese: A Daguerreotype of Daily Life in China*, Sampson Low, London.

FOUCAULT, M. (1976). *Histoire de la Sexualité*, vol. 1. Gallimard, Paris.

GASKELL, E. (1857). *The Life of Charlotte Brontë*, Folio Society, London, 1971 reprint, p. 318.

GERNSHEIM, H. (1984). *Incunabula of British Photographic Literature, 1839–1875*, Scolar Press, London, p. 147.

GIDAL, T. and WILSHER, A. (1990). *History of Photography*, vol. 14, no. 3, frontispiece.

HEMLOW, J. (1958). *History of Fanny Burney*, Oxford University Press, Oxford, p. 164.

HERZEN, A. (1852). *Ends and Beginnings*, chapter 3, translated by Constance Garnett, revised by Humphrey Higgins. Modern edition in *The World's Classics*, Oxford University Press, 1985, p. 36.

KELLER, U. (1987). "The Twilight of the Masterpiece," *Bulletin of the California Museum of Photography*, vol. 6, no.1, p. 2.

KOPPEN, E. (1987). *Literatur und Photographie*, J. B. Metzlersche Verlagsbuchhandlung, Stuttgart.

MAYER, D., III (1969). *Harlequin in His Element*, Harvard University Press, Cambridge, Massachusetts, pp. 177, 275.

OSGOOD, F. S. (1843). "Daguerreotype Pictures Taken on New Year's Day," short story in *Graham's Lady's and Gentleman's Magazine*, vol. 23, pp. 255–57.

PEMBLE, J. (1988). *The Mediterranean Passion: Victorians and Edwardians in the South*, Oxford University Press, Oxford, pp. 187–88.

SAUSSURE, F. de (1960). *Course in General Linguistics*, Peter Owen, London.

SOYER, A. (1857). *Soyer's Culinary Campaign*, George Routledge & Co., London, pp. 234–35.

STENGER, E. (1938). *Die Photographie in Kultur und Technik*, Verlag E. A. Seeman, Leipzig.

STEVENSON, Sara (1990). Personal communication, acknowledged with thanks.

WEPRICH, T. M. (1990). Personal communication, acknowledged with thanks.

2

PHOTOGRAPHIST IN CHARGE

The Iconographer

Studio portrait photographers—or photographists, as they often liked to be called—have always been the most long-suffering members of the photographic community, anxious to leave their artistic mark on the scene, while being totally dependent on the patronage and taste of philistine clients. From the very first, customers clamored for miniature portraits in the style of paintings, taken with a minimum of fuss, and sold at a fraction of the price. And yet, the photographer never enjoyed the latitude extended to the practitioners of the more ancient art. Painters were willingly granted several studio sessions, in which they came to know their clients; accordingly, what they painted was not any specific attitude, but the integrated memory of all the poses and postures assumed by the client during such encounters. They were able to ignore the accidents and concentrate on the essence. To be sure, their commission was to achieve "a good likeness" in general terms but, just as much, their aim was to convey character and personality features that transcended the transient. Photographers aimed at the same result, but their objectives were frustrated, first by the insensitivity of the plates, and later, indeed,

by their very sensitivity. The former made it necessary for clients to assume unnaturally stiff attitudes that could be held during the long exposures; the latter tended to produce snapshots, where icons were called for. The photographer's dilemma was solved less by any resolution of the inherent conflict than by a change in the client's expectations; we no longer demand or expect an icon. Over the years, photography has changed too, and operators have learned to make studio images that embody a precious element of spontaneity, without descending to the triviality of a snapshot.

Not everyone recognized the problems for what they were. It is, for instance, altogether astonishing that someone as sophisticated as George Bernard Shaw, who certainly regarded himself as a potent critic, failed to do so. He maintained that only ingrained conservatism caused portrait painters to adhere to their outdated techniques with brush and palette, and that nothing which deserved to be called "art" could be embodied in brush-strokes and textures. More than half a century after Paul Delaroche ("From today painting is dead"), Shaw wrote:

> For surely nobody can take three steps into a modern photographic exhibition without asking himself, amazedly, how he could ever allow himself to be duped into admiring, and even cultivating an insane connoisseurship in, the old barbarous smudging and soaking, the knifing and graving, rocking and scratching, faking, forging, all on a basis of false and coarse drawing, the artist either outfacing his difficulties by making a merit of them, or else falling back on convention and symbolism to express himself when his lame powers of representation break down.

> If you cannot see at a glance that the old game is up, that the camera has hopelessly beaten the pencil and paintbrush as an instrument of artistic representation, then you will never make a true critic; you are only, as most critics, a picture fancier.

> I marvel at the gross absence of analytic power and of imagination which still sets up the works of the great painters, defects and all, as the standard, instead of picking out the qualities they achieved and the possibilities they revealed, in spite of the barbarous crudity of their methods.

[From *The Amateur Photographer*, London, October 11, 1901. See also Shaw 1906, Jay and Moore 1989, and Parsons 1990.]

Despite the relative speed of camera work, studio clients knew well enough that the photographer could not be hurried. Posing the sitter took time, and so did the actual exposure, depending, at any rate in the earliest period, on the operator's skill in preparing the plates, the reliability of the supplier of chemicals, the time of day and, to a very notable extent, the quality of the camera lens. Most photographers of the daguerreotype era used the Petzval lens, the first composite lens of any kind to be actually designed, rather than assembled by trial and error, which had been the general practice. In the years following 1840, the Petzval lens made portraiture commonplace, because of its high light power.

Joseph Max Petzval was one of the giants of nineteenth-century science. Born in Slovakia, of Czech parents, who spoke German, as all intellectuals did, and also Hungarian (the official language at the time), Petzval was probably preoccupied in his boyhood with the linguistic diversity surrounding him, which may account for the fact that his first recorded deed was to fail mathematics in school. However, the experience did the young man no harm, and when we next hear of him, he is professor of mathematics at the University of Budapest. Soon afterward he came to hold the same title at the even more prestigious University of Vienna. His

polyglot origins now enable five nations to claim him as a native son. When he learned of Daguerre's invention and its needs for higher light sensitivity, he realized that the customary triplet (three-component lens) design could be improved and optimized by taking into account the nature (refractive indexes) of the glasses used and the curvatures of the lens surfaces. The calculations took many months and, in order to speed the work, Petzval contracted some of it out to none other than the Austrian Army. That army (like all others at the time) kept a group of able but run-of-the-mill mathematicians at hand to calculate such fascinating things as the trajectories of cannon shells, and it was just such a group that Petzval came to use (Skopec 1963, 1978). It is a poignant thought that there actually was a Golden Age in which an academic scientist could issue a research contract to the army, instead of waiting cap-in-hand for one from the High Command. Considering that Petzval was primarily a mathematician, he is on record with a wholly unorthodox evaluation of his own craft: "Nearly all learned men are agreed that analytical optics is a science whose value depends entirely on the successes of the art associated with it . . ." (Petzval 1843).

Equipped with a good lens, photographers claimed to be able to take portraits in a jiffy, and so indeed they could, in relative terms, but it was found in due course that such portraits tended to depict disconcerting parts of the sitter's personality, parts revealed by spontaneous, unplanned, and often unwanted gestures and expressions. During the early years, that did not constitute a problem, since the plates were too slow to support the photographer's boast. On the contrary, with exposures lasting several seconds, clients, already intimidated by the unfamiliar ambiance of the studio, and roasted to tender conformity with the photographist's wishes by the sunlight that mirrors concentrated on their faces, had to be instructed to keep absolutely still. For those unable to comply, aids were provided during the early years in the form

of head clamps and supporting stands. H. J. Rodgers (1872) of New York, for instance, in his self-published book of personal reminiscences (and much else), described his headrest equipment as "indispensable." Supporting stands may be seen in many mid-nineteenth-century portraits, for example, in Figures 2-1 and 2-2. The results were occasionally respectable, but more often they proved to be artistic disasters, catching victims in poker-stiff poses, eyes staring with expressions of anything between apprehension and near-terror at the strange machine in front of them. (See also Chapter 9.) All too often, an aura of suspended animation clung to the images, giving an overall impression of permanent, demented rigor (Fig. 2-3). Photographers did their best to counteract the tendency and, even in the early years, contrived the carefully posed "snapshot." Though the results were rarely convincing, a few distinguished achievements are on record. The portrait in Figure 2-4a succeeds in large part because the subject is *not* looking into the camera, thereby suggesting a scene or happening outside the frame of the picture. The stratagem was already well-known to painters. Of course, the subject, C. Hayden Coffin, was a professional actor, and the spontaneity of Figure 2-4a is gracefully contrived; in the earlier image of Figure 2-4b, and the much earlier one of Figure 2-4c, it is achieved by transparently thespian feats of mime, less subtle perhaps, but effective nonetheless. In contrast, another theater photograph, Figure 8-19, looks stiffly posed, with members of the group having only compositional and geometrical relationships to one another, presented as a collection of stage props, rather than a group of stage actors.

Figure 2-3c is an early example of an "occupational" photograph, showing a client with the tools of his trade, his "cards of identity," thereby conveying notions of character and status. The practice of doing this was already familiar in painting, as can be seen, for example, in Giovanni Battista Moroni's "Bearded Man" of 1561 (Golahny 1990), and the roots of such

(a) (b)

FIG. 2-1. Cabinet cards of the 1880s. American.

(a) Paperboy, cap in hand, newspaper under arm. Unknown photographer. Two footstands are clearly visible, one in use, another "parked" on the right. Elaborately painted backdrop.

(b) Portrait of a young man holding on to a paper-thin studio prop, incongruously placed in front of a painted background, as if anticipating Ogden Nash's "I think that I shall never see / A billboard lovely as a tree."

emblematic representations are, indeed, much older still. In this particular image, the everyday objects help to define the subject for the viewer, but seem to have done little for the client to ease the strain of the sitting.

The problem of stiffness received its partial solution when plates became fast enough (during the 1870s and 1880s) to allow something resembling a real snapshot to be taken, but the cardinal problem of characterization remained and, indeed, remains with us to this day. It arose quite simply, but profoundly, from the fact that

a photographer can photograph only what is in front of the camera at the time; the machine itself is incapable of functioning as an "integrator of experience." Photographers knew this well, even though the clients themselves did not appear to understand it, and took steps to ensure that what was in front of the camera was a "significant image," not a mere accident of the moment. Accordingly, clients were carefully posed, but before electric studio lights became common (at the end of the century), little could be done to vary the setting by means of dramatic lighting

control. All auxiliary light sources were welcome, however humble, however whimsical. Along such lines, Dr. John Vansant of the United States Marine Hospital at St. Louis claimed in 1887 to be the first to have taken photographs by the light of fireflies. He reported placing twelve fireflies in a three-ounce bottle and covering its mouth with a fine net. The average duration of the flash from each insect was half a second, and the luminous area near the abdomen about one-eighth of an inch square. The time of exposure was fifty flashes (Vansant 1887). There is no evidence that the learned doctor's technique was widely imitated. However, of other fanciful attempts to control lighting there was no shortage, nor was this aspect of studio work considered minor in any sense. No less a person than J. H. Kent, of Rochester, New York, later president of the Photographers' Association of America, presented a paper on the subject to the assembled members of the National Photographic Association in Philadelphia in July 1871. In his lecture he described, with the utmost earnestness, a gi-

(a) (b)

FIG. 2-2. American cartes-de-visite of the late 1870s. Gelatin silver prints. Note footstands on both images.
(a) Young girl, leaning on a standard mail-order studio chair. Made by M. J. Bixby, Castleton, Pennsylvania.
(b) Naval officer. Unknown studio.

(a)

(b)

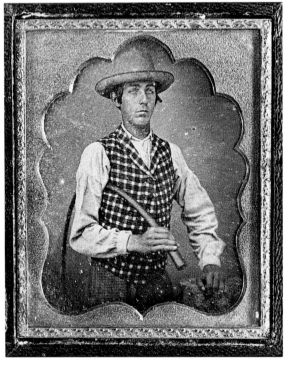

(c)

FIG. 2-3. Horror in suspended animation. American sixth-plates.

(a) Portrait of a Lady with hat, c. 1860. Unknown photographer. Ambrotype, ruby-glass type.

(b) Hand-tinted portrait of a young lady, with elaborately painted backdrop, c. 1860. Ambrotype, ruby-glass type.

(c) The Cattle Drover. Early "occupational" portrait. Mid-1850s. Daguerreotype, possibly by John Plumbe, Jr.; see Rinhart 1969 for a brief biographical note.

FIG. 2-4. Examples of "planned spontaneity."

(a) Portrait of C. Hayden Coffin, by Walery (Count S. Ostroróg) of London. 1887. Woodburytype, 4⅜ × 3½ inches. Coffin was a Shakespearean actor, and the photographer a Polish nobleman-emigré who operated studios in Paris and London (164 Regent Street). The London studio was probably opened in the early 1870s, after the Franco-Prussian War. This particular portrait was commissioned by *The Theatre*. In 1892 Ostroróg was made a member of the Linked Ring Brotherhood. See Garztecki 1977 and Harker 1979.

(b) The Trump Card. Half-plate ambrotype of a poignant moment: one player holds four aces, the other four kings, supported, however, by a Derringer pistol, which is certain to make him the winner. Late 1860s or early 1870s. American. Art Menard Collection. See also Buberger 1978.

See also (c)–(d).

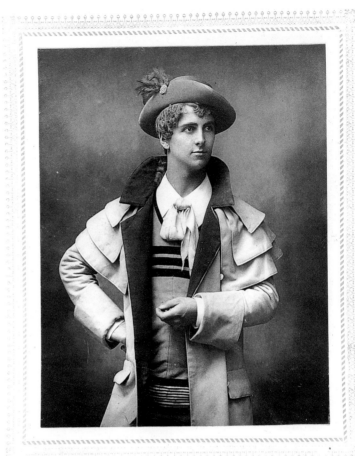

(a)

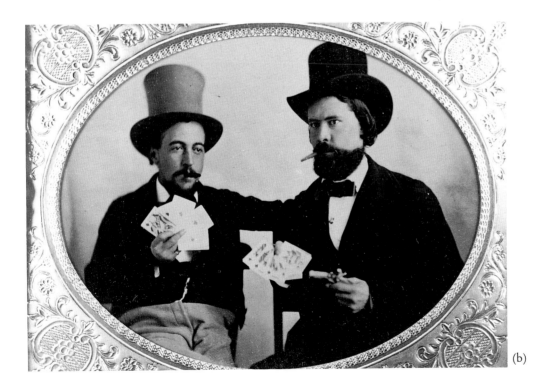

(b)

(c)

FIG. 2-4 (c) The Wine Tasters. American daguerreotype, quarter-plate, c. 1850. Unknown photographer. Note the story-telling element and informality, unusual in a daguerreotype.

(d) Newspaper Readers. American tin-type, quarter-plate, c. 1900. Unknown photographer. A posed picture, but one managing to convey a degree of informality that was still uncommon, even at the turn of the century.

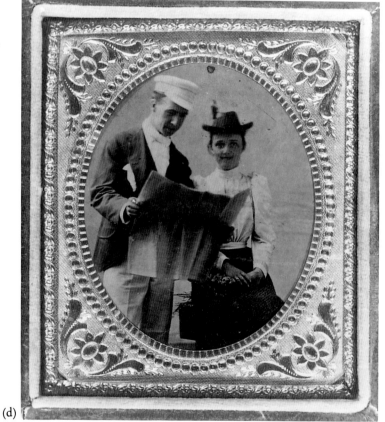

(d)

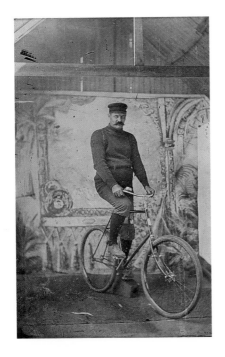

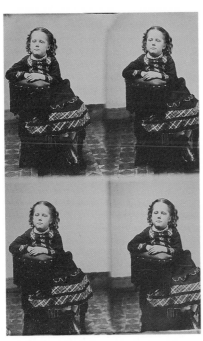 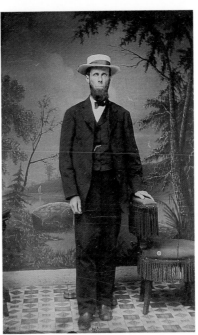

(a)

FIG. 2-5. Tintype Studio Miscellany, illustrating studio practice, backdrops, furnishings, and artifacts, c. 1890. American. Various photographers.

(a) Half-plates. *Top left:* Note incongruous backdrop, and reflecting screen. *Top right:* Note mock grass. *Bottom left:* Image made with a four-lens camera (see Lothrop 1973, Scheid 1977, and Fig. 2-7). *Bottom right:* Note jungle backdrop, linoleum floor, and footstand.

(b) Drawing Room Scene, 3½ × 2½ inches. The bicycle is here a double symbol of technical progress and of women's emancipation. Compare (a) top left. See also Ruby 1990.

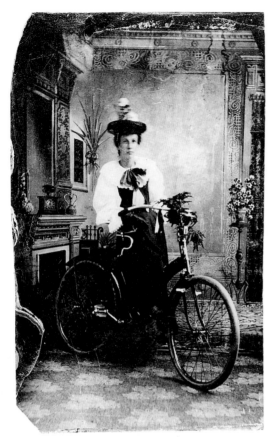

FIG. 2-5 (b)

ant hand-held paddle that could be used to reflect light into desirable places:

> I have resorted to the use of a rod upon the end of which is a very light frame about 3 feet square, covered with tissue paper. This frame is held in the hand during the exposure, shutting off the light here and throwing it on there, until I get as nearly as possible what is needed.

Kent's essay was duly published (Kent 1871), and the device, simple as it was, proved to be popular. In 1878, another writer referred to it in the same journal, claiming: "You Kent afford to be without it" (Hough 1878).

While the available means of controlling light were limited, in the control of ambiance a great deal could be attempted with backdrops and studio props, and the fabrication of such items became a secondary industry in its own right. Here and there, fashionable photographers did, indeed, attempt to match their studio props to the status and calling of individual clients but, in a far larger number of cases, and to an extent altogether surprising to twentieth-century minds, almost no care was taken to make backdrops consistent with the client's character and dress, or even self-consistent with the studio furnishings. Thus, an elegant young man with a top hat might well be depicted against a wilderness background, romantic, sometimes fierce and impenetrable, reaching almost, but not quite, down to a patterned linoleum floor (Fig. 2-5a). Such things were done not only by provincial studio operators but also by some of the leading luminaries of the profession. Thus, Paul Nadar, in 1890, depicted the artist Caran d'Ache in elegant court dress against a totally incongruous nature-in-the-wild setting (Daval 1982). Simulated action photographs were particularly popular, at a time when the slowness of the available plates prevented photographers from capturing the real thing. We thus find mock boxers, for instance, poised for an avalanche of punches that were never destined to land (Fig. 2-6 a and b). However, a photographer of Paul Nadar's caliber was not satisfied with anything like that; in 1892 he took a whole series of pictures of boxers, under the title "La Lutte et les Lutteurs," in which "contact" was indeed established (Braive 1966). Clients who had no interest in boxing were often photographed as bathers about to brave a studio sea (Fig. 2-6c) or as daring horsemen on stationary steeds (Fig. 2-6d).

Figure 2-7a shows an example of a multiple tintype portrait made, for speed and convenience, with a sixteen-lens camera. The individual photographs were later separated by cutting the sheet metal with shears. That kind of equipment achieved its peak of popularity during the carte-de-visite period, but had been known much earlier. For a daguerreotype example, see

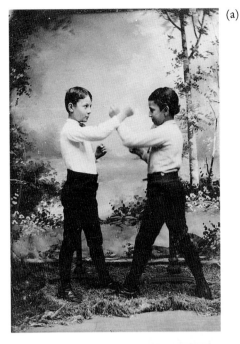

(a)

FIG. 2-6. The Great Outdoors. Unknown photographers. American.

(a) Boxers in vicious combat; staged studio event. Tintype, 3½ × 2½ inches. 1880s. Note the vertical props.

(b) Boxers in vicious combat; staged in the open air. Ambrotype, sixth-plate, c. 1863. Amon Carter Museum, Fort Worth, Texas.

(c) The Bather. Tintype, 5 × 3¼ inches. 1880s–1890s.

(d) Valiant studio horsemen and their steed. Tintype, 3½ × 2⅜ inches. 1880s–1890s.

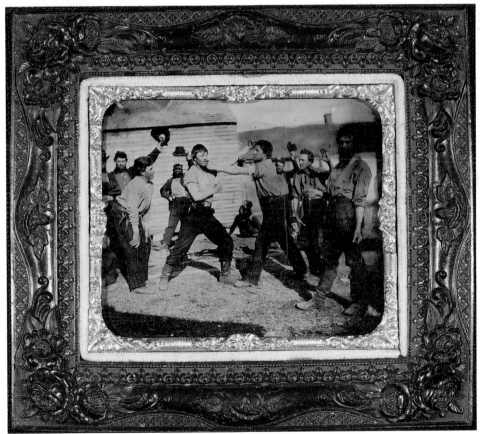

(b)

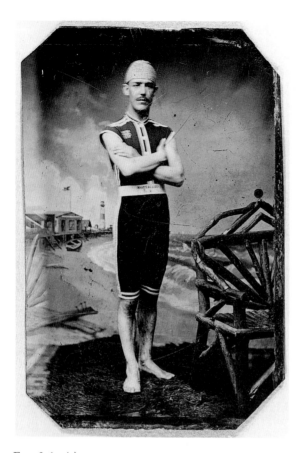

FIG. 2-6 (c)

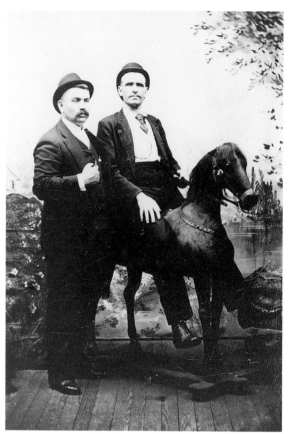

(d)

Kemmler (1987), who also found a contemporary cartoon showing multiple pictures being taken *before* multiple-lens cameras were actually available (Fig. 2-7b). This technique is known to have been used by Isenring, the Swiss daguerreotypist and pioneer in hand-coloring; for more on Isenring, see Chapter 4. Figure 2-7c shows that the same effect could be achieved with a single camera and a single (asymmetrically placed) lens, albeit here for a compositional purpose, by the simple method of rotating the daguerreotype plate.

FIG. 2-7. Multiple Exposures.

(a) Group of "gem" tintypes, made simultaneously with a sixteen-lens camera, and intended for mounting on cartes-de-visite. 4⅛ × 3⅛ inches. 1860s. Unknown photographer. American. Taking sixteen photographs at a time was a widely practiced revenue-boosting technique.

(b) Cartoon of the daguerreotype period showing the simultaneous use of single-lens cameras, according to a suggestion by Isenring. Karl O. Kemmler Collection. See also the *Photo-Antiquaria Special* (W. Siener), November 1987.

(c) Mirror daguerreotype, made with a single-lens camera; successive exposures after plate rotation. Rare example, sixth-plate. 1850s. American. Art Menard Collection. See also the *Photo-Antiquaria Special*, November 1987.

(b)

(a)

(c)

MASTER OF MAKE-BELIEVE

To those who spend long hours looking at nineteenth century photographs, certain standard pieces of studio furniture, like the fringed plush chair in Figure 2-2a, become as familiar and as welcome as old friends. Such props were mass-produced, and intended to give even the most fly-by-night establishment an air of professional legitimacy. To this stock of routine items, held in common by a thousand operators, the enterprising photographer tried to add a touch of fantasy, some piece of illusionistic stage equipment—such as, for example, the swing shown in Figure 2-8. That "swing" was designed to stay permanently at rest before the camera; its "ropes" were in fact sticks that never touched the ceiling, and so never put its strength to the test. (Lothrop 1984)

By many simple devices, the conventional studio could be transformed into a wonderland of different settings. There is, for instance, a British patent (Spec. 18410), filed on November 15, 1890, by William Watson of Glasgow under the title "Improvements in Photographic Backgrounds," which provides for "a background having, preferably, interchangeable parts, interior or exterior views of a railway carriage, 'Pullman car', tramway car, or omnibus." Once this was in place, the customer could be "photographed as just going to or stepping into a train or car, or as looking out of the window, or sitting in a seat, etc." (Heathcote 1984). In December 1885, Alexander Robinson had already sought a patent for an even more eccentric device, one that made it appear as if the client had three legs (Fig. 2-9). Three-leggedness was never a universally cherished attribute, but it was and is much loved in Robinson's homeland, the Isle of Man, where such a creature is featured in the official coat of arms. Robinson, not a wordsmith of distinction, was doggedly thorough in describing his invention:

. . . a light artificial leg made to any required size, bent or straight, or with adjustable joint or joints, and to be attached to the person so as to appear to be a third leg. The end next the body is provided with straps, and a joint close to the body or soft air cushion or both so as to fit it in any required position to the body. It must be dressed with trousers, knickerbockers, stocking, sock, legging, shoe or boot to correspond with the dress of the wearer, and can be fitted with spurs or not as desired. It is preferably made of papier mâché, cork, tin, pasteboard or inflated rubber cloth. To enable two of the legs to rest clear of the ground I prefer to let the real leg at least, or both, to rest on a fine wire suspended from above." [Heathcote 1985]

Business enterprise made it possible for standard props and backdrops to be mail-ordered and sent out across the country, to appear again and again in studio portraits taken at different times in different places (Fig. 2-10a). Thus, for instance, "Interiors, Landscapes, Cottage Windows, Balustrades, and Artificial Rocks," as well as "Artificial Ivy, Artificial Vines, and Rustic Accessories," were all advertised in the 1878 and 1888 issues of the *St. Louis Practical Photographer* and in similar publications all over the world. A January 1890 advertisement in *The Photo-Miniature* offered "six backgrounds for a dollar; a special design, printed on cotton, four feet square, with which SIX different effects can be produced. . . ." In passing, the advertisement mentions that LUXO, at 33 cents per ounce, is the Best Flash Powder in the World.

The need for make-believe was felt from the first. A daguerreotypist in the south of England took care to point out the enticing additions he had made to his own studio in an advertisement placed in a local newspaper in September 1848: "Having introduced some novel and INTEREST-ING SCENERY, Mr. S. begs also to intimate that

the dull monotony of the background is destroyed, and the general pictorial effect increased." (Scott 1991)

With such resources readily at hand, even the humblest photographer could hope to spin his own web of illusion, creating some endearing incongruities in the process. Farm boys in mud-encrusted boots stand shyly at the foot of sweeping ballroom staircases; young men in their Sunday best cling nervously to cardboard trees (Fig. 2-1b). Because the medium was slow and needed a great deal of light, the first "studio" photographs were made in the open air, but the aim was to create the appearance of an indoor scene, a formal study governed by the traditions of the painted portrait. A simple sheet might be hung behind a client to hide distracting background material (Daval 1982), but more elaborate measures were soon taken to create the illusion that the pictures were made in a drawing room or study. With the passage of time and the march of progress, all this was soon reversed, and indoor studios were cunningly disguised to represent the great outdoors. The reversal brought its own examples of photographic whimsy; little boys on rustic bridges angle solemnly for paper fish (Fig. 2-10b), and ladies swathed in fur calmly endure a blizzard of artificial snowflakes (Fig. 2-11). Studio snow fell everywhere, but was considerate enough never to cover a client's face. It was produced by manual retouching on both sides of the glass negative, so as to make the outline of the flakes fuzzy (Palmquist 1990; Klens 1983). Rain or shine, accessories were routinely provided to lend status to clients; a bowler hat was often used to fulfill just this kind of function. And when the motor car came upon the scene at the turn of the century, it too was drawn into service, not immediately as a stylish conveyance in wide-open spaces, but as an easily recognizable studio prop in front of an easily recognizable backdrop (Fig. 2-12). Some universal mannerisms of late nineteenth-century studio practice can be found in

an unusual context: a series of stamps issued by the Netherlands in 1974 (Fig. 2-13).

While elaborate studio settings created their own dream world, they also tended, at times, to distract attention from the actual sitter. At times, certainly, but circumspect operators and

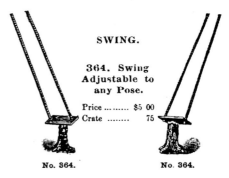

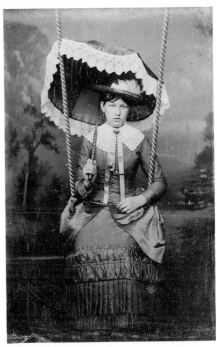

FIG. 2-8. The Rope Trick. Client sitting on a fake swing, advertised as "No. 364, Swing, Adjustable to any Pose" in the *Illustrated and Descriptive Catalogue*, published by W. D. Gatchel of Louisville, Kentucky, 1888. The photograph is a tintype, 8.7 × 6 cm. Lothrop Collection. See also Lothrop 1984.

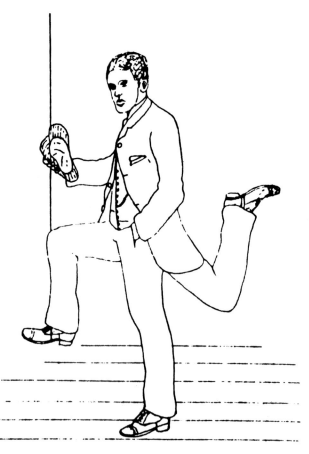

FIG. 2-9. Three-step, an invention by Alexander Robinson of the Isle of Man. British Patent Specification No. 15376 of December 15, 1885. (Heathcote 1985)

(a)

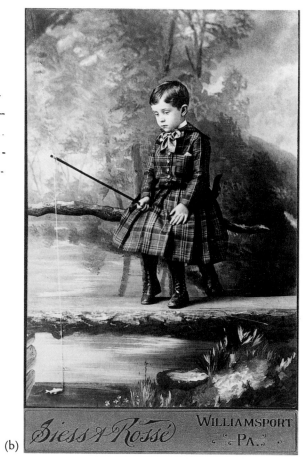

(b)

FIG. 2-10. Studio Make-Believe.
 (a) Example of a painted backdrop from Estonia. 1880s–1890s. Photomuseum Tallinn. (Tooming 1991)
 (b) Cabinet card made by Siess and Rossé of 124 West Fourth Street, Williamsport, Pennsylvania, c. 1890s. Note that the boy's fishing rod was steadied for the exposure by means of a string attached to some higher fixed point. It was then carefully (but not carefully enough) retouched out of the picture.

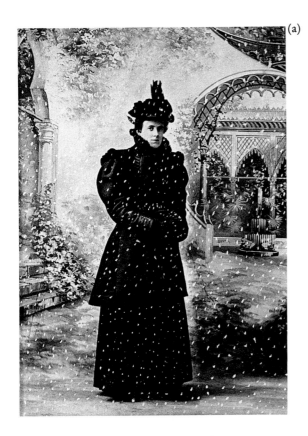

(a)

(c)

FIG. 2-11. In the bleak midwinter. Cabinet cards of the 1890s, with mock snow. American.

(a) Made by Fowler Bros. of Washington, Pennsylvania.

(b) Made by Sweet of Cramer Block, North Baltimore, Maryland.

(c) Made by Eclipse Studio, 324 Market Street, Sunbury, Pennsylvania.

(b)

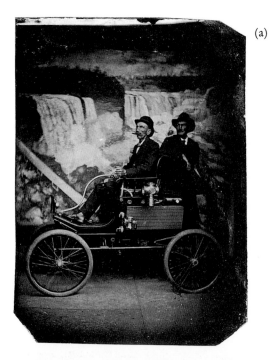

(a)

FIG. 2-12. Conquest of space.

(a) Turn-of-the-century tintype, 3½ × 2½ inches. American. Unknown photographer. Note backdrop of Niagara Falls, and studio-prop motor car.

(b) Album page, with postcard photograph showing intrepid aeronauts in their Sunday best at the controls of a studio machine. Gelatin silver print. 1913. American. New York State.

(b)

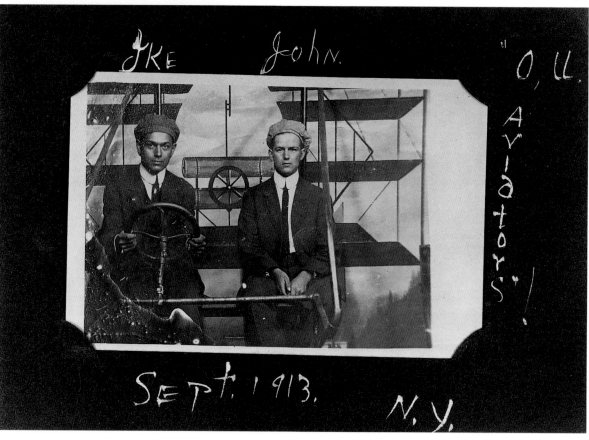

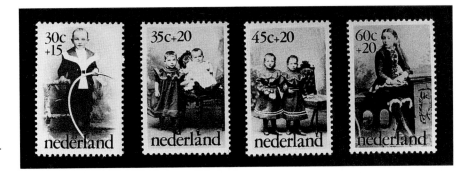

FIG. 2-13. Late nine-teenth-century studio photographs, issued by the Netherlands as post-age stamps in 1974.

clients alike knew when the moment had come to cease experimentation and concentrate on essentials:

> He took her picture in a chair,
> With books and works of art around;
> The Proof, she said, was more than fair,
> But then no atmosphere was found.
>
> He took her picture on a rock
> A stream and rustic bridge behind.
> It gave her nerves a frightful shock
> Because there was no soughing wind.
>
> He took her picture in the sand,
> A nymph disporting by the shore.
> The scene, she cried, was nice and grand;
> It only lacked the ocean's roar.
>
> He took her picture by a wheel,
> A Grecian maid, who spins and nods.
> Alas! She thought it would reveal
> The early lights of ancient gods.
>
> He took her picture by flashlight,
> Where smoke and smell will often linger.
> Her joy was boundless, out of sight;
> It showed the gem upon her finger!
>
> ["Her Picture," by Homer Fort (1900). Ruby 1989.]

Inasmuch as the portrait photograph remained a substitute for a painting (Fig. 2-14), gestures of homage to the senior art were common (Fig. 2-15), sometimes explicit, sometimes implicit. However, by and large, photographers contrived to make studio images that were neither stand-in paintings, nor snapshots, nor sensitive characterizations, but rather archival records for the ever-open Museum of Human Life (Fig. 2-16). Passport photography became another activity on behalf of that museum; as early as 1851, Dodero, a photographer in Marseille, predicted that the time would come when a signature, by itself, would no longer be acceptable as identification; it would have to be accompanied by a picture. His prediction did not have to wait long for fulfillment. In 1863, the Novelty Iron Works of New York City used photographs of prospective workers, imported from England, on its employment contracts (Spira 1980).

At the domestic end of the scale, Stenger (1938) reports, without giving chapter and verse, on an American lady who, in 1856, placed a newspaper advertisement in which she invited suitable applicants to send in their daguerreotype portraits, and compete for her hand. "The American Lady" may well have been following London's lead (Weprich 1991). The *Pittsburgh Daily Gazette and Advertiser* of October 3, 1846, carried a disapproving note from its British correspondent: "Gentlemen advertising for wives in London hung out their daguerreotypes in the window of a fashionable shop, with the label: WANTED, a female companion to the above. Apply personally." Still in the marriage market, as late as 1890, James Coates, Ph.D.,

(a)

FIG. 2-14 (a and b). Late nineteenth-century cabinet cards, mostly from Pennsylvania, all paying tribute to the senior art of painting in one form or another, explicitly or implicitly.

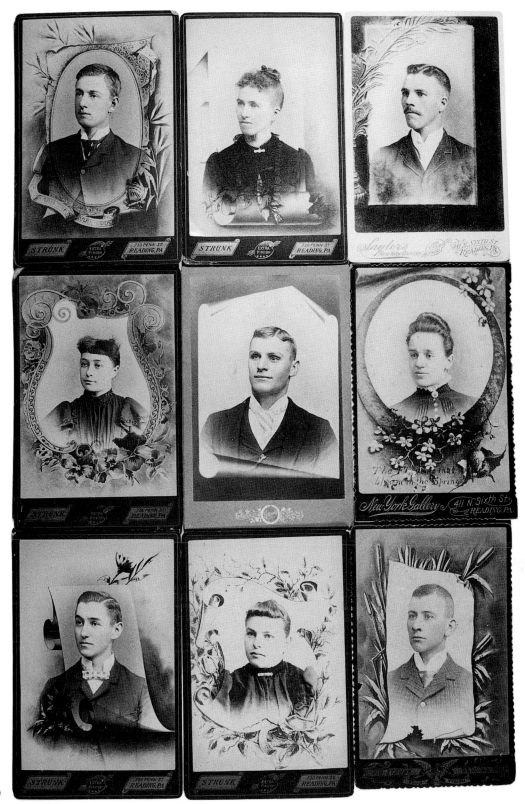

(b)

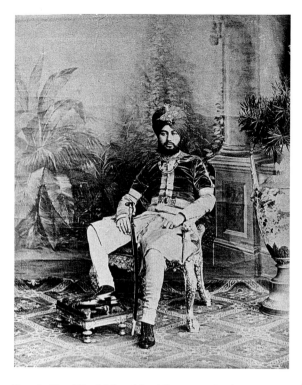

FIG. 2-15. The Maharajah. Albumen print by unknown photographer. 1880–1890s. India. 11¼ × 9¼ inches.

phrenologist of Glasgow, offered subscribers to *The Housewife* his services as a character reader from photographs (Ashdown 1972). For greatest reliability, two pictures were called for, a frontal view and a side view, and clients were also asked for "a nominal fee of sixpence in stamps for each Delineation." "Will you kindly delineate the enclosed photo, say is he likely to make a good husband," asked Miss A. from Darlington. Coates was never one to hedge his bets: "Mr. Blenheim has sharp, clear, and well-defined features, and a well-formed head; the whole indicating refinement, adaptability, suavity, humour, as well as decision and self-reliance. He is a man of keen perceptions, vivid thoughts and prompt action . . . and will not allow grass to grow on his shoes." The service was evidently popular, as attested by the response of many satisfied customers.

Group portraits of large numbers of people were made from astonishingly early times (see also Chapter 6), but posed a challenge until plates became fast enough to cope with the problem of clients moving during exposures. By the 1880s, with the advent of dry gelatin plates, the difficulty had largely disappeared. The enigmatic gathering shown in Figure 2-17 has, as yet, failed to yield the secret of its purpose and origin, but it is a fine example nevertheless, not only of technical mastery, but of stern crowd control as well.

Situations of poignant delicacy confronted studio operators in the photographing of Muslim women. Examples of this kind call, at the very least, for an appropriate redefinition of what is meant by "a good likeness," but the portrait in Figure 2-18 is also a monument to the fact that a wealth of meaning can be conveyed by highly economical means. Even during the early part of this century, it was still considered unacceptable in Islamic countries for women to be photographed in the company of men. Oddly enough, the strict separation of the sexes in certain societies offered opportunities to women photographers; there are examples of European ladies in India who won permission to make portraits inside otherwise secluded women's quarters. In the first years of the twentieth century, for instance, Mrs. Bremner helped her husband with his photographic business in India, and on several occasions "had the pleasure of photographing Indian ladies of the harem" (Sharma 1989). Occasionally, the laws of segregation would be breached by irrepressible human ingenuity, when two girls chose to be photographed together, with one dressed up as a young man (Croutier 1989). Another instance of hidden identity is represented by photographs of hooded penitents. McCulloch (1981) shows one of those, taken in the 1870s (see also Fig. 11-1b).

The photography of children was a special problem, because the needs of the photographic process could not be readily explained to young clients. Great ingenuity was lavished on ways and means of keeping them happily, but not too vigorously, occupied (Fig. 2-19; see also Fig. 9-

 (a)

 (b)

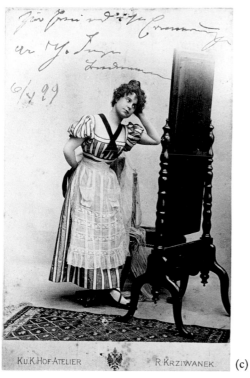 (c)

(d)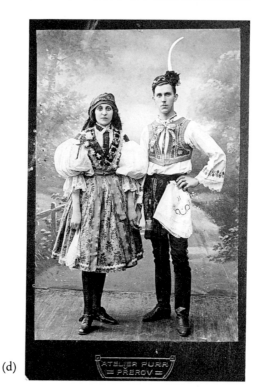

FIG. 2-16. Cabinet cards of the 1880s, illustrating conventions and tastes shared the world over. Photographs by:
 (a) New York Gallery of Reading, Pennsylvania.
 (b) Knipe's Studio of Lancaster, Pennsylvania.
 (c) R. Krziwanek Studio of Bad Ischl, Austria.
 (d) Atelier Pura, Přerov, Bohemia.

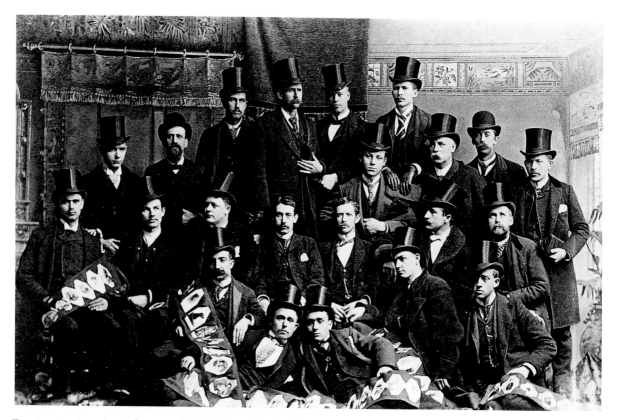

FIG. 2-17. American cabinet card. 1880s. Bravado piece by an unknown photographer. Note display photographs mounted on a long black banner, suggesting that members of the group represent the men of a large family.

16). The egg motif, with all its chicken over-tones, proved irresistible (Fig. 2-20). On occa-sions, half-open scallop shells, in graceful hom-age to Botticelli, were used for a similar purpose (McCulloch 1981). In an effort to reduce the amount of studio commotion, many photo-graphers, including the great Sarony of New York, supplied doting parents with sets of sam-ple poses, from which a choice was to be made, once and for all, *before* the sitting actually be-gan, in the relative calm of the studio waiting room.

Despite all such efforts, studios remained menacing places, in which grown-up men, never the most rational of creatures, hid below black cloths and stared into puzzle boxes with giant glass eyes in front. Mama was a treasured standby on such occasions, even when cun-ningly disguised as a piece of furniture (Fig. 2-21a). Father could also be a tower of strength, inadequately hidden behind a crudely cut piece of plywood (Fig. 2-21b). In the absence of pa-rental protection, familiar dolls (Fig. 2-22) did valiant service to deprive the studio scene of its alarming air for the child, while doing little to soothe the photographer's brow. Root (1864) recognized the problem, which was not actually confined to photographing the young:

The would-be eminent heliographer must especially have patience, as few places more urgently require it than the operating room. For, from the nature of his art, a single day may bring under his hand a host of persons,

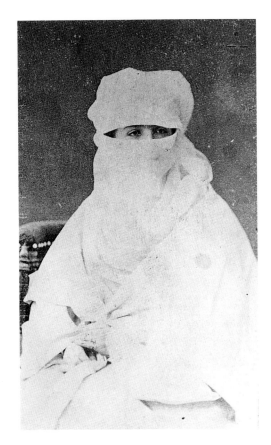

FIG. 2-18. Portrait of a veiled woman by
Basile Kargopoulo, "Photographe à Constan-
tinople," a prominent Greek studio operator
in the Turkish capital. Carte-de-visite. 1860–
1870s. See also Croutier 1989.

"Taking Baby" appeared in *The Philadelphia
Photographer*. Taylor begins promisingly by
saying: "A baby is a very nice thing to have
about the house," but a studio is not a house,
and still less a home. His enthusiasm soon cools,
as he describes the tribulations inflicted upon
him by infants of various ages, with or without
the complicity of doting mothers. Among other
things, he notes, parents want their offspring to
look beautiful on photographs, and there are
times when that calls for the retoucher's help:
"You must make a nose, where there is only a
little shapeless knob of flesh." Should he, Taylor

comprising almost every type of organiza-
tion; the ignorant and stolid, the flippant
and conceited, the fastidious, the difficult
&c. To deal with all these, even so as to
avoid giving mortal offence, often taxes his
patience to an extent that might make him
almost envy even the patriarch Job himself.

The problem of how to survive young clients
in a studio setting was the subject of a lengthy
exposition by Taylor (1867), indeed, the Rev.
A. A. E. Taylor, who seems to have added stu-
dio practice to his pastoral duties; his article

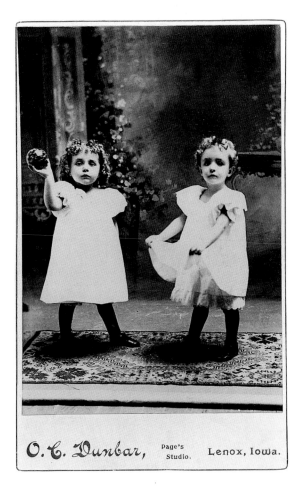

FIG. 2-19. Dance and Drama. Cabinet card. 1880s.
By O. C. Dunbar, Page's Studio, Lenox, Iowa.

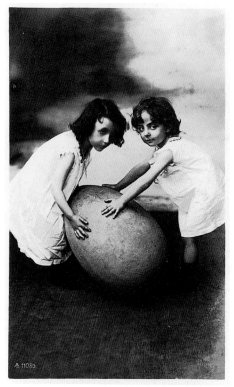

(a)

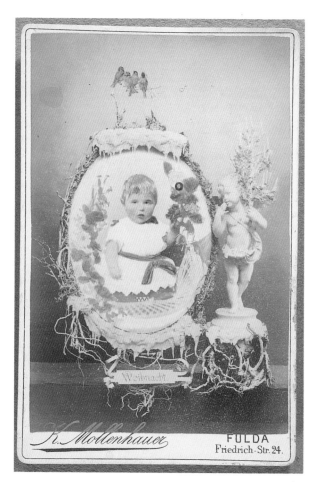

(b)

(c)

Fig. 2-20. The Egg Theme.

(a) Two small girls and a giant studio egg. Photographic postcard by an unknown artist. 1890s. American. Gelatin silver print, 5¼ × 3¼ inches.

(b) The Fertile Egg I. German cabinet-card montage by K. Mollenhauer of Fulda, c. 1900. Courtesy of G. and A. Siggemann.

(c) The Fertile Egg II. Cabinet-card montage made by James Thompson Bigler of Nebraska. March 31, 1896.

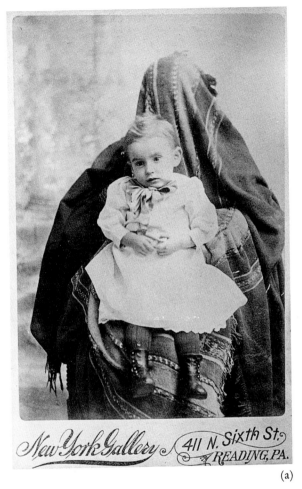

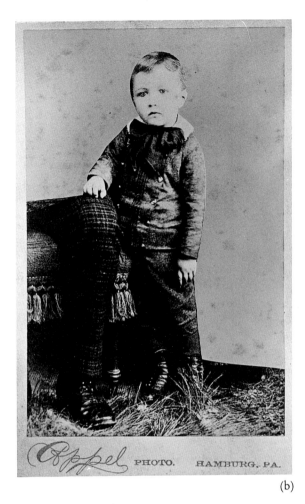

(a)

(b)

FIG. 2-21. The Art of Disguise. American cabinet cards of the 1890s. Gelatin silver prints.

(a) Baby on mother's lap; mother disguised as an armchair. Made by Saylor's New York Gallery of Reading, Pennsylvania.

(b) Small boy, leaning against the trousered leg of his (inadequately) hidden father. Made by Appel of Hamburg, Pennsylvania.

wonders, charge double for motherly interference?

The literature contains many other examples of studio photographers who burst into print to relieve the daily anguish of their professional lives. One such public testimony is *Twenty-Three Years Under a Skylight* by H. J. Rodgers (1872); it begins with these words:

The pages here presented to the Public, form a book of facts; of useful information for everybody. They unfold to the mind of the reader, the beauties, the pleasures and the perplexities of the Heliographic Art, and will aim to uproot those errors, false habits and notions which are in conflict with advanced and enlightened photography. The direct aim of this art treatise is *not* to speak to the passions and the imagination, but to the understanding. This book is one of solid truth, devoid of the shades of fiction, or the coloring of the imagination; therefore, the many faults in its style, management and composition,

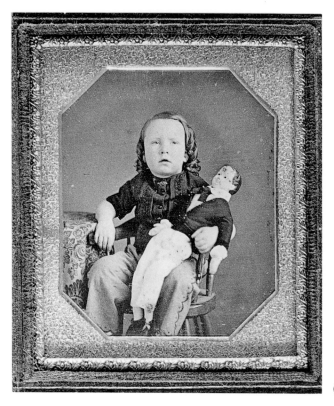

Fig. 2-22. Helpful studio props.
 (a) Daguerreotype of a little girl with doll, c. 1850. American. Unknown photographer. Sixth-plate.
 (b) Cabinet card of a child in a plaid dress, with large hat and doll propped up in foreground. Gelatin silver print. 1880s. American. Made by T. S. Bell of 1008 Eleventh Avenue, Altoona, Pennsylvania.

(a)

must become with the author, affairs of minor consideration, and for this reason, he will offer or make no apologies to embarrass the critics, and he cherishes the hope that a work of this kind (which for the first time is given to the world) may prove both interesting, *profitable* and instructive. [He was wrong in claiming this priority, as will be seen.]

Every expression and sentiment that might gratify the taste of a corrupt mind, or offend the eye or ear of innocence, has been carefully avoided; and all the aims to the promotion of a love and *possession* of the beautiful is specially regarded.

In his introduction on photography's history, Rodgers pays generous tribute to portraitists like Morse, Bogardus, Gurney, Brady, Anthony, Whipple, and even Sarony, Kurtz, and Fredricks, but omits all reference to Claudet and Beard; the chances are that he knew nothing of

their work. Bogardus is singled out for special praise as president of the National Photographic Society and a perfect "master of the situation," one who possesses a "natural inventive genius," as well as the "genial courtesy of a whole souled artist."

As late as 1872, Rodgers still regards "sun-painting" as a viable description of the photographic process. A photographer, he also says, has to keep a clear mind; "reason and prejudice are as opposite as fire and water." Nevertheless, he manages to maintain contradictory positions on many issues, for instance, chivying clients for not coming in the morning (when the light is good) and, at the same time, raving against the "prejudice" that good images cannot be secured on a cloudy day. Indeed, he insists, "The most beautiful pictures are made on a cloudy day." In passing, he describes albums as "the biggest photographic humbug," not because he believes that darkness (or even acid paper, which he doesn't mention) harms the photographs, but

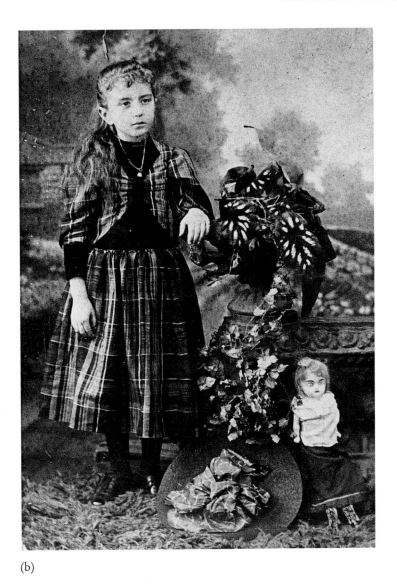

(b)

because he associates darkness inevitably with dampness. Photographs should be given a periodic airing, he recommends. In a curious but apparently serious aside, he reproaches the sun for not taking better care of the products of its own creation. Thus, darkness and sun were equally to blame, and the instability of the photographic image remained an important concern to photographers and their clients, well to the end of the century. Clients were reluctant to invest good money in portraits that were likely, in due course, to self-destruct, and artists were offended by the thought that their works might be unavailable for the edification and delight of posterity, however distant.

A random example of how the problem manifested itself is shown in Figure 2-23, of which (a) represents an image taken, presumably around 1890, with the first Kodak camera. For presentation purposes, the photograph was glued to a sheet of cardboard and was then kept in a stack with other photographs. Thus stored, it came to be immediately above a photograph (not taken with a No. 1 Kodak) of a young man in the traditional posing chair. In the course of time, that image diffused into the cardboard

(a)

(b)

FIG. 2-23. Silver diffusion from a photographic image.
(a) Cardboard-mounted photograph taken with a No. 1 Kodak camera, c. 1890. See Kemmler 1988.
(b) Imprint on the cardboard mount from the diffusion of an (earlier) image stored in contact with it.

with which it was in contact, and left on it the imprint seen in (b). The original, having lost some of its silver, must have been correspondingly weakened.

Most of Rodgers' reminiscences are about studio encounters with clients who nourish false expectations, who don't understand the "perplexities of a photographer's life," and who don't understand "the impossibility of seeing ourselves as others see us." However, there is also a discourse on how to expose pictures of clients dressed in black (recommended for gentlemen) or white or, "woe, woe, in black *and* white." He offers sage advice to all and sundry on how to look beautiful, with the help of "sugar of lead" (lead acetate!) face powder, the least desirable of cosmetic aids. Along those lines, photographer George Downing, of To-

peka, Kansas, proved himself to be more circumspect. One of his advertisements in *The Topeka Historical* of 1877 offers a distinctly less lethal solution to the same old problem:

> The good times are coming, mother,
> Pretty photographs are all the go,
> So taller [tallow] my nose, dear mother,
> 'Twill reduce its size, you know.
> [Filippelli 1981]

Rodgers took great pains to instruct fellow photographers in how to depict the principal human emotions (Fig. 2-24), showing them, one would have thought needlessly, what people look like when they are somehow moved or agitated. His concentration on facial features was a matter of principle. Photography was best, he

felt, when "the whole power or optical capacity of the camera is brought to bear chiefly upon the head, producing a more natural likeness and a more meritorious specimen of the art." Charles Darwin's photographically illustrated study of the same subject was published a year later (see Fig. 11-7). In a special chapter on "Hints for Men of More Advanced Years," Rodgers recommends that they should deport themselves with dignity in the studio.

For a campaigner against "prejudice," Rodgers had some remarkable views on human nature; from his chapter on "Facial Resemblance Between Man and the Brute of Creation," we learn that men who look like hogs "have a natural (not acquired) feeding instinct, and a peculiar antipathy of feeling against work."

Like Rodgers, Root (1864), who preceded him, had a great deal of psycho-therapeutic advice on how obstreperous clients should be endured and how their antics should be handled in the studio. "The aim," Root said, "must be to act upon the mind, that is, both the intellect and feelings of the sitter. But how?" No fail-safe answer was available in 1864, nor indeed was it five years later when H. P. Robinson (1869) addressed himself to the problem of client-management in Tunbridge Wells, England:

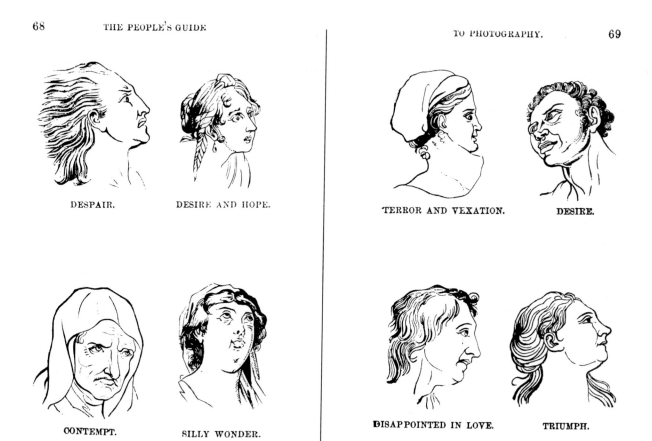

68 THE PEOPLE'S GUIDE

DESPAIR.

DESIRE AND HOPE.

CONTEMPT.

SILLY WONDER.

TO PHOTOGRAPHY. 69

TERROR AND VEXATION.

DESIRE.

DISAPPOINTED IN LOVE.

TRIUMPH.

FIG. 2-24. Physiognomy and emotions. Drawings from H. J. Rodgers' *Twenty-Three Years Under a Sky-Light, or Life and Experiences of a Photographer,* 1872.

Sitters often want to be made to look like other people; or, rather, they think that if they sit in the same position, and attempt the same expression, however unsuitable, they will look as well as some example they have seen. It constantly occurs that persons will come into the reception room, and, selecting a portrait of another, totally unlike in age, style, and appearance, will say: "There, take me like that". Peter Cunningham gives an anecdote that may, possibly, be out of place here, but is too good to omit. "When Bernard Lens was drawing a lady's picture in the dress of Queen Mary of Scots, the fastidious sitter observed: 'But, Mr. Lens, you have not made me like Mary Queen of Scots!' 'No, madam,' was the reply; 'if God Almighty had made your ladyship like her—I would'." The same might be said on behalf of the *lenses* of the present day!

The educated photographer [Robinson goes on to say] will endeavour to so entertain his sitter that he will feel more at ease than if he were taken into a strange room, fixed incontinently in a chair, and photographed. It will be found that not only the expression will be improved, but that pictorial effect, as regards arrangement of lines, will also be much improved by the increased ease the sitter feels as he becomes more familiar with the studio and the student. I have known many persons who, after months of persuasion, have consented to have their portraits taken, and who came in fear and trembling, but who, by judicious treatment, have eventually so positively enjoyed the operation, that it has become almost a passion.

It is more than probable that this objection to "sit" has been engendered by the brusque manners, and rough, uncourteous, and conceited behaviour, of photographers themselves. A certain amount of self-confidence, if there is any basis for it, reacts fa-

vourably on the sitter, but it should not be carried too far, for some sensitive people may consider it amounted to rudeness.

Despite all these problems, it did not take long for the photograph, no matter what stratagem was involved in its production, to become a substitute for a person. This was an easy step to take, for there was an established convention in which the painted portrait stood proxy for its subject (Fig. 2-25). In Figure 4-10a, a photograph propped on an easel is treated as a full-fledged member of the family tea-party. Similarly, Perrot and Martin-Fugier (1990) show an 1890s photograph by E. Beaudion, depicting a widowed father with two children, posing in a studio, where two photographs are displayed on the wall, one of the dead mother and one of yet

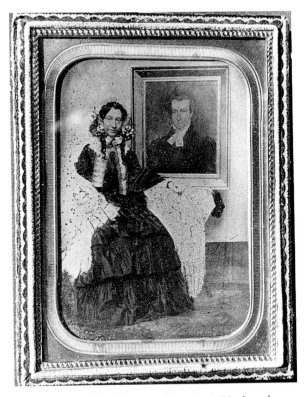

FIG. 2-25. Lady with portrait, c. 1854–55. American. Unknown photographer. Ambrotype (black backpaint), quarter-plate.

another family member, a young girl, presumably also mourned. The same attitude manifested itself in speech and writing, and not necessarily just on behalf of the dead. Thus, G. C. Spinner, who was Treasurer of the United States, said in an 1863 letter to a friend: "I wish I could spend a few days with you in New York, but that is quite out of the question. —But as I cannot come myself, I enclose you the 'counterfeit presentment.' Hoping to see you soon" (Mann 1990). That counterfeit presentment was his photograph. The sentiment, age-old, is still very much alive today; for instance, Gregor von Rezzori (1989) expresses it movingly with reference to a photograph of an old family retainer, alas, no longer in life and service (see also Chapter 6).

With the advent of mail-order studio furnishings, the photographers' own emphasis, the way in which they thought of their role, shifted; they had begun as technological pioneers but found themselves functioning as stage directors. Over the years, this role firmly consolidated, and it was mainly in that realm that studio photographers competed with each other. The task of making a portrait has always called for great and quick perception, not forgetting diplomatic skills and good taste; it could be sloppily discharged, and often was, but it could also be discharged with consummate mastery. Though, of the millions taken in the nineteenth century, most studio photographs occupy the artistic lower-middle ground, there have always been outstanding masters who knew how to overcome the limitations of the medium and to extend its potential. David Octavius Hill (Bruce 1973), Julia Margaret Cameron (Ford 1975; Powell 1973), and Nadar (Gosling 1976) are three outstanding examples, to say nothing of the countless fine operators who remain anonymous (Becker 1989; Wood 1991). The machine has its say, but the artist behind the machine has the last word.

Fig. 2-26. Alter Ego. Young man with his four reflections in two carefully placed mirrors. Tintype by C. A. Hughes, 5 × 3½ inches. 1880s. American.

THE MAGICIAN

Photographers often delighted in bravura pieces, designed to demonstrate their skills as artists. Perhaps the simplest of these involved the use of one or more mirrors, to show the client, as well as the client's alter ego. Figure 2-26 gives a "provincial" example, but the practice was by no means confined to humble operators; Clementina, Viscountess Hawarden, produced her fine albumen print "Girl in Fancy Dress by a Mirror" in about 1864 (Daval 1982), with no inten-

tion of promoting rustic fun. By that time, Rejlander had already begun to develop the practice along more elaborate lines, by means of photomontage rather than studio mirrors and other furnishings. He did not actually invent photomontage, but brought it into prominence, first with his renowned "Two Ways of Life" (1857), and later with a whole series of other works, including a playful exercise in self-portraiture, a composition entitled "O.G.R the Artist Introduces O.G.R. the Volunteer," made around 1871 (Jones 1973), and irresistible in its subtlety at the time.

The photographic and artistic merits of "The Two Ways of Life," not to mention the use in it of female models photographed in various stages of undress, immediately became the subject of controversy (Lawson 1990), mostly superficial, but occasionally penetrating. William Donaldson Clark (1816–73), a prominent Scottish photographer of the period, commented that Rejlander's creation was

> . . . perhaps the most elaborate attempt yet made to produce a picture by means of photography. The first impression, on looking at it, was wonder at the ingenuity of the author who had produced so elaborate a work with such imperfect means; the second was to wonder what it all meant. The meaning has been explained by Mr. Rejlander, but I question if anyone could have found it out for himself. If it was unintelligible, it must have been a failure. So with all other attempts I have seen of the same kind; they fail from the total absence of expression in the figures that should tell the story. [Clark 1863]

Whether any profound message will ever be intelligible to everyone is another matter, but the lack of "internal cohesion" is, indeed, a problem with pseudo-realistic montage, though never one designed to deter the enthusiastic practitioner. Among the many remarkable examples of such work from around the world is an image by the Brazilian photographer Valério Vieira (1862–1941), who managed to incorporate thirty pictures of himself into one convincing composition (Fig. 2-27a; Kossoy 1978). Vieira was not only a prominent photographer, but also a painter and a notable public figure. He was known for, among other things, his defense of Italian immigration into Brazil, an activity for which the Italian government made him a Knight of the Cross.

The taste for such exercises was truly international. In Estonia (and many other places) studios offered pictures of a client "standing without his head, alongside him on a pedestal, his head, wearing a top hat. . . . " A variant on the same basic theme was to present a man greeting himself and offering a light from his pipe (Teder 1977). I. G. Davidson, of Portland, Oregon, made a similar double self-portrait in 1885, as both the photographer and his client, while Ginter and Cook of Lewisburg, Pennsylvania, contrived a formally dressed figure side by side with his alter ego in a sports outfit. A further variant was produced by John A. Todt, of Sacramento, California, who portrayed his subject in the process of being painted by "himself" (Palmquist 1981).

From Russia comes an example by Valery V. Carrick, born in 1869 and son of William Carrick, a well-known Scottish-Russian photographer. In Figure 2-27b, Valery plays the double part of a newspaper editor jovially drinking with a humble member of the staff. Valery was, indeed, a newspaperman in St. Petersburg. In 1908 he came to Britain and made a series of caricatures for the *Manchester Guardian*, with some of the noted personalities of the day as his targets, including Winston Churchill and Max Beerbohm. (See Ashbee 1978, 1979.) The most famous photograph of this kind is probably one by Maurice Guibert, a French photographer who, in 1890, made a double image showing Toulouse-Lautrec in the process of painting his own portrait. The artist himself was a willing

collaborator; his own interest in photography expressed itself in a number of his sketches, in advertising posters which he designed for friends, and in a magnificent cartoon of an amateur photographer with his camera, which he made in 1895 for *La Revue Blanche* (Braive 1966).

Quite apart from such playful and, occasionally, very profitable exercises, identity games sometimes had a more serious purpose. A different form of composite photography, the art of superimposing several prints on one another to create a portrait that may be regarded as the sum of their parts, enjoyed a brief outburst of popularity in America during the second half of the nineteenth century. At the time, there was considerable interest among scientists in finding ways to isolate the special features characteristic

(a)

FIG. 2-27. The Art of Montage.
 (a) Valério Vieira: "Os 30 Valérios." Montage, size unestablished; turn of the century. Brazilian. The original has been lost. (Kossoy 1978)
 (b) Valery V. Carrick (1869–1942). Dual self-portrait montage, c. 1897. Russian. Gelatin silver print, 9 × 12.75 cm. Felicity Ashbee Collection. Valery Carrick was the son of William Carrick, well-known Scottish-Russian studio photographer and recorder of "Russian types." See Ashbee 1978, 1979.

FIG. 2-27 (b)

of a group, whether national or professional. The idea was that the essence of "a typical Russian" or "a typical grocer" could somehow be distilled in this way, for further study. Francis Galton proposed the use of the camera for this kind of work, in an article he wrote for the May 23, 1878, issue of *Nature*. He claimed there that, by combining individual pictures taken on the same plate, a portrait characteristic of the whole group could be achieved, "bringing into evidence all the traits on which there is agreement, and leaving but a ghost of a trace of individual peculiarities." Over the next few years, Galton elaborated his theory in a series of essays, and the idea caught on. During the 1880s it became fashionable to make composite portraits of such heterogeneous collectives as college graduate classes. In an 1885 lecture, even the ever-skeptical Bernard Shaw paid tribute to Galton, and gave it as his opinion that the essence of, say, the ideal Juliet could be captured in this way, by merging the features of many actresses who had played the part (Weintraub 1989).

One of those attracted by Galton's idea was Dr. Henry Pickering Bowditch (1840–1911), a distinguished professor of physiology at the Harvard Medical School. Among his many hobbies, which included kite-flying and chair design, was photography, and throughout the 1880s and 1890s he made composite portraits of many groups, from horse-cab drivers to Saxon soldiers. He did not, presumably, find the latter in the immediate Boston area, but he did find there an ideal subject in a small dining club to which he himself belonged. The society consisted of twelve doctors and, as the membership remained constant for several years, Bowditch was able to create a series of composite portraits to record the slight changes that increasing age and growing eminence brought to the face of the collective self. The example in Figure 2-28 is dated 1892, and Bowditch himself appears at the top, to the left of center (Bowditch 1894; Wilsher 1981). Similarly, Skopec (1963) gives an example of an 1880 composite by G. Lovell representing the "average features" of 287 students

FIG. 2-28. H. P. Bowditch: "The Doctors' Dinner Circle, 1892." Composite Photo-
graph. Francis A. Countway Library of Medicine, Boston Medical Library, Boston,
Massachusetts. (Bowditch 1894; Wilsher 1981)

in Northampton, England. Professors, con-
fronted by a sea of faces, have been tempted to
this kind of vision since times immemorial, but
only photography has been able to provide a
practical fulfillment.

In the twentieth century, the entire exercise
would have been enormously amusing to Alfred
Döblin, had he known about it. In a 1946 essay,
"Fotos ohne Unterschrift" (quoted by Schmoll
1980), he gives a lively account of his reactions

FIG. 2-29. I. W. Taber: composite photo-collage souvenir of the San Francisco Midwinter Fair of 1894. Reproduced from a halftone print measuring 8 × 24 inches. (Palmquist 1980)

upon seeing a series of unidentified portraits by Hugo Erfurth (1874–1948). The idea was to guess the occupation and character of the men depicted. The outcome was, *pace* Bowditch, that Max Liebermann was classified as a banker, Paul Klee as a musician, Oskar Kokoschka as a Slavic partisan, and Heinrich Zille as a village schoolmaster. "Nature is not obligated," Döblin adds, "to make a shingle out of every face. . . . What photographers photograph is ultimately the aversion of their clients to the camera."

Darkroom magic of another kind was pioneered by I. W. Taber (1894). Figure 2-29 shows an unusual photographic collage, published (together with many other items) as a souvenir of the San Francisco Midwinter Fair of 1894. Isaiah West Taber described it as a "Conglomerate

Character Sketch . . . a picture made up of snapshot photos of types at the fair." He himself, interesting "type" that he was, appears with his camera on the far left. Taber (1830–1912) was the official photographer of the Fair, and in his book he also described some of his encounters with visitors, including the "big Cossack" on the extreme right (Palmquist 1980).

THE MEMORY-MAKER

In the early days, having one's picture taken was an event very much linked to family happenings: births, marriages, deaths. It is obvious enough that, in the mid-nineteenth century, most peo-

ple who died had never been painted or photographed, and grieving families felt very strongly that the deathbed photograph offered the last chance. Accordingly, "doing postmortems" became a distinctive task of the professional photographer. Indeed, some of them complained bitterly that the task had to be instantly discharged; it could not be indefinitely postponed to await a more convenient moment. The problems are vividly described by Max Dauthendey (1925), who had occasion to experience them in his father's photographic practice. Carl Dauthendey was one of the earliest German photographers, and later practiced in St. Petersburg. Max was supposed to follow in his father's footsteps, but preferred to abandon photography altogether and become a poet. More on the subject of postmortem work will be found in Chapter 6.

Of course, portraits of any kind taken during a client's lifetime were used as commemorative keepsakes after death, and displayed on drawing room walls, so as to keep the family together (see Figs. 2-25 and 4-10). That practice was used for an intriguing plot by Johannes Schlaf in his *Meister Oelze* (1892), a play in which a stepfather's photograph hangs as a familiar presence on the sitting-room wall for some twenty years after his death, before it is revealed that the old man had in fact been murdered by his kin. The loving display was somehow intended to counterbalance the gruesome cause of death (Koppen 1987). By the end of the nineteenth century, as Koppen points out, photography, and particularly photographic portraiture, had become a routine activity of everyday life, making its inclusion in works of fiction no longer remarkable. Schlaf's plot would have been equally potent had he chosen a painting; he used a

photograph, not because it still carried magic but because it was, by then, a more plausible image in that milieu. The photograph had become "part and parcel of a middle-class culture that accepted replication of every sort, from furnishings and architecture to fine art prints, as the natural advantage of living in an advanced, technological world" (Orvell 1989).

In the ordinary way, we think of studio photography as personal portraiture, but the medium served other purposes from the earliest days, beginning with Fox Talbot's own experiments on the reproduction of manuscripts and hieroglyphics (Arnold 1977). Astonishing as it may seem, even someone as farsighted and sophisticated as Fox Talbot believed that the new medium would also find a major application in the reproduction of silhouettes. It did not, but silhouettes were nevertheless photographed on occasions, so that they could be multiplied and distributed, not only by provincial studios but also by some of the dominant figures in the pro-

(a)

(b)

FIG. 2-30. Photographs of silhouettes.
 (a) Image by Frederick Gutekunst (1831–1917) of 712 Arch Street, Philadelphia. Cabinet card, c. 1880. Gutekunst, a prolific portraitist, was born in Germantown, Pennsylvania, and was active as a photographer from 1856 onward. See Finkel 1980.
 (b) Carte-de-visite by M. B. Brady of Washington and New York, c. 1870s. Inscribed on the front: "Neil McLean."

FIG. 2-31. Cabinet photograph of a painted portrait, by Pratt's Studio of 727 South Broad Street, Philadelphia. Verso inscription: Mary Yeates, married March 3, 1791, to Judge Charles Smith. Charles H. Pratt's studio was active from the mid-1880s to the mid-1890s (Finkel 1991).

fession (Fig. 2-30). Figure 2-31 is representative of a whole genre of studio products in the making of which the great photographer functioned as a technical expert, rather than an artist. It was, to be sure, not the most exalted role, but the world of Art History owes it an inestimable debt.

The daily work of a busy studio included many other tasks outside the realm of personal portraiture. Treasured possessions were brought in to be photographed by proud owners (Fig. 2-32), as well as historical mementos (Fig. 13-18) and the occasional work of art of marginal pretensions (Fig. 8-12). Above all, there was an insatiable demand for "ghosts," as will be seen in the next chapter.

FIG. 2-32. Cabinet-card portrait of a table lamp, c. 1890. Gelatin silver print. Made by Cummins of Auburn, Maine. Unusual subject, photographed when electric light was only just beginning to be fashionable. The practice of recording common objects in this way is actually a good deal older; Shimshak (1991) shows a daguerreotype of a spanner, c. 1850–55.

Chapter 2 References and Notes

ARNOLD, H. J. P. (1977). *William Henry Fox Talbot: Pioneer of Photography and Man of Science*, Hutchinson Benham, London, p. 101, fig. 25.

ASHBEE, Felicity (1978). "William Carrick," *History of Photography*, vol. 2, no. 3, pp. 207–22.

ASHBEE, Felicity (1979). "Valery V. Carrick," *History of Photography*, vol. 3, no. 2, p. 110.

ASHDOWN, B. M. (Editor) (1972). *Over the Teacups: An Anthology in Facsimile from Women's Magazines of the 1890s*, Cornmarket Reprints, London, p. 5.

BECKER, Wm. B. (1989). *Photography's Beginnings: A Visual History*, Oakland University, Rochester, Michigan.

BOWDITCH, H. P. (1894). "Are Composite Photographs Typical Pictures?" *McClure's Magazine*, September, p. 331.

BRAIVE, M. F. (1966). *The Era of the Photograph*, Thames & Hudson, London, pp. 205, 262, 267.

BRUCE, D. (1973). *Sun Pictures: The Hill-Adamson Calotypes*, Studio Vista, Cassell & Collier; Macmillan & Co., London.

BUBERGER, J. (1978). "Trump Card," *History of Photography*, vol. 2, no. 3, p. 264.

CLARK, W. D. (1863). "Photography as a Fine Art,"

British Journal of Photography, May, p. 259.

CROUTIER, A. L. (1989). *Harem: The World Behind the Veil*, Abbeville Press, New York, p. 12.

DAUTHENDEY, M. (1925). *Der Geist meines Vaters*, Albert Langen / Georg Müller, Munich.

DAVAL, J.-L. (1982). *History of an Art: Photography*, Skira/Rizzoli, New York, pp. 23, 53, 66.

FILIPPELLI, R. L. (1981). "Greenback Shutterbug," *History of Photography*, vol. 5, no. 3, pp. 263–64.

FINKEL, K. (1980). *Nineteenth Century Photography in Philadelphia*, Library Company of Philadelphia and Dover Publications, New York, p. 218.

FINKEL, K. (1991). Personal communication, acknowledged with thanks.

FORD, C. (1975). *The Cameron Collection*, Van Nostrand Reinhold, in association with the National Portrait Gallery, London.

FORT, H. (1900). *Recreations*, vol.14, December. Reprinted from an earlier issue of the *New York Herald*.

GARZTECKI, J. (1977). "Early Photography in Poland," *History of Photography*, vol. 1, no. 1, pp. 39–62.

GOLAHNY, A. (1990). *Source*, vol. 10, no. 1, p.22.

GOSLING, N. (1976). *Nadar*, Secker & Warburg, London.

HARKER, M. (1979). *The Linked Ring*, Heinemann, London, p. 185.

HEATHCOTE, B. V. and P. F. (1984). "The Carriage Waits," *History of Photography*, vol. 8, no. 4, frontispiece.

HEATHCOTE, B. V. and P. F. (1985). "Three-Step," *History of Photography*, vol. 9, no. 1, frontispiece.

HOUGH, E. K. (1878). *Philadelphia Photographer*, November, p. 328.

JAY, B., and MOORE, M. (1989). *Bernard Shaw on Photography*, Peregrine Smith Books, Salt Lake City, Utah.

JONES, E. Y. (1973). *Father of Art Photography: O. G. Rejlander, 1813–1875*, David & Charles, Newton Abbot, U.K., p. 102.

KEMMLER, K. O. (1987). *Photo-Antiquaria Special*, November, p. 79.

KEMMLER, K. O. (1988). "Die runden Bilder des George Eastman," *Photo-Antiquaria*, no. 2, p. 1.

KENT, J. H. (1871). *Philadelphia Photographer*, September, p. 289.

KLENS, E. M. (1983). "The Manipulated Photograph, 1839–1939," M.A. thesis, Department of Art History, Pennsylvania State University.

KOPPEN, E. (1987). *Literatur und Photographie*, J. B. Metzlersche Verlagsbuchhandlung, Stuttgart, p. 61.

KOSSOY, B. (1978). "Os 30 Valérios," *History of*

Photography, vol. 2, no. 1, p. 22.

LAWSON, J. (1990). Personal communication, acknowledged with thanks. Also, see Lawson's essay on "William Donaldson Clark," The National Galleries of Scotland, Edinburgh (1990).

LOTHROP, E. S. Jr. (1984). "The Rope Trick," *History of Photography*, vol. 8, no. 3, p. 236.

MANN, C. (1990). Personal communication, acknowledged with thanks.

MATHEWS, O. (1974). *The Album of Carte-de-Visite and Cabinet Portrait Photographs, 1854–1914*, Reedminster Publications, London.

McCULLOCH, L. W. (1981). *Card Photographs: A Guide to Their History and Value*, Schiffer Publishing Co., Exton, Pennsylvania, pp. 38, 45.

ORVELL, M. (1989). *The Real Thing: Imitation and Authenticity in American Culture, 1880–1940*, University of North Carolina Press, Chapel Hill and London, p. 75.

PALMQUIST, P. E. (1980). "Ménagerie en Collage," *History of Photography*, vol. 4, no. 3, p. 242.

PALMQUIST, P. E. (1981). "Seeing Double," *History of Photography*, vol. 5, no. 3, pp. 265–67.

PALMQUIST, P. E. (1990). Personal communication, acknowledged with thanks.

PARSONS, M. B. (1990). "Bernard Shaw's Aesthetics of Photography, and the New Art History," in *Rewriting Photographic History* (ed. Michael Hallett). The Article Press, Birmingham, England.

PERROT, M., and MARTIN-FUGIER, A. (1990). In *A History of Private Life* (ed. M. Perrot), Belknap Press of Harvard University Press, Cambridge, Massachusetts., vol. 4, p. 107.

PETZVAL, J. (1843). *Bericht über die Ergebnisse einiger dioptischer Untersuchungen*, Conrad Adolph Hartleben Verlag, Pesth, Hungary.

POWELL, J. (Editor) (1973). *Victorian Photographs of Famous Men and Fair Women by Julia Margaret Cameron*, Hogarth Press, London.

REZZORI, G. von (1989). *The Snows of Yesteryear*, Alfred A. Knopf, New York, p. 272.

RINHART, F. and M. (1969). *American Miniature Case Art*, A. S. Barnes & Co., South Brunswick and New York, p. 197.

ROBINSON, H. P. (1869). *Pictorial Effect in Photography, Being Hints on Composition and Chiaroscuro for Photographers*, Piper & Carter and Marion Co., London, pp. 84–87. Facsimile reprint 1971 by Helios, Pawlet, Vermont.

RODGERS, H. J. (1872). *Twenty-Three Years Under a Sky-light; or, Life and Experiences of a Photographer*, H. J. Rodgers, Hartford, Connecticut, 1973 reprint by Arno Press, New York.

ROOT, M. A. (1864). *The Camera and the Pencil, or The Heliographic Art*, M. A. Root, Philadelphia. Facsimile reprint 1971 by Helios, Pawlet, Vermont, chapter 3, p. 38.

RUBY, J. (1989). Personal communication, acknowledged with thanks.

RUBY, J. (1990). "The Wheelman and the Snapshooter; or, The Industrialization of the Picturesque," in *Shadow and Substance* (ed. K. Collins), Amorphous Institute Press / New Mexico State University Press, Albuquerque, New Mexico, pp. 261–68.

SCHEID, U. (1977). *Photographica sammeln*, Keyser Verlag, Munich.

SCHMOLL, gen. Eisenwerth, J. A. (1980). *Vom Sinn der Photographie*, Prestel Verlag, Munich.

SCOTT, C. (1991). "The Life and Times of Castle Terrace: A Daguerreotype Studio in Exeter," *History of Photography*, vol. 15, no. 1, pp. 27–36.

SHARMA, B. B. (1989). "Fred Bremner's Indian Years," *History of Photography*, vol. 13, no. 4, pp. 293–301.

SHAW, G. B. S. (1906). *Camera Works*, no. 14, April.

SHIMSHAK, R. H. (1991). *The Daguerreian Annual* (ed. P. Palmquist), The Daguerreian Society, Lake Charles, Louisiana, p. 91.

SKOPEC, R. (1963). *The History of Photography in Pictures, from Earliest Times to the Present*, Orbis, Prague, figs. 140–45, 576.

SKOPEC, R. (1978). "Early Photography in Bohemia, Moravia and Slovakia," *History of Photography*, vol. 2, no. 2, pp. 141–53.

SPIRA, S. F. (1980). "Photographs in Early Employment Contracts," *History of Photography*, vol. 4, no. 4, p. 308.

STENGER, E. (1938). *Die Photographie in Kultur und Technik*, Verlag E. A. Seemann, Leipzig.

TABER, I. W. (1894). *The "Monarch" Souvenir Sunset City and Sunset Scenes, being Views of California's Midwinter Fair and Famous Scenes in the Golden State*, 15 vols., H. S. Crocker Co., San Francisco.

TAYLOR, Rev. A. A. E. (1867). "Taking Baby," in *Philadelphia Photographer*, vol. 2, p. 41.

TEDER, K. (1977). "Early Photography in Estonia," *History of Photography*, vol. 1, no. 3, pp. 249–68.

TOOMING, P. (1991). Personal communication, acknowledged with thanks.

VANSANT, J. (1887). *Science*, vol. 10, September 9, p. 129.

WEINTRAUB, S. (1989). *Bernard Shaw on the London Art Scene*, Pennsylvania State University Press, University Park and London, pp. 62–63.

WEPRICH, T. M. (1991). Personal communication, acknowledged with thanks.

WILSHER, A. (1981). "Look here, upon this Picture, and on this," *History of Photography*, vol. 5, no. 3, p. 206.

WOOD, J. (Editor) (1991). *America and the Daguerreotype*, University of Iowa Press, Iowa City.

3

SIDELIGHTS

CULINARY DIMENSIONS

If photographists could look to the theater for ideas, turn the studio into a stage, and conjure up dream worlds of their own devising, they could also draw inspiration from the pleasures of the table. This detour into domesticity stemmed from the demands of early darkroom procedures and techniques. The salted paper process that superseded the daguerreotype had several advantages, of which the most important were the simplicity of the method and the cheapness of its main ingredient. The drawback was that it did nothing to hide the fiber and texture of the paper

itself. When a paper print was laid beside the smooth silver surface of a daguerreotype, it seemed unpleasantly dull, coarse, and irregular. The albumen alternative, made public by L.-D. Blanquart-Evrard in 1850, was hailed as a distinct improvement, because it closed the pores of the paper and covered its surface with a thin, shining coat that retained the minute, sharp details of the photograph.

To make the albumen mixture, egg whites were separated from the yolks, added to a salt solution, and then beaten to a froth. The beating was necessary to break down the different protein structures and create a uniform liquid. Al-

though much emphasis was put on the importance of using fresh eggs, the albumen mixture itself had to be left to age for a week. After that, it could be stored for some time longer, and used until even the most dedicated darkroom fanatic began to have misgivings. As one French writer bluntly put it, "À ce moment, elle exhalera une forte odeur animale" (Dillaye c. 1876). No wonder that Lydia Bonfils, wife and mother of two famous photographers in Lebanon, was once heard to exclaim, "I never want to smell another egg again," after forty years of valiant whisking (Rockett 1983).

Cooking and chemistry have strong family ties; in the flurry of suggestions on ways to improve the basic albumen recipe, they seem to be twin sisters bending over the solution and throwing in a pinch of this or that, as inspiration strikes. M. Blanquart-Evrard himself believed that the egg whites should be whisked with whey separated from curdled milk: "Beat up with about three fourths of a pint of this serum the white of one egg; this solution is then to be boiled, and again filtered, after which five grains per cent. of iodide of potassium is to be dissolved in it." (Blanquart-Evrard 1850) The same issue of the *Art Journal* that carried this note also offered M. Niépce de Saint-Victor's advice: the addition of a touch of honey from Narbonne. A Scottish photographer, James Mudd, suggested (c. 1862) a refinement of his own when he found that duck eggs were preferable to the chicken variety, because they produced a particularly "bright, hard film." (Lawson 1990; Clark 1863)

The albumen process dominated the world of photography from the mid-1850s to the 1890s. As that world expanded, with the endless discovery and development of new applications for the art, so the demand for commercially prepared, ready-to-use albumenized paper grew more and more insistent among amateurs and professionals alike. By the 1880s, after the arrival of dry gelatin plates, the number of amateurs had grown enormously, but few were prepared to spend time sensitizing papers in the confines

of the kitchen; the great need was for reliable commercial sources. It was realized quite quickly that the albumen process worked best on thin, smooth paper of exceptionally high quality, made in mineral-free water. Only two paper mills achieved this standard consistently, one established at Rives in France, and one whose product was made in Malmedy (then part of Germany) and known as "Saxe" paper. However, for a variety of social and economic reasons, the German city of Dresden became the capital of the albumen world. Several factories flourished there, and the scale of manufacture can be gauged from the output of just one. In 1888 the Dresdener Albuminfabriken A.G. produced 18,674 reams of albumen paper. To make the coating for each of these reams, twenty-seven dozen egg whites were needed and so, in the course of one year, this factory alone used over six million eggs (Fig. 3-1). As all the factories in the city believed in encouraging the albumen to ferment for several days before it was made into a solution, the atmosphere must have been overwhelming, and it comes as no surprise to learn that Dresden paper could always be identified by smell alone (Reilly 1980).

Although albumen was an exceedingly useful substance as a transparent glue, its weaknesses showed themselves unmistakably as time passed. To an altogether disconcerting extent, the properties of albumen depended on the diet of the particular hen whose largesse made it available in the first place. Consistent supplies could not be depended on. Moreover, albumen prints had an unfortunate tendency to turn yellow, and to fade away. From the 1860s onward, citric acid had been added to act as a preservative (Anon. 1860), but its secondary effects were unwelcome: it had a tendency to make the prints excessively brown. Criticism mounted, and the new collodion and gelatin papers were introduced in the late 1880s, with triumphant claims of tonal virtue and archival permanence. The immortal phoenix came to be used in advertisements, in place of albumen's stock emblem, the

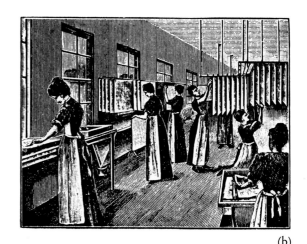

(a) (b)

FIG. 3-1. Albumen paper manufacture; the Dresden scene, c. 1890.
 (a) Separation of the eggs.
 (b) Sheets of paper hung up to dry, after floating on the albumen solution. (Eder 1898)

sturdy hen (Fig. 3-2). The old process soon fell from favor. As one enthusiast (with more feel for photography than poetry) wrote in 1887:

> . . . soon may all follow
> A "Permanent way",
> And from out of our albums
> No prints fade away.
> For when Albumen's yellow,
> and Chloride is flown,
> Platino and Carbon
> Shall still hold their own.
> [See Reilly 1980.]

While albumen was king, its manufacture presented both problems and opportunities. What was to be done with the egg yolks? Large commercial enterprises could make a profit from them; in Dresden they were preserved with salt, and sold to bakers, or to tanners who used them for finishing their kid leathers. However, no such outlet was available to the amateur user, whether in a private darkroom or one attached to a photographic studio. And yet, it was not to be expected that any conscientious wife could bear to stand by and see that golden hoard thrown away and wasted. On September 2,

1861, the *British Journal of Photography* suggested a solution:

> A HINT TO ALBUMENIZERS. What can you do with the yolks of your eggs? Make them into cheesecakes that will be pronounced unrivalled. . . . This is one of the pleasantest "bye-products" we are acquainted with in the economics of manufacturing photography. Try it!

The idea must have proved popular, for the recipe was published again in the journal's *Photographic Almanac* for 1862:

> *The Photographer's Cheesecake.* To convert the yolks of eggs used for albumenizing to useful purposes: Dissolve a quarter of a pound of butter in a basin placed on the hob, stir in a quarter of a pound of pounded sugar, and beat well together; then add the yolks of three eggs that have been previously well-beaten; beat up altogether and thoroughly; throw in half a grated nutmeg and a pinch of salt; stir, and lastly add the juice of two fine-flavoured lemons, and the rind of one lemon that has been peeled very

(a)

(b)

(c)

FIG. 3-2. The albumen paper period.

(a) 1885 advertisement by A. Rivot et Cie of London. "Rives" and "Saxe" refer to two highly esteemed rawstock papers made, respectively, in France and Germany, using 85 percent linen and 15 percent cotton fibers.

(b) 1887 advertisement by Miss Amy Scott, "Practical Sensitizer," presumably of rawstock paper supplied by clients to suit their own needs and tastes.

(c) 1899 advertisement for Aristo collodio-chloride print-out papers, enlisting the services of the immortal Phoenix to symbolize stability.

See Reilly (1980) for a comprehensive treatment of albumen and salted paper prints.

thin; beat all up together thoroughly, and pour into a dish lined with puff-paste, and bake for about twenty minutes. This is a most delicious dish. [Thomas 1969]

Gernsheim (1969) makes a reference to "the culinary period of photography," characterizing thereby not so much the use of albumen as such but the use of edible "preservatives" to keep collodion layers moist over longer periods of time, for wet-plate photography. The establishment of that process in the years following its first showing at the Great Exhibition of 1851 was hailed with great acclaim by photographers, who were prepared to overlook the "wet" aspect in return for other virtues. That tolerance proved to be temporary. Nothing else could be expected, considering that the final goal was clear to all: dry plates with the sensitivity and tone-rendering qualities of wet plates. Pending that achievement, there was a need to find some way of keeping wet plates moist, if not actually dripping, thereby avoiding the necessity of preparing them *in situ* immediately before each exposure.

The search for ways to do this began very soon, indeed, before the mid-1850s. The fact was that the pores of collodion layers contracted when the material dried out, thereby making the layers impermeable to developing and fixing solutions. Several ideas for preventing this were proposed, of which one involved the coating of collodion plates with hygroscopic substances. Only a limited number of such materials was within the Victorian photographer's reach. Zinc nitrate and magnesium nitrate were among those and, according to one entry in *The Journal of the Photographic Society of London* of July 21, 1854, were successful enough to maintain plate sensitivity for up to three weeks. However, these chemicals were not cheap, and something more "domestic" seemed to be called for. Thus, E. Maxwell Lyte (1854) suggested syrup, George Shadbolt (1854) honey, and J. D. Llewellyn, in 1856, a syrup of vinegar and honey (see Gernsheim 1969). Lyte was by profession a chemical

engineer; a biography honoring his achievements appeared in the *British Journal of Photography* of 1906 (p. 206). Earlier he had been one of the first to draw attention to the dangers of allowing residual "hypo" to remain in photographic prints.

A detailed, step-by-step account of "The Honey Process" appears in a brochure by M. H. Ellis (1856), who, in turn, reprinted it from *The Photographic Journal* of 1855. Indeed, most of the essay takes the form of a letter to that journal from the editor's Obedient Servant, John Sturrock, Jun. of Dundee. "The syrup should be thrown away as soon as it has the slightest sour smell," he advises. Of course, the problem was not only to get the honey into the right places before the exposure, but to remove the sticky mess afterward before printing. No matter, after eight pages of instruction, Sturrock asks, ". . . what other method is superior in economy, certainty, easiness of manipulation, simplicity, and sensibility?"

In due course, treacle, malt, raspberry juice, raisin syrup, pine-kernel juice, milk, licorice juice, chestnut juice, ginger wine, beer, tea, coffee, and gum arabic were all pulled into service, along with opium and morphine. The gum arabic process was actually patented (No. 2029) in England on September 1, 1856, by Richard Hill Norris, who in time came to favor gelatin. Indeed, he began the manufacture of such plates, and became a powerful figure in the photographic industry. Baier (1977) gives a comprehensive list of ingredients proposed, with references to the original publications. In a book on *Collodion Sec*, Chaumeux had already listed over a hundred different substances for "preserved and dry collodion" in 1864; inevitably, a pedantic reviewer of his work (Anon. 1864) noted that the author's list was by no means complete. As late as 1898, Abney described the action of an eggwhite-coffee-fruitsugar mix or, alternatively (in 1901), eggwhite and ammonium hydrate "mixed immediately before use with an equal quantity of beer or stout." In the same

1898 volume (p. 428) Beechey defends the advantages of pyrogallol in ale or black coffee.

All these notions naturally attracted a good many humorous comments in the literature from the earliest stages; by 1866, James Mudd, with mock seriousness, had proposed a gin-and-water technique that was thought to be pleasant in all sorts of ways. "The question of photography as a fine art will now be indisputable, for our commonest works will be always *spirituelle*," one appreciative reader commented. In the end, all these exotic, eye-catching contenders dropped out of the race, and it was that dull substance, gelatin, barely edible and not notably palatable, which won the prize for plate manufacture. In 1876, Dillaye still gave it as his opinion that "Le papier albuminé est le papier type par excellence . . . ," but by the turn of the century albumen prints were beginning to be quite rare; enterprising enthusiasts no longer headed for the kitchen, and ingenious recipes were falling out of favor. Nevertheless, one link with the dinner table has held firm. Wine bottled on the Niépce estate at Rully (Saône & Loire) is still in circulation, to clear the minds and cheer the hearts of weary workers in the field of photo-history.

FASHION IN FOCUS

Less than twenty years after its introduction, photography had taken firm root in society. No longer thought of as a marvel, it was accepted as an ever-present feature in the ever-changing scene. The photographer's equipment had become familiar, the products had been set in circulation, the tools of the trade were widely recognized, but the image of the art still glowed with the glamor of the new, the up-to-date.

Conditions were ripe for photography's entry into the world of luxury and conspicuous consumption. From this time onward, a photographic detail might be included in a fashion-plate, to add to the scene a touch of contemporary chic and the hint of a story (Fig. 3-3a). In the March 1856 issue of *L'Observateur des Modes*, published by Fontaine in Paris (Fig. 3-3b), spring outfits are on show, as debonair children cluster around the camera, set up to capture a spectacular mountain view (Braive 1966). In another French example, from the 1870s, the attitudes struck by two ladies as they bend over an open album have been chosen to draw the viewer's notice to the modish details of their dress (Fig. 3-4a) The plate shown in Figure 3-4b takes a more practical approach, and illustrates a sensible costume for a hands-on camera enthusiast.

The use of such tiny references as stage props in a fashion journal put no great strain on ingenuity, but to weave them into the story of fashion itself was quite another matter. Cameras and chemicals had no obvious links with costume, darkroom and dressing table stood poles apart. J. B. Dancer's development of microphotography in the 1850s made photographic jewelry both possible and popular (Fig. 3-5; see also Chapter 5), but the tilt of a bonnet, the set of a shawl, remained untouched by the new art.

Only in the world of fantasy could photography fire a fashion designer's dreams. On February 13, 1864, *The Illustrated London News* carried a description of the "grand Fancy Ball" given recently in Paris by the Minister for Foreign Affairs. Of all the costumes worn on that gala occasion, one in particular had caught the reporter's eye: "One lady personified Photography, being covered from head to foot with portraits, and wearing the *camera* as a *headdress*."

The story was picked up and printed again on the other side of the Atlantic, in the April issue of *The Philadelphia Photographer*, and in due course it traveled north to Canada, to the Montreal studio of William Notman. Notman had been a regular subscriber to that periodical for some years, and the amusing little social note must have lodged in his memory. A few months

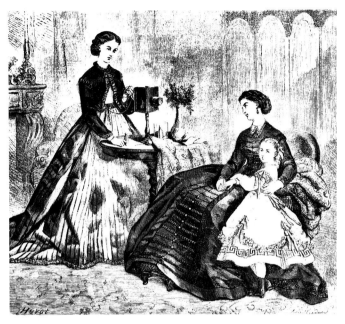

(a)

FIG. 3-3. Photography and Fashion.
 (a) Lithograph of 1864 from *La Mode Illus-
trée, Journal de la Famille* (Paris). Note Dub-
roni camera. (Scheid 1983)
 (b) Lithograph from *L'Observateur des
Modes*, March 1856. Engraving by DeBierne.
(Braive 1966)

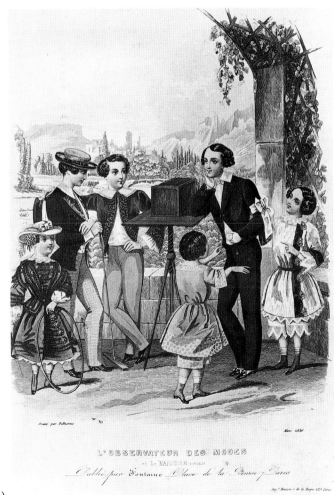

(b)

FIG. 3-4. French nineteenth-century fashion plates.

(a) Ladies admiring a photograph album. 1870s. From *La Mode Illustrée* (Paris). Imprint: Gilgan, Paris. Réville. A. Coudouze. Bud Wagner Collection.

(b) Outfit for the practical lady photographer. From *La Mode Pratique*. 1890s. Color lithograph printed by Helio Fortier-Marotte, published by Libraire Hachette & Cie, Paris. Storsberg Collection. (Storsberg 1990)

(a)

later, in 1865, he made a full-length portrait of a client, Miss Stevenson, dressed for a masquerade as the very spirit of photography (Fig. 3-6; Bara 1989). It is not known whether Miss Stevenson was really on her way to a party, but her costume may well have been inspired by the one worn the year before at the Paris ball. She wears a camera on her head, and her dress is indisputably covered with photographs. Even the buckles and ankle-bands of her slippers gleam with photographic cameos.

The idea refused to die. Another year passed, and "Photography Personified" took her place

in a group of dashing fancy-dress costumes proposed for fall in the American magazine *Godey's Ladies Journal* in October 1866 (Fig. 3-7). William Notman's sedate Miss Stevenson cannot compete in charm with the saucy model, but the two costumes are remarkably alike. Only the photographic ornaments on the shoes find no place in the engraving.

The details of dress match well enough to suggest a bond between photograph and picture. Did *Godey's* borrow the idea from William Notman, or was there an earlier prototype for both? The missing link may have been supplied by yet

La Mode Pratique

(b) Hélio Fortier-Marotte, 75, rue Jessen Libraire Hachette & Cie

another fashion-plate, in the French magazine *Les Modes Parisiennes* (Fig. 3-8). In this case, Photography has been paired with a lethargic lady in full, crinolined regimentals, wearing a large busby on her head and wielding a business-like battle-axe in one hand. (Storsberg 1989) For Photography herself, costume and pose correspond exactly with those of the *Godey's* model. The fact that the daringly revealed legs of the French figure have been demurely sheathed in pantaloons for her American counterpart is the only hint of any loss of nerve on the transatlantic crossing. The illustration is dated January 16, 1864 (Mayer 1991), and the resemblance between the two figures is so close that it seems permissible to speculate that the *Godey's* image of 1866 was poached from this French source. It is also possible, even probable, that just such a picture was needed by Notman, or Miss Stevenson, to supplement the imprecisions of the newspaper account, and supply the essential elements of the costume in the photographic portrait. The seed of the idea may have been planted even earlier, in a very different context: a cartoon by Marcelin that appeared in the Parisian *Journal Amusant* in 1856 (see Fig. 9-14b and

 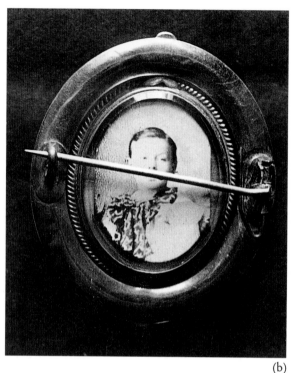

(a) (b)

FIG. 3-5. Photographic jewelry of the 1860s. A two-sided swing brooch, giving the wearer a choice of displays.
1 × ¾ inches. Unknown photographer. American.
 (a) *Front*: tintype.
 (b) *Reverse side*: albumen print.

Stelts 1990). In this, Photography is personified as a tough female revolutionary, armed with a camera and threatening to topple the whole artistic establishment. This truculent character has nothing in common with the flirtatious charmers of the fashion-plates except the dress: her limp skirt is covered with photographic panels.

The metaphor "I am a Camera" is a figure easy to grasp but hard to embody (Plagenz 1991). The task seemed daunting even in that realm of dreams and boundless possibilities, the masquerade. After this first flurry of attention, the motif fell from favor and was rarely revived (Braive 1966). Strangely enough, it was in the hard, thrusting world of cut-throat competition between commercial studios that the idea got its second wind. In the last years of the century, it was not uncommon for a photographer to at-tract customers by loading a model with pictures and portraying her as a living, breathing billboard for the studio's achievements (Fig. 3-9; see also Chapter 8). To demonstrate the vagaries of spontaneous combustion, the idea that first flamed as an amusing fancy at a gala ball flared into life again in such endearing eccentricities. Parisian elegance had found its faint echo in provincial publicity.

FICTIONS AND FANCIES

The photographic ghost has a mundane technical provenance in imperfectly cleaned and reused daguerreotypes, or in the context of fast-moving objects photographed on slow plates (Fig. 11-2).

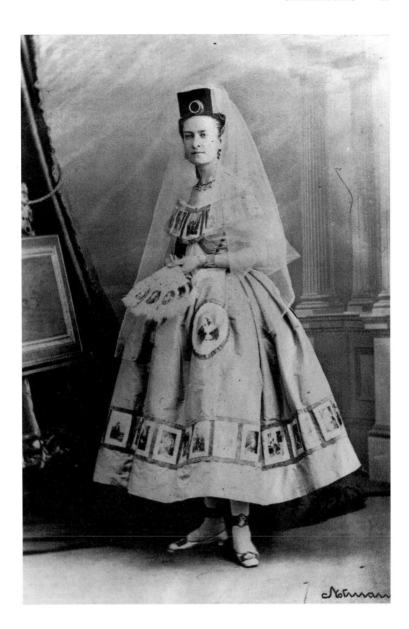

FIG. 3-6. William Notman: "Miss Stevenson." Albumen print, 3½ × 2⅜ inches. 1865. Canadian. Notman Photographic Archives, no. 14647-1. McCord Museum of Canadian History, McGill University, Montreal, Quebec.

Photographers were quick to capitalize on the possibilities, and none more successfully than William H. Mumler, a Boston portraitist during the carte-de-visite period. Images of long-dead relatives were some of his lucrative specialties, and since most clients did not in fact know what their more distant dear ones used to look like, the deception, fruit of a skillful darkroom manipulation, often succeeded. See also Chapter 10.

There was also room for ghosts of a playful kind, for entertainment or, more often, for ghosts with a mission, produced to substantiate spiritualist theories and psychic phenomena, or to support religious sentiment, however shallow. In Prague, for instance, monks of the Monastery of Emmaus actually specialized in spirit photography, on the grounds that they, more than most practitioners, could claim a natural af-

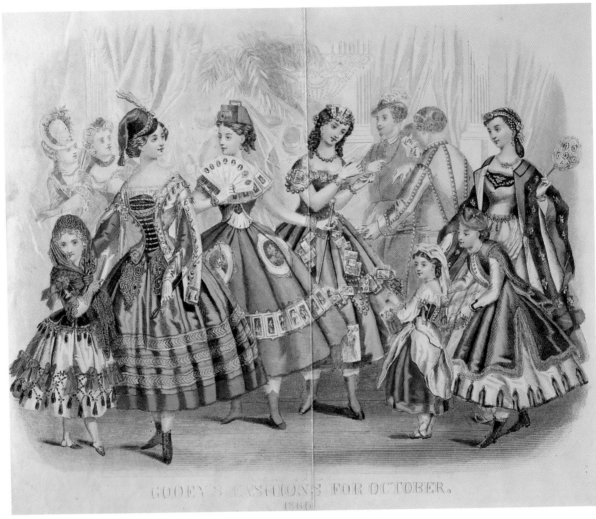

FIG. 3-7. *Godey's Fashions for October*. Litho-engraving by unknown artist, 9¼ × 11½ inches. 1866. American.

finity with their subject; ghosts would feel at ease in the company of their earthbound brethren. Neatly dressed in bed sheets, the spirits mingled with the monks to be photographed, a temporary lie in the service of eternal truth. These photographs were issued in 1878, but Skopec (1963) documents a similar image, albeit not made in a monastery, dating from as early as 1845 and depicting a writer inspired by an ethereal guide. An American example of this kind is shown in Figure 3-10a, in stereo, which gives the ghost a solidity and authenticity that no flat im-

age could have conveyed; the artist dreams by his easel, about to be rewarded by a visiting muse. A similar technique was used in Figure 3-10b for a gloomy scene, tactlessly entitled "The Sands of Time." McCulloch (1981) shows a montage in which a pensive young man holds a cigarette, while an image of his beloved is formed by the emerging smoke. In another such picture, a translucent ghost (evidently a victim of her own vice) plays cards with a pipe-smoking, gin-drinking skeleton, well beyond all saving grace. A more congenial and, indeed,

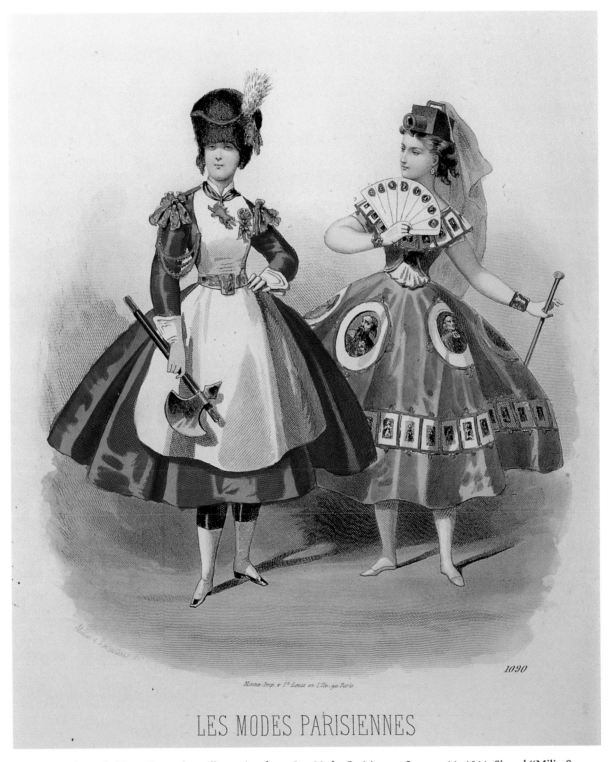

LES MODES PARISIENNES

FIG. 3-8. Photo-fashion. Fancy dress illustration from *Les Modes Parisiennes*, January 16, 1864. Signed "Milin S. Lacouriere." Storsberg Collection. (Storsberg 1990; Mayer 1991)

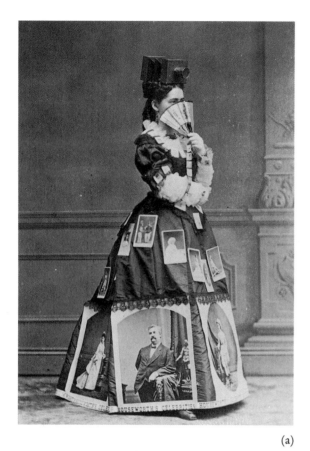

(a)

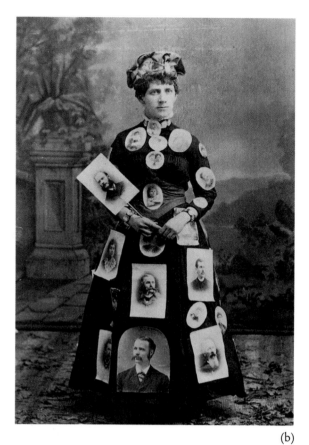

(b)

FIG. 3-9. Photo-fashion and photo-advertising. Palmquist Collection. (Palmquist 1990, 1991)

(a) "The Masquerade," by Thomas Houseworth & Company, San Francisco. Cabinet card from the Houseworth Celebrities Series (note hemline inscription). 1880s.

(b) Portrait of Mrs. Mary M. Ley, wife of photographer Thomas Allen Ley (b. 1848, Australia). Cabinet card of the 1880s. Mrs. Ley herself was a photographer, and a partner in her husband's gallery at Woodland, Yolo County, California, which opened its doors in 1865.

compassionate representative of *spiritus photographicus* is shown in Figure 3-11, comforting a young girl after a bereavement. For other examples, see Klens (1983) and, for an extensive discussion of ghost photographs, Krauss (1992).

Not all ghosts were introduced in the darkroom; some actually played a part on stage. Enterprising showmen took advantage of the fact that a sheet of glass, held at an angle, could be reflective and transparent at the same time. The resulting double image, of which Atget was to make such inspired use at the turn of the century, became known as "Professor Pepper's Ghost" (Fig. 3-12). It was so named after John Henry Pepper, director of the Polytechnic Institution in Regent Street, London. However, though Pepper took the credit, he did not actually make the invention; he bought it from a civil engineer, Henry Dircks, in 1862 (Senelick 1983). At the Polytechnic, the device was first used for a performance of Charles Dickens' *The Haunted Man*, on Christmas Eve of 1862, to the delight and acclamation of the audience. Photographing Professor Pepper's Ghost was actually easier than observing him "live" on stage, because of the limitations of gas lighting. Senelick

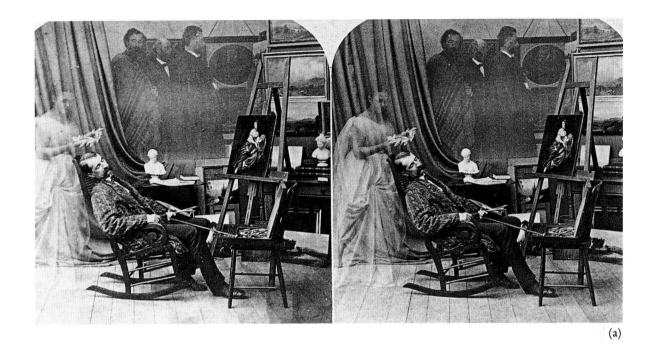

(a)

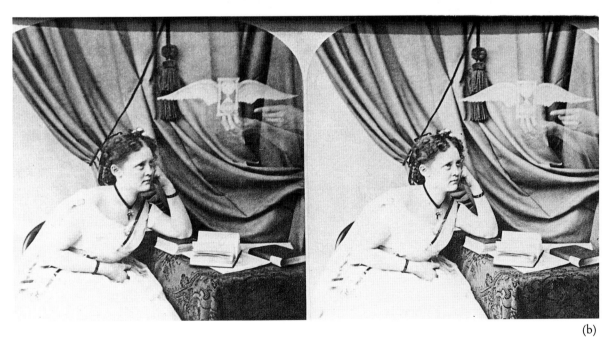

(b)

FIG. 3-10. Stereo Ghosts. Stereo cards by F. G. Weller of Littleton, New Hampshire (1875–80). Gelatin silver prints.
 (a) "The Artist's Dream" (1875).
 (b) "The Sands of Time" (late 1870s).

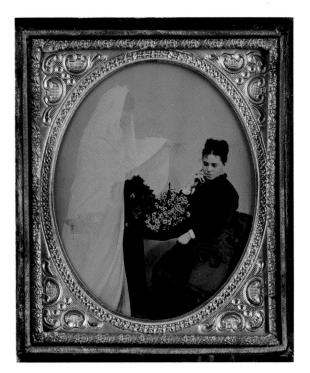

FIG. 3-11. Comforting Spirit. Unknown photographer. 1860s. American. Tintype 3¼ × 2¾ inches. Wm. B. Becker Collection.

traces the first full-stage performance to 1883, when *A Russian Honeymoon* was performed at Madison Square Theater in New York. See also Chapter 13.

With ghosts or without, the photographic "docu-drama" (though mercifully not yet so called) was a well-established commercial item by the end of the century, but it was not an invention of the photographic era; photographers had simply stepped into a tradition already firmly rooted in the world of entertainment. Throughout the eighteenth and nineteenth centuries, some of the most popular forms of indoor amusement in mixed company were dressing up, playing parts, and acting out riddles and charades. Sometimes words were used, and a scene was performed or read aloud, but sometimes the fun was in the silence, as one group struck poses in imitation of a well-known work of art, and the other struggled to guess the answer to the puzzle. The comments Diderot made as early as 1765 on the subject of *tableaux* performances equally describe many early photographic works:

> I have sometimes seen select companies, assembled in the country, amuse themselves during the autumn evenings with a most interesting and agreeable game: imitating the compositions of well-known paintings with living figures. First, one establishes the background of the painting by means of a similar decor. Then each person chooses a role from among the characters in the painting, and after having adopted its dress, seeks to imitate its attitude and expression. When the whole scene and all the actors are arranged according to the disposition of the painter and the place is suitably lit, one calls in the spectators, who give their opinion on how the *tableau* is executed. [Seznel and Adhémar 1957; Meisel 1983]

The custom has long roots, and examples abound. Thus, for instance, Jan de Braij's 1668 painting "Cleopatra Betting Anthony That She Can Spend More Than Ten Million Ducats on a Meal" (Currier Gallery of Art, Manchester, New Hampshire) is known not only for its quality and arresting title, but also for the fact that the painter and his wife appear as the principal characters in the painted scene (Blankert et al. 1981). Staged *tableaux* were arranged not only in private but also in public. In the early years of the nineteenth century, Sir David Wilkie, the Scottish artist, was enchanted by an entertainment of this kind which he saw in a Dresden theater. It was a complete re-creation on stage of a painting by Teniers. The *tableau* was perfect, but lasted only twenty seconds, because the actors were unable to hold their poses any longer. (Stevenson 1991)

Early photographers had been brought up in this tradition and were at home in the world of amateur theatricals and *tableaux vivants*. In one novel of the 1850s, a Christmas party at a country house comes to a climax with the acting out of a charade on the currently fashionable word "calotype" (Bede 1853–54). Traces of enthusiasm for the pastime are also easy to find in the work of two celebrated women photographers. Mrs. Cameron loved to bully long-suffering family and friends into costume, and to photograph them as Arthurian characters and allegorical figures. Lady Hawarden created elegant, enigmatic *tableaux* with herself and her daughters in mysteriously beautiful and haunting scenes (Dodier 1990).

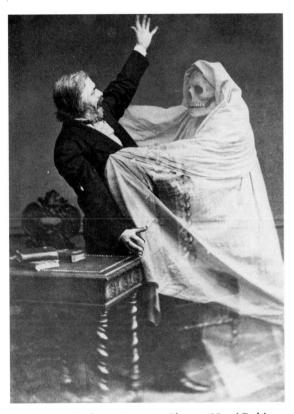

FIG. 3-12. Professor Pepper's Ghost: "Henri Robin Encountering the Living Phantasmagoria," by Thiébault. Carte-de-visite. 1860s. Paris. Collection of Laurence Senelick.

Commercial photographers were quick to sense the possibilities in the practice and turn them to advantage. Thousands of story-telling cards poured out, on everything from *Little Red Riding-Hood* to *The Pilgrim's Progress* (Darrah 1964, 1977). Stereo photographic series offered a significant advantage: they allowed several *tableaux* to be viewed in quick succession, and so extended the narrative range. Such series were forerunners of the early cinema, indeed, of the newsreel. One set of stereographs issued around 1900 by the H. C. White Company of North Bennington, Vermont, offers ten views that show the predictable progress of a young couple from (1) "The Proposal" to (10) "Alone at Last," with several glimpses along the way of the wedding ceremony ("With this Ring I thee Wed") and the champagne reception.

Figure 3-13 is more daring, for it gives an account of two women—nay, ladies—engaged in a duel. In real life, the duel had been at the core of the code of honor for men, and so the idea of women fighting duels amused, and perhaps titillated, the Victorian public. A popular romance with this theme, *The Marchioness of Brinvillers* (1846) by Albert Smith, was reissued by Richard Bentley in London in 1886, its cover decorated with a gilt vignette of two female fighters in dueling combat. (See also Darrah 1964, 1977.)

Beyond attempts to deceive and amuse were the endeavors of many photographers to convey profound messages on the human condition by photographing suitably composed *tableaux vivants*, the results of careful stage management. Rejlander began it with his classic "The Two Ways of Life" (1857), now the prop-and-stay of every history of photography course. That was a composite photograph, assembled in the darkroom, but the pure *tableau*, photographed in the studio, had a life of its own.

Cuthbert Bede (the Rev. E. Bradley), prolific clerical wit of the 1850s and 1860s, poked fun at photographic *tableaux* in his *Mattins and Mutton's* (Bede 1866), with a passing sideswipe at

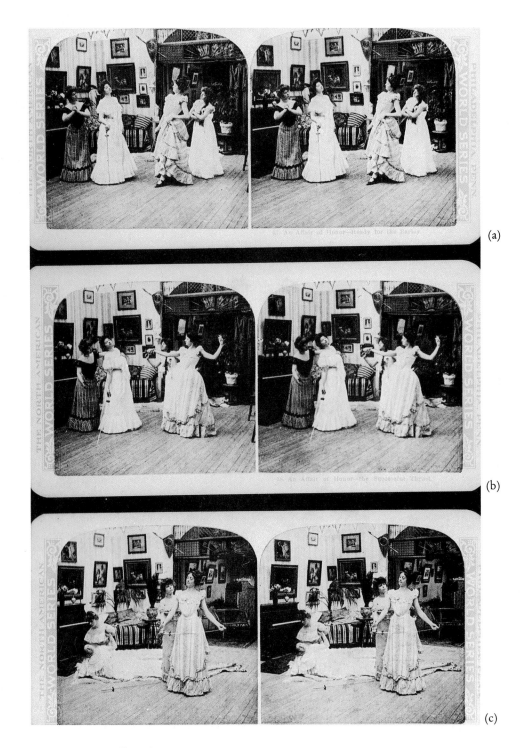

(a)

(b)

(c)

FIG. 3-13. An Affair of Honor. Stereo cards by an unknown photographer, c. 1900. Tinted photomechanical prints, published by the North American World Series. Philadelphia.
(a) "Ready for the Parley."
(b) "The Successful Thrust."
(c) "Honor Satisfied"; one of the elegant protagonists lies vanquished on the floor. See also Darrah 1964, 1977.

Low Church prejudice. Says Edgar, the hero, to the much admired Miss Galloway:

> One cannot always be posing oneself before the camera. Now, if you could only be persuaded, Miss Galloway, to sit, or rather to stand, to some photographer in the impressive attitude and costume in which I was fortunate enough to find you, enwrapped in Mutton's table-cloth, minus its soup mark, and with your hair well let down; and if you would but permit the artist to publish it with a title that should mysteriously hint at its being a portrait of a penitent who has had something to do with the confessional, you would make the man's fortune, and the *carte* would sell by the *cart*-load. There is a great talk among a certain class, and that by no means a small one in Brighton, about the High Church people having established a regular confessional; and as the Low Church people would be prepared to believe anything of the High, as long as it was something in their disfavour, they would accept your portrait in Mutton's table-cloth as a veritable exposure of Romanizing practices.

Never far from the "pure" *tableau* created only in the studio was always the *tableau* re-created in the studio after some production elsewhere. Figure 3-14 shows an example, dated on the back June 1874, the charming record of a costume party, or perhaps a scene from some amateur dramatic performance. The use of a mirror to provide a back view of one figure had by this time become an attractive, widely used convention. When he added this touch, the provincial photographer in Central Pennsylvania who made the scene followed in the footsteps of such aristocratic practitioners as Lady Hawarden, at ease in the heart of Britain's artistic establishment.

Ever since the photographic profession came into being, photographers have been found not only in the ranks of artists, but also in the ranks of moralists. People with a message need a medium, and preferably one that is capable of reaching a lot of other people when their guard is down. What could be better for this purpose than a slide lecture in a darkened room, with a captive audience mesmerized by pictures on a bright screen? That fact was discovered quite early, and began to be exploited in the 1890s, when better slide projectors became available, and when the story-telling slide-lecture had been established as a popular entertainment, a true forerunner of television.

In Britain, the firm of Joseph Bamforth, operating in the Midlands, called itself "The largest Producer of Life Model Slides in the World," and for all we know it may have been just that. *Mother's Last Words* was the name of their most popular slide set (in five parts), based on a ballad in verse that had appeared in 1860, some thirty years earlier, and had sold 190,000 copies (Gordon 1980). The author was Mrs. Sewell, whose daughter was to write the children's classic, *Black Beauty*. Joseph Bamforth set out to give the story new life in serial picture form, in a studio well-equipped with costumes and willing actors. To begin with, Mother herself issues a final exhortation to her destitute sons, which is "to work and always pray." Subsequently, young John and Christopher find honest employment as road sweepers. One day, a truly bad lad (but a talented cash-flow analyst) comes their way and points out that pocket-picking would be more profitable than road-sweeping. The boys remember mother, and promptly decline the suggestion. Yet, when winter comes and the little one has no shoes, the older boy steals a pair for him, only to suffer the most terrible pangs of conscience when alone in bed at night. No, he can't go through with it and, after much heart searching, he returns the stolen shoes. As a result, the little one catches a cold, which shows just how complex moral dilemmas tend to be. However, the young boy's coughing draws the attention of a rich lady, whose compassion, de-

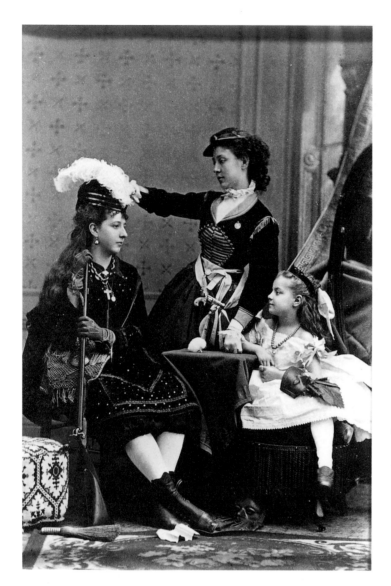

FIG. 3-14. Mask and Musket. Charming cabinet card of a scene with feminist overtones, from a costume party or some amateur dramatic performance. Gelatin silver print. June 1874. Made by J. F. Nice (1837–1924) in Williamsport, Pennsylvania. Nice was active in his studio from 1867 to 1883. (Grugan 1982; Wilsher 1982a)

scribed as being so characteristic of her kind, is duly moved. She procures a pair of worn-out boots (not new ones, of course), and throws in an old coat for good measure, the implication being that *such* bounty is forever the reward of true virtue.

In terms of reformist zeal, this ballad about life among the poor is something less than the Communist Manifesto. In this story, and in all others like it, the poor were asked to accept their lot, bearing gratefully in mind that rewards were waiting for them in the life thereafter, and to remember that it is easier for a camel to pass through the eye of a needle than it is for a rich man to enter the Gates of Heaven.

Photographic slide-shows of this kind enjoyed enormous popularity in England at the turn of the century, and in America photographers were similarly occupied with the problem of social classes. In England, the upper circles generally

preferred to hide their riches behind substantial garden walls, but in America "conspicuous consumption" was always the order of the day. Characteristically, American photographic entertainments dealt not so much with the plight of the underprivileged (as nobody would have dreamed of calling them), but frankly and joyfully with the life of the rich. That life also had its problems, all capable of photographic rendering for entertainment and profit. Figure 3-15 shows such a story, and its synopsis is simple enough. A rich family has a cook, of course. On one of his rare visits to the kitchen, the master of the house discovers that his cook has virtues that exceed and transcend the lightness of her pastry, and in due course he gives tangible expression to this new insight. However, as so often in life, things do not run smoothly. There is a noise in the hallway, which means that someone is coming, in fact, none other than the mistress, a suspicious character, very much given to putting two and two together and making four. Her forensic skills alerted, she identifies the culprit, while the husband protests that he has no idea how those floury handprints got onto his jacket; that is a total mystery to him. However, the mistress declines his protestations; the cook has to go, she says, and, in the next frame, the cook does indeed go, suitcase packed and smile on her face, ready to wreak havoc in the next household. With the offending party gone, peace reigns, and nothing stands in the way of an affectionate reconciliation. Domestic tranquillity is assured, not only for the present, but for the future; a new cook has just been engaged, to nourish the body if not the soul.

By no means exhausted by the vicissitudes of life with Mr. and Mrs. Newly-Wed and their domestic staff, the popular imagination found other titillating themes, of which the office romance proved to be particularly potent. The time was ripe for such a plot at the turn of the century, when women were beginning to make an appearance in what had always been a sanctuary for men. In one stereo series, made by Underwood & Underwood, the boss's wife pays an unexpected office visit, to find her husband and his pretty secretary in much closer collaboration than she had ever sanctioned. She goes for her rival, while the lord and master prays for peace in a corner. Another husband was more experienced, and took appropriate precautions (Fig. 3-16). In the wider world of stereographs, the henpecked husband, the Valkyrie-like woman frightened by a little mouse, and the fading of marriage's first bloom were all typical themes that proved to be forever durable.

MUSICAL MOMENTS

From the earliest times onward, photography, never a law unto itself, interacted with other arts (see also Chapter 4), and one of those was music, for which it occasionally provided a new stimulus and provocation. The collaboration began when, in 1864, Alexander Leitermayer of Vienna was commissioned to compose the "Daguerreian Waltz," to celebrate the twenty-fifth anniversary of Daguerre's discovery (Fig. 3-17). The piece itself has survived in merciful obscurity, enormously more favored by devotees of photo-history than by lovers of music. The cover design, indeed, is more charming than the composition. It shows two *putti* photographing a chain of dancing couples as they step onto the floor, join hands, and whirl away to the strains of a waltz more exhilarating than the one created by Leitermayer. The cherubic operators are capturing movement itself, with the new instantaneous photography that had been praised in 1861 by the critic Philippe Burty for its ability to record the passing scene (Mauner 1981).

In due course, other composers followed in Leitermayer's footsteps, on less significant occasions, maybe, but in some ways more successfully (Fig. 3-18). All the texts are, predictably,

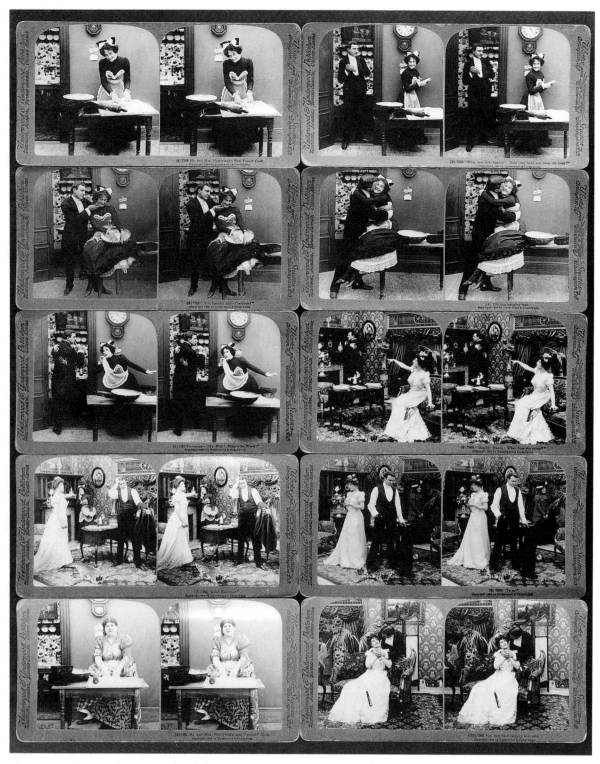

FIG. 3-15. "Mr. and Mrs. Newly-Wed's New French Cook." Stereo *tableaux vivants*. 1900. American. Unknown photographer. Gelatin silver prints. Story-telling picture series in ten parts, with subtitles in six languages. Published by Underwood & Underwood, Works and Studio, of Baltimore and Washington, D.C. As many as eight other companies made imitations, including one depicting black actors. See Darrah 1977.

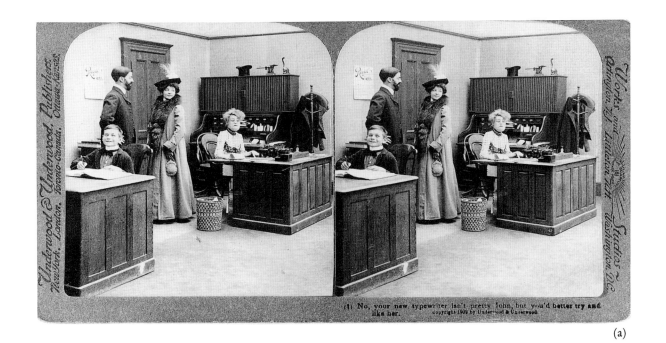

(a)

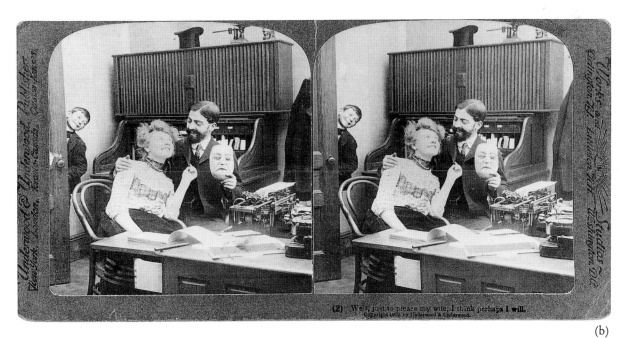

(b)

FIG. 3-16. Office docudrama. Stereo *tableaux vivants,* c. 1900. Unknown photographer. Published by Underwood & Underwood of New York, London, Toronto, and Ottawa. Subtitles in six languages.

(a) "No, your new typewriter (= typist) isn't pretty, John, but you'd better try and like her."

(b) "Well, just to please my wife, I think perhaps I will" ("Para complacer a mi esposa, voy a hacer esto").

FIG. 3-17. *The Daguerreian Waltz*, composed in 1864 by Alexander Leitermayer of Vienna, to commemorate the 25th anniversary of Daguerre's invention. Piano score commissioned by the Photografen Verein, Vienna. 13 × 10 inches. Wiener Lehr- und Versuchsanstalt.

(a)

(b)

(c) (d)

FIG. 3-18. Musical Miscellany. Sheet music with photographic themes.

(a) "When I send you a picture of Berlin," E. P. Heiffer (graphics). World War I. Published by Harry von Tilzer, New York City. Halftone, 13½ × 10½ inches.

(b) "The Kodak Girl" by William T. Cramer, composer, c. 1900. Rochester, New York. Lithograph, 14 × 10½ inches.

(c) "The Focus," a pasodoble by Harry J. Lincoln, composer. 1908. Williamsport, Pennsylvania. Halftone, 13½ × 10½ inches.

(d) "You Press the Button," by W. S. Mullaly, composer. After 1892. Published by Willis Woodward & Company of Broadway, New York. Lithograph, 11 × 8½ inches. The title echoes the famous Kodak advertising slogan "You press the button, and we do the rest." Words by Webster Fulton. Republished 1980 by the Historical Group of the Royal Photographic Society, Bath, U.K., and by the California Museum of Photography at Riverside. (Diage 1980)

FIG. 3-19. The *Photograph Waltz* (1882), a theme from *Les Noces d'Olivette*. Published by H. L. Benham and G. S. Shaw of Cincinnati, a businessman and a photographer working in partnership to celebrate their favorite art form. (Wilsher 1982b; Craven 1982)

of the "boy meets girl" variety. When item 3-18d was published, the Kodak camera was only three years old. Its famous advertising slogan was made part of the song's lyrics:

> Isn't it simple? Isn't it quick?
> Such a small box, it must be a trick!
> How do you work it? What is the test?
> *You press the button; we do the rest.*

The key phrase soon entered the language (see Weintraub 1987) and was used in many other works, from cartoons to Gilbert and Sullivan's last collaborative venture, *Utopia Limited* (1893):

> If evidence you would possess
> Of what is maiden bashfulness,
> You only need a button press—
> And *we* do all the rest.

The decoration of sheet music with pictures made from photographs began quite soon after photography's arrival on the scene. The printed version of a song, *The Forsaken One*, published in New York around 1848, carries on its cover a hand-colored lithograph of a young girl with the imprint "From a Daguerreotype by W. H. Durang, 303 Broadway" (Spira 1989). In 1881, a collection of pieces by H. S. Perkins issued in Boston was illustrated with a photo-mechanical halftone portrait of the composer, based on an image by the famous Canadian photographer William Notman, who had opened a branch studio in the city during the late 1870s.

The *Photograph Waltz* (Fig. 3-19) was issued in 1882 as a joint venture in graceful publicity by two Cincinnati businessmen. H. L. Benham, the publisher, sold sheet music at 42 Emery Arcade from 1881 until his death in 1900. A few doors away, at No. 28, worked G. S. Shaw, described as an "Artist and Photographer," and active in the town from 1882 until 1890. Putting their heads together, and doubtless pooling their resources, the two neighbors devised a charming advertisement. From Benham's ample stock they chose one of the popular operettas of the day, *Les Noces d'Olivette*, composed by Edmund Audran in 1879 and, with bold simplicity, extracted one short section, named it the "Photograph Waltz," and sent it forth to the citizens of Cincinnati. The front cover, decorated with a picture probably made by Shaw himself, was first and foremost a tribute to the photographer, while the inside pages drew customers to Benham with tempting selections from his latest catalog (Wilsher 1982b).

Of about the same period is *The Gay Photographer*, "Popular Song with Imitation Banjo Accompaniment" (Fig. 3-20), composed by George Grossmith, Jr., and published by J. Bath of 40 Great Marlborough Street, London. A small imprint on the sheet music inside explains that the imitative role, not only of a banjo but also of a penny whistle, is assigned to the "Pianoforte accompaniment" (Gidal 1983). The text is a moral tale, with many a lesson (but not in poetry) still valid to this day:

> Miss Jenkins was a lovely maid in
> Kensington located,
> And there never was a fellow who could
> win her heart, all mankind she hated;
> Some forty lovers sought her hand, but she
> baffled all their hopes,
> So the forty lovers left this world by means
> of forty ropes.
>
> But there came upon the scene a gay
> photographer,
> There came upon the scene a gay
> photographer,
> There wasn't a biographer,
> Nor e'en a lexicographer,
> Who did not write about this gay
> photographer.
>
> Miss Jenkins went to the studio of Mr.
> Peter Guffin,
> And he won her heart by taking of her
> photograph for nuffin,

THE POPULAR SONG WITH IMITATION BANJO ACCOMPANIMENT,
COMPOSED & SUNG BY
GEORGE GROSSMITH JUNR.
LONDON J. BATH, 40, GT MARLBOROUGH ST W.
WHERE MAY BE HAD BY THE SAME COMPOSER,
HE WAS A CAREFUL MAN. 4/ TOO SLOW! 4/. HE WAS A CARELESS MAN. 4/ YEO HEAVE O! TO SEA WE'LL GO. 4/

FIG. 3-20. *The Gay Photographer*, by George Grossmith, Jr. Published by J. Bath of 40 Great Marlborough Street, London, 1890s. (Gidal 1990)

But heartless was this man of art, to her he
did confess,
That he'd won the hearts of many other
nice young girls, by the very same
process.

Oh! Peter Guffin was a gay photographer,
Yes! Peter Guffin was a gay photographer,
There wasn't a biographer,
Nor e'en a lexicographer,
Who didn't write about this gay
photographer.

She said, "I'll be his ruin, though to perish
be my lot."
Then she swallowed all his photographic
chemicals, and died upon the spot.
So here's a moral for all young maids,
which you'll very plainly see,
Don't go to a photographic studio, for to
be taken free.

Or you may also meet a gay photographer,
Yes! You may also meet a gay
photographer,

There wasn't a biographer,
Nor e'en a lexicographer,
Who didn't write about this gay
 photographer.

Song and music (four sheets) cost four shillings, a bargain maybe, but not actually a trivial amount of money at the time. Also from London (and likewise sold at four shillings), we have from the 1890s *The Photographic Fiend*, a "humorous song" about photographic flirtation, written and composed by Herbert Harraden and published by Robert Cooks & Company of Regent Street. "We take supper in the darkroom" is one of its poignant paroles. Braive (1966) mentions an early French piece, *La Photographie sur Papier* (alas, undated), a "comic scene" by Jules Couplet, published in Paris.

Along loftier and later lines, there is on record a work of greater fame: Kurt Weill's opera *The Czar Has His Photograph Taken*, composed in 1928. Although the music itself would have to be described as "forgettable" or at least "controversial," the libretto's popularity and humor have never been questioned. The Czar has his photograph taken, but the legitimate photographer and his assistants have been replaced by a band of revolutionaries. What they are planning is not so much "a good likeness" as a successful assassination. The gun is hidden in the camera in place of a lens. An assistant has the job of posing the Czar for the "shot" but, with total disregard for her revolutionary responsibilities, she falls in love with her client. The Czar begins to be impatient with the lengthy preparations, and wants to get the whole thing over with, while the love-struck assistant tries her best to delay the operation, praying for a *deus ex machina* to relieve her of a task no longer relished. *Deus* relents, and does.

It is part of the magic of the creative arts that each remains distinct, while each can draw nourishment from any or all the others. Photography seemed at first a brash intruder, a menace to the established order, but it quickly became a thread woven into the traditional fabric of values, to blend with and yet change forever the complex harmonies of an age-old pattern.

Chapter 3 References and Notes

ABNEY, Sir William de W. (1898). In the *Jahrbuch für Photographie und Reproduktionstechnik*, Halle, p. 276.

ABNEY, Sir William de W. (1901). *A Treatise on Photography*, Longmans, Green & Co., London (10th edition), p. 171.

ANON. (1860). "Printing and Toning in Albumenized Paper," *The Photographic News*, vol. 3, p. 206.

ANON. (1864). In *Photographisches Archiv*, vol. 5, p. 44.

BAIER, W. (1977). *Quellendarstellungen zur Geschichte der Fotografie*, Schirmer-Mosel, Munich.

BARA, J. (1989). "Photography Personified," *History of Photography*, vol. 13, no. 3, pp. 241–42.

BEDE, C. (1853–54). *The Adventures of Mr. Verdant Green*, James Blackwood, London, part 2, chapter 9, p. 84.

BEDE, C. (1866). *Mattins and Mutton's; or, the Beauty of Brighton, a Love Story*, Sampson Low, Son, & Marston, London, p. 221.

BLANKERT, A., et al. (1981). *Gods, Saints and Heroes: Dutch Painting in the Age of Rembrandt*, National Gallery of Art, Washington, D.C.

BLANQUART-EVRARD, L.-D. (1850). *The Art Journal* (London), p. 329.

BRAIVE, M. F. (1966). *The Era of the Photograph*, Thames & Hudson, London, pp. 87, 96, 21.

CLARK, W. D. (1863). "Notes on the Collodio-Albumen Process," *British Journal of Photography*, May, p. 194.

CRAVEN, R. J. (1982). Personal communication, acknowledged with thanks.

DARRAH, W. C. (1964). *Stereo Views*, W. C. Darrah, Gettysburg, Pennsylvania.

DARRAH, W. C. (1977). *The World of Stereographs*, W. C. Darrah, Gettysburg, Pennsylvania.

DIAGE, K. V. (1980). Personal communication, acknowledged with thanks.

DILLAYE, F. (c. 1876). *La Pratique en Photographie*, À la Librairie Illustrée, Paris, p. 249.

DODIER, V. (1990). *Domestic Idylls: Photography by Lady Hawarden from the Victoria and Albert Mu-*

seum, brochure for an exhibition at the J. Paul Getty Museum, Malibu, California.

EDER, J. M. (1898). *Die photographischen Copirverfahren mit Silbersalzen (Positiv Prozess),* W. Knapp Verlag, Halle, pp. 121, 123.

ELLIS, M. H. (1856). *The Ambrotype and Photographic Instructor; or, Photography on Glass and Paper,* Myron Shew, Philadelphia. (Myron Shew, the publisher, was himself a daguerreotypist and inventor, who had originally studied under Samuel F. B. Morse.)

GERNSHEIM, H. and A. (1969). *The History of Photography,* McGraw-Hill, New York, p. 324.

GIDAL, T. N. (1983). Personal communication, acknowledged with thanks.

GIDAL, T. N. (1990). Personal communication, acknowledged with thanks.

GORDON, C. (1980). *By Gaslight in Winter: A Victorian Family History Through the Magic Lantern,* Elm Tree Books, London, pp. 83–89.

GRUGAN, A. K. (1982). Personal communication, acknowledged with thanks.

KLENS, E. M. (1983). "The Manipulated Photograph, 1839–1939," M.A. thesis, Pennsylvania State University.

KRAUSS, R. H. (1992). *Jenseits von Licht und Schatten,* Jonas Verlag, Marburg.

LAWSON, J. (1990). Personal communication, acknowledged with thanks. See also her essay on William Donaldson Clark (1816–73), *Scottish Masters 15,* National Galleries of Scotland, Edinburgh, 1990.

LYTE, E. M. (1854). In *Notes and Queries,* June 17.

MAUNER, G. (1981). "The Putto with the Camera: Photography as a Fine Art," *History of Photography,* vol. 5, no. 3, pp. 185–98.

MAYER, A. (1991). Personal communication, acknowledged with thanks.

McCULLOCH, L. W. (1981). *Card Photographs: A Guide to Their History and Value,* Schiffer Publishing Co., Exton, Pennsylvania, pp. 159, 173.

MEISEL, M. (1983). *Realizations: Narrative, Pictorial and Theatrical Arts in Nineteenth Century England,* Princeton University Press, Princeton, New Jersey.

MUDD, J. (1866). *The Collodio-Albumen Process,* London (publisher unknown).

PALMQUIST, P. E. (1990). *Shadow Catchers: A Directory of Women in California Photography Before 1901,* Palmquist, Arcata, California, pp. 72, 140.

PALMQUIST, P. E. (1991). Personal communication, acknowledged with thanks.

PLAGENZ, G. R. (1991). *New York Times Book Review,* Correspondence, February 3. ". . . one critic's two-word review of John Van Druten's play *I am a Camera*: 'No Leica'." (Original book by Christopher Isherwood.)

REILLY, J. M. (1980). *The Albumen and Salted Paper Book,* Light Impressions, Rochester, New York, pp. 29, 33–34.

ROCKETT, W. H. (1983). "The Bonfils Story," *Aramco World Magazine,* vol. 34, no. 6, p. 13.

SCHEID, U. (1983). *Als Photographieren noch ein Abenteuer war,* Harenberg Kommunikation, Dortmund, p. 49.

SENELICK, L. (1983). "Pepper's Ghost Faces the Camera," *History of Photography,* vol. 7, no. 1, pp. 69–72.

SEZNEL, J., and ADHÉMAR, J. (Editors) (1957). *Diderot Salons,* Clarendon Press, Oxford.

SHADBOLT, G. (1854). In *The Photographic Journal,* July 21.

SKOPEC, R. (1963). *The History of Photography in Pictures, from Earliest Times to the Present,* Orbis, Prague, p. 268.

SPIRA, S. F. (1989). "Sheet Music and Photography," *History of Photography,* vol. 13, no. 4, pp. 286, 310.

STELTS, S. (1990). "À bas la Phothographie!!" [*sic*], in *Shadow and Substance: Essays on the History of Photography* (ed. K. Collins), Amorphous Institute Press / University of New Mexico Press, Albuquerque, New Mexico, pp. 225–28.

STEVENSON, S. (1991). *Hill and Adamson's "The Fishermen and Women of the Firth of Forth,"* Scottish National Portrait Gallery, Edinburgh, p. 47.

STORSBERG, K. (1989). In *Photo-Antiquaria,* vol. 16, no. 1, p. 34.

STORSBERG, K. (1990). Personal communication, acknowledged with thanks.

THOMAS, D. B. (1969). *The Science Museum Photography Collection,* H.M. Stationery Office, London, p. 70.

WEINTRAUB, S. (1987). "Utopia, Limited," *History of Photography,* vol. 11, no. 3, p. 236.

WILSHER, A. (1982a). "Mask and Musket," *History of Photography,* vol. 6, no. 1, p. 20.

WILSHER, A. (1982b). "Double Bill," *History of Photography,* vol. 6, no. 3, p. 280.

4

MIXED MEDIA

THE ENGRAVER

The daguerreotype was a unique object, without duplicate, a fact that ensured its treatment as something precious, a form of fine jewelry. The very same characteristic also made it impossible to introduce any individual image to a wider public, except with the help of an intermediary, the skilled engraver. N. P. Lerebours of Paris was one of the first to realize how eagerly the public would buy engravings based on original daguerreotypes of famous and faraway places. By December 1839 he was able to offer for sale in his Paris shop actual daguerreotypes taken for him in Italy and on Corsica and, soon after that,

engravings made from those views. Lerebours' anthology of such prints, *Excursions Daguerriennes*, was published in serial form over a number of years, from 1840 onward. Figures 4-1 and 4-2 give two examples. The pedestrians and bystanders in Figure 4-1 were, of course, a contribution of the engraver, freely drawn from his imagination. Engravers everywhere felt that they should make such additions, partly in order to enliven the pictures, and partly in order to show they were active and artistic participants and not merely mechanical transfer agents. A little-known engraving by Hurlimann, recently unearthed by Gidal (1990), and also from *Excursions Daguerriennes* (plate 43), contains not

FIG. 4-1. Engravings after daguerreotypes I. Example from *Excursions Daguerriennes*, published by N. P. Lerebours of 13 Place du Pont Neuf, Paris, from 1840 onward. (Gernsheim 1982) "Eglise St. Marc, à Venise." Early 1840s. Paris. S. Hurlimann, engraver. 5¾ × 8⅛ inches. The figures are contributions by the engraver.

merely people as decorative elements in the scene, but actually a photographer and his imagined client leaning against the "Portail de Notre Dame de Paris" (Fig. 4-2). Because portraiture was still quite uncommon at the time, the engraving probably represents a piece of wishful thinking, and is all the more charming for that. It may, indeed, be the earliest image of a daguerreotypist at work. See also Figure 14-3.

Issues of *Excursions Daguerriennes* are now among the most hallowed of photographic icons, and tend to overshadow similar, and perfectly equivalent, work done elsewhere. Thus, for instance, Maurycy Scholtz of Warsaw produced an elaborate engraving based on a da-

guerreotype of the Saxonian Square (later Victory Square) in that city, and did so, like Lerebours, in 1840 (see Fig. 4-3a). The urban architecture is there enlivened not only by people but also by two dogs and two horses. His engraving of Theatre Square (Fig. 4-3b), with its deep perspective and mottled sky, owes even more to his manual intervention (Garztecki 1977). Scholtz, originally a painter and lithographer, became the first professional photographer in Warsaw. He also used his daguerreotypes as preliminary "sketches" for his paintings. Elsewhere, in Prague, a famous lithograph of the Horsemarket (later Wenceslas Square) was made by a practitioner named Trajc.

FIG. 4-2. Engravings after daguerreotypes II. Example from *Excursions Daguerriennes* (Plate 43), published by N. P. Lerebours of 13 Place du Pont Neuf, Paris, from 1840 onward. Detail from "Portail de Notre Dame." Early 1840s. Paris. S. Hurlimann, engraver. 10 × 8 inches. (Gernsheim 1982) T. N. Gidal Collection.

Similarly, the Czech painter-photographer Be-dřich Anděl was responsible for a lithograph of the Prague Guard in 1851, composed of elements taken from several daguerreotypes (Skopec 1978).

Such views were very popular with the public, and *The Illustrated London News*, the world's first illustrated weekly, took note of the fact. As soon as it appeared, on May 14, 1842, it promised to every reader willing to remain a faithful subscriber for six months "a grand panorama print of London, a picture bigger than anything previously issued . . . drawn by the light of the sun." The lucky photographer commissioned for the job was Claudet, who made a number of views with a specially built camera from the top of the Duke of York's Column in Pall Mall. The daguerreotypes were copied in pencil onto sixty separate pieces of boxwood, and cut by nineteen engravers over a period of two months (Gernsheim 1969). The gigantic engraving, which measured 50 by 36 inches, was published on January 7, 1843, a triumph for the journal, the photographer, and the exhausted team of artists. With justifiable pride, the journal offered a facsimile of the original panorama in conjunction with its 150th anniversary issue in 1992.

Ventures of this kind sharpened a general appetite for illustration, and small images began to brighten the text of the most sober publications.

(a)

(b)

FIG. 4-3. Engravings after daguerreotypes III. Examples of the work of
Maurycy Scholtz of Warsaw, Poland. 1840. Warsaw street scenes. (a) Saxonian
Square. (b) Theatre Square. (Garztecki 1977)

Thus, an album on selective cattle-breeding, issued in St. Petersburg in 1857, contained two pictures of a cow and an ox, with the caption "These drawings were reproduced from daguerreotypes made by Mr. Blondelis in Vilnius . . . September 8th–10th, 1854" (Juodakis 1977).

Photographic portraits of men and women were harder to achieve than city views or documentary records, because the long time exposure required made each sitting an ordeal. Once that problem had eased, the image still had to be reproduced in some form, if it was to have any chance of reaching the public. It is, indeed, to the engraver's art that we owe a myriad Victorian portraits, all based on daguerreotypes and given

a flourishing, extended life in the print medium. Figure 4-4, the frontispiece of a proud author's book, is a typical example. The unknown engraver of Figure 8-2 commemorated and publicized the daguerreotype made of Daguerre himself in 1849 by the American photographer Charles R. Meade, one of the famous Meade Brothers, during his visit to the great man in Paris. See also Chapter 11 and Figure 14-11. For a list of other books illustrated with engravings made from daguerreotypes, see Buerger (1989).

The practice of making prints of engravings based on photographs did not, of course, cease with the passing of the daguerreotype. On the contrary, the invention of the wet collodion

(a)

FIG. 4-4. *The Great Harmonia*, by Andrew Jackson Davis. Published by Benjamin B. Mussey & Company, Boston, 1850.

(a) Frontispiece, engraving from the author's daguerreotype portrait. 3⅝ × 3 inches.

(b) Title page.

THE

GREAT HARMONIA;

BEING

A PHILOSOPHICAL REVELATION

OF THE

NATURAL, SPIRITUAL, AND CELESTIAL UNIVERSE.

BY

ANDREW JACKSON DAVIS,

AUTHOR OF " THE PRINCIPLES OF NATURE, HER DIVINE REVELATIONS, AND A VOICE TO MANKIND."

Spontaneous and profound Questions are living representatives of internal Desires; but to obtain and enjoy those pure and beautiful responses, which are intrinsically elevating and eternal, the Inquirer should consult not superficial and popular Authorities, but the everlasting and unchangeable teachings of Nature, Reason, and Intuition.

There is an omnipotent, purifying, and fraternizing Principle permeating and pervading the Natural, Spiritual, and Celestial Departments of God's Universal Temple — a principle, which unites atoms and planets into one stupendous System; which unfolds spirits and angels as immortal Flowers; which endows the Divine Mind with eternal Power and Loveliness; and which is the divinely-inherited Treasure of the human soul — and this principle is called, THE GREAT HARMONIA.

VOL. I.

BOSTON:
BENJAMIN B. MUSSEY & CO.
29 CORNHILL.
———
1850.

(b)

FIG. 4-5. Young man with hat and cravat. Unknown photographer. Mat printed by the Keystone Copying Company of Picture Rocks, Pennsylvania, c. 1880. Black pigment on albumen print, 7½ × 5¼ inches, oval. Faded photograph with heavy retouching.

process made it possible to print photographs on any surface, and specifically on wood, where they could be engraved *in situ*. Thus, the *Pittsburgh Post* of August 15, 1859, carries an interview with Robert Price, described as "the patentee of a new process of photographing on wood, which seems destined to work an entire revolution in the manner of engraving. . . . The pictures, when finished, present a beautiful appearance." Price goes on to say that the process can be "applied equally to stone, copper, steel, and other articles used for engraving" (Weprich 1990). Price, of Worcester, Massachusetts, was one of several ingenious experimenters who

struggled to solve this technical problem in the 1850s (Taft 1938). His own patent had been granted in 1857, and his method was used by *Scientific American* to reproduce a portrait in the May 21, 1859, issue.

THE RETOUCHER

As photography became more widely known outside the circle of its pioneers, admirers found it hard to understand how a medium that could render shapes and textures in exquisite detail

FIG. 4-6. Seated woman in spotted dress, c. 1860s. American, probably Pennsylvania. Unknown photographer. Black pigment on albumen print, 8¼ × 5¾ inches. Note elaborate and unsuitably grand backdrop, retouching of facial features.

could fail to respond to that ever-present element in the real world: color. It was a mystery. Not only were early photographic materials "color blind," in the sense that colors were not recorded, but that very blindness caused tone values in general to be distorted, making all greens very dark, and blues and violets disproportionately light. Photographers, ever anxious to please their public, sought remedies, and resorted to manual intervention. They had several other motives also, one of which derived from the fact that early photographs tended to fade in the course of time. Customers, photographers rightly argued, would not value impermanent

works of art. Indeed, the problem of fading got worse as the world became more and more industrialized; in any case, the problem called for sophisticated photochemical research.

Photographers could not wait. They began almost at once to retouch their images, emphasizing a desirable outline here, suppressing an unfortunate feature there, partly in an attempt to improve upon nature, and always in the hope that the ravages of time would leave important details intact, even if the underlying photograph itself had to be given up as irretrievably lost. This was one of the original purposes of retouching, and Figures 4-5 and 4-6 show just

how important this form of manual intervention really was. Without it, little of those particular images would now be left. However, retouching had other uses; one was simply to increase contrast, another was to embellish and "correct." These practices are almost as old as photography itself, the coloring of daguerreotypes having been introduced by Johann Isenring of St. Gallen, Switzerland, in 1839 (Gernsheim 1969). Isenring described his techniques in his own inimitable style, as "the fruit of unceasing studies," with products "resembling accomplished paintings"; see *Photo-Antiquaria Special* of November 1987 for an example of his advertising prose.

The seriousness of the fading problem throughout the 1840s, 1850s, and the 1860s, can be judged from the fact that no less a personage than Prince Albert came to be deeply involved in it. When the Photographic Society of London set up a special "Fading Committee" in 1855 to investigate causes and remedies (Gernsheim 1969), Prince Albert showed support with a gracious (albeit modest) subvention of £50. The committee's work had been stimulated by many years of public complaint, eloquently expressed by *Punch* in 1847 (p. 143). The journal's comment on the situation draws a poignant parallel between the photograph and love, both occasionally wilting with the passage of time:

Behold thy portrait—day by day,
I've seen its features die;
First the moustachios go away
Then off the whiskers fly.

.

Those speaking eyes, which made me trust
In all you used to vow,
Are like two little specks of dust—
Alas! where are they now?

.

Thy hair, thy whiskers, and thine eyes,
Moustachios, manly brow,
Have vanished as affection flies—
Alas! where is it now?

When the Fading Committee came to make its report, late in 1855, it found no shortage of factors to blame: harmful chemicals that tended to sneak into the processes while no one was looking, human failings (insufficient patience with print-washing), and the ever-deteriorating quality (sulfur content) of London's air. The committee had done its work conscientiously, and the photographic public was duly grateful, but no one believed that quick and foolproof remedies were close at hand.

The retouching of daguerreotypes was always a delicate matter, but calotypes were easier to handle, because they could be retouched with a pencil, an instrument itself still new enough, in its modern form, to warrant a special exhibit in London's 1851 Crystal Palace (Petroski 1990; Hunt 1851). Retouched calotypes were first demonstrated by Henry Collen of London, a miniature painter and one of Queen Victoria's drawing masters. He was also the first of Fox Talbot's licensees (Anon. 1842), and he counted among his admirers the formidable Sir David Brewster, who saw in the practice not a regrettable necessity but actually a fertile marriage between art and science.

At times, the contemporary terminology was totally misleading as, for instance, when Root (1864) used the term "Crayon Daguerreotypes" to refer to vignetted daguerreotype plates, sometimes cylindrically curved, and not to images retouched and colored with crayons. Why the experienced Root should have wanted to adopt such a term remains a puzzle, all the more since we know that he was interested in color daguerreotypy and alert to the danger of misleading descriptions. Thus, he reserved some scathing comments for the Rev. Levi L. Hill, whose Hillotypes he denounced as tricks and fakes. A few years before Root's book came to be written, Hill had claimed the invention of daguerreotypy in natural colors (Hill 1856). In those early days, Root had been one of Hill's supporters. However, in his choice of this particular term, Root was not thinking of Hill, but

was following in the steps of the renowned John Adams Whipple, first daguerreotypist of the moon. In 1849, Whipple had patented (U.S. Patent No. 6056, January 23) a vignetting process, calling the products "crayon portraits" (Newhall 1961). The vignetting was actually achieved by interposing a rotating mask between the camera and the sitter and, since Whipple was a steam-power enthusiast, that device (and much else in his studio) was driven by a steam turbine. Whipple and Root notwithstanding, "crayon" did mean crayon pigments in most photographic advertisements; see, for example, Figure 7-23c.

The scope of "retouching" has no obvious limits, and what began as a purely technical corrective measure developed in due course into a full-fledged secondary art, the art of overpainting.

THE OVERPAINTER

Photographs were often hand-colored, from the earliest daguerreotype days (e.g., see the essay by Alice Swan, contributed to Buerger 1989), but toward the turn of the century new fashions came into being. By then, technical advances had made it possible for photographers (often itinerants) to rephotograph and enlarge pictures of their clients' ancestors for conspicuous display on the walls of rooms, stairways, and corridors, in inexpensive imitation of the painted portraits that for centuries had graced the houses of the rich and powerful. Figures 4-7, 4-8, and 4-9 are typical examples of the result. Each one is overpainted, in varying degree, and that was actually a necessity, because all pleasing image contrast tended to be lost during enlargement. The faint imprint which resulted from that process was "gone over" with charcoal, and sometimes with crayon as well, or else with watercolor or even oil paint. Watercolor was generally applied to straightforward prints on paper; charcoal and crayon to prints on canvas or, more of-

ten, paper applied to stretched canvas. The tintype surface called for oil, and the photographic basis of the images was often obliterated beyond recognition. If the final result does not quite look like a fine painting, it did nevertheless serve almost as well as a support for family pride and affection. Figure 4-10a shows a family at tea in a room crowded with memories, overpaintings on the wall and in their midst, the dead keeping company with the living. In the ordinary way, such pictures were used as permanent wall ornaments, but those in Figure 4-10b were certainly brought out for the special occasion of a family photograph in front of the family home. The sentiment of accepting the image in place of the person was already old when photographers began to exploit it in a determined way toward the end of the nineteenth century, and it is by no means dead in our own day (see Haberman 1990). For most overpaintings now surviving, the original photograph has been lost or, at any rate, has remained untraced, but in a few instances (see Figs. 4-7 and 4-11) it is available for comparison.

As late as 1905, an English photography handbook (Hasluck 1905) gave instructions on hand-coloring, observing enigmatically, "When the colours are in proper relationship, it is called harmony," without going so far as to define what a "proper relationship" might be. It further recommends vermilion for upper lips, and carmine for lower. "It is a common mistake of the beginner to make the lips far too red, or to unduly accentuate the outline, which gives a curious pursed-up appearance. Faults of this description must be carefully guarded against"; so, indeed, must split infinitives. Hasluck goes on to observe: "An artist who is able to paint a portrait in opaque oil colours requires no photographic basis. The advantage of using such a basis is merely in the saving of time" (see also Ayres 1878).

The term "overpainting" is used (without pedantic precision) for a wide variety of techniques and practices, from the delicate staining of da-

(a)

FIG. 4-7. Portrait of a Young Man. 1880s. Knoxville, Pennsylvania. Unknown photographer.
 (a) Charcoal on silver gelatin print, 17¾ × 13¾ inches, oval.
 (b) The silver gelatin print, 5¼ × 2½ inches, that served as the original from which the over-painted enlargement was derived.

guerreotypes with translucent pigments, to the simple retouching of paper prints, to partial hand-coloring (Figs. 4-9 and 4-12), to powerful reinforcement by means of charcoal (Figs. 4-7 and 4-14c) or crayon (Fig. 4-13), or both (Figs. 4-14 a and b), with alcohol-based pigments (Fig.

4-15) and, finally, to heavy overpainting with oil-based pigments (Figs. 4-8, 4-11, 4-16, 4-17). The purpose of this last procedure was no longer to preserve the photograph or even to improve upon it, but to use it as the foundation for a very different art object. The final result was to be a

(b)

painting, and the fact that the pigment, applied with an artist's brush, hid a photograph was often guarded as a secret from the customer.

In turn, any customer who knew what had been done was hardly ever anxious to reveal the deception, lest it diminish the value of the final product. This kind of doctoring not only enhanced the social prestige of the image, it had an added advantage. In the client's opinion, whether a portrait painter would achieve a "good likeness" had always been a matter of luck; with a photograph as a base, the chances of success were immensely improved. Even so, as one would expect, the products vary enormously in competence and aesthetic appeal,

from sensitive interpretations (Figs. 4-9, 4-13, 4-16) to grotesque extravaganzas (Fig. 4-18). In the course of overpainting, artists did not necessarily accept the dictates of the photograph, but exercised their editing skills—for instance as shown in Figure 4-11, one of the few cases in which the original photograph (here a tintype) has survived, along with the overpainted enlargement. Occasionally, it is possible to find a group photograph in which only one person is colored in (Fig. 4-18b), perhaps to signify a birthday or some other special occasion. Perrot and Martin-Fugier (1990) mention another convention with the same purpose. In France, a young unmarried girl was often photographed in

FIG. 4-8. Standing Couple, arm in arm, c. 1880s. American. Unknown photographer. Oil on tintype, 8½ × 6½ inches. Background removed by etching.

FIG. 4-9. Family Group, c. 1850s. American. Unknown photographer. Watercolor and ink on salt print, 7¼ × 7 inches. Overpainting made partly to add a color interest, partly to increase image contrast. Fine example of its kind.

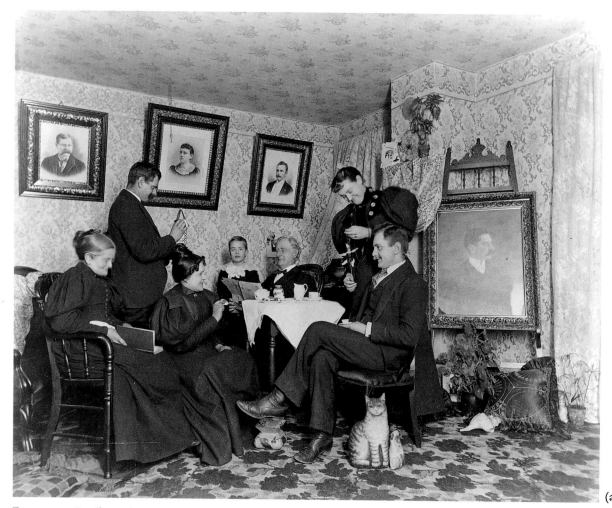

(a)

FIG. 4-10. Family Gatherings. American. Unknown photographers. Gelatin silver prints.
 (a) The Family at Tea. 1890s. American. 7¾ × 9½ inches. Note overpainted photographs on walls and easel. A man and a woman are playing a game with party toys, while a stuffed cat guards the scene. The picture on the easel is probably a portrait of a relative, recently deceased but still regarded as a member of the party.
 (b) The Clan Assembled, c. 1905. 5½ × 7½ inches. Note the overpainted photographs on display, brought out for the occasion to keep the past and present in step.

virginal white, in the company of other family members, all dressed in black, a practice that certainly made overpainting unnecessary.

Though much of the appeal of the finished product depended on the skill of the colorist, these craftsmen usually labored, unknown and unsung, in the shadow of the studio's operator-owner. There still exists, however, a rare tribute paid by one artist to another. During the 1870s, Henry Sandham made a sketch of William Fra-

ser, on the staff of the famous Canadian photographer William Notman, caught in the act of adding color to a stereo card laid on the table before him (Thomas 1979). From an earlier era there survives a daguerreotype showing a colorist posed with the tools of his trade (Isenburg 1992).

It would be wrong to think of "overpainting" as a humble practice designed for provincial tastes. Figures 4-19, 4-20, 4-21, and 4-22 show

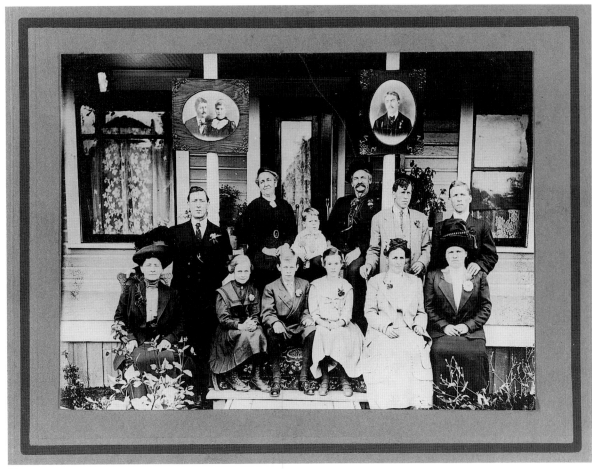

(b)

examples of its use by clients of substantial means and standing. Figure 4-19 was made in the 1870s by the famous Cornelius Jabez Hughes, who had begun his photographic career in the early daguerreotype days, had worked as an assistant to the renowned Mayall, and had eventually (1855) bought Mayall's gallery. In 1861 he moved his activities to Ryde on the Isle of Wight, from where he was regularly summoned to Osborne House, Queen Victoria's residence on the island. He did, indeed, do a great deal of photographic work for the royal household, and enjoyed the formal title of "Photographer to the Queen and H.R.H. the Prince of Wales" (Dimond and Taylor 1987). To create the example shown (Fig. 4-19), Hughes called on the services of "Miss Bond of South-

sea," a hand-colorist who, in her own right, claimed the "Patronage of H.M. the Queen and the Royal Family" in her advertising—a proudly recorded fact rather than a formally awarded title.

Miss Bond must have won respect for her work, since it is unusual for the name of the colorist to appear on a photographer's mount. Photography had already dealt a blow to the profession of miniature-painters, and the success of photographic colorists represented a further and dangerous threat. Thus, John Leighton (1861) remarked: "The miniature painter's occupation is nearly gone, and we may perhaps see the second-rate portrait painter also superseded, and the same negative made to print pictures for the walls of the town-hall or mansion, or for the album of the lady's boudoir."

(a)

(b)

FIG. 4-11. Male Trio, c. 1900. American, probably Pennsylvania. Unknown photographer.

(a) Oil on tintype, 8½ × 6½ inches. Note "improved" floor covering. Background removed by etching.

(b) Original tintype, 3½ × 2½ inches. Since tintypes cannot be directly enlarged, this image must have been rephotographed with a larger tintype camera to produce (a). Note the fragment of a white screen on the right, used in the studio for brightening shadow areas.

"Pictures for the walls of the town-hall" were outside Miss Bond's scope; they were, however, the very special province of Jabez Edwin Mayall, "Professor High-School," as he called himself. Mayall had been trained in Philadelphia during the earliest daguerreotype days, and later gained great prominence for the distinguished work of his London and Brighton studios. "Truly, when we can inspect photographs that are eight feet high, we must allow that the art has made gigantic strides. For the execution of portraits of this description, Mr. Mayall stands alone . . ." (Anon. 1866).

As formidable an expert as Thomas Sutton of Jersey, editor of *Photographic Notes*, remarked that his favorite type of photograph was "either a plain daguerreotype or an oil painting upon a life-sized photograph" (Sutton 1859). Sutton probably developed his taste for large pictures after seeing Mayall's work, but he had many contacts on the continent, and it is entirely possible that he was also familiar with the work of Jakob Wothly in Germany. Wothly, incidentally a bear-keeper at the zoo during an earlier career, had just designed a new type of solar enlarger and, in 1860, persuaded a certain Abbé Moigno

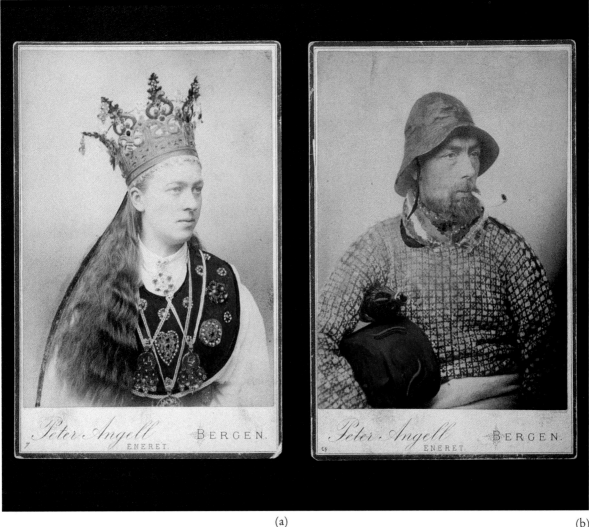

(a) (b)

FIG. 4-12. Norwegian Souvenirs. Issued by Bennett's Tourist Office, of Bergen, Norway. 1880s. Cabinet cards, tinted albumen prints. Souvenir photographs made for foreign visitors.
 (a) Portrait of a woman in Norwegian regional festive costume.
 (b) Portrait of a sailor.

to act as a proxy and submit a giant image to the Academy of Sciences in Paris on his behalf (Baier 1977). No surviving examples of Wothly's work are known, but a specimen of Mayall's megalocreative work can be seen in the Peabody Institute of Baltimore. It is a solar enlargement (from a carte-de-visite!) of superb quality, nearly three meters tall and, as such, actually larger than life. The print is mounted on canvas, and over-

painted in oil by "one of the Queen's best portrait painters." The portrait represents George Peabody, an influential English businessman and early investor in the Baltimore and Ohio Railroad. Schaaf (1985) has traced how this giant picture came to be where it is, and Reynolds and Gill (1985) have given an overview of Mayall's complex and brilliant career. In the ranks of "clients of substantial means and standing,"

George Peabody was ensured a prominent place, and his sponsorship of the portrait must have given this type of photography a powerful boost.

Figure 4-20 takes its stylistic cues from Frances Hodgson Burnett's novel *Little Lord Fauntleroy* (1886). Indeed, the popularity of that book must bear the blame for the indignities suffered by innumerable small boys, as they were bullied for special events into their mothers' recreations of the "Fauntleroy" costume. The present victim has at least been spared the worst humiliation of all, the long ringlets that were an important ingredient of the hero's charm in the eyes of his soft-hearted admirers.

Overpainting was, in every sense, a response to public demand, but not all photographers, let alone all photographic critics, subscribed to its necessity and virtue. P. H. Emerson (1899), for instance, never at a loss for a vituperative word, said while discussing the subject:

> Such abominations from an art point of view may . . . be useful in the trades, for pattern plates and such things. Consider for a moment the habit of working up in crayon, monochrome, water-color and oils. What does it mean, and how is it done? In some establishments that practice is for a clerk to note down certain of the sitter's characteristics, such as "hair light, eyes blue, necktie black"; these comments are then sent with a photograph, generally an enlargement, to the *artist*! He, in a conventional and crude manner makes necessarily a travesty of the portrait, and for these abominations the customer pays from £5 to £20. Consider the utter sham and childishness of the whole proceeding. . . . It is astonishing to think that there are people in the world foolish enough to pay for such trash.

Emerson's sentiments could be deemed to be clear enough, but he was anxious to eliminate all room for misinterpretation: "Lash the insincere and petty *homunculi* who are working for vanity. . . . Hold up to scorn every coxcomb who paints *artist-photographer* or *artist* on his door or stamps it on his mounts." (See also Chapter 7.)

From time to time, overpainters themselves suffered pangs of conscience over the whole practice of retouching and overpainting. As corrective measures for the aesthetic infidelities of unvarnished truth, they were an indispensable part of studio practice, but what of the proud claim of the photograph to be a faithful representation of the facts? An uncommonly tedious editorial in *The Philadelphia Photographer* (1866, p. 264) addressed itself to the problem, under the heading "The Tale of Two Giants," and took a stand, however uneasily, on the side of truth:

> A long while ago, the sleepy world was awakened by a loud blast from a trumpet. Such a sound had never been heard before, and when they found that it came from a huge giant who had made his appearance in the midst of the people, they trembled and were much afraid. The name of this giant was *Delusion*.

Two agonizing pages later, we read that "truth must be released from her imprisonment" and that the giant must be stopped:

> "Who will do it?" "I", says a presumptuous Frenchman. "I will undertake to create a *new* giant . . . *Fidelity*". Having placed his one-eyed box in position, by the motion of a black cloth, everything would creep into it, [to be] handed out to people on a copper plate all polished and silvery. . . . "With what shall I defend myself?" cried the people?

Scarcely a year later, in the same publication (1867, p. 337), a new great editorial thought was

FIG. 4-13. Head and Shoulders Portrait of a Young Woman. 1850s. American, probably Pennsylvania. Unknown photographer. Crayon on salt print, 6 × 4¾ inches, oval.

put on record, reconciling long established practice with noble principle, by leaning on a theological crutch. Yes, indeed, retouching and overpainting were common, and there was justification for their use: whereas photographers should take care "not to falsify and distort the work of the Creator . . . , it is the job of the *translator* to secure the true meaning of the scriptural text."

There are many examples in which photographers sought out vantage points from which famous pictures had been painted, and made

their own "modern" renderings for comparison. Daval (1982), for instance, shows a daguerreotype of Notre Dame taken (by an anonymous operator) from the viewpoint adopted by Camille Corot for his 1833 oil painting of the same vista.

On the reverse side of the coin, the use of photographs by painters for their own purposes has a well-documented history. The practice was by no means confined to minor or provincial practitioners. Indeed, some of the most famous names in nineteenth-century painting feature in

Fig. 4-14. American Overpaintings. (a)

(a) Portrait of a Lady. 1890s. American, probably Pennsylvania. Unknown
photographer. Charcoal and crayon, gelatin silver print on canvas, 20 × 16 inches.
The costume is of an earlier period; overpainting made on an enlargement of an
1860s photograph. Note hand-painted jewelry, which may or may not have been on
the original image.

(b) Portrait of a Gentleman, c. 1890s. American. Unknown photographer. Char-
coal and crayon. Overpainting made on an enlargement of an 1860s photograph.

(c) Portrait of a Lady. Overpainting, 20 × 16 inches. Made c. 1890 of an en-
largement based on a rephotographed c. 1850 image, probably a daguerreotype.
American. Note the photographic brooch worn by the sitter.

that history. Some, to be sure, regarded the
photograph simply as an *aide memoire*, but oth-
ers did not hesitate to use it as the very canvas of
their own art. Either way, something of the
character of the photograph always came
through, sometimes a special impression of

spontaneity, sometimes a mannerism derived
from camera use. In simple and complex ways,
photography left its mark on the vision of the
modern painter, and thereby on modern paint-
ing (see Coke 1964; Lindquist-Cock 1977; Bille-
ter 1977; and Jussim and Lindquist-Cock 1985).

(b)

An interesting experiment is on record, carried out by Franz von Stuck, one of the "Malerfürsten" (painter-aristocrats) of Munich in 1895. He had a photographic portrait taken of himself, and kept a copy of it for comparison purposes. He used another for a direct overpainting on the photographic surface, and also painted a self-portrait on a smooth ground, using the photograph only as a help and reminder. In the photograph, the mustache is prominent and obtrusive, in the overpainting it is more delicate, and in the straight painting most delicate of all. In the photograph, an ear is in total shadow and thus invisible, but von Stuck was obviously unwilling to paint a relatively large featureless area in black; in the overpainting, the ear is gently outlined, and in the straight painting it is given substantial emphasis (Schmoll 1970). One might hope to derive deep insights from the study of such a personal triptych, but the self-conscious and self-reflective nature of the exercise really precludes general conclusions. We cannot know which features of the photograph were subconsciously "transferred" to the painting in response to the persuasive realism of the image, and which were consciously elaborated by the artist, in response to his wish to appear handsome and manly in the final paintings. All we can say is that he succeeded on both counts, and evidently knew how.

Fig. 4-14 (c)

FIG. 4-15. Old Lady with Headscarf, by
Lardner of Philadelphia, c. 1860s. Relievo
ivorytype, tinted with alcohol-based pig-
ments, 3¾ × 2⅜ inches. The term "over-
painting" is not here strictly correct, since
ivorytypes are tinted from the "offside" of
the photographic image, i.e. not from the
side actually viewed. See Root 1864.

FIG. 4-16. Portrait of a Gentleman, by C. and A.
Stein, c. 1860s. American. Oil on albumen print,
10 × 8 inches.

Not only von Stuck, but also Franz von Len-
bach, another of Munich's Malerfürsten, used
photographs extensively as the basis of his paint-
ings as, indeed, did painters all over the world,
and still do. However, the Stuck–Lenbach epi-
sode is particularly instructive because the mat-
ter had been kept out of all the considerable
publicity that surrounded the two artists during
their lives. When their use of photographs was
finally revealed, in the course of a 1969 exhibi-
tion at the Museum Folkwang, Essen, the art-
loving public reacted with shock. Many re-
garded the practice as a form of cheating, or at
the very least as a degradation of the artistic

achievement for which Stuck and Lenbach had
been so highly revered. The exhibition included
Lenbach's "Selbstbildnis mit Frau und Töch-
tern," an oil painting he made in 1903, which
has all the appearance of a flash photograph, for
the best reason in the world: it was in fact made
from a flash photograph. The photographic ori-
gin of the painting is readily apparent, not only
from the sharp shadow pattern and the uneasy
stances assumed by the family members, as they
waited expectantly (indeed, apprehensively) for
the magnesium flash to ignite, but also from the
peculiar and unrealistic color balance (Stelzer
1966). However, this point has been contested

FIG. 4-17. Portrait of a Young Girl. 1890s. American. Unknown photographer. Oil on tintype, 10 × 7 inches. Note painted lace and background, original gilded frame.

(Schmoll 1970), a fact that testifies only to the fickle nature of even the most informed exercises under the heading of "criticism."

A fine example of photo-painterly symbiosis, and one free from controversy, is Hans Olde's "Caroline, Grossherzogin von Sachsen, Weimar-Eisenach," likewise painted in 1903, though never actually completed. It features a charming and highly painterly impressionistic landscape, and a tall slender figure in white, with a head and face that closely imitate the texture of the photograph from which they were in fact copied (Schmoll 1970). Caroline, beautiful and serene, was only eighteen at the time and, as Schmoll puts it in an aside, "her delicate nature and intellectual as well as artistic interests were not appreciated by her husband." They were, on the other hand, only too well appreciated by the artist, and on those grounds the Grossherzog refused to pay for the painting.

To painters like von Lenbach, von Stuck, Hans Olde, and scores of others, photography served in part as a stimulus and in part as a practical aid, but for some artists the invention had a dispiriting effect. Samuel Morse, for instance, almost abandoned art, perhaps because his purely technical interest in photography (not to mention the electromagnetic telegraph) presented a crucial distraction. At any rate, on November 20, 1849, he wrote to Fenimore Cooper:

> Alas! My dear sir, the very name of *pictures* produces a sadness of the heart I cannot describe. Painting has been a smiling mistress to many, but she has been a cruel jilt to me. I did not abandon her; she abandoned me. I have taken scarcely any interest in painting for many years. Will you believe it? When last in Paris, in 1845, I did not go to the Louvre, nor did I visit a single picture gallery. [Morse 1914]

The pervasive preoccupation of painters with photography is well illustrated by a somewhat incestuous snapshot, taken by Degas around 1893, of Renoir making a portrait of Mallarmé with a large studio camera (Braive 1966). Many examples of the fruitful symbiosis have been presented and persuasively analyzed in the classic works by Van Deren Coke (1964) and Aaron Scharf (1968) and, in the special context of Jugendstil painting, by Kempe and Spielmann (1986). Indeed, the associated crosscurrents engaged the attention of serious commentators from the first. Early in the twentieth century, Sadakichi Hartmann still asked:

> To paint, or photograph—that is the
> question:
> Whether 'tis more to my advantage to
> color
> Photographic accidents and call them
> paintings
> Or squeeze the bulb against a sea of critics,
> And by exposure kill them?
> [Hartmann 1904; Newhall 1980, 1990]

A detailed treatment of the complex aesthetic relationship between the two arts, and their mutual dependence, is not contemplated here. The principal conclusion is clear enough; it is that the manifold influences of painting on photography have their counterpart in the equally manifold influences of photography on painting. It was bound to be so. Photography was invented in a world in which painting and drawing were the established and principal arts, and most of the images that early photographers had ever seen in their lives had indeed been paintings and drawings. Photography took its aesthetic cues from painting, because no other cues were on the scene. Conversely, artists who now practice painting have seen more photographs in their lives than any other forms of graphic art. Both types of background experience left their mark, and yet the situation was never "balanced." The mannerisms photography took from painting helped it to establish a measure of social and artistic respectability, but they also generated a hybrid art form, the painterly photograph,

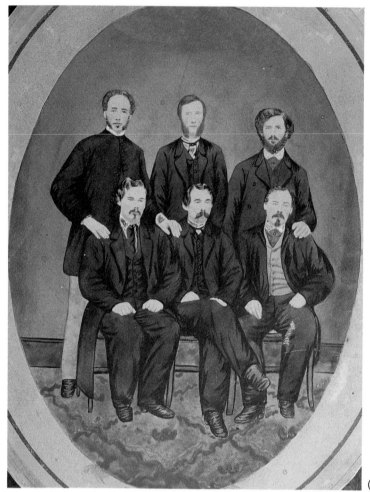

(a)

(b)

Fig. 4-18. The colorist at work.

(a) Six Young Men on a Red Carpet, c. 1870s. American. Watercolor and ink on salt print, 7¾ × 5¾ inches, oval. Overpainted by an exuberant practitioner, who has remained mercifully anonymous.

(b) Tinted carte-de-visite. 1860s. Albumen print by S. R. Miller of Dudley, Pennsylvania.

which actually inhibited the development of new and independent photographic styles. One might cynically argue that it was not until photographers-at-large became *ignorant* of painting that photography was able to develop its full potential as an independent art form, an achievement that can be safely credited to general trends in modern education.

In contrast, photographic influences on painting represented an influx of new ideas, not only in terms of style but also in terms of subject matter. The origins of abstract painting as such predate photography by a wide margin, but it is also true that the modern popularity of abstract representations would have been unthinkable if the liberating influence of photography had not been at work over many decades. Photography freed painters from any residual obligation they may have felt to represent the world "as it is." Not only life but art follows art, and so, in due course, truly imaginative photographers of the modern school came to reject the same obligation; they threw off the same chains, and divorced themselves from all notions of *reportage*. In a very real sense, the future of the medium rests in their hands. Because painting is relatively slow and photographic darkroom work relatively fast, photographers enjoy the unique freedom of experimenting with a much greater variety of compositions and tonal renderings. It is perfectly true that photographers can photograph only what is in front of the camera, but they have a large measure of control over what that is, and how it should be made to appear after darkroom ministrations. Just like the painter, the photographer is ultimately concerned with the presentation not of surface alone, but of symbols as well (see Collins 1985).

Within the framework of the photography-painting symbiosis, the "overpainting" of portraits is only one specialized aspect and, in the nature of things, not the most imaginative or creative. On the other hand, its manifestations were widespread and, indeed, more accessible than "high" gallery art, and were thus in a po-

FIG. 4-19. British Officer in Red Tunic, by Cornelius Jabez Hughes (1819–84) of Ryde, Isle of Wight. 1870s. Pigment on albumen print, 7½ × 4 inches. Overpainted by "Miss Bond of Southsea," who claimed "the Patronage of H.M. the Queen and the Royal Family" in her advertising.

sition to exert a powerful influence on popular taste.

Overpainting was practiced everywhere, but one thinks of it as primarily an American art, widely enjoyed in a land less constricted than the Old World by social inhibitions and explicit rules of taste. The fashion peaked during the 1880s and 1890s, that "gilded age" of soaring aspirations and conspicuous consumption. Itinerant photographers or their agents would call on potential clients, and point to the desirability of displaying ancestral portraits, for decoration and as a source of family prestige. How could such

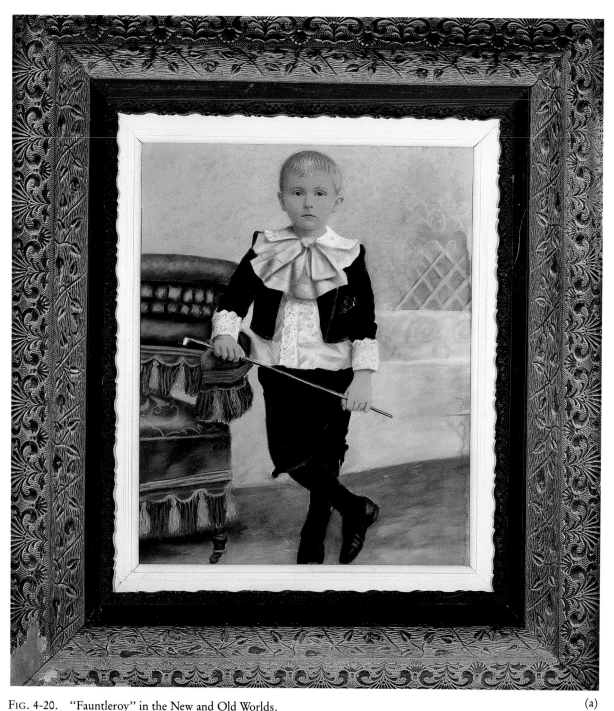

FIG. 4-20. "Fauntleroy" in the New and Old Worlds.
 (a) American, c. 1890. Unknown photographer. 24 × 20 inches, crayon; silver print on canvas.
 (b) English. 1903. Wilsher children, cabinet card made by C. Wilson of Lowestoft, "Electric Light Studios."

C. Wilson 91 LONDON ROAD, LOWESTOFT.

(b)

portraits come into being? Through photography, of course, using treasured album prints in the form of cartes-de-visite or cabinet cards. Enlargements were made, and then reinforced with charcoal and crayon art work, for display in ornate frames. Indeed, many itinerant photographers added the lucrative trade in frames to their original craft. Figure 4-23 shows an advertising sampler used to entice potential customers. The small, easy-to-carry scroll was made to unroll and reveal samples of the kind of work that could be done at the cost of one or two dol-

lars, depending on the amount of color used and time involved. Its designer understood the convenience of one-stop shopping, for specimens of assorted frames, and even photographic "Family Record" certificate templates (with "press-outs" for the insertion of photographs; see Chapter 6), are included in the package. Quite often, the original photographs were by this time twenty to thirty years old, which accounts for the fact that most turn-of-the-century portrait overpaintings (see Fig. 4-14) show people in the fashions of an earlier generation. The final results were often

FIG. 4-21. Portrait of a Young Lady. Ambrotype (black back-paint type) by F. Mares of 76 Grafton Street, Dublin, c. 1860. Quarter-plate. Mares was also a landscape photographer, and he illustrated a number of books on Irish scenery. The name is unusual in Ireland; it may be German or Czech.

for use with electric light sources. Because the enlargements were usually based on existing photographs, the senior partner did not actually have to travel; he sent canvassers out to do that for him. They, in turn, offered to rephotograph the objects, and have enlargements made "without obligation." Customers bought the finished product only when they liked it; fortunately for the firm, they usually did. "Satisfaction guaranteed" was the official position but, with well-honed negotiating skills, canvassers nevertheless attempted to extract deposits, presumably returnable, as demonstrations of serious intent. About one hundred enlargements a week were solicited in this way by Walker. Prices ranged from 7s 6d to 10s, and Walker received a 2s commission. The final prints were made on rough paper (paper "with a tooth") glued to a cotton

"primitives," but occasionally transcended that category by a comfortable margin.

The practice continued until well into this century and, in some respects, is still with us. Few of the early practitioners recorded their professional experiences, but there are some interesting sidelights on the business in the tape-recorded reminiscences of a late operator, Tony Walker (born 1906) of Bradford, England, who was still "on the road" in 1934 (Linkman 1989). Walker worked in association with a senior partner, Will Johnson (born 1867). As a dutiful employee, Walker married Johnson's daughter, and thereafter called him "Dad." Dad turned out to be an able teacher of techniques, including enlarging with gas light and solar instruments, which the progressive son-in-law soon adapted

FIG. 4-22. The Prince of Wales, c. 1863. Hand-colored portrait by the W. H. Mason Repository of Art, 108 Kings Road, Brighton. 5 × 4 inches. The portrait was probably made to commemorate the Prince's betrothal in October 1862, or his marriage in March 1863.

(a) (b) (c)

(d) (e) (f)

FIG. 4-23. Advertising Scroll, with overpainted silver prints on canvas, 17½ × 2½ (diameter) inches. 1890s. American. Itinerant photographer's advertising kit, illustrating some of his wares, in this case enlargements of existing photographs, overpainted with charcoal or crayon or both. The cost of the simplest overpainting was about $1, of the most elaborate $2. The scroll also contains advertising material for suitable frames. Successive canvases:

(a) Plain charcoal overpainting. (b) Portrait with a small amount of color. (c) Portrait in full color. (d) "Family Record" template, with ten "press-outs" for the insertion of photographs. (e) Funeral commemoration template, with one "press-out." (f) Advertisement for frames.

fabric on a "stretcher" frame. The prints were steamed after coloring, to make the pigments diffuse into the gelatin emulsion, and then sprayed with shellac after drying for additional stabilization.

Retouching was an important part of studio work, in England, as everywhere else, one in which truth was not always rigorously respected. Walker recounts an instance in which a postmortem photograph of a little girl, "laid out," was transmuted into one of the little girl apparently sitting up, alive and well. Three pounds seemed a small charge for such a revitalizing service. The Walker record, compiled by Audrey Linkman of the Documentary Photography Archive, Manchester, England, is unique in its detailed authenticity.

A fine line separates the sales pitch from the confidence trick, and it was not unknown for a hit-and-run photographer to cross from one side to the other. Ruby (1990) has traced a century-old *cri de coeur* from a writer equally interested in protecting his public and himself:

This is a scheme which has been operated for some time, but never to as great an extent as now. The agent may tell you the artist has just returned from Paris, where he drew a gold medal for superior artistic skill, and having received many requests to visit your locality by parties familiar with his work in Paris, has consented to do a little work here and give the people an opportunity of securing the highest degree of art at the lowest prices, &c., &c., when the probability is the "French Artist" is a cheap country photographer who could not make a living where his work is known. There are so many schemes on getting orders for enlarged photographs finished in oil, India ink, water color, &c., that we can only say: "If you wish for anything of the kind, visit your photographer, and he will undoubtedly do better work, give you a better frame, and at living prices."

[From a tract with the succinct title *How 'Tis Done: A Thorough Ventilation of the Numerous Schemes Conducted by Wandering Canvassers Together with the Various Advertising Dodges for the Swindling of the Public* (Anon. 1890). See also Chapter 10.]

A considerably more succinct warning against the blandishments of fly-by-night operators appears on the back of a carte-de-visite issued by F. J. Weber & Brother, of Erie, Pennsylvania: "Do not trust your pictures-to-be-copied to travelling photograph bummers, who make great promises and generally deliver very poor work" (Linkman 1992).

To be sure, overpainting, competently done or otherwise, was often presented as an attempt at "conservation." Though the practice did nothing for the original photographs, it provided their derivatives and surrogates with a new lease on life. It was also a way of allowing later tastes to be superimposed on earlier ones, the drab monochrome of the 1860s to emerge thirty years later in vivid color. Thus, Canadian photographer C. W. Mathers advertised "Old photographs to any size and made to look better than the original" (Silversides 1990).

For all the archaic air that surrounds it, overpainting is actually a living art. Many artists in modern times have overpainted photographs, not in order to "improve" them but in order to create composite images suggesting the confluence of fantasy and reality. Wolf Vostell, for instance, painted his expressionist "Venus of Urbino" in acrylics over a photograph, and Arnulf Rainer's "impertinently annotated" portraits have a wide following (Daval 1982).

Other Links

With painting, photography's relationship was uneasy from the start. The public, unused to anything else and slow to adapt to a new graphic

language, tended to applaud photographs most fervently when they looked most familiar, like paintings, etchings, or drawings. Photographers, on the whole, obliged, though some nourished other ambitions. Even stalwart fighters for photography as a distinctive and independent art shared a pro-painterly prejudice, implicitly, of course, but nonetheless firmly. Stieglitz, for instance, greatly favored the painterly photograph for his own collection, no matter what his enunciated policy of the moment happened to be.

In truth, the taste for that kind of photograph is still very much with us—with the "man in the street," at any rate, if not with the "man in the museum." Accordingly, we find conflicting trends throughout the history of photography: one that looked to the imitation of painting as the source of artistic respectability (not to mention financial success), and one that tried to cultivate photography's own distinctive virtues. At the same time, painters found themselves sharply challenged by the new art, all the more because many prominent nineteenth-century photographers came from their ranks. The most obvious temptation was to ignore the whole new process, in the hope that it would never intrude beyond the purely utilitarian and technical level, but that proved to be increasingly difficult, as more and more people began to receive the photograph as the principal source of their pictorial experience. Painters looked at photographs again and found, much to their dismay, something they could even like, a certain freedom in the choice of subject matter, an attractive tonality, impeccable perspective, incredibly subtle gradations of gray, the photographic negative as a pictorial language in its own right, and image superposition, as well as other intriguing effects that could be achieved by manipulation in the darkroom. Each artist selected the element that produced a resonance in his own outlook, and used it in his paintings. The result was a mutual interplay of style and mannerisms, and if that interplay made decades of photography

more painterly, it also left its indelible mark on modern painting. The analysis of paintings for photographic influences, whether implicit or explicit, is now a flourishing branch of art-historical criticism.

Among the other arts with which photography has had some kind of relationship are wood engraving and, to a smaller degree, sculpture. The links with wood engraving came about in a somewhat different way, mainly through attempts to reproduce photographic images by letterpress techniques. Initially, engravers *looked* at photographs beside them while engaged in the transfer process; later, photographs were printed directly onto the wooden block. Engraving artists faced with such material did not manage to ignore its character, and often did not try; on the contrary, photographic mannerisms were transferred to the engraving, which thereby changed its character. Jussim (1974) has documented this development in a classic treatise on the subject.

Indirectly, photography also served sculpture, and did so most effectively after the popularization of stereo photography. The stereo medium as such did not permit any transfer of photographic style, but stereo photographs were widely distributed for the education of sculptors (see Fig. 4-24). On the one hand, they acquainted beginners with famous works, seen through the stereo viewer with a degree of immediacy and impact that no book had ever achieved, and on the other hand, they provided images of models in every conceivable pose; sculptors found this way of learning cheaper and more convenient than engaging the models themselves. The value of this educational tool for the artist cannot be doubted, even though its influence may be difficult to trace and document. The importance of such views in the education of the general public was enormous. Whether published in the form of stereo cards, cartes-de-visite, or lecture slides, images of works of art were made available, through photography, at low cost and in hitherto uni-

(a)

(b)

FIG. 4-24. Stereo Sculpture. Cards illustrating the use of this medium for art-history studies and as an aid to practicing sculptors.

(a) "La Sonnambula," by C. Fontana. International Exhibition, London, 1871. Made by the London Stereoscopic Company, organized in 1854 by George Swann Nottage. By 1858 the company had issued more than 100,000 stereo titles.

(b) "Lady Godiva," by R. Monti. Photographed by William England, 1872–73. W. England was chief photographer for the London Stereoscopic Company from 1858 to 1863 and later made himself independent. See Darrah 1977.

maginable abundance. They were collected and studied for private enjoyment and, in due course, began to be used in formal instruction. An art historian illustrated his lectures with slides at Princeton as early as 1882 (Leighton 1984).

The two-dimensional photograph proved to be highly versatile in the reproduction of other kinds of art, and attempts were soon made to achieve three-dimensional effects. At the London Exhibition, held in 1862, Edmond Fierlants showed a full-sized model of the reliquary of Saint Ursula, hand carved and decorated not with the original paintings but with photographic panels (Joseph and Schwilden 1983).

On a less lofty but more ambitious plane, photography also aided the process of portrait sculpture, and continues to do so to this day. "Photo-sculpture," as it was called, was invented in France by Villème, and brought to England by Claudet (Greenhill 1980; Anon. 1864). In its simplest form, the process involved taking photographs of a client (or, more often, a client's head and torso) from several angles, and using the resulting images to guide the sculptor's hand. Claudet came to know about the process through a letter from Ernest Lacan, the writer and journalist who had made himself an advocate and sponsor of Villème's work (Jones 1976). Within less than a year, Claudet presented some of his own creations at a Soirée of the Royal Society in 1864. A writer in the *Art Journal* was duly impressed, and commented: "They had, indeed, all the appearance of photographic productions, so correct were the forms and proportions, and so natural was the expression of countenance; they were, in fact, the very 'carte-de-visite' raised in solid form." Claudet later accepted commissions that, however, he did not execute himself; he sent them to Villème's Paris studio, the "Société Générale de Photosculpture de France," as the inventor modestly called his establishment. A picture of the handsome building appeared in one of the 1864 issues of *Le Monde Illustré* (see also Anon. 1991). At the core of the substantial structure was "a large circular room, 30 feet high and 40 feet in diameter, surmounted with a cupola, all of glass" (Anon. 1864):

> All round the circular wall supporting the cupola are, at regular intervals, twenty-four round holes of about 3 inches in diameter, being the apertures of twenty-four *camerae obscurae* placed behind the wall in a kind of dark corridor surrounding the building; for we have to explain that twenty-four photographs of the person sitting in the centre of the large round operating room are to be taken at the same moment, in order to supply the modelling apparatus with twenty-four different views of the person whose sculpture is to be executed. By a very simple and ingenious contrivance, the twenty-four *camerae obscurae*, in each of which has been placed a prepared plate, are open and shut at the same moment.

The photographs were then projected by means of a magic lantern, in sequence as the sculptor turned his clay.

As Greenhill (1980) points out, the hope was that the invention would help to make portrait sculpture popular and, above all, affordable to wide sections of society. Thus, six copies of a sculpture so executed could be purchased for a mere forty-five francs. Moreover, as an anonymous writer in *Le Monde Illustré* pointed out, the invention had the potential of liberating the sculptor from fossilized convention. No longer would it be deemed necessary for a work of sculpture to be a timeless icon; it could be the solid equivalent of a snapshot, something which, indeed, photography itself had not yet fully achieved at the time. And yet, however attractive in practice and theory, photo-sculpture, unlike stereo photography, never really caught the popular imagination.

Photography made a difference to many arts in many ways. For the most part, its contribu-

tion was accepted without fuss or fanfare but, just occasionally, acknowledgment was made in unexpected quarters. A tribute from a fresco painter can be found on a Vatican ceiling (Fig. 1-1), another from a tile-maker in the Oyster Bar of a handsome Scottish pub. The Café Royal, West Register Street, Edinburgh, is the proud owner of a series of murals composed of painted wall tiles manufactured by the Doulton pottery company. One of the designs shows a youthful Daguerre, somewhat suspiciously watched by a stooping Joseph Nicéphore Niépce, pictured above the title, "Joint Discoverers of Photography." A camera is in the background, and the implication is that the two men are shown at the very moment of enlightenment, oblivious of the fact that no such enlightenment came to them while they were at work in their uneasy partnership. John Eyre was the painter, and the tiles themselves were made by Katherine Sturgeon and W. J. W. Nunn, sometime in the late nineteenth century, probably in 1886. Other panels of the series show an assortment of important inventors, including James Watt, Michael Faraday, Benjamin Franklin, and William Caxton (MacWilliam 1975). Surprisingly, as Schaaf (1980) comments, no place was found for Fox Talbot, despite his Scottish connections. The omission may be yet another example of that centuries-old irritant to England, the "Auld Alliance" between Scotland and France. On the other hand, the designers may have been well aware that Talbot would have thought it no honor to be shown in the company of his arch-rival, particularly in a city he regarded with some proprietorial pride, Edinburgh herself, the Heart of Midlothian.

Chapter 4. References and Notes

ANON. (1842). *The Chemist* (London), April, p. 122. See also Gernsheim (1969), p. 163.

ANON. (1864). *Art Journal* (London), p. 141.

ANON. (1866). "Photographic Art," *Brighton Gazette* (U.K.), August 23, p. 5.

ANON. (1890). *How 'Tis Done: A Thorough Ventilation of the Numerous Schemes Conducted by Wandering Canvassers Together with the Various Advertising Dodges for the Swindling of the Public*, W. I. Patterson, Syracuse, New York, p. 192.

ANON. (1991). "Vom Licht geformt—die Photoskulptur," *Photo-Antiquaria*, no. 1–2, p. 77.

AYRES, G. B. (1878). *How to Paint Photographs in Water Colors and in Oil; How to work in Crayon; Make the Chromo-Photographs, Retouch Negatives and Instructions in Ceramic Painting: A Practical Handbook*, 4th edition, D. Appleton & Co., New York.

BAIER, W. (1977). *Quellendarstellungen zur Geschichte der Fotografie*, Schirmer-Mosel, Munich, p. 227.

BILLETER, E. (1977). *Malerei und Photographie*, Benteli Verlag, Bern, Switzerland.

BRAIVE, M. (1966). *The Era of the Photograph*, Thames & Hudson, London, p. 201.

BUERGER, J. E. (1989). *French Daguerreotypes*, University of Chicago Press, Chicago, p. 243.

COKE, Van D. (1964). *The Painter and the Photograph*, University of New Mexico Press, Albuquerque, New Mexico.

COLLINS, K. (1985). "The Camera as an Instrument of Persuasion: Studies of 19th Century Propaganda Photography," Ph.D. diss., Pennsylvania State University.

DARRAH, W. C. (1977). *The World of Stereographs*, W. C. Darrah, Gettysburg, Pennsylvania.

DAVAL, J.-L. (1982). *History of an Art: Photography*, Skira/Rizzoli, New York, pp. 14, 218.

DIMOND, F., and TAYLOR, R. (1987). *Crown and Camera: The Royal Family and Photography, 1842–1910*, Penguin Books, Harmondsworth, Middlesex, U.K., p. 217.

EMERSON, P. H. (1899). *Naturalistic Photography for Students of Art*, Scovill Adams Co., New York, 1973 reprint by Arno Press, New York, book 2, p. 124; book 3, p. 39.

GARZTECKI, J. (1977). "Early Photography in Poland," *History of Photography*, vol. 1, no. 1, pp. 39–62.

GERNSHEIM, H. (1982). *The Origins of Photography*, Thames & Hudson, London, p. 83.

GERNSHEIM, H. and A. (1969). *The History of Photography*, McGraw-Hill, New York, pp. 142, 160, 163, 335.

GIDAL, T. N. (1990). "Lerebours' *Excursions Daguer-*

riennes," in *Shadow and Substance* (ed. K. Collins), Amorphous Institute Press / University of New Mexico Press, Albuquerque, New Mexico, pp. 57–65.

GREENHILL, G. (1980). "Photo-Sculpture," *History of Photography*, vol. 4, no. 3, pp. 243–45.

HABERMAN, C. (1990). *New York Times*, June 4, p. C6. "Rome, June 3—When the Naples soccer team won the national championship three years ago, its fans went predictably wild. They danced. They yelled. They drove around town honking their horns. Somewhat less predictable was the response of a few Neapolitans who plastered photographs of dead relatives against their car windows, facing out to the street. Uncle or Cousin, they explained, would not have wanted to miss out on the fun."

HARTMANN, S. (1904). In *Camera Work*, vol. 6, April, p. 25.

HASLUCK, P. N. (1905). *The Book of Photography*, Cassell & Co., London.

HILL, L. L. (1856). *A Treatise on Heliochromy*, Robinson & Caswell, New York. Facsimile reprint 1972 by Carnation Press, State College, Pennsylvania (ed. William B. Becker).

HUNT, R. (Editor) (1851). *Hunt's Handbook to the Official Catalogues: An Explanatory Guide to the National Productions and Manufactures of the Great Exhibition of the Industry of All Nations*, Crystal Palace, London.

ISENBURG, M. (1992). *The Daguerreian Journal* (ed. P. E. Palmquist), The Daguerreian Society, Lake Charles, Louisiana, p. vii.

JONES, J. (1976). *The Wonders of the Stereoscope*, Jonathan Cape, London, p. 122.

JOSEPH, S. F., and SCHWILDEN, T. (1983). "Phototriptych," *History of Photography*, vol. 7, no. 3, pp. 249–50.

JUODAKIS, V. (1977). "Early Photography in Eastern Europe: Lithuania," *History of Photography*, vol. 1, no. 3, pp. 235–47.

JUSSIM, E. (1974). *Visual Communication and the Graphic Arts*, R. R. Bowker Co., New York.

JUSSIM, E., and LINDQUIST-COCK, E. (1985). *Landscape as Photograph*, Yale University Press, New Haven and London.

KEMPE, E. and F., and SPIELMANN, H. (1986). *Die Kunst der Kamera im Jugendstil*, Umschau Verlag, Frankfurt.

LEIGHTON, H. B. (1984). "The Lantern Slide and Art History," *History of Photography*, vol. 8, no. 2, pp. 107–17.

LEIGHTON, J. (1861). "Life-Size Portraits," in *Photographic Notes*, vol. 6, no. 134, p. 279.

LINDQUIST-COCK, E. (1977). *The Influence of Photography on American Landscape Painting*, Garland Publishing, New York.

LINKMAN, A. (Editor) (1989). *Document T34*, Documentary Photography Archive, Manchester, U.K. (The present authors are indebted to Mrs. Audrey Linkman for making this material available.)

LINKMAN, A. (1992). Personal communication, acknowledged with thanks.

MACWILLIAM, C. (1975). "The Café Royal, Edinburgh," in *Scottish Georgian Science Society Bulletin*, vol. 3, p. 18.

MORSE, E. L. (Editor) (1914). *Samuel F. B. Morse: His Letters and Journals*, Houghton Mifflin Co., Boston and New York. (On page 331 of this work, Samuel Morse is quoted as he expresses himself on the subject of slavery, an institution which he finds "ordained from the beginning of the world for the wisest purposes, benevolent and disciplinary, by Divine Wisdom." Along similar lines, he describes immigration and foreign influences as "insidious and dangerous assaults upon all that Americans hold dear, political and religious.")

NEWHALL, B. (1961). *The Daguerreotype in America*, Duell, Sloane & Pearce, New York, Revised edition 1976, Dover Publications, New York, p. 92.

NEWHALL, B. (1980). *Photography: Essays and Images*, Museum of Modern Art, New York, p. 185.

NEWHALL, B. (1990). Personal communication, acknowledged with thanks.

PERROT, M., and MARTIN-FUGIER, A. (1990). In *A History of Private Life* (ed. M. Perrot), Belknap Press of Harvard University Press, Cambridge, Massachusetts, vol. 4, p. 226.

PETROSKI, H. (1990). *The Pencil*, Alfred A. Knopf, New York, p. 133.

REYNOLDS, L., and GILL, A. T. (1985). "The Mayall Story," *History of Photography*, vol. 9, no. 2, pp. 89–107.

ROOT, M. A. (1864). *The Camera and the Pencil; or, The Heliographic Art*, M. A. Root, Philadelphia, pp. 316–17. Facsimile reprint 1971 by Helios, Pawlet, Vermont.

RUBY, J. (1990). "Enlarged Photographs," *History of Photography*, vol. 14, no. 4, p. 382.

SCHAAF, L. (1980). "Daguerre and Niépce in a Pub," *History of Photography*, vol. 4, no. 4, frontispiece.

SCHAAF, L. (1985). "Mayall's Life-size Portrait of George Peabody," *History of Photography*, vol. 9, no. 4, pp. 279–88.

SCHARF, A. (1968). *Art and Photography*, Allen Lane / The Penguin Press, London.

SCHMOLL, gen. EISENWERTH, J. A. (1970). *Malerei nach Photographie*, Münchner Stadtmuseum, Munich.

SILVERSIDES, B. V. (1990). "Charles Wesley Mathers," *History of Photography*, vol. 14, no. 4, pp. 327–48.

SKOPEC, R. (1978). "Early Photography in Bohemia, Moravia and Slovakia," *History of Photography*, vol. 2, no. 2, pp. 141–53.

STELZER, O. (1966). *Kunst und Photographie: Kontakte, Einflüsse, Wirkungen*, Piper, Munich.

SUTTON, T. (1859). *Photographic Notes*, vol. 4, no. 67 (January 15), p. 22.

TAFT, R. (1938). *Photography and the American Scene*, Macmillan Co., New York, 1964 reprint by Dover Publications, New York, p. 422.

THOMAS, A. (1979). *Fact and Fiction: Canadian Painting and Photography, 1860–1900*, exhibition catalog, McCord Museum, Montreal, p. 30, fig. 13.

WEPRICH, T. M. (1990). Personal communication, acknowledged with thanks.

5

SETTING AND FRAME

CASES OF CHARACTER

One of the earliest needs of the photographic trade was to guard the delicate surface of the daguerreotype from abrasion and dust, and thereby permit such images to be conveniently handled. The daguerreotype case, much loved and by now extensively described (see Rinhart 1967, 1969; Krainik and Walvoord 1988), had its origin in this need. The design of such protective covers rapidly became an important secondary art, especially when thermoplastic "Union" cases (made of a mixture of soot, finely ground sawdust, and wood resin) were introduced in the

early 1850s. This material not only lent itself to mass production, but was capable of accepting a variety of decorative imprints of considerable delicacy, and thereby gave a great deal of scope to artists ambitious to succeed in the new medium. For all its virtues, which might have appealed to people in other parts of the world, daguerreotype case design remained a specifically American art, mostly because daguerreotypes themselves stayed popular in America for many years after Europe had already succumbed to the utility (if not the charm) of photography on paper. The daguerreotype case itself was not a *generic* novelty, but simply an adaptation of covers

traditionally used for the protection of miniature paintings. However, whereas such miniatures were the treasured possessions of a few, daguerreotype cases were small works of art to which the many came to be exposed. Photographic studios derived a substantial part of their earnings from the sale of such accessories, and competed with each other in the variety of designs offered. And because the process of mass production called for a certain amount of standardization, as far as size was concerned, the sizes of (social) photographs themselves came to be standardized. The terms "sixth-plate," "quarter-plate," etc., have their origin in that fact. To be sure, they were first applied to daguerreotypes, but later they came also to denote the sizes of prints on paper. During the 1840s and 1850s, the daguerreotype and case-maker trades supported each other; Guglielmi (1982) has described a rare daguerreotype of a case salesman proudly displaying his wares on a table.

Among the pictorial themes used by case artists were, as one would expect, notions and images derived from literature, mythology, famous paintings, patriotic sentiments, religious symbolism, and the social scene. A few notable examples of cases and the origins of their designs will here suffice; a comprehensive overview has been provided by Krainik and Walvoord (1988). Both minor and major artists played significant roles, sometimes purposefully, sometimes unwittingly. Thus, it has been clear for some time (Navais 1976; Henisch 1978) that the "Union" cases popularly known and described by Rinhart (1969) as "Angel Scattering Roses" and "Angel Carrying Babies" (both made by S. Peck & Company, c. 1856) were based on designs by the Danish sculptor Bertel Thorvaldsen (1770–1844) (Fig. 5-1). The original titles were, respectively, "Day, Aurora with the Genius of Light" and "Night with her Children"; the popular names fit the surface details but miss Thorvaldsen's symbolic intent. Both models are large relief sculptures; indeed, there exists a daguerreotype that shows Thorvaldsen at work on just

such a composition (Meyer 1977, 1978), though not one of those mentioned here. The themes proved popular, and were duly imitated by at least one other case-maker. H. and D. Wills (1979) describe a Union case, imprinted "Smith's Patent, 1860," which shows a relief sculpture almost identical with "Angel Scattering Roses," but with its angel flying in the opposite direction, in close conformity with Thorvaldsen's original design.

Thorvaldsen used the "Day" and "Night" themes more than once, originally in the form of two marble medallions, about 80 centimeters in diameter, modeled in 1815. The artist had been inspired by several sources—specifically, paintings by Francesco Albani in the Palazzo Verospi, Rome; works by Taddeo Zuccari in the Villa Caprarola, and by Annibale Carracci in Chantilly; as well as various Greek sculptures known to him (Helsted 1977).

Thorvaldsen was, during his lifetime, the most respected and revered artist in Europe. Kings and governments competed with one another in paying homage to the great man, who had won his first gold medal at the age of twenty-three. He spent much of his working life in Rome where, indeed, the two medallions were sculpted. It was there that he saw the recently excavated sculptures from the temple of Aphaia in Aegina. Thorvaldsen, already famous at the time, was asked to restore these finds and, in the words of Lorenz Eitner (1967), "This close occupation with Greek originals left its mark on Thorvaldsen's work and, unfortunately, on the Greek originals as well." This is not, of course, how Thorvaldsen's contemporaries and immediate biographers were inclined to evaluate the situation. Thus, Silliman and Goodrich (1854) refer to one of his works (exhibited in the New York Crystal Palace of 1853), and remark that "Christian art has reached, in this immortal work of Thorvaldsen, its noblest expression." Alas, time tends to play havoc with "immortal reputations"; Thorvaldsen's name is still a household word in Denmark, but no longer in the rest of the world.

(a) (b)

FIG. 5-1. Thorvaldsen's Themes. Daguerreotype case designs of c. 1856. Union thermoplastic. Peck & Halvorson patent. 3 × 2½ inches.
 (a) Rinhart (1969) case no. 51, "Angel Carrying Babies."
 (b) Rinhart (1969) case no. 50, "Angel Scattering Roses."

During the second half of the last century, indeed, from the 1840s onward, photography played an important part in the presentation of art and architecture to scholars and to the general public. Art history had been largely the study of artists' lives and artistic philosophy; photography permitted it to become, to an ever-increasing extent, a study of art itself. When Ruskin made daguerreotypes, they were for his own use but, after the arrival of the carte-de-visite, publishing companies came into being, especially in Germany, Italy, France, and England, that specialized in photographic reproductions of great works of art and in their dissemination. In America, firms like David Appleton & Company of New York imported and sold vast quantities of such views (Darrah 1981). Figure 5-2 shows products of this kind published in Berlin during the 1860s. However, the Thorvaldsen medallions they depict were widely

known in Europe considerably earlier. Indeed, an extraordinarily clumsy rendering of "Night" had already found its way on to the headboard of a bed (!) shown at the Great Exhibition in 1851 (Fig. 5-3). It was a needlework piece produced, as the catalog claimed with pride, "principally from British materials and worked entirely by Englishwomen in London" (Anon. 1851). To even the score, "Morning" claimed its own place of domestic honor on the side of a cast-iron kitchen range, recorded by Carl Larsson in a watercolor painted in 1896 and now in the National Museum in Stockholm.

The question remains, how did the "Day" and "Night" themes come to be known in America in time to be used for daguerreotype case design in or before 1856? The search for a source led inevitably to the *Art Journal* of London, which in 1849 had already reported on Thorvaldsen's work and fame. At the time, some

FIG. 5-2. Cartes-de-visite of Thorvaldsen medallions, entitled "Morgen" and "Nacht." Issued by Ziegler et Cie, Berlin, during the 1860s. Many other Thorvaldsen works were so reproduced and popularized.

of Thorvaldsen's bas-reliefs were in circulation in the form of very simple drawings. By 1852 something better was available (Anon. 1852): detailed engravings by W. Roffe (Fig. 5-4) based on drawings by F. R. Roffe, which in turn were made from original works in the collection of the Duke of Devonshire. Indeed, the very publication of these engravings in the *Art Journal* was made possible through "the courteous liberality of His Grace." His Grace's largesse provided the editor with an occasion for a gentle homily:

We are perfectly aware that the acquisition of a sculpture gallery is not within the means of many, but the possession of some two or three examples is attainable by a very large number of our moneyed classes, who, nevertheless, seem generally most unwilling to spend their surplus wealth on such objects. [Anon. 1852]

The *Art Journal* offered copies of the prints to new subscribers as a bonus with its 1852 January issue. "Night" and "Morning" (as the editor calls them) "are among the most exquisitely pictorial conceptions of a mind whose constitution was eminently of a poetical order." It seems very likely that these reproductions were the source of inspiration for the artist (regrettably unknown) who designed the daguerreotype cases. Certainly, the *Art Journal* was read on both

sides of the Atlantic, and the prints were distributed in quantity at the right time. No other possible source has come to light so far. As one would expect, the engravings and moldings are mirror images of one another. The making of bas-reliefs "in reverse" for later molding, combined with a reduction of scale, is no easy matter, and the transfer from the flat "positive" to the three-dimensional "negative" was not accomplished very well. The figures are distorted, and the owl has mysteriously disappeared from "Night." These daguerreotype cases owe a debt to Thorvaldsen, but the engraver, while paying homage, fell short of actually paying him an artistic compliment. Several years later, in a hand-drawn lantern-slide advertisement, the owl makes a cheerful reentry on the scene at a rakish angle (Fig. 5-5). Marcy's 1877 *Sciopticon Manual*, published in Philadelphia, describes the image as "one of the most popular" of its class, and the comment provides further proof of its continuing influence. The slide itself, a photographic positive transparency, cost sixty cents, and was one of several based on Thorvaldsen's works.

Thus, daguerreotype cases by no means represent Thorvaldsen's only influence on the photographic scene. Another example comes from the front cover of *The Photographic and Fine Art Journal*, which was edited by H. H. Snelling in New York from 1851 on. Not only does the June 1858 issue contain a "crystallotype" print of another Thorvaldsen work, but the cover design of the journal itself has been freely adapted from the master's "Night" (Fig. 5-6). Note, in passing, the portraits of Daguerre and Niépce at the top of the design. Crystallotypes were albumen prints made from albumen-on-glass negatives. Printed on large sheets of paper, they were offered as illustrations in books and journals, the sheets being directly bound into the volume, as an alternative to "tipping-in" by hand. The invention goes back to J. A. Whipple of Boston, who developed the method in the early 1850s (Taft 1938).

Fig. 5-3. Headboard of a "State Bedstead," needlework design. Shown at the Great Exhibition in London, 1851. Made by Messrs. Faundel and Phillips.

Associated with another daguerreotype case, popularly known as "The Capture of Major André," is a very different kind of story. John André was a charming, talented, and unlucky young man who, at the age of twenty-nine, was hanged as a British spy, at the order of George Washington, on October 2, 1780. Born in London to a prosperous Swiss merchant and his French wife, he enlisted in the army and, as a second lieutenant in the Royal English Fusiliers, sailed to join his regiment in Canada in 1774. Captured by the Americans in November 1775, he spent the next year as a prisoner of war but, despite this loss of time, managed to rise by the

FIG. 5-4. Engravings by W. Roffe. Published by the *Art Journal* (London) in 1852 and also distributed to subscribers as separate prints for framing. Similar roundels (c. 18 cm. diameter) can be found in America, photographs made from the original marble plaques rather than engravings.

STATUARY.

This class of pictures should be photographed directly from the statuary, or bas-relief, by a skilful artist, who

Fig. 18.

understands lighting and how to secure the proper degree and gradations of shading. It appears to the

FIG. 5-5. Thorvaldsen's "Night." Used as an advertisement for a lantern slide in *The Sciopticon Manual* of 1877, p. 53. The book was written by L. J. Marcy, Optician, of 1340 Chestnut Street, Philadelphia, with the object (as he succinctly put it) of "explaining Lantern Projections in general, and the Sciopticon Apparatus in Particular, including Magic Lantern Attachments, Experiments, Novelties, Colored and Photo-Transparencies, Mechanical Movements, etc." It was published by James A. Moore, Philadelphia.

FIG. 5-6. Front cover of *The Photographic and Fine Art Journal* (ed. H. H. Snelling), June 1858.
Note the Thorvaldsen-inspired image, as well as the representations of Daguerre and Niépce. See also
Snelling 1849.

fall of 1779 to the rank of deputy adjutant general of the army under its commander-in-chief, Lord Clinton.

Early in 1779, Clinton asked André to carry on some delicate negotiations with Benedict Arnold, commander of West Point, the American military stronghold on the Hudson River. Arnold had made a startling offer, too tempting to resist: in return for a handsome bribe, he was prepared to hand over West Point to the British. After months of somewhat leisurely correspondence, André sailed up the Hudson from the British base at New York on September 20, 1780, to discuss the details with Arnold. On his way home, he got through the American lines with the help of a pass from Arnold made out to "John Anderson" but, by a series of small mischances, he was captured by three militiamen before he had safely reached territory under British control. To compound the disaster, he was dressed at the time not as an innocent abroad, in full British uniform, but as a civilian; the false pass and the plans of West Point were found hidden in his boots. Twelve days later he had been tried, convicted, and executed at Tappan, the little town in New York where General Washington happened to be quartered.

The event caused ripples of reaction on both sides of the Atlantic. Countries are notoriously ungrateful to citizens tactless enough to be captured in suspicious circumstances, but in André's case Britain rose to the occasion with unusual alacrity. Borne along on a wave of public indignation, the government awarded a baronetcy to his younger brother and a pension for life to his mother and sisters. In a more visible gesture of displeasure, it commissioned a monument to André's memory; designed by Robert Adam, sculpted by Peter Van Gelder, the memorial was erected in Westminster Abbey in the fall of 1782. A frieze on the monument shows Washington receiving and rejecting the pleas of a British delegation for mercy, and André marching off heroically to his death. Britannia and a gloomy lion sit on top, brooding over the unfor-

tunate affair. As the *Gentleman's Magazine* for November 1782 perceptively put it: "The British lion . . . seems instinctively to mourn his [André's] untimely death."

In America, reactions at first were remarkably sympathetic. There André was known to a wide circle of friends and acquaintances, both British and American, as a man of social grace, with a talent for sketching and silhouette-cutting. He put those talents to good use when, as a prisoner of war in Lancaster, Pennsylvania, he gave drawing lessons to children, and so made friends with several families. After his release, he made a name for himself in amateur theatricals, as an actor, designer, and speaker, and was showered with praise. When he finally made his way to the gallows, he was watched by an audience of American officers, many of whom knew him personally. André retained his poise to the very end, and walked along as though at a reception, bowing left and right to the acquaintances he recognized.

However, despite the warmth of feeling for the ill-starred young man, the event itself, the capture of André, was from the first regarded as one of the key episodes in the War of Independence. As such, it became for Americans part of the patriotic folklore of the struggle, a favorite story kept alive by frequent retelling. One work of art did more than anything to keep André's memory fresh: an oil painting by A. B. Durand (Fig. 5-7), made in 1833 and exhibited two years later at the National Academy of Design. In 1846 a line engraving of it was published and distributed in thousands of copies. Though the figure of André is treated with dignity, Durand's emphasis is on the foiling of a dangerous plot against the state, and for this reason the painting was widely regarded as a patriotic emblem. The painting was copied again and again, and used as a decorative motif on signs and banners for July 4th festivities. In the light of such popularity, it is not surprising that Frederick Goll, die-engraver, chose to use it for the Samuel Peck company of case-makers in 1856 (Fig. 5-8). It is

FIG. 5-7. "The Capture of Major André," by A. B. Durand. 1833. Oil. Worcester Art Museum, Worcester, Massachusetts.

FIG. 5-8. "The Capture of Major André." Daguerreotype case. Union thermoplastic, quarterplate. Designed for the Samuel Peck Company in 1856 by Frederick Goll. See also Krainik and Walvoord 1988, p. 39.

(a)

FIG. 5-9. A Case History.

(a) "Country Life." Daguerreotype case, c. 1858. Union thermoplastic, half-plate. (Rinhart 1969, case no. 15) Made by Littlefield, Parsons & Company, loosely copied from a Currier and Ives lithograph. The case is sometimes listed as made by A. P. Critchlow & Company; the two companies merged at about the time of manufacture.

(b) "American Country Life: Summer's Evening." Currier and Ives lithograph; original engraving made by Frances Flora Palmer in 1855. Ohio Historical Society. See also Krainik and Walvoord 1988, p. 12.

fitting that a painting has immortalized a man who so loved to draw that he found comfort on the day before he was to die in sketching his self-portrait. (Henisch 1976)

Figure 5-9a shows another case, one made by Littlefield, Parsons & Company around 1858, with a design copied from a familiar Currier and Ives lithograph, "American Country Life: Summer's Evening." The original was made in 1855 by Frances Flora Palmer, an Englishwoman who had come to America in the 1840s and who

worked for many years thereafter as a landscape artist for Currier and Ives. The die-engraver did not set out to reproduce the original (Fig. 5-9b) in faithful detail, but edited and simplified it, giving greater emphasis to the boy in the foreground, and thereby making it more "dynamic." One cow was omitted, but nobody missed it.

The Thorvaldsen designs, as well as "The Capture of Major André" and "Country Life," are among daguerreotype cases much in demand

(b)

by collectors, along with several others whose background and art-historical provenance have been well researched (Krainik and Walvoord 1988). However, many cases of artistic merit that are much less well-known have survived. Among them are several varieties of mother-of-pearl inlay designs (see Figs. 5-10 and 5-14), as well as thermoplastic "Union" cases with thematic origins that remain to be fully documented. Figures 5-11 and 5-12 provide a small pictorial anthology, to illustrate the charm and variety of this minor art form.

In the field of case design, there was ample room for individuality. This was particularly true in the beginning, when designers were feeling their way toward an acceptable formula.

Thus, Figure 5-13 shows an unusual sixth-plate case, made probably in the very early days of photography, and almost certainly in New York City. A scrap of newspaper in the binding bears an advertisement for "The Emporium," 102 Nassau Street, New York. Made in the form of a book, closed with a clasp, and with "Gem" stamped on the spine, the case's design and "fairy" decoration may have been inspired by words of praise for the first daguerreotype displayed in New York. They appeared in the *Morning Herald* on September 30, 1839: "The specimen at Chilton's [on Broadway] is a most remarkable gem in its way. It looks like fairy work. . . . It is the first time that the rays of the sun were ever caught on this continent, and im-

FIG. 5-10. "Spray of Flowers." Clasp case,
c. 1855. American. Unknown designer and case-
maker. Mother-of-pearl inlay in black papier-mâché
background, quarter-plate. Unlisted variant; see
Rinhart 1969.

prisoned, in all their glory and beauty, in a mo-
rocco case, with golden clasps" (Taft 1938).

Christmas annuals, anthologies of literary and
pictorial trifles, were another source of inspira-
tion. They had originated in Germany and were
introduced to England, and then to America, in
the 1820s. Prettily bound, and sweetly senti-
mental, they became favorites with the general
public, and by the 1830s the bookshops at
Christmas time were glutted with the latest titles
in the endless flood. Thackeray, as a reviewer for
Fraser's Magazine in December 1837, waded his
way through "*Friendship's Offering* embossed,
and *Forget-Me-Not* in morocco; Jenning's *Land-
scape* in dark green, and the *Christian Keepsake*
in pea; *Gems of Beauty* in shabby green calico,
and *Flowers of Loveliness* in tawdry red wool-
len." Needless to say, his thunderings against
"such a display of miserable mediocrity, such a
collection of feeble verse, such a gathering of

small wit" had no effect on the paying customer,
and the "little gilded books" found their way
onto the occasional tables of every self-respect-
ing parlor for many years to come. Book pub-
lishers were not the only ones to scent profit;
photographic case manufacturers took note and
produced their own miniature versions of famil-
iar album bindings, each with an appropriate ti-
tle, *The Keepsake*, *The Memento*, *Forget-Me-
Not*, or *The Token* stamped on the spine. Figures
5-10 and 5-14 give two examples of the genre.

As time went on, and daguerreotypes slowly
fell out of favor, such bindings began to house
other kinds of photographs. Some of these, like
the carte-de-visite and the tintype, had no need
of any protective covering, but the convention
continued because a case, however simple, en-
hanced the value of the image (Fig. 5-15a). Al-
though leather, papier-mâché, and thermoplas-
tic were the materials most often chosen,

Fig. 5-11. Anthology of small thermoplastic daguerreotype cases I. American.

(a) "The Blind Beggar," c. 1860. Unknown artist. Ninth-plate.

(b) "The Music Group," A. Schaefer, die-engraver, c. 1859. Northampton, Massachusetts. Quarter-plate.

(c) "Children and Lamb at Stile," c. 1860. Northampton, Massachusetts. Unknown artist. 1⅝ × 2⅛ inches, oval.

(d) "Pharaoh's Daughter Finds the Baby Moses," c. 1865. Northampton, Massachusetts. Unknown artist. 2½ × 2 inches, oval.

(e) "Cupid and Wounded Stag," c. 1856. Unknown artist. Quarter-plate.

(f) "Jacob at the Well," c. 1850s. Unknown artist. Sixth-plate.

(a)

(b)

FIG. 5-12. Anthology of small thermoplastic daguerreotype cases II. American.

(a) "Chess Players," c. 1860. Unknown artist. 2½ × 3 inches, octagon. Variant of Rinhart (1969) case no. 41. The players, here a young man and woman in period costume, may be Ferdinand and Miranda in *The Tempest*, act 5, scene 1; see Anon. 1986.

(b) "Children with Lambs," by F. Seiler, die-engraver. Early 1850s. Sixth-plate. Seiler was active in New York City from 1850 to 1854. See Rinhart 1969, supplementary list, no. 16.

(c) "Man in Wheatfield." 1850s. Unknown artist. 1⅞ × 2⅛ inches. Probably derived from late eighteenth- to early nineteenth-century designs of picture series on "The Four Seasons."

(d) "The Highland Hunter," by Hiram W. Hayden, die-engraver, c. 1858. Probably New York City. Sixth-plate.

(c)

(d)

(e) (f)

(g)

FIG. 5-12 (e) "The Elopement," c. 1858. Unknown artist. Ninth-plate. Made by Wadham's Manufacturing Company, a firm that made plastic daguerreotype cases featuring the "Kinsley and Parker hinge." (Rinhart 1969, 1981)

(f) "The Wheat Sheaves," by F. Key, die-engraver, c. 1860. Sixth-plate. Made by S. Peck & Company. Key worked in New York City in the 1840s and in Philadelphia after 1850. In later years he was associated with the Scovill Manufacturing Company, likewise makers of daguerreotype cases. (Rinhart 1969, case no. 14) The case is listed there as made by the Scovill Manufacturing Company; the two companies merged in 1855.

(g) "The Country Dance," by Smith & Hartman, die-engravers, c. 1856. Union thermoplastic. Quarter-plate. Made by S. Peck & Company.

FIG. 5-13. "Fairy Scene." Daguerreotype case, c. 1840. American, New York City. Unknown artist. Watercolor print set into die-stamped leather case, sixth-plate. (Taft 1938; Wilsher 1988)

FIG. 5-14. "Temple Ruins." Example of clasp daguerreotype case in book form. 1850s. American. Unknown designer. Mother-of-pearl inlay in papier-mâché background. Quarter-plate. "Memento" imprinted on the spine. See also Wilsher 1981.

(a)

(b)

FIG. 5-15. Tintype displays. American.
 (a) Album for "gem-size" tintypes, 3¼ × 2¼ × 1 inches, c. 1870. Various photographers. Miniature clasp album with deeply embossed covers.
 (b) Thermoplastic tintype case in the form of a rouge pot, c. 1860. Unknown designer. 1¾ inches diameter.

fashion's changing imperatives led to many delightful variations. Cases were covered in velvet, modeled on rouge pots (Fig. 5-15b), or disguised as tiny books, sometimes gleaming with mother-of-pearl. It takes only a small effort of imagination now to hold these chipped and faded trifles in the hand and see them once more as charming temptations, cunningly contrived to weaken resolution and coax money from a purse.

PRESENTATION, PRIVATE AND PUBLIC

Because of their characteristic reflective properties, daguerreotypes were rarely used in wall-mounted displays; only in France are examples of hang-up frames occasionally found. With the increasing popularity of paper photography from the early 1860s onward, quite different forms of protection and display became popular, some (e.g., albums) because they were specifically needed, and others (e.g., photographic jewelry, stanhopes, photographs on porcelain) as idiosyncratic mementos. Again, tastes were shared by a worldwide public. To America, the leading fashion dictates tended to come from England, and in England, more often than not, Queen Victoria set the tone. After Prince Albert's death in December 1861, the Queen was determined to cherish his memory, in public as in private, and photography played an important role in this endeavor. The Prince's death created an enormous demand for portraits of the Royal Family, and the Queen nourished that demand by beginning to wear photographic jewelry.

The first examples were produced for her with the help of William Bambridge of Windsor, whom Dimond and Taylor (1987) describe as a "photographic factotum" to the Royal Family. His photographs were sent to other craftsmen to be delicately mounted. On New Year's Day 1862, Garrard & Company, Goldsmiths to the Crown, supplied "nine gold lockets for photograph Miniatures, with Crown loops and black pearl drops." These lockets were probably made to be given to the Queen's children. For the rest of her life, the Queen continued to wear such mementos. At the time of her Diamond Jubilee in June 1897, she was portrayed wearing a bracelet containing a photograph of the Prince Consort (Gernsheim 1959). Victoria's interest in photography had been first stirred by Prince Albert's enthusiasm, and may have been rekindled in later years by her daughter-in-law, Princess Alexandra, a competent amateur. Not only did the Queen collect and exchange an enormous number of images, but she even made occasional glancing references to photographic processes, as when she wrote to her eldest daughter, the Princess Royal, in 1890: "I send you today some platinotypes from platino [sic; i.e., made with the use of platinum] which have been brought to a great perfection by Elliott and Fry." (Ramm 1991; Weintraub 1991)

The problem of producing photographs small enough to go into jewelry had been solved in passing a few years before Prince Albert's death by J. B. Dancer of Manchester, pioneer in micro-photography. A memorial ring was designed for the Queen, containing a micro-photograph of the Prince Consort, made in 1861 and attributed to Mayall (Dimond and Taylor 1987). For the Queen's lockets, the photographs measured only a few millimeters in diameter, and were magnified by a small lens, the whole assembly being called a "stanhope." When the Queen was seen wearing photographic lockets and bracelets, the fashion-conscious public took its cue. But though Her Majesty had made an influential gesture, memorial jewelry of some kind had been known for many years, in many levels of society. Thus, for instance, Fink (1990) describes an American pendant, containing a postmortem daguerreotype of a lady. Just such a brooch, worn as an ornament, can be seen in Figure 4-14c.

"Stanhopes" were based on albumen or collodion positive transparencies. Because of the high degree of magnification required to view them, very fine-grain images were called for. Lord Stanhope (1753–1816) did not invent them, but he did, in a different context, design the small magnifying systems with which they came to be viewed. A thick plano-convex lens and the transparency were mounted at a fixed distance in a small tube, and the whole assembly was small enough to be inserted into all manner of decorative items, sometimes "jewelry," but mostly more humble souvenirs of one kind or another. Eder (1905) makes a delicate allusion to their use with pornographic pictures, needless to say "in Paris." He also gives references to methods of manufacture. To Sir David Brewster of St. Andrews fell the honor of showing the first stanhopes to Pope Leo XIII, one photographic enthusiast sharing news of the latest invention with another; for Leo XIII, see also Chapters 1 and 15. In 1858, a rare plant was named *stanhope oculata* in honor of Lord Stanhope and, of course, promptly photographed (see Baier 1977 and Gernsheim 1969). However banal, or hard to see, the images inside may be, the stanhope cases themselves have a doll's-house charm and come in a variety of engaging forms, from a diminutive spyglass (see Fig. 5-19) to a baby's rattle.

From the earliest daguerreotype days, pictures had been inserted into watchcases, and inevitably the same was later done with ambrotypes and tintypes (Fig. 5-16). A closed locket or watchcase provided a small pocket of privacy in the most public life, and occasionally a withered flower or note was tucked in with the image—touching proof of their importance to the owner (Fig. 5-16b). Figures 3-5, 5-17, 5-18, and 5-19 present a small anthology of photographic jewelry, often of little monetary value but always much treasured. Photographs were used as souvenirs of absolutely anything, from views of Paris set in a miniature album, hung as a charm on a necklace (Fig. 5-18a), to a stanhope image

of a Civil War battlefield, tastefully embedded in an authentic bullet. Tintypes, by nature tough, were particularly suitable for use in jewelry items intended for daily wear (see Gilbert et al. 1991).

There are to be found among the more esoteric uses of photographs, pictures on plates and teacups (Fig. 5-20); among the most utilitarian, a daguerreian coat button (West and Abbott 1990); among the most sentimental, postmortem photographs framed in human hair (Fig. 5-21), and arguably among the most macabre, "premortem" portraits of the occupants on funerary urns (Fig. 5-22; see also Chapter 6). Among the least surprising adaptations are certainly photographs used as Christmas and greeting cards (Fig. 5-23c), but personal advertising of the kind shown in Figures 5-23a and 5-23b was a new idea, encouraged by the increasing popularity of photography by the turn of the century. Such souvenir booklets, bearing the photograph of a teacher, a minister, or a building, and given to students at school or Sunday school, were popular in America during the first years of this century. (See also Chapter 8.) There is believed to be no European equivalent. The little brochure shown in Figure 5-23b follows its front-page slogan inside with a grim reminder:

Life is a School of Education,
Each day brings a new recitation,
Death ends with a long vacation,
Then comes the hard examination

—an echo of hard truths not, alas, softened by literary graces.

The photograph in miniature was not the principal preoccupation of the supporting trades; the main emphasis was on frames that lent dignity to family portraits on mantelpieces and piano tops (Fig. 5-24, a, b), or on frames for large photographs and overpaintings that fulfilled a grander role when hung on walls. Thus, for instance, itinerant photographers carried advertising material (see Chapter 4), not only for

(a)

'Tis but a little faded flower
But oh how fondly dear
'Twill bring me back one golden hour
Thro' many a weary year
I would not to the world impart
The secrete of its power
But treasured in my inmost heart
I'll keep my faded flower.

(b)

FIG. 5-16. Ambrotype lockets of the 1860s. American.

(a) Family portraits in a watchcase. 1½ inches diameter.

(b) *Left*: Faded flower and inscription inside front cover (enlargement). *Right*: Blue velvet case with portrait of a young woman, 2 inches diameter.

(a)

(b)

FIG. 5-17. Photographic pendants. Wareham family, c. 1900. English. Unknown maker.
 (a) Tintype pendants, 1½ inches and 1 inch diameter.
 (b) Reverse sides of (a).

FIG. 5-18. Photo-jewelry.

(a) Pendant in the form of a miniature album, with photographs of Paris. Made to celebrate the opening of the Eiffel Tower in 1889. 1 × ⅝ inches. See also Fig. 12-10.

(b) Watch fob with photographic pendant. 1880s–1890s. American. See also Spira 1991.

FIG. 5-19. Stanhopes. 1870s–1880s. American and British.

FIG. 5-20. Photo-esoterica, c. 1900.
(a) Photograph on a cup. American. Collodion positive on porcelain, 3 × 5 × 5 inches.
(b) "Photographic" napkin ring. Relief carving on ivory, 2 × 2¼ inches diameter. The carving shows a photographer under the hood of a large camera, taking portrait of a bearded man (not seen here).

(a)

(b)

FIG. 5-21. Postmortem with hair sculpture. 1860s. American. Unknown photographer. Albumen print. The photograph itself is a standard carte-de-visite; it is housed in a deep wooden case, which also holds the hair ornament in place.

FIG. 5-22. Photographic funerary urns, "his" and "hers," with pictures of the occupants, made with foresight in better times. American. Urns from the turn of the century; height 15 inches. Photographs from the 1870s.

(a) (b)

FIG. 5-23. Personal Promotion. Souvenir greeting brochures of
the turn of the century. American.

(a) Souvenir advertising card issued by a parish minister. 1903.
Pennsylvania.

(b) Souvenir advertising card issued by a patriotic schoolteacher.
1911.

(c) Example of the ease with which a routine studio portrait
could be turned into a greeting card by the deft addition of an
appropriate message.

(c)

FIG. 5-24. The Framer's Fancy.

(a) and (b) Massive brass frames for the display of cabinet cards. 1880s. American. Height: 13¼ inches.

(c) T. Roosevelt in Three Dimensions. Pach Brothers. 1904 (see also Fig. 6-10). Three-dimensional photograph on paper, unidentified process. 9 × 7 inches. Portrait set in a lavatory seat by someone who was evidently not a wholehearted admirer of the President. Height: 10 inches.

(b)

FIG. 5-24 (c)

photographs as such, but also for frames in great variety. The objective was not to start new fashions but to conform to old ones, and to present the photograph as a worthy successor to the painted portrait. Just occasionally, a frame might be used as a political gesture, as in Figure 5-24c, which presumably was not made by an unequivocal supporter.

UNDER COVER

Photographs made on metal or glass were handled like miniature portrait paintings, and protected from light, moisture, and an increasingly noxious urban atmosphere by being housed in individual cases. Similarly, the first photographs on paper were treated like prints or drawings, and placed for safe keeping within the covers of a traditional portfolio, or even an ordinary book. This practice carried its own dangers, considering the acidity of most papers, but it did at least protect the photographs from excessive light that might have bleached them.

In due course, the invention of a special kind of album was prompted by the invention of a special kind of photograph. In 1854, André Adolphe Disdéri, sensing the public's growing appetite for photographic portraits, had a lucra-

tive brainwave: he began to issue small, inexpensive photographs of the famous, each pasted on thin cardboard cut to standard visiting card size. Figure 5-25 shows the flowery signature he imprinted an all card versos. The response to these small photographs was sensational; cartes-de-visite enjoyed an instant triumph, and though the prominent took pains to deplore the blatant vulgarity of the new craze, they trooped into the studios to be immortalized and distributed, while the collecting fever raged unchecked throughout society. Everybody wanted the small pictures, bought them, swapped them, and displayed them. An album served as the perfect container for the treasure. Disdéri worked in Paris, so it was only natural that the first album designed expressly for this type of photograph made its appearance there in 1858. (McCauley 1985; Maas 1977) Disdéri's novelty catered to a need, namely that of creating large numbers of small portraits, intended for distribution by the client as personal mementos or, indeed, for sale.

The carte-de-visite was thus the very antithesis of the museum print—not an art object, but rather what we would now call a "consumer product." When the popular size increased from the visiting card to the cabinet card (about 4 by 6 inches) after the mid-1860s, the size of albums increased also. By then, albums had long ceased to be simple books with blank pages; on the contrary, they made elaborate provision for the easy (and sometimes not so easy) insertion of photographs behind ornamental mats (Fig. 5-26), and for their later removal, if need be—the latter process being often fraught with pain and peril.

Many designs were patented in the general competition for the user's favor. In due course, the album ceased to be a mere convenience; it became a novelty item on its own account, sometimes ornate, sometimes ingenious, and just occasionally (Fig. 5-27) whimsical. Figures 5-26b and 5-28, for instance, show photographs used as pictorial elements in page design for its

Fig. 5-25. Carte-de-visite by Disdéri of Paris, c. 1860.

(a)

Fig. 5-26. Travel album belonging to a well-to-do American family with wide interests on both sides of the Atlantic. Mid-1870s. Leather binding and elaborate page decor preprinted in color. A cardboard slide is provided with each triple-thickness album leaf (double page) for coaxing photographs into their intended slots. The need for such an instrument must have been widely felt. For instance, the *St. Louis Practical Photographer* of December 1877 contains (on p. xxi) an advertisement for "Shaw's Gem Cutter and Enserter" [*sic*]. Some photographs in the present album are of family members, others are of famous people or notable works of art, distributed in carte-de-visite form. Typical pages (11½ × 9½ inches):

(a) Display of hand-colored carte-de-visite of Alexandra, Princess of Wales. Photograph inserted into a slot.

(b) Alternative page design from the same volume, with some photographs glued on in predesignated places, as part of the decor.

(a)

FIG. 5-27. "Miss Popkins Prefers Photography." General-purpose photograph and scrap album, c. 1860. England. 7 × 5½ inches. Imprint on inside back cover: "From John Jerrard, 172 Fleet Street, London, E.C. Depot for Scraps, Albums and Scrap-Books."

(a) Ornate title page, "illuminated by Samuel Stanesby."

(b) Album page with a photographic theme. Watercolor and appliqué print, a charming example of a Victorian hobby, the creation of composite pictures in color. New printing processes made tempting ingredients readily available.

(b)

FIG. 5-28. Photographs as elements of page design. Lady Filmer (1840–1903). Watercolor with collaged photographs, c. 1864. British. 28.7 × 23 cm. University Art Museum, University of New Mexico, Albuquerque. Note the image on the left, which shows two ladies looking at a (less ornate) photograph album.

own sake. Toward the end of the century, when albums were no longer new, manufacturing standards tended to deteriorate. A German trade journal commented sarcastically on a problem familiar to this day, that the shoddiness "shows itself only during use; it generally remains hidden at the time of purchase" (Maas 1977; see also Kessler 1991).

Albums were often embellished with the owner's inscriptions in prose or verse, and the contents might bear the stamp of engaging idiosyncrasy, but the album itself was usually designed to embody and convey established Victorian virtues. Its trappings were sometimes gaudy, but the overall purpose was a serious one; it is significant that many family albums have the look and weight of family Bibles (Fig. 5-29a). The anthology made a statement about its owners and their tastes. Such an album might open with a dedication, or a printed description of its purpose. Oliver Mathews (1974) quotes a particularly charming one:

Within this book your eye may trace
The well known smile on friendship's face;
Here may your wandering eyes behold
The friends of youth, the lov'd of old;
And as you gaze with tearful eye,
Sweet mem'ries of the years gone by
Will come again with magic power,
To charm the evening's pensive hour.

Some in this book have passed the bourne
From whence no travellers return;
Some through the world yet doomed to
 roam,
As pilgrims from their native home,
Are here by nature's power enshrined,

(a)

FIG. 5-29. American carte-de-visite album. 1860s–1870s. Albumen prints.
(a) Deeply embossed cover design, with clasps.
(b) The Washington-Lincoln Apotheosis, painted by S. J. Ferris, photographed and distributed by the Philadelphia Photo Company.
See also (c)–(f).

As lov'd memorials to the mind —
Till all shall reach the happy shore,
Where friends and kindreds part no more.

It quickly became the custom to reserve the first few pages for photographs of leaders of society whom the family specially admired: a selection of approved statesmen, clergymen, and artists. In England, the place of honor was usually given to Queen Victoria and Prince Albert, while in America this was often filled with an imaginary apotheosis showing Washington embracing Lincoln in heaven, a famous fantasy of which many variants were made just after Lincoln's assassination (Fig. 5-29; see also Chapter 12). Public figures would be followed in the album by some reputable, or at least respectable,

(b)

WASHINGTON and LINCOLN, (APOTHEOSIS,)

relatives, and then, at last, by the core of the family: parents, children, friends, pets, and all, with an occasional frivolity or joke inserted to hold the interest of incorrigibly lighthearted viewers.

In August 1860, J. E. Mayall published his *Royal Album* of portraits, and thereby set the seal on a fashion that spread to all parts of the kingdom and, indeed, the world: that of collecting cards. Gernsheim (1959) quotes a less than totally respectful letter from one of Queen Victoria's ladies-in-waiting, in which she remarked: "I have been writing to all the fine ladies in London for their husbands' photographs, for the Queen. I believe the Queen could be bought and sold, for a photograph."

So popular had albums become by the 1860s that Charles Kingsley (1863) featured one in his fairy story *The Water Babies*. The fairy's album, waterproof and safely stored in the crack of a rock, had been created in response to a need, one that made itself felt some 13,598,000 years ago, following the invention of photography in color. It contained photographs of "the great and famous nation of Doasyoulikes," but the remarkable collection proved no help against the fatal combination of indolence and self-indulgence. Despite many gifts, and many photographs, the whole race frittered away its advantages, ate "bad food," a sure sign of moral decay, and vanished from the face of the earth.

Family albums were traditionally kept in the drawing room or front parlor, and visitors were often asked to add their own contributions to the collection:

Grateful thanks you will receive
If your portrait here you leave.
[Mathews 1974]

They were also to prove invaluable to characters in search of something to do. A flustered lover in Jerome K. Jerome's *Three Men in a Boat* takes refuge in an album when his flirtation is interrupted by a tactless intruder: ". . . when

(c)

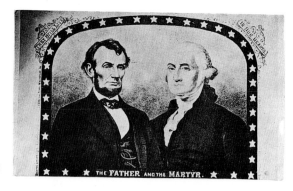

(d)

MRS. LINCOLN.

(e)

ZALUMA AGRA,
Star of the East.

(f)

FIG. 5-29 (c) Lincoln and Washington, crowned by Liberty with victors' wreaths. Artist and publisher unknown. See Chapter 12.

(d) Lincoln and Washington, framed in stars, with the inscriptions "The Father and the Martyr" and "They Still Live in Our Hearts." Photographer and publisher unknown. See Chapter 12.

(e) Mrs. Lincoln. Photographer and publisher unknown.

(f) Zaluma Agra, Star of the East. Photographer and publisher unknown.

you get in, Emily is over by the window, full of interest in the opposite side of the road, and your friend, John Edward, is at the other end of the room with his whole soul held in thrall by photographs of other people's relatives" (Jerome 1889). The initial attitude toward albums was one of respect, but as the style mannerisms of studio photography became fossilized, reverence gave way to irreverent frivolity. Frank Wing's *The Fotygraft Album* (1915) is an example of that, with its charcoal-and-wash sketches of ghastly relatives and ancestral types, instantly recognizable by every reader. See also Train (1981).

The original untouched family album is a rarity now. Albums offered for sale have usually been raided for valuable contents, and then "reconstituted" by inserting photographs from a random pile, without historical cohesion, just to fill the vacant spaces; sociologists beware. Only one type of album was immune from such ravages, while still catering to the universal desire to keep images of the Great and Powerful conveniently trapped between hard covers. Figure 5-30 shows an example, based entirely on photomontage, each (stiff) page a "group portrait" made up not only of photographs from a variety of sources but also of paintings and engravings. A key is provided for easy identification. The page shown includes, among many others, "the late Earl Disraeli," and Lord John Manners, who had helped Disraeli come to prominence in the 1840s. Also in the group are "the late General Gordon, Hero of Khartoum," and Lord Randolph Churchill (father of Winston), as well as Gladstone who, presumably, did not relish any display shared with Disraeli. Among the foreign potentates is Emperor Franz Joseph of Austria (see also Chapter 8). Sobieszek (1978) has described an example of the 1870s in which the same idea is actually taken a good deal further. Not only are the members of a "Group of Actors" montaged onto the same page, but the full-length portraits are set out, standing or

sitting, so as to mimic a view of a large and crowded salon filled with people strenuously ignoring each other.

Not all albums were family or "celebrity" anthologies. Simpler, but generally larger, volumes (Figs. 5-31 and 5-32) were devoted to informal picture lessons in descriptive geography, at a time when armchair travel often had to be a substitute for travel itself. Those who did actually venture to distant places regarded it as their duty to prepare a souvenir of the expedition, containing photographs lovingly collected at each port of call, and assembled into a permanent memento after the safe return. One of the photographs (Fig. 5-32) in such a volume is of an engraving, based on a painting by Turner, which must have caught the traveler's fancy: "Ancient Rome; Agrippina Landing with the Ashes of Germanicus. The Triumphal Bridge and Palace of the Caesars Restored." The painting was exhibited at the Royal Academy in 1839 and is now in the Tate Gallery, London. This finding is of special interest, because no such engraving is listed in the standard reference work on Turner: Butlin and Joll (1977), Mauner (1987). In the ordinary way, the form and contents of this album genre are highly predictable but, between the covers, unexpected treasures await sharp-eyed explorers.

Another type of album (Fig. 5-33) was the forerunner of the modern artbook; it played an enormous role in making "art history" the formal academic discipline it is today. This particular example, *Album Artistique et Biographique, Salon 1882*, is a record of the Paris Salon of that year. The added phrase, "2me Année," suggests that a similar album had been printed in 1881. On the cover, stamped in gold, is a design (signed Henri Tilly) showing the Spirit of Painting, with a palette, and the Spirit of Photography, with a camera. The album contains a photograph of each artist who exhibited in that Salon, and a photograph of his painting. The pictures were made by Godet, who specialized

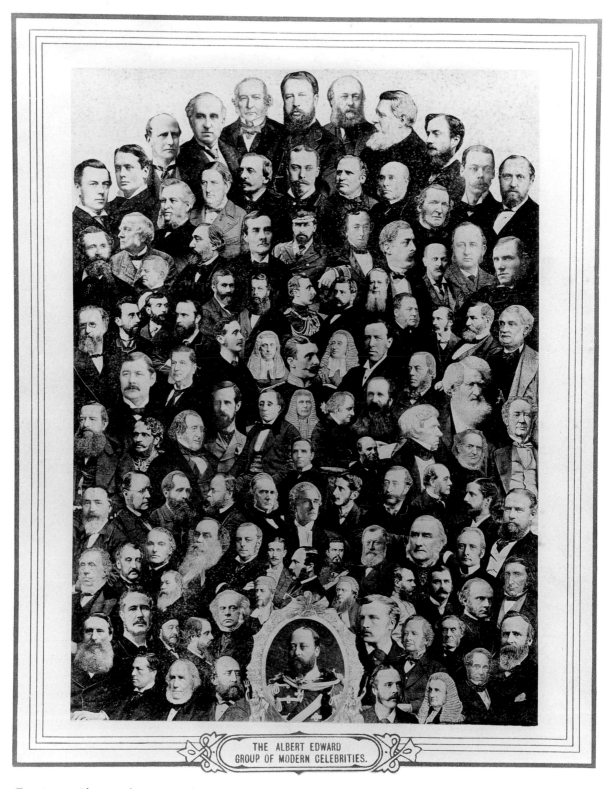

THE ALBERT EDWARD
GROUP OF MODERN CELEBRITIES.

Fɪɢ. 5-30. *Photographic Groups of Eminent Personages.* Montage. 1880s. British. Various photographers and painters. Gelatin silver prints, 13 × 10½ inches. Composite group portraits mounted on stiff boards, each with an explanatory key on the facing page. Original material drawn from paintings, engravings, and photographs. Page titles include "Group of Bishops," "Operatic and Dramatic Celebrities," "Celebrities in the Church, Science, Literature and Art," "Eminent Women," and others.

FIG. 5-31. *"Tipy Kavkasa"* ("Types of the Caucasus"), by D. Ermakov. 1880s–1890s. Tiflis, Georgia. Albumen prints. Album 18½ × 13½ inches. Two examples from the hundred (alas untitled) tipped-in prints, all of views and "types" of Georgia, by the best known of early photographers there. D. Ermakov opened his studio in the 1870s and died in 1914. The album bears a commercial sticker: "Otto Siebert, Tiflis," presumably the firm of distributors. See also Mamasakhlisi 1978.

in the photographing of art works, and whom Manet chose to make records of some of his paintings, including "Le Chemin de fer" (1873–74) (McCauley 1985).

Albums brought pleasure to the public, and profit to photographers, many of whom earned their reputation and the bulk of their income from work designed to find a place within the covers, whether in the form of studio portraits or not. Major firms often specialized; thus, W. and D. Downey of London were known for portraits of royalty and of celebrities (Fig. 8-29),

and Kusakabe Kimbei, in faraway Japan, focused on the picturesque costumes and native "types" that fascinated Western visitors (Fig. 14-16). G. W. Wilson and J. Valentine of Scotland offered landscape views from many countries (Fig. 14-18), and the Alinari Brothers, as well as

Giacomo Brogi, all of Florence, concentrated on studies of architectural detail and of masterpieces by great artists. Each helped to make the album not only a family shrine but also a window open to a wider world. (Maas 1975, 1977)

FIG. 5-32. Example from a private album of the Grand Tour. Mid-1870s. American. Cartes-de-visite, small and large prints, with handwritten captions. A photographic record of a European tour that began and ended in Ireland. Many fine commercially reproduced photographs are included, some by the Scottish firms of G. W. Wilson and J. Valentine. The photograph here shown is of an engraving after Turner's painting, "Ancient Rome: Agrippina Landing with the Ashes of Germanicus." See the text and Butlin and Joll 1977.

Chapter 5 References and Notes

ANON. (1851). *The Crystal Palace Exhibition: Illustrated Catalogue*, London, 1970 reprint by Dover Publications, New York, p. 41.

ANON. (1852). Editorial in *Art Journal* (London), January 21, p. 21.

ANON. (1986). *Chess in Art and Society*, Victoria and Albert Museum, London.

BAIER, W. (1977) *Quellendarstellungen zur Geschichte der Fotografie*, Schirmer-Mosel, Munich, p. 231.

BUTLIN, M., and JOLL, E. (1977). *The Paintings of J. M. W. Turner*, Yale University Press, New Haven and London. Color illustration no. 354.

DARRAH, W. C. (1981). *Cartes-de-Visite in Nineteenth Century Photography*, W. C. Darrah, Gettysburg, Pennsylvania, pp. 57–59.

DIMOND, F., and TAYLOR, R. (1987). *Crown and Camera: The Royal Family and Photography, 1842–1910*, Penguin Books, London, pp. 19, 23.

EDER, J. M. (1905). *Geschichte der Photographie*, 2 vols., W. Knapp Verlag, Halle. English version (1978), translated by E. Epstean, Dover Books, New York, p. 389.

EITNER, L. (1967). *Encyclopedia of World Art*, McGraw Hill, New York, p. 55.

(a)

(b)

FIG. 5-33. The *Album Artistique et Biographique, Salon 1882*, edited by E. Francfort, R. de Paradis No. 45, Paris. Photographs by Godet.

(a) Die-stamped emblem on front cover, depicting the Spirit of Painting and the Spirit of Photography. Signed "Henri Tilly."

(b) Example of contents: *Les Pêcheries de Dieppe*, by Pierre-Marie Beyle. Painted in 1881.

FINK, D. (1990). In *The Daguerreian Annual* (ed. P. E. Palmquist), The Daguerreian Society, Lake Charles, Lousiana.

GERNSHEIM, H. and A. (1959). *Queen Victoria*, Longmans, Green & Co., London, pp. 261, 235, fig. 297.

GERNSHEIM, H. and A. (1969). *The History of Photography*, McGraw-Hill, New York, p. 318.

GILBERT, G., WEST, L., and ABBOTT, P. (1991). "Photographs to Adorn and Be Worn: The Era of Tintypes in Jewelry," in *Photographica*, vol. 20, no. 2 (April), pp. 16–19.

GUGLIELMI, S. (1982). "Daguerreotype Case Salesman," *History of Photography*, vol. 6, no. 3, frontispiece.

HELSTED, D. (1977). Personal communication, acknowledged with thanks.

HENISCH, B. A. and H. K. (1976). "Major André," *Journal of General Education*, vol. 28, no. 3, p. 237.

HENISCH, B. A. and H. K. (1978). "Thorvaldsen Daguerreotype Cases," *History of Photography*, vol. 2, no. 2, p. 135.

JEROME, J. K. (1889). *Three Men in a Boat*. Modern reprint: Penguin Books, Harmondsworth, Middlesex, U.K., 1971, chapter 12, p. 109.

KESSLER, M. (1991). "The Art of the Album," *The Photographist*, no. 90, pp. 12–16.

KINGSLEY, C. (1863). *The Water Babies*, Macmillan & Co., London, chapter 6.

KRAINIK, C. M., and WALVOORD, C. (1988). *Union Cases*, Centennial Photo-Service, Grantsburg, Wisconsin.

MAAS, E. (Editor) (1975). *Das Photoalbum, 1858–1918*, Karl M. Lipp Verlag, Munich.

MAAS, E. (1977). *Die goldenen Jahre der Photoalben*, Studio Dumont, Cologne.

MAMASAKHLISI, A. (1978). "Early Photography in Georgia," *History of Photography*, vol. 2, no. 1, pp. 75–84.

MARCY, L. J. (1877). *The Sciopticon Manual*, James A. Moore, Philadelphia, p. 54.

MATHEWS, O. (1974). *The Album of Cartes-de-Visite and Cabinet Portrait Photographs*, Reedminster Publications, London, p. 7.

MAUNER, G. and M. (1987). Private communication, acknowledged with thanks.

McCAULEY, E. A. (1985). *A. A. E. Disdéri and the Carte-de-Visite Portrait Photograph*, Yale University Press, New Haven, Connecticut, pp. 46–47, 193.

MEYER, R. (1977). "The Thorvaldsen Daguerreotype," *History of Photography*, vol. 1, no. 1, pp. 85–87.

MEYER, R. (1978). "The Thorvaldsen Daguerreotype: Correspondence," *History of Photography*, vol. 2, no. 1, pp. 85–87.

NAVAIS, R. (1976). In *Photohistory III*, Symposium proceedings, Photographic Historical Society of Rochester, New York.

RAMM, A. (Editor) (1991). *Beloved and Darling Child: Last Letters Between Queen Victoria and Her Eldest Daughter, 1886–1901*, Allan Sutton, London, p. 105.

RINHART, F. and M. (1967). *American Daguerreian Art*, Clarkson Potter, New York.

RINHART, F. and M. (1969). *American Miniature Case Art*, A. S. Barnes & Co., South Brunswick and New York.

RINHART, F. and M. (1981). *The American Daguerreotype*, University of Georgia Press, Athens, Georgia, p. 326.

SILLIMAN, B., JR., and GOODRICH, C. R. (1854). *The World of Science, Art and Industry, from Examples in the New York Exhibition, 1853–1854*, Putnam, New York.

SNELLING, H. H. (1849). *The History and Practice of the Art of Photography; or, The Production of Pictures Through the Agency of Light*, G. P. Putnam, New York, 1978 reprint by Morgan & Morgan, Hastings-on-Hudson, New York.

SOBIESZEK, R. A. (1978). "Composite Imagery and the Origins of Photomontage," *Art Forum*, September, p. 58.

SPIRA, S. F. (1991). "Daguerreian Saloon," *History of Photography*, vol. 15, no. 1, p. 74.

TAFT, R. (1938). *Photography and the American Scene*, Macmillan Co., New York, 1964 reprint by Dover Publications, New York, pp. 16, 120.

TRAIN, J. (1981). *Remarkable Relatives*, Clarkson Potter, New York.

WEINTRAUB, S. (1991). Private communication, acknowledged with thanks.

WEST, L., and ABBOTT, P. (1990). "Daguerreian Jewelry," in *The Daguerreian Annual* (ed. P. E. Palmquist) The Daguerreian Society, Lake Charles, Louisiana.

WILLS, C. H. and D. (1979). "Union Cases Based on Designs by Bertel Thorvaldsen," *History of Photography*, vol. 3, no. 1, p. 93.

WILSHER, A. (1981). "Christmas Albums and Photographic Cases," *History of Photography*, vol. 5, no. 1, p. 20.

WILSHER, A. (1988). "Fairy Work," *History of Photography*, vol. 12, no. 4, p. 294.

WING, F. (1915). *The Fotograft Album*, Reilly & Lee Co., Chicago.

6

FAMILY MILESTONES

FOR LOVE'S SAKE

". . . the enormous practice which our operators enjoy combines to render the daguerreotype a necessary contributor to the comforts of life. Does a child start on the journey of existence, and leave his 'father's halls'; forthwith the little image is produced to keep his memory green. Does the daughter accept the new duties of matron, or does the venerated parent descend into the grave, what means so ready to revive their recollection? Does the lover or the husband go to Australia or California, and not exchange with the beloved one the image of what afforded so much delight to gaze upon? The readiness with which a likeness may be obtained, the truthfulness of the image, and the smallness of cost, render it the current pledge of friendship; and the immense number of operators who are supported by the art, in this country, shows how widely the love of sun-pictures is diffused." (Horace Greeley 1853)

In his flowery style, Greeley thus expressed a certain basic truth. He went on to say that "several thousand industrious artists and artisans" were engaged in the task of catering to the universal demand.

Photography's entry into that role of family

recorder was prompt, and its position stable. Among the earliest such references is one by Elizabeth Barrett to Miss Mitford (Miller 1954):

Dec. 7, 1843 50 Wimpole Street

My dearest Miss Mitford, do you know anything about that wonderful invention of the day, called the Daguerreotype?—that is, have you seen any portraits produced by means of it? Think of a man sitting down in the sun and leaving his facsimile in all its full completion of outline and shadow, steadfast on the plate, at the end of a minute and a half! The Mesmeric disembodiment of spirits strikes one as a degree less marvellous. And several of these wonderful portraits, like engravings—only exquisite and delicate beyond the work of graver—have I seen lately—longing to have such a memorial of every Being dear to me in the world. It is not merely the likeness which is precious in such cases—but the association, and the sense of nearness involved in the thing, the fact of *the very shadow of the person* lying there fixed for ever! It is the very sanctification of portraits I think—and it is not at all monstrous in me to say what my brothers cry out against so vehemently, . . . that I would rather have such a memorial of one I dearly loved, than the noblest Artist's work ever produced. I do not say so in respect (or disrespect) of *Art*, but for *Love's* sake. Will you understand? —even if you will not agree?

May God bless you, my beloved friend! Tomorrow you will receive a little fish, which I hope may make itself welcome.

Ever your affectionate B.B.

Such sentiments are still in currency. Thus, Barthes (1981) begins his exposition on the nature of photography with the words: "One day, quite some time ago, I happened on a photograph of Napoleon's youngest brother, Jerome, taken in 1852. And I realized then, with an amazement I have not been able to lessen since: I am looking at the eyes that looked at the Emperor." From that amazement grew what Barthes calls his "ontological" desire to learn something about the nature of photography as such, taking it for granted that the answer would be found in the realm of metaphysics.

The making of theoretical mountains out of factual molehills has forever been one of the privileges of high-level criticism and analysis. In hectic prose, Barthes marvels over a simple truth: from the earliest days, photography recorded family milestones, for the pleasure of the living and for the future delight of those not yet born. Figures 6-1 and 6-2 show popular types of photographic marriage certificates, with oval "press-outs" for the insertion of cartes-de-visite. The inclusion of the minister's picture in Figure 6-1 is unusual, and hints at pride in his profession as well as his confident sense of partnership with God. One of the principal makers of such certificates was the H. M. Crider Company of York, Pennsylvania, which claimed to have invented such documents in 1868. The idea quickly caught on in the northeastern United States and remained popular until the 1880s.

It is noticeable that the couples whose photographs have been inserted into these marriage certificates are not wearing anything that to modern eyes suggests wedding finery. Throughout the nineteenth century, while myrtle and orange-blossom, waterfalls of satin, and clouds of white veiling were all cherished for their symbolism and desired for their charm, they were not universally worn by brides. Such trimmings tended to add considerably to the expense of the occasion, and many had to be content with a costume less theatrical and more durable. Even when expense was no object, the bride often wore at the marriage ceremony the travel outfit in which she would set forth on her honeymoon a few hours later. So, for instance, Louise Whitfield chose a sumptuous but serviceable dress in gray and red for her wedding to the great indus-

(a)

FIG. 6-1. Mertz-Lessman Marriage Certificate. 1889. Northumberland County, Pennsylvania. Unknown photographer.

(a) Preprinted sheet, 19½ × 15½ inches, with three oval "press-outs" for insertion of cartes-de-visite. Hand-colored. The inclusion of the minister's picture in such a document is unusual. Certificate design copyrighted by the H. M. Crider Company of York, Pennsylvania, in 1882. Indeed, the firm had invented the photographic marriage certificate in 1868. The idea quickly caught on in the northeastern states, and remained popular until the late 1880s.

(b) Sample "press-out."

(b)

FIG. 6-2. Betts-Hough Marriage Certificate. 1873. Probably Pennsylvania. Unknown photographer. Pre-printed sheet, 12 × 9 inches, with inserted cartes-de-visite; hand-colored. Templates of a similar type were also produced for memorial certificates and general family histories (Fig. 4-23d).

trialist Andrew Carnegie in 1887 (McKune 1991).

The truth is that, woven through the exuberant Victorian orchestration of wedding-day traditions, there ran a sobering thread of distaste for eye-catching extravagance and ostentatious display. For those who placed particular emphasis on the solemnity of the event and the private significance of the vows, any preoccupation with fashion or appearance struck a jarring note. Everyone today, who was a schoolgirl when she first followed with absorbed attention the adventures of Jane Eyre, remembers the stab of disappointment felt at Jane's implacable resolve to be married in gray merino. Every reader of *Emma* has been led by its author, gently but firmly, to accept that it is a mark of good sense and good taste when Emma and Mr. Knightley choose to be married quietly, in the last paragraph of the novel: "The wedding was very much like other weddings, where the parties have no taste for finery or parade." Disapproval expressed by the foolish Mrs. Elton merely confirms the propriety of the choice: "Very little white satin, very few lace veils; a most pitiful business." (Austen 1816)

To these restraints photography added one of its own. It was hard for the first cameras to handle sharp contrasts between light and shade, and for some time photographers had to take pains to urge their clients to dress with particular care for the studio. In 1846, any lady sitting for a daguerreotype portrait was advised by Dr. Andrew Wynter, in the *People's Journal*, to "avoid pure white as much as possible." In the 1850s, the fashionable Mr. Mayall issued explicit instructions to all his sitters: "Ladies are informed that dark silks and satins are best . . . colours to be avoided are white, light blue and pink" (Ginsburg 1982). Cuthbert Bede, in 1855, joked that the camera, "who is rather peculiar in his notions," cannot abide either the ethereal white dress of the bride or the white surplice of the clergyman conducting the service: "Photographs of people in white dresses would appear to be the portraits of as many ghosts" (Bede 1855).

All these reasons, in any combination, ensured that the most characteristic photographic memento of marriage, that very special milestone in life, was not the formal wedding group so familiar today, but a portrait of the couple posed together in everyday dress, although doubtless each had made the best selection from the wardrobe for the occasion (Fig. 6-3).

The wedding pictures of royalty, of course, were in a class of their own, and the publicity given them must have been a spur to emulation. Such special figures were expected to be seen in special costume, and no expense or skill was spared to achieve a satisfactory image. Because both Queen Victoria and Prince Albert were interested in photography, they were quick to commission photographs of important family occasions for their private archives. Daguerreotypes were made of the Princess Royal on her wedding day, January 25, 1858, by T. R. Williams, a gifted photographer who began his career as an assistant to Claudet in London (see Fig. 6-4). Williams made pictures of the bride, her bridesmaids, and her parents, and several studies of the elaborate white dress and veil. (Dimond and Taylor 1987) Such records were not intended for publication but, once the era of the carte-de-visite and the cabinet card had arrived, it became the custom for royal wedding group pictures to be issued for sale, widely circulated, and eagerly studied. (Fig. 6-5)

Such formal portraits are today familiar elements in the celebration of marriage throughout society, and photography may fairly claim to have fathered a fashion. This is an example of a major tradition in which photographers played the part of pioneers, but in another, very minor, variation they simply followed precedent, and added a grace note to an already flourishing convention. Ever since the mid-eighteenth century, when it had become feasible to make large, substantial fruitcakes and sheathe them in white icing, the British public had been bewitched by

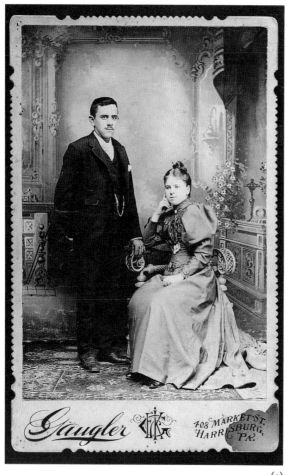

(a)

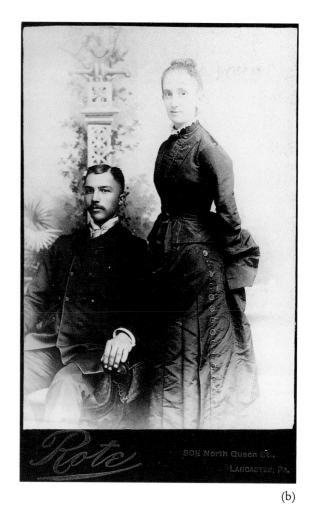

(b)

FIG. 6-3. Marriage Portraits; cabinet cards; gelatin silver prints.
 (a) Photograph by E. K. Gaugler of 408 Market Street, Harrisburg, Pennsylvania, c. 1890.
 (b) Photograph by Rote of 50½ North Queen Street, Lancaster, Pennsylvania. 1880s.

the possibilities of a new art form. Elaborately decorated cakes dominated the window displays of the most ambitious confectioners; their designs were reported in the press and illustrated in woodcuts. Such marvels were made for great occasions, for the Christmas season itself, for christenings, and for weddings. (Henisch 1984)

A gigantic specimen was created for Queen Victoria's marriage, which took place on February 10, 1840. Richard Doyle noted in his journal of that year the excitement the cake provoked: "Messrs. Gunter and Waud the confectioners have been commanded to supply her Majesty with a great beast of a plum-cake, some ten feet in circumference. . . . A portrait from life of the interesting big un [*sic*] has appeared in all the printshop windows" (Doyle 1885). Another witness has described the cake's elaborate enchantments: "It weighed three hundred pounds, was three yards in circumference, and fourteen inches in depth. On the top was a device of Britannia blessing the bride and bridegroom, who were dressed, incongruously, in the costume of ancient Rome. A host of gambolling Cupids, one of them registering the marriage in a book, and bouquets of white flowers tied with

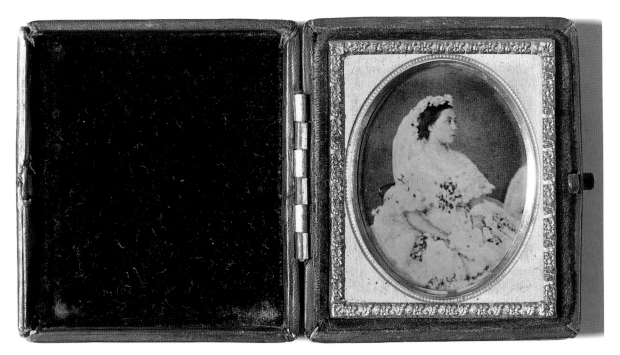

FIG. 6-4. Victoria, Princess Royal, in her wedding dress. Buckingham Palace, January 25, 1858. Daguerreotype by T. R. Williams. Royal Archives, Windsor Castle. Copyright reserved; reproduced by gracious permission of Her Majesty Queen Elizabeth II. (Dimond and Taylor 1987) Williams was also famous as a photographer of the (new) Crystal Palace, erected in Sydenham in 1854.

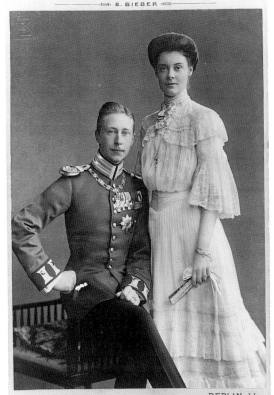

FIG. 6-5. The Crown Prince of Germany and his Bride, married June 6, 1905. Cabinet card by E. Bieber of Berlin and Hamburg. Gelatin silver print.

FIG. 6-6. The Wedding Cake of Victoria, Princess Royal, and Prince Frederick William of Prussia, January 25, 1858. Royal Archives, Windsor Castle. Copyright reserved; reproduced by gracious permission of Her Majesty Queen Elizabeth II. (Dimond and Taylor 1987)

true-lovers' knots, completed the decorations." (Hindley 1878)

Photography was still too young in 1840 to add its own contribution to the print-shop displays, but by 1858 it was ready to record the marvels achieved by the Queen's First Yeoman of the Confectionery in the icing of the bride cake for the Princess Royal. (Fig. 6-6) This was the first in a long line of photographic portraits of royal wedding cakes that stretches to the pres-

ent day. The custom was not directly imitated, but such studies, coupled with newspaper descriptions, fed an insatiable public with details about the glamour of great occasions. They played their part in the elaboration, and the standardization, of traditions, and ensured that the celebration of weddings throughout the land would come to bear a faint but recognizable resemblance to the grandeur of such state affairs.

From the turn of the century comes a commemorative photograph of a very different kind; Figure 6-7 shows a double portrait, perhaps a montage, of a couple born respectively in 1814

FIG. 6-7. Commemorative double portrait on a postcard, celebrating a 65th wedding anniversary. 1904. American. Unknown photographer. Gelatin silver print, 1⅝ × 2⅜ inches.

and 1822, married in 1839, and celebrating a trans-platinum wedding anniversary. On November 14, 1839, when they joined hands, photography was not quite ready to set its seal on the union, but by the time their sixty-fifth anniversary arrived, the camera had become the official recorder, the silent witness of every important stage in life, from birth to death.

LANDMARKS

Graduations, engagements, departures and arrivals, birthdays and name days, all were celebrated in similar fashion. Thus, the daguerreotype of Figure 6-8 was made to commemorate the graduation, on June 25, 1853, of a class at the Buffalo Female Academy, each graduate being identified by a careful annotation, prettily set out on the inside cover of the daguerreotype case. An even larger (11 × 14 inches) group daguerreotype of this kind, dating from 1851, has been described by Buckland (1980), representing what is believed to be the first genuine group daguerreotype taken at a graduation ceremony in the United States. It was made by a superb (but, alas, anonymous) practitioner at Rutger's Female Institute, at Fifth Avenue and 42nd Street, now the site of the New York Public Library. The first collective "class photograph," of the Yale class of 1810, is believed to have been made by Professor S. F. B. Morse, not, indeed, at graduation time, but on the occasion of their thirtieth reunion in 1840. Of course, a genuine group daguerreotype was not then feasible, and Morse had to be satisfied with a collection of thirty-five individual daguerreotype portraits assembled in a unifying frame (Welling 1978).

A number of photographers made a specialty out of such commemorations, notably George K. Warren of Boston, who calculated quite explicitly that a successful group portrait might lead to continued patronage by a large number of appreciative clients. The collective record, to

be sure, had to be taken while everybody was assembled in one place. A sense of occasion prevailed, and made everyone receptive to the suggestion of fixing a later appointment for that very special, personal portrait, whether in the form of a pure photograph or of an overpainting, as for instance that shown in Figure 6-9. Another prominent group photographer was George W. Pach, who operated a portrait gallery on Broadway in New York City (Fig. 6-10). Pach likewise succeeded in capturing a great share of the fashionable and profitable business of photographing graduation classes, relying on the fact that every class in the nation has a graduation sometime, and that a photographic record of the event had become just about obligatory by the 1870s. Harvard selected Pach for such a commission in 1878. Along somewhat different lines, and in humbler circles, Lewis P. Peters of East Mauch Chunk, Pennsylvania, advertised himself some years later as "The Expert Glass Paperweight Photographer and Publisher." He recorded school groups and encapsulated the results in photographic desktop souvenirs (Fig. 6-11). Other specialties offered in his advertisements were "Pastors, Churches, Pastor and Church, Pastor and Wife," all provided "Wholesale to Churches and Societies."

Figure 6-12 is an example of a more intimate memento, a painterly primitive of a family affair, made at a time when much of the business of overpainting had long passed from the hands of sensitive operators. As *quasi* folk art, such works have come to occupy an endearing place nevertheless. The painting shown in Figure 6-13 is a family souvenir of a different kind, but one that testifies eloquently to the affection in which photographs were cherished. The little girl holds a daguerreotype of two adults and a younger child, presumably her sister (Ploog and Wormhoudt 1990). The presence of the photograph in the painting is not explained, but its inclusion is easy to understand. By this device, absent figures of importance in the child's world have been drawn into the scene, and the ties that bind the

FIG. 6-8. Graduation at the Buffalo Female Academy, June 25, 1853.
 (a) Half-plate daguerreotype, by O. B. Evans, who had begun his activities in the city c. 1850.
 (b) Annotations inside the daguerreotype case.

FIG. 6-9. Violet MacClain, a young lady transfixed by academic success. Graduation portrait, 1902. Overpainting, 20 × 16 inches. American. Unknown photographer. Crayon on gelatin silver print.

View of Pach's Portrait Gallery,

FIG. 6-10. Pach's Portrait Gallery. Engraving by J. R. Asher, from an unidentified photograph, with artistic embellishments. New York City. 6 × 8¾ inches. This famous gallery specialized in cabinet cards, as well as platinum and carbon printing and, above all, photographs of graduation classes. The view shows the corner of Broadway and Thirteenth Street, opposite Wallack's Theater, looking up Broadway to Union Square. Made at the Cooper Union Engraving Department. See also Fig. 5-24c. (Jussini and Lindquist-Cock 1988)

FIG. 6-11. Class Photograph. Paperweight by Lewis P. Peters, of East Mauch Chunk, Pennsylvania. 1907. Gelatin silver print, 4 × 2½ × ¾ inches. The verso bears a preprinted label: "——— School, Taught in 190 — by ——— Teacher." The entries in handwriting are respectively "Center Intermediate," "7," and "Bruce B. D Perick."

FIG. 6-12. Parents and child. Early twentieth century. American. Unknown photographer. Overpainting, crayon on gelatin silver print, 16 × 20 inches.

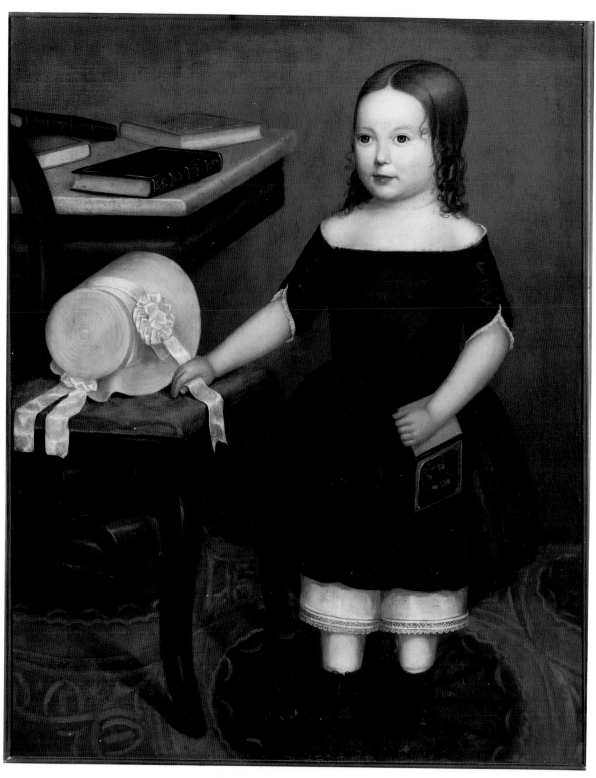

FIG. 6-13. Portrait of Anna Walraven, age four, c. 1850. American. Unknown artist. Oil on board, 35½ × 28 inches. Delaware Art Museum, Wilmington. Bequest of Ada W. Manning, 1983. (Ploog and Wormhoudt 1990)

group have been brought to the attention of the viewer. Miniature photographic portraits set in jewelry were worn for the same reason, and served the same purpose (Fig. 4-14c).

The portrait has stood proxy for the person in every age, every country, every class of society. Patrician families in Republican Rome kept images of their ancestors, to be brought out and honored on ceremonial occasions; at times, a Roman tomb sculpture shows a husband with one arm around the shoulders of his dead wife (Walters 1990). Queen Victoria and her children were photographed in mourning around the marble bust of Prince Albert (Dimond and Taylor 1987). An American ambrotype of the mid-1850s, presenting a woman seated beside a large portrait of a close relative (Fig. 2-25), can be matched by a carte-de-visite made far away in Finland, ten years later, of a mother and daughter, with a picture of the father propped up on a table beside them (Hirn 1977). Some of the most moving examples of the genre are photographs of dignified, desolate mothers displaying on their laps small images of lost children, mute testimony to much grief (Burns 1990). Daguerreotypes of this kind were sometimes set in cases designed to resemble miniature books with such titles as "In Memoriam" or "Memory's Leaflet" imprinted on the spine. (See also Chapter 5.)

'TIL DEATH DO US PART

Death, among all milestones the most certain, received an enormous amount of attention (see also Chapter 2), and its theme was treated in a variety of ways, from the simple postmortem portrait (Figs. 6-14 and 6-15) to the elaborate overpainted enlargement (Fig. 6-16), or the decorated pair of funerary urns shown in Figure 5-22, with hand-colored photographs of their occupants. Figure 6-15 is a particularly touching example because it sets, side by side, two portraits, one taken while the child was still alive, the other made after death.

The importance of such mementos is vividly illustrated by a passage in a letter written by children's author Juliana Horatia Ewing during her short stay in Canada from 1867 to 1869. At a country funeral for a baby, the mother's sorrow had been sharpened by an unfortunate circumstance: "Mrs. Hannington was so terribly grieved at having no photo or memorial of any kind of the bairn." Mrs. Ewing's impulsive kindness came to the rescue: "This gave *me* something to do, for I slipped into the room where the coffin was, and made a sketch of the poor little face in its coffin and with flowers at its feet . . . , and I sent it to her. She was very much pleased, I believe." (Blom 1983)

The first recorded photograph of a dead person appears to date from 1839, which for all present purposes is early enough: a correspondence item in *Comptes Rendus*, Paris. It refers to an "image d'une personne morte," without, of course, reproducing the actual picture (Speter 1937; Donné 1839). The letter deals with Daguerre's procedures, and the image under discussion must have been a daguerreotype.

In an overview of American social practices, Blauner (1977) comments on the conflict between society's need to push the dead away and its need to "keep the dead alive," going on to say:

> . . . the deceased cannot simply be buried as a dead body; the prospect of total exclusion from the social world would be too anxiety-laden for the living, aware of their own eventual fate. The need to keep the dead alive directs societies to construct rituals that celebrate and insure a transition to a new social status, that of spirit, a being now believed to participate in a different realm.

The postmortem photograph was, indeed is, part of just such a ritual, ideally suitable because of its lifelike appearance, and lovingly created in a great variety of ways. Deathbed paintings had always been accepted as edifying, generalized re-

(a)

FIG. 6-14. Postmortem photographs.
American. Unknown photographers.
 (a) Tinted daguerreotype of a little girl.
Late 1840s. American. Unknown photo-
grapher. Sixth-plate.
 (b) Dead child in open casket, c. 1857.
Ambrotype, ruby glass. Sixth-plate,
mounted in a clasp case.

(b)

FIG. 6-15. Pre- and postmortem photographs. Unusual double portrait of a child alive and dead. Late 1850s. American. Unknown photographer. Ambrotype, ruby glass. Sixth-plate. Photographs mounted in a union case by Holmes, Booth & Hayden, a firm active in New York City from about 1857 on. (Ruby 1984)

presentations, for the spectator, of the soul's passage from life to death, the *ars moriendi*, but photographs, with all their transparent realism, were seen as family keepsakes, records of very personal events. Meinwald (1990) has pointed this out, and has also drawn attention to the fact that Henry Peach Robinson's famous 1858 image, "Fading Away," was widely criticized precisely because it was a *tableau vivant*, and therefore artificial, an unseemly staging of a private grief.

Images conceived essentially as family commemorations may well have been therapeutic for the original viewers, particularly after the death of a child, or of an old person, who had never before been portrayed (Ruby 1984). When we look at such pictures today, we tend to approach them with attitudes excessively analytic, patronizing, or censorious, to treat them as objects of philosophical inquiry or as grist for the social

anthropologist's mill. Nineteenth-century photographers themselves faced a dichotomy of objectives, that of recording the dead in a cool, unemotional manner (e.g., Fig. 6-17), and that of making images which pretended death had never happened. This last aim was responsible for the occasional postmortem of a child holding a favorite toy or of an adult propped up in a chair as if in animated conversation (Meinwald 1990).

In an early essay on postmortem photography, Burgess (1855) chose to ignore the complexity of the sentiments at work, and gave it as his opinion that, whatever the style, such images had only one justifiable purpose: that of assisting the "painter in the delineation of the portrait." Without total consistency, he also suggested that dead infants should be photographed in the mother's lap, as though asleep; even fathers were occasionally pressed into service (Fink 1990). He further discussed the special dif-

FIG. 6-16. Overpainted postmortem of a baby. 1890s. American. Unknown photographer. Charcoal and crayon on gelatin silver print, 20 × 16 inches.

FIG. 6-17. Funeral parlor postmortem. 1890s. Pennsylvania. Unknown photographer. Gelatin silver print, 7 × 9 inches. Note photographs (probably overpainted) on the wall.

ficulties of photographing bodies that had already been placed in their coffins. (See also Rinhart 1981.) Indeed, problems and complexities lurked beyond the coffin. Bodies that could not be photographed "in time" were occasionally exhumed for the very purpose of facing the camera. Fink points out that, in the early years, court orders were not required for such procedures.

Photographers were divided in their views on the best methods of recording death, and inherent conflicts of purpose were never resolved. Some believed images that recall sleep were the most appropriate; others prided themselves on being able to make bodies appear lifelike. Thus, Broadbent & Company, of Philadelphia, advertised that it could photograph dead bodies with eyes open, a notion that may seem gruesome today, but one that evidently filled an aching need at the time (see Fig. 6-14a).

Although photographing the dead was very much a routine business by the 1870s and 1880s, photographers who actually specialized in that branch of the profession occupied a position outside the mainstream, along with embalmers and grave diggers. William Raabe, in his *Der Lar*

of 1889, describes such a (fictional) "Leichenphotograph," his outlook and his isolation. Association with death was only one of the problems; another was the concentration on photography as a trade, and the implied abdication of the photographer's role as a creative artist. A Leichenphotograph was part craftsman, part businessman, without ever gaining high prestige in either role (see Hoppe 1966). Raabe's photographer, who rejoiced in the name Bogislaus Blech, hints at one point that the photography of corpses is not the only lucrative form of fringe specialization, and that erotic photography might be a viable alternative. That line of work would call for a "well-developed, not-too-thin, not-too-ugly and, above all, not-too-prudish, wife" who had the interests of the business at heart. For the studio, such a pearl would become "an essential piece of equipment" (see also Koppen 1987).

Another fictional photographer who suffered from a lack of social standing (in spite of knowing Latin!) was Carl Sternheim's character Alfons Seidenschnur in his play *Die Kassette* of about 1910 (Schürer 1990). Prominent though he was in his profession, Seidenschnur shared with other photographers the reputation of being a failed painter and, besides, a lady killer, the type who might be expected to exploit the studio setting and its artistic pretensions for his own purposes. On one occasion, his bourgeois father-in-law was heard to proclaim that he detested the whole breed, presumably on both counts. Seidenschnur was not a Leichenphotograph, but the aura of belonging to the fringes of society, rather than the core, clung to him in the same way, and he was regarded with the same kind of suspicion.

From the earliest times, daguerreotypes (often, but not always, circular) were made for mounting on a tombstone. For such a purpose, the images needed some special protection from moisture, and indeed at least three designs for mountings were patented (in 1851 and 1859); see Rinhart 1981 and Fink 1990. Jesse Whitehurst's

Gallery of Washington advertised "Morteotype" images in the early 1850s, and claimed to hold a patent ("the art of embedding a daguerreotype likeness in tombstones, so as to make them resist the ravages of time and weather"), but no such registration has ever been traced (Krainik 1990). The protective techniques actually used were almost never totally successful, but a few examples survived *in situ* for many years. Rudisill (1971) found a comment in *Wilson's Photographic Magazine* of December 5, 1891, which testified to that fact:

> A remarkable example of the durability of the daguerreotype is to be found in the old graveyard at Waterford, Connec. In the headstone that marks the grave of a woman who died more than forty years ago, her portrait is inlaid, covered with a movable portable shield. The portrait is almost as perfect as when it was taken.

A similar note appeared in the *Indianapolis Sunday Star* of November 3, 1907, saying: ". . . the hand of love had done its work so well that the picture may be copied today by any ordinary camera."

Spira (1981) has given an overview of gravestone daguerreotype-mounting devices, a specialty of the Mausoleum Daguerreotype Company of New York. The enterprise issued a neatly printed catalog in 1855 and guaranteed that its cases would "secure the picture from air and dampness." The firm advertised widely, not only in New York, but also in the provinces. Thus, for instance, an illustrated piece with substantial text may be found in the *Daily Pittsburgh Gazette* of April 15, 1856 (Weprich 1991). Later in the nineteenth century, the World Manufacturing Company of Columbus, Ohio, offered "the Indestructible Patent Aluminum Monumental Photograph Case," made, as one might expect, of "the Wonderful New Metal." Their advertising prose struck a sanctimonious (if confused) note, by saying: "Your duty to

your beloved friends and relatives remains unfulfilled without having placed one of these beautiful cases upon their monument, so that you and your friends might often see them as they were known on earth."

Despite all such efforts, through decay and, above all, through vandalism, the number of tombstone daguerreotypes still on display in their original setting has now become very small. Indeed, Krainik (1990) believes there is only one, an image of Mary Gideon in a cemetery near Washington, D.C. A superb tombstone photograph in the form of a collodion positive on glass survives in England: the Hopkins Memorial Stone in the Parish of St. John, in Bedwardine, Worcester (Hallett 1987); see Figure 6-18. Two stone angels watch over it, and an inscription (not legible in the illustration) immediately below the photograph reads "OH DEATH WHERE IS THY STING?" The image is of a twelve-year-old boy, looking mature for his age. He was a son of T. M. Hopkins, a local hop and seed merchant, and died in 1871. While the craze for the carte-de-visite was at its height, the little pictures settled like snowflakes over every corner of life; in due course they drifted into the graveyard. At one such place in England, their arrival proved to be a mixed blessing, for they managed to divide opinion and disrupt the cash flow (Ruby 1991):

Photographic Galleries in Churchyards. The Shrewsbury Burial Board finds itself just now in a curious difficulty. It appears that a practice has grown up in the town of affixing to the tombstones in the cemetery the photographic carte-de-visite of the person buried beneath. The exhibition attracts the curious, who in their efforts to get near the illustrated tombstone, walk over the grass, to the detriment of the board's property. "By allowing the grass to grow long, and then cutting it," the Board realize as much as £20 to £30 a year, and consequently view with gravest dis-

pleasure this new manifestation of mourning. The deterioration of the graveyard hay crops is, of course, a very serious matter. But there are other considerations that make the threatened new fashion one which it is eminently desirable should be nipped in the early bud. In some minds there is probably a feeling of revolt against the desecration even of an unfamiliar graveyard by turning it into a photographic gallery through which the curious may roam on a fine Sunday afternoon. . . . The subject is one which is not to be argued on its merits, and on which hard words may not be said. But we are free to make the observation that it is the duty of a local burial board carefully to guard its sources of revenue and that the grass which, allowed to grow long and then cut, brings in from £20 to £30 a year, is worth looking after. [From *The Photographic News*, September 25, 1874.]

Of all the early kinds of photograph, the tintype proved to be the most durable on outdoor memorials. To this day, photographs are still incorporated in many tombstones in central and eastern Europe and, here and there, in the United States (Bunnen and Smith 1991). In his general survey, Ruby (1984) reports on that rarest of cases: a photographic tombstone in a Jewish cemetery. Burns (1990) has provided a rich anthology of postmortem photographs of the more picturesque kind, including images of dead children with their toys, a murdered family of five, two babies laid to rest in one casket, and a bandit in his coffin with some favorite guns, together representing almost every conceivable style and approach.

The designers of mourning and memorial keepsakes took their inspiration from cemetery sculptures, and also from familiar paintings. Thus, for instance, Mauner and Spear (1982) have described an American memorial card (Fig. 6-19a) that makes use of an image strongly reminiscent of a Thorvaldsen design (see Chapter 5),

(a)

FIG. 6-18. Hopkins Memorial Stone, Parish Church of St. John in Bedwardine, Worcester, U.K.

(a) Memorial stone with postmortem photograph in the form of a collodion on glass positive, 15.3 × 33.5 cm.

(b) Close-up of the photograph. Courtesy of Michael Hallett. See also Hallett 1987.

(b)

but actually borrowed without acknowledgment from a much reproduced painting by Wilhelm von Kaulbach (1805–74); see Figure 6-19b. The painting appears, for instance, in William C. Prine's (1865) *O Mother dear, Jerusalem,* and was distributed in the form of cartes-de-visite (Darrah 1981). It is also reproduced in *The Angels of Heaven* (Anon. 1870); see Chapter 11. Kaulbach enjoyed a wide reputation, winning important commissions in the German states, medals in Paris, and praise in England. In the present case, the card designer has carefully followed the model in most respects, but has introduced a serviceable variation. Kaulbach's moon has been displaced, and in its old position there appears a round frame, ready to receive a photograph of the person commemorated. See also Gurlitt (1900) for other Kaulbach paintings that proved to be popular in the form of photographic reproductions. The particular image

shown here in Figure 6-19a is an adaptation; in its original form it is also found on an elaborate album cover, a paper print cemented to glass, furnished with a black background and a somber black frame (Maas 1977).

In many of the above illustrations, the death reference is explicit, but more understated memorial designs also enjoyed wide popularity. It was, for instance, simple and inexpensive to mount a "pre-mortem" image on a black card (Fig. 6-20). An alternative was to present a photograph showing only a funeral wreath, with a suitable message. In Figure 5-21 a carte-de-visite portrait of a baby encircled with a wreath of hair has been set under glass, in a wooden frame. Among the myriad mementos produced at the turn of the century, there was room also for roundels of the kind shown in Figure 6-21, often with flower or gem designs traditionally linked with the subject's month of birth. Heyert (1979)

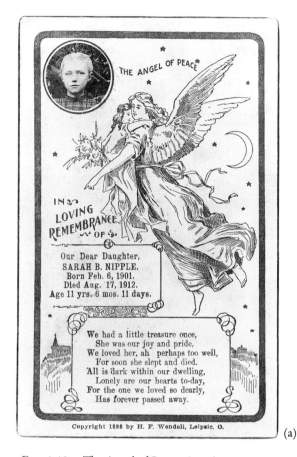

(a)

(b)

FIG. 6-19. The Angel of Peace. American.

(a) Photographic memorial card. Published 1888 by H. F. Wendell of Leipsic, Ohio. Cabinet-card size. Design borrowed from a painting by Wilhelm von Kaulbach (1805–74), a well-known German artist of the period, who specialized in large paintings on literary, historical, and biblical themes. Many were distributed and popularized in the form of photographs. Note the circular image of the dead girl, top left. 1912.

(b) Kaulbach's painting, as reproduced in Prine 1865. See also Waters and Hutton 1894, Gurlitt 1900, and Mauner and Spear 1982.

has written about photographic funeral albums that have a clock inserted in the cover, permanently "set to the death" of the loved one commemorated inside.

Because the photograph was, among other things, the Xerox machine of the nineteenth century, it proved useful for the distribution of death commemoratives consisting only of text on a card, without any image. The example shown in Figure 6-22 bears witness to the fact that the loyal employees of the M. L. Shoemaker

Company had regarded Mr. Shoemaker, recently deceased in 1895, as A TRUE FRIEND. It was a public gesture, but one addressed to a limited circle. Charles D. Mosher of Chicago, a successful studio photographer there from 1863 to 1890, had far more ambitious ideas. In 1876 he caused the Memorial Safety Vault to be built, and embedded in the wall of City Hall, with heavy metal doors. It was intended to contain photographs of "prominent men and women, with memoirs and statistics." The vault was

FIG. 6-20. Commemorative tintypes in goldstamped black cardmounts, carte-de-visite format. 1880s. American Unknown photographers.

"Deeded to the City of Chicago as an offering for the recent centennial, 1876" (Fig. 6-23; Vis-kochil 1976; McGill 1991). However, City Hall came to be scheduled for destruction in 1908, and the time-capsule had to be moved. It led an uneasy, peripatetic existence until at last it found a permanent home in 1915, in the Chicago Historical Society. In his grand proposal, Mosher had intended that the collection should be put on display once every twenty-five years, from July 4, 1876, as a "quarterly memorial reunion" of the living and the dead. Once Mosher himself had gone, the plan began to crumble, but it did not collapse. His extraordinary collection of

well over 8,000 beautifully printed portraits has been exhibited twice in the present century, in 1926 and in America's bicentennial year, 1976. Mosher's own confidence that the ritual would be repeated yet again in 2076 may well be justified. Nations, like their private citizens, take pride in special family milestones.

Mathews (1974) makes reference to an item similar in form to the Shoemaker memorial, but much more joyful in content: a carte-de-visite that shows *The Times* of London logo at the top, followed by that newspaper's column of registered births for April 2, 1890. The practice of preserving these columns as souvenirs was by

(a)

FIG. 6-21. Memorial roundels. Turn of the century. American. Unknown photographers. Tinted gelatin silver prints on metal mounts, with transparent enamel covering. 9 inches diameter.

(a) 3¾ × 2⅜ inch photograph, flower design.

(b) 4¾ × 3⅜ inch oval photograph, "Rock of Ages" design.

(b)

FIG. 6-22. Memorial cabinet card; the message on the medium. 1895. Made by Rhoads of Philadelphia, testifying to the fact that the employees of M. L. Shoemaker Company had regarded Mr. Shoemaker as a true friend, and mourned his recent passing, the sentiments being expressed as a formal resolution, with a great deal of "Whereas . . ." and "Resolved. . . ."

FIG. 6-23. Verso of a cabinet card by Charles D. Mosher, 1880s, describing the Memorial Safety Vault he had set up in 1876. Mosher called himself "The National Historical Photographer" and had a studio at 125 State Street ("take elevator"). At the Philadelphia Centennial Exhibition, he was awarded a medal for Artistic Excellence in Art Photography.

then well established (see also Starl 1979). Along more private lines, Braive (1966) offers a vignetted composition of four children, Paul, Jean, Renée, and André, announcing, on January 12, 1908, with undisguised indifference, the arrival of their new sister, Marcelle. Such cheerful records are reminders, if any were needed, that the camera was used to celebrate life as well as to mourn death, and that not every baby picture was the cause of tears; indeed, proud parents and happy offspring beam from every album (Fig. 6-24). The ease with which a photographic image could be printed on more or less any surface, including silk and cotton, made it possible for the cyanotype picture of a special little girl to smile from a special little pillow (Stieglitz 1977). A particularly elaborate example of this kind recently came to light at a sale (Sotheby 1991): a cotton quilt with a center panel (about 29 inches square), exhibiting some ninety-five photographs of family members, friends, homes, boats, picnics, and pets, each one an individual cyanotype printed on a piece of cloth and sewn together. (For other forms of family commemoratives, see Maas 1977.)

In short, family photographs were everywhere, and the point of one modern joke would have been perfectly understood a hundred years ago: "Have I shown you the latest pictures of my grandchild?" "No, you haven't, and I appreciate it." That horrid social invention, the baby picture party, had become well established by the end of the century, and its arcane delights were celebrated in the *Pittsburgh Morning Post* of March 14, 1897:

> The mother of a leader in Chicago society was asked to send the earliest photograph of her son . . . a little card of her boy at the age of 3 weeks in a wash bowl. The mortified leader of society nearly fainted when he recognized his first picture, on view for 300 of Chicago's ultras. [Harris 1897; Weprich 1991]

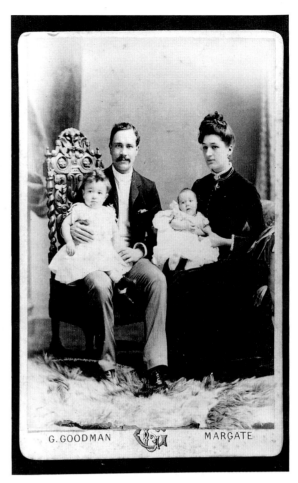

FIG. 6-24. Family group by G. Goodman of Margate, U.K. Cabinet card. 1880s.

The indignant gloom felt by any guest when confronted by such evidence of a former self, as shown for instance in Figures 2-20 b and c, is easily understood and merits compassion.

Images of private life lose much of their power once they lose their identity. It is hard to bear in mind, while flicking through a pile of faded photographs, that these forlorn, forsaken pictures once marked important moments in a family's history, and stood as milestones in its own particular progress from one generation to the next (Fig. 6-25).

FIG. 6-25. "Grandma Takes the Baby to the Photographer's." American cartoon of 1904, made for Life Publishing Company. (Farmer 1990)

Chapter 6 References and Notes

ANON. (1870). *The Angels of Heaven: Meditations on Records of Angelic Visitation and Ministry Contained in Scripture*, Seeley, Jackson & Halliday, London.

AUSTEN, J. (1816). *Emma*, chapter 55. Modern edition (1966), Penguin Books, Harmondsworth, Middlesex, U.K.

BARTHES, R. (1981). *Camera Lucida: Reflections on Photography*, Hill & Wang, New York.

BEDE, C. (1855). *Photographic Pleasures*, T. Mc'Lean, London, 1973 reprint by Amphoto, Garden City, New York, chapter 5, p. 42.

BLAUNER, R. (1977). *Passing: The Vision of Death in America*, Greenwood Press, Westport, Connecticut, p. 187.

BLOM, T. E. (1983). "Adventures of the Mind: Juliana Horatia Ewing in Canada," lecture given to the Friends of the Osborne and Lillian H. Smith Collections at Boys and Girls House, Toronto Public Library, on October 19, 1983, p. 31.

BRAIVE, M. (1966). *The Era of the Photograph*, Thames & Hudson, London, p. 326.

BUCKLAND, G. (1980). *First Photographs: People, Places and Phenomena, as Captured for the First Time by the Camera*, Macmillan Co., New York, p. 106.

BUNNEN, L., and SMITH, V. W. (1991). *Scoring in Heaven: Gravestones and Cemetery Art of the American Sunbelt States*, Aperture, New York.

BURGESS, N. G. (1855). *The Photographic and Fine Art Journal*, vol. 8, p. 80.

BURNS, S. B. (1990). *Sleeping Beauty: Memorial Photography in America*, Twelvetrees Press, Altadena, California.

DARRAH, W. C. (1981). *Cartes-de-Visite in Nineteenth Century Photography*, W. C. Darrah, Gettysburg, Pennsylvania, p. 116.

DIMOND, F., and TAYLOR, R. (1987). *Crown and*

Camera: The Royal Family and Photography 1842–1910, Penguin Books, Harmondsworth, Middlesex, U.K., pp. 19, 25.

DONNÉ, M. (1839). "Correspondance: Transformation en Planches . . . ," *Comptes Rendus*, Paris, Academy of Sciences, vol. 9, p. 485.

DOYLE, R. (1885). *A Journal Kept by Richard Doyle in the Year 1840*, Smith, Elder, London, pp. 12–13.

FARMER, B. (1990). Private communication, acknowledged with thanks.

FINK, D. (1990). "Funerary, Posthumous, Postmortem Daguerreotypes," in *The Daguerreian Annual* (ed. P. Palmquist), The Daguerreian Society, 203 West Clarence Street, Lake Charles, Louisiana, 70601.

GINSBURG, M. (1982). *Victorian Dress in Photographs*, B. T. Batsford, London, p. 17.

GREELEY, H. (1853). *Art and Industry as Represented in the Exhibition at the Crystal Palace, New York, 1853–54*, Redfield, Nassau Street, New York.

GURLITT, C. (1900). *Die deutsche Kunst des neunzehnten Jahrhunderts*, Georg Bondi, Berlin, p. 312.

HALLETT, M. (1987). "The Hopkins Memorial Stone," *History of Photography*, vol. 11, no. 2, pp. 119–22.

HARRIS, F. (1897). "New Form of Baby Show," *Pittsburgh Morning Post*, March 14, p. 27, cols. 1–2.

HENISCH, B. A. (1984). *Cakes and Characters: An English Christmas Tradition*, Prospect Books, London, pp. 140–42.

HEYERT, E. (1979). *The Glass-House Years: Victorian Portrait Photography, 1839–1870*, Allanheld & Schram / George Prior, Montclair and London, p. 46.

HINDLEY, C. (1878). *The Life and Times of James Catnach*, Reeves & Turner, London, p. 354.

HIRN, S. (1977). "Early Photography in Finland," *History of Photography*, vol. 1, no. 2, pp. 135–52, fig. 16.

HOPPE, K. (Editor) (1966). *Wilhelm Raabe, Sämtliche Werke*, Göttingen.

JUSSIM, E., and LINDQUIST-COCK, E. (1988). Personal communication, acknowledged with thanks.

KOPPEN, E. (1987). *Literatur und Photographie: über Geschichte und Thematik einer Mediendeckung*, J. B. Metzlersche, Verlagsbuchhandlung, Stuttgart.

KRAINIK, C. (1990). "The Everlasting Portrait," in *The Daguerreian Annual* (ed. P. Palmquist), The Daguerreian Society, Lake Charles, Louisiana.

MAAS, E. (1977). *Die goldenen Jahre der Photoalben, Fundgrube und Spiegel von gestern*, DuMont Buch-Verlag, Cologne, especially fig. 18.

MATHEWS, O. (1974). *The Album of Carte-de-Visite and Cabinet Photographs, 1854–1914*, Reedminster

Publications, London, p. 93.

MAUNER, G., and SPEAR, B. (1982). "The Angel of Peace," *History of Photography*, vol. 6, no. 2, p. 178.

McGILL, T. (1991). Personal communication, acknowledged with thanks.

McKUNE, A. (1991). *To Love and to Cherish: The Great American Wedding*, exhibition catalog, Margaret Melville Blackwell History Museum, Museums of Stony Brook, New York, pp. 8, 10.

MEINWALD, D. (1990). "Memento Mori," *California Museum of Photography Bulletin*, vol. 9, no. 4.

MILLER, B. (Editor) (1954). *Elizabeth Barrett to Miss Mitford*, Yale University Press, New Haven, Connecticut, p. 208.

PLOOG, R., and WORMHOUDT, K. (1990). Personal communication, acknowledged with thanks.

PRINE, W. C. (Editor) (1865). *O Mother Dear, Jerusalem: The Old Hymn, Its Origin and Genealogy*, Anson D. F. Randolf, New York, p. 68.

RINHART, F. and M. (1981). *The American Daguerreotype*, University of Georgia Press, Athens, Georgia, pp. 302, 304.

RUBY, J. (1984). "Postmortem Portraiture in America," *History of Photography*, vol. 8, no. 3, pp. 201–22.

RUBY, J. (1991). Personal communication, acknowledged with thanks.

RUDISILL, R. (1971). *Mirror Image: The Influence of the Daguerreotype on American Society*, University of New Mexico Press, Albuquerque, New Mexico, p. 217.

SCHÜRER, E. (1990). "Carl Sternheim's 'Die Kassette': Photography and Art in the 'Heroic Life of the Bourgeoisie,' " in *Shadow and Substance* (ed. K. Collins), Amorphous Institute Press, Bloomfield Hills, Michigan / University of New Mexico Press, Albuquerque, New Mexico, pp. 229–37.

SOTHEBY (1991). *Photographs*, auction catalog for sale no. 6160, April 17, 1991, item 107 (illustrated). Sotheby's, New York.

SPETER, M. (1937). In *Photographische Korrespondenz*, vol. 37, no. 3, p. 38. (The authors are indebted to Mr. W. Kollow for drawing their attention to this reference.)

SPIRA, S. F. (1981). "Graves and Graven Images," *History of Photography*, vol. 5, no. 4, pp. 325–28.

STARL, T. (1979). *Visitkarten Photographie (1860–90)*, Katalog 8, Antiquariat Timm Starl, Frankfurt-am-Main.

STIEGLITZ, M. (1977). "Historic Photographs on Cloth," *History of Photography*, vol. 1, no. 2, pp. 105–110.

VISKOCHIL, L. A. (1976). "Chicago's Bicentennial

Photographer: Charles D. Mosher," *Chicago History*, vol. 5, Summer, pp. 95–104.

WALTERS, E. (1990). Private communication, acknowledged with thanks.

WATERS, C. E. C., and HUTTON, L. (1894). *Artists of the Nineteenth Century and Their Works*, Houghton Mifflin Co., Boston and New York, 1969 reprint by Arno Press, New York, pp. 19–20.

WELLING, W. (1978). *Photography in America: The Formative Years (1839–1900)*, Crowell Co., New York, 1987 paperback reprint by University of New Mexico Press, Albuquerque, New Mexico, p. 254.

WEPRICH, T. M. (1991). Personal communication, acknowledged with thanks.

7

THE HELIOGRAPHER'S ARMS

AGE-OLD WORDS AND SYMBOLS

When it came to advertising, photography found itself from the earliest days in a peculiar state of professional isolation and helplessness. Portrait photographers, in particular, were anxious to tell the world about the new craft and about their personal skills, but photographs could not be mechanically reproduced at the time, and older graphic media—woodcuts, engravings, lithographs, and die-stampings (Fig. 7-1)—had to be relied upon to carry the message. Since these processes were not able to convey the texture and tonality of the real thing, designers of advertising matter had to stress a variety of other virtues, virtues that could be conveyed either with words, or else through figures and symbols.

When it came to prose, photographers rose to the occasion with eloquence and, just occasionally, with disarming charm. A fine example from the earliest period (c. 1845) comes from J. M. von Humnicki who, notwithstanding his aristocratic name, was actually a humble itinerant in German lands. And yet, there was nothing humble about his style. In translation:

Daguerreotype Portraits, executed by J. M. von Humnicki, according to a method known to him alone. After many experi-

ments, and after studies over several months under the principal artists in the capital, Herr Humnicki has finally been able to improve upon Mr. Daguerre's admirable invention, to a degree not previously achieved. From now on, anyone can, for a very moderate sum, have a portrait made from nature, a perfect likeness, reproducing all facial hues, something that has hitherto been very expensive, and rarely successful. The natural color of the face is reproduced with a fidelity that has been totally unknown to this day. Herr Humnicki supplies the portraits only when they meet with the complete satisfaction of the clients who have honored him with their patronage. . . . Frames extra. . . .

. . . Portraits of deceased persons: we go to the homes of clients when called upon to do so. . . . All images treated with gold chloride, which renders them permanent and distinctive. Portraits also made for rings, brooches and bracelets. . . . During the brief stay in Solothurn, we will operate in the backyard of the house belonging to Judge A. F. Glutz. [*Photo-Antiquaria Special*, November 1987, p. 100.]

Another piece of notable advertising prose of the earliest period comes from Messrs. Moore and Ward, itinerant photographers from another part of the world, who announced a forthcoming visit and stay in the *Pittsburgh Daily Gazette* of May 3, 1841:

THE DAGUERREOTYPE or PENCIL OF NATURE.

Messrs. Moore and Ward have the honor to inform the Ladies and Gentlemen of Pittsburgh, that they propose to remain at Mrs. White's Boarding House, near the corner of Liberty and Fourth streets, opposite Hay st., for a few days, where they will be prepared to take Daguerreotype likenesses in a

FIG. 7-1. Antoine Claudet. Die-stamped daguerreotype case, sixth-plate. London. Claudet had been using a "glass house" erected on the roof of the Royal Adelaide Gallery since June 1841 (Gernsheim 1969), first for demonstrations and, in due course, for professional photography. The crown is here a reference to the gallery's name. In 1853, Claudet was appointed "Photographer in Ordinary" to the Queen, and thereafter Royal insignia appear on daguerreotype cases that bear the die-stamped addresses of later Claudet studios, e.g., 18 King William Street, and 107 Regent Street, London.

superior style, which being the reflected forms of the objects themselves far surpass in fidelity of resemblance any thing which can be accomplished by the eye and hand of the artist.

Likenesses by diffused light, can be taken by them in any kind of weather, during the daytime and sitters are not by this kind of light subjected to the slightest inconvenience, or unpleasant sensations, as has often proved to be the case, in attempts by others, to obtain miniatures by the Daguerreotype.

Persons wishing to perpetuate the true resemblance of themselves or friends, have

now an opportunity of doing so, at a very moderate expense, and are respectfully invited to call and examine for themselves. [Weprich 1990]

Claims to all-weather photography were routinely made at the time, and routinely taken with more than a small pinch of salt. The text is unremarkable, but the advertisement's heading itself calls for thought and further research. "[The] Pencil of Nature" is a familiar enough title, but one that is widely believed to have been used for the first time by Fox Talbot, who would have been dismayed to see it associated with daguerreotypes, of all things. His book, *The Pencil of Nature*, was the first ever to be illustrated with tipped-in silver prints; it appeared in six paper-covered installments, beginning in June 1844 (Talbot 1844). The American use of the title thus predates it by three years. We may safely assume that Fox Talbot, for all his circumspect interest in public affairs, was not among the regular readers of the *Pittsburgh Daily Gazette*, and must conclude that the term had a much wider and earlier currency than is usually believed. It did, indeed. Schaaf (1990) has traced the expression in the first instance to William Jerdan (1782–1869), the editor of the *Literary Gazette* and a great supporter of Talbot. In the February 1839 number of the journal, Jerdan published an article on daguerreotypes entitled "French Discovery—Pencil of Nature," and Talbot must have seen it, since a letter of his own, dealing with photogenic drawing, appeared in the same issue. How Messrs. Moore and Ward came to be acquainted with it is, of course, another matter. In any event, Jerdan had not himself invented the phrase. He probably read it in a book found in every respectable library at the time, *The History of the Decline and Fall of the Roman Empire* (1776–88), where Gibbon had used it in a very different context. (See also Schaaf 1989 and Chapter 11 below.) Trachtenberg (1991) has drawn attention to an article which, appearing (in an unidentified New York publication) in

April 1839, may well represent the first American use of the phrase, certainly in the context of photography. Under the title "The Pencil of Nature," N. P. Willis discussed "the latest phantasmagoria of inventions," among which photography was notably included.

One of the most obvious uses of figurative and symbolic advertising terms involved the association of photography with painting. That link was forged by the many emblems that deftly combined the camera with the painter's palette and brushes in suggestive designs (Fig. 7-2 and Fig. 7-3 top left) and became popular worldwide. Gay's of Fall River, Massachusetts, testified to that fact by announcing boldly (Fig. 7-4) that their card mounts were imported. They were, indeed, widely used in Europe, among others by J. W. Gorsuch of Junction Road, Upper Holloway, London, in the early 1890s (Harker 1975). Many photographers of the carte-de-visite and cabinet-card periods, still uncertain of the esteem in which they were held by the public, claimed on their emblems to be "Artistic" (Fig. 7-5), unaware that this could have been grievously misinterpreted as claiming a status *close* to that of the artist, without actually reaching it. See Fig. 7-7b for a confident exception.

With pardonable lack of consistency, this association with the symbols traditionally linked to high art was much prized even by practitioners who fought for the recognition of photography as a distinctive, equivalent, and independent art. To client and studio operator alike, palette and brush, and references to awards won, conveyed the notion of personal skill and, above all, the notion of artistic respectability. Thus, for instance, in days before anyone suspected that *less* might ever become *more*, Bizioli Hermanos of Buenos Aires (c. 1875) touched every base with a logo that included a camera, a palette with brushes, a sunburst, five medals, a handshake symbol denoting faith and reliability, a *putto*, two lovebirds, and two royal crowns, together with suitable assurances ("Retratos eternos inalterables, garantiendo su duracion"), all

FIG. 7-2. Cabinet-card versos of the 1880s, with designs that symbolize the close relationship (in intent, if not always in fact) between photography and painting. Note the owl, for wisdom, on the top left.

under a banner of Fotografía y Pintura. (See Braive 1966.)

From time to time, a hovering owl did valiant and more traditional service as a symbol of wisdom (Fig. 7-2, top left). Painters had long delighted in filling the corners of their work with diminutive *putti*, each playing with the tools of his trade, the sculptor's mallet or the musician's lute. Photographers borrowed this charming convention (Figs. 7-6 and 7-7), and very soon *putti* with newly acquired skills could be seen pouring out darkroom chemicals (Fitzgibbon 1877) or, as in Figure 7-8a, showing off photo-

graphic masterpieces. (See also Figure 3-17.) An informative and affectionate study of the world of *putti* in photography by Mauner (1981) traces one of the earliest appearances to the cover of the September 1856 issue of the *Journal Amusant* (Paris). There, painterly and photographic *putti* are in competition with one another, but cooperative themes are also known. An example of those is shown in Figure 7-9, where the photographic *putto* is an accredited team player. Even so, as Mauner points out, the photographer cherub is still subordinate to the one symbolizing art. He is photographing that figure—in

J. Řezníček
Fotograf
ÚPICE.

FIG. 7-3. Carte-de-visite versos of the 1870s and 1880s. Note the internationally popular sunburst symbol. See also Fig. 7-5a. The symbol refers to the old notion of photography as "sun painting." Along with many other professionals, John Adams Whipple used it as an emblem in the 1850s, but he went a step further by having a steam-driven, revolving, and attention-getting version installed over the entrance of his Boston gallery. (Newhall 1982)

FIG. 7-4. Cabinet card by Gay's of Fall River, Massachusetts, with "imported" design on the verso.

FIG. 7-6. *Putti* at Work. Cabinet-card verso of the 1880s. American. See also Fig. 7-7.

FIG. 7-5. Cabinet-card versos with emblems used by "Artistic" photographers of Pennsylvania, c. 1890. The reference to "crayon portraits" refers to overpaintings of the kind described in Chapter 4; see also Fig. 7-6.

(a)

(b)

(c)

FIG. 7-7. Carte-de-visite versos of the 1860s and 1870s.
 (a) A. Reinhard studio, Neustadt, Germany.
 (b) John F. Nice, Williamsport, Pennsylvania.
 (c) G. A. Baker, London.

(a)

(b)

FIG. 7-8. Carte-de-visite versos; *putti* on active service.

 (a) *Putti* showing their work. 1860s–1870s. The design, here used by H. Rosenstock of Bloomsburg, Pennsylvania, was shared by many other studios.

 (b) Cherub Chain Gang. Trade emblem, undated but obviously made before cherubs were unionized and consciousness was raised about civil rights. Of two examples known, one is stamped "D. P. Morgan, Traveling Photographer, Copying and Enlarging done to order," and another "A. Lidberg, Photographer, Ishpeming, Michigan." Peter E. Palmquist Collection. The same design was also used by J. Beard & Company of 220 Wabash Avenue, Chicago, in a May 1877 advertisement that appeared in the *St. Louis Practical Photographer*.

FIG. 7-9. Detail from the title page of the *Atlas National* by V. Levasseur, Paris, 1866, published by Pelissier Editeur. Design by Eugène Duchez. (Mauner 1981)

(a)

(b)

FIG. 7-10. Photography Between Heaven and Hell.

(a) Advertisement made, or commissioned, by Gioacchino Boglioni, one of the first daguerreotypists to open a studio in Turin (Via Carlo Alberto, 13). References to Boglioni's work appeared in the Turin press between 1850 and 1852. He offered his customers not only many kinds of stereoscopes and photographs, but also copies of *La Lumière*, the weekly photographic journal published in Paris. (Becchetti 1978; Pieske 1987)

(b) Devil in the Box trade emblem on the back of a carte-de-visite issued by the Garrett Studio, 828 Arch Street, Philadelphia, in the mid-1870s. Crabtree Collection, Rare Books Room, Pattee Library, Pennsylvania State University (Stelts 1990).

other words, duplicating art, and represents a reproductive process "with, perhaps, higher ambitions."

Occasionally the playful *putto* gave way to a senior executive version of the species, as in Figure 7-10a, an advertisement by one of the first daguerreotypists in Turin. Here, the angel is active on three fronts: in the studio, in the darkroom, and in the salesroom. When the invocation of heavenly help proved insufficient, it was always possible to take a different turn (Fig. 7-10b) and appeal to lower quarters. Though *putti* deserve much of the credit for performing the day-to-day work of the photographic industry, the sad fact is that their civil rights were rarely respected. More often than not, the toilers were

exploited, sometimes in the crudest way for crudest purposes, as Figure 7-8b can testify. The particular logo in that figure comes from an advertisement by D. P. Morgan and A. Lidberg of Michigan, but several other photographers used the same motif. It failed to bring lasting fame to any of them, a heartening example of cosmic justice (Wilsher 1987).

FOREIGN APPROACHES

Inasmuch as photographers were recruited from the ranks of painters, the aura of "high art" went with them, and photographic logos served to

perpetuate this happy state. Thus, a shingle of 1852 called the studio run by Charles D. Fredricks of New York a "Temple of Art." That sentiment enjoyed worldwide popularity. With equal pride, J. Božetěch Klemens, a Slovak daguerreotypist in Prague from 1842 onward, described himself in his logo (Fig. 7-11) as an *academic* painter, such a person being presumably someone who knew not only how to paint but also why (Skopec 1978). Klemens was, indeed, one of the Prague pioneers, with a studio—a "Light-imaging Establishment," as he called it—on University premises. However, after such a promising beginning, he returned to Slovakia in 1843, and ceased to be professionally involved in photography.

To an uncommon degree, learning and academic standing were hallmarks of photographers in central Europe. Thus, the very first daguerreotypists in Bohemia-Moravia were Frederick Franz in Brno (1839), a professor of physics, and F. I. Stašek, rector of the Gymnasium in Leitmeritz (1840). In Pilsen, the leading operator was J. F. Smetana, a natural historian. In Prague, most early daguerreotypists were in fact "academic painters," such as Klemens, in the sense that they were graduates of the Academy of Painting, and proudly publicized their calling. Another prominent figure in Prague, H. Eckert (1833–1905), described himself in Latin as a photographer "CAES. REG. AULAE ET CAMERAE," that is, as Photographer to the Imperial and Royal Court, as well as a practitioner with his own studio. In the 1860s he took successful stereo pictures of the moon, and at the turn of the century he played a leading role in the photographic documentation of the Prague ghetto (Scheufler 1986; Skopec 1978).

If early photographers in Bohemia tended to come from the ranks of painters as, indeed, they did in many other countries, Bulgarian photography can boast a very different origin. It was introduced in that country by a monk, Hrissan Rashov of Kazanluk, who had graduated from a

FIG. 7-11. Advertising stickers used by Czech daguerreotypists. 1840s. (Skopec 1978)

(a) (b)

FIG. 7-12. Cabinet-card versos from Indiana and Ohio. 1870s–1880s.

(a) C. T. Dorwin of Decatur, Indiana. Note the photographer's black cloth and his darkroom equipment, including a Bunsen burner.

(b) L. E. Miller's Studio of Alliance, Ohio. Note medals with photographic designs of their own, earned in professional competitions.

theological seminary in Russia, where he had also, surprisingly, mastered photography. When he returned to his own land, he functioned not only as abbot of the Muglish Monastery but, some time from the mid-1860s onward, also as a professional photographer (Boev 1978; Kanitz c. 1877). Boev shows one of Rashov's card versos with a composite emblem that might, in terms of style, just as well have come from London, Philadelphia, or Buenos Aires. One unusual feature in the familiar jumble of cameras and palettes: the sitting muse holds a photographic sampler in a frame.

All over the world, many a photographic enterprise advertised itself as a "Rembrandt Studio" or "Rembrandt House," leaning heavily on the great master's fame, though whether Rembrandt himself would have regarded it as a compliment remains in doubt. The practice was universal, with Rembrandt studios as popular in Bulgaria (Boev 1978) and faraway Georgia (Mamasakhlisi 1978) as they were in England (Hallett 1990) and the United States. Never a "Raphael Studio," or one named after any other master, but we will charitably dismiss the notion that Rembrandt was the only painter with whose

name photographers were familiar. He was probably chosen in part because of his standing as a portraitist, and in part because Dutch painting in general was valued for its detail and its "realistic" qualities.

Beyond the wish to lean on established prestige was a certain admiration of the "Rembrandt style," loosely defined as a portrait taken with sharply angled side-lighting. Taft (1938) describes the technique used by Kurtz of Broadway in the 1870s, whereby movable light and reflecting screens served to outline the dark parts of the sitter's face against a lighter background, and the light parts against a dark background. Kurtz's portraits were called "Rembrandtish" by others, but he himself was too sophisticated an artist to characterize his work in this way. Oddly enough, the more widely educated Samuel F. B. Morse had no such hesitation. After seeing Daguerre's pictures in Paris, he described them in an 1839 letter from Paris as "Rembrandt perfected" (Rudisill 1971; Prime 1875). A few days earlier, the same term had already been used by a correspondent of *The Athenaeum* (Anon. 1839).

Universal, also, was the wish of photographers to make their past successes known. Medals abound in their logos, to an extent that suggests inflationary coinage (Figs. 7-12b and 7-13b). A photographer who described himself as "Le Chevalier Lafosse" of Manchester, England, claimed virtue on the basis of medals of a different kind: "Won with Honour" in 1870, during the Franco-Prussian War, and "Worn with Pleasure" ever after (Mathews 1974). They had no relevance to his art, but conformed to emblematic traditions, and were a source of prestige on those grounds alone.

Inside America, small-town photographers wanted to share the glamour not of great European cities but of American ones. An 1889 cabinet card bears an incongruous but potent address: "New York Photographic Art Studio, Corner of 3rd and Pine Streets, Williamsport, Pa." Because American photographic practice was widely admired, many European operators, even some without any kind of connection to the New World, capitalized on it by calling their enterprises "American Studio" or "American Art Studio" (Fig. 7-14). In one known instance (Fig. 12-14), the reference to America was actually political rather than photographic (see Chapter 12). Just occasionally, other countries were similarly honored. From Bangalore and Madras, India, comes a cabinet card with "Italian Photography" printed on the verso in English (Gilardi 1976). To add to the mystery, the company was headed by a woman, Madame L. Del Ufo, and claimed to be "Photographers by Special Appointment to His Majesty, the King of Italy." What they were doing so far away from court base still awaits an explanation. From Rio de Janeiro comes an example with the imprint "Photographia Allemã" (Ferrez and Naef 1976). Both designations were probably the nostalgic gestures of recent immigrants, or commercial appeals to compatriots in a foreign land, rather than genuine photographic tributes. On similar grounds, Schier and Leithner of Buenos Aires advertised their "Photographie de Vienne," oddly enough, in French (Gómez 1986).

European compliments to the United States were rarely reciprocated, and the general admiration for American photographic practice was very much in evidence in America itself. Henry H. Snelling set in 1849 what proved to be a popular and enduring tone when he wrote: "All the English works on the subject—particularly on the practical application of Photogenic drawing—are deficient in many minute details, which are essential to a complete understanding of the art. Many of their methods of operating are entirely different from, and much inferior to, those practiced in the United States. Their apparatus, also, cannot compare with ours for completeness, utility or simplicity" (Snelling 1849). He then goes on to say: "English pictures are far below the standard of excellence of those taken by American artists. I have seen some me-

(a) (b)

FIG. 7-13. Cabinet-card versos from Austria and Turkey.

(a) Photographic Art Institute of Victor Angerer, court photographer to the Emperor, perhaps the most prestigious commercial studio in the Austro-Hungarian empire. 1870s–1880s.

(b) Sébah and Joaillier, Constantinople. Note garland of medals, which also featured in other advertisements by the firm. 1880s–1890s. (Thomas 1990)

dium portraits for which a guinea each has been paid, and taken too, by a celebrated artist, that our poorest Daguerreotypists would be ashamed to show to a second person, much less suffer to leave their rooms." *Pace* Richard Beard, *pace* Antoine Claudet. Snelling's mentor, Edward Anthony, owner of the most important photographic supply house at the time, responded appreciatively: "The American mind needs waking up upon the subject. . . ."

In passing, Snelling held that the essentials of

photography had been discovered in 1828 by James M. Wattles of Indiana, "a mere yankee boy, surrounded by deepest forests . . . by the force of his natural genius." Such claims should never be categorically dismissed, but this particular one has not been substantiated during the century and a half since elapsed. In contrast, very plausible documentation has been provided for claims on behalf of Hercules Florence of Brazil, who was engaged in photographic experimentation in 1833. (Kossoy 1977)

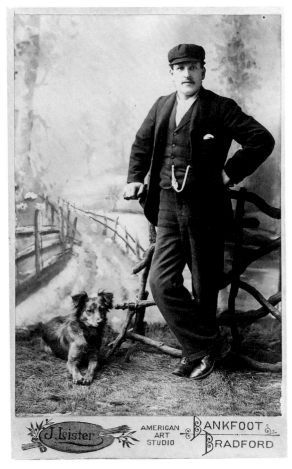

FIG. 7-14. Cabinet card by J. Lister's "American Art Studio" of Bankfoot and Bradford, England. 1870s. Recto and verso.

COSMIC PURITY AND HI-TECH

Another common theme in the practitioners' public image was that of photography as a scientific tool, the camera as an aid in the search for truth and, what is more, a search guided by the purest means available: sunlight. Niépce himself, earliest of the pioneers, had called his pictures "heliographs", that is to say sun paintings, and early photographers did indeed regard themselves as "collaborators of the sun." This idea of a happy and, one might add, profitable partnership between earthman photographer down below and heavenly body up above was to persist for several decades. At first, photographic practitioners were appropriately humble about their role in the process; later they became more confident, not to say cocksure. One of Cuthbert Bede's cartoons, made during the 1850s, shows a photographer (indeed, Daguerre himself) hand-in-hand with his cosmic partner and introducing him to John Bull (the personification of the British public) with the modest words: "My sun, Sir" (Bede 1855); see Figure 9-18b. Ten years later, even this degree of self-restraint was no longer fashionable. Thus, the verso of a carte-de-visite made in the 1860s by MacCollin of Williamsport, Pennsylvania,

FIG. 7-15. Verso of a carte-de-visite by MacCollin of Williamsport, Pennsylvania, c. 1870s. Note the "I have chained the sun to serve me" banderole.

from the fact that the photographer, dressed for reasons best known to his designer in eighteenth-century costume, has just lit his pipe. "Deeply rooted in the past" was the intended message, and those who did not consider the eighteenth century far enough away in time did not find it difficult to cast anchor 2,000 years further back. Greek costumes often link the modern art with the ancient world (Fig. 7-4) and suggest, besides, a striving for classic simplicity

FIG. 7-16. Fredrick's Pun. Advertising design used by Fredrick's Knickerbocker Family Portrait Gallery of Broadway, New York. 1860s. All the familiar elements are present: the sunburst, easel, camera, posing chair, and the palette with brushes. In addition, the great master is here depicted in eighteenth-century costume in the act of lighting himself a pipe under the motto "ET FACTA EST LUX," in more than one sense.

shows the photographer's crest and the motto "I have chained the sun to serve me" (Fig. 7-15). Chained or unchained, on its own or supplemented by a decorative Griffin, as in Figure 7-5 (top left), a sunburst was the conventional symbol of this association, widely used and widely understood. In one interesting case (Fig. 7-16), there is yet another playful double meaning, arising from the imprint ET FACTA EST LUX and

(a)

OPPOSITION THE LIFE OF BUSINESS.

(b)

(c)

FIG. 7-17. Photography in tune with the irresistible urgency of affairs in modern life. Advertising logos of the 1870s.

(a) Verso of a carte-de-visite. Patton & Dietrich's Photograph Gallery of Reading, Pennsylvania.

(b) Verso of tintype, mounted in a carte-de-visite album. Design used by Schoonmaker's of Troy, New York. (De Lellis 1990) Collection of Keith De Lellis Fine Art Photography, New York.

(c) Verso (partial) of a carte-de-visite of Hall's Studio, Lowell, Massachusetts.

and High Art, as well as a determination to place a photographic muse among her sisters on Mount Parnassus.

If the purpose of period costume was to counteract the impression of untried novelty, other details were chosen to show that the photographer was a new man, part of a new age. Of all contemporary symbols of nineteenth-century energy and progress, none was more potent than the railway; accordingly, trains can be found roaring across the back of many a carte-de-visite as symbols of a "hi-tech" society (Fig. 7-17a). Thus, for instance, the logo of a Troy, New York, photographer depicts a practitioner galloping on his camera in a neck-and-neck race with a train, determined to win the Progress Stakes, while a smiling sun looks on (Fig. 7-17b). Easily recognizable alternatives to the glamour of the railroad were the chemist's retort and his Bunsen burner (Figs. 7-12a, 7-18a),

(a)

(b)

(c)

FIG. 7-18. Cabinet-card versos of the 1870s and 1880s with "Hi-tech" designs. American.

(a) G. M. Elton of Palmyra, New York. Note chemical retort in happy partnership with a painter's palette.

(b) P. H. Rose of Providence, Rhode Island. Note the reference to the availability of an "elevator" (of the hydraulic variety, at the time).

(c) Simmons & Latier of Waterloo, Iowa. Note tramways, albeit horse-drawn, bringing clients to the photographer's studio, neatly situated between the town's principal hotel and a piano dealership.

which might also have served as reminders of the debt which photography owed to chemistry.

Photographers took care to advertise their mobility (Fig. 7-8b) and the ready accessibility of their studios by modern means of transport (Fig. 7-18c). Once there, clients found that their further comfort was not forgotten. From the very beginning, city customers had complained of the number of stairs they had to climb to reach the photographer's studio—almost always located on the top floor of a building in order to catch the light. The advertisement shown in Fig. 7-12a takes care to stress that rare amenity, a "Ground Floor Studio." Toward the end of the century, it became possible to lure customers with the promise of an elevator (Fig. 7-18b), initially one of the hydraulic type, and only later (in the twentieth century) electric. Just how important that promise was can be gleaned from an 1886 cartoon series by Wilhelm Scholz that appeared in a Stuttgart cartoon anthology: *Über Land und Meer*. In the cartoon, client Herr Nuttig is tempted by the photographer's street-level display; he decides to have his picture taken; he has second thoughts, and third thoughts, on the way up. At the top he presents himself in a state of exhaustion. The photographer has little sympathy, and tries every conceivable pose in painful succession. Eventually, the client leaves, making a solemn promise to himself: "Nie wieder!"

Another complaint familiar to all early studio photographers was related to bad weather, which nearly always meant the postponement of appointments; that particular irritation was later allayed by the promise of electric light, a promise often included in advertising emblems. The first studio photographer to use electric light was reportedly Count Sergei Levitsky (1819–98) of St. Petersburg (Anon. 1883) and Paris. He began in the late 1870s, having studied law, physics, and chemistry in his previous career, and practiced as a daguerreotypist in Rome, years earlier, in 1845 (Morozov 1977). In his own assessment: "As far as I know this new application of electric light has never been tried; it is something new, which will be accepted by photo-

graphers because of its simplicity and practicality" (Levitsky 1882). When he wrote these words, Levitsky was not aware that a fellow pioneer was busy far away in England. Henry Van der Weyde, an American portrait painter, opened a photographic studio in London at 182 Regent Street in 1877, using the proud logo "The Van der Weyde Light" (see Fig. 7-19). As it happens, this particular card shows not a private client but Richard Mansfield, a leading American actor who created a sensation on the

FIG. 7-19. "Dr. Jekyl [*sic*] and Mr. Hyde on View." Cabinet card by Van der Weyde, London. 1888. Henry Van der Weyde, an expatriate American portrait painter, was the first photographer in London to use electric light in his studio. Note logo: "The Van der Weyde Light."

London stage in 1888 by transforming himself from the virtuous Dr. Jekyll to the beastly Mr. Hyde before the very eyes of the audience. Van der Weyde commemorated the triumph in the composite studio photograph shown in Figure 7-19 (Senelick 1982). See also Chapter 8.

DOUBLE-DIPPING

In the early days, and well past the middle of the nineteenth century, photographers often combined their trade with other professions. Indeed, the tradition is associated with one of photography's most famous names:

> M. Disdéri, a well-known photographer in Paris, has been sentenced to a fortnight's imprisonment, by the Tribunal of Correctional Police for irregular bankruptcy. In the course of the proceedings, it was stated that before turning photographer, Disdéri was by turns a comedian, a dealer in ready-made lady's linen, a manufacturer of nightcaps, and director of a diorama, and that in all these capacities he contracted debts which he left unpaid. [*The San Francisco Morning Globe*, August 19, 1856; Palmquist 1979a]

Disdéri's versatility, impressive as it is, did not quite match that of two less eminent operators, Wothly and Szacinski. Jacob Wothly, who was later to invent the uranium-based Wothly-type, began his photographic career in Aachen while otherwise engaged as Assistant Bear-Keeper in the zoo (Eder 1945). Szacinski, a Pole from Lithuania, was fortunate enough to capture the attention of King Carolus V of Sweden while photographing him. His Majesty was charmed, and promptly engaged Szacinski in the royal service—not indeed as Photographer to the Court but in a much more prestigious capacity, as Trainer of the Royal Hounds (Garztecki 1977). However, of all the secondary occupa-

tions chosen by photographers, the most popular was probably dentistry. Indeed, it is worth recalling that some of America's earliest photographic pioneers were dentists—for example, Alexander S. Wolcott, the designer (in 1840) of the famous lens-less Walcott mirror camera, and Dr. Samuel Bemis who, on April 19, 1840, took an unbeautiful but historic 6½-by-8½-inch daguerreotype of the King's Chapel Burying Ground in Boston. Glenner et al. (1990) have provided a comprehensive and engaging overview of such "photo-dental cross-currents."

Wolcott and Bemis did not actually do photographic work in the course of their dental practice, but many other dentists did (Fig. 7-20), exploiting the photographic temptations presented by a terrified and submissive patient already firmly lodged in a constricting chair. From time to time, indeed, dentists shared with photographers the status of itinerant traders, traveling from village to village in a wagon-coach that served as living quarters and professional premises, as well as transport. Photographer and dentist might be the same person, or else two collaborating specialists in their respective fields. "Have entered into co-partnership for the purpose of carrying on the business of DENTISTRY AND PHOTOGRAPHY, and am now prepared to perform any operation pertaining to either branch of . . . the business, in a style superior to any yet done north of Sacramento," proclaimed Willis and Hamilton of Yreka in 1859 (Palmquist 1979b; Anon. 1859). In passing, the partners also mention "Office hours from 9 o'clock in the morning to 9 o'clock next morning," a demanding schedule. In contrast, a solitary operator, Dr. N. M. Wright of Pittsburgh, proclaimed himself proudly as "Dentist and Professor of the Daguerreotype," suggesting unmistakably which side of his profession was held in higher academic esteem (Harris 1841; Weprich 1990).

John Hall, in tooth and rhyme a kindred soul from Scarborough, England, advertised in 1858:

> He won't detain you—just begin it—
> And all is over in a minute!

(a)

Dr. W. J. Guild,
Dentist and Photo Artist,
Pine Street,
ROLLA, MO.

Having practiced dentistry twenty-four years,
I never make a mis-fit. Hence offer a full
Set of Teeth at the extreme low
price of $10.00 and
warranted for
5 years.

M. S. ELDRIDGE,

A beautiful set of Teeth put up in first class style, with Gums, and warranted, from $70 to $75.

37 Dorrance Street,
PROV., R. I.

Chloroform, Ether, or Laughing Gas given when required.

(b)

FIG. 7-20. Photo-dentistry. Cartes-de-visite. American. To dentists, already furnished with a solid chair and used to keeping their clients in terrified submission, the advent of photography provided irresistible temptations for "double dipping."

(a) A Missouri advertisement (c. 1860s) for a two-pronged practice, promising fine work in the realm of dentistry, but leaving the quality of the photographs wide open.

(b) A dentist's advertisement (from Providence, Rhode Island, c. 1870s) of the more single-minded kind, conveying its message in carte-de-visite style, embossed with an eye-catching photograph as focal point. (Wilsher and Spear 1986)

Then let me you invite to call,
And get your portrait from John Hall.
John Hall's great fame all Scarboro' fills,
Proprietor of Toothache Pills.
[Heathcote 1989]

As early as 1865, dentists with serious operations in mind were advised to take photographs before and after the treatment, in order to make sure the patient looked more or less the same once the ordeal was over. McQuillan (1865), the writer of an article on "Photography and Den-

tistry," was impressed by the ingenuity of this procedure and ends his comments with: "Oh Photography, where will thy uses and applications end?"

Though dentists were superbly equipped for "double-dipping" as owners of an intimidating chair, they were not the only professionals to yield to the temptation. In Dallas, Texas, Alfred Freeman, "Miniature and Portrait Painter," used a logo that claimed "excellence, politeness and the aim to please" and then went on to offer, inter alia, a fine selection of organs (from $250),

"Music and Price Lists furnished free." In Cape Town, South Africa, Monsieur F. Gayrel opened an establishment in September 1852 in which he offered to teach people fencing *and* to take their likenesses, cautiously omitting to say whether he intended to do so before or after any possible disfigurement:

> SCHOOL OF ARMS. Monsieur F. Gayrel, Professor of Fencing, lately arrived in this Colony, intends opening a School of Arms, where he will teach the use of the Sword, in the most modern style, by which it is rendered much more formidable than the lance, or any weapon of this class. This will be taught thoroughly in thirty lessons.
>
> He will also give instruction in *gun and pistol firing* to be acquired with great perfection in eight lessons.
>
> Monsr. G. has also to announce that he takes Likenesses with the Daguerreotype, at very *moderate prices*, and with great faithfulness.
>
> No. 5, Zieke Street. Lessons will be given at the Dwellings of those who may prefer it. [Bull and Denfield 1970]

An even more esoteric combination of professional interests is on record in California, where Julia Shannon was active in San Francisco from 1850 to 1852, as a daguerreotypist and midwife (Palmquist 1990). She had a certain flair for advertising in which, however, she addressed herself (without pedantic insistence on grammar) to only half of her potential clientele:

> Notice—Daguerreotypes taken by a Lady. —Those wishing to have a good likeness are informed that they can have them taken in a very superior manner, and by a real lady too, in Clay street, opposite the St. Francis Hotel, at a very moderate charge. Give her a call, gents. [Anon. 1850]

The diversity of photographers' second professions is well illustrated by items in the renowned Darrah Collection, which features (We-

prich 1990) not only dentists, but also dealers in musical instruments, books, and sewing machines, not to mention ten physicians, five jewelers, three watchmakers, two druggists, one grocer, a musician, a printer, an insurance agent, a taxidermist, an egg dealer, an artificial flytier, and, to no one's surprise, sixteen portrait painters (see Fig. 7-21). Mathews (1974) mentions an "animal painter," and Starl (1979) a bookseller and stationer. In 1867, an article on the professional photography of children was contributed to *The Philadelphia Photographer* by the Rev. A. A. E. Taylor, whose pastoral duties did not prevent him from also running a prosperous studio (Taylor 1867). Photographer W. G. Staford of Wilkes-Barre, Pennsylvania, advertised "Groceries and General Merchandise" as a sideline. In 1851, W. & W. H. Lewis of 142 Chatham Street, New York ("Do not mistake the Sign of the Silver Eagle"), managed to combine a Daguerrian [*sic*] Gallery ("unsurpassed by any other in the city") with the specialized business of marketing "Straw Hat Pressing Machines" (Mann 1990). The Sign of the Silver Eagle actually belonged to Smith & Risley's Boot and Shoe Store, but it formed a convenient focal point nevertheless; the Lewis studio was located on the floor above that business.

There is no evidence that any of these hopeful entrepreneurs remained in the photographic field for any length of time. Already in 1851, when he wrote *The House of the Seven Gables*, Nathaniel Hawthorne had noticed how easily people slipped in and out of the photographic business, as the craze mushroomed in America. Holgrave, his hero, is a serious daguerreotypist throughout the novel, but he is a young man who has tried many careers before the story begins:

> Though now but 22 years old, Holgrave had already been, first a country schoolmaster, a salesman in a country store . . . political editor of a country newspaper. . . . In an episodical way he had studied and practiced dentistry. . . . His present phase, as a daguerreotypist, was of no more im-

(a)

(b)

(c)

(d)

FIG. 7-21. Photographic Double-Dippers. Carte-de-visite versos of the 1870s. Pattee Library, Pennsylvania State University. (Weprich 1990)
 (a) Insurance agent, Hoosick Falls, New York.
 (b) Watch and jewelry repairer, Atkins, Arkansas.
 (c) Taxidermist, Medina, New York.
 (d) Sewing machine and piano salesman, Auburn, New York.

portance in his own view, nor likely to be more permanent, than any of his preceding ones. It had been taken up with the careless alacrity of an adventurer who had his bread to earn. It would be thrown aside as carelessly. . . . [Hawthorne 1851]

The practice of "double-dipping," though not unknown in Europe, appears to have been more common in the United States, where professional demarcation lines have always been less rigid. It continues to this day, not so much among professional photographers as, to a notable extent, among photo-historians.

PLAYING THE PUBLIC

Most of the sentiments expressed in photographic logos were general and international, but at times a personal and idiosyncratic note is struck. Such an oblique reference was used by Henry W. Taunt, who had made his reputation in the late 1860s with landscape photographs of the Thames Valley (Read 1989). The river had always been affectionately referred to as "Old Father Thames," and Taunt, in one of his emblems, made a joking allusion to his own success, showing himself in the act of catching the likeness of the fresh-water Poseidon (Fig. 7-22).

A California photographer, John Pitcher Spooner (1845–1917), never passed up an opportunity to use his name in a double entendre. His trade cards (Fig. 7-23a) featured a symbolic wrought-iron "J," a water pitcher, and a large spoon, with the letters "er" close by in rebus fashion (Palmquist 1980a). A similar playful reference to a photographer's name determines the design of Fig. 7-23c. Fig. 7-24 shows another "photo-rebus," a broadside of the early 1870s, as yet undeciphered (Spira 1985). Among other known photo-cryptograms is one used by Van Deusen's Excelsior Gallery of Indianapolis,

Father Thames sitting to Henry W. Taunt for his Photograph.

FIG. 7-22. Art of the Oblique Reference. "Old Father Thames" advertising emblem, used by Henry W. Taunt in his book *A New Map of the River Thames*, Henry Taunt, Oxford, first edition 1872. (Read 1989)

(a)

(b)

(c)

FIG. 7-23. Pun and Spoonerism.

(a) Photographer John Pitcher Spooner (1845–1917) used two of his names for pictorial puns. According to Palmquist (1980a), he was a native of Rochester, Massachusetts, who went to sea on the whaler *Rainbow* at the age of fourteen. Five years later he arrived in San Francisco, where he was employed by the well-established photography firm of Bradley & Rulofson (see also Fig. 7-25). In 1867, he opened his own studio in Stockton, California, where he remained active until shortly after 1900.

(b) Spooner's Portrait. 7 × 5 inches. Peter E. Palmquist Collection.

(c) Carte-de-visite verso of the 1880s, with a pictorial reference to the photographer's name: B. Frank Saylor. Lancaster, Pennsylvania. Note the offer of overpainted enlargements; see Chapter 4.

FIG. 7-24. Photo-rebus. Advertising broadside of the early 1870s in rebus form, not yet convincingly deciphered. S. F. Spira Collection.

FIG. 7-25. Bradley & Rulofson's Funny Money, recto and verso. Coupon redeemable for one dollar's worth of photographic services. Issued by the well-known San Francisco firm in 1874. 8 × 17.5 cm. Peter E. Palmquist Collection.

Indiana (Palmquist 1982). In that case, the meaning is perfectly clear—for wedding photographs, Van Deusen is supreme. "Learn our prices" is his message or, rendered in reboid, "L urn" [Learn] "60 minutes" [our] "p rice es" [prices].

However, such individual symbols are rare. By and large, photographers all over the world preferred to choose from a common stock of emblems that, limited and banal as they may be, still have the power to reveal something of the anxious aspirations of the new art to eyes prepared to read them. The universality of the symbols and designs used in a great variety of countries is, indeed, one of their interesting features.

From the first, photographers hoped to woo their customers with words as well as emblems. The style chosen ranged from the concise and classical, "sol fecit," to the verbose and jocular: "Why is York, the Photographic Artist, like the celebrated Robespierre of the French Revolution? —Because he feels a pleasure in taking off people's heads." (Bruce 1973; Bull and Denfield 1970) On just a few occasions, the ever-potent lure of mammon was enlisted, with photo-

graphers giving away pseudo-money as a tried-and-true attention-getter. Figure 7-25 shows examples used in 1874 by Bradley and Rulofson (Palmquist 1980b). Note the imprints "Redeemable at par in payment for photographs of bearer," and "The only elevator connected with photography in the world," as well as the reference to a gold medal award, and the logo with camera and retort, which is, for all the partnership's claims to exclusivity, identical with that used by G. M. Elton of Palmyra, New York (Fig. 7-18a). Among the many other studios that made use of the same idea was Fitzgibbon's Daguerrean Gallery of St. Louis, Missouri (1 dollar), Gurney's of New York (100 dollars), and Chase's Daguerrian [sic] Gallery of Boston (257 dollars, 257 being also the house number of the studio in Washington Street); see Rodgers 1988.

SECURING THE SHADOW

Of all the mottoes begged and borrowed from the past, or newly minted for the present, by far

the most haunting was "Secure the Shadow Ere the Substance Fade." The graceful imperative was soon in circulation. In May 1849, T. S. Arthur wrote an essay on the American daguerreotypist in *Godey's Lady's Book* and noted: "There is scarcely a county in any state that has not one or more of these industrious individuals busy at work in catching 'the shadow' ere the 'substance fade.'" (Rudisill 1971) By mid-century, the words were doing trojan service in studio advertisements throughout the English-speaking world, from Ione City, California, to Sydney, Australia; from Cape Town, South Africa, to Hereford in England. (Palmquist 1990; Davies and Stanbury 1985; Bull and Denfield 1970; Heathcote 1990)

The origin of the motto is an intriguing mystery. John Paul of Cape Town, in 1854, confidently attributed it to Shakespeare (Bull and Denfield 1970), but the confidence, however convincing to his clients, was misplaced. Although Shakespeare, like many another Elizabethan poet, could make substance and shadow chime together in a score of striking phrases, he never coined this particular combination. The two had been flitting together through the language for centuries, and the man responsible for their pairing was a master whose work had entered the public domain long before Shakespeare was born.

Aesop, in his fable *The Dog and His Shadow*, told of a dog running home with his prize, a stolen joint of meat. Crossing a bridge, the triumphant villain caught sight of his reflection in the stream below. There, tantalizingly at hand, was the mirror image of his trophy. The temptation was too much. He bent down to seize the second joint and, in the process, lost the first. As John Ogilby put it in his 1668 version of the tale:

> Too rash he bites: down to the deepest
> Stream
> The Shadow and the Substance, like a
> Dream
> Vanished together.
>
> [Ogilby 1668]

Aesop's legacy was the inheritance of childhood. His fables were used as a beginner's Latin textbook, and were published in innumerable English versions, from Caxton's in 1483 right on into the nineteenth century. They had their place on the bookshelf of every well-regulated nursery; in 1709, in *The Tatler*, a little boy was described as "a very great historian in Aesop's fables" (Muir 1954). Their popularity was just as great across the Channel. Between 1666 and 1674, a labyrinth was built in the gardens of Versailles, punctuated with fountain-statues of Aesop and his characters (Berger 1985). Artists from William Blake to Thomas Bewick loved to illustrate the stories, the characters were regarded as familiar friends, and the pithy comments on human frailty became common stock. "Catch not at the shadow, and lose the substance" found a place in *Bohn's Handbook of Proverbs* (1855).

The saying was so well-known that it was possible to play with it, to turn it this way and that, and give a new twist to the old words. In the literary realm, Jane Austen tried her hand at the game in chapter 22 of *Emma* (1816), when she remarked, "He had caught both substance and shadow." It is likely that the photographers' slogan was just such an ingenious reversal of the fable's theme, eye-catching because it was a witty variation on a universal commonplace. Its popularity in the photographic world is understandable, because there it is not merely funny but also fitting. "Shade" and "shadow" had long been terms for images of every kind, and were peculiarly appropriate for the mysterious black-and-white world conjured up by the camera. Photographers were quick to make the connection. Already by 1841, the L. P. Hayden studio in New York declared in its advertisement: "The Daguerreotype art is nothing more or less than the power of rendering shadow tangible" (Rudisill 1971). John Whipple of Boston, famous above all for his 1851 daguerreotype of the moon, exhorted potential clients in the 1850 *Cambridge Directory*: "Secure the Shadow while the Substance is in Life" (Fink 1990). In

the same city, Noah North, daguerreotypist, had already used the slogan in its original form in a newspaper advertisement some years earlier, adding, to leave no room for doubt or ambiguity, "Now is the time, while life, health and opportunity offers [sic]."

"Substance" and "shadow" were a natural photographic pair, so hard to separate that the mention of one almost invariably triggered some allusion to the other. The possibilities were endless. An English carte-de-visite portrait bears on its back this playful message: "Please accept my shadow as a grateful acknowledgement for your substantial and very liberal present for my 14 years service as secretary to the Nottingham Caledonian Society. Wm. Johnstone." (Linkman 1990)

"Secure the Shadow," in emblems and advertisements, became the stock-in-trade slogan for many photographers, and at least one non-photographer gave a new turn to the well-worn words, to make them into a personal motto. Sojourner Truth, a remarkable black woman who lectured in America during the 1860s, financed her work and travels partly by the sale of photographic pictures of herself, each one issued with this printed caption: "I sell the Shadow to support the Substance" (Collins 1983).

Studied with a literal eye, photographic advertisements present a baffling portrait of modern business enterprise. Staffed almost entirely by *putti*, with senior operators dressed in anything but contemporary costume, the premises are cluttered with the cast-off equipment of other professions, rattled by railroad traffic thundering past outside, flooded with light from a remorseless sun. Medals for unspecified achievements drop from the sky or roll along the floor, owls doze on cameras, lethal chemicals are in the hands of hypo-active cherubs. All is confusion, and everything points to commercial catastrophe. Studied through properly corrected, allegorical lenses, the scene looks much more hopeful. Every feature embodies aspiration and promises achievement. Every symbol links the new art with the glories of the past and sets it in the vanguard of progress, society's pathfinder to the triumphs of the future.

Chapter 7 References and Notes

ANON. (1839). *The Athenaeum*, London, no. 587, January 26, pp. 11–12.

ANON. (1850). *San Francisco Alta*, January 29, p. 2.

ANON. (1859). *Yreka Weekly Union*, July 2, p. 4.

ANON. (1883). *Nature*, January 18, p. 276.

BECCHETTI, P. (1978). *Fotografi e Fotografia in Italia, 1839–1880*, Edizione Quasar, Rome, p. 115.

BEDE, C. (Rev. E. Bradley) (1855). *Photographic Pleasures, Popularly Portrayed with Pen and Pencil*, T. Mc'Lean, London, 1973 reprint by Amphoto, Garden City, New York, pp. 18–19.

BERGER, R. (1985). *In the Garden of the Sun King*, Dumbarton Oaks Research Library and Collection, Washington, D.C., p. 30.

BOEV, P. (1978). "Early Photography in Bulgaria," *History of Photography*, vol. 2, no. 2, pp. 155–72, fig. 12.

BRAIVE, M. F. (1966). *The Era of the Photograph*, Thames & Hudson, London, p. 117.

BRUCE, D. (1973). *Sun Pictures: The Hill-Adamson Calotypes*, Studio Vista, Cassell & Collier-Macmillan & Co., London, p. 13.

BULL, M., and DENFIELD, J. (1970). *Secure the Shadow*, Terence McNally, Cape Town, South Africa, pp. 53, 118, 120.

COLLINS, K. (1983). "Shadow and Substance: Sojourner Truth," *History of Photography*, vol. 7, no. 3, pp. 183–205.

DAVIES, A., and STANBURY, P. (1985). *The Mechanical Eye in Australia*, Oxford University Press, Melbourne, Australia, p. 125.

DE LELLIS, K. (1990). Personal communication, acknowledged with thanks.

EDER, J. M. (1945). *History of Photography*, (trans. E. Epstean), Columbia University Press, New York, 1978 reprint by Dover Publications, New York, p. 392. Both volumes based on the author's original *Geschichte der Photographie* (1905).

FERREZ, G., and NAEF, W. J. (1976). *Pioneer Photographers of Brazil*, Center for Inter-American Relations, Washington, D.C., p. 19.

FINK, D. (1990). "Funerary, Posthumous, Postmortem

Daguerreotypes," in *The Daguerreian Annual* (ed. P. Palmquist), The Daguerreian Society, Lake Charles, Louisiana.

FITZGIBBON, J. H. (Editor) (1877). *The St. Louis Practical Photographer, an Illustrated Monthly Journal Devoted to the Elevation and Improvement of the Photographic Art*, January issue, front cover. (Under the banner of "Westward the Star of Empire Takes Its Way," one *putto* photographs the rising [setting?] sun, while his partner attends to bottles and retorts.)

GARZTECKI, J. (1977). "Early Photography in Poland," *History of Photography*, vol. 1, no. 1, pp. 39–62.

GERNSHEIM, H. and A. (1969). *The History of Photography*, McGraw-Hill, New York, pp. 138–39.

GILARDI, A. (1976). *Storia Sociale della Fotografia*, Feltrinelli, Milan, p. 267.

GLENNER, R., DAVIS, A. B., and BURNS, S. B. (1990). *The American Dentist: A Pictorial History with a Presentation of Early Dental Photography in America*, Pictorial Histories Publishing Co., Missoula, Montana.

GÓMEZ, J. (1986). *La Fotografía en la Argentina, 1840–1899*, Abadía Editora, Témperley, Argentina, pp. 170, 178.

HALLETT, M. (1990). "Victorian and Edwardian Photographers in Herefordshire," *Royal Photographic Society Historical Group Supplement*, no. 91, Winter, p. 5. (The author lists a "Rembrandt Studio" run by George Henry Finch of Gloucester Road, Ross, Herefordshire, c. 1890–1900.)

HARKER, M. F. (1975). *Victorian and Edwardian Photographs*, Charles Letts Books, London, p. 25.

HARRIS, I. (1841). *Harris' General Business Directory of the Cities of Pittsburgh and Allegheny*, A. A. Andersen, Pittsburgh, p. 56.

HAWTHORNE, N. (1851). *The House of the Seven Gables*. Modern reprint by Holt, Rinehart & Winston, New York, 1967, chap. 12, p. 153.

HEATHCOTE, B. V. and P. F. (1990). Private communication, acknowledged with thanks.

HEATHCOTE, P. F. and B. V. (1989). "A Life-like Portrait," *History of Photography*, vol. 13, no. 2, p. 188.

KANITZ, F. (c. 1877). *Donau, Bulgarien und Balkan*, Leipzig.

KOSSOY, B. (1977). *Hercules Florence, 1833: A descoberta isolada da Fotografia no Brasil*, Faculdade de Comunicação Social Anhembi, São Paulo, Brazil.

LEVITSKY, S. L. (1882). *Fotograf*, no. 3, St. Petersburg, Russia.

LINKMAN, A. (1990). Private communication, acknowledged with thanks. (A copy negative of the card is in the Documentary Photography Archive, Manchester, England.)

MAMASAKHLISI, A. V. (1978). "Early Photography in Georgia," *History of Photography*, vol. 2, no. 1, pp. 75–84.

MANN, C. (1990). "Daguerreotypes and Straw Hats," *History of Photography*, vol. 14, no. 1, p. 86.

MATHEWS, O. (1974). *The Album of Carte-de-Visite and Cabinet Portrait Photographs, 1854–1914*, Reedminster Publications, London, pp. 48, 95.

MAUNER, G. (1981). "The Putto with the Camera: Photography as a Fine Art," *History of Photography*, vol. 5, no. 3, pp. 185–98.

McQUILLAN, J. H. (1865). *The Philadelphia Photographer*, vol. 2, p. 57.

MOROZOV, S. A. (1977). "Early Photography in Russia," *History of Photography*, vol. 1, no. 4, pp. 327–47.

MUIR, P. (1954). *English Children's Books, 1600–1900*, Batsford, London, p. 23.

NEWHALL, B. (1982). *The History of Photography*, New York Museum of Modern Art / Little, Brown & Co., Boston, p. 33.

OGILBY, J. (1668). *The Fables of Aesop Paraphras'd in Verse*. Modern reprint, 1965 (ed. Earl Miner), William Andrews Clark Library, University of California, Los Angeles, pp. 3–4.

PALMQUIST, P. E. (1979a) "Disdéri Vignette," *History of Photography*, vol. 3, no. 4, p. 329.

PALMQUIST, P. E. (1979b). "Gold and Silver," *History of Photography*, vol. 3, no. 2, p. 180.

PALMQUIST, P. E. (1980a). "Spoonerism," *History of Photography*, vol. 4, no. 1, p. 38

PALMQUIST, P. E. (1980b). "Bradley and Rulofson's Funny Money," *History of Photography*, vol. 4, no. 1, p. 72.

PALMQUIST, P. E. (1982). "Van Deusen's Photo-cryptogram," *History of Photography*, vol. 6, no. 2, pp. 117–18.

PALMQUIST, P. E. (1990). *Shadow Catchers: A Directory of Women in California Photography Before 1901*, Palmquist, Arcata, California, pp. 196, 239.

PIESKE, C. (1987). Personal communication, acknowledged with thanks.

PRIME, S. I. (1875). *The Life of Samuel F. B. Morse*, D. Appleton & Co., New York, p. 401.

READ, S. (Editor) (1989). *The Thames of Henry Taunt*, Alan Sutton, Gloucester, U.K.

RODGERS, W. (1988). *Photo-Antiquaria*, no. 2, p. 21.

RUDISILL, R. (1971). *Mirror Image*, University of New Mexico Press, Albuquerque, New Mexico, pp. 45, 199, 223.

SCHAAF, L. (1989). *W. H. Fox Talbot's "The Pencil of*

Nature" Anniversary Facsimile, Hans P. Kraus Jr., New York, p. 10.

SCHAAF, L. (1990). Personal communication, acknowledged with thanks.

SCHEUFLER, P. (1986). *Praha, 1848–1914: Essays on the History of Photography*, Panorama, Prague, Czechoslovakia, p. 276.

SENELICK, L. (1982). "Double Trouble," correspondence in *History of Photography*, vol. 6, no. 4, p. 370.

SKOPEC, R. (1978). "Early Photography in Bohemia, Moravia, and Slovakia," *History of Photography*, vol. 2, no. 2, pp. 141–53, fig. 5.

SNELLING, H. H. (1849). *The History and Practice of the Art of Photography*, G. P. Putnam, New York. Facsimile reprint 1970 by Morgan & Morgan, Hastings-on-Hudson, New York, pp. 6, 9–10.

SPIRA, S. F. (1985). "Photorebus," *History of Photography*, vol. 9, no. 2, frontispiece.

STARL, T. (1979). *Visitkarten-Fotografie, 1860–1900*, Katalog 8, Antiquariat Timm Starl, Frankfurt-am-Main.

STELTS, S. (1990). Personal communication, acknowl-edged with thanks.

TAFT, R. (1938). *Photography and the American Scene*, Macmillan Co., New York. 1964 reprint by Dover Publications, New York, p. 336.

TALBOT, W. H. F. (1844). *The Pencil of Nature*, Longman, Brown, Green & Longmans, London. Near-facsimile reprint 1969 by DaCapo Press, New York.

TAYLOR, Rev. A. A. E. (1867). "Taking Baby," *The Philadelphia Photographer*, vol. 2, p. 41.

THOMAS, R. (1990). "Sébah and Joaillier," *History of Photography*, vol. 14, no. 1, pp. 87–88.

TRACHTENBERG, A. (1991). "Photography, the Emergence of a Keyword," *Photographs in Nineteenth-Century America*, Amon Carter Museum, Fort Worth, Texas / Harry N. Abrams, New York, p. 27.

WEPRICH, T. M. (1990). Personal communication, acknowledged with thanks.

WILSHER, A. (1987). "Cherub Chain-Gang," *History of Photography*, vol. 11, no. 3, frontispiece.

WILSHER, A., and SPEAR, B. (1986). "Photo-Dentistry," *History of Photography*, vol. 12, no. 1, p. 36.

8

ADVERTISING AND PUBLICITY

CATCHING THE EYE

Inside and outside the studio, the business of business has always been to catch a customer, and skills for trapping the quarry have been honed for centuries. Trade emblems have long served as shop signs, and in many streets throughout the world one can still be charmed at every step by a bold black boot of wrought iron, or a giant pair of golden scissors glinting overhead in the sun. Deep in the shadows of some country store, a model camera made for just this purpose can occasionally be found, its once-bright gilding cracked by time and dulled

with dust. However, photographers on the whole preferred to pin their faith not on a single, emblematic device, but on an ever-changing display of tempting wares, thereby following the lead of the traditional, established print-shops.

For a hundred years before the arrival of photography, the print-shop had been regarded by the public as a cave of enchantment, a magical peep-show. Its place was at the center of the art world, and there hovered in the air about it something of the fizz and glamour, the malice and the fun, of the social season and the fashion show. Until the second half of the nineteenth century, there were remarkably few public art

FIG. 8-1. Professional Display. 1857. American. Ten quarter-plate daguerreotype portraits in one original gilded frame. Each is dated on the back and inscribed with the client's name. Frame 12 × 20½ inches.

galleries, and print-shops filled some of their functions. Rival artists jockeyed for the best position on the walls, and work in progress was first unveiled to favored friends in quiet corners. People of note made it their business to visit such establishments on a jaunt through town, to jostle with the crowds, and catch a glimpse of the latest attractions. At the end of the eighteenth century, Rudolph Ackerman, indeed, advertised his showroom in London as "the best morning's lounge." (George 1959) There was something for everyone—a window display for the curious spectator, and a well-stocked showroom for the committed enthusiast.

Photographers used the same two-pronged approach. One of the very first daguerreotypes ever made in America went on show at Chilton's on Broadway at the end of September 1839 (Taft 1938), and by December 15 of that year Lerebours in Paris was showing in his shop daguerre-

otypes of Italy and Corsica, which he had commissioned for *Excursions Daguerriennes*, the illustrated travel book he began to publish in installments during the next few months (see also Chapter 4). (Gernsheim 1982) The daguerreotypes were for sale but, while they remained in the shop, they were a potent advertisement for the venture. Such exhibitions, whether on Broadway or the Place du Pont-Neuf, were events, recognized at the time as first steps on exciting new paths. Once photography had become part of the familiar, everyday landscape, photographers strove to enhance the appeal of their routine stock with handsome mounts and frames, such as the display boards that transformed small, unpretentious portraits of individual sitters into one mesmerizing panel (Fig. 8-1). The display boards were mounted at street level, in the hope that their quality and luster might entice clients into the studio upstairs. By

THE FAMILY CHRISTIAN ALMANAC. 17

DAGUERRE.

Every one is familiar with the Daguerreotype, in which not only likenesses of persons, but images of all kinds of objects are transferred from the lens of the camera obscura, and permanently fixed on metallic plates. Though it is said to have been the joint invention of M. Daguerre and M. Niepce, yet common consent seems to have given it the name of the former. The engraving gives the appearance of the man whose name is thus associated with one of the most interesting discoveries of the age. It was copied from a daguerreotype of M. Daguerre, taken in France by Messrs. Meade.

Fig. 8-2. Portrait of Daguerre. Engraving in *The Family Christian Almanac* (early 1850s), based on a daguerreotype by Charles Meade of New York (1848). 2¾ × 4 inches. See also Fig. 8-3.

implication, the photographs on view were the work of the great master under the skylight, but this was by no means guaranteed, original sin being a good deal older than photography.

Operators with any pretensions to high fashion tried to bathe the bare bones of their trade in a glow of opulence, confident that this would ensure pampered clients and favorable publicity. The "American Daguerreotype Depot" was opened at 233 Broadway in New York City, on April 1, 1850, by Charles and Henry Meade, two gifted and enterprising brothers who had already laid the foundation of a successful partnership. In 1848, Charles had brought back to America five daguerreotype portraits he had been permitted to make of the great Daguerre himself, portraits that became familiar throughout the country in many engraved versions (Fig. 8-2). When the brothers felt ready for business

in New York, they chose an enviable central location, and designed a building to suit their special needs. A reporter for the *Albany Morning Express*, writing on May 3, 1850, was suitably impressed: "The reception room on the first floor above the street is sixty feet deep, superbly furnished and finished in the most magnificent style." (Lyons 1990) A picture of this oasis, its walls lined with encouraging examples of the brothers' work, appears several times in the illustrated journals of the decade. (See Fig. 8-3.)

A few years later, in 1871, Napoleon Sarony, a superb showman who specialized in theatrical portraits, set himself up for business in Union Square, at the heart of New York's entertainment district. For the pleasure of star-struck fans, he filled his showcase windows with portraits of their favorites (Bassham 1978). For his glamorous clients, he made magic in the studio,

conjuring up drama and romance with a confusion of enchanting props, from Russian sleighs to desiccated crocodiles. Everybody laughed, everybody gossiped, everybody came.

Those who aimed at targets set considerably lower on the social scale believed in a brisk and brutal courtship of the customer. Henry Mayhew described one method being used in the mean streets of London in the 1850s: "A touter at the door is crying out 'Hi! hi!—walk inside! walk inside! and have your c'rect likeness took, frame and glass complete, and only 6d.!—time of sitting only four seconds!' " An unwary workman answers the call, and steps inside to have his portrait made. The developed photograph is a distinct disappointment, black all over except for a sliver of light down one side of the face. Even so, and despite his protests, the victim in the end hands over for the picture not sixpence but eightpence, on the baffling grounds

that "you've got a patent American preserver, and that's twopence more" (Mayhew 1861). The "American preserver" was in fact a plain sheet of paper, albeit one impregnated with the high reputation of American photography on the one hand (see Chapter 7), and all things outlandish on the other. Its effect was to raise the client's confidence in the permanence of his photograph by psycho-therapeutic, rather than photo-chemical, means.

Selling itself to the public was only one of photography's myriad tasks. Its infinite adaptability as a tool for selling anything whatsoever was recognized, and called on, at every turn. An advertising ploy already mentioned (Fig. 3-9), in which a human mannequin was costumed in the contents of the photographer's studio, bears a faint family resemblance to some delightful trade cards of the seventeenth and eighteenth centuries. These pay homage to a craft by assembling

FIG. 8-3. Meade Brothers' Daguerreotype Gallery, Broadway, New York. Engraving published in *Gleason's Pictorial Drawing-Room Companion* (Boston), February 11, 1854. 5½ × 9¼ inches.

FIG. 8-4. Pretty girls as ubiquitous sales agents.
 (a) Simmons College publicity. Silver gelatin cabinet card by Thompson of Camden, New York, c. 1902. Wm. B. Becker Collection.
 (b) "Kodak Simplicity." Advertisement designed by C. Allen Gilbert, c. 1905. Rochester, New York. 14¼ × 9¾ inches.

(a)

its characteristic equipment into one little figure: a tall, thin chandler built from bundles of tall, thin candles, a cook made entirely of saucepans and ladles.

The old idea took a new turn at the end of the last century, when the photographing of living models dressed to publicize places and products became a minor craze. With one of those flashes of insight that mark the progress of the human race, it had been found that photographs of

pretty girls could be used to sell absolutely anything, from phonographs in Brisbane, Australia (Brown 1988), to Simmons College in Boston. The college, founded in 1902, offered courses in domestic science, cookery, and household management. A cabinet card, made by Thompson of Camden, New York, was issued to draw the attention of the public to the new establishment (Collins 1990). It shows an understandably gloomy young woman holding a Simmons Col-

KODAK SIMPLICITY

has removed most of the opportunities for making mistakes. No dark-room, few chemicals, little bother.

Kodaks, $5.00 to $108.00

$2,000 in prizes for Kodak pictures.
Kodak catalogues free at the
dealers or by mail.

EASTMAN KODAK CO.

Rochester, N. Y.

(b)

lege banner and hung with the badges of her office: egg whisks and rug beaters, dustpans and dinnerbells. (See Figure 8-4a.)

The human eye and human heart being what they are, it can come as no surprise that, while Eminent Worthies were photographed by the thousands, bewhiskered bishops and their peers could not long compete for interest with the countless pretty girls whose faces smiled from every surface. The debt owed by charming young women to the camera was handsomely repaid in time, when a succession of "Kodak Girls" appeared over the years, from 1888 onward, in a brilliant advertising campaign to celebrate the marvels of the Kodak camera. (See Fig. 8-4b.)

Peddlers, who dealt in little things, had always been able to carry their wares from door to door, but selling on the move presented problems for those with larger objects in their stock. An answer sometimes found in the luxury trade was to make a scale model, of a dress or a tallboy, to show to a prospective customer. It was a beguiling solution, but one with serious drawbacks for, while diminutive masterpieces compel respect, they themselves demand a considerable outlay of skill and capital. It was easier by far to illustrate a sale sheet with woodcuts or engravings, and this had been a method widely used ever since the invention of printing. The photograph seemed the natural heir to this tradition, but presented a problem of its own. Until quite late in the century, it was not technically possible to integrate photographs and text on one printed page. The laborious alternative, glorified by Fox Talbot himself, was to use actual photographs, hand-tipped on separate sheets. Although cumbersome, the method was adopted from time to time, to add an air of modern progress and the weight of authenticity to a particular publication, long after it was used (as in *The Pencil of Nature*) to advertise photography itself.

In 1865, Peter Robinson, one of London's elegant department stores, issued a catalog of mourning clothes, illustrated throughout with tipped-in photographs to show the different styles. A few years later, in 1876, the same enterprising firm put together a series of separate cartes-de-visite, each with a photograph of an outfit on the front, and details of the price and fabric on the back. (Ginsburg 1982) At some time in the 1880s, the German firm of Günther, in Schöningen, designed a neat, folding sample book for its traveling salesmen. The tall, narrow album, made to fit easily into a pocket or a case, opens to reveal twenty-eight cartes-de-visite, glued two to a sheet (Fig. 8-5). The photographs, taken by J. Hecht, are touched here and there with color for effect, and display wicker furniture of ingenious ugliness. Each has a num-

FIG. 8-5. Furniture sample book, made for the firm of Günther in Schöningen, Germany. 1880s. Cartes-de-visite photographs by J. Hecht.

ber, added in ink, to simplify the order record. Darrah (1981) mentions earlier carte-de-visite advertisements, one for "what-not shelves," from a dealer in Massachusetts, another, along less romantic lines, for a patented steam rudder, by Ricks, Murray & Owen of Muskegan, Michigan, both of the 1860s.

In the 1880s, a Philadelphian photographer, Robert Newell, issued a special advertisement, an offer to make photographs of any product a company might want to market (Finkel 1989). The eye-catching card is a gelatin silver print that shows one wall in the Newell studio covered with twenty-nine publicity pictures of items ranging from a set of suspenders to a plumbing valve. The text urges its readers to seize the initiative: "If you produce an article of merit, get it photographed and distributed. The entire country is your market, this is the age of progress, keep up with the times and make money." Even the renowned William Notman of Montreal developed advertising photography as one of his sidelines. Among other things (Schwartz 1986), he produced a whole series of "industrial portraits" of R. Eaton's "Patent Automatic Ventilating Stove for Burning Coal, Wood and Peat," having found the appliance a rewarding commission and a patient client.

The daguerreotype, though always at a disadvantage in commercial ventures because it could not be endlessly duplicated from one negative, was occasionally pressed into service. The mid-nineteenth century was a period marked by an ever-sharpening insistence on punctuality, at work in factories, and on the move, in new ways of travel governed by the imperatives of railroad and steamship timetables. An enormous market for clocks was opening up; it had at last become possible to produce them in large numbers and at low prices. In 1837, Chauncey Jerome, at his factory in Bristol, Connecticut, was the first to succeed in mass-producing cheap brass clocks. His triumph was so great, and so obvious, that many competing companies were formed to seize their own share of the market. (Landes

1983) N. L. Bradley, a traveling salesman who represented several manufacturers in the 1850s, carried with him a slotted case designed to hold eighteen daguerreotypes, each picturing a different kind of shelf-clock made by a number of companies, from Owen & Clark in New York to the Waterbury Clock Company of Connecticut (Fig. 8-6). (Spira 1979)

Nineteenth-century society had a thirst for illustration, a thirst that photography both satisfied and stimulated. In the early years of the century it had to be content, by and large, with black-and-white pictures, but advances in color printing, made by George Baxter in England and his rivals from the 1830s onward, released to a receptive public an ever-growing stream of pictorial material, to raise the demand for manufactured goods (Buday 1964). Color prints of every size and kind poured onto the market, and it became a characteristic pleasure of the period to decorate any surface, for any purpose, with some ornamental little scrap of gaily colored paper. Somber-toned photographs could never compete in charm with the bright new prints, but they were certainly better than nothing and, once it was possible to reproduce them easily and cheaply, they too joined the stream. Often a photograph, apparently chosen at random and quite irrelevant to the matter in hand, can be found slapped onto the back of an advertisement, as a tiny hook to catch an eye. A little cardboard ticket, for example, with the words "Bradley and Co.'s Dollar Novelty. Please Examine our Goods, marked Class B, which we sell for One Dollar" printed on one side, bears on the front an untitled photograph of a woman bending over a baby's crib (Fig. 8-7).

Because they were new, and so able to draw attention, photographs proved to be potent fund-raisers in schemes for assorted worthy causes. During the American Civil War, and in its aftermath, strenuous efforts were made to raise money for individual victims of the conflict, from homeless Confederate widows to orphans and disabled veterans. (Collins 1987) The

FIG. 8-6. Six daguerreotypes of shelf clocks, carried in lieu of actual samples by N. L. Bradley, traveling salesman. 1850s. American. Clocks made by different manufacturers. S. F. Spira Collection.

face of a desolate child on a carte-de-visite, or the portrait of a soldier in uniform, with one sleeve hanging empty by his side, touched hearts and opened purses more readily than pages of indignant prose. Another approach was the appeal to patriotism. By careful choice of subject matter, contemporary sacrifice could be linked with heroic actions in the nation's past. M. Witt, of 81 South High Street, Columbus, Ohio, issued one card with the caption "Sold by a Wounded Soldier." On the back is the revenue stamp required by law on all photographs sold

during the Civil War, while on the front is a photographic reproduction of a picture by W. H. Powell, "Battle of Lake Erie." The painting, which today hangs in the east stairwell of the Senate Wing of the Capitol, shows Commander Perry transferring his colors from the damaged flagship *Lawrence* to the *Niagara*, during the War of 1812 (Fig. 8-8). This use of a photograph (albeit in this case a photograph of a painting) is by no means unique. Thus, for instance, the *Daily Pittsburgh Gazette* of November 18, 1859, carries a note (Weprich 1991) which reads:

BRADLEY & CO'S

DOLLAR NOVELTY

Please Examine our Goods,

MARKED CLASS

B.

WHICH WE SELL FOR

One Dollar.

FIG. 8-7. Advertising card (n.d.), with albumen print on one side and the words "Dollar Novelty" on the other. Recto and verso.

RELIEF FOR JOHN BROWN'S FAMILY. The brief but pathetic statement made by John Brown of the pecuniary distress in which his family is left by his mishap, has stirred up a great deal of sympathy for them, and inquiries are freely made as to how relief can be extended to them. Mr. Taddeus Hyatt, of New York, has volunteered to become the Treasurer of such a fund, and agreed to furnish a photograph of the old man, with his autograph attached, for every dollar contributed. Every body [sic] can afford to give a dollar for such a purpose, and every sympathiser with John Brown, in his misery, would doubtless be glad to possess a photograph of him.

Ten thousand copies of the photograph were printed, but by the time this notice appeared, only $35 had been received by the fund. Taddeus Hyatt emphasized that the picture supplied would be a real photograph, not an engraving.

A more elaborate fund-raising scheme was devised by Queen Alexandra of England, in the early years of this century. Alexandra enjoyed photography, and by 1889 she had equipped

FIG. 8-8. Carte-de-visite with repro-
duction of a painting by W. H. Powell,
"Battle of Lake Erie," sold to bring in
money for soldiers injured in the Ameri-
can Civil War. Issued by M. Witt, of 81
South Street, Columbus, Ohio, c. 1865.
On the back is the revenue stamp re-
quired by law on photographs sold dur-
ing the Civil War (Fuller [Collins] 1980).

FIG. 8-9. Page from *Queen Alexandra's Christ-
mas Gift Book: Photographs from My Camera,
Daily Telegraph*, London, 1908. Engravings from
original photographs by H.M. Queen Alexandra.
Book in the form of a family photograph album,
sold to raise money for charity.

herself with one of the first Kodak cameras. The hobby gave her great satisfaction, and in due course she felt confident enough to show samples of her own work in one or two public exhibitions. Pleasant pictures by a popular member of the royal family were bound to be of interest, and her achievement attracted considerable attention. In 1907, the Queen agreed to select some of her snapshots for inclusion in a *Christmas Gift Book*, with all the proceeds going to charity. The book was carefully designed to look just like a family album, with reproductions of the original photographs printed in photogravure and mounted by hand on dark-green pages (Fig. 8-9). It was published in November 1908 by Britain's *Daily Telegraph*, and expertly marketed worldwide with the help of Kodak Limited, "whose Kodaks were used by Her Majesty" (Dimond and Taylor 1987). The venture was a great success. The Queen was delighted, the profits for charity were high, and Kodak basked in the glow of royal approbation.

A small camera, available in the form of a deeply etched printing block, made an unremarkable decoration for the letterhead of a photographer's studio (Fig. 8-10), but its use was not confined to such obvious contexts. Just as a photographer sometimes chose a railroad or a steamship as an emblem, to link his efforts with the wonders of the modern world (see Chapter 7), so the makers of a pot-pourri of other products added photographic touches to their own publicity (Scheid 1983). Determined ingenuity could find room for a camera in an advertisement for anything, from shoes to chocolate, gingerbread to coffee. Otto Schieblich advertised his "Photographie-Bonbons" in the *Lausitzer Zeitung* for July 11, 1863. (Anon. 1991) "Herr Willy" offered "Edible Cards de Visite, a Beautiful Little Novelty" in *The British Baker* (1893). (Charsley 1992)

Liebig's Meat Extract, a Victorian convenience food like the Bovril still familiar today, was developed by Baron Justus von Liebig, a wealthy businessman with a passion for nutrition, and a vast commercial network that

FIG. 8-10. Camera emblem on a printing block. Turn of the century. American. 1½ × 1½ inches.

stretched across Europe and South America. The sturdy little jar of concentrated nourishment was particularly popular, for good reason, among tough travelers and intrepid adventurers. During the 1877–78 Russo-Turkish War, a Turkish shell hit the baggage cart of the *Illustrated London News* and *Times* correspondents, and among the wreckage was found their Liebig stockpile. (Hodgson 1977) In the 1890s, however, the familiar jar was marketed with a series of oddly inappropriate advertisements, set in cozy interiors of conscious charm, where small children took its portrait with a camera (Braive 1966) or marveled at its image in a magic lantern show (Fig. 8-11).

A photograph might be used to draw attention to an achievement as well as to a product. Once images could be made cheaply and duplicated with ease, it became possible for anyone to devise his own publicity, and both excellence and eccentricity were recorded by the compliant, ubiquitous camera. The woodburytype, with its rich, beautiful tones, was chosen to illustrate a book on the making of fine violins, and to convey the magnificence of the finished masterpiece (see Fig. 11-15); a humble carte-de-visite preserves the memory of a remarkable

sculpture (Fig. 8-12). On the back of the card is this explanatory note: "1776–1876. The Dreaming Iolanthe, King René's daughter, by Henrich Herz. A study in BUTTER, by Caroline S. Brooks, daughter of Abel Shawk. The tools used were a common butter paddle, cedarsticks, broom straws, and camel's hair pencil. Nine pounds of Butter were used in modeling this subject."

As the dates suggest, this particular example was made as a contribution to the Philadelphia Centennial Exposition, but the fashion for butter sculpture flourished until the end of the century (Marling 1987). It was sufficiently widespread to be noted in an American story of the 1890s. There, the ghosts of the great, from Caesar to Napoleon, while away eternity with a series of agreeable dinner parties held on board a houseboat anchored in the river Styx. Phidias, the legendary sculptor, deplores the modern rage for modeling in butter, and is not comforted by Homer's hearty pun, "You did your best work in Greece." (Bangs 1899)

Best of all, a photographer could promote his own ends with his own means. Gustav Cramer was a German who settled in America and opened a studio in St. Louis, Missouri. Remem-

FIG. 8-11. Advertisement for Liebig's Meat Extract. Lithograph, n.d. (c. 1890s). Probably British.

1776. 1876.

THE

DREAMING IOLANTHE,

King Rene's Daughter, by Henrich

Herz.

A STUDY IN

BUTTER,

BY

CAROLINE S. BROOKS,

DAUGHTER OF

ABEL SHAWK.

The tools used were a common butter paddle,

cedar sticks, broom straws, and camel's hair pencil.

Nine pounds of Butter were used in modeling

this subject.

FIG. 8-12. Beauty in Butter, butter sculpture. "Dreaming Iolanthe," created by Caroline S. Brooks in 1876 for the Philadelphia Centennial Exposition. Works of art made of butter were fashionable in the late nineteenth century. Carte-de-visite, recto and verso. Photographer and publisher unknown. (Wilsher 1986; Marling 1987)

bered in the annals of photography today as a partner in the firm of Cramer & Norden, which in 1881 introduced the first professionally certified dry-plate negatives in the United States (Welling 1987), Cramer had a long career, spanning more than thirty years of enterprising studio practice. At some time in the early 1880s he designed a "show-piece" entitled *The Progress of Photography* (Fig. 8-13). In this still-life he assembled every kind of photographic mount and ornament he could offer to his clients, from

brooches to wall plaques, simple head-and-shoulder portraits to elaborate studio productions. No piece is notable, but the whole is greater than its parts, and from very ordinary ingredients an expert hand has fashioned a handsome, confidence-inspiring collage. See also Figure 11-14.

With such tasks in hand, the photographic industry's heart always beat fastest when promoting itself (see Figs. 3-9 and 4-23, for example); from the 1880s, the photographic amateur be-

Fig. 8-13. "The Progress of Photography," by Gustav Cramer, of St. Louis, Missouri. Gelatin silver print, 7 × 5½ inches. Exhibited at Milwaukee, Wisconsin, August 1883. See also Fig. 11-14.

came the prime target of its attentions. Many engravings used for camera advertisements featured women handling the equipment, not only because they were easy on the eye, but also because of a widely held view that if women could use cameras, photography had to be simple indeed. Mrs. Cameron would not have been amused. One such advertisement, issued by the Rochester Optical Company in the 1890s, shows a woman in the process of focusing the camera, but its text takes care to broaden the appeal considerably: "Just the Christmas Gift for your boy, lover, husband, pastor or friend . . ." (Lothrop 1991). An 1885 advertisement issued by the World Manufacturing Company of 122 Nassau Street, New York, addresses itself frankly to the dominant male, and claims: "You cannot engage in a more profitable business than photography, nor anything that is more genteel and gentlemanly." Its notions of gentility, never actually in doubt, are also explained: "The profits are enormous, and you will become a well-known and important citizen" (Gilbert 1970). The sentiments are typical enough; what is unusual in advertising practice is the loving care with which they are here explained:

> Hitherto photography was considered an art requiring years of study and practice and very costly apparatus, but since the introduction of Gelatine Bromide Process Dry Plates, any one having common sense and a small capital to buy an outfit, will be able to make the finest photographs without the aid of a teacher; either to make money or merely for amusement. This process dispenses entirely with the preparation of chemicals by the operator. He finds already prepared, and distinctly labeled, everything necessary for his work, and when these materials are exhausted they can be renewed by us at a very low price. Our cameras are not mere toys, they have been used and approved by eminent photographers. . . .

During the past year, the business of photographing city and farm residences, family groups at home, farm stock, school houses and scholars in groups, churches, factories, country views, etc. has rapidly developed. The men who are doing this have a very easy way of getting orders, entirely different from soliciting. They start up early in the morning with a good stock of dry plates and their Camera in hand, all weighing but a few pounds, approach a residence or building of any kind, and at once note from what point they can get the most attractive view of it; then politely telling the owner you are photographing the notable scenery and buildings in that neighborhood, you request him and family to stand at the window or door, or other natural position. Well, the novelty of having a photographer with full equipment appear at his door at once excites his curiosity, and he readily complies with your request, and in five seconds or less you have a negative. While this is being done, you quietly suggest that "Nero", the family dog, or the fine team would make an interesting picture; and by this time the whole family cannot resist the temptation to have a photograph of themselves or a favorite article, and it is so "cute" to have it done right at home, no fixing up to do. Even the hired man has his taken in his shirt sleeves, slouch hat, cowhide boots, and tools in hand. In 30 minutes you have from Mr. A's from one to five negatives and, passing on to his neighbor, Mr. B, you call him out in the same manner, and in addition remark that you have just photographed Mr. A's residence and family, his dog, blooded cow or horse, and immediately Mr. B will try to outdo Mr. A. In this manner you continue till about 4 pm, and then go home with your 20 or 30 negatives, develop them, and get them ready for printing the next day. From one negative you can print 1000 photo-

graphs, if necessary, and every negative you take will be worth from $1 to $2 profit to you. A school is a perfect bonanza for you. Only one negative is required, from which you can print as many photographs as there are scholars in the group. At 50¢ each you will clear from $10 to $15 profit on the school. Photography is unquestionably the most profitable of the regular trades. No chance of failure, unless through laziness. We will send a sample photo made with one of our equipments on receipt of 10 cents in stamps. [See also Chapter 5 and Ruby 1988.]

Even a decade and a half later (1901), J. Girard et Cie of Paris still advertised its Radieux camera with similar prose, while pulling at different emotional strings. Under the heading "Triomphe du Radieux," it promises *succès colossal*, as well as *la joie et le bonheur*. No wonder, for a mere 4½ centimes, the buyer would be able to take "souvenirs of sunlit days, cherished babies, and loved parents." "Anyone can be an artist! No apprenticeship, no work":

> Dear Readers. Be good enough to give us a few moments of your attention and, in exchange, we will guarantee joy and happiness for many years to come. We promise you the fulfilment of an enchanting dream that you have had many times, and, as though we possessed the magic of an all-powerful fairy, we will make it possible for you to capture and preserve at will the wonderful moments passed amidst those who are dear to you. Inexorable time will have rushed on in its mad course, carrying with it, each day, a shred of your youth, but, from this moment on, you will have a marvellous talisman, an inexpressible comfort, the power to retain and to enjoy forever the unchanging and faithful image of those charming scenes in which are gathered together adored parents, and true friends, where

cherished babies play . . . those dear little angels, those naughty imps, so tenderly loved!

THE CULT OF CELEBRITY

The camera's power to focus attention was not lost on its human subjects and, from the first, it was used by those in public life to confirm, or to confer, celebrity. Nothing in this was really new, except the scale of the operation. Print shops were pioneers in the fine art of promotion, and for a long time their displays had been crowded with pictures of current favorites. In 1728, the hit of the London season was *The Beggar's Opera*, and Lavinia Fenton, the first actress to play Polly Peachum, became the toast of the town. Her portrait was engraved, set out in every print-shop window, and snapped up by a shoal of admirers. (Hargrave 1966) In the years that followed, the faces of other star attractions found their way onto fans and patchboxes, playing cards and jugs. Actors loved such souvenirs, and ardent admirers loved to collect them. When photography entered the scene, the stage was set and the play had already begun. It did not need to shape new attitudes; it merely had to foster old ones.

Queen Victoria shared her subjects' enthusiasm for the theater, and had loved opera and drama ever since she was a young girl. She recorded her passionate responses and decided preferences in her own journal, and filled her sketchbooks with impressions of performances she had specially enjoyed. (Warner 1979) Her pleasure continued long after marriage, and was well-known to her family and household: in the pile of presents arranged for her on Christmas Eve 1857 were several photographs of actors (Dimond and Taylor 1987).

There still survives in the royal archives a magnificent, full-length daguerreotype of Jenny Lind, "the Swedish Nightingale." It was made by W. E. Kilburn in 1848, at the height of the

FIG. 8-14. "Mademoiselle Jenny Lind." Full-length daguerreotype portrait, 11.6 × 9.1 cm., by W. E. Kilburn, London. 1848. Copyright reserved. Royal Archives, Windsor Castle. Reproduced by gracious permission of Her Majesty Queen Elizabeth II.

singer's brilliantly successful first visit to England from 1847 to 1849 (Fig. 8-14). In 1850, she sailed to America where, under the management of the great showman P. T. Barnum, she scored another triumph. Barnum, a master of public relations, took care to see that her picture and her name were everywhere. Daguerreotype portraits were taken by fortunate operators, and the right to duplicate them was sold by advertisement to less-enterprising competitors (Newhall 1961; Kelbaugh 1991). Of course, multiple daguerreotypes of painted portraits could always be taken with greater ease than studio photographs of the famed artist in person; Figure 8-15 shows one example. In the photographic world, "Jenny Lind" was used as a brand name for anything, from a certain style of daguerreotype case, made in the form of a velvet-covered book (Rinhart 1969), to an elaborate studio headrest fastened to a fluted column.

The promoters of the Jenny Lind cult did their best with the means at their disposal, but for high-powered publicity the daguerreotype was an inadequate tool. Only when the carte-de-visite appeared, late in the 1850s, could the floodgates be flung wide open to let a torrent of portraits pour into the market and fill the albums of a waiting world. Quite suddenly it became possible to make, and to obtain, the portrait of anyone with the smallest claim on public attention, from politician to preacher, artist to author. The carte-de-visite was followed in due course by the larger cabinet card which, in turn, could be supplemented by the end of the century with such novelties as the "cigarette" card, a little photographic portrait tucked as a giveaway token into a packet of cigarettes or a can of cocoa (Fig. 8-16).

For a long time, an inexhaustible supply of portraits whetted an insatiable appetite. The

FIG. 8-15. Jenny Lind. Daguerreotype copy of a painted portrait, sixth-plate, c. 1850. American. Unknown photographer. See also Kelbaugh 1991.

public's enthusiasm was so great that a card offering only one celebrity at a time seemed insufficient. Micro-photography came to the rescue, and with its help it proved possible to squeeze a remarkable number of heads onto one small card, in an ingenious mosaic designed to fill the life-list of the committed collector. One example, issued by the Ashford Brothers in London, is undated, but it was probably made to celebrate the engagement or wedding of the Prince of Wales and Princess Alexandra, in 1862 or 1863, as the young couple appear at the center of the composition (Fig. 8-17). At the foot of the card is this imprint: "Upwards of five hundred photographs of the most celebrated personages of the age. With a hand magnifying glass every portrait will be seen near perfect." Disdéri himself, the inventor of carte-de-visite photography, suggested such creations (Baier 1977; Disdéri 1863), and called them "mosaic cards." The use of a magnifying glass was always meant to be part of the viewer's pleasure:

A card of the same size as ordinary cartes-de-visite, on which the artist accommodates as many people as he pleases. Depending on their number, those images might then be [anything between] the size of a pinhead, or the size of a penny. With the aid of a magnifying glass, the astonished viewer is presented with portraits of striking fidelity. The first mosaic card which Disdéri brought out contained no fewer than 320 portraits of famous contemporaries; in the middle, the Emperor and his family; round him statesmen, academicians, artists, lawyers, doctors, in short, everybody who was anybody in France. It is said that on the first day at the beginning of May [1863] 70,000 such cards were ordered. [Schrank 1864]

This systematic pictorial assault on the public proved even more potent than the occasional poetic tributes offered later at the amateur's shrine:

O weary worldling, empty soul,
So long by doubts and fears distressed,
Leave Love and Fame to Fate's
 control,
But buy a Kodak, and be blest!
 [Anon. 1902]

Despite the encouraging imprint below the photograph shown in Figure 8-17, such a crowded scene was bound to give more satisfaction to its maker than comfort to its viewer. A larger canvas was required, and in due course it was supplied, in the form of albums designed expressly for composite group portraits. Figure 5-30 is an example. The large page was easier to decipher than the small card, but it still left much to be desired. Such a gallery could never please discerning eyes, because its portraits had been pulled from many periods and drawn by many hands. There was no visual harmony to satisfy the senses. Far more successful was an album that did not attempt to be inclusive and that placed the emphasis squarely on quality control. One firm taking this line was Lock & Whitfield,

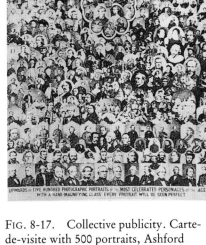

FIG. 8-17. Collective publicity. Carte-de-visite with 500 portraits, Ashford Brothers & Company, 76 Newgate Street, London, c. 1862–63.

FIG. 8-16. Photographic Cigarette Cards, issued by Caporal, "The Old Reliable" Cigarette Company. Albumen prints, each 2⅜ × 1⅜ inches. Late 1890s. American. Unknown photographer(s). Advertising slogan: "Absolutely Pure. Has stood the test of time. More sold than any other brand." Similar, but larger, cards of stage personalities were issued by the Lorillard Tobacco Company, albeit without specific claims to absolute purity of the product. (McCulloch 1981)

(a) (b)

FIG. 8-18. Portraits from *Men of Mark*, Lock & Whitfield, 1877. Woodburytypes, 4¼ × 3¼ inches.

(a) M. Jules Verne, French novelist, born 1828. His earliest science fiction writings date from 1863 (*Cinq Semaines en Ballon*). In 1875, a dramatic version of *Le Tour du Monde* was successfully presented on the English stage under the title "Around the World in Eighty Days."

(b) Lyon Playfair, C.B., LL.D., F.R.S., born 1819 in India and educated at St. Andrews as a chemist. In 1838, he studied under the famous Liebig in Giessen, and translated some of his works into English. In 1851, he was appointed Special Commissioner and Gentleman Usher, in connection with the Great Exhibition. President of the Chemical Society of London (1857); Liberal Member of Parliament (1868); Postmaster General (1873). Playfair was also the recipient of many foreign honors; thus, he held a Knighthood of the Portuguese Order of the Conception.

(c) James Nasmyth, engineer and astronomer, born 1808, educated at Edinburgh University. Inventor of the steam hammer (1839) and of many other mechanical devices, including a form of steam engine. Studied the surface of the moon with telescopes of his own design and construction. See also Chapter 11, Fig. 11-8.

which had studios in London and Brighton. For a number of years after 1876, the company issued a series of books of famous contemporaries, "photographed from life," under the general title *Men of Mark*. In these anthologies, each short biography was paired with a woodburytype portrait, and no pains were spared in every aspect of production, from paper to typeface and to print. (See Fig. 8-18.)

Such a luxurious sampler was a compliment to the taste of its readers and the dignity of its subjects. The woodburytype, with its rich, velvety tones, ennobled every portrait, and shed a certain glory onto every face. Its spellbinding power was not lost on the theater world, and made it a special favorite there, relied on to produce the most beguiling pictures possible (see Fig. 2-4). The flattery of beautiful tone quality was particularly welcome at a time when other forms of studio magic had yet to be fully developed. No photographer of the period, not even the great Napoleon Sarony himself, could soften shortcomings with the veil of romance and glamour spun around the sitter by such later masters as Cecil Beaton and Man Ray.

Compared with tributes paid by pen and

(c)

profit from this ever-widening pool? Some operators used the press to alert potential buyers. Sarony of New York, for example, advertised far afield, in the newspapers of Boston and Philadelphia. Many made up their own lists, filled with numbered illustrations, and sent these out to draw in mail orders. Others showed their work at professional meetings, and relied on trade journals to spread word of exciting new offerings.

In the last decades of the century, large firms with many outlets, like the London Stereoscopic Company, bought up stock from studios which had gone out of business, and reissued portraits made from old negatives. Small pictures of popular perennials and bright new favorites were marshaled, hand-numbered, photographed together, and printed on sample sheets. One huge example, still in existence, is made up of twenty-seven albumen prints, each measuring 4½ by 5½ inches and each containing a number of portraits (Fig. 8-21a). The prints are mounted on 7 feet of thin canvas, designed to be spread out in one particular shop or carried from store to store by a traveling salesman. The entire display offers a grand total of 850 subjects, surely enough to wring one order from the most resistant customer. (Mann and Collins 1984)

More often, such celebrity portraits, singly or in groups, were printed on smaller cards and displayed in shop windows. In 1871, a London shop devoted one window to stage personalities and another to Men of the Law, and recorded, to absolutely no one's surprise, that the former group was the greater commercial success (Senelick 1985). Several years earlier, that feature of London's street scene had already been noted by W. S. Gilbert, who acknowledged it in his own characteristic way:

> Looking lately in at LACY's
> at the photographic faces
> of the many Thespian races
> who are living or have gone,
> I began aloud to wonder
> on the most dramatic blunder

brush to the stars of the stage, these first publicity photographs seem curiously static and staid, respectable rather than riveting (Fig. 8-19). Perhaps this very quality helped them play a part in the battle waged by Victorian actors to shed the old image of the raffish outsider and win acceptance as full members of established society. Certainly the biographical notes issued with one portrait of the popular husband and wife team, Mr. and Mrs. Kendal (Fig. 8-20), put daunting emphasis on domestic virtue: "Mrs. Kendal's great gifts as an actress are harmoniously blended with the noblest qualities of pure and gracious womanhood. She is a fond but judicious mother, and in her home-circle she shines not less brightly and happily than she does in the best of those impersonations with which she gratifies and delights us upon the stage." (Anon. c. 1885)

The clamor for celebrity portraits fed upon itself, but for each studio this posed problems as well as possibilities. How could one firm fish

which my criticism's thunder
would be exercised upon.

The reference is to Lacy's Theatrical Bookshop, and one gathers that Gilbert did not actually think highly of their practice. (See also Figure 8-21b.)

With their prevailing sameness, standard studio poses tend to blunt the sharpest appetite, and enterprising photographers were always on the lookout for new ways to revive public interest and relieve the tedium of their own daily practice. Darkroom manipulation yielded handsome dividends. Through photomontage, it was possible to approach the freedom of the artist and to compose something more suggestive than a straightforward portrait (see also Chapter 2 and Fig. 7-19).

When Sir Edwin Landseer, the painter who had dominated the Victorian art world, died in 1873, an ingenious photographic tribute was issued (Fig. 8-22). Landseer had enjoyed a long and affectionate relationship with Queen Victoria, as both art tutor and friend, and so he is shown dreaming at his easel before a portrait of the Queen. Around him crowd the creatures for which his paintings were most famous and most loved. Landseer was the man to beat when it came to animals; a critic's gruff comment that a portrait of a dog would "do no discredit to Mr.

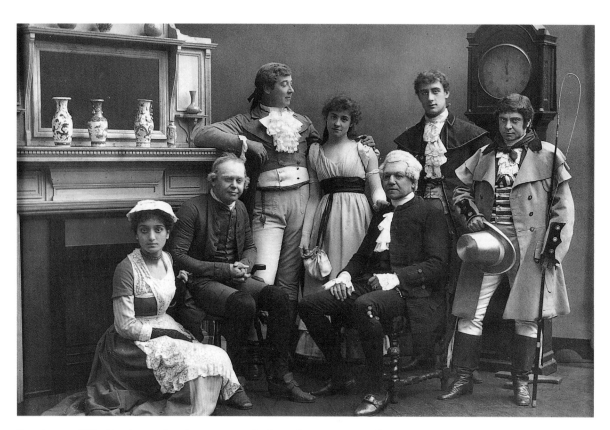

FIG. 8-19. "The Road to Ruin," by W. Barraud of London. 1886. Woodburytype, 4⅝ × 6½ inches. Group from a play performed at the Vaudeville Theatre, London, in 1886, commissioned by *The Theatre*. The actors are named as Mr. Charles Warner, Miss Kate Rorke, Mr. Fuller Mellish, Mr. Fred Thorne, Miss Louisa Peach, Mr. Thomas Thorne, and Mr. James Fernandez. William Barraud's London Studio was at 263 Oxford Street, and he also had a branch at Liverpool. His theatrical studies were well-known in the 1880s and 1890s. See Mathews 1974.

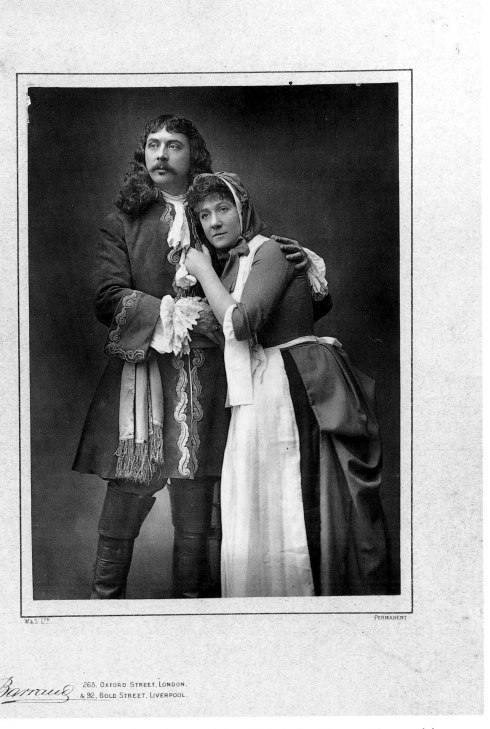

FIG. 8-20. "Mr. and Mrs. Kendal," as characters in Tom Taylor's play *Clancarty*. Photograph by W. Barraud. 1880s. Woodburytype, 6½ × 5 inches.

FIG. 8-21. Personalities of the day. (a)
 (a) Studio sample sheet (detail), c. 1893. British. Unknown photographer. Albumen print. Pattee Library, Special Collections, Pennsylvania State University. (Mann 1988)
 (b) Cabinet card by W. and D. Downey of Newcastle-upon-Tyne and London. C. 1890. Tim Gidal Collection. (Senelick 1985)

Landseer" was considered by any aspiring artist to be praise indeed (Anon. 1848). This composite cabinet card was made by H. S. Mendelssohn, a photographer active in the second half of the nineteenth century. He began his career in Newcastle-upon-Tyne, and went on to open studios in London and New York, where he advertised himself, modestly, as "High Art Photographer Royal." (Mathews 1974) See also Figure 7-5.

Ingenious packaging extends publicity's range, and the fact that a photograph can be printed on almost any surface opened many avenues for exploration. This adaptability made it possible to create charming novelties, such as the fan designed to be a "Who's Who" of Vienna's theater world in the late 1880s. Depicted there (Fig. 8-23a), among many others, is Adele Sandrock, then a beautiful young woman, who was to become an abrasive old lady of the 1930s screen. With a few well-chosen and devastating words, her role was to put pretension and presumption in their place, as only someone could, who no longer needed popularity or acclaim

(b)

(Spear and Wilsher 1980). Also on the fan (Fig. 8-23b) is Katherina Schratt, ("die Schratt"), famous actress of the day, and the Emperor's mistress besides, or, as it would have been more respectful to call her, His Serene Apostolic Majesty's Mistress.

Free gifts have always warmed the public's heart, and in the 1870s the theater journals of several countries used this lure to tempt their readers. The idea was first tried in Paris, and within months was copied in Brussels and in London. The weekly journal *Paris-Théâtre* be-

IN REMEMBRANCE OF SIR EDWIN LANDSEER.

FIG. 8-22. "Landseer Reverie,"
H. S. Mendelssohn, London, c. 1873.
Cabinet card. Gelatin silver print.

gan publication on May 22, 1873, and offered on its front page a woodburytype portrait of a celebrity. *Bruxelles-Théâtre* appeared on January 11, 1874, in an almost identical format, including a front-page woodburytype. (Joseph and Schwilden 1987) By July 25 of the same year, London had its very own *Figaro-Programme*, with its very own woodburytype, a portrait of England's leading actor, Henry Irving, prominent on the front cover. The London journal was produced by Lock & Whitfield, the same

firm that, a little later in the decade, was to issue its series of illustrated biographies, *Men of Mark* (see above). In their English imitation, Lock & Whitfield offered one intriguing improvement on the French original. The portrait of Irving came complete with printed instructions on how to detach the picture and glue it into an album or scrapbook (Fig. 8-24).

The postage stamp appeared on the scene in 1840, just one year after photography's arrival, and it soon became an accepted fixture in the

(a)

(b)

FIG. 8-23. Detail of a theatrical fan. Late 1880s. Vienna. Various photographers. Gravure print, 12 inches folded length.
 (a) Portion with picture of actress Katherina Schratt (upper half, right of center)
 (b) Portion with picture of actress Adele Sandrock (bottom row, second from right)

FIG. 8-24. Figaro-Programme, with portrait of Henry Irving. Lock & Whitfield, London. 1874. Woodbury-type, 3½ × 2¼ inches.

(a)

(b)

FIG. 8-25. Portraits of Henry Irving.

(a) Close-up in postage-stamp form. Genelli, 1885. St. Louis, Missouri. Albumen print, 2¼ × 1¾ inches.

(b) On stage as Cardinal Wolsey in *Henry VIII*. Cabinet card by W. and D. Downey of London. 1880s.

Western world. Its familiar format, and its characteristic design feature, the bust of a head of state, made it an obvious model for portraiture, and in the 1880s its possibilities were put to good use by photographic publicists.

Henry Irving and his theater company played twice in the American city of St. Louis, in 1884 and 1885. Both visits were personal triumphs for the great actor-manager, with full houses, generous critics, splendid parties, and approving editorials. (Brereton 1908) Genelli, a local photographer, made a portrait of Irving and, perhaps to steal a march on his competitors, had the idea of issuing the finished photograph as an intriguing novelty. The picture was made to look like a postage stamp, complete with care-

fully deckled edges, and the actor's head set in the typical frame (Fig. 8-25). (Wilsher 1986b)

Genelli's photographic stamp bears the imprint: "Patented Dec. 29th 1885." This suggests that Genelli may have applied for the patent himself, but he was certainly not the only one to whom the ingenious notion had occurred. Far away in Northford, Connecticut, Stevens Brothers published their own advertisement: "Something New: Postage Stamp Photographs. Fifteen Genuine Photographs of Yourself, Size of Postage Stamp, with Gummed Backs, only Thirty Cents" (Fig. 8-26). Stevens Brothers did not offer to photograph their customers, but only to give the conventional photographs supplied this fashionable new look: "Photographs, reduced

FIG. 8-26. Advertisement for postage stamp photography by Stevens Brothers of Northford, Connecticut. 1880s.

to postage stamp size, thoroughly washed and toned. . . . We send them with gummed backs, and edges neatly trimmed." The advertisement claims that this "coming craze" in America had started on the other side of the Atlantic, "in England, where the suggestion was had from the head of the Queen on the ha'penny stamps in use there."

Embedded in the long, discursive text is a clue to a profound change taking place in social attitudes, helped on by photography's extraordinary powers of persuasion: "Genuine Photographs of Yourself . . . ready to mount on letter heads, business, visiting or wedding cards, autograph albums, etc." In all other forms of advertising, whether of products or personalities, photography was just the latest and most forceful agent. It followed paths already well-trodden by the woodcut and engraving, and developed new variations on old established practice. In the publicizing of the private self, photography opened windows onto new territory. It was a natural, perhaps inevitable development. Between the covers of the album, the faces of public figures and family members had been gathered for years in democratic assembly. The standard size of the carte-de-visite and the cabinet card had given equal weight to an aunt or a queen, a living bishop or a long-dead brother. On cardboard, at least, private people seemed to have the same value as the well-known, so why should they not enjoy their own moment in the sun?

Studio windows were always there to be filled with pictures of actors on the world stage (Figs. 8-27, 8-28, and 8-29), and if the principal beneficiaries of the new fashion were the living, the eminent and famous of former times were not forgotten (Fig. 8-30); if they in person could not be sold to the public, their books certainly could. By the 1880s, windows also displayed faces with no claim to fame except good looks and good background. Society figures who, a generation earlier, would have shuddered at the thought of exposing their portraits to the com-

mon gaze, now were quite happy to win in this way a little notoriety and a little cash. In a short story by Henry James, *The Real Thing* (1892), two brave, sad nonentities, down on their luck and desperate for money, vainly try to become professional models. They think they can do it because in happier, far-off days they had been much in demand for photographs:

"We've been photographed, *immensely*," said Mrs. Monarch.

"She means the fellows have asked us," added the Major.

"I see—because you're so good-looking."

"I don't know what they thought, but they were always after us."

"We always got our photographs for nothing," smiled Mrs. Monarch. . . .

"Are they to be got in the shops?" I inquired. . . .

"Oh, yes; *hers*—they used to be."

"Not now," said Mrs. Monarch, with her eyes on the floor. [James 1892]

Not every face, of course, was welcome in displays. Photographers knew their public and had grasped a simple fact of life, that there was far more drawing-power in the portrait of "Mrs. Wouldbe Butterfly, Well-known Society Hostess" than in that of "Miss Moffat, Milliner." And yet, even so, it had come within the scope of anyone to fashion personal publicity. The inexpensive ease with which a photograph could be printed on any surface offered endless opportunities for innocent self-flattery. Ordinary citizens discovered that photography had made it possible for them to star in their own Christmas cards (Fig. 5-23c), or smile at their guests from the side of their own teacups (Fig. 5-20a).

Each tiny act of assertion, whether sweet or silly, was a hint of new aims and new needs. The lure of the spotlight grew, and in the glare old virtues lost their luster; reserve and modesty were thrust aside in the rush for center stage. For

(a) (b)

FIG. 8-27. Celebrity Cards I. Tinted cartes-de-visite by E. Desmaisons of 5 Rue des Grands Augustins, Paris. 1860s.
 (a) Empress of Russia.
 (b) Czar of Russia.

guardians of tradition there was much to deplore, and many rear-guard actions were mounted. In 1878, *Punch* published this lament:

A Sad Shillingsworth

Time was when English maids and wives
Led modest and secluded lives;
But in these latter days they vie
In seeking base publicity.
The face that once at home would shine—
The glory of the ancient line—
The lips, the sweetest under sun,
That in old days smiled but for one;
The eyes that veiled themselves always

Beneath the rude observer's gaze;
All these, if haply he be willing—
The cad can purchase for a shilling!

[*Punch* 1878]

In vain, mockery fell on deaf ears, and old taboos were worn away. Even the most conservative were changed by current fashion. Beatrix Potter, for instance, belonged to a family that, even by the highest Victorian standards, was rigidly reserved. Her father, however, was an enthusiastic photographer and a friend of Millais, the noted painter. This link with an artist whose name was a household word drew Mr. Potter

Ole Bull.

MAXIMILLIAN AND CARLOTTA.

(a)　　　　　　　　　　　　　(b)

FIG. 8-28. Celebrity Cards II. Carte-de-visite albumen prints of the 1860s.

(a) Ole Bull (1810–80), famous Norwegian violinist and founder of a short-lived religious community in northern Pennsylvania in the early 1850s. American. Unknown photographer.

(b) Emperor Maximilian (1832–67) and Empress Carlotta. Maximilian was a younger brother of Emperor Franz Joseph of Austria, and was offered the throne of Mexico in 1861; he was executed there in 1867. The curt base caption, with no hint of rank or title, is highly unusual, and may be a hint of political hostility.

FIG. 8-29. Benjamin Disraeli, the Earl of Beaconsfield. 1870s. Woodburytype by W. and D. Downey, of London, photographers sometimes described as "the Holbeins of the Victorians." The fact that the print is a Woodburytype—i.e., suitable for multiple reproduction—marks it as a publicity photograph. Indeed, thousands of copies were sold during Disraeli's second term as Prime Minister, and laid the foundation of the Downey fortunes.

(a)

(b)

FIG. 8-30. Celebrity Cards III. Cartes-de-visite of eminent personages of the past, albumen prints reproduced from engravings.

(a) Johann Wolfgang von Goethe (1749–1832), c. 1860.

(b) Johann Christoph Friedrich von Schiller (1759–1805), c. 1859, and possibly made for the Schiller centenary celebrations of that year.

into the public eye. Two of his portraits of Millais were chosen by the *Art Journal*, in the autumn of 1885, to illustrate its special supplement on the popular celebrity. Far worse, they were used as part of the *Art Journal*'s advertising campaign, and blazoned all over London. The entry on the episode that Beatrix Potter wrote in her journal betrays, if anything, a mild pleasure, and certainly not a shock of disapproval: "The *Art Journal* has a life of him [Millais] as Art Annual of the Season. There are reproduced two of papa's photos. It is rather amusing to see them up on the advertisement at the Book Stalls." (Potter 1885)

Her tranquil comment is only one among a myriad indications in the last quarter of the

nineteenth century that the old order was indeed beginning to give way to the new. Elizabeth Thompson wrote of a similar experience. In May 1874 she had achieved sudden fame when her somber painting ("The Roll Call") of a Crimean War scene was exhibited at the Royal Academy. The painting was a sensation, in part because it was so unusual for a military subject to be depicted by a young girl of twenty or so. As a result, photographers wanted her picture, only to meet with initial resistance. The account of its collapse appeared in an autobiography she (as Lady Butler) wrote long after the event:

Of course, the photographers began bothering. The idea of my portraits being pub-

lished in the shop windows was repugnant to me. Nowadays one is snapshotted whether one likes it or not, but it wasn't so bad in those days; one's consent was asked, at any rate. I refused. However, it had to come to that at last. My grandfather simply walked into the shop of the first people that had asked me, in Regent Street, and calmly made an appointment. I was so cross on being dragged there that the result was as I expected—a rather harassed and coerced young woman, and the worst of it was that this particular photograph was the one most widely published. Indeed, one of my Aunts, passing along a street in Chelsea, was astonished to see her rueful niece on a costermonger's barrow amongst some bananas! [Butler 1923]

What would have been regarded as unthinkably vulgar in the very recent past had become an accepted, if not always approved, feature of late Victorian life: the advertising of the self. The photographer's attention was both a compliment and an intrusion, welcomed and deplored in equal measure. (See Fig. 8-31.)

THE ANTI-CAMERA SHADE. — II.

FIG. 8-31. Coping with "The Amateur Photographic Pest" (a *Punch* of London designation), American style. From *Puck* (New York), 1890. The drapery is ordinarily housed on the underside of the umbrella, to be released in time of need. See also Krauss 1978.

Chapter 8 References and Notes

ANON. (1848). *The Morning Chronicle*, May 15, quoted by Raymond Postgate in *The Story of a Year: 1848*, Caswell, London, 1955. 1984 edition, p. 134.

ANON. (c. 1885). *Biographical Notes on Mr. & Mrs. Kendal* (n.d.). (Detached fragment, accompanying a large woodburytype of the two actors, made by W. Barraud, a well-known theater photographer in the 1880s and 1890s, with studios in London and Liverpool.)

ANON. (1902). *Pall Mall Gazette*, July, Lines from an anonymous poem, "I Photograph with Joyous Zeal," reprinted in *Photo Era*, vol. 9, no. 1.

ANON. (1991). *Photo-Antiquaria*, No. 1–2.

BAIER, W. (1977). *Quellendarstellungen zur Geschichte der Fotografie*, Schirmer-Mosel, Munich, p. 517.

BANGS, J. K. (1899). *The House-Boat on the Styx*, Harper & Brothers, New York and London, p. 122.

BASSHAM, B. L. (1978). *The Theatrical Photographs of Napoleon Sarony*, Kent State University Press, Kent, Ohio, p. 13.

BRAIVE, M. (1966). *The Era of the Photograph*, Thames & Hudson, London, p. 170.

BRERETON, A. (1908). *The Life of Henry Irving*, Longmans, Green & Co., London, vol. 2, pp. 348–53.

BROWN, J. K. (1988). "The Manufacturing of Photographic Papers in Colonial Australia, 1890–1900," *History of Photography*, vol. 12, no. 4, pp. 345–54 (Fig. 7).

BUDAY, G. (1964). *The History of the Christmas Card*, Spring Books, London, pp. 37–39.

BUTLER, Lady E. (1923). *An Autobiography*, Houghton Mifflin Co., Boston and New York, p. 114.

CHARSLEY, S. R. (1992). *Wedding Cakes and Cultural History*, Routledge, London and New York, figure 2.

COLLINS, K. (1987). "Photographic Fundraising," *History of Photography*, vol. 11, no. 3, pp. 173–87.

COLLINS, K. (1990). "Offensive Weapons on the Home Front," in *Shadow and Substance* (ed. K. Collins), Amorphous Institute Press / University of New Mexico Press, Albuquerque, New Mexico, p. 272.

DARRAH, W. C. (1981). *Cartes-de-Visite in Nineteenth Century Photography*, W. C. Darrah, Gettysburg, Pennsylvania, p. 120.

DIMOND, F., and TAYLOR, R. (1987). *Crown and Camera: The Royal Family and Photography, 1842–1910*, Penguin Books, Harmondsworth, Middlesex, U.K., pp. 73–77, 80.

DISDÉRI, A. A. (1863). *Photographisches Archiv*, Düsseldorf, vol. 4. p. 125.

FINKEL, K. (1989). *The Annual Report of the Library Company of Philadelphia*, pp. 35–37.

FULLER [Collins], K. (1980). "Civil War Stamp Duty: Photography as a Revenue Source," *History of Photography*, vol. 4, no. 4, pp. 263–82.

GEORGE, M. D. (1959). *English Political Caricature*, Clarendon Press, Oxford, vol. 1, p. 176.

GERNSHEIM, H. (1982). *The Origins of Photography*, Thames & Hudson, New York, p. 83.

GILBERT, G. (1970). *Photographic Advertising from A to Z: From the Kodak to the Leica*, Yesterday's Cameras, New York, p. 31.

GINSBURG, M. (1982). *Victorian Dress in Photographs*, B. T. Batsford, London, p. 17.

HARGRAVE, C. P. (1966). *A History of Playing Cards*, Dover Publications, New York, p. 198.

HODGSON, P. (1977). *The War Illustrators*, Macmillan Co., New York, p. 108.

JAMES, H. (1892). "The Real Thing," in *The Aspern Papers and Other Stories*, Penguin Books, Harmondsworth, Middlesex, U.K., chapter 1, p. 112.

JOSEPH, S. F., and SCHWILDEN, T. (1987). "A Dramatic Duo," *History of Photography*, vol. 11, no. 4, pp. 325–27.

KELBAUGH, R. J. (1991). "The Swedish Nightingale and the Baltimore Daguerreians," in *The Daguerreian Annual 1991* (ed. P. Palmquist), The Daguerreian Society, Lake Charles, Louisiana, pp. 155–59.

LANDES, D. (1983). *Revolution in Time: Clocks and the Making of the Modern World*, Belknap Press of Harvard University Press, Cambridge, Massachusetts, pp. 311–12.

LOTHROP, E. (1991). Personal communication, acknowledged with thanks.

LYONS, V. V. (1990). "The Brothers Meade," *History of Photography*, vol. 14, no. 2, pp. 113–34.

MANN, C. (1988). Personal communication, acknowledged with thanks.

MANN, C., and COLLINS, K. (1984). "Studio Sample Sheet," *History of Photography*, vol. 8, no. 3, pp. 197–200.

MARLING, K. A. (1987). "She Brought Forth Butter in a Lordly Dish: The Origins of Minnesota Butter Sculpture," *Minnesota History*, vol. 50, no. 6, pp. 218–28.

MATHEWS, O. (1974). *The Album of Carte-de-Visite and Cabinet Portrait Photographs*, Reedminster Publications, London, pp. 60, 122.

MAYHEW, H. (1861). *London Labour and the London Poor*, Dover Publications, New York, 1968 reprint, vol. 3, p. 205.

McCULLOCH, L. W. (1981). *Card Photographs: A Guide to Their History and Value*, Schiffer Publishing Co., Exton, Pennsylvania, p. 165.

NEWHALL, B. (1961). *The Daguerreotype in America*, Duell, Sloan & Pearce, New York, pp. 81, 59.

POTTER, B. (1885). Entry for November 9, 1885, in *The Journal of Beatrix Potter from 1881 to 1897*, transcribed by Leslie Linder, Frederick Warne & Co., London (1966), p. 154.

PUNCH (1878). "A Sad Shillingsworth," quoted in Alison Aldburgham, *A Punch History of Manners and Modes*, Hutchinson, London, 1961, p. 120.

RINHART, F. and M. (1969). *American Miniature Case Art*, A. S. Barnes & Co., South Brunswick and New York, p. 43.

RUBY, J. (1988). "Images of Rural America," *History of Photography*, vol. 12, no. 4, pp. 327–42.

SCHEID, U. (1983). *Als Photographieren noch ein Abenteuer war*, Harenberg Kommunikation, Dortmund, pp. 182, 184, 190, 209.

SCHRANK, L. (1864). *Photographisches Archiv*, Düsseldorf, vol. 5, p. 88.

SCHWARTZ, J. M. (1986). "Another Side of William Notman," *History of Photography*, vol. 10, no. 1,

pp. 63–69.

SENELICK, L. (1985). "Ladies of the Gaiety," *History of Photography*, vol. 9, no. 1, pp. 39–41.

SPEAR, B., and WILSHER, A. (1980). Personal communication, acknowledged with thanks.

SPIRA, S. F. (1979). "Daguerreotypes as a Selling Tool," *History of Photography*, vol. 3, no. 4, p. 378.

TAFT, R. (1938). *Photography and the American Scene*, Macmillan Co., New York. 1964 reprint by Dover Publications, New York, p. 15.

THOMAS, A. (1978). *The Expanding Eye: Photography and the Nineteenth-Century Mind*, Croom Helm, London, p. 81.

WARNER, M. (1979). *Queen Victoria's Sketchbook*, Macmillan & Co., London, p. 71.

WELLING, W. (1987). *Photography in America: The Formative Years, 1839–1900*, University of New Mexico Press, Albuquerque, New Mexico, p. 271.

WEPRICH, T. M. (1991). Personal communication, acknowledged with thanks.

WILSHER, A. (1986a). "The Beauty of Butter," *History of Photography*, vol. 10, no. 1, p. 30.

WILSHER, A. (1986b). "Philatelic Flattery," *History of Photography*, vol. 10, no. 4, pp. 327–29.

9

HUMOR

MAGIC, OLD AND NEW

The effect of photography's invention on life in general was deep and intimate and, as far as its associated humor was concerned, the new art and craft proved to be an inexhaustible stimulus over the years. This was no doubt helped by the fact that the outward appearance of photographic paraphernalia kept changing as time went on, providing each generation of cartoonists with new challenges and opportunities. The situation was by no means unique; high technology and its impact on society have always been grist for humor's mill. It was probably so when the wheel was first invented, and has remained so ever since. Indeed, long before the camera, another visual device, the Magic Lantern, attracted the same sort of attention. In the seventeenth century, casual references to such instruments, with scenes painted on glass and then projected onto a wall or screen, began to be jotted down in the notebooks of the curious. In the last quarter of the next century, there was a sudden burst of enthusiasm for such toys (Altick 1978); the Magic Lantern became a topical talking point, and several satirists used it as a fashionable prop in their cartoons (Fig. 12-21), all the more because it "was of greatest service to the magicians of those times, enabling them to

work on the credulity of the ignorant and super-stitious with the utmost facility" (Pepper 1863).

That the Magic Lantern was often misused along those lines may have been widely sus-pected, but the public's attitude remained am-bivalent, sufficiently so for the renowned St. Andrew's sage, Sir David Brewster, to address himself to the problem in one of his letters to Sir Walter Scott. Brewster was anxious to provide strictly scientific explanations for the "magic" produced with the *laterna magica*, but he also encouraged young readers of his book, *Natural Magic*, to believe that *some* manifestations of "magic" were indeed due to divine, not human, intervention (Brewster 1832). It was a view that allowed him to be thoroughly scientific while hedging his bets and remaining within the main-stream of popular opinion. Thus, for instance, the anonymous authors of *The Wonders of Light and Shadow*, published in 1851 by the Society for Promoting Christian Knowledge, echo this opinion (see Bunnell and Sobieszek 1973), and add: "That these instruments [Magic Lanterns] have been abused, cannot be denied; and that they have been abused to the worst ends, this sketch will have sufficiently demonstrated. But that they are capable of higher uses is equally true." Other intellectuals solved the problem in different ways to their own satisfaction. Balzac (1847) maintained that all aspects of the camera, photography included, should be considered under the same heading as precognition, astrol-ogy, and card-reading and should be accorded serious respect just because those other endeav-ors so obviously deserved it. See also Hrabalek (1985).

When photography came upon the scene, with all its inherently startling possibilities, it was inevitable that it should serve as a butt for the caricaturist's much older art. Probably the first cartoon on the new invention was also the most perceptive. The well-known December 1839 Parisian broadside by Maurisset, called *Fantaisies: La Daguerréomanie*, was addressed not to photographic malpractice but to photo-graphy as such, and what distinguished it from

later works was its prophetic character. In par-ticular, the cartoon foreshadows the demise of the draftsman and engraver, likely to be deprived of their livelihood by the dangerous new rival. Those worthies, among whom Maurisset counted himself, are invited to take advantage of the gallows, conveniently provided at center-stage (Fig. 9-1). Indeed, the subject of painters made unemployed by the new art gave rise to a whole genre of photo-cartoons (see Krauss 1978). Often these contrast the fate of painters who "joined the photographic bandwagon" by becoming photographers or, at least, photo-colorists, with that of the few who remained true to their art. The former prospered; the lat-ter lived in penury.

Maurisset's drawing is also prophetic inas-much as it envisages in those earliest of days the emergence of photojournalism, and of aerial photography, long before either occupation be-came technically feasible. It shows crowds en-thralled by photography and, with an under-standing of human nature, crowds already disenchanted by it; among many other prescient offerings, we have here also the first example of an obstreperous child making life difficult for a strange and eager *homo photographicus*.

Though the genuine, classic daguerreotype is very much at the center of things, the cartoon also mentions, at one place (not here shown) in its complex design, "épreuve Daguerrienne sur papier," as well as prints according to "Dr. Donné's system." Alfred Donné (1801–78) was already active as a researcher in the optical arts at the time (Stenger 1938). In February 1840, he was to submit to the Academy of Sciences a se-ries of daguerreotypes taken through the solar microscope, in competition with his distin-guished contemporary and principal rival, Ben-jamin Dancer of Manchester. Donné did publish such pictures later, printed directly from deeply etched daguerreotypes, and thus "on paper," but there is no suggestion that he invented any form of paper-based photography.

Fox Talbot must have been dismayed to see Maurisset's more explicit reference to "da-

FIG. 9-1. Detail from Th. Maurisset's December 1839 cartoon *Fantaisies: La Daguerréomanie*, or alternatively, *La Daguerréotypomanie*. Lithograph. Courtesy Rolf H. Krauss.

guerreotypes on paper," and probably had scathing comments about crass "terminological inexactitudes" and the sheer clumsiness of Donné's method. And yet Maurisset may have had a very different episode in mind: there is at least one report, according to which Daguerre himself had managed to prepare light-sensitive paper. Indeed, by what M. Biot (1839) described as "un ménagement d'une extrême délicatesse," the process is said to have yielded positive images, albeit only of a semi-permanent nature. Biot was a physician who claimed to have been instructed by M. Daguerre to bring the matter to the attention of the French Academy of Sciences. His paper refers to Daguerre's activities along those lines, allegedly as early as 1826, well before Niépce came into his orbit. (See also Speter 1937 and Kollow 1987.) It seems that Da-

guerre found the task of producing positives on paper altogether too cumbersome, and promptly decided on a different approach. Biot remarks nevertheless that Daguerre grasped all his opportunities with "une sagacité rare." His explanation of the process itself remains obscure, with enigmatic references to "uneven electrical states," to (by implication) infra-red sensitivity, and to those stalwart supports of scholarly claims, "as yet unpublished results." A circumstantial detail: the papers prepared by Daguerre were most sensitive when wet. This phase of Daguerre's activities qualifies as one of the most grievously overlooked and neglected episodes in all photo-history. However this may be, Daguerre himself must have decided that the process was not worthy of his further attention; even more remarkable, for such an energetic

self-promoter, was the fact that at no time did
he challenge Fox Talbot's or Bayard's status as
the inventors of photography on paper (see also
Anon. 1937).

In any event, the term "daguerreotype on pa-
per" had wide circulation in Europe before a
more precise terminology became firmly estab-
lished, and stood simply for a photograph on
paper. Thus, Jacques Raphael Barboni, one of
the first photographers to open a business in
Brussels, used the phrase in this sense as late as
1848 (Joseph and Schwilden 1990). In 1841,
Horatia Feilding, Fox Talbot's sister, had en-
countered it while on a visit to Bologna, and
mentioned it in a letter to her brother at Lacock:
"There is a professor of medicine here . . . who
offered to show us some daguerreotypes on pa-
per, a curiosity we had perhaps never heard of!"
(Smith 1990, 1991). In the years leading up to
1839, and even outside the closed world of Da-
guerre and Talbot, notions of photography on
paper had already been entertained. Thus, Till-
manns (1981) mentions that Andreas Friedrich
Gerber, a Swiss anatomist, made positive prints
from paper negatives in 1839, after first suc-
cesses in 1835, though his claims were contested
(Gerber 1839; Anon. 1839). Moreover, Kossoy
(1977) has described the independent invention
of photography in Brazil in 1833. Nor should
one forget the claims of Lord Brougham of
Vaux, which, indeed, date back to 1795
(Brougham 1871).

All these episodes show that success calls not
only for a distinguished player but also for an
audience. Heinrich Schwarz (1985) has talked
about "the concentration of all forces that make
an invention historically imperative" but, in the
last analysis, we tend to diagnose the presence of
that "historical imperative" in retrospect, only
when an invention has actually succeeded. (See
also Freund 1968.) Sociological insights help to
explain why certain inventions succeed and oth-
ers do not, but they rarely predict them, and
even then mostly within the realm of visionary
science fiction.

M. Nadar nommé général inspecteur des photographes mili-
taires

FIG. 9-2. Cartoon by Cham of Paris, 1865, made
apropos the suggestion that the French Army might
establish a photographic corps. Here Nadar is shown as
a possible inspector-general. From *Nouveaux Habits!*
Nouveaux Galons!

Maurisset's cartoon is not only the earliest
known but also the most farsighted and pene-
trating. That fact was recognized by Nadar's son
Paul, who reproduced *Daguerréomanie* in his
1893 *Paris-Photographe* (p. 486), and by Eder,
who gave it extensive coverage in 1905 (see Eder
1945 and Krauss 1978). Nadar himself had al-
most certainly been inspired by the cartoon to
undertake his own ballooning exploits from the
late 1850s onward.

Maurisset's was a truly prophetic vision. Later
cartoonists often offered as amusing fancies
scenes that were far closer to contemporary fact
than they and most other people realized. In
1865, for instance, Cham of Paris published a
brochure, *Nouveaux Habits! Nouveaux Galons!*,
with a series of cartoons in which he envisages
that units of the French Army might be formed
for specifically photographic tasks, with Nadar
as inspector-general (Fig. 9-2). Little did he re-

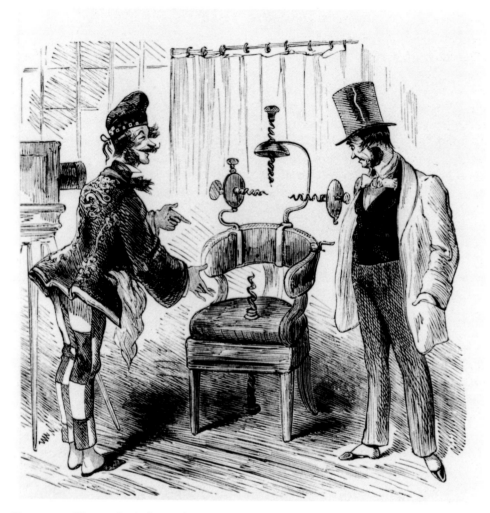

FIG. 9-3. "The Mechanical Armchair" in the photographic studio. Cartoon by Marcelin.
Journal pour Rire (Paris, 1851); *Journal Amusant*, 1857. The original caption reads something
like: "Please take pains (the trouble) to seat yourself!" (Krauss 1978)

alize that, across the Channel, the British Army
had already taken steps to establish a photo-
graphic branch. In France itself, Camille Silvy
had been officially appointed photographer to
the army in 1859, although the campaign was
over before he could take up the position
(Haworth-Booth 1992). Military photography
soon came to be an important, if artistically dis-
mal, application of the new art. (See Chapter
13.)

CONTRAPTIONS, INFERNAL

In due course, the car, the airplane, radio, tele-
vision, rocketry, and now man's best friend, the
computer, have taken turns to serve as the target
of popular jokes, just as photographic equip-
ment did in the nineteenth century (Figs. 9-3
and 9-4), especially that responsible for the dis-
comfort of studio clients. The comparison with
dental chairs was irresistible (see also Chapter

7), and cartoonists made painful use of it. "Bitte recht freundlich," says a German studio operator to his chained client, as he prepares to extract one of his teeth with a giant pair of tongs while the camera looks on (see McCulloch 1981). Oddly enough, under the heading of *The British Tradesman* (Sullivan 1880), someone deftly appropriated an item (Fig. 9-4a) that was not native to the Sceptered Isle at all; the essential characters in the cartoon first appeared in the April 1879 issue (p. 575) of the *St. Louis Practical Photographer*, under the title "Posing Quite an Art in Itself" (Fig. 9-4b). A brief text explains the winged thoughts in the air between master and client:

> What? Don't think the machine quite suits you? Not a natural pose? Would rather sit easily in an armchair, so? Oh, my dear sir, most preposterous! Wouldn't do at all. No ART in it. Oh dear, you'll excuse my laughing at the notion!

The grotesque appearance of various studio contraptions occupied not only humble operators in the Midwest but also the great and famous in the East. Thus, an editorial in *The Philadelphia Photographer* of 1867 (p. 82) describes an interview with Napoleon Sarony of New York during which the budding master of theatrical studio portraiture demonstrated his "posing machine": "We were very comfortable, and could keep still an hour in its pleasant embrace. The sensation is almost indescribable. It must be experienced to be fully realized." The editor describes it, nevertheless, at considerable length, and though he thoroughly approved of the device, he found a passing reference to the Tortures of the Inquisition irresistible.

The formidable Towler (1864), author of *The Silver Sunbeam*, had already given it as his opinion that headrests were absolutely essential in studio practice. Only a few years later, H. P. Robinson (1869) had some doubts, pointing out that, for the best results, "the rest should be moved to the head, not the head to the rest." By

1899, Emerson was able to write: "Head rests must be entirely taboo. We have taken many portraits, some with very long exposure, and no head rest was necessary. In nine cases out of ten, it simply ruins the portrait from an artistic point of view." Moreover, he goes on to say, "All artificial backgrounds should be banished, together with such stupid lumber as banisters, pedestals, and stiles; they are all inartistic in the extreme!" (Emerson 1899)

The posing chair was only one of the many baffling items in a studio; indeed, so complicated and mysterious was the whole procedure that photographers themselves were often suspected of failing to understand it and its needs (Fig. 9-5). And if photographers did not fully fathom the process, their clients could scarcely be expected to. Thus, a *Punch* cartoon of December 19, 1863, shows a lady in the studio tying her skirt round her ankles to make sure it doesn't fall when she appears upside down on the focusing plate. Understandably, cartoons dealt with the apparent absurdity of studio implements, but no humorist seems to have lampooned the almost provocatively sumptuous elegance of some of the principal establishments (for example, see Figure 8-3, and Daval 1982). In England, *Punch* regarded the caricaturing of photography as one of its special responsibilities, and accompanied its graphic offerings with elaborate captions and texts that readers found adroit and scintillating. These, however, now serve only to remind us that the psychological gap which separates the late twentieth century from the nineteenth is larger than we often care to admit. In retrospect (Jay 1989), it is clear enough that neither *Punch* nor any of its rivals succeeded in illuminating the essence of photography as such ("What's the difference between photography and whooping cough?"—"One makes facsimiles, the other makes sick families"), nor could such a thing have been expected, but caricaturists the world over said a good deal about the response of a naive public to new inventions that intruded into life. Photography was certainly one of those, and human

(a)

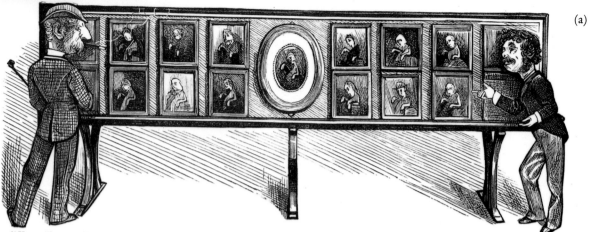

"You will notice," says the Photographic Artist, "the immense variety of the poses in my photographs. Quite an art in itself to pose the subjects ! I shall be able to make a first-rate picture of you !"

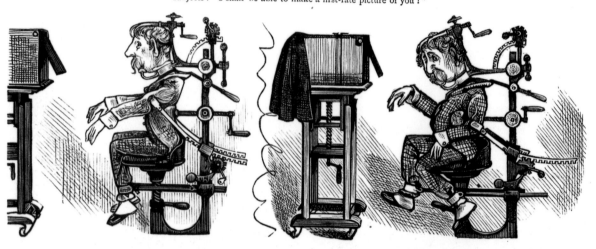

"You see, I place you first in my patent posing machine—that machine's quite an art in itself, too——."

"Then, by simply turning a handle or two, I screw you at once into a most natural and picturesque pose—quite an art. Put a little more contentment into the features, please."

"What? 'Don't think the machine quite suits you?' 'Not a natural pose?' 'Would rather sit easily in a chair, so?' Oh, my dear sir, most preposterous ! Wouldn't do at all ! No ART in it. Oh, dear, you'll excuse my laughing at the notion !"

7

(b)

POSING QUITE AN ART IN ITSELF.!

FIG. 9-4. Photographic Furnishings.

(a) A page from *The British Tradesman and Other Sketches*, by J. Sullivan (1880). Engraving by Balziel Brothers. *Fun*, the London publisher of the volume, also issued a weekly magazine each Tuesday for one penny.

(b) From the *St. Louis Practical Photographer*, April 1879, p. 515. Rare Books Room, Pattee Library, Pennsylvania State University. (Mann and Stelts 1990)

(c) Engraving in T. S. Arthur, *Sketches of Life and Character*, published in 1850 by J. W. Bradley, 48 North Fourth Street, Philadelphia. (Mann 1990)

(d) Gentle fun by Lucien Métivet (1892), showing a modern Leonardo in the process of posing Mona Lisa in a head clamp.

(c)

THE DAGUERREOTYPIST.

(d)

— Ne bougeons plus ! Dessin du L. Métivet.

FIG. 9-5. "The Difficult Instant." Cartoon by L. Métivet, from *Le Rire*, April 1902. The cake, in mid-career, is exhorted to keep still.

pretensions, rather than aesthetic theory, are the proper targets for the humorist's art.

People tend to be serious about matters that concern them deeply and, just because these are important, there is a need to step back and see them in perspective, including lighthearted perspective. At its core, humor is often a serious business. The didactic intent of photographic humor may be some way below the surface, but it is always there. A mining of its examples amounts to a mining of critical and popular attitudes toward photography, and can sometimes be more revealing than scrutiny of the printed word.

On the whole, inventors and inventions had "a good press" in the nineteenth century, but public approval was balanced by the conviction that old technology was better and more com-fortable to live with than new. If there was a sense in which photography occupied a special position in the company of other incomprehensible inventions, it arose from the fact that it catered not only to human aspirations but also to that most enduring of foibles, human vanity.

VANITY, OH VANITY

Never far behind the sheer absurdity of the photographer's equipment were the manifold uses to which all those paraphernalia were put, some well-meaning, some scatterbrained, some vulgar, all too many intrusive and frequently downright bullying, especially when it came to the "management" of studio clients (Figs. 9-6 and 9-7), who were supposed to look their best, rather than their typical selves. For photographic purposes, natural smiles and smiles induced by cunning were treasured alike. The *Fliegende Blätter* of 1891 shows a client of massive girth, induced to grin amiably in front of the camera while staring at a congenial image of beer and sausage, projected onto the wall by a photographer who knew his man. Of course, there are two sides to every conflict, and photographers saw themselves not as jackbooted bullies but as downtrodden victims (Fig. 9-8).

By the turn of the century, photography was an old story, and air travel was the stunning new marvel. In Figure 9-9 a French cartoonist has brewed a charming fantasy from both ingredients, borrowing the posing chair and head clamp from the nearest studio on terra firma. There is a debonair decorum in the relationship between photographer and client, a graceful give-and-take, in contrast to the usual battle for dominion. As in this case, cartoonists on occasion followed the photographer out-of-doors. Thus, for instance, the cartoon shown in Figure 9-10 appeared in 1901, when amateur photographers were swarming over the English countryside, in-

FIG. 9-6. "Saving Face." Caption: Artist(!) photographic: "You've rather a Florid Complexion, Sir, but (producing a Flour Dredger to the Old Gentleman's horror) if you'll take a seat, we'll obviate that immediately" (*Punch*, July 5, 1862). An extensive bibliography of *Punch* cartoons and verse on photographic themes has been prepared by Bill Jay of Arizona State University (Jay 1989).

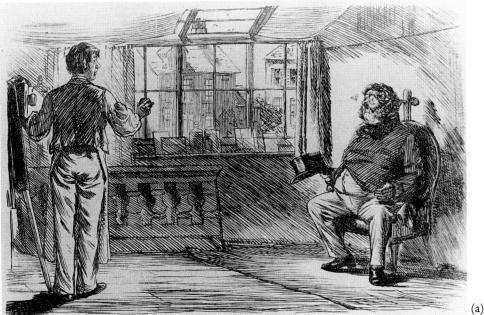

(a)

FIG. 9-7. Management of Clients by the Photographer.

(a) "Trying." Country photographer (removing Cap from the Lens): "Quite steady now, Sir, if you please." (Not so easy with a lively wasp threatening your nose.) *Punch*, May 6, 1865.

(b) "The Joys of Photography." Photographer about to make his fourteenth attempt: "Could you manage to look a little bit less dreary, Sir, just for half a second—not more!" *Punch*, August 28, 1886.

(c) Illustrated letter, sent by John Parry (1812–c. 1865), an English amateur caricaturist. From *The Illustrated Letter*, by Charles Hamilton (1987). Copyright Charles Hamilton; reproduced by permission of the author.

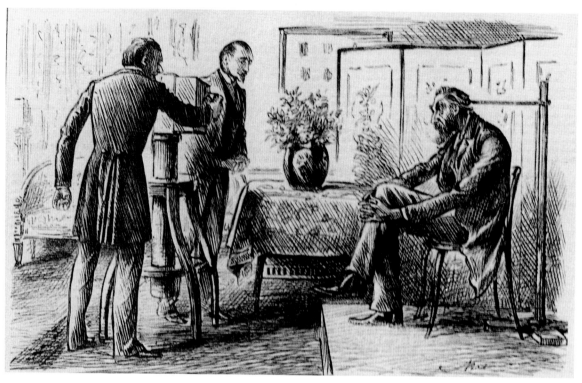

FIG. 9-7 (b)

(c)

FIG. 9-8. Management of the Photographer by Clients. Cartoon by V. Rotkirch of Lithuania (1854), referring to an episode in which the photographer was asked to daguerreotype the Company of Princes, only to run into assorted troubles with his clients, too high in rank to be marshaled and disciplined. Courtesy of Vilnius University Library. See also Juodakis 1977.

FIG. 9-9. Always Under the Sun. Color lithograph by Albert Guillaume (1873–1942) for a special issue of *L'Assiette au beurre* entitled "*À Nous l'Espace*" (no. 37, December 14, 1901, p. 574). (Mann 1989)

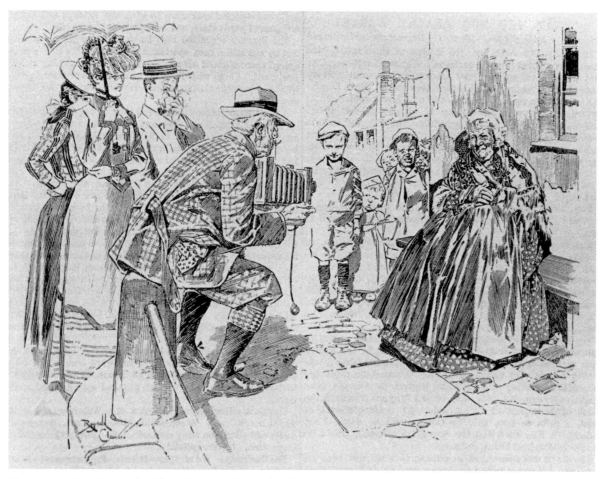

FIG. 9-10. Rural Record. "The Oldest Inhabitant (female) to Paterfamilias, who has taken to snapshooting and has been fiddling with his finder, and focusing, etc. for the last ten minutes: 'I can't hear what you be *a-playing*, Sir, being hard o'hearing, but thank 'e kindly, sir, all the same.' " *Punch*, May 15, 1901.

tent on recording every picturesque costume and custom of a vanishing way of life. Their model and inspiration was Sir Benjamin Stone (1838–1914), a Member of Parliament and an indefatigable photographer, who had founded the National Photographic Record Association for just this purpose in 1897. Within ten years, the efforts of the volunteer members of this society had produced over 4,000 prints for the British Museum's archives, and had inspired local photographic surveys all over the country. Stone's vision and enterprise are comparable with those of Sir Cecil Sharp in the collection of En-

glish folk songs during the same period (Wilsher 1981).

From the earliest days, photographers were proud of the fact that their craft could claim to represent a pursuit of truth, however much that claim had to be hedged with cautions. Since the truth was obviously a noble thing, how could its pursuer be anything but a noble creature? The notion of automatic nobility had a special appeal among photographers, who needed moral support in their competition with painters. "The camera cannot lie!" became a battle cry, but the double-edged nature of that slogan soon proved

to be embarrassing. If the camera couldn't lie, if it depicted "the truth, the whole truth, and nothing but the truth," then how could photography claim to be an art? From such simple origins grew a sophisticated debate that, in some forms, has survived to this day. So also have the illusions about truth; even modern photographers still nourish them occasionally. Certainly, members of the public tend to believe that whereas the camera can lie, it generally doesn't, or that, even if it does, it conveys an inner important truth that may be more significant than the outward falsehood. And because nothing escapes the sharp eye of the critic, car-

toonists were anxious to reveal just how easy it was for photographers to cheat, whether reporting events or presenting clients to their wider public.

Many cartoons (Fig. 9-11) are sarcastic comments on the tendency of professional portraitists to flatter their clients by bending truth to serve illusion. Indeed, photographers were regarded as recorders of truth everywhere except in the studio, where clients were convinced they had powers for good or evil. Dissatisfaction with the outcome was a favorite theme: "He has given me a stupid little turn-up nose, and a mouth that is absolutely enormous," says a customer in a

(a)

FIG. 9-11. The Truth but not the Whole Truth.
(a) "Artful," showing how the use of miniature furniture can give the appearance of a more "Imposing Stature in the Carte de Visite." *Punch*, January 18, 1862.
(b) "Art v. Nature." Sitter: "Oh, I think this position will do, it's natural and easy." Photographer: "Ah, that may do in ordinary life, Ma'am, but in photography it's out of the question entirely!" *Punch*, March 4, 1865.
(c) Illustration from H. P. Robinson's compendium on composition. Wood engravings. (Robinson 1869, p. 98)

ART v. NATURE.

FIG. 9-11 (b)

(c) *Fig. 3.* *Fig. 4.*

typical *Punch* cartoon, which shows her studying her own photograph and, at the same time, takes care to prove the operator blameless. In other instances, studio artists were expert in "reconciling" truth with expectation. Figure 9-11a suggests that miniature furniture might be used to make the client look impressive. However outrageous, the fancy represented only a small extension of what photographers were (and still are) routinely doing by other means. Thus, H. P. Robinson (1869), in his famous work on pictorial effects, devotes considerable attention to the ways in which a photographer can make a short woman seem taller than she is by taking the picture from a lower viewpoint (Fig. 9-11c). This kind of thing became a habit, so much so that in the studio, at any rate, Truth ceased to be King. Indeed, up to a point it ceased to matter altogether (Fig. 9-11b), which

prompts the recollection of a story, ascribed to Susan Sontag (1973), of a mother who is proudly showing someone her new baby. "What a lovely boy," says the dutiful friend. The mother can't leave it at that. "Yes," she says, "but you ought to see his photograph!" (See also Fig. 9-16.)

Figure 9-12 makes a superficially naive but inherently subtle point of how easily the truth can lend its services to the lie; on the right is the scene photographed, and on the left is the finished product, created by a photographer from Schwindeldorf, ever a promising place-name. The fact that the naked, unadorned truth can look quite different when viewed from unexpected angles and unusual distances was also addressed by the Keystone stereo card shown in Figure 9-13. The company felt it necessary to add a misguided, disingenuous, and excessively hopeful explanation (see caption).

FIG. 9-12. How they swindle in Schwindeldorf. Cartoon from *Fliegende Blätter*, 1906. Courtesy R. H. Krauss. See also Krauss 1978.

Fig. 9-13. Stereo card issued by the Keystone Company of Meadville, Pennsylvania. 1890s. Inscription on the back: "The picture on the reverse side of this card, which shows the feet entirely too large relative to the head, finally disproves the oft-repeated statement that the camera does not lie. When seen in the stereoscope, however, the feet are seen in their proper proportion. This proves that it is only the stereoscopic camera that can be relied upon for final accuracy."

HAREBRAINED GENIUS AND FLIRTATIOUS FRINGE

As photography became a familiar presence, the attention of cartoonists shifted gradually from the endlessly amusing peculiarities of the process as such to the human foibles displayed in the public's response to them. Photography became a context, rather than a subject. Within and without the studio, lofty pretensions made easy targets for low humor, and cartoonists had a happy time puncturing delusions of grandeur in photographer and client alike, raising gales of heartless merriment over the technical flaws of the incompetent and the practiced deceptions of the proficient. In any event, it was always good sport to poke fun at the photographer's ineptitude (Fig. 9-14a) and, indeed, lack of modesty. "I will bury Raphael, Titian and van Dyck," says the personification of photography, an irascible revolutionary in a Marcelin 1856 cartoon

(Fig. 9-14b). (See Stelts 1990 and also Palmquist 1980, as well as extensive surveys by Heyert 1979, Krauss 1978, and Scheid 1983.)

At all times, studio clients themselves provided ample copy for the humorist as, one by one, their hopes, fears, delusions, and vanities were held up for laughter (Figs. 9-15 and 9-16). Similar reactions to a portrait in oils or a sculpture in marble could have been mocked by cartoonists in any century, but photography was more widely accessible, and offered choice additions to the timeless anthology of human folly. As photography became cheap and available to all, completely new figures appeared for the indulgent amusement of middle-class viewers: the lower orders as patrons of the arts (Fig. 9-15). Any photographic crook could lure the naive into the studio, as Henry Mayhew described so vividly in his *London Labour and the London Poor*, a survey of the 1850s (see also Chapter 8). Clients could be just as devious.

(a)

(b)

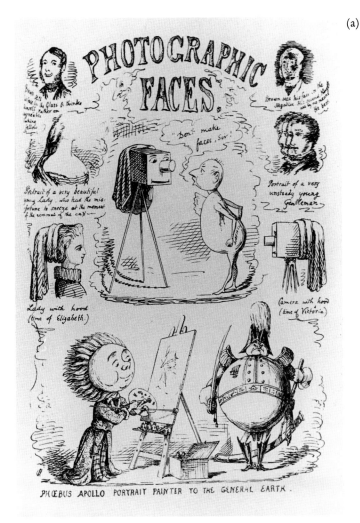

FIG. 9-14. Photographic Faces.
(a) Cartoon from *Photographic Pleasures, Popularly Portrayed with Pen and Pencil*, by Cuthbert Bede (Rev. E. Bradley), London, 1855.
(b) Cartoon by Marcelin, *Journal Amusant* (1856), no. 36, p. 3. Courtesy of the Library of Congress.
(Stelts 1990)

Adam (1986) reports on a cartoon published in *Schorers Familienblatt* of 1888, in which a helmeted soldier, evidently off duty, has a joint portrait taken with his girlfriend. She faces the camera, but he has been made to turn his back to it. A ponderous caption, in Viennese dialect, explains that the pretty maid has many lovers in the ranks, all wearing the same uniform; rather than having a portrait taken with each, she finds that great economies can be achieved by posing for a single picture while preserving the facial anonymity of her admirers.

From the beginning, people marveled over the amount of detail in a photographic portrait.

Every fold of a dress, every line in a face, was captured by the miraculous new machine, which made the apparent passivity of the photographer ("What did he actually do, and how was what he did connected with the final result?") all the more baffling. To achieve such effects, a painter would have to strain every nerve, but that mysterious rival, the photographer, seemed to spend most of the time waiting while the magic box did its secret, silent work.

The fact that portraits were so sharply realistic in most respects made their total lack of color disconcerting (Fig. 9-17a). The exquisite, moonlit world of the photograph, so admired today as

ENCOURAGEMENT OF ART.

FIG. 9-15. Encouragement of the Arts, from *Punch*, July 27, 1867.

First curled and powdered Darling (to photographer): "You'd better take pains with these 'ere carte-de-visites, as they'll be a good deal shown."

Second curled and powdered Darling (on the sofa): "Yes—pertiklerly in the Hupper Suckles [upper circles]—get you customers, you know."

PHOTOGRAPHING THE FIRST-BORN.

FIG. 9-16. Photographing the First-Born. From *Punch*, July 15, 1876.

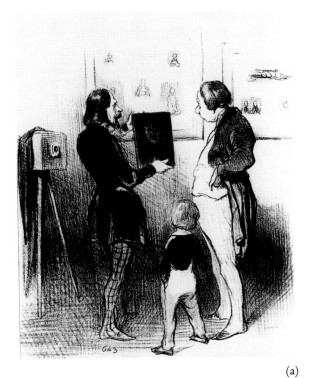

(a)

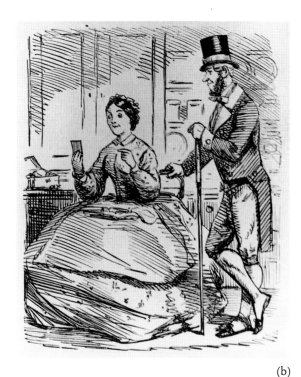

(b)

Fig. 9-17. The Photograph—off-color.
(a) From *Charivari* (Paris), cartoon by Honoré Daumier, 1844.
(b) From *Punch* (London), July 20, 1861.
Mary: "Why, Tummas, it's the very Moral of yer!"
Tummas: "Pretty thing, ain't it. Pity the yaller of the uniform comes so black!"

an abstraction from reality, seemed drained of all vitality at the time it first burst upon the public, with images eerily blanched when overexposed, and ludicrously blackened when exposures were insufficient. In Figure 9-17b, Mary is looking at a portrait of Tummas, who had presented himself to the camera proudly wearing his yellow footman's jacket, which, in the finished picture, was rendered black. She knows she is not expected to be critical, but both would have loved it if the glory of his livery had been more faithfully depicted. In the circumstances, the temptation to warm pictures into life became irresistible, and the hand-colorist was soon at work, adding a touch of pink to a cheek, a dash of gold to a cherished ring (see also Chapter 4). In a much earlier cartoon comment, which appeared in *Charivari* in 1844 (Fig. 9-17a) on the theme of excessive blackness, the client says: "I

have been under the sun for only 3 seconds, but look as if I had been exposed for 3 years." Still, he goes on to say, his wife likes it that way and, in such circumstances, who would want to quarrel with the shortcomings of photography? "Don't you think," says a lady in a German 1880 cartoon, "that I look rather silly in this picture?" "Oh, I think it is a brilliant photograph," replies her husband with enigmatic charm (Scheid 1983). And just as if to prove that some humor travels, however much one might regret it, *Punch* of 1901 follows up with a dialogue between a beauty past her prime and a younger man. "I am afraid it's rather faded" brings forth a heartless "Yes, but it's just like you." *Punch* takes pains to soften the blow: the answer stems from the young man's inexperience, not from malice. It would not be altogether simple to invoke the same explanation for:

(a)

(b)

FIG. 9-18. From *Photographic Pleasures, Popularly Portrayed with Pen and Pencil*, by Cuthbert Bede (Rev. E. Bradley), London, 1855.
(a) Title page.
(b) "Mon. Daguerre introduces his Pet [sun; son] to Mr. Bull [the symbol of staunchly conservative and common-sense England]."

Photographer with elderly female client: "The negative is simply superb. Now—er—how many years back would you like to have it retouched?"

In one way or another, more often than not, expectations and results were indeed at odds with one another. "Honor the photographer," pleaded Wilhelm Busch in 1865, "he can't help it." Indeed, he had problems of his own, eloquently expressed a few years earlier by *Punch* (October 9, 1858), in an Ode to Apollo (Day 1984):

Oh, monarch of the Muses and the Graces,
Down on this earth a moment cast thy gaze,
And see what foolish, vulgar, snobbish faces
Those fellows to portray compel thy rays.
The silly smirk, the grin of vacant folly,
The sensual mouth, low front and snubby nose,
The leering eye, or maudlin melancholy,
Of pert, affected, Cockney belles and beaux.

At times, discontent acquired a legal dimension:

> A man sued a London photographist for the price paid for two *cartes de visite*. He told the court that he had sat for seventeen days, and the only result was one picture that made him look as if he was going to be hung. The court gave him its sympathy, and the artist had to give him his money. [*Pittsburgh Morning Post*, December 2, 1863; Weprich 1991]

One of the notions that appealed to the photographer and his public, right from the earliest days, was that of the sun behaving, through photography, as if it were a painter in its own right (Fig. 9-14a; see also Chapter 7). The man responsible for this drawing was Cuthbert Bede or, to give him his proper name, the Rev. Edward Bradley. Bede was a clergyman who found his pastoral duties less than totally consuming. At any rate, he found time to draw cartoons for *Punch* and to incorporate them in a book,

Photographic Pleasures (1855), which has proved to be a gold mine for generations of photohistorians. In his cartoon of the Sun as an artist, he shows the heavenly body actually at work in front of the easel, painting the world. The sun took on that role because it was dissatisfied with the work of painters on earth, who had to be taught a lesson. Bede played with the idea again in the design of the title page of the book (Fig. 9-18a). The sun is not, here, making the picture directly, but the photographer is very conscious of its controlling force, as well as of the weighty equipment inflicted upon the devotee. In yet another variation (Fig. 9-18b), the sun has been demoted from artist to assistant. The photographer shown by Bede in this sketch is M. Daguerre himself, and the man to whom he introduces "his sun" is Mr. Bull, by tradition, since the early eighteenth century, the comic personification of England.

In a class by themselves are images that may or may not have been intended as humorous but that strike us now as such. Figure 9-19 gives an

FIG. 9-19. Engraving from an essay by A. Londé, which appeared in an issue of the *Scientific American* of December 30, 1893, illustrating chronophotography at the Salpêtrière mental asylum, outside Paris. (Wolf 1990)

(a)

FIG. 9-20. Ingenious Jones at work. Cartoons from *Punch*, October 24, 1868.

(a) "Happy Thought." "Ingenious Jones sits for his portrait to a peripatetic photographer and, cunningly, places himself exactly between the apparatus and the unconscious Oriana, whom he worships at a respectful distance, and whose likeness he would like to possess."

(b) "Ingenious Jones's Happy Thought's Result."

(b)

example, an engraving taken from *Woodbury's Encyclopedic Dictionary of Photography* (1896). Woodbury himself took it from an 1893 issue of the *Scientific American* (Wolf 1990; Woodbury 1896), which connects it with chronophotographic experimentation in a French mental asylum. Some technical equipment can be seen, but cool, dispassionate, and painstaking "research" is not actually a notion strongly conveyed by the image. Its original purpose remains unclear, but we can enjoy it now as an example of the heroic posturing before the camera that was popular in studios throughout the world, and that gave studio photography itself some of its theatrical flavor. (See also Figure 2-6.)

Beyond the confines of the studio, photography was a hobby enjoyed by men and women. Both sexes loved the magic, the happy dabbling, the irresistible vocabulary. Shared enthusiasm led to intimacy, and neither side was slow to sense the possibilities for flirtation offered by picturesque places, photographic picnics, black cloths, and the basic fact that dark-rooms were, above all, dark rooms (see Chapter 15). When amateur photographers first burst upon the scene in the 1870s and 1880s, cartoonists used the fashionable motifs to pump new life into old stories, stories of dashing lovers, coquettish young wives, and tedious husbands. In Figure 9-20 (a and b), we have another favorite theme. Ingenious Jones, a cad if there ever was one, is having his picture taken in such a way that the lady he worships will be included in the print, whether she likes it or not, on no better grounds than "All is fair in love and war." And even the professional can turn to desperate photographic word-play, when all else fails (Fig. 9-21).

THE WORM TURNS

If it was inevitable that photographers had to become the butt of the cartoonists' art, it was equally natural for photographers themselves to try their hand at using the camera for comedy.

FIG. 9-21. Artist (in despair): "Cruel Girl! For years I have tried to photograph your image in my 'eart—and all I get is a 'negative.' " *Punch*, September 25, 1886.

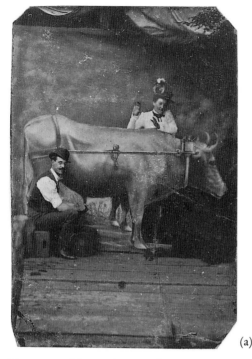

(a) (b)

FIG. 9-22. Tintype humor of the 1870s. American. Unknown photographers. 3½ × 2½ inches.
 (a) Milking the studio cow.
 (b) Photography at the Fair.

FIG. 9-23. Photomontage Christmas roundel of 1883. American. Albumen print, 4 inches diameter. The initials stand, presumably, for some collegiate or fraternal association, not yet identified. The emphasis is evidently on hobbies.

None of the early examples (see Fig. 9-22) would have made a Daumier feel threatened by new-born rivals. Amid the photographed drawings and laborious studio setups, most of these products rely on the simple humor of the board-walk and the carnival. Cheerful victims beam for friends from peepholes cut in painted bodies in unlikely settings. Just occasionally there is a reference to collegiality (Fig. 9-23), albeit achieved with the same techniques, and, even more rarely, an attempt at a real character sketch (Fig. 9-24).

In most cases, photomontage simply added to the harmless pleasures of a summer outing, but it was also used, with considerably more sting, to make political points about public figures (see Chapter 12). From these tentative beginnings grew the black comedy of such twentieth-century masters of the art as John Heartfield, Paul Citroen, George Grosz, Marcel Duchamp, and Francis Picabia (Ades 1976). Buchloh (1989) refers to "the relatively late discovery" of photomontage, but that discovery was anything but late; indeed, its invention will just have to be ascribed to Fox Talbot himself, who in 1839 made an image of an oak leaf with an engraving of Christ's head superimposed (Lassam 1979). Within the realm of darkroom bravado, humor, and politics, outstanding nineteenth-century successes are on record, notably the work of Sir Edward Blount (1870s), whose pre-surrealist compositions were aeons ahead of their time (see Gernsheim 1962), and helped to shape modern notions and expectations of photographic caricature.

* * *

Fun at the expense of the photographer's foibles and the client's follies was a staple on the cartoonist's bill of fare. Now and then, this bland diet offered to the public was brightened with a touch of spice, when some other aspect of the story caught the eye of the attentive observer. Two or three threads in the tapestry already examined in the pages of this book were held up to the light for all to see. Thus, "Mr. Punch" was

FIG. 9-24. Carte-de-visite montage-caricature of a bookkeeper, c. 1870s. American. Unknown photographer.

well aware that operators often combined photographic business with other occupations (see Chapter 7); in the November 14, 1857, issue, an entrepreneur on the street offers to take pictures of clients while he shines their shoes. "Mr. Punch" found the combination of High Art and Low Life incongruous although, as every photohistorian knows, there is indeed a link between photography and boot-polishing. The only human figures in Daguerre's famous picture of a Paris street are the two who stayed still throughout the long exposure: the shoeshine man and his top-hatted customer.

Photography's crucial dependence on good weather was mocked by the creator of a cartoon that appeared on January 21, 1871. London had been muffled in one of its (then) notorious midwinter fogs, and photographers are shown beg-

ging for handouts because no pictures could be taken. Another cartoon, this time made by George du Maurier for the January 6, 1883, issue of *Punch*, gently derides the convention that every important moment in life, whether public or private, must be recorded by the camera. In this, a proud shopkeeper poses for posterity with his magnificent display of pork and poultry, in a group portrait caught by a street photographer (Hallett 1991).

Every dramatic new turn in photography's path was fair game for the humorist. By 1881, Eadweard Muybridge's pioneering studies of horses in action, made during the previous decade, had become a fashionable topic for magazine articles and private debate. Inspired by this interest, in the June 18 issue of *Punch*, a cartoonist goes to the races at Ascot, and shows just how confusing a "photo finish" can be. In 1896, X-ray photography was the sensation of the hour, and *Punch*, on January 15, presented the German Kaiser gloomily frowning over a picture of John Bull's unbending backbone. In 1901, the kaleidoscope had turned again, and the subject in focus was underwater camera work. Once more, "Mr. Punch" was quick off the mark; on December 18 he had climbed into a diving suit and was caught in the act of photographing the prettiest mermaid on his beat (Fig. 9-25).

FIG. 9-25. "Catching a Mermaid: Submarine Photography Is Now Possible." Cartoon from *Punch*, December 18, 1901, p. 450.

Time has taken its toll; not one of these cartoons, on any photographic theme, seems irresistibly amusing today, and yet, however long-winded and heavy-handed it may be, each has at its core a kernel of truth, a glimpse of the issues and attitudes that shaped society's response in the first sixty years of photography's existence.

Chapter 9 References and Notes

ADAM, H. C. (1986). "Humour from Schorer's Familienblatt," *History of Photography*, vol. 10, no. 2, p. 168.

ADES, D. (1976). *Photomontage*, Thames & Hudson, London.

ALTICK, R. D. (1978). *The Shows of London*, Belknap Press of Harvard University Press, Cambridge, Massachusetts, and London, p. 117.

ANON. (1839). *Schweizerischer Beobachter*, February 16, Bern, Switzerland.

ANON. (1937). "Daguerre's übersehenes Papiersubstrat Photographier-Verfahren von 1826–1839," in *Photographische Korrespondenz* (Vienna), March.

BALZAC, H. de (1847). *La Comédie Humaine: Le Cousin Pons*, Bibliothèque de la Pléiade, Paris.

BEDE, C. (Rev. E. Bradley) (1855). *Photographic Pleasures, Popularly Portrayed with Pen and Pencil*, T. Mc'Lean, London.

BIOT, M. (1839). *Comptes Rendus des Séances de l'Académie des Sciences* (Paris), January–June, p. 246.

BREWSTER, Sir D. (1832). *Natural Magic*, John Murray, London, letter 4, and p. 350.

BROUGHAM, H. (1871). *The Life and Times of Henry Lord Brougham, written by himself in three volumes*, vol. 1, William Blackwood & Sons, Edinburgh and London, pp. 69–70. (The present authors are indebted to Mr. Geoffrey Batchen for

drawing their attention to this publication.)

BUCHLOH, B. H. D. (1989). "From Faktura to Factography," in *The Contest of Meaning* (ed. R. Bolton), MIT Press, Cambridge, Massachusetts.

BUNNELL, P., and SOBIESZEK, R. A. (Editors) (1973). *The Wonders of Light and Shadow*, reprint of 1851 edition, Arno Press, New York, p. 105.

DAVAL, J.-L. (1982). *History of an Art: Photography*, Skira/Rizzoli, New York, p. 52.

DAY, D. (1984). Personal communication, acknowledged with thanks.

EDER, J. M. (1945). *History of Photography* (trans. E. Epstean), Columbia University Press, New York, 1978 reprint by Dover Publications, New York. Both volumes based on the author's original *Geschichte der Photographie* (1905).

EMERSON, P. H. (1899). *Naturalistic Photography for Students of Art*, Scovill & Adams, New York, 1973 reprint by Arno Press, New York, book 2, pp. 66–67.

FREUND, G. (1968). *Photographie und bürgerliche Gesellschaft*, Rogner & Bernhard, Munich.

GERBER, A. F. (1839). *Schweizerischer Beobachter*, February 2, Bern, Switzerland.

GERNSHEIM, H. (1962). *Creative Photography*, Faber & Faber, London, p. 195.

HALLETT, M. (1991). Personal communication, acknowledged with thanks.

HAMILTON, C. (1987). *The Illustrated Letter*, Universe Books, New York.

HAWORTH-BOOTH, M. (1992). *Camille Silvy: River Scene, France*, Getty Museum Studies in Art, Malibu, California, p. 70.

HEYERT, E. (1979). *The Glasshouse Years: Victorian Portrait Photography, 1839–1870*, Allanheld & Schram, Montclair, New Jersey.

HRABALEK, E. (1985). *Laterna Magica: Zauberwelt und Faszination des optischen Spielzeugs*, Keyser, Munich.

JAY, B. (1989). "Comprehensive List of Prose, Verse and Caricature Relating to Photography in Punch, 1844–1910" (unpublished). Personal communication, acknowledged with thanks.

JOSEPH, S. F., and SCHWILDEN, T. (1990). "The First Daguerreian Studios in Brussels," in *The Daguerreian Annual*, The Daguerreian Society, Lake Charles, Louisiana, p. 93.

JUODAKIS, V. (1977). "Early Photography in Eastern Europe: Lithuania," *History of Photography*, vol. 1, no. 3, pp. 235–47, fig. 1.

KOLLOW, W. (1987). "Daguerre's Versuche mit lichtempfindlichen Papier," *Photo-Antiquaria Special*, Club Daguerre, Darmstadt.

KOSSOY, B. (1977). *Hercules Florence, 1833: A descoberta isolada da Fotografia no Brasil*, Faculdade de Comunicação Social Anhembi, São Paulo, Brazil.

KRAUSS, R. H. (1978). *Die Photographie in der Karikatur*, Heering Verlag, Seebruck-am-Chiemsee, Germany, pp. 8, 11, 14, 72.

LASSAM, R. (1989). *Fox Talbot, Photographer*, Compton Press, Tisbury, Wiltshire, U.K.

MANN, C. (1989). "Always Under the Sun," *History of Photography*, vol. 13, no. 1, p. 18.

MANN, C. (1990). Personal communication, acknowledged with thanks.

MANN, C., and STELTS, S. (1990). Personal communication, acknowledged with thanks.

McCULLOCH, L. W. (1981). *Card Photographs: A Guide to Their History and Value*, Schiffer Publishing Co., Exton, Pennsylvania, p. 159.

PALMQUIST, P. (1980). "Photography as Seen by Caricaturists in Harper's New Monthly Magazine," *History of Photography*, vol. 4, no. 4, pp. 325–28.

PEPPER, J. H. (1863). in *Peterson's Familiar Science*, Christopher Sower Co., Philadelphia, p. 512.

ROBINSON, H. P. (1869). *Pictorial Effect in Photography, Being Hints on Composition and Chiaroscuro for Photographers*, Piper & Carter and Marion Co., London, pp. 97–98. (For better or for worse, the book became highly influential. It was followed, in due course, by a collection of essays on landscape photography [Robinson 1888], with a photogravure of the author as the frontispiece.)

ROBINSON, H. P. (1888). *Letters on Landscape Photography* (reprinted from *Photographic Times*), Scovill Manufacturing Co., New York.

SCHEID, U. (1983). *Als Photographieren noch ein Abenteuer war*, Harenberg Kommunikation, Dortmund.

SCHWARZ, H. (1985). *Art and Photography: Forerunners and Influences* (ed. W. E. Parker), Peregrine Smith Books, Layton, Utah.

SMITH, G. (1990). Personal communication, acknowledged with thanks.

SMITH, G. (1991). "Talbot and Amici: Early Paper Photography," *History of Photography*, vol. 15, no. 3, pp. 188–93.

SONTAG, S. (1973). *On Photography*, Farrar, Strauss & Giroux, New York.

SPETER, M. (1937). "Photohistorica antiqua nova varia," *Photographische Korrespondenz*, vol. 73, no. 3, p. 33.

STELTS, S. (1990). "À bas la Phothographie!!" [*sic*], in *Shadow and Substance: Essays on the History of Photography* (ed. K. Collins), Amorphous Institute Press / University of New Mexico Press, Albuquer-

que, New Mexico, pp. 225–28.

STENGER, E. (1938). *Die Photographie in Kultur und Technik*, Verlag E. A. Seemann, Leipzig.

SULLIVAN, J. (1880). *The British Tradesman and Other Sketches*, Fun Office, 153 Fleet Street, London.

TILLMANS, U. (1981). *Geschichte der Photographie*, Verlag Huber Frauenfeld, Stuttgart.

TOWLER, J. (1864). *The Silver Sunbeam*, Joseph H. Ladd, New York, 1969 reprint by Morgan & Morgan, Hastings-on-Hudson, New York, p. 25.

WEPRICH, T. M. (1991). Personal communication, acknowledged with thanks.

WILSHER, A. (1981). "Rural Record," *History of Photography*, vol. 5, no. 4, p. 338.

WOLF, E. (1990). Personal communication, acknowledged with thanks.

WOODBURY, W. (1896). *Encyclopedic Dictionary of Photography*, Scovill & Adams, New York.

10

CAMERA IN COURT

OPENING SKIRMISHES

Photography has been a legal battleground from the first, and a comprehensive overview of such controversies remains to be written. Meanwhile, there is no shortage of accounts of individual skirmishes that helped to establish the business climate in which the profession was conducted during the early years. Heathcote (1978) has described the case Richard Beard brought against Thomas Barber, a painter, who set up a daguerreotype studio in Nottingham, England, in 1841. In a front-page newspaper article, Barber announced not only that he was able to make daguerreotypes, but also that he would do so "by an improved process," the nature of which was left unspecified. At the time, Beard was the "sole patentee" of the daguerreotype in England (*pace* Claudet). Barber had not ignored Beard; indeed, he had agreed to pay him £1,200 for a license to operate the studio in Nottingham but, after making the down payment, found himself unable to come up with the rest of the money; business had been poor. Beard saw no extenuating circumstances in that fact (which, as such, he did not contest), and promptly sued Barber in 1843. The court granted an injunction against Barber's operation. No profound principle,

FIG. 10-1. The Photographic Detective, from *Photographic Pleasures*, by Cuthbert Bede (1855).

other than competitive greed, was involved, and no new concepts were generated by the case (which has been further documented by Wood 1979), but the story is symptomatic of the ferocity with which battles were fought and positions defended.

More astonishing is the fact that cities themselves often remained sensitive to the presence of photographers for much longer than would appear reasonable. Thus, the Earl of Lincoln (1864–1928) is known to have formally applied to the city of Paris for permission to photograph its woods, parks, and squares, as late as 1891 (Heathcote 1985). (One might with a degree of puzzlement recall that even now photography is still prohibited in the New York subway system.)

In histories of photography, minor battles

are, of course, overshadowed by the dramatic cases of Talbot versus Laroche, and Goodwin versus Eastman, which did, indeed, have a profound effect on developments, social as well as technical. A very substantial literature exists on both. Talbot patented his calotype process in 1841, and in subsequent years threatened explicitly all who attempted to take photographs (other than daguerreotypes) for profit, and implicitly all who attempted to take them for pleasure (Gernsheim 1969). He did obtain an injunction against a London professional, James Henderson, in May 1854, but Henderson contested the verdict. That particular matter was never resolved, because Talbot versus Laroche took center-stage later in the same year. Sylvester Laroche, a French Canadian, had likewise been served an injunction, not one prohibiting his use of the calotype, but one directed against his use of the collodion process. Talbot never claimed to have invented *that*, but he considered that after inventing *photography* as such the whole generic negative-positive process was covered by his patent. In *The Photographic Journal* of June 27, 1854, Laroche wrote: "It is my intention to resist such application to the utmost of my power, and in so doing I trust that I may meet with the wellwishes and support of all who are interested in the art of photography." Those "wellwishes" were abundantly with him, but the purses of well-wishers were not; a fund opened in his support failed to cover the court costs (Gernsheim 1969). On December 20, 1854, the jury acknowledged that Talbot was the inventor of the calotype, and that he had been the first to publish this specific process, but they refused to find Laroche guilty of any material patent infringement. By implication, the court denied Talbot's claim to a *generic* invention. It made patent law thereby, rejecting the very notion of generic protection. Henceforth, only specific methods of manufacture could be patented. That was the court's greatest legacy, not only within the realm of photography, but also in far-reaching ways outside it.

Talbot had the right to apply for a renewal of his calotype patent in 1855 but, in view of the court's verdict, did not. Photography was thereby freed from legal shackles, "for ever," as vainly hoped by professionals and amateurs alike, but new and varied battles were in fact ahead, among them the titanic fight of the Goodwin Film & Camera Company against Eastman Kodak. That case began in 1902 and dragged on for some twelve years. This particular contest, like Talbot's, revolved around patent rights and patent practice, not forgetting the influence that powerful interests managed to exert on both (Taft 1938; Ackerman 1930; Schütt 1985).

FORENSIC FOCUS

As one might guess, not all brushes with the law took place inside the courtroom; from the beginning, photography was also heavily involved in the collection of evidence and the apprehension of suspects (Fig. 10-1). Indeed, even before photography's official birth in 1839, the humble *camera obscura* had served that purpose. A report of such an occurrence during the Glasgow Fair Week of 1824 appeared in a local journal:

A person happened to be examining, with great interest, the various lively and ever-shifting figures which were portrayed upon the white tablet during the exhibition, when he beheld, with amazement, the appearance of a man picking another man's pocket. Perfectly aware of the reality of this appearance, he opened the door and, recognizing the culprit at a short distance, ran up and seized him in the very act of depredation. It is, perhaps, unnecessary to add that he was immediately handed over to the Police. From this circumstance, the utility of placing such apparatus in all places of public amusement and exhibitions must be

obvious. Whether it might be proper to erect it in the streets of a populous city like this, and to place it under the inspection of an officer for the detection of mischief and crime is a matter worthy of the consideration of the local authorities. [Anon. 1824]

The report goes on to say that it might even be possible to communicate the observations to police headquarters by means of the telegraph. Then, "if any impropriety or misconduct were observed, it would only be necessary to send a posse to the particular spot where it happened."

Talbot himself suggested that the camera's ability to record (using ultraviolet light) what goes on even in darkness might be put to good use. Despite the brilliance and originality of his mind, he was unable to foresee that the age of the detective story was about to dawn; he ended his brief note with a sigh: "Alas! that this speculation is somewhat too refined to be introduced with effect into a modern novel or romance; for what a *dénouement* we should have, if we could suppose the secrets of the darkened chamber to be revealed by the testimony of the imprinted paper" (Talbot 1844). Less than twenty years later, the camera had become an agent of justice on stage. In Dion Boucicault's play, *The Octaroon*, dated 1859 and produced in 1861, the villain is caught in the act of murder by a self-activating camera, and the hero exults over the proof in the developed print: "The camera cannot lie!" (Stelts 1991).

In the real world, as early as November 1841, a German police report (quoted by Stenger [1938], without identification of the source) mentions the employment of a special daguerreotypist, whose job it was to "record the faces of thieves and crooks for eternity." Somewhat later, it was a happy idea of the Paris police to photograph thieves with their *corpora delicti*; Skopec (1963) shows an irresistible 1890 portrait of a young offender with a fat goose tenderly tucked under his arm. Another practice was to photograph suspects and criminals holding a

FIG. 10-2. Top hats on location. (a)
 (a) Sketches in Newgate [prison], from *Illustrated London News*, February 22, 1873.
 (b) Hat Trick. Detective camera for 9 × 12 cm. plates. (Le Docte 1888; Gidal and Spear 1987)

(b)

mirror close to their faces, so that the resulting image would show them in profile as well as from the front. For the rest, and to a remarkable degree, police photographs followed the practices and mannerisms of ordinary studio photo-

graphy; even the official Newgate prison photographer, not to mention the official Newgate prisoner, favored the much-loved top hat as an accessory (Fig. 10-2). By the 1870s, police "mug-shots" were frequently taken (Fig. 10-3), for records and "Wanted" notices.

Under the heading "The Collartype; or, Sun Pictures of Scoundrels," an April 30, 1853, issue of *Punch* had already carried a poem about the indignant reactions to the whole process that might come from its potential "clients." The piece contains a passing reference to *Punch*'s rival, *The Illustrated London News*, and is full of concern for the integrity of photography on the one hand, and wanton misapplications of sunlight on the other:

> A VULGAR print has just come out,
> To aid the low detective scout;
> Appealing chiefly to the eye:
> The *Illustrated Hue and Cry*.

Name, *Elmer B. Scott*
Alias, *C. C. Ellis*
Crime, *Horse Thief*
Age, *28* Color, *White*
Born, *Providence R. I.*
Trade, *Painter*
Read, *Yes* Write, *Yes*
Married, *Yes* Build, *Stout*
Height, *5—8* Weight *135*
Hair, *light* Eyes, *Blue*
Nose, *straight* Face, *Mustache*
Complexion, *light*
Marks, *Face freckled*
Officer,
Date of Arrest,
Remarks, *Wanted by*
District Police Michigan
Northampton Mass

FIG. 10-3. Mug shot, with crime record on the verso. Carte-de-visite by unidentified New England photographer. 1860s–1870s. Elmer B. Scott, alias, was allegedly a horse thief.

The object of this journal base
Is to facilitate the chase
Of gentlemen, for whom the air
Is warmer than their health can bear.

To coarse descriptions not confined,
Which are most personal in kind,
Your portraits also it appends,
Or superadds to them, my friends.

This periodical—excuse
The literary slang I use,
Strange in our fashionable haunt—
Is issued to "supply a want".

That is, in short, should you, or I,
From legal persecution fly,
'Twill circulate the stations round,
That we, the Wanted, may be found.

And—can you fancy any one
So void of taste?—the very Sun

Its soulless publishers degrade
The common Constable to aid!

Grave as the fact is, one might laugh
Almost, to see the photograph
So ignominiously applied,
To serve as the Policeman's guide.

The likeness most correct you'd deem.
Indeed, 'tis rather too extreme;
The least obliquity it shows
Of eyes converging to the nose;

The faintest lines our feelings trace
On our characteristic face;

The cast that to the visage cleaves
Of those called harshly, Rogues and
 Thieves.

Oh, Sects! for mastery that fight,
And do obscure a deal of light,
Would you could intercept the rays

Whose pencil thus the Prog betrays!

(By a Gentleman of the Predatory Profession)

The first public suggestion to enlist photography systematically in the "war against crime" (as it was not yet called) is often attributed to Ernest Lacan (1856), who pointed to the prospect of reducing recidivism in this way. He also claimed that such practices were already common in England. Common or not, it is true that they were used from the earliest days of photography, not only in England but also (probably unbeknownst to Lacan) in France itself, a fact documented in an engaging brief survey by B. and P. Heathcote (1990). Indeed, the whole idea was very much in the air. Cuthbert Bede (1855) refers back to chapter 40 of Dickens' *Pickwick Papers* (1837), in which Mr. Pickwick's face was inspected with intrusive care as he entered jail. In this way, Mr. Pickwick's appearance was carefully memorized by his warders. Dickens, writing in the antediluvian, pre-photographic era, described the ritual as "sitting for your portrait" and "having your likeness taken." Bede, in the 1850s, chose a fashionable new phrase for the same process: "taking mental daguerreotypes." (See also Chapter 1.) The expression was amusing, but not intended to be highly specific; the daguerreotype was not the only police weapon of choice. Thus, the faces of two poachers caught near Nottingham on March 25, 1869 were recorded on an ambrotype (Spira 1991).

Daguerreotypes of apprehended criminals had been taken at least from 1841 onward, when an English newspaper commented on the fact that "Mons. Daguerre never contemplated such an application of his *types*" (Anon. 1841). A celebrated 1850 case involved a particularly horrible murder of a woman in South Wales, for which Patrick Sullivan and Maurice Murphy were tried and hanged. A French daguerreotypist, who happened to be active in the town of Newport, was engaged to photograph them in jail and was allowed a mere quarter of an hour to complete the task. A picture of the two men in chains was later widely circulated in the form of an engraving, mostly to satisfy people's morbid curiosity about how brutal murderers really look. B. and P. Heathcote (1990) also document some of the measures that were taken to prevent prisoners from frustrating the photographer by moving or pulling faces (Anon. 1862). An obstreperous prisoner would be simply invited to watch a compliant one being photographed, and, while doing so, would, be caught himself, unawares, by another camera. Pritchard (1882) gave an account of photographic procedures used in London's Pentonville prison, from the moment "clients" entered the studio to the moment of truth.

The Pentonville proceedings were essentially private and, in the light of events recorded elsewhere, that was wise and circumspect. In contrast, the municipal jail in Pittsburgh, Pennsylvania, had no such facilities:

The Murderers Daguerreotyped—Charlotte Jones, Henry Fife and Monroe Stewart were taken yesterday to a daguerrean gallery, and had their likenesses taken. The pictures are in the possession of Mayor Weaver and Jailor [*sic*] Philips. To avoid trouble in getting through the crowd that did assemble, and prevent any excitement, Mayor Weaver had the prisoners brought down yesterday morning and locked up in the tombs. [*Pittsburgh Morning Post*, May 8, 1857]

Mayor Weaver was persistent, and by 1863 the August 22 *Pittsburgh Morning Post* was able to report:

The rogues' gallery at the Mayor's office contains the photographs and daguerreotypes of one hundred professional thieves, pickpockets, burglars, of which eight are women.

Indeed, a few years earlier (*Pittsburgh Morning Post*, September 27, 1855), Mayor Weaver had placed his Rogues' Gallery, of which he was evidently very proud, at the disposal of a county fair. "This is a good idea," the newspaper declared, "as it will give many strangers visiting there a knowledge of the general appearance of the thieves, pickpockets, etc, which infest the country, and place them on their guard against them." The basic theory that faces reflect character in a readily readable way, was manifestly fashionable, more than three decades before the venerable Dr. Bowditch made spectacular use of it (see Fig. 2-28). On another occasion, the Mayor's Office is on record as having displayed a series of stolen ambrotypes, hoping that someone might come to claim them (*Pittsburgh Morning Post*, June 13, 1860; Weprich 1991a).

Pittsburgh, always less prominent in the photographic realm than Philadelphia, Boston, or New York, gained fame nevertheless by being "photographically crime prone." Only a year after the above theft, on December 17, 1861, by which time Mayor Wilson had succeeded Mayor Weaver, the *Pittsburgh Post* revealed:

The Soldier Liked Pictures—A soldier named John Johnston was arrested and taken before Mayor Wilson yesterday, charged by E. T. Boyd, ambrotypist, of Fifth Street, with stealing from him a lot of pictures valued at $20, breaking his showcase and disarranging his business so that he suffered much damage. Johnston was in the watch-house last night, awaiting a hearing. [Weprich 1991a]

For reasons not given, the next day's paper reported that Johnston, "the soldier arrested on Monday charged with stealing a lot of ambrotypes," was discharged and allowed to return to the army, presumably on the grounds that this would be punishment enough. For a heinous crime of a different nature, Lewis Smith and John Ott, both of Pittsburgh, were charged and fined twenty-five dollars each. They were found in the act of photographing on the Sabbath (Weprich 1991b).

In Pittsburgh, then very much a provincial American town, the administration was in some ways more alert to the potential of photography as a weapon in the war on crime than the authorities in Paris, the capital of France. Although, as mentioned earlier, occasional photographic portraits of criminals had been taken in Paris from the first, it was only in the 1870s that the police there began to make systematic use of the tool. During the events of the Commune in 1871, and its bitter aftermath, photography became a major player in the deadly game between rebels and authorities (see Chapter 12; English 1984; Lemagny and Rouillé 1987). Supporters of the Commune posed proudly on the barricades, and the photographs then taken were used to identify the demonstrators. Eugène Appert later took photographs of those detained at Versailles. However, because prison pictures in general were initially made haphazardly, without uniform rules, they turned out to be less useful than had originally been hoped. The situation began to change in 1872, with the work of Alphonse Bertillon, whom Corbin (1990) describes as "the least gifted member of a prestigious family of physicians." Bertillon's system, which came to be known as *bertillonage*, consisted of standardized photographs and associated measurements. By the 1880s, the Paris police had some 90,000 images and records of this kind on file. That decade saw the first use of "Wanted" cards in France, and the Paris police in particular used photographic posters widely in the course of an 1894 drive against anarchists. In Vienna, it was suggested as early as 1864 that all prostitutes be required to carry health passes with identification photographs (Stenger 1938), even at the risk of indecent exposure on the part of studio operators. Bertillon himself was interested not

only in police and prison work, but also in "detective" photography by means of small cameras unobtrusively disguised as hand guns. (See also Starl 1990.)

Another ingenious disguise for the detective camera was that ubiquitous item of the Victorian wardrobe, the top hat. In 1884, Herr Luders of Görlitz, Germany, actually patented a photographic hat that contained a camera, a lens, and dry plates. Exposures were made by pulling on a string. *Punch* of February 27, 1886, had fun with the idea and produced a poem on the new possibilities, which included the verse:

> If I'm stopped in the street—
> that may happen, you know—

By a robber whose manners are not *comme il faut*,
His identification should never be hard,
There's my neat little photograph in
 Scotland Yard.

Luders was not alone; a camera of similar design was also offered by J. de Neck of Brussels in 1885 (Anon. 1885), and yet another had already been marketed in England for some years. The heavier model shown in Figure 10-2b is ascribed to a Spaniard, Mara Mendoza (Stenger 1949; see also Gidal and Spear 1987).

Gernsheim (1969) reports that in England the first public "Wanted" notice with a photograph was actually issued in 1861, several years after

PHOTOGRAPH OF SERGE DEGAIEF DISTRIBUTED THROUGHOUT THE EMPIRE BY THE POLICE.

FIG. 10-4. Handsome terrorist WANTED. From a halftone in an article by George Kennan on "The Russian Police," which appeared in *Century Magazine*, vol. 37, 1889, p. 890. The imprint reads: "Assassin of the Officer Sudeikin, Sergiei Degaief." See also Guglielmi 1982.

Punch had expressed its tender concern for the fugitive. With astonishing promptness, the poster led to a suspect's identification only a month later, not actually by a London Bobby on the beat, but by a roving English detective who (for reasons unspecified) happened to be looking for the man in question in faraway Turin.

In mid-century, studio conventions tended to triumph over other considerations, and this was as true in Russia as it was in the West. When, in 1860, a Caucasian rebel surrendered to the Czar's forces, he was photographed with full studio honors, in a ceremonial uniform, against a painted background, with mountain scenery designed to make him feel at home. The same courtesies were not followed when Lewis Payne was arrested in 1865 as a member of the conspiracy to assassinate President Lincoln; a simple tent served as the background, and Payne's handcuffs took center-stage (Braive 1966). Nor, indeed, was Russian practice invariably congenial. In one of a series of articles on his experiences in the Czar's empire, Kennan (1889) told a story about the Russian police advertising for information about a terrorist in 1883 by distributing six different versions of his photograph coupled with the offer of a 10,000-ruble award. The photographs (Fig. 10-4) showed what the wanted man looked like "in a cap and without a cap; with a full beard and without a beard; and with a mustache and without a mustache." The suspect's name was Degaief, and the photographs had, presumably, been made on the occasion of a previous arrest. In Siberia (where else?), a village policeman with vodka-impaired vision arrested four luckless tramps on the strength of this poster, and promised to look out for the remaining two criminals (see also Guglielmi 1982). Kennan mentions in passing that photographers in Russia needed police permission to practice. In a very different context, Spira (1985) reports on an early Philadelphia notice, issued by the Mayor's office in 1875, with a photograph not actually of a wanted criminal but of an abducted child. The desperate appeal for information was made almost seven months after the crime, and there can have been very little hope for its success. Unfortunately, no photograph of the victim was available, and a picture of another little boy had to be used: "The accompanying portrait resembles the child, but is not a correct likeness."

THE IMPRESSIONABLE EYE

If Siberian follies were inherently amusing to Western eyes, Italian affairs, in contrast, tended to be taken very seriously. An anonymous correspondent in the *Harper's Weekly* of February 25, 1865 (p. 123) concerned himself with the photograph as evidence for the prosecution, after an introduction in which the editor says "It has often been asserted that the eyes of dead persons would be found to contain images of objects seen immediately before death, and the correspondent of a London paper in Florence makes known what we believe is the first instance of an official test of the theory." The contributor unfolds his story with elephantine care:

> On the 13th of last April, Luisa Carducci, a woman in a comparatively humble rank of life, but of respectable character, who let lodgings, was found murdered in her house, under the following circumstances: The corpse was discovered lying on the floor, with the throat cut from ear to ear, a pool of blood below her head, but only there—no marks of blood in any other part of the room—and a pocket-handkerchief, the property of some unknown, close to her person. The trinkets and money which she was supposed to have about her had disappeared, as well as other articles in the house. As no cries had been heard by the neighbors, the conclusion come to by the Florence police was to the effect that the

murder had been perpetrated, in all probability, by two assassins, who had obtained admittance into the house when the poor woman was alone, under the pretext of wishing to see and hire her rooms; that one of them had suddenly thrown a pocket-handkerchief over her mouth and brought her to the ground, and that, while thus held fast, and her cries effectually stifled, his accomplice had cut her throat. Such was the conclusion come to by the police, and, in particular, by its chief officer—the Capo Commeso di Publica Vigilanza, Leopoldo Viti—who, among other steps taken by him at the time, applied to the higher administrative and legal authorities on whom he was dependent for permission to have the eyes of the murdered woman photographed—an application which, in the belief that the granting it could lead to no practical result, was refused.

The police were not without suspicion as to one at least of the probable murderers. Their suspicions rested upon the person of a certain Benjamino dei Cosimi, a native of Velletri, who, from that town, where he was believed to have taken part in more than one murder, had made his way to Corsica, thence to Leghorn, and from Leghorn to Florence, where he had been observed prowling about at the time of the murder. On the discovery of the murder he had already disappeared. After an interval of nearly two months, on the 2d of June, another lodging-house keeper, Ester Cellai, was found murdered in her house in precisely the same fashion. The body stretched on the floor, the throat cut from ear to ear, the strange pocket-handkerchief lying beside the corpse, every valuable removed—all this done when the poor creature was alone in the dwelling. There was no clew [sic] to the assassins beyond the extremely strong assumption that both murders had been committed by the same hands. Again

application was made by the head of the police to have the eyes of the victim photographed, and again, for the same reason as before, the application was refused.

Another interval of somewhat more than two months had elapsed, when, on the 22d of August, a third murder [was committed], differing scarcely at all in its circumstances from the two previous ones, on the person of a third lodging-house keeper, Emilia Spagnoli. . . .

Contemporaneously with this third murder, Benjamino dei Cosimi had reappeared in Florence. He was arrested. In his possession were found articles belonging to all three murdered women, and a blood-stained knife, the blood freshly shed. On these presumptions he has been consigned to prison, and there awaits his trial. . . .

But now comes the circumstance by which the history of this man will be distinguished from that of mere ordinary criminals. Viti, the head of the Florence police, again insisted with so much eagerness to have the eye of Emilia Spagnoli, the last of the three victims, photographed, that his request was complied with.

Under the direction of Marabotti, the examining judge or Giudice d'Istruzione, a series of photographic experiments have been carried out, not for the special purpose of furnishing additional criminal evidence for conviction (as the other evidence, with that view, is believed to be superabundant), but in order to establish a general principle or law of universal or very frequent application. I have said that Emilia Spagnoli was found lying on her left side, her large glazed right eye being turned upward. The eye was photographed immediately after her decease. The photograph then taken has been reproduced in a greatly magnified form, so greatly magnified as to allow the lineaments of a human face, two inches in length, to stand out distinctly

from the same. When I mention that Alinari, the first photographer of Florence, and indeed possessing a European reputation, was the artist by whom the work was executed, I need say nothing more as a guarantee of the fidelity and care employed on the occasion.

From the tracing of the dim and nebulous outline, as actually found on the eye, to the completed outline of the face executed from that tracing by an artist who had never seen Benjamino dei Cosimi, or any portrait of the man, and, again, from that completed outline of the two photographs of himself found in his possession at the time of his arrest—the transition, whether viewed as an artistic study, or as a great question of medical jurisprudence, opens up inquiries of unsurpassed interest and importance. I am not, indeed, prepared to affirm that the first tracing in the series, as shown to me by the courtesy of the Judge of Instruction, Signor Marabotti, at his official chambers, so completely resembles the photograph of the living man that, were I placed in a jury-box, my verdict would be determined by the belief in their identity, but of the following fact there can be no possibility of doubt. Whatever there is of marked prominent individuality in that first nebulous profile has an exactly corresponding feature in the likeness of the living prisoner. A peculiar dilatation of the nostril, a depression in the centre of the upper lip (Benjamino dei Cosimi has lost his two front teeth), an unusual elongation of the mouth, a square but double chin, a certain massiveness about the region of the cheek-bone, and the outline of a whisker, are common to both.

I purposely confine myself, in the present letter, to a simple statement of facts—the circumstances under which these murders were perpetrated, the consequent photographic experiments instituted, and the results obtained, of which I was myself

an eye-witness. I am happy to add that Signor Marabotti, with whom, from his official position, the prosecution of these inquiries rests, has evidently brought to his task a spirit worthy, in all respects, of a countryman of Galileo. The photographs, with all the accompanying and illustrative details, have been transmitted not only to the Medical College of Florence, but also to the medical colleges of Naples and Milan; and, by the authority of the Prefect of Florence, Count Cantelli, a series of photographic experiments will be instituted on the eyes of the patients in the hospital immediately after their decease.

Alas, neither Signor Marabotti nor his learned colleagues in Florence, Milan, and Naples are on record with further results (see also Gladstone 1979), nor is it known whether Alinari, famous for his contributions to the discipline of art history, made it a practice to help the police on such occasions. However, twenty-odd years later, and without awaiting more evidence, Rudyard Kipling used the same theme in a short story, "At the End of the Passage," attesting to the powers of the camera in a similar situation (Kipling c. 1885; Farmer 1979). Those powers actually received a limited measure of legal recognition in 1904 by John Henry Wigmore, the standard twentieth-century American authority on evidence (Wigmore 1904, Allen 1981): "If scientific testimony should declare that the retina of a dead person's eyes does (as the superstition now runs) preserve under certain circumstances a correct image of the object last seen by the deceased, then the use of this impression would be sanctioned. . . . " This is a cautious, conditional statement containing no surprises, but Wigmore himself considered the "retina theory" in the same category as evidence gained by X-rays and, indeed, under the conditions stated it would just have to be so considered, but the "X-ray theory" proved to be the more enduring. Surprisingly, as Allen points out, the entry

survived all subsequent revisions of Wigmore's treatise, including the most recent (Wigmore 1970). Stenger (1938), with casual abandon, ascribes the original notion to a "Dr. Pollack of North America," who allegedly claimed in newspaper articles of "1856 or 1857" that a dead person's retina yields the last-seen image faithfully, "zart, klar und genau," when later examined under a microscope. In 1857, Wilhelm Horn, famous pioneer and photographer in Prague, went a giant step further by suggesting in the *Photographisches Journal* (p. 192) that a stereo-microscope be built for postmortem retinal investigations of both eyes, in order to gain a plastic, stereo-image of the murderer. Finally, and just to prove that no country was immune to folly, Stenger (1938) credits (for want of a better term) a London photographer, M. Varner, with the discovery in 1863 that even the eyes of a calf retain the image of the slaughterhouse for up to eight hours after the fatal event. H. W. Vogel, the great Berlin photochemist (under whom Alfred Stieglitz later came to study) pronounced the retinal idea "American humbug" in the form in which it was ordinarily applied, but also expressed his belief that "in favorable circumstances, which are not, however likely to apply in murder cases," such image retention might actually be possible.

PLAGIARISM, PRETENSIONS, AND PRETENSE

Tableaux vivants were photographed for a variety of purposes (see Chapter 3); Figure 10-5 gives an example that, as it happens, has a legal dimension. The stereo card was made in April 1859, as a careful recreation of the 1855 painting by Henry Wallis, "The Death of Chatterton." James Robinson of the Polytechnic Museum and Photographic Galleries, Grafton Street, Dublin, was the photographer. In the original painting, the model for Chatterton had been the poet

George Meredith, whose wife soon afterward ran away with the painter. No equally dramatic story lies behind the photograph, but that image enjoyed great popularity because of the aura of mystery and notoriety that had surrounded Thomas Chatterton's life and death. On August 25, 1770, at the age of seventeen and in a spell of despondency, he had committed suicide by taking arsenic, after being accused, for good reason, of forging medieval manuscripts. Despite this unusual aspect of the story, the life and death of a very young man might have faded from the public's memory, had it not been for the fact that Chatterton became the subject of a best-selling novel, *Love and Madness*, published in 1780 (see Croft 1780). The combination of youth, promise and early death makes potent legends. The story was a favorite in the Victorian period, as its choice by Wallis for his painting attests; the subject was evidently ripe for photographic exploitation. In November 1859, a few months after the card had appeared, a court pronounced Robinson's picture a "piratical imitation," in response to a suit brought by the copyright owner. The photographer's defense relied on the notion that his work was a stereo image, one that could not, by its very nature, have been reproduced from a flat original. An injunction against Robinson was granted nevertheless. In the ongoing controversy, the *Art Journal*, ordinarily a staunch guardian of artists' rights, was on the photographer's side: "We confess we cannot see what injury could have been sustained. . . ." Even so, the plaintiff prevailed, and was awarded costs though no actual damages.

If the Chatterton episode, of which Greenhill (1981) has given an extensive and absorbing account, was not photography's first brush with the law, neither was it the last. Though the perennial question: "Is photography art?" proved forever intractable on semantic grounds, attempts were made to resolve it on legal ones, specifically in 1861 and 1862. The respected Paris firm of Mayer & Pierson had just issued carte-de-visite photographs of Lord Palmerston

FIG. 10-5. "The Death of Chatterton," by James Robinson, April 22, 1859. Dublin, Ireland. *Tableau vivant* reconstruction of an 1855 painting by Henry Wallis. Albumen print, standard stereo card. (Greenhill 1981)

and Count Cavour, and soon, to their dismay, found them pirated by another photographic partnership, namely that of Betbeder & Schwabbe. The laws then on the statute book originated in 1793 and 1810 — that is, long before the complicating issues of photography could have been in the minds of any legislators. Such as they were, these laws provided copyright protection for "works of art" — hence the potent question. The plaintiffs made a great deal of play with the distinction between the power to observe and the power to create, the latter being noble, the former allegedly worthless in that context. On the other hand, a portrait painter who prides himself on achieving "a good likeness" manifestly puts special emphasis on the very powers of observation that are otherwise photography's great prerogative. The Court proved itself sensitive to this argument and, with the approval of the French attorney-general, photography was formally declared an art on July 4, 1862, by a law that proved more fickle than most in its definition and more erratic in its enforcement. Yet, in a formal sense, photographers from then onward enjoyed copyright

protection, though not without a great deal of protest from some of France's most notable painters, including Ingres and Rousseau. The protesters did not prevail, and photographers exulted in their triumph: not only was the photograph a work of art, equivalent to a painting, but it was one that, by virtue of its example, had actually made bad painting impossible. Alas . . . See Scharf (1968), and Mayer and Pierson's own, presumably impartial, account of the episode in *La Photographie*, Paris, 1862.

It took another twenty years for photography to achieve the legal status of art in America. This came about in 1883, in the form of a decision by the U.S. Supreme Court in December of that year. The case before it had been brought by Napoleon Sarony of New York against the Burrow-Giles Lithographic Company, for the unauthorized copying of his photograph of Oscar Wilde, made a year earlier. All the arguments advanced, by both sides, followed their expected course, but those put forward by Sarony's counsel were particularly elegant. He contended that his client's picture was the result of the photographer's:

own original mental conception, to which he gave visible form by posing the said Oscar Wilde in front of the camera, selecting and arranging the costume, draperies, and other various accessories in the said photograph, arranging the subject so as to present graceful outlines, arranging and disposing the light and shade, suggesting and evoking the desired expression, and from such disposition, arrangement, or representation, made entirely by the plaintiff, he produced the picture in suit, Exhibit A, April 14th, 1882, and that the terms "author", "inventor", and "designer", as used in the art of photography and in the complaint, mean the person who so produced the photograph.

The court agreed, while admitting that *some* photography may be without originality, and thus outside the range of copyright protection. (See Allen 1986 and Lewis and Smith 1936.) The semantic sands of the "Is it art?" question proved to be as shifting in Washington as they had earlier been in Paris.

"The said" Oscar Wilde happened to be in New York in January 1882, in order to promote, albeit indirectly and without actually saying so, Gilbert and Sullivan's opera *Patience*, a satire on the Aesthetes and their ways. To immigration and customs officials, he stated on arrival that he had "nothing to declare but my genius" (Brasol 1938), a majestic greeting now often envied but rarely matched. Sarony, himself a *poseur* in the grand tradition, jumped at the chance to photograph him, knowing of his fame and sensing the commercial potential of the photographs. (See also Bassham 1978.)

Allen (1986) also points to two cases that were much less far-reaching, but were remarkable for the photographers' insistence that they were *not* artists. In one such case, decided in 1883 by the State Supreme Court of Tennessee, a photographer wanted to protect his equipment from a creditor's grasp by taking advantage of an existing law that prohibited seizure of "mechanic's tools." A mechanic he therefore claimed to be. The Court took a different view, one that would have been music to many other photographers' ears, insisting, "The photographer is an artist, not an artisan." Peter Rinaldi, another operator in trouble, claimed not to be an artist when, on June 25, 1863, he was charged at the Mansion House, London, with making photographic forgeries of Austrian bank-notes (Palmquist 1989). The temptation to use photography for "making money" must have been enormous. Thus, the *Pittsburgh Gazette* of November 17, 1860, complained that "so rapidly are they [bank-notes] produced and put into circulation, it is impossible to keep the run of them." Fortunately, the paper says, the forgeries are easily detected; it recommends a test with potassium cyanide, actually better designed to keep the number of subscribers under control than to uphold the currency laws (Weprich 1991a). Photographers without the nerve or skill to print actual bank-notes occasionally designed their own, as advertisements, in the hope thereby of making money the hard way (see Fig. 7-25).

In 1889, another case involved a New Orleans photographer who claimed a tax exemption of the kind ordinarily granted to mechanics (a term that at the time had a broader definition than the one we are now familiar with), but not to "professionals," such as painters. Once again, the Court would have none of it, maintaining that "in both painters and photographers, the hand and the sense of sight are controlled by an unusual exertion of a superior intellect, which, to direct and accomplish properly, must be distinguished and actuated by a rare knowledge, ability, and practice not found in, or required by first comers" (Anon. 1890). The reference to "first comers" remains enigmatic but, presumably, the Court included mechanics under this heading, in the mistaken belief that mechanics needed only a minimum of training or none at all. Meanwhile, "superior intellect" has been routinely claimed by photographers the world over.

FIG. 10-6. Mumler's Ghost Photography I. Carte-de-visite, recto and verso, albumen print of the 1860s by William H. Mumler of 170 West Springfield Street, Boston, Massachusetts; Mumler was also active at 630 Broadway, New York.

The case of Boston's William H. Mumler (see also Chapter 3) involved a very different issue, hinging as it did on the question of the photographer's artfulness, rather than his art. A successful studio operator in the 1860s, Mumler became famous for his claim that he could capture in the camera not only the likeness of any customer, but also the image of long-dead relatives (Fig. 10-6). Unwary clients rewarded him richly for this skill, but in a celebrated 1869 court case he was put on trial for fraud; he had offered for sale the "ghost" of a client's father-inlaw, who had turned out to be still very much alive, without in the least resembling his alter ego. For *Harper's Weekly*, the trial was front-page news on May 8, 1869, with several examples of Mumler's work presented in the form of woodcuts. (See Fig. 10-7 and Henisch 1978.) In any event,

there was no guarantee that only welcome ghosts would make their appearance on the plate. An 1869 cartoon in *Harper's Weekly* shows one of Mumler's clients who, recently engaged to be married, has a portrait taken at his fiancée's loving request. No fewer than five spirits respond to the call, each one the ghost of a previous wife (Jay 1991).

The ghost picture shown in Figure 10-8 is not known to have featured in any court case. It was, presumably, an honest exercise of darkroom skills by a virtuous practitioner who shared Mumler's interests. It is thoroughly unlikely that any of these operators knew of the first Serbian photographer, Anastas Jovanović (Djordjević 1980), but Jovanović had made manipulated photographs of the same kind a good deal earlier, around 1850.

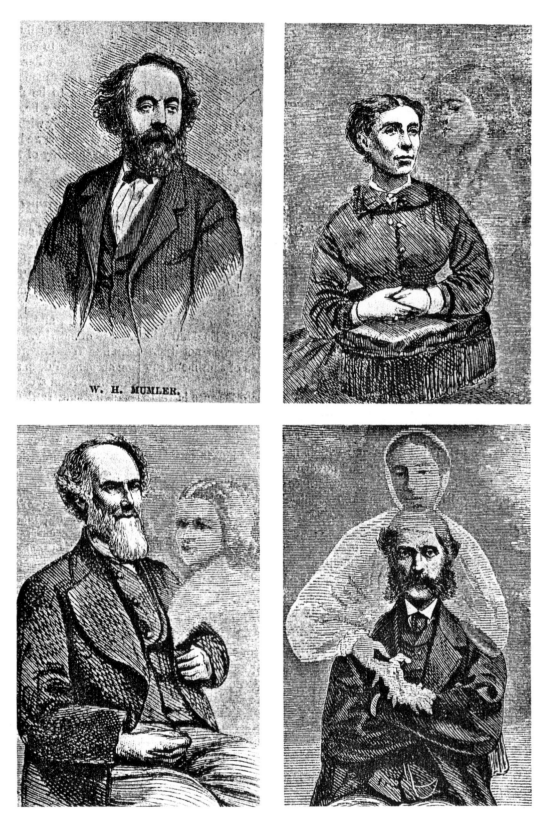

FIG. 10-7. Mumler's Ghost Photography II. Examples from *Harper's Weekly*, May 8, 1869. Wood engravings after cartes-de-visite. William H. Mumler himself appears, *sans* ghost, top left.

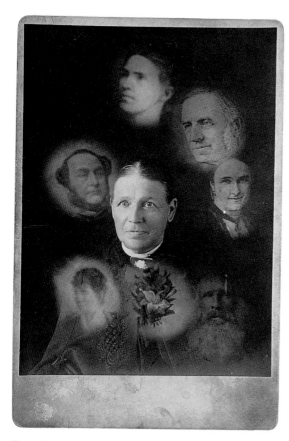

Fig. 10-8. Composite photograph by Howe's Photo Studio of 18 South Paulina Street, Chicago, Illinois, c. 1890. Gelatin silver print, cabinet card.

ler pretended to photograph. The idea that an object not luminous enough to form an image on the retina, could reflect rays of light sufficiently strong to decompose photographic chemicals, is one . . . that can hardly, perhaps, be seriously entertained. . . . Of course spirit-photographs are humbug; but the ability to give a reason for the disbelief that is in us, of anything how contrary soever to common sense, appears desirable to your humble servant.

PHOTOGRAPHS AS *CORPORA DELICTI* AND EVIDENCE

In just a few known cases, photographs featured in court as *corpora delicti*. One such episode, recently unearthed by Palmquist (1990), took place in San Francisco in 1856 and was duly reported by the *Evening Bulletin* of May 9 and 12, and by *The Wide West* of May 20. The police, ever on the alert for heinous crimes and undesirables at large, arrested a certain M. Maurin, reportedly a Frenchman, and searched his room, finding there a whole cache of daguerreotypes that different studios had reported as stolen. All were of women. When Maurin appeared in court, he did not deny that he had stolen the pictures, but pleaded movingly that there were extenuating circumstances. His wife had just left him, and he felt in need of female company, even company by silver-image proxy, thereby giving the term "daguerreotype lover" a new meaning. More than that, Maurin felt that, as a husband, he had certain rights to his wife's likeness and, on those grounds, considered himself entitled to images that resembled hers. Alas, the Law in its Majesty remained unmoved; the Court called for a medical report on the culprit's sanity.

The Mumler episode made ripples in far away London. The ever-alert *Punch* picked up the story and, on June 16, 1869, a reader, using the pen name "Pyrrho," commented on the published report in a serious vein, with a logic peculiarly his own:

On the subject of "spirit photographs", . . . I am happy to say I do feel a satisfactory degree of certainty. There may be, for aught I know, disembodied spirits. I do not know that disembodied spirits, if they exist, have not the power of making themselves visible. A visible spirit could be photographed as well as anything else. But nobody pretended to see the spirits that Mum-

The Maurin case was actually not unique; some months earlier, the *Daily Pittsburgh Gazette* (and, likewise, the *Pittsburgh Morning*

Post) of December 15, 1855, had reported that a certain William de Haven had been committed to await trial on a charge of larceny, the theft of daguerreotypes from Margaret Rachel Bain (Weprich 1990). Tantalizingly, the report does not explain the nature of Mr. de Haven's interest, nor do we know how he pleaded.

It took time for photographs themselves to be accepted as *evidence* in court cases. Attitudes varied, and much depended on the individual judge. During the 1862–63 forgery trial of William Roupell in England, photographs of some of the documents in question were offered for the jury to study, but the judge ruled that only the actual papers could be submitted in evidence. When told that photography was a new art, merely a method of reproducing the handwriting, the judge remarked that "he had great doubt about it" (Baker 1991). On the other hand, extensive use of photographs was made as early as 1857, in a Canadian court inquiry after the Desjardins Canal bridge disaster (Schwartz 1990). According to *The Weekly Spectator*:

Mr. Milne, the Photographer, has sent a force of artists to the freight sheds with several sets of apparatus. They are taking likenesses of the unrecognized dead. This is a novel, and at the same time a most excellent plan, so that months or years hence, if any of the deceased should remain so long unidentified, their friends may recognize them. [March 19]

Photographs have been taken by Mr. Milne, under the order of Mr. Richards, of every important fracture in the timber of the bridge. Also of the Jury when engaged in examining the bridge, and of the reporter of the *Spectator* taking notes on that occasion. [March 26]

Mr. Richards was the barrister acting on behalf of the Crown. In the April 9 *Weekly Spectator*, the editor, still discussing the episode, remarks:

We are not aware that a similar use of photography has ever been made before, and certainly it has never been pressed into the service of a Jury to the same extent. [April 9]

Another early report, of a very different kind of episode, comes from the *Daily Pittsburgh Gazette* of August 10, 1858, under the headline "The Uses of Photography" (Weprich 1990):

A murderer of Antwerp, having left his boots on the scene of his crime, a photograph and description of these articles were sent round to all the neighboring shoemakers. At length one of them came forward and recognized the boots as made by him for an individual whom he described, and who was already in custody on suspicion. This led to other proof, which incontestably fixed the crime on the prisoner and an associate.

Only a few years after this example of Belgian police sagacity, a photographic success came about in an American court. According to *The Philadelphia Photographer* of May 1867:

In a recent suit for damages by a widow for the death of her husband, caused by falling into an excavation in front of a building, the defendants had subpoenaed about forty witnesses to prove that the place was not dangerous. Before they were asked to give their opinions, however, they were greatly astonished to see the plaintiff produce photographs of the place taken the morning after the accident, and showing more plainly to the court and to the jury the state of affairs than hundreds of witnesses could. The photographs were sworn to and could not be denied, and were the chief witnesses for the plaintiff, who gained her suit. Photography never perjures itself. . . .

More soberly, the writer goes on to hint that while the honor of photography as such might remain intact, someone could perjure himself with its aid, but he dismisses that dastardly possibility with a "woe be to him!" As late as 1899, a pontificating P. H. Emerson was moved to declare: "Photographic pictures may have one merit which no other pictures can ever have, they can be relied upon as historical records." However, writing as an artist, he felt compelled to add: "The chief merit of most photographs is their diagrammatic accuracy, as it is their chief vice" (Emerson 1899). On reflection, the remarkable thing is not that photography was ever doubted but that it was for so long staunchly believed. Written in 1899, thirty years after the notorious episode of Mumler's ghosts, to mention only one example of photographic guile, these words of Emerson show a curious innocence. Such touching faith, so widely shared, was ripe for exploitation. In Thomas Hardy's novel, *A Laodicean* (1885), a portrait of the hero, maliciously doctored by the photographer-villain, offers irrefutable evidence of depravity:

> By a device known in photography the operator, though contriving to produce what seemed to be a perfect likeness, had given it the distorted features and wild attitude of a man advanced in intoxication. No woman, unless specially cognizant of such possibilities, could have looked upon it and doubted that the photograph was a genuine illustration of a customary phase in the young man's private life. [Hardy 1885]

In art, as in this case, it is always possible to contrive happy endings after catastrophe; in real life it is not so easy. Many reputations were irrevocably ruined when, in the merciless skirmishes of political warfare, the tainted evidence of "truthful" photographs was used to win condemnation in the court of public opinion (see Chapter 12).

Chapter 10 References and Notes

ACKERMAN, C. W. (1930). *George Eastman*, Houghton Mifflin, Boston and New York.

ALLEN, W. (1981). "Extraordinary Application of Photography in Court," *History of Photography*, vol. 5, no. 1, p. 83.

ALLEN, W. (1986). "Legal Tests of Photography-as-Art," *History of Photography*, vol. 10, no. 3, pp. 221–28.

ANON. (1824). *The Glasgow Mechanics' Magazine*, no. 32, August 7.

ANON. (1841). *Bath and Cheltenham Gazette*, November 30, p. 2b.

ANON. (1862). "Portraits of Prisoners," *Photographic News*, vol. 6, January 3, p. 12.

ANON. (1885). *Photographisches Wochenblatt*, vol. 11, p. 214.

ANON. (1890). "City of New Orleans vs. Robira," *Southern Reporter*, vol. 8, p. 402.

BAKER, J. (1991). Correspondence: "Photographs as Trial Evidence," *History of Photography*, vol. 15, no. 3, p. 248, and personal communication, acknowledged with thanks.

BASSHAM, B. L. (1978). *The Theatrical Photographs of Napoleon Sarony*, Kent State University Press, Kent, Ohio, p. 74.

BEDE, C. (1855). *Photographic Pleasures, Popularly Portrayed with Pen and Pencil*, T. Mc'Lean, London, chapter 11.

BRAIVE, M. F. (1966). *The Era of the Photograph*, Thames & Hudson, London, pp. 146–47.

BRASOL, B. (1938). *Oscar Wilde: The Man, the Artist, the Martyr*, New York (publisher unknown), p. 95.

CORBIN, A. (1990). In *A History of Private Life* (ed. M. Perrot), Belknap Press of Harvard University Press, Cambridge, Massachusetts, vol. 4, p. 471.

CROFT, Sir Herbert (1780). *The Love-Letters of Mr. H. and Miss R.*, 1895 reprint (ed. Gilbert Burgess), Stone & Kimball, Chicago.

DJORDJEVIĆ, M. (1980). "Anastas Jovanović, the first Serbian Photographer," *History of Photography*, vol. 4, no. 2, pp. 139–63, fig. 13.

EMERSON, P. H. (1899). *Naturalistic Photography for*

Students of the Art, Scovill & Adams Co. of New York, 1973 reprint by Arno Press, New York, book 3, chapter 4, pp. 35, 40.

ENGLISH, D. E. (1984). *Political Uses of Photography in the Third French Republic, 1871–1914*, UMI Research Press, Ann Arbor, Michigan, chapter 2.

FARMER, B. (1979). "Kipling's *End of the Passage*," *History of Photography*, vol. 3, no. 4, p. 374.

GERNSHEIM, H. and A. (1969). *The History of Photography*, McGraw-Hill, New York, pp. 204, 515.

GIDAL, T., and SPEAR, B. (1987). "Hat Trick," *History of Photography*, vol. 11, no. 2, p. 154.

GLADSTONE, W. (1979). "Extraordinary Application of Photography," *History of Photography*, vol. 3, no. 4, pp. 373–74.

GREENHILL, G. (1981). "The Death of Chatterton, or Photography and the Law," *History of Photography*, vol. 5, no. 3, pp. 199–205.

GUGLIELMI, S. (1982). Personal communication, acknowledged with thanks. See also "Photographic Justice," *History of Photography* (1982), vol. 6, no. 4, p. 326.

HARDY, T. (1885). *A Laodicean*, Macmillan & Co., London (1951 edition), book 5, chapter 4, pp. 354–55.

HEATHCOTE, B. V. and P. F. (1990). "The Custodial Photograph," *Shadow and Substance* (ed. K. Collins), Amorphous Institute Press / University of New Mexico Press, Albuquerque, New Mexico, pp. 115–18.

HEATHCOTE, P. (1978). "The First Ten Years of the Daguerreotype in Nottingham," *History of Photography*, vol. 2, no. 4, pp. 315–24.

HEATHCOTE, P. (1985). "The Duke's Permit," *History of Photography*, vol. 9, no. 3, p. 226.

HENISCH, H. K. (1978). "Mumler's Spirit Photographs," *History of Photography*, vol. 2, no. 2, Frontispiece.

JAY, B. (1991). *Cyanide & Spirits, an Inside-Out View of Early Photography*. Nazraeli Press, Munich, p. 14.

KENNAN, G. (1889). "The Russian Police," *The Century Magazine* (New York and London), vol. 37, April, pp. 890–99.

KIPLING, R. (c. 1885). "At the End of the Passage," in *Short Stories by Rudyard Kipling, in the Vernacular: The English in India* (ed. R. Jarrell), Doubleday & Co., New York (1963), pp. 77–99.

LACAN, E. (1856). *Esquisses Photographiques à propos de l'Exposition Universelle et de la Guerre d'Orient*, Grassart, Paris, p. 39, 1979 reprint by Arno Press, New York.

LE DOCTE, A. (1888). *Manufacture Belge pour la Photographie* (catalog), Brussels, p. 208.

LEMAGNY, J.-C., and ROUILLÉ, A. (Editors). (1987). *A History of Photography*, Cambridge University Press, U.K. First published in 1986 by S. A. Bordas, Paris, pp. 51, 74.

LEWIS, L., and SMITH, H. J. (1936). *Oscar Wilde Discovers America*, Harcourt Brace & Co., New York, p. 39, 1967 reprint by Benjamin Blom, New York.

PALMQUIST, P. E. (1989). Personal communication, acknowledged with thanks. The information comes from an entry in the *Journal of Photography*, London, vol. 10, no. 193 (1863).

PALMQUIST, P. E. (1990). In *The Daguerreian Annual*, The Daguerreian Society, Lake Charles, Louisiana, p. 51.

PRITCHARD, H. B. (1882). *The Photographic Studios of Europe*, Piper & Carter, London, 1973 reprint by Arno Press, New York, pp. 119–23.

SCHARF, A. (1968). *Art and Photography*, Allen Lane, The Penguin Press, London, p. 113.

SCHÜTT, H. W. (1983). "David and Goliath," *History of Photography*, vol. 7, no. 1, pp. 1–5.

SCHWARTZ, J. M. (1990). "Fearful Catastrophe on the Great Western Railway," in *Shadow and Substance* (ed. K. Collins), Amorphous Institute Press / University of New Mexico Press, Albuquerque, New Mexico, pp. 325–34.

SKOPEC, R. (1963). *History of Photography in Pictures, from Earliest Times to the Present*, Orbis, Prague, p. 189.

SPIRA, S. F. (1985). "Abducted," *History of Photography*, vol. 9, no. 1, p. 74.

SPIRA, S. F. (1991). "Night Poachers," *History of Photography*, vol. 15, no. 2, p. 152.

STARL, T. (1990). "Detektiv Fotograf," in *Photogeschichte*, vol. 10, no. 38, Jonas Verlag, Frankfurt.

STELTS, S. (1991). Personal communication, acknowledged with thanks.

STENGER, E. (1938). *Die Photographie in Kultur und Technik*, with an introduction by Prof. H. Hoffmann (later Hitler's personal photographer), Verlag E. A. Seemann, Leipzig.

STENGER, E. (1949). *Die Geschichte der Kleinbildkamera bis zur Leica*, Ernst Leitz, Wetzlar, p. 40.

TAFT, R. (1938). *Photography and the American Scene*, Macmillan Co., New York, 1964 reprint by Dover Publications, New York, pp. 400–401.

TALBOT, W. H. F. (1944). *The Pencil of Nature*. Near-facsimile edition 1969, Da Capo Press, New York, note to plate 8, "A Scene in a Library."

WEPRICH, T. M. (1990). Personal communication, acknowledged with thanks.

WEPRICH, T. M. (1991a). Personal communication, acknowledged with thanks.

WEPRICH, T. M. (1991b). Personal communication, acknowledged with thanks. Information in *The Pittsburgh Gazette and Commercial Journal*, August 20, 1862, p. 3.

WIGMORE, J. H. (1904). *A Treatise on the System of Evidence in Trials at Common Law*, Little, Brown & Co., Boston, vol. 1, p. 903 (section 795). In the fourth edition, under the revised title *Evidence in Trials at Common Law* (1970), the note appears in vol. 3, p. 251 (section 795a).

WOOD, D. (1979). "The Daguerreotype in England: Some Primary Material Relating to Beard's Lawsuits," *History of Photography*, vol. 3, no. 4, pp. 305–9.

11

THE PHOTOGRAPHICALLY ILLUSTRATED BOOK

THE VERSATILE MEDIUM

In the context of nineteenth-century photography, the term "photographically illustrated book" refers to a published volume illustrated with actual photographs. Pages were left blank for this purpose, and photographs "tipped in" between text pages. Before it became possible (in the 1880s) to reproduce photographs by photomechanical means, this was the principal way whereby photographs could be introduced into books. A possible alternative, though one never widely used, was the crystallotype, an albumen print made from an albumen-on-glass negative,

printed on a large sheet of paper that was then bound directly into the volume, along with normal text pages (see also Chapter 5). The photographically illustrated book was one of the most revolutionary changes introduced into book production since the invention of printing. If it was not immediately recognized as such, this was in part because photographs were expensive, and in part because the texts of the books they illustrated during the initial years were often less than overwhelmingly significant. By subject matter, these books can be (roughly) classified into books about photography, art(-history) books, land-and-travel reports, scientific sub-

jects, personal memoirs, and miscellaneous ephemera.

The first book with tipped-in photographs (see below, however) was Fox Talbot's *The Pencil of Nature*, published in sections during 1844 and 1845. Copies, now exceedingly rare, are among the most treasured of photo-historical documents. Fox Talbot began the enterprise in an attempt to illustrate the versatility of photographic techniques, and to put his achievements in this field on record as "some of the early beginnings of a new art before the period which we trust is approaching of its being brought to maturity by the aid of British talent." This was a reasonable desire, however clumsily expressed. Talbot's introductory note also reflects a measure of the nationalist chauvinism that has been associated with photographic achievements in every country and at every stage. Talbot went on to explain: "The little work now presented to the Public is the first attempt to publish a series of plates or pictures wholly executed by the new art of Photogenic Drawing, without any aid whatever from the artist's pencil." The brief essay that accompanies each picture describes how the image was made and, beyond that, offers the reader a humanist's introduction to the principles of photo-chemistry and optics. These notes could not have been of wide interest outside the photographic context. Talbot ends in typically Victorian fashion: ". . . with these brief observations I commend the pictures to the indulgence of the Gentle Reader." The Gentle Reader was rightly impressed. The photographs used by Talbot were all calotypes, products of his own invention. Technically, such photographs are also known as "salt prints," because they had no photographic emulsion; the necessary chemicals permeated the paper base itself.

The status of *The Pencil of Nature* as the world's first photographically illustrated book is actually open to challenge; Anna Atkins had already published her *British Algae: Cyanotype Impressions* in 1843. The cyanotype (see Fig. 14-20b) was the brainchild of Sir John Herschel; we still know it as the familiar "blue print" used until quite recently by technical draftsmen and designers. *British Algae* was intended not so much as a separate book but as a companion to William Harvey's 1841 *Manual of British Algae*. Anna Atkins was, like Harvey, a botanist, and her illustrations were made as an aid to scientific research: ". . . the difficulty of making accurate drawings as minute as many of the Algae and Confervae has induced me to avail myself of Sir John Herschel's beautiful process of Cyanotype, to obtain impressions of the plants themselves, which I have much pleasure in offering to my botanical friends." The prints were "photogenic drawings," made without lens or camera by simply placing the objects themselves on sensitized paper and exposing them to light, with subsequent processing. In contrast, most (but not all) of Talbot's pictures in *The Pencil of Nature* had been taken with a camera. Of Talbot and Atkins, Schaaf writes: "They shared a vision but were after different goals" (Schaaf 1985). By convention, all the honors go to Fox Talbot, but Anna Atkins deserves a prominent place in photography's Pantheon.

Two other books were contemporary, or almost so. Fox Talbot himself began work on his *Sun Pictures of Scotland* (1845) even before the completion of *The Pencil of Nature*. Though produced at much the same time, the books were very different; one was a sampler, the other was devoted to a single theme, the Scottish beauty spots made famous by Sir Walter Scott. Indeed, it was one of the original hopes that the association of the images with the immensely popular stories and person of the great writer would help to promote Talbot's new photographic process. The other publication was Hill and Adamson's *A Series of Calotype Views of St. Andrews*, first advertised in the *Edinburgh Evening Courant* on August 3, 1844 (Smith 1984, 1983).

The production of photographically illustrated books by "tipping in" was widely imitated, and these publications are now much sought-after collectors' items. Through such

books, a larger public became acquainted not only with the matters illustrated, but also with photography itself, and with the wonders of the world that it could bring into the drawing room. Although the "tipping-in" method was not suitable for long press runs, it opened up the possibility of adding very personal illustrations to many private memoirs intended for restricted circulation. The "photographically illustrated book," as here defined, demands a text; without it the assembly of prints might more properly be called an album or a portfolio. According to this strict definition, *Sun Pictures* itself is a portfolio, rather than a full-scale book, for its images are accompanied only by a bare identification of each scene.

Photographic art books became popular in the 1850s and 1860s, and publishers were often anxious to sell photographs in this form, whether a suitable text was immediately available or not. In the trade, fine distinctions between different kinds of such publications were rarely made; they represented a continuous line of products, for which only the use of photographs was the common denominator. Heidtmann (1984) has provided a detailed overview of what happened, where and when. Similarly, Goldschmidt and Naef (1980) give extensive listings and examples of such publications. See also Gernsheim (1984) for a specifically British bibliography, Collins (1991) for a wide-ranging survey, and individual studies of such important publishers of photographically illustrated books as Joseph Cundall (McLean 1976), George Washington Wilson (Taylor 1981), and Alfred Brothers (Joseph 1987). For firms that did enterprising but less well-known work in this field, see Joseph (1982).

All the formidable literature notwithstanding, unlisted books come to light almost every year, to the joy of photo-historians and collectors everywhere. In 1980, Goldschmidt and Naef estimated the total number of photographically illustrated books (in the present sense) published before the onset of halftone printing as between 3,000 and 4,000. Only twenty years earlier,

R. S. Schultze's number had been a mere 1,000 items (in Zahlbrecht and Helwich 1961). The brief anthology below is intended to convey the flavor and richness of these works; a truly comprehensive and international survey remains to be made. The number of known examples will undoubtedly continue to grow, and many others will continue to lie forgotten in dusty corners, awaiting chance discovery. Photography made illustration possible for the most transient, ephemeral publications, valued even at first appearance only by proud authors and fond friends. With heroic diligence, the compiler of a recent list of photographically illustrated books in nineteenth-century Australia (Holden 1988) has managed to sweep into the net a bewildering variety of titles, from *A Treatise on Tennis* (1875) to *A Report on the Outbreak of Small-Pox of 1884–85*, and a somewhat specialized item, *The Scone Merinos, Owned and Bred by Messrs. W. Gibson and Son, 1883*, a sheep auction catalog.

The first photographically illustrated book produced outside the British Isles appeared in 1846: *Gedenkblätter an Goethe*, published by Hermann Johann Kessler of Frankfurt. It contained a single salt print of Frankfurt's Goethe monument. However, Goldschmidt and Naef hold that the key event which stimulated public interest in the illustrative potential of photography was the June 1846 issue of *The Art Union*, (London), which contained a highly positive article on the new practice, and a talbotype (Talbot's later name for the calotype), albeit one of inferior quality. *The Art Union* had 7,000 subscribers at the time, who thereby became alerted to the new possibilities and, in turn, spread the word. Unfortunately, the publicity provided by the journal's ambitious venture proved two-edged, for the talbotypes faded with disturbing speed. Nevertheless, it can be claimed that *The Art Union* was a pioneer in the photographic reproduction of art works, a business that, a few years later, was to expand into the enormous, ever-increasing publication of cartes-de-visite and cabinet cards from 1860 onward.

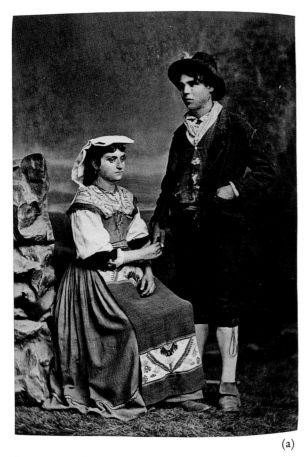
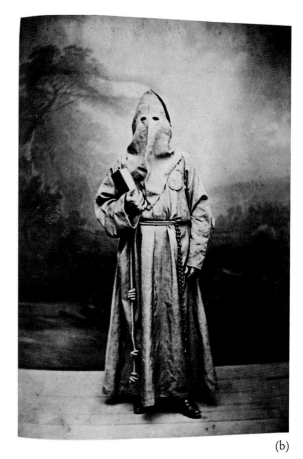

(a) (b)

FIG. 11-1. Photographically illustrated books issued by the Bernhard Tauchnitz Verlag of Leipzig, Germany, I.
Each book was supplied with a number of blank pages, and the tipped-in illustrations were chosen from a selection
provided by the bookstore; in principle, no two copies are alike. Image from *The Marble Faun (Transformation, or
The Romance of Monte Bene)* by Nathaniel Hawthorne, vol. 1 (1860). Albumen prints, 5¼ × 3¾ inches.
 (a) From the chapter on "Peasant and Contadina."
 (b) "Penitent."

BOOKS OF DISTINCTION; EXAMPLES OF CHOICE

The enterprising publishing firm of Bernhard Tauchnitz of Leipzig offered tourists in Italy custom-made copies of current best-sellers (in English) by letting them make their own selection from a display of photographs, and only then binding text and images together (Figs. 11-1, 11-2, and 11-3). Heidtmann (1984) points out that these books were actually made up of pages from earlier editions, printed but unsold, to which empty pages for photographs had been added before rebinding. These volumes do not, for instance, feature in the Tauchnitz publication records; they appear to have been something in the nature of afterthoughts, rather than parts of a concerted plan. Accordingly, also, the imprinted publication dates are misleading; they refer invariably to the first editions, sometimes in the 1840s, whereas the photographs were evidently added later, in the 1850s and 1860s, and

026 FIRENZE Loggia del Bigallo, d'ignoto autore, edificata nel 13⁵

FIG. 11-2. Photographically illustrated books issued by the Bernhard Tauchnitz Verlag of Leipzig, Germany, II. Albumen print from *Romola* (1863): "Firenze, Loggia del Bigallo." 5¼ × 3¾ inches. Note the photographic ghosts.

the books themselves continued to be reissued until the turn of the century. This imaginative idea must have added considerably to the amusement of choosing a book in an idle hour, during a leisurely Victorian vacation in Florence or in Rome, but there are often telltale signs of haste in execution. Nobody, for example, bothered to trim the stock number and catalog description from the photographs shown in Figures 11-2 and 11-3b, before tipping them into the book. There are also startling variations in quality and refinement of presentation. Some books are crudely cobbled together, while in others the layout has been designed with attentive care.

A single photograph was sometimes set into the cover of a book to add a special interest to the design; this was in direct imitation of an attractive feature that had been introduced a few years before photography's appearance on the scene. In the 1830s it began to be the fashion to decorate the cover with a hand-painted picture (Daniels 1988). Although it is not uncommon to find a photographic print used in the same way, it is rare indeed to find an example in which the inserts are actually daguerreotypes mounted under glass. Becker (1981) describes a two-volume set of the writings of Robert Burns (Fig. 11-4), with bindings of gold-tooled red leather and daguerreotype inserts, both copied from engravings. The edition was published in 1847. Figure 11-5a shows a late example, originally issued in 1865 but republished at the end of the century, in which a photo-mechanical halftone (of indifferent quality) is used as an internal frontispiece, but a genuine silver print has been mounted on the front cover of the chamois leather binding.

(a)

FIG. 11-3. Albumen prints from *The Marble Faun* (Fig. 11-1), 5¼ × 3¾ inches.
(a) Hands, from the chapter on "A Sculptor's Studio."
(b) Raphael's tomb.

(b)

For the collector today, photographically illustrated books of the time before photo-mechanical reproduction have an added importance because they bring to hand a remarkable anthology of actual photographs by distinguished practitioners. *Ruined Abbeys and Castles of Great Britain* (1862), by William and Mary Howitt, for example, offers its lucky owner a doll's house medley of small images (Fig. 11-6), made by such artists as Roger Fenton, Francis Bedford, and Russell Sedgfield. Yet another prominent photographer, the indefatigable Francis Frith, wrote and illustrated accounts of his own adventures in Egypt and the Holy Land, and also supplied pictures for other books by other authors (Mann 1990). In 1865, for example, he spent six enjoyable months with his camera in Switzerland and the Tyrol, making a series of photographs from which he selected twenty-four for an edition of Longfellow's romance, *Hyperion*, which came out in London later that year.

Photographic illustrations enriched such books on landscape and history, and their value for scientific, technical, and art-historical studies was soon recognized, if not actually from the

FIG. 11-4. Books with photographic front-cover inserts, I. Daguerreotypes.

Two-volume set, *The Works of Robert Burns, with a Complete Life of the Poet and an Essay on his Genius and Character by Professor Wilson*, Blackie & Son, Glasgow, 1847. Each volume 10 × 7 × 2¼ inches. Bindings in gold-tooled red leather. The daguerreotypes are copied from two engravings in volume 1: the frontispiece portrait of Burns, and one of his wife, Bonnie Jean, with one of their granddaughters. The eighty-one engravings illustrating the set are mostly landscapes, after designs by David Octavius Hill, first published in the 1840 volume, *The Land of Burns*. Wm. B. Becker Collection. See also Becker 1981.

FIG. 11-5. Books with photographic front-cover inserts, II. Silver prints.

(a) *Precious Thoughts*, by John Ruskin, originally printed in 1865. Here, as republished by J. Wiley & Son, New York, at the turn of the century.

(b) *Beautiful Thoughts*, by Thomas Carlyle (1900). James Pott & Company, New York. The small oval medallion contains a photograph of Thomas Carlyle, made some time before the book's publication date. See also Fig. 11-15b.

(a) (b)

THE STRID.

When the huntſman ſtood before Lady Alice, his mother, he aſked her " What is good for a bootleſs beane ?" (What avails when prayer is uſeleſs ?) And the mother, inſtinctively reading his woe-ſtruck countenance, replied, " Endleſs ſorrow !" And on hearing the fatal truth ſhe became the ſecond foundreſs of Bolton, ſaying, " Many a poor man ſhall be my heir."

When Lady Aäliza mourned
Her ſon, and felt in her deſpair
The pang of unavailing prayer ;
Her ſon in Wharf's abyſſes drowned,
The noble boy of Egremond ;
From which affliction when the grace
Of God had in her heart found place —
A pious ſtructure fair to ſee,
Roſe up, this ſtately priory !

C

(a)

FIG. 11-6. *Ruined Abbeys and Castles of Great Britain*, by William and Mary Howitt, London, 1862. First series. Albumen prints (2½ inches wide) by several artists, including Francis Bedford and Roger Fenton. The book covers, front and back, are ornamented with small photographic medallions similar to those shown in Fig. 11-5. The book was published by A. W. Bennett of 5 Bishopsgate Without, London. (Goldschmidt and Naef 1980) The prints here shown are by W. R. Sedgfield.

(a) The Strid, near Bolton Priory, p. 9.

(b) Conway Castle, Wales, p. 107 and front cover.

(b)

FIG. 11-7. O. G. Rejlander displaying emotions. Sample heliotypes from *The Expression of the Emotions in Man and Animals*, by Charles Darwin. Darwin commissioned the illustrations for this book, and Rejlander not only took the photographs but posed for some of them himself. The book was published by John Murray of Albemarle Street, London, in 1872. See also Goldschmidt and Naef 1980 and Spencer 1985.

beginning. For a general discussion of early photography as scientific book illustration see Krauss (1978, 1979). Among the earliest such books to appear in German is the *Atlas der allgemeinen Gewebelehre* by Theodor von Hessling and Julius Kollmann, published in Leipzig in 1861, with forty-two tipped-in images. A few years later, in England, a scientific study of facial expressions (Darwin 1872) contained tipped-in photographs by O. G. Rejlander, who indeed served in a double role, inasmuch as he also provided the faces, by displaying a variety of emotions and photographing himself (Fig. 11-7). Rejlander was Swedish, and had spent much of his life as a painter in Rome, before settling in Wolverhampton, England. There he played his resourceful and enormously successful role in the cultivation of composite prints, productions designed to carry a moral message or noble sentiment, much in the way paintings had traditionally done. Always astute, Darwin knew where to turn for help.

Even more remarkable is Nasmyth and Carpenter's (1874) book on the surface of the moon, *The Moon, Considered as a Planet, a World and a Satellite*. It represents the first example of space simulation, and contains photographs of plaster models designed to illustrate the moon's surface (Fig. 11-8). At the time, such representations were still far beyond the capabilities of photography through the telescope. Instead, James Nasmyth constructed his plaster models as accurately as he could from visual observations, and then photographed them as table-top models with suitable side-lighting. In most cases, the effect is near perfect and utterly convincing, but in at least one instance (Fig. 11-8b) a crack in the plaster is clearly visible. The tipped-in illustrations themselves were woodburytypes (see below). The many-sided Nasmyth had already gained fame as an inventor and engineer, having been associated with the development of the steam engine. After 1835, he served as Superintendent of the Woolwich

Fig. 11-8. Woodburytypes from *The Moon, Considered as a Planet, a World, and a Satellite*, by J. Nasmyth and J. Carpenter, London, 1885, first edition 1874. The illustrations are tabletop photographs of plaster models, with dramatic side-lighting. Note the crack showing in the lower photograph.

Dockyards. (See also Fig. 8-18c.)

The book is dedicated to His Grace, the Duke of Argyle, "in recognition of his long continued interest in the subject." The authors take their didactic mission seriously, and begin with an exposition of the problems of "cosmical heat," an informal treatment of thermodynamics, as then understood. On more romantic themes, they say that they can point to "two or three almost conclusive arguments against the possibility of life, animal or vegetable, having existence on our satellite." With an endearing form of selective logic, they maintain that it is "consistent with our conception of Creative omnipotence and impartiality, to suppose that the protogerms of life have been sown broadcast all over space, and that they have fallen here [on earth] upon a planet under conditions favourable to their development, and have sprung into vitality when the fit circumstances have arrived, and there [on the moon] upon a planet that is, and that may be for ever, unfitted for their vivification."

Another many-sided Victorian who took advantage of the new possibilities was Charles Piazzi Smyth, whose *Teneriffe, an Astronomer's Experiment, or Specialities of a Residence above the Clouds* appeared in 1858. It described observations made during the author's 1856 expedition to the volcanic mountain in the Canary Islands, a "pivotal accomplishment that transformed the respected but relatively unknown son of a famous admiral into an international scientific figure" (Schaaf 1980). (See also Schaaf 1981.) By 1860 he found himself Astronomer Royal of Scotland, and Professor of Practical Astronomy at Edinburgh University. In his youth he had been trained as a painter, but later he became more widely known for his expedition to the Great Pyramid (Schaaf 1979). To photography he was actually a slow convert, and it was only at the urging of Sir John Herschel that the expedition to Teneriffe was equipped with cameras at all. *Teneriffe* was illustrated with twenty albumen prints in stereo (40,000 were needed for the first edition) and turned out to be

a best-seller, with nearly 1,600 copies sold for one guinea each (Schaaf 1980). To be sure, stereo views, as such, were not actually helpful for astronomical photography, but Smyth used them to illustrate many other aspects of the experience, including the island's life and geography.

Piazzi Smyth's publisher, Lovell Reeve, was himself a remarkable personality, originally a grocer's apprentice, and later editor and proprietor of the *Literary Gazette*. Reeve (1814–65) packed many achievements into a short life racked with illness. A self-taught scholar, he became an authority in the field of conchology, and wrote and published a number of magisterial studies on the subject. In 1858 he launched *The Stereoscopic Magazine*, the first journal to be devoted to stereo photography (Stark 1981). After the publication of *Teneriffe*, he went on to issue several other books illustrated with stereo photographs.

An edition of Scott's *Marmion* offers fifteen albumen prints by Thomas Annan (Figs. 11-9 and 11-10), and was evidently intended for a wide readership. Thomas Annan (1846–1907) had opened his first studio in 1855; some years later, he gained further fame by photographing the painting which David Octavius Hill had made to commemorate the foundation (in 1843) of the Free Church of Scotland. In that year (1866), Annan's print was used as a prestige item by Sir Joseph Wilson Swan's company, to demonstrate the potentialities of the carbon process (Gernsheim 1969). In his later career, Thomas Annan took a prominent part in recording life in the slums of Glasgow and Birmingham, thereby goading the Victorian conscience. He depicted not only the dismal buildings, which were obvious enough, but also the human misery that survived within them (Thomas 1978). Much more than research items, the resulting prints were moving documents on the one hand, and technical masterpieces on the other. (See also Mozley 1977 and Buchanan 1984.)

The tipped-in photographs made items like *Marmion* possible and attractive, and gave rise

LINLITHGOW PALACE.
p. 95.

(a)

MARMION;

A TALE OF FLODDEN FIELD.

Sir W. Scott, Bart.

SCOTT'S MONUMENT AT EDINBURGH.
PHOTO., THOMAS ANNAN.

London:
A. W. BENNETT, 5, BISHOPSGATE WITHOUT.

1866.

FIG. 11-9. *Marmion*, by Sir Walter Scott.
Tipped-in albumen prints by Thomas Annan
(1866). Title page, 7½ × 5¾ inches, with a photo-
graph of Scott's Monument, Edinburgh.

CITY OF EDINBURGH.
p. 111.

(b)

FIG. 11-10. Albumen prints from *Marmion* (see Fig. 11-9).
3¼ × 3¼ inches.
 (a) Linlithgow Palace. Note the picturesque but artificially
enhanced reflections.
 (b) City of Edinburgh, with Scott Monument and Scottish
National Art Gallery. (David Octavius Hill, who did not, of
course, contribute to this work, had his home and studio on
the slopes of the hill visible in the background.)

EFFINGHAM WILSON.

TAKEN MARCH 13th, 1862, WHEN 79 YEARS OF AGE.

FIG. 11-11. From *In Memory of Effingham Wilson*, London, "printed for private circulation," 1869. Front-cover die-stamping, and albumen print, 3½ × 2¼ inches. "In all life's battles, and in each distress, He feared but two things—Sin and Wickedness." The printing was done by Effingham Wilson's own company; the editor's identity is indicated only by the initials W.W.

also to photographically illustrated books of a very different kind (Wilsher 1982). The carte-de-visite sized photograph shown in Figure 11-11 is inserted as the frontispiece to a small, anonymous memoir printed in London for private circulation in 1869, as a tribute to Effingham Wilson. Born in Yorkshire in 1783, Wilson went up to London as a young man and established himself there as a vigorous, radical publisher. Although his printing house issued a wide variety of books, including a translation of Victor Hugo's *Hunchback of Notre Dame* in 1830, and, in the same year, the very first volume of poetry by Alfred Tennyson, Wilson's main interest lay in economics and politics.

The first Parliamentary Reform Bill was passed in 1832, after more than a decade of steady, insistent pressure for electoral change. Public opinion was slowly formed by a stream of pamphlets and books designed to uncover and ridicule the gaping holes in the old, established system. One of the most effective weapons in the hands of the reformers was *The Black Book*, first published by John Wade and John Fairburn in 1820 (Wardroper 1973). This, produced in 10,000 copies, issued in weekly parts, made irresistible reading, being a detailed account of jobbery and corruption in high places. Effingham Wilson achieved fame in 1831 by agreeing to publish Wade's sequel, *The Extraordinary*

Black Book, which swept into the light of common day a cobwebbed mass of hoary privileges and shabby practices in both church and state. The book was an instant sensation. Appearing, as it did, in the months just before the passage of the bill, it was quoted everywhere and used as ammunition in the fight. It helped to make reform possible, and established Wilson's reputation as a fighting champion of the liberal cause (Woodward 1962). Wilson died on June 9, 1868.

A photograph added considerably to the interest of such personal productions, and its value was recognized from the first. At the end of 1844, only a few months after part one of Fox Talbot's *The Pencil of Nature* had appeared, an eminent judge in Scotland, Lord Patrick Robertson, decided to publish some observations on his travels in Europe, *Leaves from a Journal*. The heart of a poet had long lain hidden beneath the sober suiting of the eminent lawyer, and Robertson daringly seized the chance to include a few of his own poems, with apologies for "measure [that] is sometimes irregular, perhaps illegitimate," and the disarming excuse that his printer had insisted on extra material to fill out the volume to a respectable size. The endearing idiosyncrasy of this venture into print was dignified by a frontispiece, a magnificent calotype portrait of the judge, made earlier that year in Edinburgh by Hill and Adamson (Spira 1991). Robertson's book was instantly forgotten, even by indulgent friends, but it has won a place in the history of the book trade as the first photographically illustrated book produced outside England, and the first to include a photographic frontispiece.

Art lovers everywhere were (and are) fascinated by the inner workings of the artist's mind, and one port of entry into that realm is a glance at an artist's sketchbook or memoirs. Photography made it possible to produce such notebooks with relative ease, to garnish them with stories and "great thoughts," and to illustrate them with tipped-in reproductions. An example is *Gatherings from an Artist's Portfolio*, by James E. Freeman, published by D. Appleton & Company, of 549–551 Broadway, New York, in 1877. The artist, who undoubtedly sponsored the publication, presents an albumen-print photograph of himself as a frontispiece (Fig. 11-12a), followed by a dedication: "With his permission, this volume is dedicated to my old and much-valued friend, Edward Satterlee, Esq., a gentleman distinguished for his love of art and letters. It was he who first urged me to write these unpretending reminiscences, and who generously volunteered to read, revise, and prepare my manuscript for the press. Rome, January 1877." As so often, willingness to help was not quite enough, and the state of the printed text cries out for the cold eye of a professional proofreader.

Within the book's covers are examples of Freeman's paintings (Figs. 11-12 b and c) and a series of essays. One of these is entitled "The Caffe Greco"; it describes a famous hostelry on Rome's Via Condotti, and, indeed, one with a special "photographic resonance." It was primarily in this café that artists, writers, and photographers tended to congregate when they visited the city. At one time or another, Thorvaldsen, Morse, Keats, Washington Irving, Hans Christian Andersen, Shelley, and even King Ludwig of Bavaria, were among its many distinguished guests. In Freeman's own words: "Wit and mirth, penury and fortune, the sad and the gay, met and joined hands and hearts over the generous falerian, the *vino ordinario*, or the invigorating cup of coffee" (see also Poensgen 1957; Hager 1983). The café served as a *poste restante* mail drop for visiting artists of no fixed address, and Freeman makes a reference to that. Inter alia, the Greco was an important marketplace for art works. Robert MacPherson and Monsieur Flachéron, both prominent as early photographers of Rome's antiquities, were among its habitués, and so was the already famous Lorenzo Suscipj, who came to be responsible for Freeman's frontispiece portrait. We do not know who took the remaining photographs in the Freeman memoir; the chances are that Suscipj provided them all. (See Wilsher and Spear 1986.)

(a)

FIG. 11-12. *Gatherings from an Artist's Portfolio*, by James E. Freeman, published by D. Appleton & Company, Broadway, New York, 1877. Illustrated with tipped-in albumen prints. Picture titles in the artist's handwriting. Examples:

(a) Frontispiece, portrait of the author (4¾ × 3¾ inches) by Lorenzo Suscipj. Suscipj had been prominent among early photographers of Roman antiquities from the daguerreotype days (1840). See Becchetti 1983 and Wilsher and Spear 1986.

(b) "The Blind Man and His Child," painting.

(c) "The Dying Model," painting.

From c. 1850 onward, D. Appleton & Company was a major importer and distributor of photographic views of European paintings and sculpture (Darrah 1977).

Similarly personal, but along more whimsical lines, are the 1875 *Works of Nancy Luce*, of West Tisbury, Duke's County, Massachusetts, a slender volume of thirty-three pages, containing "God's Words – Sickness – Poor Little Hearts – Milk – No Comfort – Prayers – Our Saviour's Golden Rule – Hens' Names — Etc," as well as an albumen carte-de-visite of the author, fondly cuddling Pinky, one of her much-loved hens (Fig. 11-13). Indeed, the author's "poetic works, touching or demented, according to

one's point of view, are all memorials to her chickens. Pinky, one of her special favorites, had been suffering from distemper, until mercifully released from this vale of tears." (Mann 1980)

Likewise from the New World comes an example that demonstrates American ethnic diversity, a book in German by E. A. Zündt entitled *Dramatische und lyrische Dichtungen* and published by "C. Witter's Buchhandlung, 21 südl. 4 Strasse, St. Louis, Missouri" in 1879. It contains two tipped-in albumen prints (Fig. 11-14), made

Fɪɢ. 11-12 (b) (c)

Fɪɢ. 11-13. "In Memoriam, to Pinky." Frontispiece
from *A Complete Edition of the Works of Nancy Luce*,
of West Tisbury, Duke's County, Massachusetts.
Mercury Job Press, New Bedford, 1875. Albumen
print, 3¼ × 2½ inches. The "Complete Works"
comprise thirty-three pages, and Pinky was the
author's favorite chicken. (Mann 1980) Special
Collection, Rare Books Room, Pattee Library, Penn-
sylvania State University.

G. CRAMER, Photo. Die Gemsenjäger. ST. LOUIS, MO.

FIG. 11-14. Albumen print from *Dramatische und Lyrische Dichtungen*, by E. A. Zündt, 1879, issued in St. Louis, Missouri, to commemorate celebrations of the Centennial in that city. Text in German. Photographs (3¾ × 6 inches) by Gustav Cramer, printed by his Dry Plate Company. See also Fig. 8-13, Taft 1938, and Wilsher and Spear 1985.

by G. Cramer on occasions when two of the plays in the book, *Die Gemsenjäger: Alpenscene [sic] mit Gesang und Tanz in zwei Akten nach einer Gebirgssage* and *Dornröschen* (a translation of "The Sleeping Beauty"), "freely adapted from the English for the German stage, for performance by a juvenile cast," were produced by local amateurs. The book is a celebration of the American homeland newly found by recent immigrants, as well as a nostalgic gesture toward the Vaterland left behind. The contents (including a poem about Washington, and another entitled "Amerika 1492–1876") suggest that they were used in connection with the 1876 Centennial.

Gustav Cramer, the photographer, was German by birth, and had a studio in Carondelet, a suburb of St. Louis. He was also a partner of the Cramer & Norden firm, which became the G. Cramer Dry Plate Company in 1882 (Taft 1938). Cramer had begun the commercial production of dry plates in 1880, and in August of that year his was one of the only three firms that supplied samples at the request of the Photographers' Association of America for test and evaluation (Wilsher and Spear 1985).

Most surviving examples of the photographically illustrated book contain albumen prints, but volumes with tipped-in woodburytypes of exceptional quality are often found in publications issued from the 1870s to the end of the century. Woodburytypes, a form of photomechanical reproduction, lent themselves very well to the demands of book production. In his *The Complete Photographer*, undated but evidently of the 1920s, R. Child Bayley remarks that "a good woodburytype is almost indistinguishable from a carbon print," and that is not in the least surprising, considering the pigment is in fact carbon. Bayley goes on to say that a choice specimen "is the finest photo-mechanical rendering of a photograph that anyone could wish to have." Indeed, the tonal range of which that (basically primitive) process was capable remains astonishing to this day.

The superb quality of the woodburytypes used for such purposes can be seen from an anthology of prose masterpieces, published in 1886, in which each selection is accompanied by a portrait of the author. As it happens, the splendid study of Thomas Carlyle (Fig. 11-15b) was also the one chosen for the front-cover medallion shown in Figure 11-5b. More fine woodburytypes are found in a loving, leisurely study, *Violin Making, as It Was and Is*, published in 1884, with a second edition in the following

(a)

(b)

FIG. 11-15. Woodburytypes from *Prose Masterpieces from Modern Essayists*, edited by G. E. P. Bickers & Son, 1 Leicester Square, London, 1886. Twelve illustrations, 4½ × 3½ inches. The two examples shown were printed by the famous London firm of Elliott & Fry, which had played an important role in the late 1870s in the popularization of gelatin dry plates.
(a) Ralph Waldo Emerson.
(b) Thomas Carlyle. See also Fig. 11-5.

year. The book is richly decorated throughout with drawings and woodcuts; a golden mouse, its paw resting reverently on a violin bow, is embossed on the cover, and a vigorous sketch of "The Cat and the Fiddle" has been contributed by the great Victorian illustrator, Randolph Caldecott. Three woodburytypes are tipped in, each of the highest quality. The portrait in Figure 11-16 is of the book's author, and was made by H. Van der Weyde, operator of London's first electrically illuminated studio (see also Chapter 7). Two photographs of violins (one shown) were made by William Field, a professional with a studio in Putney, and printed by Vincent Brooks.

A little known book, *The Angels of Heaven*, published in 1870, manages, for all the modesty of its textual offerings, to present the reader with a series of remarkable albumen prints of paintings (Figure 11-17) by Raphael, Blake, Turner, Rembrandt, Doré, Delaroche, Kaulbach, and others. One of the general problems with early photographic reproductions of art works was the malpractice of cropping paintings to fit the format of the photographic plate. Figure 11-17 suffers slightly from that procedure (left and top), but not nearly as much as many other examples.

Undemanding anthologies of this kind were always popular, but more specialized books, on

(a)

(b)

FIG. 11-16. Woodburytypes from *Violin Making, as it Was and Is, being a Historical, Theoretical and Practical Treatise on the Science and Art of Violin Making, for the Use of Violin Makers and Players,* by Ed. Heron-Allen, Ward, Lock & Company, London and Melbourne, 1885, first edition, 1884. A gilt-embossed ornament on the front cover shows a violin, as well as a mysterious mouse. The author himself contributed "upwards of 200 illustrations," drawings skillfully executed. Photographs (4½ × 3½ inches) by H. Van der Weyde and William Field.
 (a) Portrait of a violin, by William Field, whose commercial studio was in Putney, London.
 (b) Portrait of the author, by H. Van der Weyde (see Fig. 7-19).

one artist or one era, were also produced. The first such volume was William Stirling's *Annals of the Artists of Spain* (1848), illustrated with sixty-six talbotypes, made by Nicolaas Henneman under the author's supervision (Goldschmidt and Naef 1980). *Contemporary French Painters,* illustrated with sixteen albumen prints, came out in London in 1869. The author, P. G. Hamerton, was a well-known figure in the British art world, delicately described in the *Dictionary of National Biography* as "a sterling character, somewhat deficient in superficial attractiveness." Another English study, *Some Ac-*

count of the Life and Works of Hans Holbein, Painter of Augsburg, by Ralph Nicholson Wornum, Keeper and Secretary of the National Gallery in London, appeared in 1867, with two albumen prints. In Berlin, the enterprising Gustav Schauer, one of the first specialists in art reproduction, issued in the early 1860s a short essay on a triptych in Cologne Cathedral, containing a folded photographic model of the original, which opened out to reveal the three inner panels of the altarpiece (Joseph and Schwilden 1983).
 Photography's potential contribution to the

RAFFAELLE.

"There was war in heaven: Michael and his angels fought against the dragon."

FIG. 11-17. Raphael's "Archangel Michael," from *The Angels of Heaven* (Anon. 1870), Seeley, Jackson & Halliday, 54 Fleet Street, London. Albumen print (frontispiece), 6½ × 5 inches. Subtitle: "There was war in heaven; Michael and his angels fought against the dragon." The source is Revelation, chap. 12, verse 7; alas, the biblical text offers no explanation for the dragon's presence.

study of painting, sculpture, and architecture was sensed by many, including Fox Talbot, from the first, but one man in particular had the idea, and the position, to encourage its use by example. Prince Albert devised a major contribution to Raphael scholarship, and took an active interest in the venture as it developed. The plan was to photograph, or otherwise reproduce, all the Raphael drawings in the Royal Collection, and to invite other owners to contribute copies of any work by the artist in their possession. By 1876, long after the Prince Consort's death, the last of the forty-nine portfolios had been issued; in all they contained about 2,000 photographs. An early volume in the series came out in 1857, with sixty-one photographs, made by C. Thurston Thompson (Dimond and Taylor 1987). Although the text of the accompanying catalog was published in a limited edition, only one complete set of the pictures exists: it is on permanent loan in the Department of Prints and Drawings at the British Museum, where it is still used, and praised, as an invaluable tool by scholars in the field.

In a few rare cases, books with panoramic illustrations were offered. The first known example of these was issued (in three parts) as the sixth annual edition of the *Royal Album Court Directory and General Guide*, "Printed and Published by the Proprietors, Spottiswoode & Co., New-Street Square, London" in 1866 (Spira 1989). It shows pictures of Windsor Castle from across the river, the Houses of Parliament, London Bridge, Trafalgar Square, etc., all of which lent themselves beautifully to panoramic rendering. The photographs were made

by means of a Johnson & Harrison Pantascopic Camera, which was able to produce a single panoramic picture, as distinct from the serial mosaics composed of separate exposures that had often been used in the past.

Once photographs could be incorporated in a book by advanced printing methods, tipped-in photographs first fell from grace, but then returned to favor on a wave of nostalgia. In a book published in the 1920s (Curzon 1923), the illustrations have been printed by photo-mechanical means, but each one has been carefully tipped in, to lend to the production an air of hands-on, meticulous craftsmanship and old-fashioned luxury.

The Victorian world was privileged to enjoy an exhilarating efflorescence in the related arts of book design and illustration. Technical improvements in the field gave gifted artists a new freedom to punctuate the pages of any volume, sumptuous or simple, with the varied charms of decoration. The photograph was one of many elements that transformed the publishing scene, and caused an old man at the turn of the century to marvel over the changes he had noticed since his own starved childhood some fifty years before:

> At the date on which I write these pages, the arts of illustration are so universally diffused that it is difficult to realize the darkness in which a remote English village was plunged half a century ago. No opportunity was offered to us . . . of realizing the outward appearances of unfamiliar persons, scenes or things. Although ours was perhaps the most cultivated household in the parish, I had never seen so much as a representation of a work of sculpture till I was thirteen. [Gosse 1907]

Chapter 11 References and Notes

BECCHETTI, P. (1983). *La Fotografia a Roma*, Editore Colombo, Rome, pp. 349–50.

BECKER, W. B. (1981). "Daguerreian Bookbinding," *History of Photography*, vol. 5, no. 1, frontispiece.

BUCHANAN, W. (1984). "James Craig Annan: Brave Days in Glasgow," in *The Golden Age of Photography* (ed. Mark Haworth-Booth), Aperture, Millerton, New York, pp. 170–73.

COLLINS, K. (1991). "The Collecting of Early Photographically Illustrated Books: A Bibliography," unpublished report. Personal communication, acknowledged with thanks.

CURZON OF KEDDLESTON (1923). *Tales of Travel*, George H. Doran Co., New York.

DANIELS, M. (1988). *Victorian Book Illustration*, British Library, London, p. 12.

DARRAH, W. C. (1977). *The World of Stereographs*, W. C. Darrah, Gettysburg, Pennsylvania, p. 4.

DARWIN, C. (1872). *The Expression of the Emotions in Man and Animals*, John Murray, London.

DIMOND, F., and TAYLOR, R. (1987). *Crown and Camera: The Royal Family and Photography, 1842–1910*, Penguin Books, Harmondsworth, Middlesex, U.K., pp. 46–49.

GERNSHEIM, H. (1984). *Incunabula of British Photographic Literature, 1839–1875*, Scolar Press, London.

GERNSHEIM, H. and A. (1969). *The History of Photography*, McGraw-Hill, New York, pp. 339–40.

GOLDSCHMIDT, L., and NAEF, W. J. (1980). *The Truthful Lens*, Grolier Club, New York, pp. 15, 183, 195, 222.

GOSSE, G. (1907). *Father and Son*, Penguin Books, Harmondsworth, Middlesex, U.K., 1970 edition, chapter 11, p. 176.

HAGER, H. (1983). Personal communication, acknowledged with thanks.

HEIDTMANN, F. (1984). *Wie das Foto ins Buch kam*, Verlag Arno Spitz, Berlin.

HOLDEN, R. (1988). *Photography in Colonial Australia: The Mechanical Eye and the Illustrated Book*, Hordern House, Sydney, pp. 107, 151, 154.

JOSEPH, S. (1982). "Lovell Reeve: Correspondence," *History of Photography*, vol. 6, no. 2, pp. 179–80.

JOSEPH, S. (1987). "Alfred Brothers and Photographic Publishing," *History of Photography*, vol. 11, no. 1, pp. 63–76.

JOSEPH, S., and SCHWILDEN, T. (1983). "Phototriptych," *History of Photography*, vol. 7, no. 3,

pp. 249–50.

KRAUSS, R. H. (1978). "Photographs as Early Scientific Book Illustrations," *History of Photography*, vol. 2, no. 4, pp. 291–314.

KRAUSS, R. H. (1979). "Travel Reports and Photography," *History of Photography*, vol. 3, no. 1, pp. 15–30.

MANN, C. (1980). "To Pinky, 'In Memoriam,'" *History of Photography*, vol. 4, no. 1, frontispiece.

MANN, C. (1990). "Francis Frith: A Catalog of Photo-Pictures of Germany," in *Shadow and Substance: Essays on the History of Photography* (ed. K. Collins), Amorphous Institute Press / University of New Mexico Press, Albuquerque, New Mexico, pp. 175–81.

McLEAN, R. (1976). *Joseph Cundall: A Victorian Publisher*, Private Libraries Association, Pinner, England.

MOZLEY, A. (1977). *Thomas Annan: Photographs of the Old Closes and Streets of Glasgow*, Dover Publications, New York.

NASMYTH, J., and CARPENTER, J. (1874). *The Moon, Considered as a Planet, a World and a Satellite*, John Murray, London.

POENSGEN, G. (1957). *C. Ph. Fohr und das Café Greco*, F. H. Kerle Verlag, Heidelberg.

SCHAAF, L. (1979). "Charles Piazzi Smyth's 1865 Conquest of the Great Pyramid," *History of Photography*, vol. 3, no. 4, pp. 331–54.

SCHAAF, L. (1980). "Piazzi Smyth at Teneriffe: Part I," *History of Photography*, vol. 4, no.4, pp. 289–307.

SCHAAF, L. (1981). "Piazzi Smyth at Teneriffe: Part II," *History of Photography*, vol. 5, no. 1, pp. 27–50.

SCHAAF, L. (1985). *Sun Gardens: Victorian Photographs by Anna Atkins*, Aperture, New York.

SMITH, G. (1983). "Calotype Views of St. Andrews by D. O. Hill and R. Adamson," *History of Photography*, vol. 7, no. 3, pp. 207–36.

SMITH, G. (1984). "William Henry Fox Talbot's Calo-type Views of Loch Katrine," *Bulletin, Museums of Art and Archaeology of the University of Michigan*, vol. 7, pp. 48–77.

SMYTH, G. P. (1858). *Teneriffe, an Astronomer's Experiment*, Lovell Reeve, London.

SPENCER, S. (1985). *O. G. Rejlander: Photography as Art*, UMI Research Press, Ann Arbor, Michigan.

SPIRA, S. F. (1989). "Panoramic Photographs as 19th Century Book Illustrations," *History of Photography*, vol. 13, no. 3, pp. 203–14.

SPIRA, S. F. (1991). "Leaves from a Journal," *History of Photography*, vol. 15, no. 1, pp. 23–25.

STARK, A. E. (1981). "Lovell Augustus Reeve (1814–1865), Publisher and Patron of the Stereograph," *History of Photography*, vol. 5, no. 1, pp. 3–15.

TAFT, R. (1938). *Photography and the American Scene*, Macmillan Co., New York, 1964 reprint by Dover Publications, New York, pp. 503–4.

TAYLOR, R. (1981). *George Washington Wilson: Artist and Photographer, 1823–93*, Aberdeen University Press, Aberdeen, Scotland.

THOMAS, A. (1978). *The Expanding Eye: Photography and the Nineteenth Century Mind*, Croom Helm, London, pp. 136, 140.

WARDROPER, J. (1973). *Kings, Lords and Wicked Libellers*, John Murray, London, p. 200.

WILSHER, A. (1982). "Effingham Wilson," *History of Photography*, vol. 6, no. 1, p. 64.

WILSHER, A., and SPEAR, B. (1985). "Dornröschen," *History of Photography*, vol. 9, no. 4, p. 319.

WILSHER, A., and SPEAR, B. (1986). "An Artist's Advertisement," *History of Photography*, vol. 10, no. 1, pp. 15–17.

WOODWARD, E. L. (1962). *The Age of Reason, 1815–1870*, Clarendon Press, Oxford, p. 28.

ZAHLBRECHT, R., and HELWICH, O. (Editors) (1961). *Jubiläums Festschrift: Hundert Jahre Photographische Gesellschaft in Wien, 1861–1961*, Vienna and Darmstadt, pp. 138–47.

12

POLITICS ON A PLATE

BUSINESS AS USUAL

One way to cope with a new invention is to tame it, to domesticate its marvels until it becomes a familiar tool, used day by day to ease familiar tasks.

Gifts have always had a part to play in the diplomatic dance, their value delicately adjusted to reflect the current worth of the recipient. In 1844, Great Britain and Russia had their eyes on Persia, a key piece in the strategic plans of both parties. As a result, by the end of that year the Shah had become the proud possessor of matched toys, examples of the very latest and most fashionable Western invention: two sets of daguerreotype equipment, one sent by Queen Victoria and one by Czar Nicholas I. (Afshar 1983)

Official portraits are even easier to exchange than other tokens; their use for ceremonial purposes eliminates the vexing questions of choice and taste. Rulers everywhere soon added photographs to their store of traditional images. Even in far away Siam (now Thailand), King Mongkut Rama IV (1851–68) sent out photographs of himself to fellow monarchs on his political circuit (Nawigamune 1988).

In the daily diplomatic round, such presents might be taken for granted, put aside without a second glance but, once royal marriage negotia-

tions were set in motion, they had a special part to play. By 1861, Queen Victoria and Prince Albert had decided it was time to choose a bride for their susceptible son, the Prince of Wales. There were anxious moments, when the quest seemed hopeless; it was no easy task to find a young woman with all the right qualifications. Besides the need for a background suitably royal and politically correct, there were two other imperatives: the candidate herself had to be undeniably acceptable in faith and indisputably pretty in person. Gloom deepened as the first crop of Protestant princesses yielded a meager harvest, but prospects grew bright once photographs of the young Princess Alexandra of Denmark had been received (see Fig. 12-1). Charm won the day, and the decision was made to overlook certain political drawbacks of the match (Dimond and Taylor 1987). An informal meeting of the young couple was arranged and, in due course, on March 10, 1863, the marriage took place.

For wedding brokerage, early photographs had a distinct advantage over the traditional portrait. While they attempted to flatter the sitter, they rarely succeeded with total conviction, and thus provided a margin of uncertainty that permitted pleasant surprises. Far different was the case of Henry VIII and Anne of Cleves (Baldwin Smith 1971). Both were ill-prepared by the blandishments of court painters for the shock of reality. Their marriage never recovered from that fateful moment in January 1540 when potbellied groom and pockmarked bride first took each other's measure.

Nor was it only on the international stage that the official portrait found a role to play. Whether painted or chiseled, stamped or carved, it had been used by rulers for centuries to impress the image of authority on the minds of sullen subjects. Photography simply added a new weapon to the arsenal. It enabled the powerful to extend their range and tighten a grip, already firm, on public opinion. Those, like Napoléon III, who were not born to rule but made their

FIG. 12-1. Princess Alexandra of Denmark (1860), by E. Lange. Royal Archives, Windsor Castle. Copyright reserved; reproduced by gracious permission of Her Majesty the Queen. See Dimond and Taylor 1987.

own roundabout way to the top, relied heavily on publicity to authenticate their claims. Napoléon was a master of the art, and used every medium to project his image.

Between 1854 and 1864, twenty-four full-length painted portraits, and forty-eight half-length ones, of Napoléon, together with matching sets of his consort, Eugénie, were commissioned for official use, while at the same time thousands of carte-de-visite pictures of the new imperial family went on sale at home and abroad. Care and ingenuity had to be lavished

on any image, for Napoléon was not an obviously handsome man. The happiest results were achieved by those who chose a head-and-shoulders view (Fig. 12-2), in which attention was concentrated on the magnificent mustache, while the Emperor's unfortunate legs, "very short and placed askew," could be tactfully ignored (McCauley 1985).

The value of publicity was understood by every leader. Manifestly, patron and photographer needed each other, and heads of state were quite willing to reward satisfactory service with permission to use such coveted phrases as "By Special Appointment" or "Photographer Royal." The custom was widely accepted, and widely used. (See also Figs. 4-19 and 7-1.) In the course of her long reign, Queen Victoria granted Royal Warrants to fifty-one photographic firms (Dimond and Taylor 1987). Most were in Great Britain, but a number did business on the Continent, including Adolf Braun, who had studios in Dornach and Paris, and Carlo Brogi in Florence.

When Shah Nasser-ed-Dini of Persia came on a state visit to London in late June 1873, he gave the coveted title "Photographer Royal to the Shah. By Special Appointment" to a fashionable society photographer, A. J. Melhuish, who promptly took care to include the new honor in his own advertisement (Fig. 12-3; see Henisch 1980). A few years later, in 1880, while visiting Warsaw, the Shah was again in a responsive mood. As a result, several happy Polish photographers, not previously conspicuous for ardent support of the Persian potentate, were able to rush into print with the magic words "By Appointment to the Shah." (Garztecki 1977)

Photography itself, not just the individual photographer, stood to gain from cordial relationships with powerful clients. Though leaders of society were not always leaders of opinion, their enthusiasm encouraged emulation. The Photographic Society of London was formally constituted on January 20, 1853. The announcement six months later, at the June meeting, that

FIG. 12-2. Louis Napoléon III (1808–73). 1860s. Albumen print carte-de-visite by Dusacq & Company, of 14 Boulevard Poissonière, Paris.

the Queen and Prince Albert had agreed to become its Patrons put the stamp of official approval on the new art. (Dimond and Taylor 1987) Prince Albert's alert, sustained interest in photography's progress throughout its first years in Great Britain opened many doors and smoothed many paths.

Photography took root early, and flowered vigorously, in Brazil, in no small part because it was fostered by the enthusiasm of the Emperor, Dom Pedro II (1840–89). In the first month of his reign, January 1840, Dom Pedro, a schoolboy of fifteen, asked for a demonstration of the daguerreotype process. Enchanted, he became both a gifted practitioner and an energetic promoter of the art (Ferrez and Naef 1976). As early as 1842, daguerreotypes were exhibited, under

FIG. 12-3. Verso of a carte-de-visite by Arthur J. Melhuish, portrait painter and Photographer Royal to Shah Nasser-ed-Dini of Persia, c. 1873. Note the inscription in Farsi script, intended to impress and mystify other studio clients.

royal patronage, at the Imperial Academy of Fine Arts, and throughout his long reign Dom Pedro took pains to meet and encourage many photographers.

On the other side of the world, in Siam, it was the active, public support of King Chulalong-korn (1868–1910) that stimulated a general interest in the art. The King took photographs himself, planned the country's first photographic exhibition, in 1904, and organized its first competition the following year. At both events, to add to the glamour of the occasion, a royal studio was set up, in which a royal operator pressed the button for his flattered clients. (Nawiga-mune 1988)

THE ESTABLISHMENT

For any figure in authority, photography's virtue lay in its versatility. It could be used to build a showcase, or to open windows on the world. It was a two-way conduit, conveying silent messages between ruler and realm. In his charming memoir of childhood, the Swiss painter Werner Miller (1892–1959) recalls the summer holiday visits to Grindelwald of Mr. Schapiro, Court Photographer to His Imperial Majesty, the Czar of Russia (Mauner 1990). Throughout the rest of the year, Mr. Schapiro was busily at work, for he had been given an important task: "Inspired by Mr. Schapiro's photographs, the Empress had this idea: if she could not be close to every one of her subjects *in persona*, she could at least be there *in effigibus*. And she could make herself beloved by her people in that way. No house and no home, from Nowaja Semlia up to the Caucasus, should be without its portrait of the Czar and the Czarina."

The Czarina's contemporary, Sultan Abdul Hamid II of Turkey, took a different tack. Instead of sending out portraits of himself to every corner of the Ottoman Empire, he decided to bring the empire into the palace. Always afraid of assassination, he had no desire to leave the safety of his compound; on the other hand, he did want to see what was happening in his domains. Photography solved the knotty problem. For several years, into the early 1890s, Abdul Hamid commissioned work from his government's photographic units, and from such well-known professional firms in Istanbul as Abdullah Frères and Sébah & Joaillier. The subjects varied, and included both landscapes and historic monuments, but the emphasis was on progress and modern improvements; schools, hospitals, military installations, all figure prominently in the selection (Allen 1984). The photographs were arranged in albums intended for presentation purposes and as a reference archive for the reclusive Sultan. A puzzling notice in the *Pittsburgh Post* of May 17, 1900, suggests that

the Sultan, despite his mistrust of the outside world, did occasionally venture beyond his palace gates; a photograph of a mosque in Istanbul was submitted in his name to the Pittsburgh International Photographic Exhibition held in 1900 (Weprich 1991). However, it is quite unlikely that the photograph was actually made by him, even though he was an amateur photographer. The most likely explanation (Öztuncay 1991) is that someone sent to the exhibition a print from one of the many albums made for the Sultan by professionals, and later distributed by him to members of foreign embassies, with the imprint: "Presented by the Sultan Abdülhamid Khan of Turkey."

The politically alert were quick to sense the potential value of the new art, but its use was initially limited by the fact that photographs could reach a wide public only in the form of woodcuts or engravings. However, as this had always been true of painted portraits, it cannot have seemed at the time such a drawback as it does today. Franklin Pierce's bid in 1852 to become President of the United States began with a visit to a daguerreotype studio (Pfister 1978). There handsome portraits of the candidate were made, ready for release on the campaign trail, not in their original form but as engravings.

Such versions are now precious as the ghosts of lost originals. A daguerreotype portrait of President Andrew Jackson, taken on April 15, 1845, just two months before his death, was long in circulation as a popular engraving, but the daguerreotype itself soon vanished, only to surface again by chance, 145 years after it had been made. (Sandweiss 1990)

Many gifted artists put their skills at the service of the photographers. Thomas Doney, a mezzotint engraver, came to America from France and worked, from about 1844 onward, with Edward Anthony, the New York photographer who built his own reputation on the daguerreotypes he made of prominent people (Hanson 1988). In 1846, Anthony published a large mezzotint by Doney, "The United States

Senate Chamber" (Fig. 12-4), which contained over one hundred portraits based on daguerreotypes produced by the Anthony studio. The work thus precedes by twenty years the more famous painting, also based on photographs, that David Octavius Hill made of the first General Assembly of the Free Church of Scotland (Michaelson 1970). That event took place in 1843, but it took Hill twenty-one years to complete his work.

By the end of the century, photography had become expected everywhere, as a matter of course, to record the milestones in public as well as private life. When forty-five delegates of the National Australasian Convention met in Sydney, on March 2, 1891, to draft the Bill to Constitute the Commonwealth of Australia, a professional photographer was at hand to make the official group portrait. The only unusual detail in such a story at this time is that the photographer was a woman, Mrs. Laura Praeger, who had a business in the city during the 1890s. (Millar 1991; Gregson 1991)

In illustrated journals, engravings based on photographs were often used to draw attention to a story. When Prince Napoléon, cousin to the Emperor Napoléon III, came to America in 1861, the first year of the Civil War, he arrived at a delicate moment. He was a representative of France, a country that still strongly favored the southern states because of its own dependence on the South's production of raw cotton. *Harper's Weekly*, on page 573 of its September 7, 1861, issue, published a picture of Prince Napoléon and his wife, "from a photograph from Fredericks [*sic*]" (Fig. 12-5). The commentary indicates the uneasiness with which the visit was viewed by a northern editor: "These are probably the best likenesses in existence of our distinguished visitors, and should any political complications grow out of the visit of the Prince—as seems not unlikely—they will possess historic interest." The portrait itself must have been brand-new, and made in America, because it was taken by Charles de Forest Fredricks, a

UNITED STATES SENATE CHAMBER.

FIG. 12-4. The United States Senate Chamber. Mezzotint engraving by Thomas Doney, after daguerreotypes by Edward Anthony. 1846. 68 × 91 cm. (Hanson 1988) Courtesy of the National Portrait Gallery, Smithsonian Institution, Washington, D.C.

fashionable and successful practitioner (Taft 1938), whose "Photographic Temple of Art" at 585 Broadway in New York City, was by the early 1860s the largest, and one of the most luxurious, in America.

Photography repaid its debt to the engravers as soon as an inexpensive reproduction of any original could be launched on the market as a photograph, on the back of the little cardboard carte-de-visite. Portraits in any medium could then be photographically copied in their thousands and as, at first, people had an insatiable

appetite for pictures of any public figure, even old engravings were often thriftily recycled. (See Figs. 8-30 and 12-6.)

The carte-de-visite and, later, the larger cabinet card enabled the partisan public to collect portraits of admired political leaders, purchased singly or, more economically, bought in bulk (Fig. 12-7). Two styles of portraiture were specially favored. In one, the subject was presented as a little larger than life, a remote and splendid figure of authority (Fig. 12-8). In the other, with a bow to democratic aspirations, the great and

PRINCE NAPOLEON AND HIS WIFE, THE PRINCESS CLOTHILDE.—Photographed by Fredricks.—[See Page 573.]

FIG. 12-5. "Napoléon and Clothilde." Engraving (15½ × 11 inches) after a photograph by Charles de Forest Fredricks, New York. *Harper's Weekly*, September 7, 1861.

FIG. 12-6. Franz Joseph I (1830–1916), Emperor of Austria, as a young man. Albumen print carte-de-visite by E. Neurdein of 28 Boulevard de Sébastopol, Paris, from an earlier engraving. The card must have been made after 1858, since the boulevard itself was opened (by Napoléon III) only in April of that year, part of Haussman's rebuilding plans for Paris. See also Fig. 8-30.

Francois Joseph Iᴱᴿ
EMPEREUR D'AUTRICHE

FIG. 12-7. The Presidents of the United States. Before 1868. American. Unknown photographer. Albumen print carte-de-visite. Composite image, consisting of seventeen presidential portraits, up to and including Andrew Johnson.

(a)

(b)

FIG. 12-8. H.M. the Emperor of Germany.
 (a) Photograph taken in June 1891 at Potsdam, by
Russell & Sons of London. The gelatin silver image on
a cabinet card was issued after May 3, 1897, when the
firm was granted a Royal Warrant.
 (b) Color lithograph ("The Kaiser Abroad") by H.
Meyer, on the title page of *Le Petit Journal*, November
6, 1898. (Scheid 1983)

FIG. 12-9. Queen Victoria and Prince Albert, by John
Jabez Edwin Mayall. 1860 or 1861 (Prince Albert died
in December 1861). Albumen print carte-de-visite.

(a)

FIG. 12-10. Photographic portrait jewelry, late nineteenth century.
(a) Emperor Franz Joseph (see also Fig. 12-6) and Queen Victoria (see also Fig. 12-9).
(b) Lucretia Mott (1793–1880), the famous campaigner for women's rights and the abolition of slavery.

mighty were shown at home, in quiet scenes of unpretentious domesticity (Fig. 12-9).

Little trinkets have always been popular as badges of loyalty, bonds between revered leaders and ardent supporters. Photography made it easier than ever before to make such favors in quantity. A fan, designed for some Union festivity early in the Civil War, was decorated with medallion photographs of President Lincoln and ten of his generals. (Braive 1966) Buttons and brooches bore portraits of established monarchs, and such leaders of nationwide campaigns as Lucretia Mott (1793–1880), icon of the abolition of slavery movement and the cause of women's rights (Fig. 12-10).

(b)

THE CHALLENGERS

Nothing in this life is perfect, and leaders soon learned, to their chagrin, that photography was not only an invaluable tool but also a two-edged weapon. Among other things, it had the power to confer celebrity on some most undesirable competitors. Indeed, the need of political challengers for visibility was even more urgent than that of established rulers; photography gave them the exposure they craved.

In any struggle against authority, the world over, photography could fan the flames of revolt, and keep the smoldering ashes alight in the desolation of defeat. Examples abound. Thus,

FIG. 12-11. "Veljko Petrović," by Anastas Jovanović, c. 1851. Print made from a calotype negative, with background retouched with drawing ink on the negative. For this portrait a model was used, as the hero Petrović had died in 1813. Belgrade City Museum, item no. AJ484. See Djordjević 1980.

for instance, in Colombia, Demetrio Paredes worked as an artist, and managed to combine success as a commercial photographer with a passionate enthusiasm for politics. On May 23, 1867, a small band of patriots overthrew President Mosquera without bloodshed, and installed their own choice in his place. To celebrate the achievement, Paredes created a mosaic made from portraits of all the conspirators, entitled it "Los Conjurados del 23 de Mayo," and issued it for sale, to be bought and enshrined by partisans. (La Huella 1983; Henao and Arrubla 1938; Schmidt 1991) Wherever there was political conflict, the photographer could play a part. In Lithuania, after the uprising of 1863 had been crushed, photographs of its leading figures made the rounds, each one a reminder, each a silent call to future emulation. (Juodakis 1977)

Pictures of those who had been killed for a cause possessed a power far stronger than any the subject had enjoyed in life. In 1861, protest flared in Warsaw against the Russian authorities, and five of the demonstrators were cut down by Cossack troops. The bodies were carried to the studio of Karol Beyer, one of the foremost Polish photographers in the nineteenth century, and one of the first, having opened for business as a daguerreotypist in 1844 (Garztecki 1977; Jackowski 1991). Beyer and his colleague took a picture of each victim, and several thousand copies of these images were issued, to deepen and darken public outrage.

Contemporary heroes are potent symbols everywhere, but a great figure from the past has special authority, a reputation already formed. Time and veneration have simplified the story and sharpened its impact. They have stripped away irrelevant details, to reveal the broad outline of a legend that moves hearts not with its facts but with its inner truth. Painters had never found it hard to embody legend. For photographers, tied to reality, the task was more difficult, but not impossible once it had been grasped that convincing fact could be conjured out of fiction by a practiced magician. In 1851, a Serbian patriot, Veljko Petrović, who had died in 1813, was brought back to life in a photograph (Fig. 12-11). The miracle was performed by Anastas Jovanović, a gifted and ingenious artist with a long career in photography, from 1840 until the 1870s. (Djordjević 1980) The portrait, of a model dressed in the well-known clothes and armor of the dead hero, was deliberately created to keep bright the memory of a great figure in the Serbian struggle for independence.

Another photographer, Aleksandr Roinashvili, reached still further into the past, to bring back inspiration for the independence movement in his own country, Georgia, an ancient nation that had been absorbed by the vast Russian empire. Roinashvili began his career as a photographer in Tiflis in 1865, and from then until his death in 1898 he did everything in his

power to fire the pride of his compatriots in their heritage. This was a time when the central government forbade the use of the Georgian language in schools, and vigorously tried to suppress all other traces of Georgian culture and tradition. Besides the straightforward pictures he made of leading Georgian personalities of the day, Roinashvili also contrived a photograph of a legendary figure from the past. He created a portrait of Rustaveli, the author of an early medieval epic, *The Knight in the Tiger Skin*, which is considered to be the first great example of Georgian literature (Mamasakhlisi 1978). The photograph was distributed widely, and became one of the symbols of the nationalist cause.

Police forces everywhere found such partisan photography both an irritant and a godsend (see also Fig. 10-4). Portraits of the heroes and martyrs of any struggle against the established order stirred public passions and eroded civil obedience. To crack down hard on the photographer, the apparent cause of all the trouble, was the most obvious but least intelligent response. In 1861, Karol Beyer's photographs of the five demonstrators killed by Cossacks proved so provocative that the enraged Russian authorities ordered his studio to be raided and its stock destroyed. Beyer himself was deported, and not allowed to return to Warsaw until 1864. (Garztecki 1977) Czarist officials in Lithuania used the same approach to a vexing problem. Once it had been observed that, in the aftermath of the 1863 insurrection, photographs of its leaders were being passed from hand to hand, the response was to forbid the distribution of such provocative material, shut down studios, and confiscate their contents (Juodakis 1977). Some photographers were arrested and deported, while others were put on a register and, with that endearing ingenuousness characteristic of all governments, required to pledge obedience to the law.

The Turkish authorities in Bulgaria were more cunning. They decided to use photographs for their own ends, and turn their adversaries' weapon to advantage. In the long struggle with Turkey that led to Bulgaria's independence in

Fig. 12-12. "The Voivoda Panayot Hitov," by Thoma Hitrov. 1868. By permission of the Cyril and Methodius National Library, Sofia, item no. III 407. (Boev 1978)

1878, photography played a significant part. Among the dashing leaders of the movement, it was fashionable to be photographed, and the studios became convenient settings for conspiracy (Fig. 12-12). As elsewhere, copies of these portraits of Bulgarian patriots were widely distributed and easy to find. Although made for supporters, they soon caught the eye of Turkish intelligence agents, who grasped how useful they could be in the hunt for any wanted man. In several cases, a photograph identified the fugitive as he tried to slip undetected through the net. (Boev 1978)

Officials in France, likewise, both feared and used photography's two-edged power. After the

overthrow of the Paris Commune in 1871, the government went to extraordinary lengths to find pictures of the Commune's leaders. The search was very thorough. Understandably, nothing was considered too trivial to warrant inspection after the triumphant discovery of subversive photographs tucked in the packets of tapioca on a grocer's shelf. While this campaign of confiscation continued, the police took pains to collect photographs for their own files. Pictures of revolutionaries were sent to points of exit from France, such as the port of Le Havre, to help local agents spot and seize the quarry (English 1984). See also Chapter 10.

SHADES OF OPINION

When the game of "cat and mouse" is played in earnest, the prey must twist and turn to elude the claws. As photographic portraits of dissidents invariably provoked a dangerous official anger, it was expedient to find less direct and less inflammatory methods with which to promote a political cause. In any struggle for national independence from foreign domination, one sure way to win support was to awaken the public's patriotism with a steady, insistent emphasis on the characteristic riches of the country's heritage. The photographer made a silent but recognizable contribution to the cause simply through the choice of subject matter.

Even something as innocuous as a photograph of some cherished natural feature of the region could promote a sense of pride and community. Many an album of landscape views, published without a single provocative caption, contained a political message for discerning eyes. Thus, for instance, in Georgia, photographer D. Ermakov, active in Tiflis from the 1870s until his death in 1914, grew prosperous on the proceeds from his discreetly patriotic landscape views (Fig. 5-31; see Mamasakhlisi 1978). Kindred

spirits were active in many lands, where drawing attention to the country's beauty or to national dress was considered a political and rebellious act by foreign occupiers. Indeed, photographers became past masters in the design of images intended to send different messages to different viewers, whose reactions were controlled not by the images alone, but by a decoding process that depended (as it still does now) on background information or the lack of it (see Bellucci 1988), or on allegiance to a cherished cause.

Georgi Danchov, in Bulgaria, was less fortunate than his Georgian counterpart. He began his photographic business in 1866, and chose to promote the cause of national independence with his pictures of characteristic regional customs and costumes. At first, all went well, and he was able, in 1867, to contribute a group of these studies to an exhibition held at Moscow University. By 1873, the Turkish authorities had been alerted to the power of such images, and Danchov was sent off in chains into an exile from which he managed to escape three weary years later (Boev 1978). Costume studies were common to many countries. Romania did not achieve full independence as a nation until the war of 1877–78. Up to that time, her three main provinces were divided between the Austrian and Ottoman empires. Any image of traditional Romanian life had a special resonance during the struggle, and in the first flush of victory. Its power lay not in its ethnographical content but in its political charge. Even innocuous studies (Fig. 12-13) of peasant "types" made by Szathmari, the prominent Romanian photographer, offered lessons to be learned by attentive viewers.

Such pictures, whether of beautiful scenery or regional costume, may carry no conscious message when issued in a stable society, but any subject can be a beacon in troubled times, the placid surface concealing passions still powerful, though long submerged. In the town of Merthyr Tydfil, in Wales, the photographic firm of Har-

FIG. 12-13. Walachian national costume. Cartes-de-visite by Carol Popp de Szathmari. 1860s or 1870s. Romanian. Albumen prints. Szathmari was a fashionable painter who became Romania's first photographer. He produced his first calotype in 1848, and went on to record the early stages of the Crimean War in 1854, as well as other important political events in his country. (Săvulescu 1977, 1985)

ris & Company was registered for business from 1873 until 1899. At some time in that period, it offered for sale a carte-de-visite of a woman in the Welsh national costume, which was by then out of common use (see Fig. 12-14). There is nothing remarkable about the little card except the advertisement printed on the back, which shows the firm's name and address, in "Merthyr, South Wales," flanked by a large flag. This is not the Union Jack, nor the Welsh Cross of Saint David, but something that, at first glance, looks remarkably like the familiar Stars and Stripes of the United States. More careful study

leads to the puzzling conclusion that the Harris design does not correspond exactly to that of any American flag, at any period.

A clue to the possible significance of the emblem may be found in the stars that decorate it. There are thirteen, the number of counties into which Wales was divided at the time. Wales, racked by poverty and the miseries of industrial modernization, had been swept by many waves of enthusiasm for both the French and the American revolutions, and thousands had emigrated to America throughout the nineteenth century (Williams 1980). It is conceivable that

FIG. 12-14. Welsh national costume. Carte-de-visite by Harris & Company of Merthyr Tydfil. 1870s. Albumen print. Note the "American style" flag on the verso, a fusion of Welsh national sentiments with notions of American freedom.

the costume shown in the image is a tribute to Wales, and the mock-American flag is a symbol in which Welsh nationalism has been fused with American freedom.

In politics, the players have one aim in common: to shape public opinion. The neutrality of photography itself led to its use by all sides. Sultan Abdul Hamid II commissioned, for his presentation albums, pictures of modern improvements to counter the West's patronizing preoccupation with the exotic, exasperating chaos of the fabled Ottoman empire. (Allen 1984)

Queen Isabella II of Spain chose as her court photographer Charles Clifford, an Englishman who began to work in her country in 1852. For publication in albums, and for exhibitions abroad, Clifford made studies of historical monuments and modern achievements. These included a contemporary marvel, the building during the 1850s of a series of aqueducts that brought a continuous water supply to Madrid. The majesty of his photographic record matches the majesty of the subject matter. (Benet and Mondejar 1988) Isabella was an unhappy woman and an incompetent queen, but she was blessed with one stroke of good fortune: the inspiration to appoint Charles Clifford. No one could have been better fitted than hé for the unenviable task of creating an image of dignity and progress from the disorder and corruption of her reign.

Photography was a good tool but, like any tool, could do nothing without skilled hands to guide it. In the cut and thrust of partisan politics, a photograph without a frame of reference was a weapon with a blunted blade. The very

neutrality that made the art versatile muted its message. The help of context, caption, or circumstance was required, to control response and drive home the intended lesson to an audience already alerted to receive it. The formal portrait of a politician, set in a gilded frame, conveys one idea; the same image, framed in a wooden lavatory seat (Fig. 5-24c), sends quite another.

In 1848, that year of revolution, the countries of Europe were in turmoil. In Britain, the aching poverty of the past decade, and the contagious fever for political change, had combined to fuel the Chartist movement, which pressed for wider suffrage. A great meeting was planned, on Kennington Common, in London, on April 10. Although the day ended in disappointing anticlimax for the Chartists, the weeks leading up to the event had been filled with tension, alarm,

and government plans to contain the crowds with military force if events got out of hand.

W. E. Kilburn (active 1846–62) made two daguerreotypes of the event, which were purchased by Prince Albert for the Royal Archives. One was published in the press (*Illustrated London News*, April 15, 1848) in the form of an engraving (Dimond and Taylor 1987). The pictures are precious as very early examples of documentary photography, but as political weapons they have no cutting edge. Each offers a general view of a large, quiet group of backs turned toward the camera, with no trace of fiery eloquence or feared violence to satisfy the partisans on either side. (See Fig. 12-15.) At the Great Exhibition of 1851, Kilburn was to win one of the two highest awards for daguerreotypes; the other went to Antoine Claudet (Gernsheim 1969).

FIG. 12-15. "The Great Chartist Meeting on Kennington Common, April 10th, 1848," by W. E. Kilburn. Full-plate daguerreotype. Royal Archives, Windsor Castle. Copyright reserved; reproduced by gracious permission of Her Majesty the Queen. (Dimond and Taylor 1987)

THE CUTTING EDGE

To score points over opponents, other instruments were needed. Stories and sentiments had to be shaped, to tip the balance in the right direction. One or two approaches were borrowed, without acknowledgment, from the artist's pattern book. A *tableau vivant*, in which living models held allegorical emblems and struck appropriate attitudes, could be arranged in the studio. In the push for freedom of all kinds in Bulgaria during the 1860s, the cause of education for women was promoted with photographs of young girls holding open books. In the fervor of the uprising for national independence, in April 1876, books were cast aside, and the young women brandished sabres for the camera (Boev 1978).

Yet another independence struggle, this time in Estonia, inspired at least one photographic contribution to the cause. In 1871, a prominent German pastor spoke against the nationalist movement at a church synod. Two opponents, with the help of the Tartu photographer Reinhold Sachker contrived a stinging response (Fig. 12-16). Posed in the studio, one holds the offending text while the other shears the paper with a pair of scissors. Contemptuously pushed to the ground is a massive Bible, representing the enemy, the despised minister (Teder 1977).

The artist has always been at liberty to populate a picture at will. Constraints of time and place cannot prevent the painter from causing Dante and Milton to embrace, or Drake to cheer on Nelson at Trafalgar. The photographer first envied this freedom, and then took pains to emulate it. Thus, after the assassination of President Lincoln in 1865, many tributes were rushed into print, including a painting by S. J. Ferris that shows Lincoln crowned and embraced by the Father of the Nation, George Washington. The Philadelphia Photo Company played its part by acting as a carrier, photographing and distributing hundreds of copies of the painting (Darrah 1981). Other photographers went fur-

FIG. 12-16. A. Reinvald and J. Kunder destroying a text written against Estonian independence by a German cleric. 1871. Photograph by Reinhold Sachker. The Bible on the floor is a symbol of anticlerical sentiments arising from the issue. Archives of the Estonian Museum, Tartu, Estonia, ERM FK355-77, copy by A. Karm. (Teder 1977; Tooming 1991)

ther, and produced their own variations on the theme, welding Lincoln to Washington for eternity by photographic means (Fig. 5-29 b, c, d).

Ingenious darkroom manipulation made it possible to encapsulate a complicated story in a telling image. Alexander Herzen, the great Russian liberal who, until his death in 1870, wrote with such perceptive brilliance on revolution and its limitations, could not for a long time make up his mind to back the Polish insurrection in 1862–63. One of his cousins, a professional photographer in Paris, summed up the struggle with a trick portrait, in which Herzen argues

with Herzen on the thorny problem. (Carr 1961)

Some time soon after the crushing defeat of France in the Franco-Prussian War of 1870, and the overthrow of the Second Empire (September 4, 1870), a carte-de-visite commentary on the disaster was distributed by the firm of Franz Unterberger in Innsbruck. The picture shows a bust composed of three heads fused together in such a way that only four eyes can be seen. The outer heads belong to Wilhelm I of Prussia and to his Chancellor, Otto von Bismarck. The one in the middle, squashed between the other two, is that of Napoléon III (Fig. 12-17). At the base runs an inscription in French: "Quatre yeux seulement? C'est que l'un des trois n'y voyait pas clair!" ("Only four eyes? That's because one of the three didn't see clearly there!"). The French text suggests that the card was designed originally for a French market, but the fact that not only Unterberger of Innsbruck but also the firm of Wurtle in Salzburg offered it for sale indicates confidence that it would find favor with a wider public. Pan-German sentiment was strong in Austria at the time, and had expressed itself in total support for Prussia during the conflict. (Sommergruber and Henisch 1981)

Photomontage became, and has remained, the mainstay of political propaganda and cartooning. As a medium, it is at once tempting and powerful, just because it overcomes some of the inherent limitations of "straight" photography, not only in political contexts but also in general. A painter begins to work with an empty canvas, which can then be filled with products of pure imagination, transcending time and space. In contrast, the photographer can photograph only what is in front of the machine, unless montage possibilities are liberally exploited in the creative isolation of the darkroom. There images can be contrived that have no necessary counterpart in reality, images composed of photographic ingredients but manipulated and superimposed for an imaginative purpose, "making matter out of mind."

Fig. 12-17. "Three by Four." Kaiser Wilhelm I, Napoléon III, and Bismarck. Albumen print carte-de-visite, a "photomontage sculpture," ingeniously composed of three heads, fused so as to make only four eyes visible. Published by the firm of Franz Unterberger of Innsbruck, Austria, c. 1870. Unterberger was actually an art and print dealer, rather than a photographer, and he marketed the work of many other people. Unterberger himself had died in 1867, but the enterprise was carried on under the same name and survives to this day. (Sommergruber and Henisch 1981)

In the political context, photomontage, a nineteenth-century art (see Chapters 9 and 3 on "ghosts"), was powerfully rediscovered and adapted in the twentieth by John Heartfield (Ades 1976; Selz 1977). The Dadaists had already made a notable beginning, but it was Heartfield who first recognized the political po-

tential of photomontage during the years following the First World War, while greatly overestimating the impact it would have. It was his view that the resurgence of nationalism and militarism could be effectively combated by elegant and powerful photomontage cartoons. One might well wish that he had been right. However, if photomontage failed at the time, as it was bound to do, it must be admitted that nothing else has since succeeded. If anything, the *un*manipulated photograph has been a more practically powerful instrument of persuasion, its effects often more subtle, because unrecognized for what they are. Selective coverage and artfully distorted contexts, the choice of an insignificant moment, the use of a misleading camera angle, or the contrived coincidence of events, all can compromise truth and meaning more powerfully than any known darkroom technique.

To assert that "there is no such thing as a nonpolitical photograph" would be to go too far, but that the camera is a powerful instrument of persuasion cannot be denied (Collins 1985b). As such, it has no favorites, but serves each sponsor with self-rewarding impartiality. And if the camera is such an instrument, the modern computer is another, since it permits a totally seamless form of interaction with the photographic image (Holzmann 1988). Whatever aura of authenticity was still attached to the photograph during the first half of the twentieth century is surely gone, and in that sense a profound dialectic change has taken place. In this way, also, the stylistic fetters that once tied photography to painting have been finally cut, after struggles lasting almost a century. Heinrich Schwarz predicted in 1964 that photography "has still a long way to go before it will be relieved by another visual and pictorial method" (Schwarz 1985). That point has now been reached, in a way no nineteenth-century darkroom manipulator could have foreseen.

The nineteenth century, of course, had to content itself with simpler techniques. Then, as so often now, unadorned facts proved hard to

handle when picture stories had to fit a party line, but darkroom skills made it possible to score a point by piecing selected facts together into one serviceable fiction. Thus, the head of a figure in the opposite camp might be photographed, joined to the photograph of someone else's body, and photographed again. In the completed picture, the enemy would then be shown for all to see, caught in some contemptible position. Along just such lines, at the Paris Exhibition of 1867, a lively undercover trade developed in suggestive photo-collages of a naked and impassioned Empress Eugénie (Laver 1966).

The same ingenious malice was used in Rome to pay off old scores and open new wounds during the tumultuous decade of partisan politics that led to the unification of Italy in 1870 (Collins 1985a). In 1862, scandalous photomontage cartoons were assembled, in which the former Queen of Naples was made to appear in compromising situations with an assortment of prominent lovers, including Pope Pius IX himself. The venomous little pictures were not only distributed in Rome, but also sent out to the courts and governments of Europe, to cause the maximum discomfort to their target prey. Indeed, it did not take long for photo-collage and photomontage to be widely recognized as convenient tools for ruining reputations. Eugène Appert used them to lethal effect in the aftermath of the Paris Commune. A successful commercial photographer and a supporter of the government, Appert produced a series of "documentary" re-creations of certain key events in the short life of the Commune, and its overthrow, in 1871. By combining photographs of the heads of the Commune's leaders and their most celebrated victims with the bodies of professional models, he choreographed and stage-managed scenes that cast the victims as martyrs and the Communards as villains. The complexity of the story was simplified into a morality play, a duel between good and evil (English 1984). Appert's creations were distributed throughout the country, and darkened the pub-

lic's perception of the Commune for many years to come.

Pure photomontage is a demanding art, and great care must be expended on achieving a seamless whole. It was easier by far to take the mixed-media path, and combine a photographed head with a lightly sketched-in body. With this combination of art's freedom and photography's reputed truth, a spirited cartoon could be rushed into print with small effort and at high speed. The three examples given below illustrate the scope and limitations of the form.

Figure 12-18 is a thumbnail commentary on a small but potentially dangerous rift that had opened between the United States and Great Britain in November 1861, during the first year of the American Civil War. In that month, Jefferson Davis, President of the Confederacy, dispatched his envoys, William Mason and John Slidell, to speak for the South's cause in London and Paris. The steamer carrying the two from Charleston slipped safely past the federal patrols and landed in Cuba. There Mason and Slidell boarded a British mail packet, the *Trent*, and set sail for England on November 7. Then the trouble began. The next day, an American steamer, under the dashing Commodore Wilkes, appeared out of the blue. Shots were fired, a boarding party of marines climbed onto the deck of the *Trent*, arrested the two envoys, and briskly departed.

The American public was enchanted, and the British were enraged. Her Majesty's Government bristled to do battle. Lord John Russell, the Foreign Secretary, prepared a stiff dispatch for Washington on November 29, with hints of outright war. Fortunately, a draft of his letter was sent to Windsor Castle, and there Prince Albert found a reason to soften its tone. The wife and daughter of Slidell were already in London, and from them it was discovered that Commodore Wilkes had acted on his own initiative, not under direct orders from the federal government. Putting this heaven-sent scrap of information to good use, Albert was able to offer

Lincoln the chance to extricate America from a very awkward situation. In January 1862, Lincoln, preoccupied with more than enough trouble at home, apologized to Britain and released the prisoners.

The carte-de-visite illustrated here was produced in New York, one of several rushed into print to make a quick killing out of the episode. The picture it offers is a drawing but, as the imprint on the back points out, "The Portraits of Earl Russell, Mason, Slidell and Sec'y Seward are Photography." The American public was angered by their government's capitulation, and the card captures this mood of bitterness. Nevertheless, it offers one crumb of comfort: the "Right of Search" on the high seas, long a cherished British claim, now had to be abandoned, as Commodore Wilkes' right to search the *Trent* had been denied. A cross Lord John Russell is shown tearing up a "Right of Search" warrant, while Lincoln's Secretary of State Seward gestures feebly across the Atlantic. Mason and Slidell float away over the horizon on an unidentified vessel. Whether the British or the U.S. Navy should accept the blame for its unseaworthiness remains unclear. (Henisch 1976)

A second example of political photomontage (Fig. 12-19) commemorates a brief, uneasy alliance between Austria and Prussia in 1864. At the beginning of that year, the two agreed to joint action against Denmark. Their campaign was successful but, even at the moment of triumph, the partnership showed signs of strain. By 1865 the allies were eyeing each other with the hostility that was to lead in the following year to the defeat of Austria and the triumph of Prussia. On the card, the union between the two countries is represented as a wedding between the Austrian Foreign Minister, Rechberg, and Prussia's Prime Minister, Bismarck. Beneath the awkward couple is written: "We have the honor to announce our liaison, which took place on January 14th 1864, in the Taxis Palace in Frankfurt a.M., and we request your sympathy." Perhaps Bismarck himself saw a copy of the cartoon; certainly he

FIG. 12-18. "The Great Surrender," by E. Anthony, 501 Broadway, New York. 1862. Albumen print carte-de-visite, recto and verso. (Henisch 1976)

used the same image when he spoke of the alliance, just before the divorce in 1865: "I think it wiser to continue the existing marriage with Austria for the time being, despite little domestic quarrels." (Taylor 1967)

These cards, on the Austro-Prussian coalition and on the "Trent Affair," had a very brief lifespan; they made contemporary viewers smile or shake the head, but left no lasting impression. The incidents they comment on loomed large at the time, but soon shrank to insignificance in retrospect. However, another (Fig. 12-20) was one of many that, all striking the same note at the same time, smashed a reputation and permanently distorted perceptions of a leading figure in a political drama.

Jefferson Davis, president of the Southern Confederacy, was caught by federal troops in Georgia on May 10, 1865. The event capped a momentous month, marked by the surrender of the Southern forces and the assassination of President Lincoln. The capture was made at dawn, and took the Davis party by surprise. Still half-asleep, Davis pulled on some clothes in the dark, and stepped out of his tent to face the Northern soldiers. With disastrous bad luck, he had snatched up and thrown over his tunic not a man's cape but his wife's shawl. The mistake of a moment was to dog his reputation from that day to this. The humiliating circumstances of the arrest provided a long-awaited occasion for Union supporters to vent their rage, a release

The photographer was not the only one to use the camera to score a point; sometimes the print cartoonist turned for inspiration to the studio as a setting. The idea was not entirely new. In the theater, the *camera obscura* had been personified to hold a mirror up to nature and to show an audience the true state of affairs (see Chapter 1 under "A New Word"), while among the print-makers the magic lantern had been popular for some time. In the mid–1790s, a Belgian professor of physics in Paris devised the first Phantasmagoria, in which images of ghosts and skeletons were projected by a magic lantern onto a semi-transparent screen. Such shows were relished by audiences and cartoonists alike, and

FIG. 12-19. "Marriage of Convenience." 1864. Probably Austrian. Albumen print carte-de-visite. Cartoon, alluding to an uneasy agreement between Austria and Prussia, on joint action against Denmark; here the two statesmen are about to take their vows. (Maas 1975)

FIG. 12-20. Jefferson Davis, captured in woman's clothes by federal troops, on May 10, 1865. Webster & Popkins, 293 Main Street, Hartford, Connecticut, c. May 1865. Albumen print carte-de-visite.

that took the form of contemptuous editorials and satirical cartoons.

All laid brutal emphasis on the one damning detail of the clothing. The incidental shawl became a full dress, sometimes with a crinoline hoop added for good measure. The proud Davis, whose judgment may have been flawed but whose courage had never been doubted, was transformed into a coward, huddled for safety in a demeaning disguise. Forever after that May dawn, Davis has been condemned to scuttle though popular history, clutching his skirts and his shawl, shriveled by the scorn of the North and the shame of the South (Collins and Wilsher 1984).

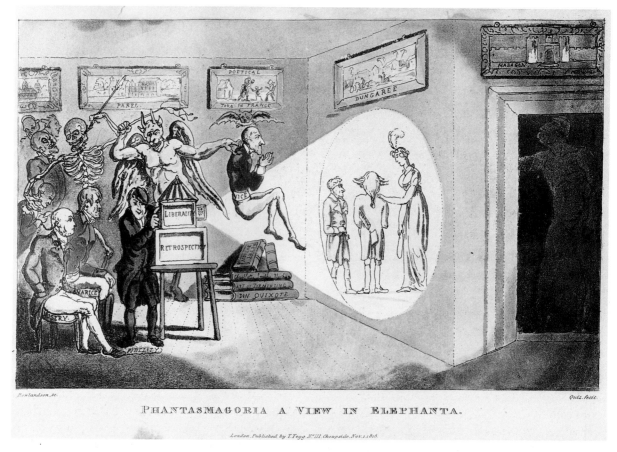

FIG. 12-21. "Phantasmagoria, a View in Elephanta," by Thomas Rowlandson. 1816. British. Aquatint lithograph, 4½ × 7½ inches.

were often chosen as a motif in political caricatures during the early years of the nineteenth century. (George 1949) The point of the example shown here (Fig. 12-21) has been lost in the mists of time but, for photo-historians at least, the magic lantern itself is hearteningly clear. (Becker and Wilsher 1979)

In an 1863 cartoon (Fig. 12-22), a photographer and his client are shown in the middle of a portrait session. The sitter is, unmistakably, Napoléon III, looking properly imperial with his military cap and magnificent mustache. The photographer is only partially identified in the enigmatic caption: "The Latest Imperial Carte-de-Visite. Mr. K–NGL–KE (a Photographer): 'Oh! that pose won't do at all. You must be much more in shade!' " The cartoon appeared in

the February 7 issue of *Punch*, and may have been a little too enigmatic even at the time for, in the bound volume of the year's issues which came out twelve months later, the editor felt the need for an explanatory note: "Mr. Kinglake, Q.C., had written and spoken very disparagingly of the Emperor Napoleon in the most remarkable book of the year, *The Invasion of the Crimea.*"

Although the Crimean War itself had ended seven years earlier, the joke was topical in 1863 because the first two volumes of Kinglake's authorized history of the campaign had been published just a few weeks before the cartoon was sketched. Despite its length, and its character as a sober, official chronicle, the book is brightened by flashes of mordant observation and per-

Fig. 12-22. "The Latest Imperial Carte-de-visite," *Punch*, January 7, 1863. Napoléon III in the hot seat.

sonal prejudice. Napoléon III is introduced to the reader in chapter 14 of volume 1, and promptly cut down by a sustained barrage of stinging contempt. Pilloried as the man who had sworn to uphold the French Republic, only to break his word for the chance to become "what men call a French Emperor," he is described as "one . . . who never made a campaign except with counterfeit soldiers, and never fired a shot except when he fired by mistake," a shifty schemer who proved that freedom "may be stolen and made away with in one dark winter night, as though it were a purse or a trinket."

The scorching portrait of yesterday's Gallant Ally burned itself into the memory of a generation. It was to become the best-known feature of the entire history, in due course singled out for special mention in the *Dictionary of National Biography*'s account of Kinglake's achievements.

This cartoon was just one of the many channels through which rumors of the devastating reassessment reached an ever-widening public.

Political life is inherently partisan; the more important the issue, the deeper the convictions and the more desperate the situation, the more ferocious are the methods used to conduct the argument. All too easily, a war of words can edge over the line to become a war indeed. In the theater of politics, photography had stepped into a role already developed by its sibling arts. It enlarged the possibilities, but found no need to change the essence. In the field of war, photography had to feel its way, first to occupy the vantage points already discovered by traditional artists, and then to reconnoiter for new ones, from which to record the age-old confusions of battle with a brand-new instrument.

Chapter 12 References and Notes

ADES, D. (1976). *Photomontage*, Thames & Hudson, London.

AFSHAR, I. (1983). "Some Remarks on the Early History of Photography in Iran," in *Qajar-Iran: Political, Social and Cultural Change, 1800–1925, Studies Presented to Professor L. P. Elwell-Sutton* (ed. E. Bosworth and C. Hillenbrand), Edinburgh University Press, Edinburgh, p. 262.

ALLEN, W. (1984). "The Abdul Hamid II Collection," *History of Photography*, vol. 8, no. 2, pp. 119–43.

BALDWIN SMITH, L. (1971). *Henry VIII: The Mask of Royalty*, Jonathan Cape, London, p. 51.

BECKER, Wm. B., and WILSHER, A. (1979). "Phantasmagoria, a View in Elephanta," *History of Photography*, vol. 3, no. 3, p. 210.

BELLUCCI, P. (1988). In "150 Years of Photography,"

Life (Anniversary Issue), p. 160. (When recently confronted with Bellucci's crystal-clear color image of a radiant Yassir Arafat extending a cordial welcome to Prime Minister Shamir of Israel, a group of students betrayed neither surprise nor amusement.)

BENET, J., and MONDEJAR, P. L. (1988). *Vistas de las obras del canal de Isabel II fotografiadas por Clifford*, J. Soto, Madrid.

BOEV, P. (1978). "Early Photography in Bulgaria," *History of Photography*, vol. 2, no. 2, pp. 155–72.

BRAIVE, M. (1966). *The Era of the Photograph*, Thames & Hudson, London, pp. 43–44.

CARR, E. H. (1961). *The Romantic Exiles*, Beacon Press, Boston, p. 236.

COLLINS, K. (1985a). "Photography and Politics in Rome," *History of Photography*, vol. 9, no. 4, pp. 295–304.

COLLINS, K. (1985b). "The Camera as an Instrument of Persuasion: Studies in 19th Century Propaganda Photography," Ph.D. diss., The Pennsylvania State University, University Park, Pennsylvania.

COLLINS, K., and WILSHER, A. (1984). "Petticoat Politics," *History of Photography*, vol. 8, no. 3, pp. 237–43.

DARRAH, W. C. (1981). *Cartes-de-Visite in Nineteenth Century Photography*, W. C. Darrah, Gettysburg, Pennsylvania, p. 85.

DIMOND, F., and TAYLOR, R. (1987). *Crown and Camera: The Royal Family and Photography, 1842–1910*, Penguin Books, Harmondsworth, Middlesex, U.K., pp. 71–72, 213, 13, 26–29, 102.

DJORDJEVIĆ, M. (1980). "Anastas Jovanović, the First Serbian Photographer," *History of Photography*, vol. 4, no. 2, pp. 139–63.

ENGLISH, D. E. (1984). *Political Uses of Photography in the Third French Republic, 1871–1914*, UMI Research Press, Ann Arbor, Michigan, pp. 68–70, 73.

FERREZ, G., and NAEF, W. (1976). *Pioneer Photographers of Brazil, 1840–1920*, Center for Inter-American Relations, New York, pp. 16–17.

GARZTECKI, J. (1977). "Early Photography in Poland," *History of Photography*, vol. 1, no. 1, pp. 39–62.

GEORGE, M. D. (1949). *Catalogue of Political and Personal Satires Preserved in the Department of Prints and Drawings in the British Museum*, printed by Order of the Trustees of the British Museum, London, vol. 8, pp. 129, 133, 175, 323, 832, and vol. 9, p. 648.

GERNSHEIM, H. (1969). *The History of Photography*, McGraw-Hill, New York, p. 129.

GREGSON, D. (1991). Personal communication, acknowledged with thanks.

HANSON, D. A. (1988). "The Beginnings of Photographic Reproduction in the U.S.A.," *History of Photography*, vol. 12, no. 4, pp. 357–76.

HENAO, J. M., and ARRUBLA, G. (1938). *History of Colombia*, trans. J. F. Rippy, University of North Carolina Press, Chapel Hill, North Carolina, pp. 489–90.

HENISCH, B. A., and H. K. (1976). "Et visittkortfotografi fra Trent-episoden," *Norsk Fotohistorisk Journal*, vol. 1, no. 5 (November), pp. 116–18.

HENISCH, B. A., and H. K. (1980). "A. J. Melhuish and the Shah," *History of Photography*, vol. 4, no. 4, pp. 309–11.

HOLZMANN, G. J. (1988). *Beyond Photography: The Digital Darkroom*, Prentice-Hall, Englewood Cliffs, New Jersey.

JACKOWSKI, J. M. (1991). "The Beginnings of Polish Political Photography," *History of Photography*, vol. 15, no. 1, pp. 1–12, fig.6.

JUODAKIS, V. (1977). "Early Photography in Eastern Europe: Lithuania," *History of Photography*, vol. 1, no. 3, pp. 235–47.

LA HUELLA, T. (1983). *Cronica de la fotografia en Colombia: 1841–1940*, Carlos Valencia Editores, Bogota, p. 16, fig. 19.

LAVER, J. (1966). *Manners and Morals in the Age of Optimism*, Harper & Row, New York, p. 61.

MAAS, E. (1975). Personal communication, acknowledged with thanks.

MAMASAKHLISI, A. V. (1978). "Early Photography in Georgia," *History of Photography*, vol. 2, no. 1, pp. 75–84. (The portrait of Rustaveli is reproduced on p. 75.)

MAUNER, von Kaenel M. (1990). "Holidays in Grindelwald," translation of Werner Miller's "Ferie z Grindelwald," in *Shadow and Substance: Essays on the History of Photography* (ed. K. Collins), Amorphous Institute Press / University of New Mexico Press, Albuquerque, New Mexico, pp. 239–43.

McCAULEY, E. A. (1985). *A.A.E. Disdéri and the Carte-de-Visite Portrait Photograph*, Yale University Press, New Haven and London, pp. 63–64.

MICHAELSON, K. (1970). *The Work of David Octavius Hill and Robert Adamson*, Scottish Arts Council, Edinburgh, p. 13.

MILLAR, A. (1991). "Drafting the Pattern for a New Nation," *Canberra Times*, August 14, p. 26.

NAWIGAMUNE, A. (1988). *Early Photography in Thailand*, Sangdad Publishing Co., Bangkok, pp. 18–19.

ÖZTUNCAY, B. (1991). Personal communication, acknowledged with thanks.

PFISTER, H. F. (1978). *Facing the Light: Historic*

American Portrait Daguerreotypes, Smithsonian Institution Press, for the National Portrait Gallery, Washington, D.C., p. 84.

SANDWEISS, M. (1990). "Discovery: A Superb Cache of Long-Lost Daguerreotypes," in *Connoisseur*, October, p. 148.

SĂVULESCU, C. (1977). "Early Photography in Eastern Europe: Romania," *History of Photography*, vol. 1, no. 1, pp. 63–77.

SĂVULESCU, C. (1985). *Cronologia Ilustrată a Fotografiei din Romănia, 1834–1916*, Association of Photographic Artists, Bucharest, Romania.

SCHEID, U. (1983). *Als Photographieren noch ein Abenteuer war*, Harenberg Kommunikation, Dortmund, p. 87.

SCHMIDT, P. E. (1991). Personal communication, acknowledged with thanks.

SCHWARZ, H. (1985). *Art and Photography, Forerunners and Influences* (ed. William E. Parker), Gibbs M. Smith, Inc., Peregrine Smith Books, Layton, Utah, p. 98.

SELZ, P. (1977). *Photomontages of the Nazi Period*, Universe Books, New York.

SOMMERGRUBER, W., and HENISCH, B. A. and H. K. (1981). "Three by Four," *History of Photography*, vol. 5, no. 3, frontispiece.

TAFT, R. (1938). *Photography and the American Scene*, Macmillan Co., New York, 1964 reprint by Dover Publications, New York, p. 196.

TAYLOR, A. J. P. (1967). *Bismarck*, Vintage Books, New York, p. 77.

TEDER, K. (1977). "Early Photography in Eastern Europe: Estonia," *History of Photography*, vol. 1, no. 3, pp. 249–68.

TOOMING, P. (1991). Personal communication, acknowledged with thanks.

WEPRICH, T. M. (1991). Personal communication, acknowledged with thanks.

WILLIAMS, G. (1980). *The Search for Beulah Land: The Welsh and the Atlantic Revolution*, Croom Helm, London, chapter 1.

13

THE CAMERA AT WAR

The notion of photography as a "mirror of the times" was quick to take root, even while technical shortcomings still prevented that mirror from offering more than a fragmented reflection. Low plate sensitivity, clumsy equipment, the need for an immediately accessible darkroom, storage problems, and hazards of transportation and travel in general, made journalistic reportage difficult. Even so, attempts along such lines were made from the earliest days. To those who maintain that photojournalism began in the late 1920s, after the invention of the Leica camera and the rotogravure press, one would only have to point out that in 1845 Fox Talbot himself took a famous photograph of Nelson's Column, just then in the process of construction. That experiment in Trafalgar Square was not intended to lead to a family souvenir, nor to an item of home decor, nor indeed to a work of art destined for a museum wall; it was instead an early exercise in photojournalism.

In due course, anything that moved people came to be recorded by the camera, and war was one of those events that impinged on everyone's mind, the least likely to be ignored. It was therefore only natural that war should provide battlegrounds not only for soldiers but for photographers. The faint resemblance between a

camera and a cannon caught the imagination of many, whether as an idle fancy or a gripping fear. One of the first cartoons created for *Punch* by Cuthbert Bede, in 1853, played with the idea (Fig. 13-1), while on October 25, 1860, at the signing of a peace treaty in Peking between Great Britain and China, there was a moment of real panic when a camera was thrust into view. Prince Kung thought a large gun had been trained on him. (Anon. 1861)

THE MILITARY RESPONSE

The link between photography and war was seen in the military establishment as neither a joke nor a threat but as a possibility, one full of promise and potential advantage. The camera was welcomed as a brand-new tool, for use in a hundred old ways. The reactions of long-established institutions to innovation are notoriously slow, and it may seem at first surprising that the authorities, particularly in Britain, were so quick to grasp how helpful photography might be in army affairs. The positive response was kindled by the fact that the new art dovetailed smoothly into a very old tradition. Indeed, the sketching of military positions and strategic details had long been part of the curriculum for young cadets. Paul Sandby, the landscape artist, earned his bread and butter as chief drawing master at the Royal Military Academy in Woolwich, from 1768 to 1796, and was paid one hundred pounds a year for teaching one day a week. (Parris 1973; Ley 1975) His influence has been traced in many of the operational reports, artillery manuals, and other illustrated military documents turned out by generations of his students.

There was always a pressing call for sketches made on the spot at any likely battle front, because there was a remarkable scarcity of views and maps prepared and ready for use in a crisis. During the Napoleonic wars, the British government was quite unable to find in England any

A PHOTOGRAPHIC PICTURE.

ELDERLY FEMALE [*WHO IS NOT USED TO THESE NEW-FANGLED NOTIONS.*] "O SIR! PLEASE SIR! DONT, FOR GOODINESS SAKE, *FIRE*, SIR ! " ———

FIG. 13-1. "A Photographic Picture." From *Photographic Pleasures*, by Cuthbert Bede, T. Mc'Lean, London, 1855, p. 55. This cartoon first appeared in *Punch*, August 13, 1853.

pictures of key points in France until, by lucky chance, some official came across the print shop of Paul Colnaghi, just opened in London. Colnaghi had fled to England from Paris during the Revolution, and brought with him his stock of prints, including many engravings of French towns and waterways. The find was of benefit to both parties. As William Simpson, the war artist, tells the story: "The authorities discovered this, and when a siege was contemplated they applied to Paul Colnaghi to ascertain if he had a print of the place. This brought the establishment into the notice of all the important official people, and made it into one of the most flourishing businesses in town." The situation had not noticeably improved fifty years later when, in the autumn of 1854, Simpson himself was commissioned to travel out to the Crimea to

make a picture of the fall of Sebastopol, an event that, in the usual way, was confidently expected to take place by Christmas of that very year. Having no idea of what Sebastopol looked like, Simpson searched high and low in London for views of it: "I hunted everywhere for pictures . . . but nothing of the kind could be found in London. . . . The truth is that Sebastopol was an out-of-the-way place which travelers never visited, and no sketches of it existed" (Simpson 1903).

Haphazard provisions at home posed problems at the front, problems that could be solved only by those in position there. Skilled sketching was a necessity, to pinpoint the characteristics of the terrain itself, and to trace the ever-changing fortifications contrived by both sides. In one letter from the Crimea, written on November 17, 1854, a young lieutenant described how it was done. He watched a French party ride up to a lookout point, and settle down to draw: "The General and his engineers soon sketched the whole of the Russian position. . . . The sketch was soon made and all they wanted effected" (Warner 1977).

One of Roger Fenton's Crimean portraits is a tribute to a naval officer who put his gift to good use when the opportunity presented itself. Lieutenant Montagu Reilly was on board a British warship that sailed to Sebastopol in January 1854, to warn the Russians of the grave danger of war with Britain if they interfered with Allied and Turkish vessels in the Black Sea. While this official mission was being carried out, the enterprising Reilly used the time to make sketches and plans of the Russian fortifications in the harbor. Fenton posed him with a roll of paper by his elbow, to represent his contribution to the Allied effort (Fig. 13-2).

For officers, drawing was encouraged while on duty, and enjoyed while at leisure. The talent could even bring in a little pocket money, for the new illustrated journals, springing into print everywhere during the 1840s, were hungry for copy. The public loved the new fashion, and editors strained every nerve to keep it happy. Professional artists were employed, but often the papers made use of amateur talent, officers who liked to draw, and sent home work in the hope of earning a small fee and a gratifying byline: "This engraving is based on a sketch made by Captain R. M. Douglas of the 93rd Highlanders."

Because the long-established link between art and the armed forces had proved so satisfactory, the military world found it easy to accept the camera and recognize its family ties with the pencil. John McCosh, who served as a surgeon with the British Army in India on several tours of duty, from 1831 to the early 1850s, understood very well that anyone posted to an isolated station had to be able to keep himself amused: "All officers in India may expect to be much left to themselves, to be cast entirely upon their own resources; and happiest are they who have some pleasant hobby to mount independent of the world." Of all the interests he listed, from mathematics to music, his own favorite was photography: "I would strongly recommend . . . photography in all its branches . . . I . . . know of no extra-professional pursuit that will more repay [the officer] for all the expense and trouble (and both are very considerable) than this fascinating study." (McCosh 1856) McCosh wrote from experience, because he himself had enjoyed the new art for many years; he even has a shaky claim to the title "early war photographer," on the strength of some portraits of fellow officers and an occasional study of a piece of military equipment. (McKenzie 1987)

Despite the problems posed by early photographic processes in rough conditions, far from the comforts of a proper darkroom, a number of servicemen followed in his footsteps. Alexis Soyer, the ebullient London chef who spent some months in the Crimea striving to reform the daily diet of the British Army, ran into one enthusiast in the early spring of 1856: "Captain Ponsonby was occupied in his open-air photographic studio, taking portraits of everybody

FIG. 13-2. "Lieutenant Montagu Reilly," by Roger Fenton, c. 1855. The Gernsheim Collection, Harry Ransom Humanities Research Center, Austin, Texas.

who came in his way, including myself" (Soyer 1857). Major Halkett of the 4th Light Dragoons, who was killed at the Battle of Balaklava on October 25, 1854, shipped to the war front a camera that had been specially designed for him in England. Its maker, Mr. Sparling, later published a description, with detailed instructions on how to put its parts together (Sparling 1856). In the accompanying illustration (Fig. 13-3), the camera looks dishearteningly large, but there is reassurance in the text: "I shall only remark, that to the amateur who practices the paper processes it will prove very portable indeed."

Nothing by Halkett or Ponsonby is known to have survived and the same, unfortunately, is true of the earliest official army attempts to make some photographic record of the war. The first team to be appointed by the War Office consisted of one professional photographer, Richard Nicklin, and two soldier assistants, who

FIG. 13-3. "Major Halkett's Camera." Woodcut in an article on "Photographic Art," by Mr. Sparling, in *Orr's Circle of the Sciences*, n.p., London, 1856, p. 135.

had a day or two of hurried training in England and then set off, in the summer of 1854, for Varna, on the west coast of the Black Sea, where British forces were stationed. Whatever photographs they managed to make were lost in November of that year when, during a terrible storm in Balaklava harbor, the three men were drowned and all their baggage was destroyed.

Undeterred by disaster, the War Office hung on doggedly to its plan. The training of a handful of soldiers in the art of photography began properly in March 1856, when four noncommissioned officers of the Royal Engineers were given a few lessons. Later that year, photography was included in the regular curriculum for selected officers and soldiers of the Royal Engineers at Chatham. From that time onward, a special link was forged between photography and the army corps of engineers. Casual improvisation soon gave place to careful structure: each student, once he had passed the course, received an official "Certificate of Competency in

Photography," issued by the Government Department of Science and Art in London. (Mattison 1989) In September 1867, the Secretary of State for War ordered a team of seven trained soldier photographers to accompany a military expedition to Abyssinia, and the same arrangement was made for the 1885 campaign in the Sudan, when another group of army photographers was attached to the 10th Company Royal Engineers (Reid 1973).

It is particularly easy to trace the early use of photography by the British Army, because the records are detailed and precise, but it can come as no surprise to learn that military minds all over the world hatched their own plans for the camera. The Ministry of War in Belgium had established its photographic studio, under the direction of Captain Libois, by the spring of 1857 (Joseph and Schwilden 1990), and the Austrians used a *camera obscura* to observe the maneuvers of Italian forces during the defence of Venice in 1859 (Anon. 1892). Probably the first official American army photographer was Captain A. J. Russell, appointed in 1863 to record the work of the Construction Corps of the U.S. Army Military Railroad (Collins 1989). At one point in the struggle to free Bulgaria from Ottoman rule, in the Russo-Turkish war of 1877–78, a Bulgarian newspaper, published in Istanbul, reported on March 15, 1877: "The commander of the southern army in Kishinev has distributed among his staff officers photographs showing strongholds and other strategic places in Bulgaria, as well as the Turkish bank of the Danube" (Boev 1978).

In America, two magisterial surveys of military engagements relied on photographs for some of their illustrations. Between 1881 and 1901, the U.S. War Department Office published, in 128 volumes, a report on the Civil War: *Official Records of the Union and Confederate Armies*. To accompany these, an *Atlas* of pictures, which contained ninety-nine lithographs based on drawings and photographs of Civil War sites and structures, was issued in 1895 (Sauerlender 1983). Forty years earlier, Colonel

FIG. 13-4. "The Malakoff Fort with the Telegraph Tower," engraving based on a photograph by James Robertson, in Richard Delafield's *Report on the Art of War in Europe in 1854, 1855 and 1856*, G. W. Bowman, Washington, D.C., 1861, fig. 8A.

Richard Delafield had been dispatched by the American government to study contemporary military activity overseas. His *Report on the Art of War in Europe, in 1854, 1855 and 1856* was published by G. W. Bowman of Washington in 1861, and included a number of engravings made from photographic originals. (See Fig. 13-4.)

At the beginning, efforts in the field were often hampered by difficulties, but from the first the camera proved its worth as a teaching tool. Royal Engineer photographers in Abyssinia in 1868 produced 15,000 prints of a sketch map of a route from one point to another, for use by all units on the march (Reid 1973). At home it was found that a record of anything, from the correct way to perform a drill routine to the correct way to saddle a mule, could be made, multiplied, and dispatched to any outpost of the army's world (York 1870), to shape the dreams of

puzzled sergeants, and haunt the waking hours of harassed men.

Such work was strictly for internal consumption. The public's perception of war, its heroics and its horrors, had to be molded in the public domain. There a variety of individual enthusiasts, both amateur and professional, were busy, at different vantage points; aspects of battle were observed by many pairs of eyes, and recorded by many lenses.

CIVILIAN CAMERAMEN

Camera work in combat zones is not for the fainthearted. Strong nerves are needed, and success depends as much on luck as on sharp eyes or skilled hands. The first intrepid pioneers sometimes stumbled into real trouble. One en-

thusiast named Daviel was taken prisoner in 1854, while attempting to photograph a clash between Turkish and Russian soldiers (Bede 1855); another, Monsieur de Blocqueville from Paris, in the 1860s went into battle with the Persian army, as the Shah's official war photographer, and found himself in no time at all a slave in the enemy camp. He had eighteen weary months of captivity to endure before his ransom had been grudgingly scraped together by the Shah. As a contemporary perceptively observed: "The bitter contrast between the life of a gentleman in the Champs Elysées and that of a captive loaded with irons on the neck and feet must have often suggested itself to him as he shivered in rags beneath the insufficient shelter of a Turkoman tent, with cutlets of horse-flesh the greatest culinary delicacy within reach." (Vambéry 1884; Wilsher 1980)

Fortune smiled more kindly on the first man known to have a substantial body of war photographs to his credit. Carol Popp de Szathmari, born in Transylvania in 1812, practiced painting and photography in Bucharest, and was given the potent title "Photographer to the Court" in 1866 (see also Chapter 12, and Fig. 12-13). Moving in fashionable circles, he became acquainted with many prominent men; these connections proved invaluable in the Crimean War, for they made him an accepted figure in both the Turkish and the Russian camps, which had been established on the banks of the Danube by the spring of 1854. Passing freely from one group to another, Szathmari was able to assemble an album of 200 pictures, all made in the war zone.

The album was displayed at the Universal Exhibition in Paris, during the summer of 1855, and copies were presented to certain leading rulers and statesmen in Europe. Through a series of mishaps, every one of these was lost, although in the past year or two a scattering of single images, torn from context, has begun to surface (Lawson 1991). Despite the disappearance of the albums, a description written at the time makes it possible to reconstruct their contents. The collection was dominated by portraits of leading figures in the Russian and Turkish

forces, followed by a smaller group of images of individual soldiers. Besides these there were several views showing the landscape in which the armies skirmished for advantage. (Săvulescu 1977)

Hard on the heels of Szathmari came British pioneers Roger Fenton and James Robertson (Gernsheim 1954; Hannavy 1974; Henisch 1990). The two march together through the annals of photography. Each was gifted, and each had a short, richly productive career as a photographer throughout the decade of the 1850s. Both showed mastery in several branches of the art, and for both, as for Szathmari, success in war reportage was only one of many achievements.

Roger Fenton was already a leading figure in the photographic establishment when he set off for the Crimea in February 1855. His path there was smoothed by the unofficial patronage of Prince Albert, and by many letters of introduction. Although he spent no more than a few months at the front, from March until June, he created a splendid, varied body of work, including views of campsites, harbors, and battlefields, formal portraits, and deceptively informal groups.

James Robertson earned his living as Chief Engraver at the Imperial Mint in Constantinople, and so was strategically placed to attempt some coverage of the Crimean War. This advantage gave him the luxury of choice, and he was able to make several distinct records of the conflict, at different locations and different periods. In the summer of 1854, long before Fenton's arrival, Robertson took pictures of British troops at base camps near the city; in the autumn of 1855, long after Fenton had left, he pictured conditions once Sebastopol had fallen and the war was winding down (James 1981). Like Fenton, he photographed individuals and groups, and scenes of special interest for British eyes, but he also worked rather like an army cameraman, making a careful study, for example, of the demolition of the Russian dockyards at Sebastopol by the Royal Engineers, in November 1855.

FIG. 13-5. "The 'Fairy' steaming through the Fleet, 'Fairy' in the middle, March 11, 1854," by Roger Fenton. Albumen print, 14.6 × 20.5 cm. Royal Archives, Windsor Castle. Copyright reserved; reproduced by gracious permission of Her Majesty the Queen. (Dimond and Taylor 1987)

The first chapter in the history of war photography may be deemed to close with the American Civil War. Although this conflict broke out a mere five years after the end of the Crimean War, photographic coverage showed extraordinary advances in scale and variety. It has been estimated that more than a million images were produced between 1861 and 1865, by more than 1,500 photographers. (Davis and Frassanito 1985) Some of these, like Mathew Brady, Timothy O'Sullivan, and Alexander Gardner, have become household names; others are lost in the shadows, known today only to a handful of enthusiasts. Each, however obscure, helped to stock a treasure-house of images with details to fire the imagination and fuel the theories of future historians. (See also Kelbaugh 1990, 1991.)

Many hands contributed to a pictorial record of all the wars fought during the early years of photography, but the mosaic was not constructed at the time. By assembling scraps of evidence from different sources, the student today can piece together a surprisingly broad picture of such a conflict as the Crimean War, which took place a bare fifteen years after the introduction of photography. The informed observer can look at a hut made to house casualties and then later adapted for other uses in faraway Canada (Mattison 1989), or examine evidence of a hospital built at the end of the war on the Asiatic coast south of the Crimea, and photographed there by one of its Scottish doctors (Lawson 1988). It is possible to watch the British fleet at Spithead sailing off for the Black Sea on March 11, 1854, seventeen days before the official declaration of war (Fig. 13-5), to pity a cluster of Russian prisoners waiting out the conflict in England, very far from home (Spira 1989), or to study a group portrait of members of one of the last regiments to leave the Crimean peninsula, a month or two after the peace treaty had been signed. (See Fig. 13-6.)

FIG. 13-6. "Officers of the 18th Royal Irish Regiment, Camp Sebastopol," by James Robertson. May 1856. Crimea. Salt print, 6¼ × 11½ inches.

The record grows steadily richer, as new crumbs of evidence are uncovered where they have long lain hidden. A dozen daguerreotypes made in the course of the Mexican War (1846–48) have been valued for years as the earliest photographic images with some links to combat. That handful has grown into an even more precious hoard with the recent discovery of thirty-eight daguerreotypes: portraits, and views of scenes connected with the same war, which can now be added to the pile. (Sandweiss, Stewart, and Huseman 1989) A tiny possible addition to the Crimean War story has been found thousands of miles away, on another continent. All Nicklin's work is supposed to have been lost at sea, but in one album taken to South Africa by a Crimean veteran, there is a faded image that may have been made by Nicklin, or one of his assistants, for its handwritten caption reads: "out of the photographic office window— Varna, 8 September 1854." (Bensusan 1963)

Cameramen, in any place they happened to find themselves, made pictures of whatever caught their eye or crossed their path but, because there was no coordination of effort, the general public at the time had no chance to gain a cockpit view of any conflict. The best to be hoped for was an occasional glimpse, a partial impression, dependent entirely on the exhibition or album, single portrait, engraving derived from a photograph, or newspaper review that happened to come to notice.

PORTRAITS

The most easy-to-find record of military life was the straightforward portrait. Photography made faces in the news familiar to the public. There were commemorative portraits of accredited heroes, like that of Lieutenant Montagu Reilly (Fig. 13-2), and there were pictures of up-and-coming officers. Ambrose Burnside, inventor of the Burnside breech-loading rifle, re-enlisted in the Union Army as a colonel, in 1861, went on to become Commander of the Army of the Potomac, and ended his life, in 1881, as a senator of the state of Rhode Island. One of Mathew Brady's cameramen made an image of him with a group of fellow officers, in 1861 (Fig. 13-7).

Burnside's splendid whiskers, plain to see, became his trademark and a model for imitation. The term "sideburns," still in use, contains a clue to the link between the man and the fashion he inspired. Portraits of leading figures reached a wide public in the form of engravings. A formal study of Omar Pasha, Commander-in-Chief of the Turkish forces during the Crimean War, appeared in *The Illustrated London News* on December 16, 1854. The engraving today is specially notable as the ghost of a lost original, the photograph by James Robertson on which it is based. (Fig. 13-8)

Such pictures were valued for their news interest, but the most precious images were those with personal associations. For the first time in

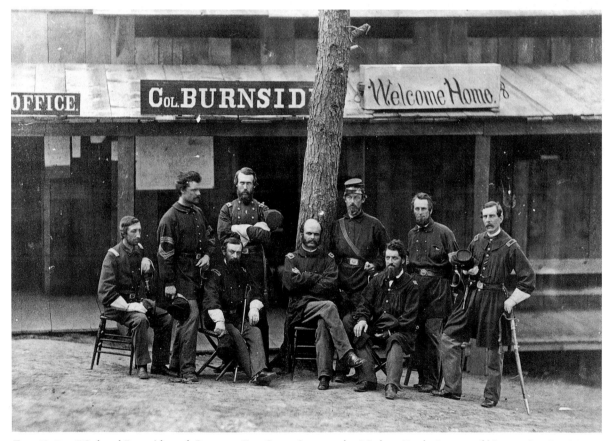

FIG. 13-7. "Colonel Burnside and Company" at Camp Sprague, by Mathew Brady (or one of his associates). 1861. Hand-tinted albumen print, 10 × 14 inches.

FIG. 13-8. "Omar Pasha." Engraving after a photograph by James Robertson, *Illustrated London News*, December 16, 1854.

history it was possible for individual portraits to be made easily and copied readily. Later in the century, the Kodak camera and its equivalents gave soldiers the chance to create their own snapshots but, as early as the Crimean War, a photographer who found his way to a campsite was ready and able to take pictures of ordinary soldiers, not simply of public figures, the all-important army commanders.

A letter written by a young lieutenant to his family in England, on March 30, 1855, demonstrates, with its matter-of-fact account, the instant acceptance of this extraordinary, unprecedented development. Roger Fenton had arrived in the Crimea a week or two earlier, and was already busily at work: "The Photograph man has taken a picture of our camp, the officers and horses standing about. . . . He has also taken me and my horse . . . and Kilburn, the latter likeness is excellent. When I can I will tell you where to go in London for copies, as many as you please at 5 shillings each." The cheerful, casual study still exists, persuasive evidence of the new art's power to convey reassurance with its records of reality (Warner 1977). To please other young men, and other families far away, Fenton produced much work of this kind during his crowded weeks in the Crimea (Fig. 13-9).

Photographers at home were also busy, taking pictures of soldiers before they set off for the front. Such mementos, cherished in life, became even more precious in death. Poignant traces of pleasant studio sessions may be found from time to time in tributes offered to men who never came back from a campaign. A memoir of Captain Hedley Vicars, a Crimean hero killed in March 1855, carries as its frontispiece a portrait that has the words "engraved from a daguerreotype" printed below. The young officer, in civilian dress, is shown seated before a large, open Bible. One of Vicars' own letters, dated May 3 1854, and included in the book, mentions the name of the studio that produced the picture: "I have just returned from Simms's, where I had my likeness taken. I think there are two for you to choose from, both as plain as life. I brought my great Halifax Bible to have its portrait taken, as you desired." (Anon. 1856; Wilson 1988)

The comfort a photograph can give in wartime is vividly conveyed in a letter written by Joseph Whitney, a Union soldier in the American Civil War. He had enlisted in the spring of 1862, a few weeks after his daughter Clara was born; a year later, in May 1863, he received a little parcel of photographs from his wife: "I think a good deal of them pictures you sent. When I open my case, I do not know which to look at first. I would not have known Clara, if any of the rest of the boys had the pictures. She looks like a three year old. Just as sweet as a lump of sugar."

5ᵗʰ Dragoon Guards in the Crimea.

Captain Halford.

FIG. 13-9. "Captain Halford," by Roger Fenton. Spring 1855. Crimea. Parker Gallery, London.

(Snetsinger 1969) The theme of "the photograph from home" was such a universal favorite that it was chosen for the full-page illustration, "Christmas Eve," which appeared in the January 3, 1863, issue of *Harper's Weekly* (Fig. 13-10). In this, a precious photograph bridges the miles between home and battlefront. Tiny images of the mother and children shown in the lefthand medallion gaze up at the soldier seated on the right, from the double portrait he holds on his knee. Cherished objects need protection; in the midst of the war, in the April 16, 1864, issue of *Harper's Weekly*, an enterprising New York businessman advertised "Patent Money Belts," specially modified for military use:

"They will not sweat or wet through under any circumstances. They are light, durable, and elegant, and are made with compartments for LETTERS, GREENBACKS, and PHOTOGRAPHS." (Collins 1984)

Early photography brought great joy, but it had at least one grievous failing: the camera found it hard to glamorize its subjects, at any rate outside the realm of studio make-believe (see Chapter 2). To the eye of love, any physical blemish in the beloved can be endearing. To the dispassionate observer, it brings less satisfaction. Photographic portraits of public figures rarely flattered. Whereas a painter like Van Dyck could transform the tiny, withdrawn Charles I into the

Fig. 13-10. "Christmas Eve." *Harper's Weekly*, January 3, 1863, pp. 8–9. N. T. Gidal Collection.

embodiment of magnificence and majesty, Roger Fenton's study of Marshal Pélissier on horseback did nothing to draw attention from the great man's creased uniform and short legs (Fig. 13-11). The imagination needs something more than truth to feed on, and this may be one reason for the continuing popularity of the sketch artists who, throughout the second half of the nineteenth century, sent back their dashing, spirited impressions of war from innumerable battlefronts, to brighten the pages of the illustrated journals. (Hodgson 1977)

VIEWS

Portraits were precious, and it was an entirely new privilege to enjoy them in quantity; more extraordinary still was the experience of studying campsites and battlegrounds, or the chance to peer inside a newly captured city (Fig. 13-12). Even for those not in a position to see an actual photograph, lengthy reviews of such pictures in exhibitions (see, for example, Anon. 1855) provided the reader with unprecedented descriptions of a campaign setting.

The public was dazzled, and then, such is the contrariness of human nature, disappointed. Photography showed so much and yet so little. The elaborate war paintings that had shaped responses up to this point had been packed with figures, alive with the drama of rearing horses, clashing sabers, heroic charges, poignant farewells. By contrast, early war photographs were so empty, so still. The cameraman could offer glimpses of scenes before and after an engagement, but never of the action itself. James Rob-

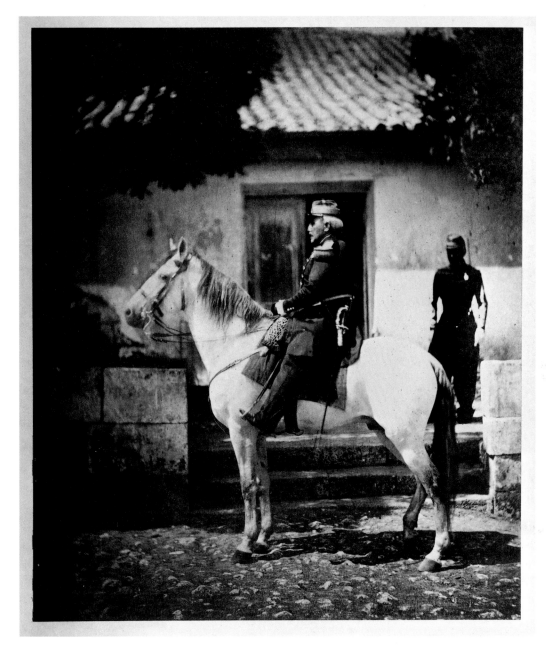

FIG. 13-11. "Marshal Pélissier," by Roger Fenton. Spring 1855. Crimea. The Gernsheim Collection, Harry Ransom Humanities Research Center, Austin, Texas.

ertson, the British photographer based in Constantinople, made his reputation with the pictures he took during the last months of the Crimean campaign. The photographs that became most familiar to the public at home were those he made of two forts—the Malakoff and the Redan—recorded just after their capture by the Allies in the first days of September 1855. They show the desolation and destruction, and have the eerie calm of a scene from some particularly chilling version of *The Sleeping Beauty*, with all action suspended, equipment dropped

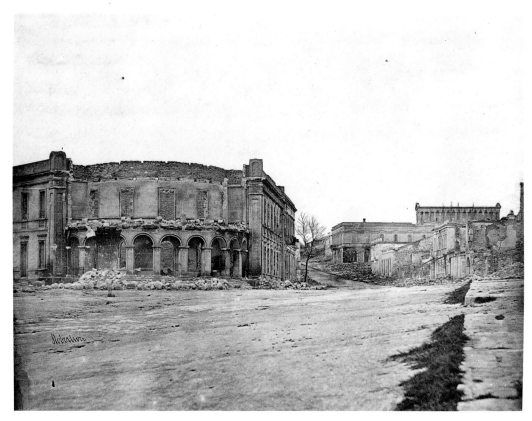

FIG. 13-12. "Inside Sebastopol," by James Robertson. Fall 1855. Crimea. Salt print. Photograph Science Museum, London, cat. no. 695/71.

from unseen, nerveless fingers, and left exactly where it fell (Fig. 13-13).

What they do not show are bodies. It is human nature to praise such decorum while secretly longing for something more sensational. Tolstoy remarks at one point, in an account of his own experiences in the Crimean campaign, on "the funny sort of pleasure" felt in watching men kill each other (Tolstoy 1986). He made the observation in 1855 and, in the spring of the same year, *Punch* printed this joke, under the heading "A Lady's Postscript to a Crimean Letter": "P.S. I send you, dear Alfred, a complete Photographic apparatus, which will amuse you doubtlessly in your moments of leisure; and if you could send me home, dear, a good view of a nice battle I should feel extremely obliged. P.S. no. 2. If you could *take* the view, dear, just in

the moment of victory, I should like it all the better." (*Punch* 1855)

Even in the sober prose of a review, the faint hint of a desire for somewhat stronger subject matter can be detected. On September 29, 1855, the *Athenaeum* published an extensive account of an exhibition of Roger Fenton's Crimean views in London, and in that the writer comments: "As photographers grow stronger in nerve and cooler of head, we shall have not merely the bivouac and the foraging party, but the battle itself painted. . . . The scenes in camp are not very varied as far as subject goes; it is always sitting on broken baskets, and filling up cups, and smoking and coming out of tents." (Anon. 1855)

The Victoria and Albert Museum in London holds a scrapbook of Crimean sketches, put to-

FIG. 13-13. "Interior of the Barrack Battery, Sebastopol," by James Robertson. Fall 1855. Crimea. Salt print, 8½ × 10¾ inches.

gether by William Simpson, the war artist. Among his own work, Simpson pasted in a number of other items that had caught his eye, including one overpainted photograph sent to him by a correspondent. The photograph itself is Robertson's view of the interior of a Russian defense position (as in Fig. 13-13), but it has been doctored and filled with figures, to show the height of battle's fury, not the desolation of its aftermath. (Simpson 1856; Haworth-Booth 1984)

It was not long before actual corpses were recorded by the camera although, as always, the bodies of enemy forces were viewed with more composure by the general public than those of its own troops. Already by 1859, when Austria and France fought each other in Italy, some of the stereo views made for sale pictured dead sol-

diers lying on the ground, waiting for burial. (Darrah 1977; Holmes 1863) By 1860, Robertson's partner and brother-in-law, Felice Beato, was with the British expeditionary force in China. D. F. Rennie, an army surgeon, mentions in his memoirs, with dour disapproval (Rennie 1864), that he had actually found Beato showing an unseemly professional appreciation of a particularly striking heap of corpses: "Signor Beato was here in great excitement, characterising the group as 'beautiful', and begging that it might not be interfered with until perpetuated by his photographic apparatus, which was done in a few minutes afterwards."

It may now be hard to believe, but there really was a blessed time when it was thought that such revelations of the wreckage of war would be too painful. In an essay he wrote on some of Ma-

thew Brady's Civil War views, Oliver Wendell Holmes observed: "Many people would not look through this series. Many, having seen it and dreamed of its horrors, would lock it up in some secret drawer. . . . The sight of these pictures is a commentary on civilization such as a savage might well triumph to show its missionaries" (Holmes 1863). Reactions in fact were more complicated. There was shock, but there was also interest, and the presence of corpses in one view whetted an appetite for more in the next. Photographers began to feel the tug of temptation, and to aim for an arresting image rather than a literal truth. During the American Civil War, some who made pictures of a battleground after an engagement did not hesitate, here and there, to alter the position of a body in order to create a more striking scene. On other occasions, living models were used to represent the dead (Frassanito 1975).

ON THE SIDELINES

Although photography could sensationalize war, it also sanitized the horror. The vast majority of pictures offered to the public were made far from the shock and fury of actual combat. In the controlled setting of a studio, and in the calm before or after conflict, photographers did their best to burnish the image of the military life. Just because it was hard to be present in the heart of the action, most concentrated on sidelines and souvenirs. Full-strength units and individual soldiers alike were portrayed at moments when everything was in its proper place, with nothing out of step or out of line.

Safe in the studio, a regimental musician could be shown in relaxed yet formal pose, with uniform immaculate and shining cornet ready on his knee (Fig. 13-14). Heroic attitudes were struck against patriotic backdrops of painted tents and fluttering flags (Fig. 13-15). Out in the open, even in the early days when it was diffi-

cult, with the means available, to catch close-ups of harsh realities, the camera always found it easy to reveal the incidental beauties in views of distant campsites (Fig. 13-16).

Long after the guns had fallen silent, an enterprising photographer could supply as many souvenirs as ingenuity was able to contrive. A tiny micro-photograph of a battle site might be tucked inside an actual bullet, or a larger view of a famous scene of engagement set within a paperweight (Fig. 13-17). Sometime in the 1880s, E. G. Lies of Allegheny, on the outskirts of Pittsburgh, issued a cabinet card that shows nothing but a dark, misshapen blob with a handwritten, explanatory caption (Fig. 13-18):

This is the Jefferson Davis ball
That glancing off from a Lincoln gun
Battered up the leg of a Pittsburg boy
So badly he couldn't get up and run.

Presumably this was a very personal Civil War memento, and the card was custom-made for one client, or a small group of family and friends, to celebrate a hair's-breadth escape some twenty years earlier, in another life.

Shared dangers forge friendships. After the crushing of the Boxer Rebellion of 1900 in China, some Allied troops remained in Tientsin until the peace treaty was signed, in September 1901. A photographer in the city, L. Yuk Sun, made at least one studio portrait to commemorate the alliance, posing two stiff soldiers, one Russian and one American, on either side of an equally stiff flower arrangement (Fig. 13-19).

War can touch the imagination, and shape the attitudes, of many far from the battle zone. The Crimean War of the mid-1850s brought home to the British government and public alike the importance of first-class marksmanship. By the end of the decade, several local Volunteer Rifle Associations had been formed, to offer some of the fun of battle with none of the disagreeable side-effects. The mixture of dashing uniforms, comfortable campsites, and competitive shoot-

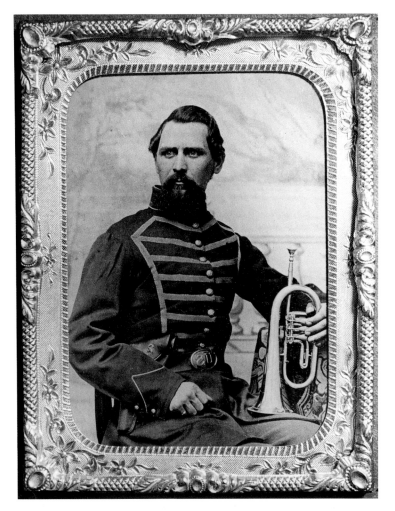

FIG. 13-14. "The Cornetist,"
c. 1861–62. American. Unknown
photographer. Ambrotype, ruby
glass, quarter-plate.

FIG. 13-15. Soldier posed in front of
studio backdrop. 1860s. American.
Unknown photographer. Albumen
print carte-de-visite.

FIG. 13-16. "In Camp," by Gorman
and Jordan. 1864. Alexandria,
Virginia. Salt print, 6 × 8 inches.
Civil War encampment of the First
Division, Fifth Corps of the Army of
the Potomac.

FIG. 13-17. "Devil's Den, Gettysburg, Pennsylvania." 1860s. Probably by Charles and Isaac Tyson, Gettysburg. Albumen print set in a glass paperweight, $3 \times 3 \times \frac{5}{8}$ inches.

FIG. 13-18. "The Jefferson Davis Ball," by E. G. Lies of 82 Ohio Street, Allegheny, Pennsylvania. 1880s. Gelatin silver print, standard cabinet card.

FIG. 13-19. "Comrades in Arms," by L. Yuk Sun, Tientsin, China, c. 1901. Gelatin silver print, standard cabinet card.

ing proved irresistible, and volunteers flocked to the colors. A number of distinguished photographers joined up, including John Dillwyn Llewellyn, Roger Fenton, and Horatio Ross. (Haworth-Booth 1985) O. G. Rejlander went one better and made a double portrait of himself: "OGR the Artist introduces OGR the Volunteer" (Fielding 1987). One of the fashionable training grounds was at Hythe, in Kent, and that is where a carte-de-visite of three gallant Volunteers was made by a local photographer, J. V. Cobb, whose studios were most conveniently situated close by, at Hythe and Sandgate (Fig. 13–20).

Darkroom wizardry made it possible for photographers to conjure up ideal pictures to satisfy a public appetite for souvenirs of great men and great events. An imaginary group portrait of President Lincoln and the commanders who led the Union forces in the American Civil War was created by William Notman, a Scotsman who became the leading photographer in Canada during the second half of the nineteenth century (Fig. 13–21). For this composite scene,

FIG. 13-20. "Studio Sharp Shooters,"
by J. V. Cobb, Hythe, Kent, c. 1860.
Albumen print carte-de-visite.

FIG. 13-21. "Union Commanders," by
William Notman. Boston, Massachusetts.
After 1876. Gelatin silver print, standard
cabinet card.

individual portraits were taken, cut out, pasted
onto a background, and then rephotographed to
make one seamless whole. Notman opened sev-
eral studios in America, after the 1876 Centen-
nial Exhibition in Philadelphia. This particular
picture was made in Boston, and adopted as an
advertisement for The Travelers Life & Accident
Insurance Company of Hartford, Connecticut.

Composite photography was used in 1899 by
a German photographer in Zweibrücken, F. O.
Samhaber, to create an idealized (if something
less than seamless) portrait of his local regiment
(Fig. 13-22). In the process he managed to trans-
form ordinary men into endearing toys. Each
little soldier is spick-and-span, each group seems
to be set out on its own base, ready to be picked

FIG. 13-22. "Zur Erinnerung an meine Dienstzeit." Regimental group portrait by F. O. Samhaber, Zweibrücken, Germany. 1899. Gelatin silver print, 11 × 15 inches.

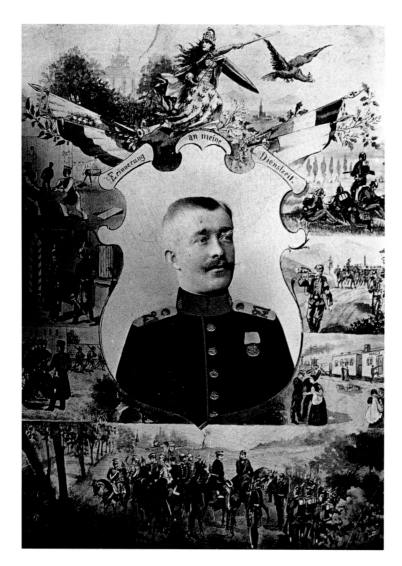

FIG. 13-23. Military cartouche by Atelier Gerdour, Thorn, Prussia. After 1894. Gelatin silver print, standard cabinet card, hand-tinted.

up and repositioned at any moment by the hand of a giant child. This is army life as it ought to be, with a little drill and a lot of drink. Cheerful decorum is the order of the day, and the proprieties are punctiliously observed. Those on duty, and those at ease, breathe the same air of contentment and well-being.

Another way to gild the image of the soldier was by association. The portrait of an unremarkable face was ennobled when set inside a frame decorated with scenes of military life and symbols of military glory (Fig. 13-23). Such a ready-made frame, used for any suitable client, imposed uniformity. It honored the man by linking him to the splendor of army tradition. The face was unmistakably his own, but tribute was paid to the member of a brotherhood, not to the individual. Such membership notions could actually be conveyed in a number of ways, even without a formal client-portrait. Figure 13-24, for instance, shows a greeting card, evidently sent by a proud German mother to her soldier son in the Franco-Prussian War (Stelts 1991; Filippelli 1991). "I congratulate" is the imprinted

FIG. 13-24. Souvenir of the Franco-Prussian War, 1871. Composite greeting card sent by a proud German mother to her soldier son. 5 × 3½ inches. Hidden under the laurel leaves are photographic portraits of General von Moltke, the Crown Prince of Prussia, and Prince Friedrich Carl, as well as the imprinted text of a patriotic song: "Die Wacht am Rhein."

message below the traditional laurel leaves, a hero's due, here mounted on simulated lace in a gilded frame. On the back there is a handwritten note: "To my [illegible] Son, for New Year's Day 1871. Pray to God that he may grant to your Mama an early reunion and peace." The laurel leaves can be folded back to reveal three gilt-framed portraits of General von Moltke, the Crown Prince of Prussia, and Prince Friedrich Carl. Under the leaves is an imprint of "Die Wacht am Rhein," a popular patriotic wartime song.

Certain engagements catch the public's imagination; they splash into the news of the day, and ripples lap the shores of the civilian world.

When the French captured the Malakoff fort outside Sebastopol on September 8, 1855, it was a famous victory, and Marshal Pélissier, who led the attack, was rewarded with the title "Duke of Malakoff." Also named after the famous fort were a marvelous cake, created by the Viennese, as only they know how, to celebrate the Allied triumph; a district in Paris; and a bubbly, high-stepping cancan dancer, the toast of the town in 1861. (McCauley 1985)

An earlier Crimean battle, at Inkerman, on November 5, 1854, caused its own aftershock and inspired a successful stage-show in Paris. Henri Robin, a well-known conjurer and illusionist, opened his theater there in 1862, and de-

FIG. 13-25. "Henri Robin and the Drummer of Inkerman," by Thiébault, Paris. 1862. Carte-de-visite. Collection of Laurence Senelick.

vised for it a new entertainment, "The Medium of Inkerman." A drum, said to have been brought from the hallowed spot, was set on stage, and the audience was encouraged to question it. Answers to the random, shouted queries were tapped out by the invisible hands of a drummer, claimed to have been slain on the battlefield of Inkerman, but still alert and helpful in his grave. The show was so popular that Thiébault, a fashionable carte-de-visite photographer, thought it worthwhile to create his own version of the magic moment in the studio (see Fig. 13-25). Henri Robin was photographed in person, addressing the drum and, through darkroom manipulation, the ghostly figure of a gallant soldier was contrived, to beat out the response. (Senelick 1983)

Photographs both entertaining and uplifting helped to foster in the public's mind an innocent patriotism, a respect for the military unshadowed by doubt, unscarred by scandal and defeat. Just as the lively, dashing sketches of war created by artists for the illustrated journals of the late nineteenth century turned every campaign into a gallant adventure, so countless photographs played their part in polishing the soldier's reputation.

THE MOLDING OF MINDS

Those in authority were quick to grasp the power of the camera to shape public perceptions, and made deliberate use of photographers as well as artists to create respect. When, in 1857, Napoléon III planned an elaborate series of army maneuvers, personally directed by himself, at the camp of Châlons, he commissioned the well-known photographer Gustave Le Gray to make a record of the event. Le Gray was treated with great courtesy, and installed in the imperial quarters of the camp from August 25 to October 10. The graceful compliment was rewarded with the body of work created during the stay. Le Gray methodically produced portraits of officers and a set of beautiful, formal views of the camp, its daily activities, and its special occasions, such as the visits by the Empress Eugénie and the little Prince Imperial. (Humbert, Dumarche and Pierron 1985) The object of the exercise, splendidly achieved, was to present the Emperor and his men as rightful heirs to the glory of the Napoleonic legend, embodiments of national dignity and resolve.

Images create mood but cannot guarantee victory. A camp is not a battleground, and the fine, disciplined army was to be smashed in the Franco-Prussian War of 1870. In the slow recovery after that humiliating defeat, France encouraged artists of every kind to rebuild public confidence in her military forces. Many paintings on army life were produced, including one by Eugène Chaperon, exhibited at the Paris Salon

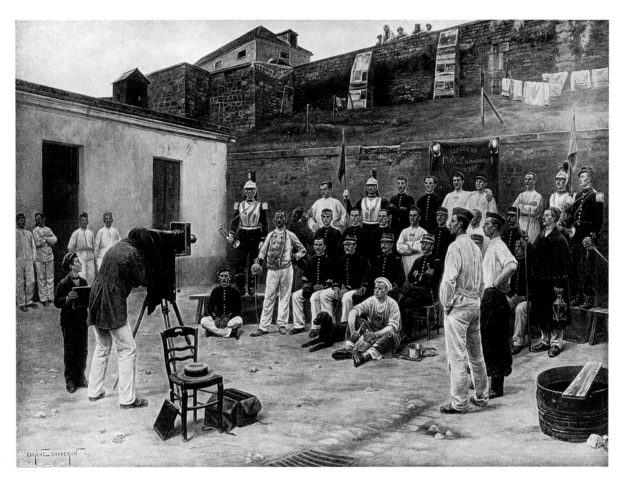

FIG. 13-26. "Le Photographe à la Caserne," by Eugène Chaperon. 1899. The painting was shown at the Paris Salon of that year and was reproduced in *Le Panorama: Salon 1899*, edited by Ludovic Boschet, published by Hebdomadaire, Librairie d'Art, Paris, and also 1 McLean's Building, New Street Square, London.

of 1899, which shows a fellow artist making his own modest contribution to national morale (Fig. 13-26). The subject is an outdoor studio session in a barracks, and the hero is a photographer, busily at work on portraits of the cheerful, capable soldiers lined up before his lens. (Mauner 1989)

The responses of the human mind to the human condition are so complicated that the very photographs that presented the acceptable side of military life helped to sharpen public awareness of the pain behind its pageantry. The portraits of very ordinary men, which photography made available in unprecedented number and va-

riety, brought home to the civilian population the vulnerability of their subjects. However safe the setting or serene the tone, such pictures gave a face to war, and prompted the uneasy awareness that the ever-expanding gallery included images of unsung victims as well as acknowledged heroes.

Traditional battle paintings had sheltered the viewer from shock by veiling particulars. Great commanders might be carefully characterized, and acts of heroism highlighted, but the vast mass of men taking part in the engagement was lost in anonymity. Painted depictions of typical soldiers, typical actions, were shaped by con-

vention, and a model might be hired to strike the attitudes demanded by the artist's theme. An 1862 review of some Civil War photographs by Mathew Brady makes this point (Anon. 1862), and then turns for contrast to the strengths and limitations of the camera's images of war: "The photographer who follows in the wake of modern armies must be content with conditions of repose, and with the still life which remains when the fighting is over, but whatever he represents must be real, and the private soldier has just as good a likeness as the General."

The hunger, aroused by photography, for images of ordinary men at arms could not be sated. Artists themselves took note of it, and began to acknowledge the need in their handling of military themes. London art critic Philip Gilbert Hamerton, in an 1869 review, praised French painter Protais for his skill in bringing out the uniqueness of each figure in his battle scenes: "This idea of the individuality of the soldier is very new to the modern mind, because from our habit of reading histories written purely from a general's point of view, and counting men in great totals of five or six figures, we think no more of them than we think of this or that particular sovereign in Rothschild's purse" (Hamerton 1869).

Whether at work in camp or in the studio, photographers were forced by circumstance to choose as subject-matter the routine attitudes, activities, and amusements of military life. Extremes of heroism and suffering lay outside their range. The calm, confident images brought comfort to the viewer, but they also brought disquiet, because they sharpened the sense of family bond between civilian and soldier. Roger Fenton's photograph of officers playing with an irresistibly round and woolly little dog (Fig. 13-27) showed not the horrors of war, which few would ever experience, but the common humanity every viewer shared. Such pictures were pinpricks for the imagination.

Although photographers could not catch the shock of battle, the hot fury at the height of the fray, the pictures they made of the aftermath helped to drain some of the romance from traditional mental images of war. Desolation, destruction, disorder were all recorded by the camera, and the dreariness was deepened by the somber tones of printed photographs. Tolstoy had firsthand experience of the Crimean War, as a Russian officer at Sebastopol, and he vividly recorded the contrast between expectations, sharpened by art, and horrifying reality: "You will see war not as a beautiful, orderly and gleaming formation, with music and beaten drums, streaming banners and generals on prancing horses, but war in its authentic expression—as blood, suffering and death" (Tolstoy 1986). With less elegance, but equal conviction, a young American private wrote to his family after a first taste of combat, and commented on the surprising discrepancies between the experience he had just gone through and the battle pictures he knew. In those, the soldiers "would all be in line, all standing in a nice level field fighting, a number of ladies taking care of the wounded, etc. etc., but it isent [sic] so" (Sears 1987). No civilian safe at home would ever grasp the realities of warfare as firmly as a combatant but, for the perceptive, photography offered sobering testimony to its cost.

To prompt even more sobering reflections, photographers could offer graphic evidence of the injuries inflicted by the savagery of war. Traditionally, in painting, such suffering was distanced and generalized, and the aim of the artist was to induce in the viewer melancholy reflection, not shock and revulsion. Turner's painting, "The Field of Waterloo," first exhibited in 1818 and now in the Tate Gallery, London, is not a celebration of victory but a lament for victory's demands. The field is seen under a night sky lit with rockets, and through the darkness there can be dimly perceived groups of mourners searching for their loved ones in the heaps of bodies scattered on the ground. The mood is elegiac, one of sadness controlled and dignified by decorum.

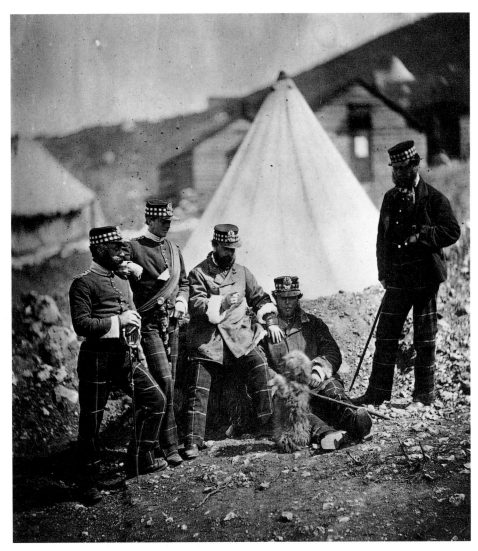

FIG. 13-27. "Officers of the 71st Highlanders," by Roger Fenton. Spring 1855. Crimea. The Gernsheim Collection, Harry Ransom Humanities Research Center, Austin, Texas.

Photography, on occasion, was used to record far more unsettling images, close-ups of terrible mutilation from which every vestige of war's glamour had been stripped away. Queen Victoria and Prince Albert paid a number of visits during 1855 and 1856 to the military hospital at Chatham, to see and talk to servicemen who had been badly wounded in the Crimean campaign. The Queen was moved, and stunned, by the suffering she saw, and she commissioned portraits of many of the patients she herself had met. The photographic partnership of Joseph Cundall and Robert Howlett produced several of these studies, of men presented as mute testimonies to their own courage and the sacrifices they had made for the country. One of these (Fig. 13-28) was produced after April 16, 1856, the date on which the Queen met the two soldiers portrayed, and actually held in her hands the shells they are holding in their own. The smaller shot

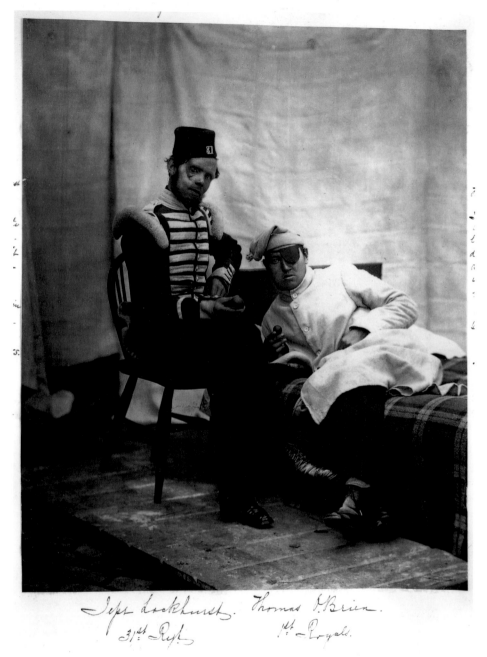

FIG. 13-28. "Privates Jesse Lockhurst, 31st Regiment, and Thomas O'Brien, 1st Royals, seen by Queen Victoria at Brompton Barracks, Chatham, April 16, 1856," by Cundall and Howlett. 1856. Gold-toned print, 8⅞ × 7½ inches. Royal Archives, Windsor Castle. Copyright reserved; reproduced by gracious permission of Her Majesty the Queen.

weighed 6.75 ounces, the larger one 18.50 ounces (Dimond and Taylor 1987). It is easy to understand the shock the diminutive Victoria must have experienced as she spoke to the men and felt for herself the dead weight of each ball. Such studies were made for the Royal Archives, but several reached a wider public in the form of wood engravings published in *The Illustrated London News*. (Lalumia 1984)

Human response to war is fickle; the pendulum never comes to rest, but swings between acceptance of battle as a necessary, at times ennobling instrument of policy, and revulsion at its blind destructive force. In the second half of the nineteenth century there were many changes of mood in the general public, and war was sometimes glorified, sometimes reviled. Only one thing held firm. Whether war was enjoyed as high adventure, or denounced as criminal folly, it was embodied, in society's imagination, in the figure of the ordinary soldier. For this, photography can claim some credit. An ever-increasing flood of photographic images had made the comfortable civilian world aware, as never before, of the human component in the world's cannon fodder. And yet, whatever battles might be won on the field, photography's own was irretrievably lost. Early war photographers of sensibility and conscience allowed their enthusiasm to be nourished by the thought that their work would make future wars impossible. Once the public could be shown the destruction and unspeakable misery, they believed, war would be totally outlawed; it was only a matter of education and time. Alas . . .

Chapter 13 References and Notes

ANON. (1855). "Photographs from the Crimea," in the *Athenaeum*, London, no. 1457 (September 29), pp. 1117–18.

ANON. (1856). *Memorials of Captain Hedley Vicars, 97th Regiment*, James Nisbet & Co., London, p. 137, frontispiece.

ANON. (1861). Report in *The Illustrated London News*, January 5, p. 18, on the signing of a peace treaty between Great Britain and China.

ANON. (1862). "American Photographs," in *American Journal of Photography*, vol. 5, no. 7 (October 1), p. 145.

ANON. (1892). "The Camera Obscura," entry in *Cassell's Complete Book of Sports and Pastimes*, London, communicated by N. M. Graver to *History of Photography*, (1982), vol. 6, no. 2, p. 144.

BEDE, C. (1855). *Photographic Pleasures*, T. Mc'Lean, London, 1973 reprint by Amphoto, New York, chapter 12, p. 82.

BENSUSAN, A. D. (1963). "Crimean War Photography: A Recent Find in South Africa," *Photographic Journal*, vol. 103, no. 4 (April), pp. 129–31.

BOEV, P. (1978). "Early Photography in Bulgaria," *History of Photography*, vol. 2, no. 2, pp. 155–72.

COLLINS, K. (1984). "The Soldier's Belt," *History of Photography*, vol. 8, no. 2, p. 106.

COLLINS, K. (1989). *Washingtoniana Photographs: Collections in the Prints and Photographs Division of the Library of Congress*, Library of Congress, Washington, D.C., p. 172.

DARRAH, W. C. (1977). *The World of Stereographs*, W. C. Darrah, Gettysburg, Pennsylvania, p. 20.

DAVIS, W. C., and FRASSANITO, W. A. (1985). *Touched by Fire: A Photographic Portrait of the Civil War*, vol. 1, Little, Brown & Co., Boston, p. 3.

DIMOND, F., and TAYLOR, R. (1987). *Crown and Camera: The Royal Family and Photography, 1842–1910*, Penguin Books, Harmondsworth, Middlesex, U.K., pp. 39, 81.

FIELDING, A. G. (1987). "Rejlander in Wolverhampton," *History of Photography*, vol. 11, no. 1, pp. 15–22, figure 10.

FILIPPELLI, R. (1991). Personal communication, acknowledged with thanks.

FRASSANITO, W. A. (1975). *Gettysburg: A Journey in Time*, Charles Scribner's Sons, New York, pp. 184–85, 190–92.

GERNSHEIM, H. and A. (1954). *Roger Fenton, Photographer of the Crimean War*, Secker & Warburg, London.

HAMERTON, P. G. (1869). *Contemporary French Painters*, Seeley, Jackson & Halliday, London, p. 35.

HANNAVY, J. (1974). *The Camera Goes to War: Photographs from the Crimean War, 1854–56*, Scottish Arts Council, Edinburgh.

HAWORTH-BOOTH, M. (1984). Personal communication, acknowledged with thanks.

HAWORTH-BOOTH, M. (1985). *The Golden Age of British Photography, 1839–1900*, Aperture / Philadelphia Museum of Art, New York, p. 118.

HENISCH, B. A. and H. K. (1990). "James Robertson of Constantinople: A Chronology," *History of Photography*, vol. 14, no. 1, pp. 23–32.

HODGSON, P. (1977). *The War Illustrators*, Macmillan Publishing Co., New York.

HOLMES, O. W. (1863). In *Atlantic Monthly*, vol. 12, July, pp. 11–12.

HUMBERT, J.-M., DUMARCHE, L., and PIERRON, M. (1985). *Photographies Anciennes, 1848–1918: Regard sur le Soldat et la Société*, Les Collections du Musée de l'Armée, Preal, Arcueil, pp. 19–20.

JAMES, L. (1981). *Crimea, 1854–56: The War with Russia from Contemporary Photographs*, Hayes Kennedy, Thame, U.K., plates 61 and 62.

JOSEPH, S. F. and SCHWILDEN, T. (1990). "Gilbert Radoux: An Early Photographic Publisher," *History of Photography*, vol. 14, no. 3, pp. 275–84.

KELBAUGH, R. J. (1990). *Directory of Civil War Photographers, Volume One: Maryland, Delaware, Washington, D.C., Northern Virginia, West Virginia*, Historic Graphics, Baltimore, Maryland.

KELBAUGH, R. J. (1991a). *Directory of Civil War Photographers, Volume Two: Pennsylvania, New Jersey*, Historic Graphics, Baltimore, Maryland.

KELBAUGH, R. J. (1991b). *Introduction to Civil War Photography*, Thomas Publications, Gettysburg, Pennsylvania.

LALUMIA, M. P. (1984). *Realism and Politics in Victorian Art of the Crimean War*, UMI Research Press, Ann Arbor, Michigan, p. 126, and note 48 on p. 261.

LAWSON, J. (1988). "Dr. John Kirk and Dr. William Robertson: Photographers in the Crimea," *History of Photography*, vol. 12, no. 3, pp. 227–41.

LAWSON, J. (1991). Personal communication, acknowledged with thanks.

LEY, R.O. (1975). Private communication from the Historical Assistant Secretary of the Royal Artillery Institution, Woolwich, acknowledged with thanks.

MATTISON, D. (1989). "Arthur Vipond's Certificate of Competency in Photography," *History of Photography*, vol. 13, no. 3, pp. 223–33, figures 1, 10.

MAUNER, G. (1989). "A Camera in the Service of National Glory," *History of Photography*, vol. 13, no. 3, frontispiece.

McCAULEY, E. A. (1985). *A. A. E. Disdéri and the Carte-de-Visite Portrait Photograph*, Yale University Press, New Haven and London, p. 104 and figure 97.

McCOSH, J. (1856). *Advice to Officers in England*, William H. Allan & Co., London, pp. 5–7.

McKENZIE, R. (1987). "'The Laboratory of Mankind': John McCosh and the Beginnings of Photography in British India," *History of Photography*, vol. 11, no. 2, pp. 109–18, figures 1, 2, 10.

PARRIS, L. (1973). *Landscape in Britain, c. 1750–1850*, The Tate Gallery, London, entry 73, p. 47.

PUNCH (1855). "A Lady's Postscript to a Crimean Letter," in *Punch*, bound volume for January–June, p. 152.

REID, W. (1973). *Images of War, 1640–1914*, exhibition catalog, National Army Museum, London, pp. 26, 30.

RENNIE, D. F. (1864). *The British Arms in North China and Japan*, London (publisher unknown), p. 13.

SANDWEISS, M. A., STEWART, R., and HUSEMAN, B. W. (1989). *Eyewitness to War: Prints and Daguerreotypes of the Mexican War, 1846–1848*, Amon Carter Museum, Fort Worth, Texas, and Smithsonian Institution Press, Washington, D.C., p. 46.

SAUERLENDER, P. H. (1983). "A Matter of Record: Photography in the Atlas to Accompany the Official Records of the Union and Confederate Armies," *History of Photography*, vol. 7, no. 2, pp. 121–24.

SĂVULESCU, C. (1977). "Early Photography in Romania," *History of Photography*, vol. 1, no. 1, pp. 66–70.

SEARS, S. W. (1987). The quotation appears in "Valor Couldn't Save Them," Sears' review of *Embattled Courage*, by G. F. Linderman, *New York Times Book Review*, July 5, p. 11.

SENELICK, L. (1983). "Pepper's Ghost Faces the Camera," *History of Photography*, vol. 7, no. 1, pp. 69–72.

SIMPSON, W. (1856). *Sketches Made During the Campaign of 1854–55 in the Crimea, Circassia and Constantinople*, Victoria and Albert Museum, London, Department of Prints and Drawings, Photographs and Paintings, Print Room, Press Mark 93.H.1, p. 63 verso, figure 568–1900.

SIMPSON, W. (1903). *The Autobiography* (ed. George Eyre-Todd), T. Fisher Unwin, London, pp. 83, 19.

SNETSINGER, R. J. (1969). *Kiss Clara for Me*, Carna-

tion Press, State College, Pennsylvania, pp. 92–93.

SOYER, A. (1857). *Soyer's Culinary Campaign*, G. Routledge & Co., London, p. 437, chapter 34.

SPARLING, Mr. (1856). "Photographic Art," in *Orr's Circle of the Sciences*, London (publisher unknown), pp. 134–35 and figure 47.

SPIRA, S. F. (1989). "Russian Prisoners," *History of Photography*, vol. 13, no. 4, frontispiece.

STELTS, S. (1991). Personal communication, acknowledged with thanks.

TOLSTOY, L. (1986). *The Sebastopol Sketches*, trans. David McDuff, Penguin Books, Harmondsworth, Middlesex, U.K., introduction, p. 13, and "Sebastopol in December" (1854), p. 48.

VAMBÉRY, A. (1884). *Vambéry's Life and Adventures, Written by Himself*, T. Fisher Unwin, London, p. 315.

WARNER, P. (1977). *The Fields of War: A Young Cavalryman's Crimea Campaign*, John Murray, London, pp. 114, 148, figure 4.

WILSHER, P. (1980). Private communication, acknowledged with thanks.

WILSON, J. (1988). Private communication, acknowledged with thanks.

YORK, P. J. (1870). "The Application of Photography to Military Purposes," *Nature*, vol. 2, pp. 236–37.

14

PHOTOGRAPHY AND TRAVEL

RAIL, STEAM, AND LENS

Photography stepped on stage at a time when the combination of iron and steam was causing the world's theater to shrink, and horizons to expand, as though by magic. Year by year, throughout the second half of the nineteenth century, the network of railway lines and steamship routes spread out to link America with Europe, northern Europe with the Mediterranean, the West with the East. Year by year, more travelers could be carried over greater distances, in greater comfort, than ever before. The comple-

tion of the Suez Canal in 1869, which opened a shortcut to India, enlarged still further the possibilities of long-distance travel for pleasure and for profit. (Fig. 14-1)

The excitement stirred by ever-expanding possibilities can be sensed in many kinds of contemporary response. Travel books of the late 1840s and 1850s are packed with up-to-the-minute, soon-to-be-outdated, information about connections, ticket prices, and timetables. In 1849, Albert Smith left Malta on August 25 and reached Constantinople on September 1 (Smith 1850). In 1854, Théophile Gautier man-

FIG. 14-1. "HMS Orontes at the Suez Canal." 1870s. Egypt. Unknown photographer. Albumen print, 9½ × 11½ inches. Early view of the Suez Canal.

aged the entire trip to Constantinople from Paris in a mere twelve and a half days (Gautier 1854). During the same decade, E.-D. Baldus made some photographic studies of the railway lines sweeping down from Paris to the Mediterranean, which are magnificent tributes to the power and promise of the revolution (Jay 1984).

Blown by the winds of opportunity, photographers settled like seeds into the system and, where conditions were right, began to sprout and flourish. The figure of the traveling photographer caught the imagination, even though the idea at first seemed a contradiction in terms.

Early cameras were by no means light, and a great deal of supporting paraphernalia had to be carried with them. On August 30, 1839, the French satirical magazine *Charivari* ran an article on the joys of a camera trip into the countryside, with the perspiring photographer plodding along under the weight of the five boxes needed to carry the camera itself and all the essential equipment. (Newhall 1971)

By the year's end, some of this bulk had been reduced, and designs for travel cameras were beginning to be made. In Théodore Maurisset's New Year's cartoon, published in Paris in late

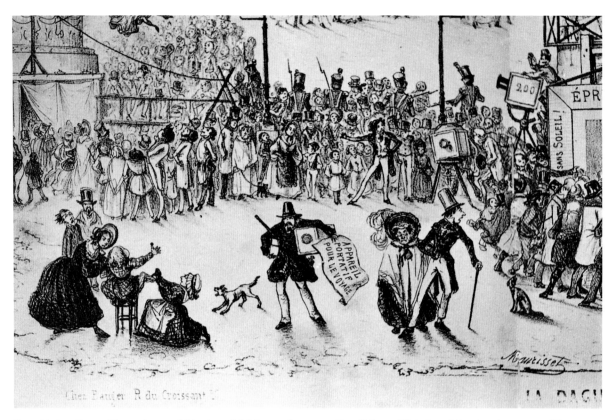

FIG. 14-2. Baron Pierre Armand Séguier with his travel camera. Detail from Théodore Maurisset's cartoon "La Daguerréotypomanie." December 1839. Paris. See also Fig. 9-1.

December 1839, Baron Pierre-Armand Séguier can be seen (Fig. 14-2) setting off for foreign parts with his own invention tucked under one arm: the first daguerreotype bellows-camera, which could be folded up and stored in a single box with the rest of the gear. (Wade 1979) The size of that box, however, labeled in the cartoon "Appareil Portatif pour le Voyage," was enough to give second thoughts to all but the stoutest hearts a mile or so out from home base.

Maurisset's choice of such a figure for his crowded scene is not surprising, for the outlines of a brilliant business venture, combining travel with photography, were already taking shape in Paris during the last months of the year. N. P. Lerebours, an optical instrument maker, had the inspired idea to gather the world between the covers of an album by publishing a series of views taken in as many famous places as possible. For technical reasons, the pictures would have to make their appearance on the printed page in the form of engravings, but they were to be captured by the new camera. The first plates of *Excursions Daguerriennes* appeared only in 1840, but months in advance of that publication date, on December 15, 1839 (Gernsheim 1982), Lerebours could offer for sale in his shop some daguerreotypes taken for him in Italy and Corsica. See also Chapter 4.

Lerebours himself made a few images in Paris, including one of Notre Dame (Fig. 14-3), and another of the Chambre des Deputés, the hallowed spot in the annals of photography where some early reports of the daguerreotype process were submitted, and where a state pension was granted to its developer. (Simcock 1989) Despite

FIG. 14-3. Daguerreotype of the West Front of Notre Dame, Paris, by N. F. Lerebours, Paris, c. 1840. Full-plate daguerreotype, 8½ × 6½ inches. Museum of the History of Science, Oxford. Though engravings made from Lerebours' daguerreotypes tend to be frequently reproduced (see Figs. 4-1 and 4-2), the original photographs are rarely seen. This particular image may have been the model for one of the engravings in *Excursions Daguerriennes*.

such occasional forays, Lerebours preferred the role of impresario, equipping acquaintances with cameras, commissioning subjects, and inviting anyone about to set off for foreign parts to bring back treasures for the great work in progress. He cast his net wide. The eminent French artist Horace Vernet was persuaded to make pictures in Egypt (Fabian and Adam 1983), and an otherwise unknown Englishman, H. L. Pattinson of Newcastle-upon-Tyne, contributed a daguerreotype of Niagara Falls. (Bannon 1982)

A mutually sustaining relationship between the camera and the tourist began to grow. It was an ideal partnership: travel stimulated photography, photography encouraged travel. The photographer took pictures of scenes that visitors were expected to see, and the tourist soon felt an irresistible compulsion to add those sites to his life-list, on the strength of photographs that had already shaped his expectations. The image set a seal of approval on the object, although the photographer was more often a popularizer than a pioneer. Throughout the length and breadth of the known world, the significance of the sites on which the camera chose to focus had been established long before the arrival of photography.

Although travel was becoming easier, some practical difficulties remained. Inevitably, most photographers followed the same paths open to most tourists, hired the same guides, and were escorted to the same spots. The only difference was that their cameras made a record of the marvels along the way. Views of the Grand Canal in Venice, the Spanish Steps in Rome, and the Church of the Holy Sepulchre in Jerusalem formed the stock-in-trade of every studio open for business in those cities. The Acropolis in Athens, the Sphinx and the Pyramids in Egypt, were obligatory mementos to offer and obtain.

From the first, photographers did their best to take advantage of the new transportation network. Success was the prize for those who could sense the points of potential profit in the system.

One such nub was any terminus. For travelers to the East, by the 1850s, Trieste was an important junction, where the railway lines of Europe met the steamers of the Austrian-Lloyd's shipping company. It was a place where passengers were forced to mark time, a place designed for desultory shopping.

People in the travel business already knew the value of subdued publicity masquerading as a gift. In the 1840s the directors of the Peninsular & Oriental Steam Navigation Company had commissioned Thackeray to write a charming guidebook laced with compliments to their ships and their service: *Notes of a Journey from Cornhill to Cairo* (London, 1845). Some ten years later, the Austrian-Lloyd's line produced in Trieste an attractive album, *Souvenirs de Constantinople*. The publication was designed, with some care, for an international market. Two languages, French and German, were used on the contents page, with an English "Remembrances of Constantinople" thrown in for good measure. The album contained neither text nor actual photographs, just twenty-eight engraved views of the fabled city, of which twenty-one were labeled "Photographie von Robertson," a reference to the British photographer who lived in Istanbul (Fig. 14-4). The business venture was an opportunity for Robertson to bring his work, in engraved form, to the attention of a wide public.

Location was important. The most desirable situation for a studio was on a fashionable street, or on a main artery through which every visitor was bound to pass. In Constantinople, the place to be was Pera, the European quarter of the city, partly because there were lingering prejudices against image-making in the Turkish population at large, and partly because Western tourists were blessedly short on prejudice and long in purse. Once inside Pera, it was best to be as close as possible to the "Grande Rue" (see Fig. 14-5); by the end of the century all the prominent photographic firms were jockeying for position around this prime territory. (Allen 1990)

(a)

FIG. 14-4. Photograph by James Robertson and Felice Beato. Early 1850s. Constantinople. "Mosque du Sultan Mohamed à Tophanna."

(a) Salt print. Photograph Science Museum, London, no. 714/71.

(b) Engraving based on (a), from *Souvenirs de Constantinople* (Section littéraire-artistique du Lloyd Autrichien). 1850s. Trieste.

(b)

FIG. 14-5. Advertisement for G. Berggren, in the 1892–93 *Annuaire Oriental du Commerce*, Constantinople (p. 32 of advertising section). Library of Congress, Washington, D.C. (Allen 1990)

In Jerusalem, Chalil Raad, the first Christian Arab photographer to practice there, opened his own studio on the Jaffa Road (Fig. 14-6) in 1897. (Nir 1985) From this enviable spot he was able to record, one year later, the ceremonial visit of Kaiser Wilhelm II, as he entered the city and rode along the street, offering "photo opportunities" (not yet so called) with imperial impartiality to Raad and his chief competitor, Garabad Krikorian, poised as he was in premises on the other side of the road.

In less hallowed, and therefore less visited, parts of the world, it was sometimes to the advantage of a photographer not to settle down in one place to spin a web to catch custom, but instead to sally forth in search of prey. As the railroads pushed their way into the vast, undeveloped regions of the American West, some photographers rode with them, stepped off for a few days of business at a station, and then, once the local market had been exhausted, caught the next train out of town to new pastures, new possibilities. In 1891, a group of four itinerant photographers arrived in Flagstaff, Arizona, on August 1, on their "Boston Railroad Photograph Car." They stayed in Flagstaff until August 6, when they left to move on through the Arizona Territory. (Hooper 1988) While in town, they produced both portraits and landscape views, each mounted on a cabinet card with the words "Boston Railroad Photo Car" printed on the front.

Just as important as the right address was the right publicity, ways to gain entry into the fickle, floating world of the tourist trade. Private contacts were always prized. When James Robertson made a photographic expedition to Jerusalem in 1857, the usual commercial worries of such a venture were eased by the fact that, through a friend, he had good relations with the proprietors of the two principal hotels in the city. As a frustrated competitor complained, this meant that Robertson "could always obtain the first access to travellers, for sale of Photographs." (Williams 1864) In the same way, a listing in any reputable guidebook was precious; a nod of approval from the all-powerful Karl Baedeker was beyond price. By 1890, Rome was swarming with photographers in cut-throat competition for business, and it was of critical importance to win a place in the pages so earnestly consulted by visitors in need of advice. In that year, one of the lucky photographers selected for Baedeker's short list was Olivieri (Baedeker 1890), who not only had two studios in fashionable locations but also offered, besides, a

FIG. 14-6. Chalil Raad's Studio, Jaffa Road, Jerusalem, c. 1900. Gelatin silver print, 2¾ × 4⅜ inches.

vast selection of Roman views by himself and favored colleagues, the services of a bookbinder to create an appropriate context for any purchase. (See Chapter 11.)

If anything, photographers were in even fiercer competition with each other at Niagara Falls than in Rome. In the 1899 Baedeker guide to the United States, by an extraordinary stroke of luck or good management, only one firm was singled out by name for approval: "Among the best photographs of Niagara are those of Zybach and Co., Niagara Falls, Ontario." This studio had the special advantage of prime location as well as prime publicity. It was situated just a mile and a half from Falls View, the point where "all trains stop five minutes to allow passengers to enjoy the splendid View of Niagara Falls." (Baedeker 1899) It is not hard to imagine an enticing

display of photographs by Zybach & Company, spread out to tempt the impulsive during the short halt.

This firm enjoyed rare good fortune in the impressive isolation of its place in the Baedeker paragraph. In most cases, even a listing in a guidebook could not guarantee custom, because rivals shared the same list. And so, other ways had to be found to make a studio's name stand out in a crowded field. An appeal to compatriots was a possible approach. A small bundle of cartes-de-visite, recently found in a Central Pennsylvanian flea market, offers evidence of one American traveler's response to such a signal. Each card is carefully dated and annotated by hand, so it is easy to trace the leisurely progress during 1872–73, from Switzerland to Italy, Germany to France. In Florence, the advertise-

ment for "L. Powers, Fotografia Americana" offered a home away from home, and the anonymous collector visited the establishment three times in four days during mid-December. On each occasion, the choice fell on photographs of sculptures by the artist Thomas Ball, a fellow American at work in the city who, a year or two later, won the commission for the statue of Lincoln with a freed slave at his feet that now stands in Boston and Washington.

PLEASING PROSPECTS

Before the age of steam and rail, few Western visitors traveled in person to the cradle of their civilization, but centuries of tradition had made its landmarks familiar to every educated mind. Images of certain buildings, monuments, and scenes were called for, and photographers, like the artists before them, were under pressure to oblige. Originality in the selection of subject matter was neither demanded nor desired. Success was measured more by mastery in treatment than by idiosyncrasy in choice. To achieve the best effect, it was imperative to have the best viewpoint, the ideal spot from which to aim the camera. Enterprising photographers had to find such places and claim them as their own. The search was not without guideposts, some of the most satisfactory positions having already been determined by terrain, tradition, or a combination of the two. Because of these constraints, a certain family likeness can be detected in views of starred attractions. There is not much to choose between one picture and another of tourists puffing their way up a pyramid (Fig. 14-7), partly because the pastime had been recommended by all the guidebooks, and partly because its appeal as an image had been recognized by all the photographers. Two interested parties converged for business at the base of any pyramid: able-bodied locals hired themselves out, in

FIG. 14-7. Mountaineering on a Pyramid. 1890s. Egypt. Unknown photographer, possibly J. Sébah. Albumen print, 5 × 3⅜ inches.

groups of three, to push and pull each sightseer to the summit (Bull and Lorimer 1979), while photographers set up their tripods, ready to supply the necessary record of the feat.

Similarly, Venice had been loved and explored by artists for centuries before the camera appeared on the scene. When the time came, photography paid its own homage to the city, with strikingly beautiful images by many gifted practitioners, but the points from which those pictures were achieved had long been established, by custom and consensus. (Costantini and Zannier 1986; Watson 1980) An anonymous panorama, taken from S. Giorgio Maggiore (Fig. 14-8), can be matched by almost identical

views, made from the same spot by such photographers as Carlo Ponti and Carlo Naya.

At times the pressure of convention was so strong that a photographer felt the need to offer what the camera was not yet able to supply. The majesty of Rome by moonlight had been a commonplace of commentaries on the city ever since Goethe described the effect in words that kindled the imagination of his readers. (Helsted 1977) There were some hazards for a visitor in any attempt to experience such a scene in person; as every guidebook warned, pestilence and malaria lay in wait for the unwary in the beauty of a Roman night. This was a sobering reality,

and the prudent soon decided that it was enough to follow Goethe in their dreams, and to echo his response at second-hand, in the enjoyment of a work of art.

"Rome by Moonlight" thus became another lucrative commission for the artist, but the subject posed serious problems for the early photographer. For some years, sky and landscape, the basic elements in such a scene, required different exposures; the only way to create a satisfactory image was to proceed by stages, aim the camera first at one and then the other, and afterward combine the two photographs by darkroom manipulation. One of Rome's most gifted early

FIG. 14-8. "Il Molo." 1860s. Venice. Unknown photographer. Albumen print, 7 × 9½ inches.

FIG. 14-9. "Chiaro di luna," by Gioacchino Altobelli. 1866. Rome. Albumen print, 10½ × 14¾ inches.

photographers, Gioacchino Altobelli, in business during the 1850s and 1860s, made a specialty of this work, and his evocative "night" views of the city were highly prized. (See Fig. 14-9.)

In the creation of such special effects, Altobelli was an acknowledged master, first among his peers. Most photographers were not as secure in their reputations, and faced sharp skirmishes with close rivals for small gains. Moreover, battles over prime locations did not always bring out the best in any character. In 1857, James Robertson, on his visit to Jerusalem, was taken on a guided tour of the city by a resident photographer, Mendel J. Diness, who, with incautious generosity, escorted him "to all his own best points of view, and at the right time of day, on the express promise that none of Mr.

Robertson's Photographs should be sent to Jerusalem for sale." (Williams 1864; Nir 1985) Sad to say, temptation proved too strong. Robertson not only broke his promise but also set up a profitable outlet for his own pictures in the two main hotels, in the very heart of the Diness domain.

Because control of the viewpoint was important, tempers could flare and fights erupt over the rights to specially coveted positions. The first photographer in residence at Niagara Falls, on the American side, was Platt D. Babbitt who, for about ten years from 1853, was the master of a certain highly desirable area in front of the Falls, known today as Prospect Point. Here he made his daguerreotypes of visitors dramatically posed against a background of cascading water (Fig. 14-10a), images made to a well-tried formula, but masterpieces nevertheless. On one oc-

FIG. 14-10. Niagara vantage points.

(a) Daguerreotype, half-plate, c. 1855. Niagara Falls, New York. Probably by Platt D. Babbitt.

(b) Ambrotype, half-plate. Mid-1860s. Possibly by S. Davis. Wm. B. Becker Collection. The scene shows Valentine and Adelaide Frantz on their honeymoon. Mr. Frantz was a veteran of the American Civil War.

(a)

(b)

casion, in 1854, Babbitt came to be one of the first (and, indeed, very few) daguerreotypists to record a news event: the last hours of Mr. Avery, an unfortunate Niagara enthusiast whose boat had capsized above the Falls, with all-too-predictable consequences (Rudisill 1971). (See also Newhall 1976.)

Babbitt's proprietorship of the advantageous spot was undisputed until the arrival on the scene of an ambitious, thrusting interloper:

> A Scotchman named Thompson, with his family, fresh from Scotland, appeared one day and claimed to be an artist. Occasionally he would go down on the Point to test his painting materials and incidentally take a camera shot of the Falls while he was about it. But Mr. Babbitt would not have it that way. Every time Mr. Thompson made an attempt to take the cap off the camera for an exposure, Mr. Babbitt and his forces would stand between the camera and the Falls swinging large-sized umbrellas to and fro, thus preventing Mr. Thompson from getting a picture. The war between the two men came to such a pitch that Mr. Babbitt was finally forced to vacate and thereafter the Scotch artist held the fort. [Anthony 1914; see also Bannon 1982]

In the search for the picturesque, photographers did their best to follow in the footsteps of painters, but there was one point at which they parted company. Whereas any feature in any subject could be conjured away by the magic of art, the photographer had to cope with the awkward reality before the lens. The inconvenience was manifest from the outset. On his visit to Spain in the spring of 1840, Théophile Gautier took a camera with him, but the fates conspired against him. Nothing, especially the weather, was ever quite right, and ambitious dreams soon faded. However, while enthusiasm was still high, he jotted down a note in Valladolid, to encourage those who might come after

him: "By a lucky chance, the façade of San Pablo is situated in a square, so that a daguerreotype view can be taken of it, which there is generally a great difficulty in doing in the case of edifices of the Middle Ages, almost always hemmed in by a heap of houses and abominable sheds" (Gautier 1853).

The demolition of man-made structures, however desirable, was hard to arrange, but nature's excesses could be drastically pruned. All that was necessary was the right attitude, coupled with the right equipment. John Werge has left a vivid account of the way he and a fellow daguerreotypist carved out for themselves the ideal prospect at Niagara Falls in 1853 (Werge 1890; Bannon 1982): "I remember . . . taking a

Pera, September, 1849.

FIG. 14-11. Engraved portrait of Albert Smith, based on a daguerreotype, made on September 25, 1849, in Constantinople. (Smith 1850)

hatchet with us . . . how we had to hew down the trees that obstructed the light; how we actually hung over the precipice, holding onto each other's hands, to lop off a branch still in sight where it was not wanted."

Between 1922 and 1930, Wallace Nutting produced a profitable series of "Beautiful" books: *England Beautiful, Ireland Beautiful, Pennsylvania Beautiful,* and so on. Each was illustrated with his own photographs, and offered its readers a world viewed through rose-colored spectacles. In contrast, Nutting's advice to aspiring photographers in search of the same magic formula for success is hearteningly down to earth: " . . . always carry a hand-axe, and never forget the needs of the inner man." (Seaton 1982) Chopping down obstructions is hungry work anywhere, but every country can offer its own sustaining consolations. Nutting's recommendations are unoriginal but very sound: doughnuts in America, cherry cake in England, and croissants in France are admirably designed to nourish the photographic muse, each in its proper realm.

THE PHOTOGRAPHER IN PLACE

Nineteenth-century photographers in search of custom were well aware that early birds catch the worms, and the enterprising among them always did their best to keep one step ahead of the enterprising traveler. The aim was to be in position, ready to receive the new arrival whenever, and wherever, the prey came within reach.

In 1849, the art of photography was still young, much talked of but not widely practiced. When Albert Smith, an energetic young journalist, set off from England for a tour of the Mediterranean in the summer of that year, it did not occur to him to take a camera to record his adventures. Instead, he packed into his bag those reliable old tools of his trade: a writing-pad, a sketchbook, and a box of watercolors. After

four stimulating weeks in Constantinople, however, he was in the right mood to try something completely new, and so, on September 25, 1849, on the very last morning of his stay, he climbed a steep flight of stairs in the European quarter of the city. Having reached his destination, he told his readers, "I was daguerreotyped by an artist who lived at the top of a Pera building, in a hothouse of glass, where it was scarcely possible to breathe." (Smith 1850) The portrait has been preserved, in the form of an engraving, on a page of the book he put together about his adventures (Fig. 14-11). That book, and others like it that Smith wrote in the course of the next decade, is a celebration of speed, and of the fantastic new adventures which it made possible. During the 1850s, Smith fashioned for himself a very successful career in the London theater, entertaining his audience with stories about his exploits and journeys in parts of the world that had suddenly become accessible to the ordinary traveler.

Smith's career was capped with the kind of feat Jules Verne had in mind a few years later, when he wrote *Around the World in Eighty Days.* From the stage, on an evening in early July 1858, Albert Smith announced that he was about to set off for China, and promised his listeners he would be back before the year had ended, "with the Cattle-Show and Pantomimes," to tell them all about it. The promise was kept. Smith started his adventure on July 17, and slipped back into London on November 14, in perfect time for the Christmas season. On such a whirlwind tour, there were not many spare moments in which to see anything, but he did manage a brisk stroll through Hong Kong on August 25. There he "paid a visit to Messrs. Negretti and Zambra's photographer, M. Rossier, who lived at the Commercial Hotel. . . . He complained much of the effect of the climate on his chemicals." (Smith 1860) Rossier had only just arrived in China that year but, like Smith, he was a fast worker. Despite his worries about the weather, he mastered the difficulties and produced a series of views of Canton and Hong

Kong that his sponsors, Negretti and Zambra, were able to bring out in 1859 in an innovative publishing venture. (Worswick and Spence 1979) They were the first views of China to be on sale to the general public, and they were offered in stereographic form.

In an extraordinarily short span of time, not only did individual photographers manage to make their way to the far corners of the earth, but a commercial network was laid down as well, so the traveler could find, ready and waiting for him, a selection of photographs for sale in the most unlikely places. It is a measure of the speed with which this was accomplished that a mere quarter of a century separates two tiny, telling episodes. In 1848, Dr. Claudius Galen Wheelhouse was arrested as a spy in Spain while attempting to make calotypes. (Buckland 1974) Officials there were suspicious of his camera, and could not grasp his explanations because they had not heard of photography. In 1874, William S. Auchincloss wrote a book, *Ninety Days in the Tropics*, on the wonders of Brazil, and illustrated it with a selection of tipped-in, commercially produced albumen prints. Auchincloss explained in his introduction how he had found them. Whenever he came to a new place, he "made it a practice . . . to visit at once a bookstore or photographic gallery and purchase a series of views which should recall the place, its scenery and other features of interest . . . so that however hurried may have been the visit, its reality for many years afterwards is recalled in all its freshness by a glance at the photograph." (Ferrez and Naef 1976)

Thus, the availability of photographs came to be expected almost from the first, and their existence soon began to change attitudes and long-established habits. Charles Kingsley, the English clergyman and novelist, had been happily making his own sketches in his own notebooks since childhood, and yet, while on a visit to Jamaica in 1870, he wrote in frustration to his wife: "As for scenery, for vastness and richness mingled, I never saw its like. . . . We can get no photo-

graphs, so that I know not how to make you conceive it all" (Colloms 1975)—a strange confession from an enthusiastic artist and a writer whose pen was never still.

Japan had only begun to open itself to Western eyes in the 1850s; even so, by 1886, when Henry Adams and John La Farge reached the site of a remote and ruined temple at Kamakura, to see a gigantic statue of Buddha, they found that the photographer had arrived before them. (La Farge 1897) In one of La Farge's letters there is a description of "the little lodge at the side, where the priest in attendance lives and gives information, and sells photographs and takes them, and generally acts as showman." (See Chapter 7 for other instances of "double-dipping.")

THE PERIPATETIC CAMERA

The kind of photographer who has figured most frequently so far, is the one who took pictures of areas that, though still accessible only to a small group of Western visitors, were nevertheless already familiar to the Western mind. Around an image made in Egypt (Fig. 14-12) or Jerusalem, Rome or Constantinople (Fig. 14-13), there clustered a thousand ideas ready for release by the mind of the viewer. For eyes alert to its significance, each picture bore witness to some aspect of history or religion, legend or art, and was in turn enriched by the association.

There was a large public hungry for such views, and there were fame and fortune to reward the photographer who could satisfy demand. In England, the man who laid the ground of his reputation and his wealth with the photographs he took in Egypt was Francis Frith, who made three major expeditions to the area, between 1856 and 1860, and still found time to lecture on his adventures, write articles for the press, and publish several magnificent albums of his work. (Wilson 1985; Goldschmidt and Naef 1980)

FIG. 14-12. "The Sphinx and Pyramid at Giza," by W. Hammerschmidt, c. 1860. Egypt. Albumen print, 9¼ × 12¼ inches. It had been one of Hammerschmidt's ambitions (Baier 1977), in the face of all sensible advice, to photograph a caravan as it made its way to Mecca across the desert, not far from Cairo. The pilgrims had other ideas, but Hammerschmidt survived, though badly beaten and wounded. The Sphinx, older and wiser, proved to be a more compliant partner in the great work of photo-reportage.

Public interest, already keen, was sharpened still more when the Prince of Wales set off on a leisurely, four-month tour of the region in 1862. As a sign of the times, an official photographer was appointed to accompany the party. The choice fell not on Frith but on another fine artist, Francis Bedford, whose work had found favor with the Queen. The royal progress was widely covered in the press, and *Punch* found room for a cartoon of the Official Photographer on location (Fig. 14-14). For Bedford, the tour

yielded a rich harvest of praise (Gernsheim 1984). The photographs he made were published in 1863 in three sumptuous portfolios, and in 1867 they were offered to a wider readership in a one-volume abridgement.

Such figures as Frith and Bedford were acclaimed for their work because they mined new gold from old seams. A second kind of travel photographer brought home "news from nowhere." Such pioneers created pictures of places like Japan which, before the middle of the cen-

FIG. 14-13. "Mosque of Sultan Achmet from the Street," by James Robertson. Early 1850s. Constantinople. Scrapbook of Architecture—Miscellaneous Photographs, A68 MQWZ, p. 17. Art and Architecture Collection, Miriam and Ira D. Wallach Division of Art, Prints and Photographs, New York Public Library, Astor, Lenox, and Tilden Foundations.

tury, had been virtually sealed to the West. They opened windows onto the vast lands of China and India, whose ancient civilizations had few perceived links with the Western heritage. They sent back images of territories like New Zealand or the American West, which were still in the process of discovery and settlement. In all these regions, there were rich traditions, but they did not resonate in the Western imagination. All were considered to be exotic, intriguing, alien; they had not yet been charted on the mental map of the Western world.

A roll-call of great names in the annals of photography preserves the memory of the explorers whose courage and enterprise, ingenuity and perseverance, created the pictures that first made these places come alive in the imagination of their viewers at home. The list includes such masters as Felice Beato in Japan, John Thomson in China, Samuel Bourne in India, and Timothy O'Sullivan and W. H. Jackson in America. (Osman 1987; Zannier 1986; White 1989; Ollman 1983; Jussim and Lindquist-Cock 1985) Photographers like these were, both, free men and fol-

FIG. 14-14. "The Sphinx Transfixed." *Punch*, June 7, 1862. Francis Bedford, here depicted, traveled with the Prince of Wales as his official photographer on a four-month royal visit to Egypt and the Middle East in 1862. Caption: "The great difficulty in Photography is to get the Sitter to assume a Pleasing Expression of Countenance—Jones, however, thinks that, in this instance, he has been extremely successful."

lowers. On the one hand, they had far greater latitude in the choice of subject than their contemporaries who covered the world of the Mediterranean and the Middle East, and the images they made established rather than confirmed the accepted viewpoint. On the other hand, their own ideas on what constituted a fine prospect, and the necessary elements in its composition, had inevitably been shaped by the long-established pictorial conventions to which they themselves were heirs.

Although groups of photographers worked in very different regions—inhospitable and cold in the north, inhospitable and cold in the south, inhospitable and hot in the middle—convenience, and the imperatives of the marketplace, bound them to many of the same practices. Sam-

uel Bourne took his camera up into parts of the Himalayas that could be reached only by an enthusiast with inexhaustible determination and endurance, not to mention long-suffering bearers, but he also made many pictures on the beaten track. His camera caught the beauty of Indian scenes that were well within the range of a European lady whose western dress made no concessions to the rigors of an eastern climate. (See Fig. 14-15.)

Because of a steady demand for such subjects, all operators kept on hand a supply of photographs that showed the characteristic costumes and customs of the region where they worked. It was often more convenient to arrange the appropriate figures in a studio than to look for them on location. Kusakabe Kimbei, a Japanese

FIG. 14-15. "Giant Banyon Tree, Barrackpore Park," by Samuel Bourne. 1867. Calcutta, India. Albumen print, 9¼ × 11¼ inches.

photographer who had been trained by the Austrian Baron von Stillfried, one of the first Westerners to operate in the country (Worswick 1979), created in his studio imaginatively posed, delicately hand-colored scenes of daily life for foreign visitors (Fig. 14-16). Guillaume Berggren, a Swedish photographer who settled in Constantinople in 1866, made his reputation with beautiful studies of landscapes and buildings (Wigh 1984), but earned his bread and butter with the "Turkish types" he photographed

against elaborate backdrops in his fashionable studio, without (judging from the title) obtrusive personal involvement (Fig. 14-17). For Berggren, see also Figure 14-5. The interest and appeal of regional costume were universally felt, and universally exploited (Fig. 4-12).

Other photographers saw possibilities for profit much closer to home. Because they worked on familiar ground, their coverage could achieve a depth and breadth impossible even to attempt when further afield. In Britain, four re-

markable photographic empires were built by four remarkable men: Francis Frith, Francis Bedford, George W. Wilson, and James Valentine. (Wilson 1985; Spencer 1987; Taylor 1981; Hannavy 1983) Between them, by the end of the century, they and their teams of assistants had managed to take pictures of every region, every major town, and innumerable tiny corners of the national scene. Like travel photographers everywhere, they responded to, and fostered, their public's interest in history and legend, religion and the arts. Attention was lavished on regions, such as the Lake District, whose beauties had long been acknowledged. Tribute was paid to

every ruined abbey and "devil's cauldron" in the country. Any stretch of scenery linked with the works of Shakespeare or of Scott was honored on a hundred photographic forays. All this was to be expected but, just because the treatment of the entire country was so dense and detailed, it became possible to find room for a more unusual feature: the celebration of contemporary achievements. The firm of Valentine & Sons of Dundee, for example, produced a study of a gigantic waterwheel, affectionately known as "The Lady Isabella," built on the Isle of Man in 1854 to pump water from the lead mines (Fig. 14-18). Francis Bedford published a serenely

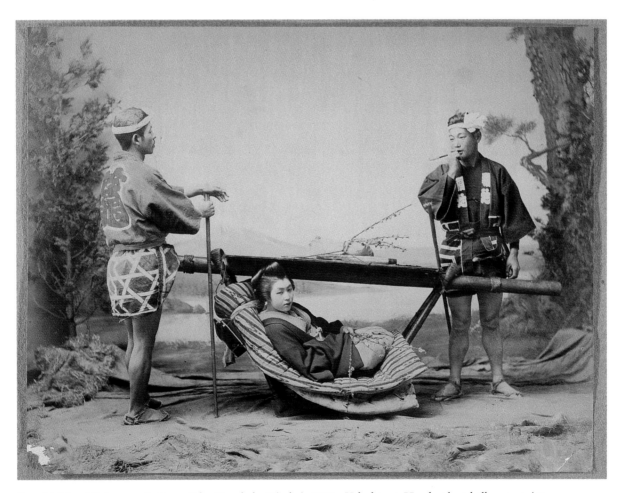

FIG. 14-16. "A Journey in Japan," by Kusakabe Kimbei. 1890s. Yokohama. Hand-colored albumen print, 9½ × 12¾ inches, one of twenty-five in an album of the photographer's work, undoubtedly made for sale to tourists. See also Fig. 4-12.

FIG. 14-17. "Dame Turque, No. 6," by Guillaume Berggren, c. 1878. Istanbul. Gelatin silver print cabinet card, from an album assembled by an American traveler in 1878. N. T. and J. B. Anderson Collection.

FIG. 14-18. "The Lady Isabella," by Valentine & Sons. Original: mid-1850s, Laxey, Isle of Man. This waterwheel was used from 1854 on to pump water from the local lead mines. The original photograph was probably made soon after the big wheel's construction, and thereafter distributed in the form of a gravure print, 6 × 8 inches, mounted on glass.

Fɪɢ. 14-19. Clifton Suspension Bridge, by Francis Bedford, c. 1864. Bristol, England.
Albumen print, 6½ × 8½ inches.

beautiful image of a modern marvel, the Clifton Suspension Bridge (Fig. 14-19), spanning the river Avon at Bristol, which had been designed by one of the most famous Victorian engineers, Isambard Kingdom Brunel, and completed in 1864.

The Amateur's Adventures

In its true sense, "amateur" is a word that describes all the early travel photographers. Enthusiasm for the enterprise marked each venture, and sustained each pioneer. The possibility of profit, however, was perceived from the first, and added its special zest to the endeavor. Those who struggled to produce daguerreotypes of distant lands for Lerebours knew full well that the grand design was to use the images, for commercial publication, in the projected *Excursions Daguerriennes*. (See Chapter 4.)

Photography was so new, and interest so keen, that many gentlemen amateurs were tempted to assemble albums of their own pictures and offer them for sale. When Gautier visited Spain in 1840, his companion was Eugène Piot, a cultivated connoisseur who undertook the rigors of the journey in search of fine buildings and precious works of art. In the next decade, he traveled widely in Greece, Sicily, and Italy, with the same purpose, and was one of the first to make use of photography to document his findings. He took a great number of calotypes during his expeditions, and published several albums, of which the most ambitious was *Italie monumentale* (1851), illustrated with 255 tipped-in photographs. (Becchetti 1978) It is a measure of the speed with which the new art developed that such a publishing venture could be carried out with success a mere ten years or so after the fruitless struggles to capture any image at all amid the fun and frustrations of the Spanish expedition. Morozov (1977) mentions an

All-Russian Ethnographic Exhibition, held in Moscow as early as 1867, in which over 2,000 "ethnographic" photographs were shown, all made by dedicated explorers.

No individual working alone, however, could hope to compete on an equal footing in the marketplace with the photographic empires, once they had been established. In a remarkably short time, the field of travel photography came to be dominated by such men as those mentioned in the previous section: Frith, Wilson, Bourne. Each was an intrepid and tireless photographer; each achieved a rare balance between the fine artist and the brilliant businessman. Each created an enormous commercial enterprise that made available for sale examples of his own pictures and those of others working for him. The sheer quantity of views that any one of these firms could offer is staggering. G. W. Wilson's 1863 list, *Stereoscopic and Album Views*, contained 440 pictures of Britain. (Taylor 1981) *Frith's Photo-Pictures: Germany* (c. 1860–65), listed about 1,500 photographs of Germany, accompanied by advertisements for other "Foreign Series": 1,000 images of "France and Paris, etc." and 800 of Italy. (Mann 1990) *Photographic Views in India*, issued by Bourne and his partner Charles Shepherd in 1875, offered well over a thousand examples. (Bourne and Shepherd 1875)

Lost in the shadows cast by such dazzling entrepreneurs, countless enthusiasts practiced photography for private pleasures, personal ends. To help in his passionate, painstaking examination of the buildings of Venice and, in particular, the Cathedral of St. Mark, John Ruskin supplemented his sketches and notes with daguerreotypes of architectural details. He was quick to grasp how valuable the camera could be as an aid to study, and to adopt it as a tool. It is likely that he bought his first daguerreotype view of Venice from a Frenchman, in the autumn of 1845. (Hanson 1981) Such a chance transaction was exciting at the time, but Ruskin was not the man to rely for long on anyone else's taste.

(a)

FIG. 14-20. Architectural studies.

(a) Daguerreotype, 101 × 74 mm., by John Ruskin. Probably Venice, late 1840s. Museum of the History of Science, Oxford. (Simcock 1991)

(b) Cyanotype, 7½ × 6 inches. Amiens Cathedral, 1880s. Anonymous. From an album with the title "Architectural Illustrations, France, Italy" stamped on the spine. The volume contains 150 cyanotype views, taken indoors and outdoors, many based on commercial picture runs.

Energetic steps had to be taken. On his return to Venice in 1849, he brought his own equipment, with which he and his servant, John Hobbs, had a happy time, recording features of particular importance for his work in progress. (See Fig. 14-20.)

Samuel Butler, best known today as the author of *Erewhon* and *The Way of All Flesh*, was also a classical scholar and art historian. From the 1860s he used the camera on his travels in

(b)

Greece and Italy to capture contemporary scenes that could illustrate his theories about the everyday behavior of people in classical antiquity. (Shaffer 1988) Several British army officers in India as, for example, Captain Linnaeus Tripe, enjoyed themselves in their leisure hours, trying to solve the technical and aesthetic problems posed for the photographer by the great monuments of India's past (Dewan 1989). Throughout the 1870s, P. V. Luke, the engineer who laid the first field telegraph in the Khyber Pass, made a valuable photographic record of Buddhist antiquities in Afghanistan. The collection was presented by his widow to the British Embassy library at Kabul in 1933. (Levi 1984; Curzon 1923)

Most amateurs were far less ambitious in their aims, and viewed photography as but one of several pleasant ways in which to pass the time when not otherwise engaged. In their eyes, ad-

venture was more important than achievement; any obstacles in the path, whether set there by man or nature, simply added to the fun. It has been claimed (Worswick and Spence 1979) that little work of merit is known to have been produced by amateurs in China before 1900. The misfortunes of such enthusiasts are recorded on a page of cartoons that appeared in the March 7, 1891, issue of *The Illustrated London News* (Fig. 14-21). A plausible explanation for the dismal record is offered in each tiny sketch: disaster strikes at every turn, but never dims the cheerful mood.

Out in the field, both nature and natives could be unpredictable. The weather was rarely cooperative, and the pages of the photographic record crackle with complaints: "But for the rain, which, with the exception of about an hour, came down with a steadiness and purpose enough to drive a photographer out of his wits, I should look back with great pleasure to the two days I spent with the monks of St. Saba." (Anon. 1857)

Misunderstandings and misadventures have dogged the intrepid through the centuries, and photographers were often met with suspicion, if not downright hostility. Sometimes they were accused of stealing secrets, and sometimes of stealing souls. (See Fig. 14-12, caption, for an example of such hostility.) Either the operator or the equipment might be feared. In Spain, Dr. Wheelhouse was arrested as a spy while making calotypes of Cádiz in 1848. (Buckland 1974) In the Western Isles of Scotland, forty years later, Colonel Gale's camera and tripod were lethal weapons in the eyes of a Highlander: "From his earnest inquiries as to the nature of the projectile and explosives used in the machine, it was evident that his bold demeanor was but a cloak to a most penetrating terror" (Anon. 1889).

Stealing souls is a more serious matter. In many parts of the world, a cloud of suspicion shadowed painter and photographer alike, and traveling artists were always getting into trouble. Thus, Holman Hunt on his expedition to the Middle East was accused, as he made portraits, of collecting souls to sell to the Devil; Edward Lear was denounced as Satan incarnate while sketching in Albania. (Stevens 1984) Traveling photographers ran into the same problems. An 1869 essay in a Warsaw magazine described the fear and hostility that greeted the camera in the Polish countryside: "The first photographers were considered by the peasants as instruments of the Evil One. The apparatus, the mysterious preparations, aroused alarm and the suspicion that evil spirits and the Devil himself must be concealed in the machine with the long tube, and that it is he who 'paints' so well, on orders of the one who sold him his soul" (Garztecki 1977). See also Chapter 15. Loss of a soul meant the loss of a life, and this black thread runs through story after story. Lady Macartney, wife of the British Representative in Chinese Turkestan at the turn of the century, mentions such an episode in her memoirs: "One day we wanted to photograph a particularly attractive little child, and were just getting the camera ready when the mother rushed out and snatched the child away, declaring that the evil eye was in the camera, and if it was trained on her child it would die" (Macartney 1931).

Once all hazards in the field had been overcome, the amateur still had to face the problem of developing and printing the harvest of images. A few might relish the rigors of darkroom work in a tent, but for the lazy and the lucky there was a luxurious alternative: the darkroom in a well-appointed hotel. Rumor has it that there was a darkroom for use by passengers on the Trans-Siberian Express in the early twentieth century. Whether or not this was the case, it is certainly true that, for a while, before everyone became used to entrusting a roll of Kodak film to the hands of unseen technicians, the darkroom was a featured attraction of many resorts. When it was the custom to stay for long, leisurely days, or weeks, in a hotel, it was a pleasure to spend some of the time making pictures, and hotel managers took note of the fact. As

1. Messrs. Tripod and Focus go ashore from a river steamer.
2. They decide to photograph a party of the natives sleeping in a field.
3. The Chinamen, awaking and alarmed, take flight with yells of terror.
4. The mob of hostile peasantry is kept at bay, dreading the levelled camera as a new kind of artillery.
5. But they drive some of their "water buffaloes," good beasts when yoked to the plough, in a fresh attack on the foreign intruders.
6. Messrs. Tripod and Focus, leaving their camera to destruction, take refuge up a tree.
7. Ransomed by paying away all their dollars, they are permitted to embark in safety. China does not yet appreciate every art of civilisation!

AMATEUR PHOTOGRAPHERS IN CHINA: SKETCHES BY THE REV. R. O'DOWD ROSS-LEWIN, CHAPLAIN R.N.

FIG. 14-21. "Amateur Photographers in China." Cartoon by the Rev. R. O'Dowd Ross-Lewin, from *Illustrated London News*, March 7, 1891. 14 × 9¼ inches.

early as 1888, the *Philadelphia Photographer* reported that the owner of several establishments on the island of Madeira had set up a darkroom in each; a year later, another journal printed the names of North American hotels that made the same provisions for their guests. (Welling 1987) The list had lengthened noticeably by the time *The American Annual of Photography for 1901* drew up for its readers a nationwide, state-by-state survey of "Hotels Having Dark-Rooms for the Convenience of Tourist Photographers" (Anon. 1901).

Appreciation of such facilities was not universal. In chapter 13 of her novel *Ziska*, published in the 1890s, Marie Corelli wrote with withering scorn about the amenities and occupants of "the Mena House Hotel" in Egypt. (Thomas 1980) It was "situated within five minutes' walk of the Great Pyramid, and happily possessed of a golfing-ground and a marble swimming-bath. That ubiquitous nuisance, the 'amateur photographer', can here have his 'dark-room', for the development of his more or less imperfect 'plates', and there is a resident chaplain for the piously inclined. With a chaplain and a 'dark-room', what more can the aspiring soul of the modern tourist desire?"

ARMCHAIR TRAVELS

Hard as it is to believe while poring over the adventures of the amateur photographer, not every traveler set out with a camera at the ready in the case. Photography can be both strenuous and demanding, and most people, even today, find it less exhausting to buy a postcard than to make a print. As the commercial possibilities of the new art were developed, the range of options for the fainthearted grew ever wider. Old-fashioned ways of experiencing a view retained their charm, while newfangled photographs were packaged to catch the eye at every turn.

Despite the swarm of photographers clustered at Niagara Falls, the magic of the *camera ob-* scura, built there in 1854 on the Canadian side, opposite the American cascade, remained popular with tourists for many years. (Bannon 1982) Even on board ship, the mysterious appeal of the old invention could be enjoyed. Frances Power Cobbe sailed from Constantinople in 1858 on the Austrian Lloyd's steamer *Neptune*, and was amazed by its modern marvels, from luxurious baths to tempting menus. (Pemble 1988) In every detail, the ship was splendidly equipped, "even to a *camera obscura* on deck."

Year by year, it became steadily easier for the public to see and acquire fine views of places far and near. It was possible, for example, to study them in galleries. Four exhibitions, mounted in London from 1852 to 1858, between them offered the indefatigable the chance to examine well over 3,000 travel pictures by British photographers. (Hershkowitz 1980) Anyone really interested in the field could subscribe to one of several societies that sent out parcels of approved photographs at regular intervals. (Downer 1991) Faraway in Australia, the trustees of the recently established State Library of Victoria in 1860 acquired a considerable body of images of the Middle East and the Mediterranean region, by taking out a subscription to the London Architectural Photographic Association.

Beautiful photographic views could be enjoyed as engravings in newspapers and journals, or in their original form, as tipped-in book illustrations. (See Chapter 11.) It was possible to obtain mementos of the main attractions in any town of respectable size with the purchase of one conveniently packaged album, which carried at the back a helpful list of all the other cities covered by the publishers. In such a venture, the contents changed from place to place, but the format stayed the same, cunningly designed to be recognized with relief by even the most unobservant tourist. (Fig. 14-22) By the end of the century, stereo views of every conceivable feature on the visitor's travel map could be bought by the handful (Fig. 14-23).

In the photographic marketplace, each customer was on an equal footing. The stay-at-

FIG. 14-22. Karlsbad, 1892. Album containing sixteen commercially produced postcard views of the famous spa, published by Romler & Jonas, Hof-Photograph, Dresden, Germany. Cover and sample illustration (of the Karlsbad Sprudel, a pulsating geyser of hot mineral water). Gelatin silver print. See also Adam 1990.

FIG. 14-23. "Catacomb of the Cappuccini, Chapel of the Skulls," Rome. Standard stereo card. Probably 1890s. Unknown maker. American? Hand-colored.

home and the inveterate explorer could not share the same experiences, but they could build the same collection. The humble, inexpensive carte-de-visite and the majestic print carried images across the world, and might be offered for sale a thousand miles from their starting-point. Every parlor could have its "Mona Lisa," every hallway its "Spanish Steps."

THE TRIVIALIZATION OF TRAVEL

By the last years of the century, the first major chapter in the history of travel photography was drawing to a close. The energy and enterprise, courage and artistry of countless photographers had assembled for the world a core collection of standard images. Sites major and minor had been covered, and the gaps that remained in the pictorial atlas were being steadily, inexorably filled. In some ways, the photographers had done their work too well. Excess can blunt the sharpest appetite and, faced with an ever-richer diet of pictures, the public showed faint stirrings of revolt. Interest began to wilt, the freshness of response grew stale. In an essay on Venice, Henry James (1882) remarked on how hard it had become to offer the jaded reader anything new on the theme: "Venice has been painted and described many thousands of times, and of all the cities in the world it is the easiest to visit without going there. . . . Everyone has been there, and everyone has brought back a collection of photographs."

At the turn of the century, photography was woven into the travel experience by so many threads that, in a sense, it had become invisible, lost in the labyrinth of the pattern. Vacation brochures were not merely filled with photographs, but designed in the shape of a camera (Fig. 14-24). An elaborate, handwritten menu from a cruise off San Juan, Puerto Rico, for the evening of April 12, 1905, offered on the inside

FIG. 14-24. "Seen through a Camera." Views from Hamilton, Ohio, c. 1907. Published by Alfonso M. Simon, New York.

"Mock turtle soup au Lord Mayor de Londres" and, on the cover, a pasted-on photograph of "Light House Tender Pansy" (Fig. 14-25). In the 1920s, passengers on the Colonial & Dominion shipping line, which linked Britain with the Pacific, whiled away the long weeks of the voyage with special card packs supplied by the company. Serious bridge players have eyes only for

FIG. 14-25. "Light House Tender Pansy." Cover of a ship's dinner menu. San Juan, Puerto Rico. April 12, 1902.

FIG. 14-26. "Pastimes for Passengers." Examples from a complete set of pictorial playing cards used on board Colonial and Dominion Shipping Line vessels, which carried passengers between Britain and the Pacific. One card bears a duty stamp with the year 1925. Each card shows a different view of notable people and places in the Pacific region. Issued by Muir & Moodie, Pictorial Playing Cards, Dunedin, New Zealand. (Gregson 1990)

the faces of their cards, but for those whose concentration wavered for a moment, the backs of these sets offered a small reward: pleasant photographic views of typical people and places in the Pacific (Fig. 14-26).

Today, travelers make considerably more snapshots of friends pretending to prop up the

Leaning Tower of Pisa than of the unlucky tower on its own. This is due partly to the streak of cheerful vulgarity that surfaces even in the best-regulated minds under the pressure of vacations, and partly to a sense of saturation. The trend started many years before, and signs of repletion appeared quite soon. By the end of the nine-

teenth century, the public had been crammed with fine photographs of famous scenes and subjects. In fulfillment of Lerebours' dream, the world had indeed been caught between the covers of an album. Once that had been achieved, there began to stir inside the restless human heart a need for change: change of pace and change of purpose.

The coming of the Kodak camera brought a welcome new note into the record of individual travel experience. The typical nineteenth-century album was filled with handsome prints of significant views, carefully chosen from the work of experienced photographers (Fig. 14-27). Thus, a wealthy and cultivated American, Caroline Sturgis Tappan, who spent many years in Europe between 1850 and 1880, amassed in that time a collection of a thousand travel photo-graphs. Piece by piece she assembled an anthology of work created by the masters of the form, from Altobelli to Sébah. (Dimock 1982)

By contrast, early twentieth-century albums contained an ever-increasing proportion of homemade snapshots, in which the official subject was treated as a backdrop to the eccentric, mysterious activities of family and friends. Even commercial brochures began to enliven formal views with a figure in the foreground. At the Chicago World's Fair in 1893, a publication offered *Gems of the White City Seen Through the Camera*, in which one image shows a young woman taking her own picture of the fairground, with the caption "The Ever-Present 'Kodak' Fiend." (Anon. 1893; Mann 1992)

Once everyone is already familiar with a famous view, the need for novelty begins to gnaw.

FIG. 14-27. "Warriors' Tombs, Canterbury Cathedral, England." Print with handwritten caption, appearing in a travel album assembled by an American family during a European tour in the mid-1870s. 10¼ × 13 inches.

How refreshing it must have been for the members of the Photographers' Association of America, when they assembled at Niagara Falls on July 17, 1891, to aim their cameras not just at the painfully well-known waters but also at a fellow photographer, S. J. Dixon from Toronto, who dared to cross the gorge on a cable, dressed in flesh-colored tights, a red and gold girdle, and "a jaunty military cap [that] set off his picturesque garb to perfection" (Schwartz 1987). What manna from heaven for the view-weary professionals, who snapped the exploit and turned it into a brand-new Niagara stereo card.

For the travel photograph, the mold was set in the first decades of the new art. Countless copies continued to be made from the form throughout the twentieth century, and the classic directness of its approach continued to command respect, but it could no longer be specially prized, because examples had become so common. As the years slipped by, any photographer who hoped to arrest the attention of the viewer with the power of a picture had to create an image that bore the unmistakable stamp of its maker's idiosyncratic vision. Step-by-step, intrepid explorers and indefatigable ethnographers alike became metamorphosed into photojournalists, would-be artists, and souvenir-makers.

Chapter 14 References and Notes

ADAM, H. C. (1990). "Der Karlsbader Sprudel," in *Shadow and Substance: Essays on the History of Photography* (ed. K. Collins), Amorphous Institute Press / University of New Mexico Press, Albuquerque, New Mexico, p. 152.

ALLEN, W. (1990). "Sixty-Nine Istanbul Photographers, 1887–1914," in *Shadow and Substance: Essays on the History of Photography* (ed. K. Collins), Amorphous Institute Press / University of New Mexico Press, Albuquerque, New Mexico, pp. 127–36.

ANON. (1857). *Description of a Series of Views of Jerusalem and Its Environs, executed by Robertson and Beato of Constantinople*, E. Gambart & Co., London and Paris, p. 11, no. 32.

ANON. (1889). "Colonel Joseph Gale," in *Sun Artists*, Kegan Paul, London, no. 1, p. 7.

ANON. (1893). *Glimpses of the World's Fair: A Selection of Gems of the White City Seen Through a Camera*, Laird & Lee, Chicago.

ANON. (1901). *The American Annual of Photography and Photographic Times Almanac for 1901*, Scovill & Adams, New York, p. 343. Private communication from E. Leos, acknowledged with thanks.

ANTHONY, J. J. (1914). "Interesting Reminiscences," in *Niagara Falls Gazette* (Niagara Falls, New York), April 18, p. 5. Quoted in Bannon 1982, p. 14.

BAEDEKER, K. (1890). *Central Italy and Rome*, Karl Baedeker, Leipzig, p. 118.

BAEDEKER, K. (1899). *United States*, Karl Baedeker, Leipzig, pp. 220, 298.

BAIER, W. (1977). *Quellendarstellungen zur Geschichte der Fotografie*, Schirmer-Mosel, Munich.

BANNON, A. (1982). *The Taking of Niagara: A History of the Falls in Photography*, Media Study, Buffalo, New York, pp. 11, 13–14, 45.

BECCHETTI, P. (1978). *Fotografi e Fotografia in Italia, 1839–1880*, Edizione Quasar, Rome, p. 89.

BOURNE, S., and SHEPHERD, C. (1875). *Photographic Views in India*, Simla Advertiser Press, Simla, India.

BUCKLAND, G. (1974). *Reality Recorded*, New York Graphic Society, Greenwich, Connecticut, p. 41.

BULL, D., and LORIMER, D. (1979). *Up the Nile, A Photographic Excursion: Egypt, 1839–1898*, Clarkson Potter, New York, p. 33.

COLLOMS, B. (1975). *Charles Kingsley: The Lion of Eversley*, Constable, London, p. 319.

COSTANTINI, P., and ZANNIER, I. (1986). *Venezia nella Fotografia dell'Ottocento*, Arsenale Editrice, Venice, p. 114.

CURZON OF KEDDLESTON (1923). *Tales of Travel*, George H. Doran Co., New York. (A portrait of P. V. Luke, made in 1894, appears on p. 271.)

DEWAN, J. (1989). "The Hoysalesvara Temple of Halebid in Early Photography," *History of Photography*, vol. 13, no. 4, pp. 343–54.

DIMOCK, G. (1982). *Caroline Sturgis Tappan and the Grand Tour: A Collection of Nineteenth Century Photographs*, Lenox Library Association, Lenox, Massachusetts, preface.

DOWNER, C. (1991). Private communication from the Curator, the Picture Collection, La Trobe Library, State Library of Victoria, Australia, acknowledged with thanks.

FABIAN, R., and ADAM, H.-C. (1983). *Masters of*

Early Travel Photography, Vendome Press, New York, pp. 53–54.

FERREZ, G., and NAEF, W. J. (1976). *Pioneer Photographers of Brazil, 1840–1920*, Center for Inter-American Relations, New York, p. 22.

GARZTECKI, J. (1977). "Early Photography in Poland," *History of Photography*, vol. 1, no. 1, pp. 39–62.

GAUTIER, T. (1853). *Wanderings in Spain*, Ingram, Cooke & Co., London, chapter 5, p. 51.

GAUTIER, T. (1854). *The Constantinople of Today*, David Bogue, London, p. 81.

GERNSHEIM, H. (1982). *The Origins of Photography*, Thames & Hudson, London, p. 83.

GERNSHEIM, H. (1984). *Incunabula of British Photographic Literature, 1839–1875*, Scolar Press, London, p. 36.

GOLDSCHMIDT, L., and NAEF, W. J. (1980). *The Truthful Lens*, Grolier Club, New York, pp. 199–200.

GREGSON, D. and R. (1990). Personal communication, acknowledged with thanks.

HANNAVY, J. (1983). *A Moment in Time: Scottish Contributions to Photography, 1840–1920*, Third Eye Centre, Glasgow, Scotland, p. 78.

HANSON, B. (1981). "Carrying Off the Grand Canal," *Architectural Review*, February, pp. 104–9.

HELSTED, D. (Editor) (1977). *Rome in Early Photographs: The Age of Pius IX, Photographs 1846–1878 from Roman and Danish Collections*, Thorvaldsen Museum, Copenhagen, entry no. 37.

HERSHKOWITZ, R. (1980). *The British Photographer Abroad: The First Thirty Years*, Robert Hershkowitz Ltd., London, pp. 91–92.

HOOPER, B. (1988). "Camera on the Mogollon Rim," *History of Photography*, vol. 12, no. 2, pp. 93–101.

JAMES, H. (1882). "Venice," reprinted in his collected essays, *Italian Hours* (1909), Grove Press, New York, 1979, p. 1.

JAY, P. (1984). *Trains: Voyages en Chemin de Fer au 19ème Siècle,* Musée Nicéphore Niépce, Ville de Chalon-sur-Saône, unpaginated exhibition catalog containing some 1859 railway photographs by E.-D. Baldus.

JUSSIM, E., and LINDQUIST-COCK, E. (1985). *Landscape as Photograph*, Yale University Press, New Haven and London.

LA FARGE, J. (1897). *An Artist's Letters from Japan*, Waterstone, London, 1986 reprint, p. 164.

LEVI, P. (1984). *The Light Garden of the Angel King: Journeys in Afghanistan*, Penguin Books, Harmondsworth, Middlesex, U.K., pp. 45, 104.

MACARTNEY, Lady (1931). *An English Lady in Chinese Turkestan*, Oxford University Press, Oxford, p. 126.

MANN, C. (1990). "Francis Frith: A Catalog of Photo-Pictures of Germany," in *Shadow and Substance: Essays on the History of Photography* (ed. K. Collins), Amorphous Institute Press / University of New Mexico Press, Albuquerque, New Mexico, pp. 175–81.

MANN, C. (1992). Personal communication, acknowledged with thanks.

MOROZOV, S. (1977). "Early Photography in Eastern Europe: Russia," *History of Photography*, vol. 1, no. 4, pp. 327–47.

NEWHALL, B. (1971). *An Historical and Descriptive Account of the Various Processes of the Daguerreotype and the Diorama by Daguerre*, modern reprint with introduction by Newhall, Winter House, New York, pp. 21–23.

NEWHALL, B. (1976). *The Daguerreotype in America*, Dover Publications, New York, pp. 68–69.

NIR, Y. (1985). *The Bible and the Image*, University of Pennsylvania Press, Philadelphia, pp. 237–38, 291–92.

OLLMAN, A. (1983). *Samuel Bourne: Images of India*, special issue (no. 33) of *Untitled*, Friends of Photography, Carmel, California.

OSMAN, C. (1987). "New Light on the Beato Brothers," *The British Journal of Photography*, no. 42, October 16, pp. 1217–21.

PEMBLE, J. (1988). *The Mediterranean Passion: Victorians and Edwardians in the South*, Oxford University Press, Oxford, p. 23.

RUDISILL, R. (1971). *Mirror Image: The Influence of the Daguerreotype on American Society*, University of New Mexico Press, Albuquerque, New Mexico, pp. 163–64.

SCHWARTZ, J. (1987). "Hazardous Feat at Niagara," *History of Photography*, vol. 11, no. 1, pp. 23–24.

SEATON, B. (1982). "Beautiful Thoughts: The Wallace Nutting Platinum Prints," *History of Photography*, vol. 6, no. 3, pp. 273–79.

SHAFFER, E. (1988). *Erewhons of the Eye: Samuel Butler as Painter, Photographer and Art Critic*, Reaktion Books, London, pp. 205–41.

SIMCOCK, A. V. (1989). *Photography 150: Images from the First Generation*, Museum of the History of Science, Oxford, p. 10.

SIMCOCK, A. V. (1991). Personal communication, acknowledged with thanks.

SMITH, A. (1850). *A Month at Constantinople*, David Bogue, London, pp. 218, 190.

SMITH, A. (1860). *To China and Back*, bound with *The Story of Mont Blanc* in a volume published "for private circulation," London, p. 27.

SPENCER, S. (1987). "Francis Bedford's Photographs of North Wales: Selection and Interpretation," *History of Photography*, vol. 11, no. 3, pp. 237–45.

STEVENS, M. A. (1984). *The Orientalists: Delacroix to Matisse*, National Gallery of Art, Washington, D.C., p. 27.

TAYLOR, R. (1981). *George Washington Wilson, Artist and Photographer, 1823–93*, Aberdeen University Press, Aberdeen, pp. 174–76.

THOMAS, G. (1980). "Point-Counterpoint," *History of Photography*, vol. 4, no. 3, pp. 239–41.

WADE, J. (1979). *A Short History of the Camera*, Fountain Press, Argus Books, Watford, Herts., U.K., p. 18.

WATSON, W. M. (1980). *Images of Italy: Photography in the Nineteenth Century*, Mount Holyoke College Art Museum, South Hadley, Massachusetts, p. 50.

WELLING, W. (1987). *Photography in America: The Formative Years, 1839–1900*, University of New Mexico Press, Albuquerque, New Mexico, p. 318.

WERGE, J. (1890). *The Evolution of Photography*, Piper & Carter and John Werge, London, p. 141. (Quoted in Bannon 1982, p. 11.)

WHITE, S. (1989). *John Thomson: A Window to the Orient*, University of New Mexico Press, Albuquerque, New Mexico.

WIGH, L. (1984). *Photographic Views of the Bosphorus and Constantinople: The Swedish Photographer G. Berggren*, Fotografiska Museet, Stockholm.

WILLIAMS, G. (1864). *Dr. Pierotti and His Assailants; or, The Defense of "Jerusalem Explored"* (publisher unknown), London, pp. 50–51. (Quoted in Nir 1985, pp. 291–92.)

WILSON, D. (1985). *Francis Frith's Travels*, J. M. Dent & Sons Ltd., London, p. 14.

WORSWICK, C. (1979). *Japan: Photographs, 1854–1905*, Pennwick Publishing, and Alfred A. Knopf, New York, p. 106.

WORSWICK, C., and SPENCE, J. (1979). *Imperial China: Photographs, 1850–1912*, Scolar Press, London, pp. 136–37, 145, 150.

ZANNIER, I. (1986). *Verso Orientale: Fotografie di Antonio e Felice Beato*, Alinari, Florence.

15

PHOTOGRAPHY IN THE WRITER'S WORLD

FIRST IMPRESSIONS

Writers are readers, if not always of each other's work, then certainly of those journals that make their circles hum with news and views, graceful praise, and growling disparagement. Mid-nineteenth-century society was very much like our own, in the speed with which ideas circulated among those who were at ease within this interlocking web of newspapers and periodicals.

The announcement of photography's invention, in January 1839, fell like a pebble into a pond, and ripples fanned out to lap the shore-

lines of the reading world. From the first, long columns of newsprint were filled with the marvels of the daguerreotype, and readers rushed to make their own experiments, wherever they felt safe to do so (not for long, alas, in England, where the patent situation was an impediment). As early as February 21, *The Times* printed a letter from a correspondent who had just managed to obtain a picture of the trees in front of his house, though "not the parts agitated by the wind." He had gone further, and invented his own name for the image, "lucigraph," confidently predicting that "in a very short time the

traveller's portmanteau will not be complete without the very portable means of procuring a lucigraph at pleasure" (Adamson 1989).

This enthusiast had been spurred to action by the accounts of the new invention he had read in his newspaper, even though he himself lived far from the centers of activity, Paris and London, in the quiet little town of Wisbech in Cambridgeshire. There was a crackle of excitement in the air, and it is hardly surprising that by October 20 another country reader, Edward FitzGerald, translator of the *Rubáiyát of Omar Khayyám*, had begun to toy with the figurative possibilities of a newly minted verb. From the depths of Suffolk, he wrote to a friend: "How well I remember when we used all to be in the Nursery, and from the window see the hounds come across the lawn, my Father and Mr. Jenney in their hunting caps with their long whips, all Daguerreotyped into the mind's eye now" (FitzGerald 1839).

Once it had become possible to make daguerreotype portraits, the extraordinary detail in each likeness fired the imagination. There seemed to be something magical about both process and result. Elizabeth Barrett wrote to a friend and fellow author on December 7, 1843 (see Chapter 6): "My dearest Miss Mitford, do you know anything about that wonderful invention of the day, called the Daguerreotype? . . . It is the very sanctification of portraits I think" (Miller 1954). Such a belief was widely held and frequently expressed. In his novel *The House of the Seven Gables*, Nathaniel Hawthorne gave a disturbing new twist to the idea (Hawthorne 1851). The daguerreotype that figures in the story reveals not merely the familiar personality of a well-known figure, but also the true character, hidden from fallible observers. The villain of the piece, Judge Pyncheon, is a pillar of the community, respectable, benevolent, and just. Only Holgrave, the daguerreotypist, is led to suspect that all is not quite as it seems, because each of his portraits of the judge reveals a cruel selfishness beneath the bland exterior:

There is a wonderful insight in Heaven's broad and simple sunshine. While we give it credit only for depicting the merest surface, it actually brings out the secret character with a truth that no painter would ever venture upon, even could he detect it. . . . The original wears, to the world's eye . . . an exceedingly pleasant countenance. . . . The sun, as you see, tells quite another story. . . . Here we have the man, sly, subtle, hard, imperious, and, withal, cold as ice.

Holgrave's name itself may have been chosen deliberately by Hawthorne to underline the ability of the daguerreotypist, in this story, at least, to see the whole truth and inscribe it on a silver plate. (Kermode 1975)

The daguerreotype was held to show the truth because it was made not with human craft alone but with God's sunlight. Stern moralists, plagued with Platonic misgivings about all art because it was at heart a lie, could find some comfort in a photographic image. That image was a fact, and thus more virtuous than any painting. This belief lies behind a tiny exchange between two characters in *The Europeans*, an early novel by Henry James (1878). When Felix—the charming young artist who, in the eyes of some Boston relatives, has been both groomed and weakened by his years in dangerous old Europe—suggests that he could paint a portrait of his uncle, the victim dampens expectations with the repressive reply: "Please don't take my likeness. My children have my daguerreotype. That is quite satisfactory." The daguerreotype was acceptable, in a sense in which the painting was not.

The case for the photograph is summed up in the graceful phrases of an unexpected champion. Pope Leo XIII (1878–1903) (Fig. 15-1), known and remembered, among other things, for his 1891 encyclical, *Rerum Novarum*, on economic and social problems, was an enthusiast who brought photography into the very heart of the Vatican in the 1880s, by commissioning a ceiling

FIG. 15-1. Pope Leo XIII (1810–1903). Carte-de-visite, distributed by the London Stereoscopic Company, c. 1878. See also Becchetti 1983 and Fig. 1-1. The Pope was himself an enthusiastic photographer.

fresco (Fig. 1-1) in the Galleria dei Candelabri, which showed the new art being blessed by the Church. A few years before he became Pope, Leo expressed his admiration in another way by composing an ode, *Ars photographica*, in which he claimed:

> O mira virtus ingeni
> Novumque monstrum! Imaginem
> Naturae Apelles aemulus
> Non pulchriorem pingerit.

> [O wonderful power of the Spirit,

> O new marvel!
> Apelles, who copied Nature,
> Could not paint a more perfect image.]
> [Becchetti 1977; Spear 1981]

Alas, the Pope's photographic interests were not popular among the crowds in St. Peter's; he was widely believed to be a *jettatoro*, one afflicted with an "evil eye," that unwittingly brought misfortune wherever it looked (Elworthy 1895).

SECOND THOUGHTS

It is not in human nature to sustain the note of exaltation for long. Once photography could be taken for granted, gratitude fell silent and critics grew bold. Was a photographic portrait really so lifelike? To many, the promised marvel proved a puzzling disappointment. It cheated expectation because it lacked color, and its cold black and white was disturbing. As one old countryman complains about the daguerreotype in Charles Kingsley's novel *Two Years Ago*: "It ain't cheerful looking . . . too much blackamoor wise" (Kingsley 1857).

Kingsley distanced himself from this popular prejudice by putting it in the mouth of an unsophisticated character. Others spoke openly of serious objections. Though lauded as the supreme portrait-painter, the Sun seemed content at times with very shoddy workmanship. The narrator of Tennyson's poem *The Sisters, or Evelyn and Edith* is left to gaze at a most unsatisfactory memento of his long-lost love:

> The Sun himself has limn'd the face for me.
> Not quite so quickly, no, nor half as well.
> For look you here—the shadows are too deep,
> And like the critic's blurring comment make
> The veriest beauties of the work appear

The darkest faults: the sweet eyes frown:
 the lips
Seem but a gash. My sole memorial
Of Edith.

[Tennyson 1850]

Turgenev's hero in his novel *Smoke* is disturbed when he turns for comfort to a portrait of the girl he is pledged to marry: "He drew out of an inner pocket a photograph of Tatyana. Her face gazed out mournfully at him, looking ugly and old, as photographs usually do" (Turgenev 1867). Trollope, in *Barchester Towers*, hammers home the point: "The likeness is indeed true, but it is a dull, dead, unfeeling, inauspicious likeness. The face is indeed there, and those looking at it will know at once whose image it is, but the owner of the face will not be proud of the resemblance" (Trollope 1857).

Photography made the dream of portraits for everyone a reality. For the vast majority, this was marvel enough, but for those familiar with the subtlety of a fine painted portrait, the mannerisms, and even the physical appearance, of the photograph began to grate. Discontent mounted as commercial studios multiplied. The development of the carte-de-visite, and then the cabinet card, led not only to the stereotypes of studio convention in props and poses (Chapter 2), but also to an overwhelming flood of images. The photograph was no longer packaged as a precious object, carefully encased; it had become no more than a slip of cardboard.

Lip-service was always paid to the blessings of universal portraiture, and journals kept appropriate tributes permanently on file: "Anyone who knows what the worth of family affections is among the lower classes, and who has seen the array of little portraits stuck over a labourer's fireplace, still gathering into one the 'Home' that life is always parting . . . will perhaps feel with me that in counteracting the tendencies, social and industrial, which every day are sapping the healthier family affections, the sixpenny photograph is doing more for the poor than all the

philanthropists in the world" (Anon. 1871). However, anything universally available ceases to be universally approved, and just beneath the obligatory praise for photography's virtues ran a current of distaste for its vulgarities. Thackeray (1860a), like several cartoonists (Fig. 15-2), made fun of the hustler whose job it was to stand in the street and bully passersby into unplanned visits to the studio high above their heads: "This gentleman with the fur collar, the straggling beard, the frank and engaging leer, the somewhat husky voice, who is calling out on the doorstep, 'Step in, and 'ave it done. Your correct likeness, only one shilling . . .' Ah, he is only the *chargé-d'affaires* of a photographer who lives upstairs."

Educated sensibilities flinched when confronted with photography's cherished mannerisms. Both Henry James and Edith Wharton wrote about studio conventions with amusement, even affection, but always from a great distance, as though describing the customs of strange tribes: "Small sallow carte-de-visite photographs, faithfully framed but spectrally faded, [with] balloon skirts and false 'property' balustrades of unimaginable terraces" (James 1909). "Her fair, faded tints, her quaint corseting, the *passementerie* on her tight-waisted dress, the velvet band on her tapering arm, made her resemble a carte-de-visite photograph of the middle sixties. One saw her, younger but no less invincibly lady-like, leaning on a chair with a fringed back, a curl in her neck, a locket on her tuckered bosom, toward the end of an embossed morocco album beginning with 'The Beauties of the Second Empire' " (Wharton 1912). (See Fig. 15-3.)

In *Hudson River Bracketed*, Edith Wharton (1929) makes one character laugh at the fashion for enlarged and overpainted photographs, and another wince with secret shame as he recalls that, once upon a time, before his eyes had been opened, he too had admired those monstrosities: " 'Frenny's never got beyond the enlarged photograph of the eighties, when people used to

ART-PROGRESS.

Artist (!) "Now, Mum! Take orf yer 'ead for Sixpence, or yer 'ole body for a Shillin'!"

FIG. 15-2. "Art Progress." Cartoon from *Punch*, May 2, 1857, showing clients forcibly "encouraged" to patronize photographic studios.

have their dear ones done twice the size of life, with the whiskers touched up in crayon'. Vance . . . remembered, with a pang, the colossal photograph which grandma Scrimser had had made of grandpa after his death, with the hyacinthine curls and low-necked collar of his prime, a photograph which the family had all thought so 'speaking' that even Mrs. Weston dared not grumble at the expense. Still, Vance, since then, had had a glimpse of other standards." (See Fig. 4-10a.)

Disparagement of photographic clichés led inevitably to disparagement of the photographer. The yawning gap between photography's pretensions and actual practice offered a tempting target. Photographers claimed to be artists, but

might be viewed as mere mechanics. Ibsen (1884), in *The Wild Duck*, goes one step further. In that play, Hjalmar Ekdal is a photographer, a weak and ineffectual man. If he had been an artist, he would have been forced to set brush to canvas himself, however incompetently, to earn a living. As it is, he can adopt a policy of remote control. It is his wife who runs the studio, pressing the button and drudging away at run-of-the-mill portraits that pay the rent and put food on the table. Ekdal spends his days on the sofa, despising the work put out in his name, and mourning fretfully over faded dreams: "When I devoted myself to photography, it wasn't just in order to make portraits of a lot of nonentities. . . . I swore that if I dedicated my powers to that

FIG. 15-3. Half of a stereo image, showing two crinolined young women with "Greek key" ornamental bands on their skirts. Early 1860s. Unknown photographer. The Gernsheim Collection, Harry Ransom Humanities Research Center, University of Texas at Austin. See also Gernsheim 1963.

craft, I would lift it to such heights that it would become both an art and a science."

Just as misgivings were expressed about photographic portraits, so there were mounting reservations about photographs of famous works of art and fabled sites in far-flung places. Never before had so much pictorial material been so readily available to so many. Gratitude was in order, but the wonder and the pleasure of it all were soon to be tempered with distaste.

It was always admitted that photography had filled an aching need. In his study of Nathaniel Hawthorne, Henry James (1879) wrote of "the New England world some forty years ago," and remarked with feeling on its painful constrictions for the would-be connoisseur: "There was at that time a great desire for culture, a great interest in knowledge, in art, in aesthetics, together with a very scanty supply of the materials for such pursuits. Small things were made to do large service; and there is something even touch-

ing in the solemnity of consideration that was bestowed by the emancipated New England conscience upon little wandering books and prints, little echoes and rumours of observation and experience."

Photography changed the intellectual landscape. Once pictures of record could be purchased, writers collected them, used them, and relied on them, quite as much as everyone else. Those with a more than casual interest in a subject quickly realized their value as a tool. Edith Wharton (1905), with a deep, well-grounded knowledge of art, recognized photography's importance to scholarship. After visiting a remote Italian monastery and discovering there some groups of terra-cotta figures, she commissioned photographs of them to be made "by Signor Alinari of Florence" and sent to Professor Ridolfi, director of the Royal Museums in the same city. With the help of these pictures, Professor Ridolfi was able to revise the accepted date and au-

thorship of the sculptures, even though he had not examined them in person, and had never before "seen any photographs of the groups." The story is told, with pardonable satisfaction, in the author's essay "A Tuscan Shrine."

Unfortunately for photography, the very usefulness of such images soon told against them. There began to cling about them the unmistakable aura of the schoolhouse, of dank, gray corridors and dull gray rooms. All too many photographs, whether of the Sphinx or of the Sistine Chapel, contrived to quench the fires of mystery and power with life-denying dreariness. In E. M. Forster's *A Room with a View*, "brown art photographs" are bought by earnest tourists, and classed, with a shudder, by the author "amongst many hideous presents and mementoes" (Forster 1908). In this novel it is only when such travesties have been tossed into the Arno that any comprehension of Italy's real beauty can begin to grow. (See Fig. 11-2.)

Photographs came to be accepted with a complex mixture of dependence and resentment. The photographer always seemed to be one step ahead of other people, shaping expectation, forestalling discovery. Henry James catches the ambivalence of his own response in two remarks, separated by some years and much experience. In his essay "Ravenna" he admits: "I remember no shop (in Ravenna) but the little establishment of an urbane photographer, whose views of the Pineta, the great legendary pine forest just without the town, gave me an irresistible desire to see that refuge" (James 1873). In *The Aspern Papers* (James 1888), a more fretful note is sounded: "When Americans went abroad in 1820 there was something romantic, almost heroic in it, as compared with the perpetual ferryings of the present hour, when photography and other conveniences have annihilated surprise."

This sigh of regret for a vanished past was often heard as the century thundered on. Daily life changed at an ever-quickening pace, and new inventions crowded on each other's heels. Photographers liked to link their art with those other

FIG. 15-4. Frontispiece design by Randolph Caldecott for the 1881 edition of Frederick Locker's *London Lyrics*.

marvels of the modern age, the locomotive and the railroad (see Chapter 7); a poet could lament the pairing:

> Where boys and girls pursued their sports
> A locomotive puffs and snorts,
> And gets my malediction;
> The turf is dust—the elves are fled—
> The ponds have shrunk—and tastes have
> spread
> To photograph and fiction.
>
> [Locker 1857]

[Fig. 15-4]

BEFORE AND BEHIND THE CAMERA

While they might deplore its deficiencies, writers could not escape from their world. Quite untouched by their reservations, photography

FIG. 15-5. Catherine Sinclair: "A First of April Nonsense Letter," in rebus form. London, 1864. 7 × 5 inches. By permission of the British Library (no. 012804-N-13). Note the reference in line 8 to a carte-de-visite, a term by then universally understood.

took its place in society with speed and assurance, and life for everyone was brushed, however lightly, by its influence. Catherine Sinclair, a popular children's author, included the carte-de-visite in a rebus letter she designed in 1864, confident that the word was already so familiar that her puzzle picture would be readily interpreted (Fig. 15-5). On one, doubtless dull, evening in the same year, even Tennyson was drawn into a desultory conversation on the correct pronunciation of the word "photography" (Tennyson 1987). When it came to their own equipment, writers could get as excited as ordinary mortals. Théophile Gautier, his imagination fired with the possibilities of the new invention, took a daguerreotype camera to Spain in 1840; in 1888, Robert Louis Stevenson carried his camera to the South Seas. (Wilsher 1985; Knight

FIG. 15-6. Daguerreotype of Henry James, with Henry James, Jr. Brady Studio. 1854. By permission of the Houghton Library, Harvard University, and of Mr. Alex E. James.

1986) It is a measure of the enormous improvements in equipment achieved for the casual amateur in fifty years that Gautier was unable to score any success in the difficult conditions in Spain, while Stevenson and his family, in similarly trying circumstances, could produce quite a respectable body of work, and plan to use it in an illustrated history of the region.

Above all, writers themselves were photographed at every stage of life from birth to death. Henry James (1913) recalls, in his memoir *A Small Boy and Others*, the day in 1854 when his father took him to Mathew Brady's studio on Broadway. For the occasion, James had to wear his best jacket, which happened to be decorated with a long line of buttons (Fig. 15-6). This was the very jacket made fun of a short while before by the great Mr. Thackeray, who had warned the little boy that if he wore it in England, crowds would shout out "Buttons!" (the nickname for a pageboy) as he went by. Not surprisingly, James felt flustered: "It had been revealed to me thus in a flash that we were somehow *queer*, and though never exactly crushed by it I became aware that I at least felt so as I stood with my head in Mr. Brady's vice. Beautiful most decidedly the lost art of the daguerreotype; I remember the 'exposure' as on this occasion

interminably long, yet with the result of a facial anguish far less harshly reproduced than my suffered snapshots of a later age."

The daguerreotype was an individual item, one of a kind, and all the more precious because it was, by and large, a private treasure. It was intended to be cherished, not collected. Once it became routine to multiply images, the floodgates opened and a tidal wave of pictures poured onto the market. The inexpensive carte-de-visite made the celebrity portrait a possibility, and all at once the public ached with a new hunger for possession.

To feed that appetite, studios photographed the leading figures of the day. At first the choice was limited to those whose names were already household words, but the stream broadened as demand remained unsated. By the last quarter of the century, the shops were filled with the faces of minor actors and society beauties. Max Beerbohm (1911) called these the "phantom harem" of the undergraduate, and demurely maintained that they prepared the ground for Zuleika Dobson's devastating effect on every male student at Oxford: "Surrounded both by plain women of flesh and blood and by beauteous women on pasteboard, the undergraduate is the easiest victim of living loveliness—is as a fire ever well and truly laid, amenable to a spark. And if the spark be such a flaring torch as Zuleika?—marvel not, reader, at the conflagration." (See also Chapter 8.)

The album was invented to contain the flood, and it became a social ritual, almost a social obligation, to examine with deliberate care the contents of a friend's collection (Fig. 15-7). In due course, as the novelty wore off, sharp pleasure could turn to dull pain, but in the first, fresh days of the new toy, delight was unalloyed and universal. Robert Louis Stevenson (1888–89) found that the magic of an album still worked in strange climes and strange company. During his voyage in 1888, he invited some Polynesians on board his schooner-yacht, and did his best to entertain them: "As in European

TIN-TYPES.

FIG. 15-7. From "Tin-Types," an essay by Gail Hamilton. January 1867. Printed page from an unidentified American magazine.

parlours, the photograph album went the round." Its effect was, if anything, better than usual. Distance had lent enchantment, and the all-too-familiar trappings of the studio were now mysteriously exotic: "This sober gallery, their everyday costumes and physiognomies, had become transformed, in three weeks' sailing, into things wonderful and rich and foreign; alien faces, barbaric dresses, they were now beheld and fingered, in the swerving cabin, with innocent excitement and surprise."

The hope of celebrity touched writers too, and residual reserve was turned to powder in its fires. The idea of such publicity was quite new. Thackeray's *The Book of Snobs* was published in 1848, and at that time his comments on the author and his admirers were funny just because they were farfetched: "Literary persons . . . are such favourites with the public that they are continually obliged to have their pictures taken and published; and one or two could be pointed out, of whom the nation insists upon having a fresh portrait every year" (Thackeray 1848). By May 1863, when Thackeray's portrait was issued by Cundall, Downes & Company of London (Fig. 15-8b), photography's dominance had shaped

FIG. 15-8. Literary Lions. Nineteenth-century authors on cartes-de-visite. 1860s.
 (a) Alexandre Dumas, by an unknown photographer.
 (b) W. M. Thackeray, by Cundall, Downes & Company, London.
 (c) Alfred Lord Tennyson, by Lewis Carroll, published by Joseph Cundall &
Company, London.
 (d) Charles Dickens, by John and Charles Watkins, London.

new attitudes and inspired new fashions; the public had found its literary lions. Already, three years earlier, Wilkie Collins was complaining, somewhat complacently, of exhaustion after all the sittings his publishers arranged for photographs to be used as frontispiece portraits in the new editions of his runaway best-seller, *The Woman in White*. (Sutherland 1976)

Politicians, no less than writers, have always been keenly aware of the need to make a good impression on their public. In earlier times, they tried to engrave themselves on the electorate's memory; by 1848, a commentator explained Winfield Scott's failure to gain the Presidential nomination of the Whig National Convention in America on the grounds that, unlike his successful rival, Zachary Taylor, he had never "*daguerreotyped* himself . . . upon the popular heart." (McMillan 1959)

By the 1860s, the figure of speech had been turned into the plain prose of everyday practice. In Mrs. Oliphant's (1866) novel, *Miss Marjoribanks*, a by-election is being fought, and both candidates are coaxed into the studio of an implacable lady amateur, to have their pictures taken: "'I wish you gentlemen would sit to her; it would please her, and it would not do *you* much harm; and then for your constituents, you know—' . . . 'I hope you don't wish me to look like one of Maria Brown's photographs to my constituents', said Mr. Cavendish" (Oliphant 1866).

The experience of being photographed, whether for family or fame, was common enough to inspire a minor literary convention: the battle of the studio, a struggle between client and operator, with no clear-cut victory for either side. Customers were restive, half-cowed and half-defiant. In his *Photographic Pleasures*, Cuthbert Bede (1855) tells what happened when the maestro's back was turned:

> I can call to mind how the Daguerreotyper fixed my head in a brazen vice, and having reduced me thereby to the verge of discomfort, maliciously told me to keep my eyes steadily fixed on a paper pinned against the wall, and to think of something pleasant. I can well remember how the Daguerreotyper thereupon left me, and how I, feeling exceedingly uncomfortable, and being lamentably ignorant that the operation had commenced, released my head from the vice, and promenaded the room for some 10 minutes, admiring the various designs in chimney pots which are usually to be studied with advantage from a Daguerreotype studio. Then, hearing the sound of returning steps, I mounted my platform, and resumed my seat and vice. I can call to mind *my* dismay when the Daguerreotyper took the plate out of the camera, and *his* dismay, when, on the development of the picture, he found that it merely contained a representation of the chairback and vice. [See Fig. 9-3.]

Sitters liked to think of themselves as victims, but to the photographer they were tormentors, never still and never satisfied. Very soon after the beginning of studio photography in France, Grandville (1842) wrote a fable called *Topaz the Portrait Painter*, in which the photographer hero is a monkey, and all the birds and beasts of the jungle are his clients. Not one felt a proper gratitude when he saw his portrait: "Pelicans thought their beaks too long. Cockatoos complained of the shortness of theirs. Goats said their beards had been tampered with. . . . Squirrels wanted action." (See Fig. 15-9.)

Lewis Carroll in 1857, with a bow to Longfellow, rattled off "Hiawatha's Photographing" (quoted by Gernsheim 1969), and caught the indignation of a family when they set eyes at last on the unfortunate photographer's masterpiece:

> Then all joined and all abused it,
> Unrestrainedly abused it,
> As the worst and ugliest picture
> They could possibly have dreamed of.

FIG. 15-9. "Topaz's Critical Customers." Cartoon by J.-J. Grandville, from *Les Animaux* (Paris), 1842.

"Giving one such strange expressions—
Sullen, stupid, pert expressions.
Really anyone would take us
(Anyone that did not know us)
For the most *unpleasant* people."

It seems only fitting that the irresistibly imitable *Hiawatha* was itself inspired by a photograph. Longfellow was moved to write his poem after he was given a daguerreotype of the Minnehaha Falls in Minnesota Territory, made in 1851 by Alexander Hesler of Chicago. Hesler went back to the Falls and made some salt prints of the scene from albumen and glass negatives (Naef 1975). These prints, in turn, were mounted in the *Photographic and Fine Art Journal* in 1857, accompanied by four lines from "The Song of Hiawatha."

IN THE STUDY

From the first, photographers made bold claims for themselves, as standard-bearers of the truth, and trumpeted the benefits their new art would shower on mankind. Writers on the whole, after the first shock of the invention had been absorbed, wasted little time on photography's marvels, rightly sensing that its disasters and pretensions would prove a happier hunting-ground. Jokes familiar today, about the uneasy relationship between the photographer and the camera, became established early:

> Harris rushed for his camera, and of course could not find it; he never can when he wants it. Whenever we see Harris scuttling up and down like a lost dog, shouting

"Where's my camera? Don't either of you remember where I put my camera?"—then we know that for the first time that day he has come across something worth photographing. Later on, he remembered that it was in his bag; that is where it would be on an occasion like this. [Jerome 1900]

Technical flaws in finished masterpieces were pounced on with purrs of delight. None was so common in early photographs as the blurring of a subject that simply would not stay still (Fig. 15-10). Lewis Carroll, himself a passionate photographer, knew exactly what was likely to go wrong in a landscape study, and described it in "A Photographer's Day Out" (1860):

Eagerly, tremblingly, I covered my head with the hood, and commenced the development. Trees rather misty—well, the wind had blown them about a little; *that* wouldn't show much— the farmer? Well, *he* had walked on a yard or two, and I should be sorry to state how many arms and legs he appeared with— never mind! Call him a spider, a centipede, anything— the cow? I must, however reluctantly, confess that the cow had three heads, and though such an animal could be curious, it is *not* picturesque. However, there could be no mistake about the cottage; its chimneys were all that could be desired. [Gernsheim 1969]

Much appreciated were feet, hands, and heads that seemed to swell up and fill the foreground of a picture (Fig. 9-13). In *Three Men in a Boat*, Jerome K. Jerome (1889) describes what happens on the river when a photographer presses the button just as someone falls over in the boat:

Our feet were undoubtedly the leading article in that photograph. Indeed, very little else was to be seen. They filled up the foreground entirely. Behind them, you caught glimpses of the other boats, and bits of the surrounding scenery; but everything and everybody else on the lock looked so utterly insignificant and paltry compared with our feet, that all the other people felt quite ashamed of themselves, and refused to subscribe to the picture. The owner of one steam launch, who had bespoke six copies, rescinded the order on seeing the negative. He said he would take them if anybody could show him his launch, but nobody could. It was somewhere behind George's right foot.

Even more heartless merriment was provoked by the disembodied foot, or arm, or elbow, the unwanted parts of some unwanted anatomy, left on a picture after careless trimming. Frederick Locker, a friend of Thackeray and a popular minor poet in his own right, produced an engaging poem on the theme, first printed in 1872 (Locker 1884). Called "Our Photographs," it tells the sad story of a love affair between the narrator and his beloved, Di. All goes well at first, and they are photographed sitting together while he recites some of his own poems. This idyll is rudely shattered by the appearance of the insufferable Smith, who wins Di's fickle heart. With shameless disloyalty, she gives him the precious photograph, diplomatically doctored (Fig. 15-11):

I've seen it in Smith's pocket-book!
Just think! her hat, her tender look,
Are now that Brute's!
Before she gave it, off she cut
My body, head and lyrics, but
She was obliged, the little Slut,
To leave my boots.

One of the photographer's proudest claims was that he, and he alone, recorded truth. His picture of a scene had a weight and solidity that no painter's sketchy impressions could rival.

FIG. 15-10. Group tintype of a girls' class, with
teacher. 1880s. American. Unknown photographer.
3 × 4 inches. Attentive children and one restless soul.

FIG. 15-11. Censored Image. Portrait of a lady, right-
hand side of a once larger image. 1880s. American. Un-
known photographer. Gelatin silver print. Note the tip
of a boot (bottom left), belonging to the lady's erst-
while companion.

The new illustrated magazines of the 1840s and 1850s were quick to appreciate this, and while it was still technically impossible to use photographs themselves in the pages of a journal, editors were careful to label their artists' work "after the photograph by Mr. . . ." The boast became a bore, and cynicism gently sidled in to puncture pretension. In *The Filibuster*, by Albany Fonblanque, Jr. (1862), we are introduced to the *New York Illustrated Thunder Bolt*'s foreign correspondent, who has taken some highly praised pictures of the American-Mexican War. The intrepid photographer confides to a friendly maid the secret of his scoops: "Between you and me, I was only one day and night in the Filibuster's camp; but there was an old ruin, a village and a forest near at hand, so I took 20 views of each from different points, and one or the other did very well for every place mentioned in the news. No one in New York knows the difference. It was much the safest way of doing business and saved travelling expenses."

Not many hobbies were shared by men and women in the mid-nineteenth century, but photography carried all before it. Both sexes loved the magic, the happy dabbling, the picnic excursions to find the picturesque, the irresistibly impressive new vocabulary. Surprisingly, the rich possibilities in photographic flirtation were left almost untapped, but the theme is touched on in one or two stories. In Cuthbert Bede's novel, *The Adventures of Mr. Verdant Green* (Bede 1853–57), the hero is wooed by an energetic lady amateur. Miss Bouncer "had not only calotyped him, but had made no end of duplicates of him, in a manner that was suggestive of the deepest admiration and affection" (Fig. 15-12). All this effort is wasted, as the pictures Verdant most wants to see are not Miss Bouncer's but those reflected in the eyes of her rival, Miss Patty Honeywood: "her bright, laughing, hazel eyes, in which . . . he saw little daguerreotypes of himself. Would that he could retain such a photographer by his side through life! Miss Bouncer's camera was as nothing compared with the *camera lucida* of those clear eyes."

Flirtation, even the suspicion of flirtation, is treated with considerably less indulgence by Charlotte M. Yonge (1864). In *Hopes and Fears*, the young governess, Lucilla Sandbrook, is dis-

FIG. 15-12. "Miss Bouncer stalks her Prey." From *The Adventures of Mr. Verdant Green*, by Cuthbert Bede, 1853–57.

missed from her job for indecorum in the dark-room. At a time of day when she ought to have been helping her pupil with a translation exercise, Lucilla is discovered by her employer developing pictures. To make matters worse, she is not alone: "A door was opened, and out of the housemaid's closet, defended from light by a yellow blind at every crevice, came eager exclamations of 'Famous', 'Capital', 'the tower comes out to perfection', and in another moment Lucilla Sandbrook, in all her bloom and animation, was in the room, followed by a youth of some eighteen years."

A similar situation has a happier outcome in the story "In a Gentleman's Family," published in the September 4 issue of *Chambers's Journal* in 1858. (Seiberling 1986) There the tutor and the daughter of the household fall in love while he is teaching her how to photograph. In the end, he wins her hand in marriage, and the father is left ruefully sighing: "Fool that I was, to think that all was collodion and innocence, instead of being design and camera obscura!"

For centuries, the painted miniature had been sighed over by lovers, slipped under pillows, kept close to the heart; the photograph took its place in the long tradition. The Rev. Francis Kilvert was a gifted writer and a most impressionable curate, always falling in love with charming, unavailable girls (Kilvert 1947). In his diary entry for New Year's Eve 1874, he wrote: "At a quarter to twelve I began to think earnestly of dear Katie and to pray for her. . . . I had laid before me on my desk the photograph of her in her riding habit. . . . She seemed to be very near me." The theme was also used by John Everett Millais in a painting exhibited at the Royal Academy in London in 1871. His study shows a young woman deep in thought, holding a small photograph behind her back (Fig. 15-13). The title, "Yes or No?" reveals her problem: will she accept or reject the proposal of marriage offered in the open letter that lies before her on the desk? The picture caused such a stir that the story had to be continued by popular demand in

two more paintings: the gloomy "No!" of 1875, and the blissful "Yes!" of 1877. (Casteras 1986)

Photography, for all its marvels, could not turn back the hands of time. Of what use were photographs to those whose romance had bloomed and faded just before such images could be readily obtained? Thackeray (1860a) derived some dry amusement from the thought of sending one of the newly fashionable cartes-de-visite to a long-lost love: "Would Some One . . . like to have the thing, I wonder, and be reminded of a man whom she knew in life's prime, with brown curly locks, as she looked on the effigy of this elderly gentleman, with a forehead as bare as a billiard-ball?"

A more ingenious solution to the delicate dilemma was found by Turgenev (1872) in his *Spring Torrents*. The story told in the novel takes place in 1840 and ends unhappily, as the two lovers go their separate ways. Thirty years later, in an epilogue, the hero receives a letter from the dear woman lost to him forever through his own folly. It contains a wholly undeserved reward: "He unfolded the thin blue sheet of writing paper, and as he did so a photograph slipped out. He quickly picked it up—and was rooted to the spot with amazement. It was Gemma, Gemma to the life, and young as he had known her thirty years before. The eyes, the lips were the same, it was the same face. The back of the photograph was inscribed with the words, 'My daughter Marianna.' "

Nineteenth-century society was enchanted by the camera, the new view it gave of the world and, in particular, of worlds undetectable by the naked eye—life and form revealed by microscope and telescope, and recorded by photography. As Cuthbert Bede (1855) put it in his *Photographic Pleasures*: "The Camera has been introduced to the Microscope, and they have been so mutually pleased with their acquaintance, that they have agreed to assist each other in the production of pictures."

One of those who could perceive the value of such links between science and photography was

Fig. 15-13. John Everett Millais: "Yes or No?" 1871. Oil on canvas, 44 × 36 inches. Yale University Art Gallery, Stephen Carlton Clark (B.A. 1903) Fund. Photograph by Joseph Szaszfai.

Lovell Reeve, a leading conchologist and a publisher with a special interest in the use of stereo photographs as illustrations in books and journals. (See also Chapter 11 and Stark 1981.) In 1841, he opened a shop in London for the sale of natural history specimens. Because of his own love of shells, it seems likely that his display room was filled with examples of marine life. Establishments of this kind became a feature of the English scene in the mid–nineteenth century, a time of intense interest in natural history. An attractive description of just such a shop appears in Charles Kingsley's (1857) novel *Two Years Ago*, a description that evokes the charm of these oases in the grime and bustle of London. It also helps to explain the special excitement the exploration of nature held for the Victorians, by its hint of the part played by the camera and microscope together in revealing for the first time the miraculous beauty of the underwater world: "He paces up still noisy Piccadilly, and then up silent Bond Street. . . . He turns into Mr. Pillischer's shop, and upstairs to the microscopic club-room. . . . He looks round the neat, pleasant little place, with its cases of curiosities, and its exquisite photographs, and bright brass instruments; its glass vases stocked with delicate water-plants and animalcules, with the sunlight gleaming through the green and purple seaweed fronds . . . a quiet, cool little hermitage of science amid that great, noisy, luxurious West-end world."

The camera played an important role in another branch of learning, one extraordinarily dependent on the availability of secondary images: the study of art. Prince Albert was only the most eminent and most influential among many patrons who, in the 1850s, began to create photographic records of fine collections, and make them available to scholars and the general public (see Chapter 11). The gentleman-cataloger was not slow to step into the pages of the novel. *The Woman in White*, by Wilkie Collins (1860), was a runaway best-seller as it appeared in installments from 1859 to 1860, and among its characters was Mr. Fairlie, an eccentric connoisseur: "His last caprice has led him to keep two photographers incessantly employed in producing sun-pictures of all the treasures and curiosities in his possession. One complete copy of the collection of photographs is to be presented to the Mechanics' Institution of Carlisle, mounted on the finest cardboard, with ostentatious red-letter inscriptions underneath."

Well-known photographers make occasional appearances in the stories of the day. Names are usually withheld, but telltale clues hint at the true identity. Only in a letter written in 1879 did Cuthbert Bede reveal that the model for the Swedish daguerreotypist in *Photographic Pleasures* was O. G. Rejlander (Henisch 1977). Flaubert (1869) made sly fun of his close friend Nadar's ebullient energy in the sketch he drew of one character's future career at the end of *L'Education Sentimentale*: "Pellerin, after dabbling in Fourierism, homeopathy, table-turning, Gothic art, and humanitarian painting, had become a photographer; and on all the walls of Paris there were pictures of him in a black coat, with a tiny body and a huge head."

Flaubert and Cuthbert Bede were content with private references and private jokes, but at least one author took a bolder line. An American tale (Anon. 1846), *The Daguerreotype Miniature*, sets a scene in Plumbe's daguerreotype gallery on Broadway, and introduces Plumbe himself as a character. The story indeed is dedicated to Plumbe, with these disarming words: "Perhaps the author has been guilty of too much freedom in using your name and that of your gallery in the pages of this work. But it is a well-known fact to publishers and authors, that, however intrinsically good cheap novels may be, it is a *sine qua non* nowadays that they contain something which may strike the general eye, and touch the public pulse. Hence the introduction of well-known and celebrated men and places is a stroke of policy on the part of an author that may do him good."

It is a sad but indisputable fact that novelists can rarely handle scientific terms with ease. Nineteenth-century enthusiasts loved the vocab-

ulary of photography, but found their pens hopelessly mired in turgid complexities when they tried to make it their own. W. H. Mallock (1877) composed a witty, sophisticated discussion of ideas, lightly disguised as a novel, *The New Republic*. Clever as he was, he could manage nothing better than this ponderous effort when one of his characters turns for inspiration to the camera: "The mind, if I may borrow an illustration from photography, is a sensitised plate, always ready to receive the images made by experience on it. Poetry is the developing solution, which first makes these images visible." And even that subtle stylist Henry James (1909) was uncharacteristically clumsy as he struggled to adapt for his own ends an effect that had caught his attention during a visit to one of the first movie theaters: "A little sparsely feathered hat . . . that grew and grew, that came nearer and nearer, while it met his eyes, after the manner of images in the cinematograph."

The most ambitious attempt to use the new science occurs in *Peer Gynt* (Ibsen 1867), in the last scene, where the Thin Man explains the soul's development to Peer in photographic terms:

> Perhaps you know that someone in Paris
> Has recently found out how to make
> Portraits by using the sun. You can get
> Direct pictures or else what are known
> As negatives. Light and shade are reversed
> In the latter, and to the unpractised eye
> They're not attractive, but the likeness is
> there,
> And it only remains to bring it out.
> Now if, in the course of its life, a soul
> Has portrayed itself in the negative way,
> The plate is sent on to me. It is not
> Discarded. I start to work on it,
> And the metamorphosis takes place.
> I dip it and steam it, burn it and clean it
> With sulphur and other chemicals
> Until the picture that should have appeared
> *Does* appear; we call it the positive.

The speech smacks of the schoolroom: everything is clarified, nothing illuminated. Thackeray (1860b) was a wiser artist when he contented himself with a graceful, glancing use of the fading daguerreotype as a figure for impermanence in his essay "De Juventute": "O pity! The vision has disappeared off the silver, the images of youth and the past are vanishing away."

It is rare indeed for a writer to try to catch in words the essence of an artist's style. Anne Thackeray was one of the few to pay this special tribute to a photographer she loved. Anne was one of Thackeray's daughters, and a dear friend of Mrs. Cameron. She spent many happy weeks in the Cameron household on the Isle of Wight, both amused and enchanted by the atmosphere created by its mistress's eccentric genius. In 1877 she wrote *From an Island*, a slight story but a loving evocation of the life she knew so well. She was too well-mannered and too tactful to transpose her friends directly from fact to fiction on the printed page, but by veiling her subjects in a thin disguise she protected their privacy while preserving the fragrance of their special world for the pleasure of a wider audience. Her leading character is a painter, not a photographer, and indeed a man not a woman, but his work is stamped with the authentic Cameron seal.

The setting of the story is a house party, and one of the guests is Mr. Hexham, the amateur photographer, an aspiring artist with the soul of a technician. One morning proves perfect for photography, and Hexham bustles about, coaxing the girls in the party into position: "He began placing them in a sort of row, two up and one down, with a property table in the middle." His host, St. Julian, the eminent painter, is drawn to take a friendly interest in the work, and immediately demonstrates his easy mastery. After one look at the stiff little group he firmly takes command:

> "Look up Mona—up, up. That is better. And cannot you take the ribbon out of your hair?" . . . With one hand Mona

pulled away the snood, and then the beautiful stream came flowing and rippling and falling all about her shoulders. . . . Then he began sending one for one thing and one for another. I was despatched for some lilies in the garden. . . . When we got back we found one of the prettiest sights I have ever yet seen,—a dream of fair ladies against an ivy wall, flowers and flowing locks, and sweeping garments. It is impossible to describe the peculiar charm of this living, breathing picture. [Thackeray 1877]

FIG. 15-14. Julia Margaret Cameron: "The Gardener's Daughter." 1867. From an album presented by Mrs. Cameron to Sir John Herschel. 292 × 234 mm. From the National Museum of Photography, Film and Television, Bradford, U.K.

FIG. 15-15. Mural by William Bell Scott: "Iron and Coal." 1861. Wallington Hall, Northumberland, U.K., a Property of the National Trust. Note the tiny figure of a photographer on the quayside in the background (lower left).

The vision St. Julian creates, a romantic fantasy of girls and flowers, rippling hair, and softly stirring dresses, contains the essence of Mrs. Cameron's treatment of her female subjects (Fig. 15-14). The phrase used by the narrator in admiration, "a dream of fair ladies," echoes the title of that poem by Tennyson, *A Dream of Fair Women*, which describes the ideal form of womanly beauty Mrs. Cameron so admired:

A daughter of the gods, divinely tall,
And most divinely fair.
[Wilsher and Spear 1983]

In a remarkably short time, the photographer became accepted as a part of the scenery of modern society. By 1888, when *The Astonishing History of Troy Town* was published, its author, Arthur Quiller-Couch, could sketch in a list of

typical inhabitants of his small, provincial Cornish town, and add an amused but telling comment at the end of it: "Boatmen, pilots, fishermen, sailors out of employ, the local photographer, men from the shipbuilding yards, makers of ship's biscuit, of ropes, of sails, chandlers, block and pump manufacturers, loafers—representatives, in short, of all the staple industries." (Quiller-Couch 1888) Almost thirty years earlier, William Bell Scott had painted a large mural for Wallington Hall in Northumberland (Fig. 15-15). He called it "Iron and Coal," and intended it as a paean of praise for the energy and enterprise of the industrial revolution.

Behind all the gigantic figures of workmen and engineers that fill the foreground, it is just possible to find a tiny photographer with his camera on the quayside. The date on a newspaper displayed in the scene is 1861.

This potpourri, a dip into a cornucopia of small pretensions, reveals how quickly but how modestly photography slipped onto the literary scene. It found its place in casual asides, and was used as an amusing novelty, a decorative detail, not as a major theme. The references are scattered and tiny but, once pieced together, make up an intricate mosaic, a faint yet faithful echo of society's response to a new art form.

Chapter 15 References and Notes

ADAMSON, K. (1989). "The Year of Daguerre," *History of Photography*, vol. 13, no. 3, pp. 191–202.

ANON. (1846). *The Daguerreotype Miniature*, G. B. Zieber, Philadelphia, dedication page.

ANON. (1871). *Macmillan's Magazine*, London, quoted in G. M. Trevelyan (1946), *English Social History*, Longmans, Green & Co., London, p. 571.

BECCHETTI, P. (1977). "Early Photography in Rome," in *Rome in Early Photographs* (ed. D. Helsted), Thorvaldsen Museum, Copenhagen, p. 36.

BECCHETTI, P. (1983). *La fotografia a Roma, dalle origini al 1915*, Editore Colombo, Rome, pp. 51–52.

BEDE, C. (1853–54). *The Adventures of Mr. Verdant Green*, James Blackwood, London, part 2, chapter 8, p. 74; part 3, chapter 4, p. 27.

BEDE, C. (1855). *Photographic Pleasures*. Facsimile reprint 1973 by Amphoto, New York, chapter 5, p. 37; chapter 12, p. 80.

BEERBOHM, M. (1911). *Zuleika Dobson*, Penguin Books, Harmondsworth, Middlesex, U.K., 1952 reprint, chapter 7.

CASTERAS, S. P. (1986). "John Everett Millais, Yes or No?" in *Yale University Art Gallery Bulletin*, vol. 36, no. 1, pp. 18–19.

COLLINS, W. (1860). *The Woman in White*, Penguin Books, Harmondsworth, Middlesex, U.K., 1974 reprint, *The Second Epoch*, chapter 1.

ELWORTHY, F. T. (1895). *The Evil Eye*. 1958 reprint, Julian Press, New York, p. vi.

FITZGERALD, E. (1839). *Letters and Literary Remains* (ed. W. A. Wright), London (publisher unknown), 1889 edition, vol. 1, p. 53, October 20 letter.

FLAUBERT, G. (1869). *Sentimental Education* (trans. R. Baldick), 1964 edition by Penguin Books, Harmondsworth, Middlesex, U.K., part 3, chapter 7, p. 416.

FONBLANQUE, A., Jr. (1862) *The Filibuster*, Ward & Lock, London, chapter 8, p. 65.

FORSTER, E. M. (1908). *A Room with a View*, Penguin Books, Harmondsworth, Middlesex, U.K. 1958 reprint, chapters 4 and 5.

GERNSHEIM, A. (1963). *Fashion and Reality, 1840–1914*, Faber & Faber, London, plate 69.

GERNSHEIM, H. (1969). *Lewis Carroll, Photographer*, Dover Publications, New York, pp. 116–17, 125.

GRANDVILLE, J.-J. (1842). "Topaz the Portrait Painter," in *Public and Private Life of Animals* (trans. J. Thomson), Sampson Low, London, 1877, pp. 169–70.

HAWTHORNE, N. (1851). *The House of the Seven Gables*, Holt, Rinehart & Winston, New York, 1967 reprint, chapter 6.

HENISCH, B. A. and H. K. (1977). "Cuthbert Bede and O. G. Rejlander," *History of Photography*, vol. 1, no. 3, pp. 213–14.

IBSEN, H. (1867). *Peer Gynt* (trans. Norman Ginsburg), 1946 edition by Hammond, Hammond & Co., London, act 5, scene 10.

IBSEN, H. (1884). *The Wild Duck*, in *Three Plays* (trans. Una Ellis-Fermor), Penguin Books, Harmondsworth, Middlesex, U.K. 1950 edition, act 3.

JAMES, H. (1873). "Ravenna," in *Italian Hours* (1909), Grove Press, New York, 1979 reprint.

JAMES, H. (1878). *The Europeans*, Penguin Books

Harmondsworth, Middlesex, U.K., 1976 reprint, chapter 5.

JAMES, H. (1879). *Hawthorne* (ed. T. Tanner), Macmillan, London and New York, 1967 reprint by St. Martin's Press, London, chapter 3, p. 76.

JAMES, H. (1888). *The Aspern Papers*, Penguin Books, Harmondsworth, Middlesex, U.K., 1976 reprint, chapter 4.

JAMES, H. (1909). *Crapy Cornelia*, in *In the Cage and Other Stories*, Penguin Books, Harmonsdworth, Middlesex, U.K., 1972 reprint, chapters 4 and 2.

JAMES, H. (1913). *A Small Boy and Others*, Macmillan & Co., London, chapter 7, p. 94.

JEROME, J. K. (1889). *Three Men in a Boat*, Penguin Books, Harmondsworth, Middlesex, U.K., 1971 reprint, chapter 18.

JEROME, J. K. (1900). *Three Men on the Bummel*, Penguin Books, Harmondsworth, Middlesex, U.K., 1984 reprint, chapter 8.

KERMODE, F. (1975). *The Classic*, Faber & Faber, London, p. 93.

KILVERT, F. (1947). *Kilvert's Diary, 1870–1879* (ed. W. Plomer), Macmillan Co., New York, p. 317.

KINGSLEY, C. (1857). *Two Years Ago*, J. F. Taylor & Co., New York, 1899 edition, chapters 15 and 24.

KNIGHT, A. (1986). *Robert Louis Stevenson in the South Seas*, Mainstream Publishing, Edinburgh, Scotland, p. 13.

LOCKER, F. (1857) "Bramble-Rise," in *London Lyrics* (publisher unknown). Privately printed at the Chiswick Press, London, 1881.

LOCKER, F. (1884). "Our Photographs," in *The Poems*, White, Stokes & Allen, New York, pp. 241–42.

MALLOCK, W. H. (1877). *The New Republic*, University of Florida Press, Gainesville, Florida, 1950 edition, book 3, chapter 2.

McMILLAN, M. C. (1959). "Joseph Glover Baldwin Reports on the Whig National Convention of 1848," in *Journal of Southern History*, vol. 25, p. 373.

MILLER, B. (1954). *Elizabeth Barrett to Miss Mitford*, John Murray, London, pp. 208–9.

NAEF, W. (1975). *Era of Exploration*, Albright-Knox Art Gallery, Buffalo, New York, p. 20.

OLIPHANT, M. (1866). *Miss Marjoribanks*, Zodiac Press, London, 1969 edition, chapter 40.

QUILLER-COUCH, A. (1888). *The Astonishing History of Troy Town*, Penguin Books, Harmondsworth, Middlesex, U.K., 1950 reprint, chapter 2.

SEIBERLING, G. (1986). *Amateurs, Photography, and the Mid-Victorian Imagination*, University of Chicago Press, Chicago and London, p. 100.

SPEAR, B. (1981). "Papal Indulgence," *History of Photography*, vol. 5, no. 2, pp. 169–70.

STARK, A. (1981). "Lovell Augustus Reeve, 1814–1865: Publisher and Patron of the Stereograph," *History of Photography*, vol. 5, no. 1, pp. 3–5.

STEVENSON, R. L. (1888–89). "In the South Seas," reprinted (1987) in *Island Landfalls* (ed. Jenni Calder), Canongate Classics, Edinburgh, Scotland, pp. 33–34.

SUTHERLAND, J. (1976). *Victorian Novelists and Publishers*, University of Chicago Press, Chicago, p. 42.

TENNYSON, A. (1850). "The Sisters, or Evelyn and Edith," in *Poetical Works of Alfred, Lord Tennyson*, Macmillan & Co., London, 1899 edition, p. 511.

TENNYSON, A. (1987). *Letters* (ed. Cecil Y. Lang and Edgar F. Shannon, Jr.), Belknap Press of Harvard University Press, Cambridge, Massachusetts, vol. 2, p. 360.

THACKERAY, A. (1877). *From an Island*, Loring, Boston, part 2, chapter 7, p. 19.

THACKERAY, W. M. (1848). "On Literary Snobs," in *The Book of Snobs*, Alan Sutton, Gloucester, U.K., 1989 reprint, chapter 16.

THACKERAY, W. M. (1860a). *Lovel the Widower*, Macmillan & Co., London, 1904 edition, chapter 2.

THACKERAY, W. M. (1860b). "De Juventute," a Roundabout Paper in the *Cornhill Magazine*, reprinted 1869 in *The Works*, Smith, Elder & Co., London, vol. 20, p. 73.

TROLLOPE, A. (1857). *Barchester Towers*, New American Library, New York and Toronto, 1963 reprint, chapter 20.

TURGENEV, I. S. (1867). *Smoke*, in *Collected Works*, Greystone Press, New York, 1940 edition, chapter 15.

TURGENEV, I. S. (1872). *Spring Torrents* (trans. Leonard Schapiro), Penguin Books, Harmondsworth, Middlesex, U.K., 1972 edition, chapter 44.

WHARTON, E. (1905). "A Tuscan Shrine," in *Italian Backgrounds*, Scribner & Sons, New York, pp. 86–87, 105.

WHARTON, E. (1912). *The Reef*, D. Appleton & Co., New York, chapter 14.

WHARTON, E. (1929). *Hudson River Bracketed*, D. Appleton & Co., New York, chapter 35.

WILSHER, A. (1985). "Gautier, Piot, and the Susse Frères Camera," *History of Photography*, vol. 9, no. 4, pp. 275–78.

WILSHER, A., and SPEAR, B. (1983). "A Dream of Fair Ladies: Mrs. Cameron Disguised," *History of Photography*, vol. 7, no. 2, pp. 118–20.

YONGE, C. M. (1864). *Hopes and Fears*, Macmillan & Co., London, 1899 reprint, part 2, chapter 16.

INDEX